HARROW COLLEGE LIBRARY

3 8022 00007027 6

D1465578

3 8022 00007027 6

THE ART OF JAPAN

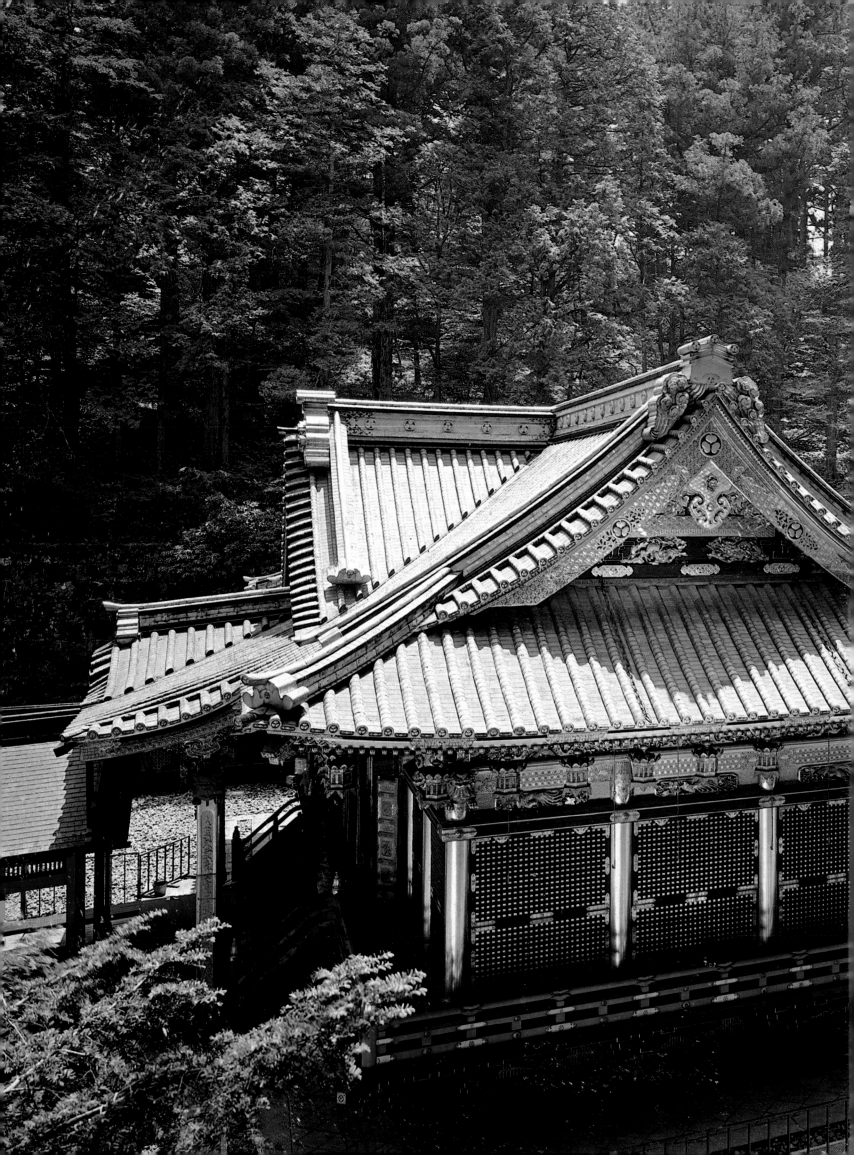

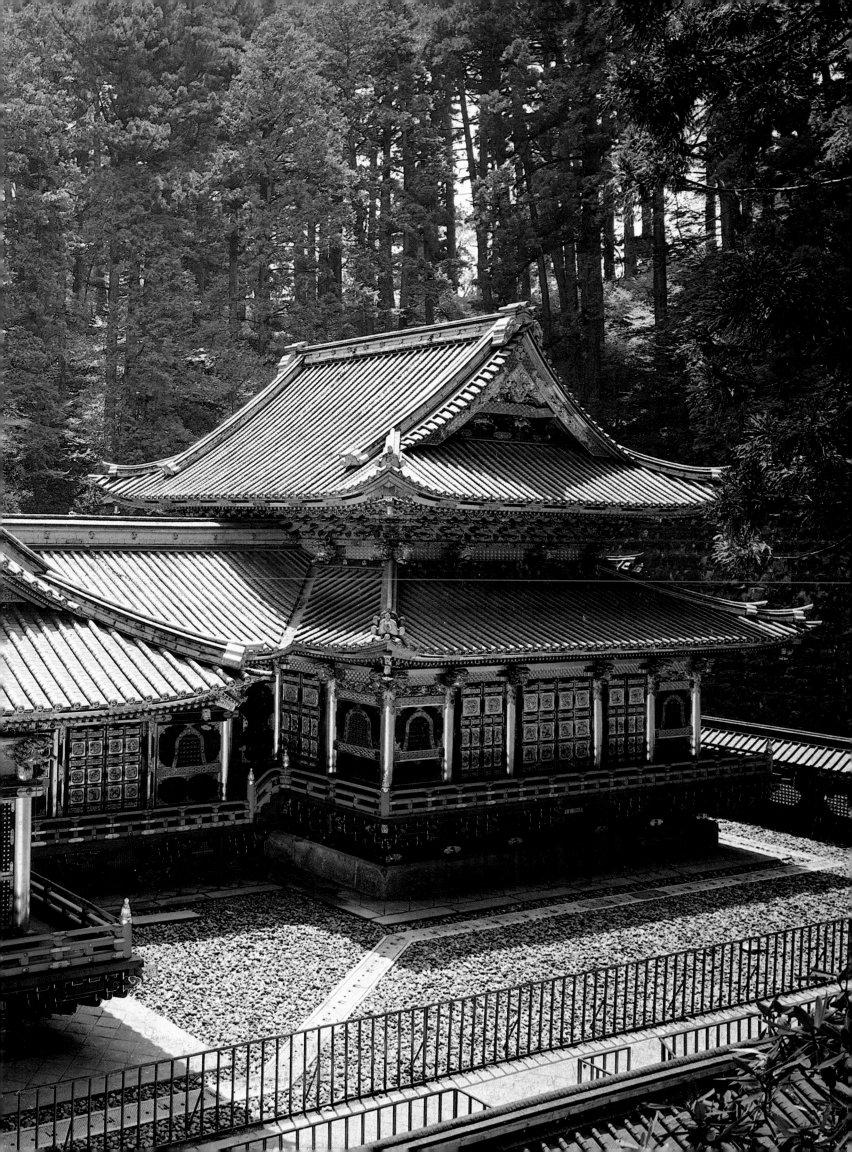

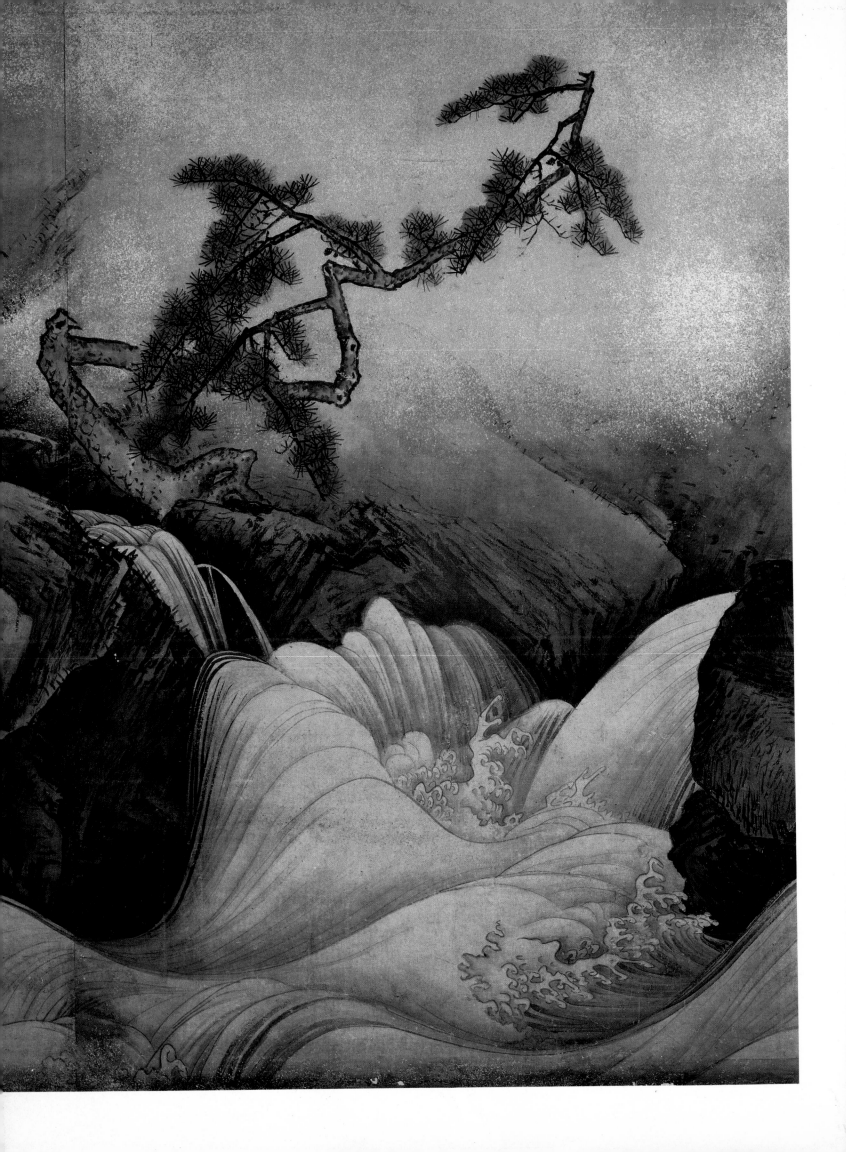

J. EDWARD KIDDER JR.

THE ART OF
JAPAN

CENTURY PUBLISHING
LONDON

Cover illustration: The Autographs of Yoshiwara Beauties *by Kitao Masanobu (1761–1816). Victoria and Albert Museum, London.*

On pages 2–3: general view of the Taiyū-in of the Rinnō-ji, a Tendai temple whose origins can be traced back to the ninth century. Nikko, Tochigi prefecture.
On page 4: river landscape by Maruyama Ōkyō (1733–95).

The meanings of the different Japanese terms are given in the text, but it may be useful to remind readers that the -ji, -dera and -in endings indicate a Buddhist temple, and that the terms jingu *and* taisha *indicate a Shintoist shrine, as does the -gu ending. The ending -e indicates painting, as in* ukiyo-e. Butsu *and* bosatsu, *even in composite names, are equivalent to "Buddha" and "bodhisattva". The main Buddhas have the following Indian equivalents:* Shaka, Sākyamuni *(the historic Buddha);* Miroku, Maitreya; Amida, Amitābhā; Dainichi, Vairocana; Yakushi, Yakshi *(the Buddha of healing);* Kannon *is the bodhisattva Avalokitesvara.*

Drawings by Marina Bighellini

Captions translated by Geoffrey Culverwell

Copyright © 1981 Shogakukan Publishing Co. Ltd, Tokyo, for the illustrations
Copyright © 1984 Arnoldo Mondadori Editore S.p.A., Milano, for the international edition
Copyright © 1985 Arnoldo Mondadori Editore S.p.A., Milano
English translation copyright © 1985 Arnoldo Mondadori Editore S.p.A. Milano

British Library Cataloguing in Publication Data

Kidder Jr., J. Edward
 The art of Japan.
 1. Art, Japanese
 I. Title
 709'.52 N7350

ISBN 0 7126 0787 0

First published in Great Britain in 1985
by Century Publishing Co. Ltd,
Portland House,
12–13 Greek Street, London W1V 5LE

Printed and bound in Italy by Arnoldo Mondadori Editore, Verona

CONTENTS

Prehistory 9

The art of the Yamato aristocracy 27
FOURTH–SIXTH CENTURY

The Asuka period 41
552–645

The Hakuhō period 57
645–710

The Nara period 85
710–794

The Early Heian period 117
794–893

The Late Heian period 139
894–1186

The Kamakura period 177
1186–1333

The Muromachi period 213
1334–1573

The Momoyama period 243
1574–1614

The Edo period 279
1615–1868

Bibliography 315

Index 316

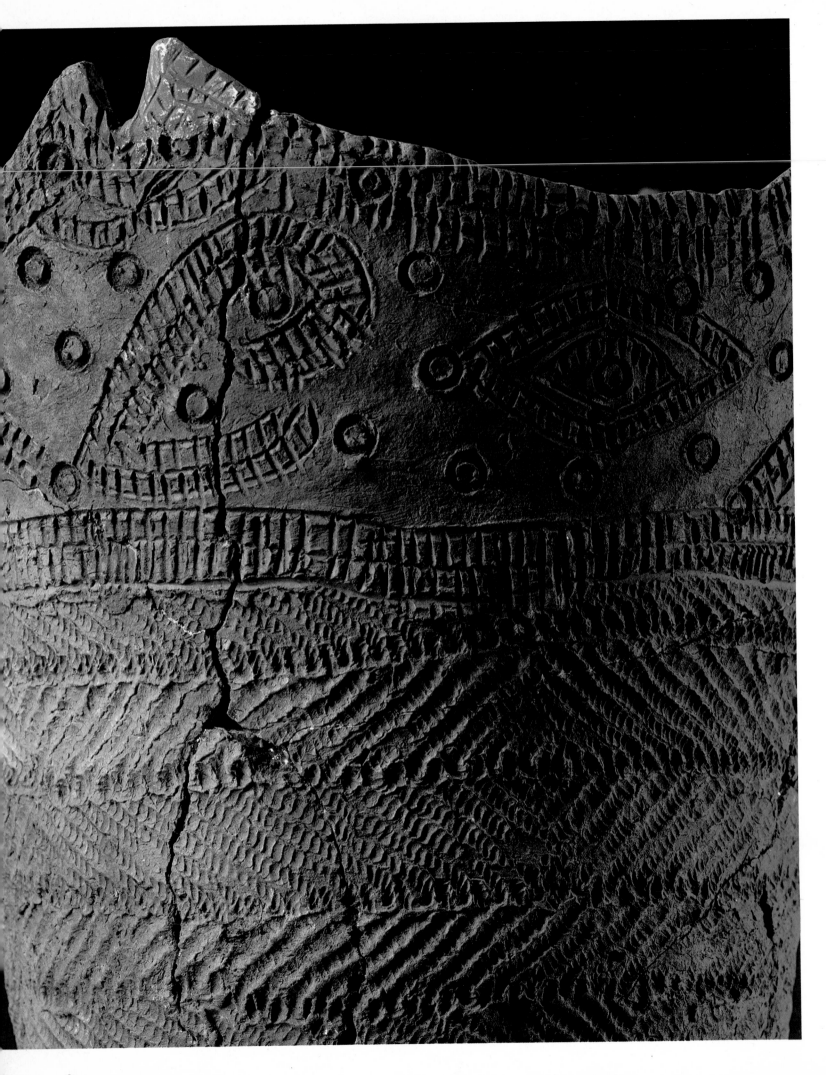

PREHISTORY

Above: prehistoric stone figure, thought to be a small female idol, discovered at Lake Nojiri.
Opposite: vase of the Jōmon period (detail). Nanzan University. On page 10: front and rear views of clay figurines with heart-shaped heads. Jōmon period. Kyohara, Azuma village, Gumma prefecture. On page 11: vase decorated with human mask. Jōmon period. Tokyo, Municipal Commercial College No. 2.

When ancient people first appeared in "Japan" a single land mass surrounded an immense lake, the present Sea of Japan, offering a vast area for the earliest people moving east. The "land-bridges" were open through both a northern and southern avenue, but in view of the glaciation in north Asia and the intensity of the cold, the northern route was inhospitable and never extensively used.

What can now be called the Korean route was the chief approach from China and, historically, always the preferred means of access to Japan. Additional migrants arrived from the south. This eastern edge of the continent was entering a late stage of about 100,000 years of intense volcanic activity involving a belt of volcanoes running the entire length of the country. A few are still active. Their eruptions laid down layers of ash, forming such features as the large Kantō Plain.

A good archaeological record of the people who made their way into "Japan" during the last 30,000 years has been progressively revealed in excavations carried out since 1949 when the first Palaeolithic site was identified. These people hunted the large herbivores as they migrated east, probably as people in China occupied more of their feeding areas. Chief among these animals were the Naumann elephants.

The first artistic products were made in the Upper Palaeolithic and were responses to religious ideas. Power was solicited from the forces of nature, often through an individual acting as a medium. The arts contributed toward this psychology of survival, with stylized figures in ivory and stone being carved, extending the practice of Europe and north Asia to Japan.

Elephants were trapped at Lake Nojiri in Nagano prefecture in swampy beds along the water's edge and several thousand bones have been recovered at low water from normally submerged shores. The 1975 excavation unearthed a finely shaped figurine made of the core of a Naumann elephant tusk. It came from deposits between 31,000 and 25,000 years old. The middle is strongly constricted and each end is smoothly tapered. Popularly called the Venus of Lake Nojiri, the upper "front" is unfortunately sheared off where "face" working had weakened the structure of the material. The lower "back" has a few thin scratches of uncertain meaning.

Its finely shaped symmetry indicates a maker of considerable skill backed by a solid tradition. It is unlikely to be the only one of its kind.

Another fertility object, closer to the end of the Palaeolithic period, is a "stone" club (*sekibo*), spoken of as in the shape of a *kokeshi* doll, found in the Iwato site in Ōita prefecture in the southern part of the country. Along with parts of two others, it was located in a layer dateable at around 12,000 B.C. Made from chlorite schist, a stone with a scaly surface and badly weathered through contact with the soil, the head was pecked out in rudimentary, faintly visible features of eyes and mouth. The lower part is a straight undecorated shaft. These are the oldest known examples of a long history of stone phallic symbols which became countryside protectors in much later times.

An abrupt worldwide cooling took place between about 12,000 and 10,000 years ago, following the long warming trend. The big game had been unable to survive the rising temperatures, the increasing pressures of improved hunting techniques and decreased land space. The southern and Korean routes were the first to go, followed by the northern route.

The search for alternative food sources led to marine fishing and shellfish gathering. Baskets were woven, dogs domesticated, dugout canoes made and, in Japan, pottery was invented in the south. The practice of cooking in pots made edible some plants which were otherwise useless and made others more palatable and sometimes more nutritious.

A sequence of carbon-14 dates, the stratigraphy in the sites where the earliest pottery is found, and the typological development of the pottery as it was diffused to other parts of the country are all evidence for its remarkable antiquity. Starting around 10,000 B.C. in Nagasaki prefecture, the earliest types were carried toward the north while the hunters, who were reduced to smaller and faster animals, took their finely balanced biface points used for spears and darts and adapted them to arrows and bows for quick, long range shots.

Modern studies of the Jōmon period, indeed for all of Japanese prehistory, started in 1877 when Prof. Edward S. Morse excavated the shell mounds of Ōmori between Yokohama and Tokyo. His site

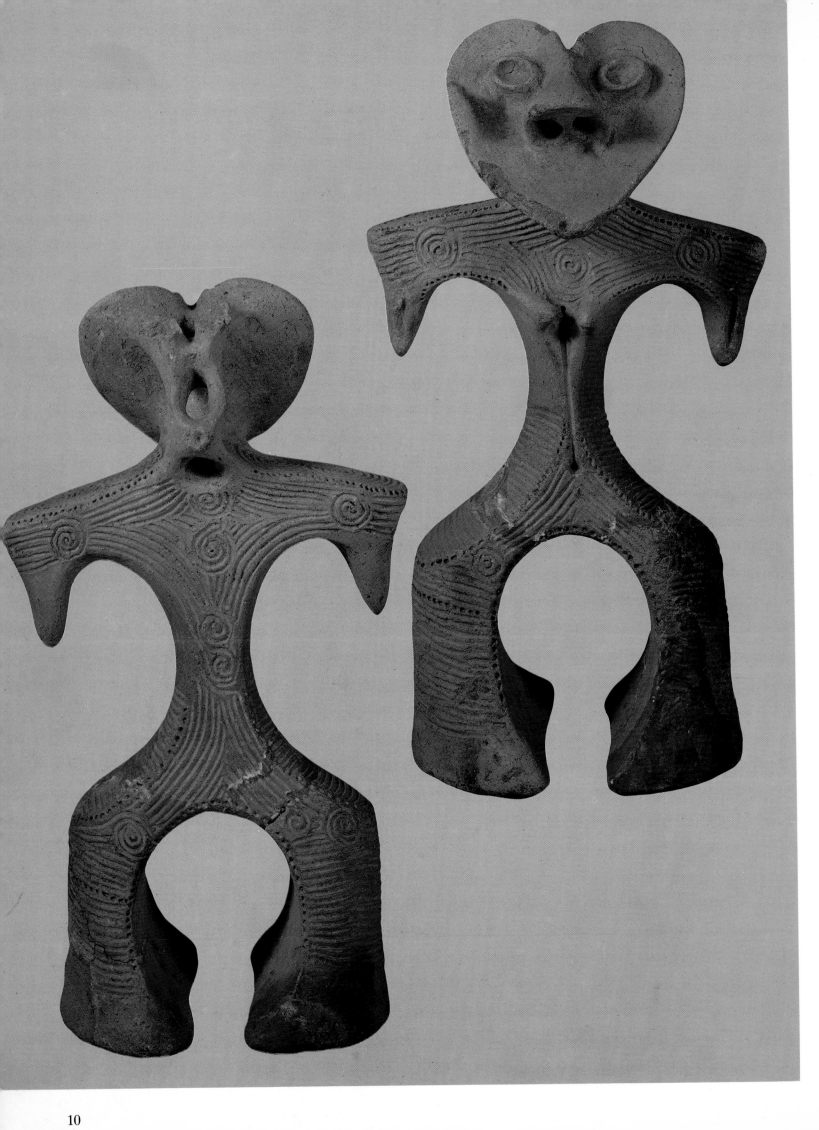

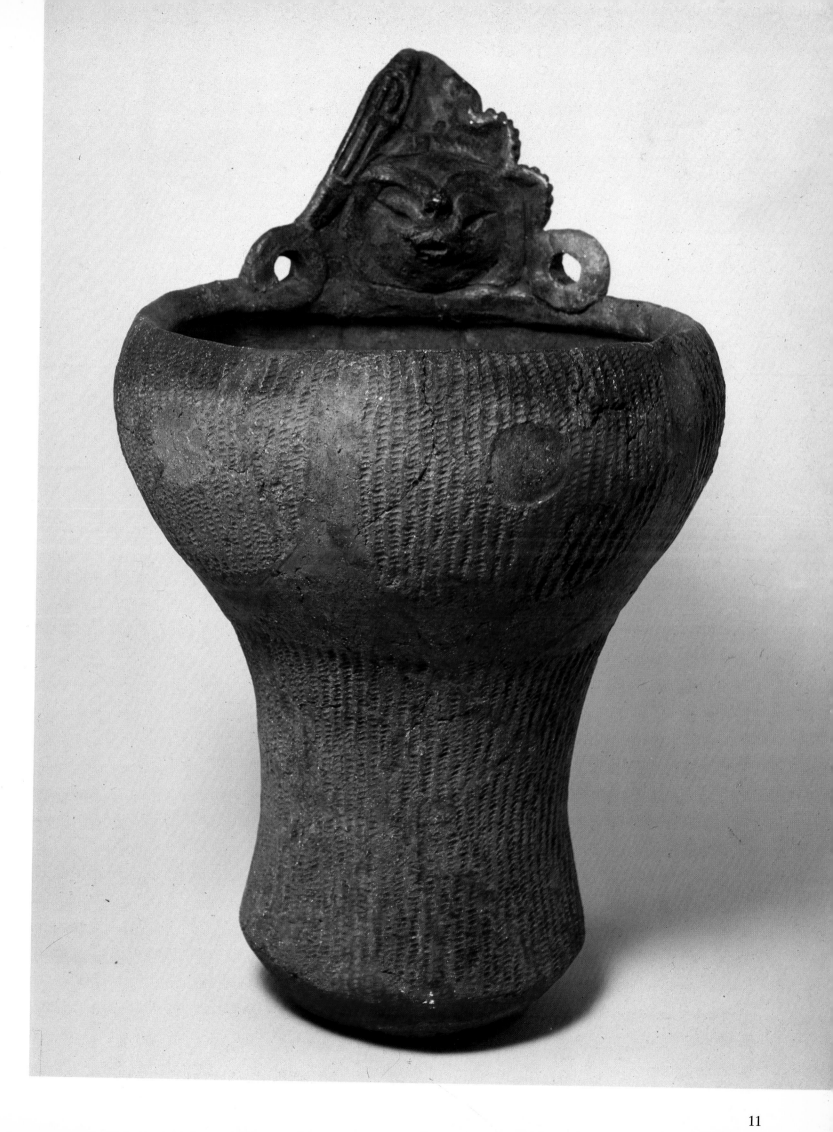

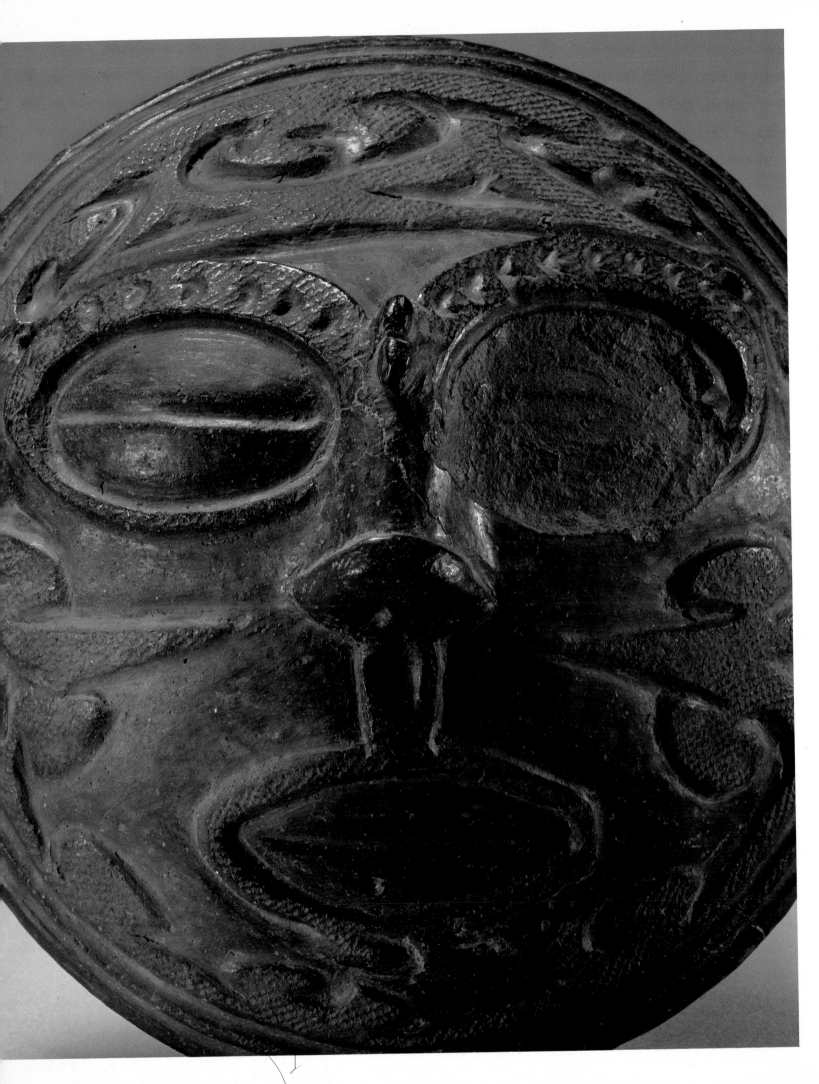

report comments on the "abundance" of pottery in "an infinite variety of form and ornamentation," and he describes it as being "cord-marked." Some time later the term was translated literally as *jōmon* and it eventually came into popular use for the entire period.

Pottery, as the major art form throughout the long preagricultural millennia, warrants an adequate description. Pottery is the most responsive artifact to influences, cultural changes and group needs. Huge quantities were produced and vast amounts have been unearthed. For thousands of years pots were used exclusively for cooking and later for storage and burials. As emerging social needs and rituals called for new ceramic forms, clay figurines were made, and earrings, offering stands and lamps were added to the repertory. Supplementing the ceramic products were lacquer, basketry, wood, ivory and horn carving which stylistically tended to follow the lead set by pottery. Some stone decorating was also done.

Because of the great length of the Jōmon period it was necessary to reduce it to manageable divisions. The system was drawn from pottery typology and its framework was devised in the late 1930s. On the basis of carbon-14 dates and other dating methods, the approximate time span of these subdivisions is as follows, omitting the problems of regional overlapping: Earliest: 9000–5000 B.C., Early: 5000–3500 B.C., Middle: 3500–2400 B.C., Late: 2400–1000 B.C., and Latest: 1000–350 B.C.. In the later stages the growth in social complexity brought on more rapid changes and shorter periods. This simplified version, however, is misleading as far as regional diversity is concerned, which was strong in Jōmon times. The period is characterized by shifting dynamic centers and local cultural lags.

Japan in the Jōmon period was not as isolated as is usually believed. Among the Jōmon arts attributable to foreign sources are items like stone earrings and clay ear lobe plugs, red painted clay drums and black burnished pottery. Cultural practices of outside origin might include the mutilation and removal of teeth, and the painting of human bones with red paint. Foreign flora are gourds, yams and taro and, eventually, rice. Among the tools, also possibly foreign, are polished

stone axes and cleaver-like implements. Borders of water provide Japan with some natural insulation, but its islands were always visible from Korea and at no time was Japan totally cut off from outside contacts.

Jōmon pottery went through several phases, the first strictly in the service of cooking. Always handmade, fired in the open under uncontrolled conditions, it remained a rather porous earthenware, occasionally in late stages waterproofed by lacquer painting or burnishing techniques.

The Kantō people used a simple form of cord-marking consisting of single strands twisted around a small roller, applying this to cone-shaped pots. People in the south produced bumps and zigzags on the surface by rolling a small carved stick over the leathery clay, in a rouletting technique. Northerners had more variety in decorating techniques, but most preferred to use shells, either as scrapers or as edge imprinters.

The temperature was rising steadily throughout Early Jōmon and peaked toward the end of the period. Deep valleys were flooded and more bays and inlets created, expanding the coastline enormously. This is when Shikoku and Kyushu became islands. Warmer conditions made life easier and the people built larger and sturdier

houses clustered in small hamlets. Some houses had indoor fireplaces, and storage pits were made both outside and in. This was the first break in the meager hand-to-mouth existence.

The switch to flat pottery bases was associated with these larger houses and more indoor living. Flat bases were practical on the hard, tamped down floors. Short plant fibers were used for clay tempering and were probably mixed in experimentally with flat bases and larger pots. Cord-marking had matured into heavy, dense indentations. Parallel curvilinear patterns and crescent marks produced with the end of a split bamboo stick represent the first serious effort toward artistic designs. This technique is referred to as nail-marking (*tsumegata-mon*),

Opposite: terracotta mask from Aso (Akita-ten). Jōmon period. Institute of Anthropology, Tokyo University.
Above: stone arrowheads.
Right: four ornamental objects dating from the final phase of the Jōmon period.

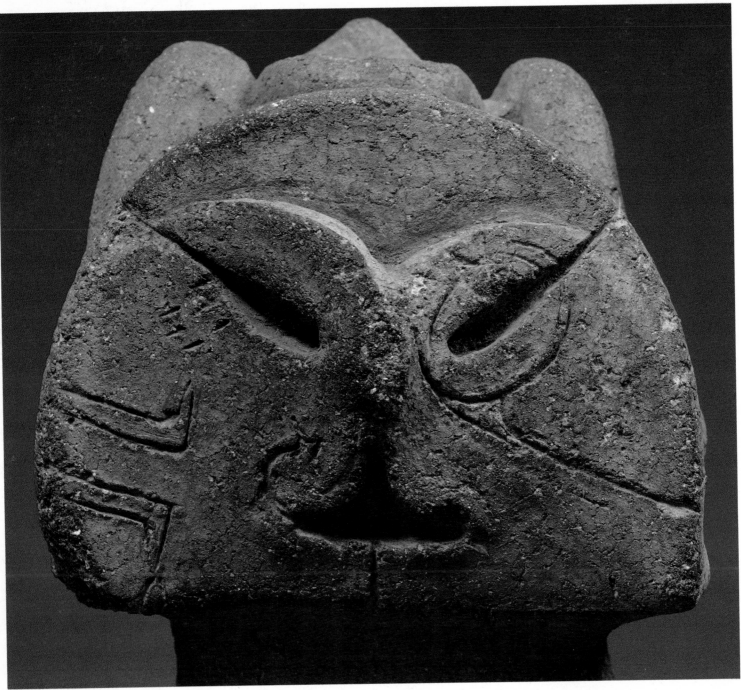

as the decoration resembled nail prints to the archaeologists first studying it. The shapes stayed simple. In the Kantō the walls flared toward the rim and frequently bulged.

Middle Jōmon people thrived on the abundant nut harvests and lived in larger villages. The population reached its maximum at this time, and was concentrated across central Japan, particularly in the lower mountains. The quantity of pottery, size of the pots, new shapes and variety in decoration – including zoomorphic motifs – are all a reflection of a more relaxed life, added leisure time and appreciation of the art. Immense mountain sites may contain scores of pit-dwellings, many of which were rebuilt and relocated. But pottery typology suggests that only a few were in use at

Right: clay figurine, dating from the third or second millennium B.C., of a half-human, half-animal being. National Museum, Tokyo. Above: detail of the head.

any one time. The houses were erected with four or five posts to support crossbeams and poles were topped by a cone-shaped roof. The fireplace in the center contributed greatly to the comfort of indoor living, and the floor plan encouraged family intimacy around the hearth.

Storage pots took over the heavy duty work from the cooking pots. The latter were both boilers and steamers. The pots are low-fired, large, heavily decorated in strong relief, often as applied ridges forming oval panels. The clay is reddish

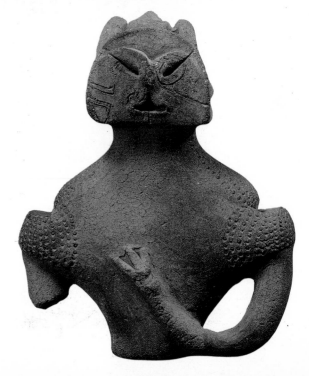

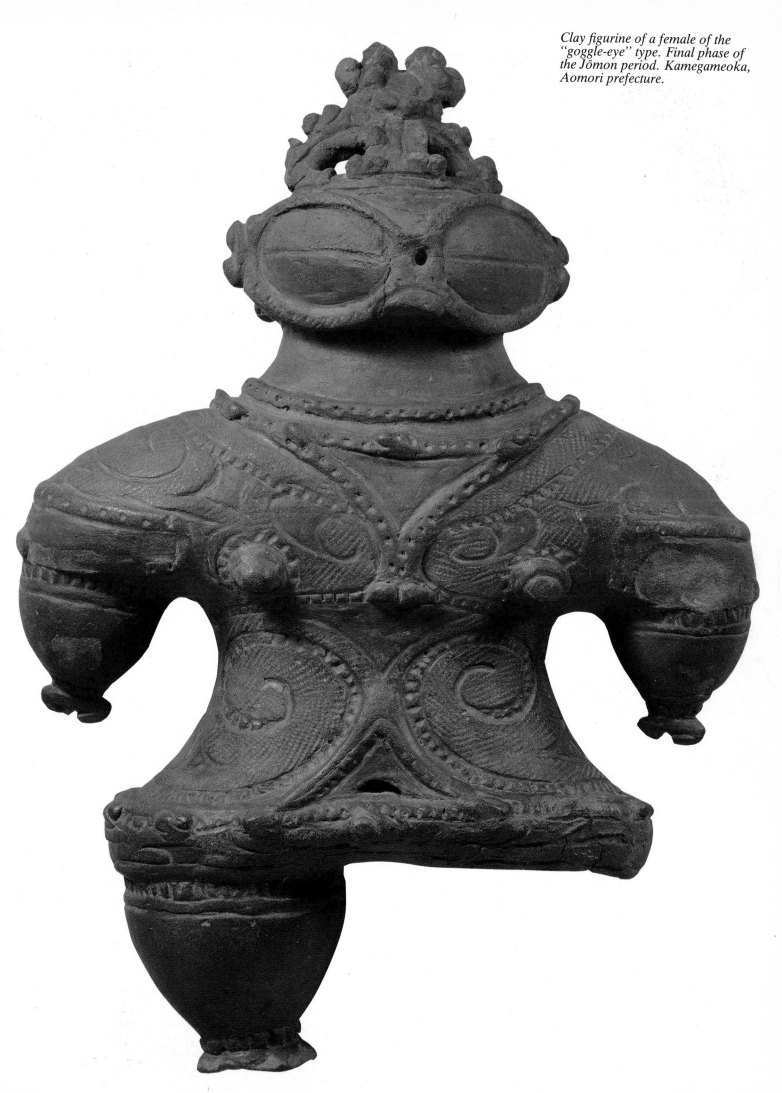

Clay figurine of a female of the "goggle-eye" type. Final phase of the Jōmon period. Kamegameoka, Aomori prefecture.

15

to salmon-orange colour. The style sprang to life.

Plastic décor is the dominant feature, with vessels often overwhelmed with asymmetrical handles, loops and rim ornaments, to the point of impairing their usefulness. But many broken pieces in sites indicate that vessels could do without a lot of the embellishments and may have become more functional in the process. While certain motifs are recurrent without symmetry, the overall scheme is not predictable. In fact, the panels are rather static. The pots have many fronts, as the decoration has little conformity to the shape until the latter half of the period. At that time the style was being carried toward the east coast and modified by the more conservative tradition of the area. Flowing spirals and oblique cord-marking are characteristic of the latter half of Middle Jōmon.

Excessive decoration was an issue at no other time in the history of Japanese ceramics, when the guiding principle of decoration complementary to shape was respected. Perhaps the conflict between decoration and shape/function was resolved at this point in time. All the exuberance considered, the imagination, liveliness and vigour of this style is unmatched.

Many appliqué ridges bear vague to explicit resemblances to snakes. There is little doubt that the *mamushi* is intended, Japan's only poisonous snake whose habitat is in the foothills and higher, partly because the motif is on pots in a region where snake cults are still celebrated today. Additionally, some vessels have a head resembling a rodent set into the luxurious rim decoration.

Middle Jōmon figurines are obese, with emphasized, distended buttocks and squirrel-like heads. All of these features were exclusive to mountain life and were abandoned as the people evacuated the region. Apparently several consecutive seasons of extremely damp weather and ruined nut harvests forced the population out.

If the Middle Jōmon style was made in the mountains, as is often said, and reflects a rugged life – sturdy houses with thick roof-walls, subhuman figurines, pervasive fertility cults, extravagantly decorated pots including zoomorphic symbols – the Late Jōmon style was shaped along the coast. It represents a more systematized life – light-weight

houses, anthropomorphic figurines, vessels decorated modestly in simple shapes with repeated motifs.

The deteriorating climate brought about a great deal of movement. The population scattered widely in the search for adequate sources of food, going in all directions but especially toward the south. For the first time the traditional regional distinctions were blurred. Marine

foods proved to be the most valuable source and the shell mounds along the east coast expanded dramatically. Some are hundreds of feet in length. A few contain pottery from Middle to Latest Jōmon, but most are primarily Late Jōmon. The number of female figurines is often so great one assumes that each household must have had its own. They are gingerbread types, more

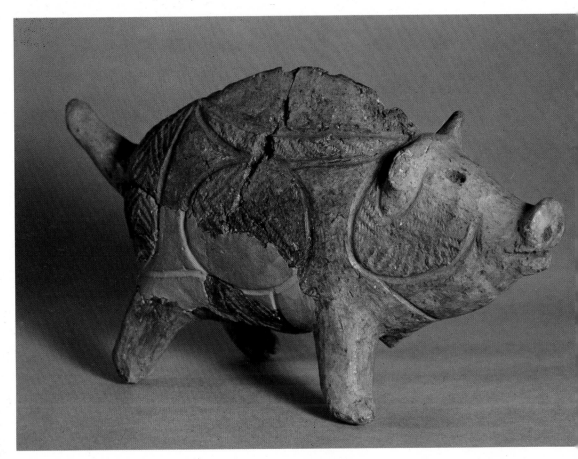

Above: figure of a boar. Municipal Teaching Museum, Hirosaki, Aomori prefecture.
Below: ear ornament.
Right: squatting figure. Municipal Teaching Museum, Fukushima. All these objects are made of terracotta and date from Latest Jōmon.

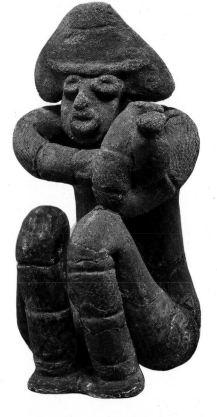

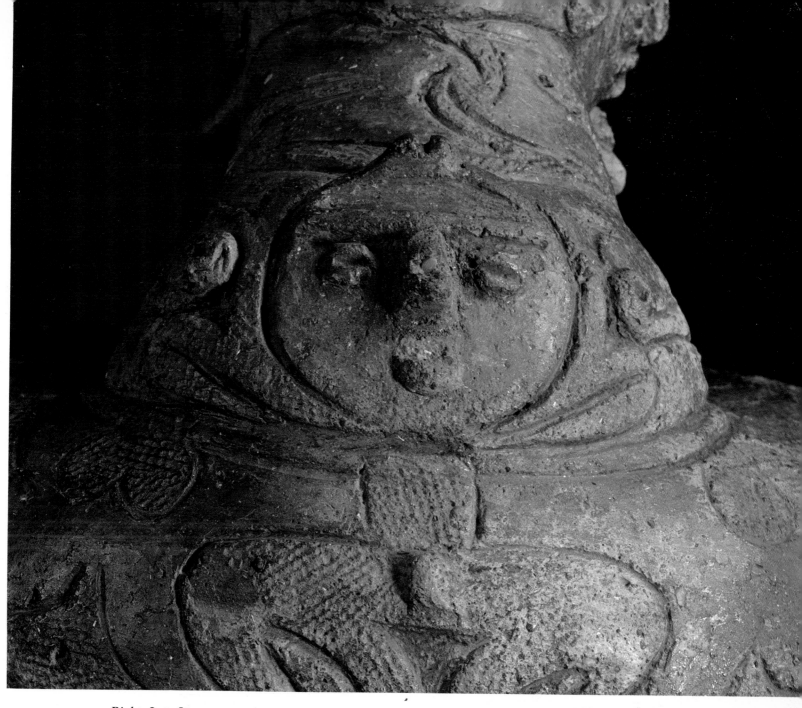

*Right: Late Jōmon ceramic vase
with highly stylized geometric and
naturalistic decoration. National
Museum, Tokyo.
Above: detail.*

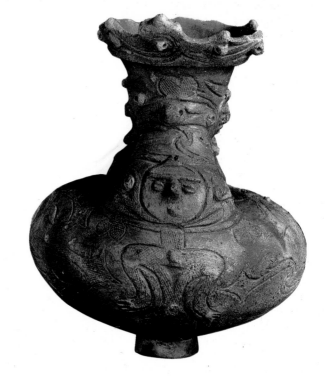

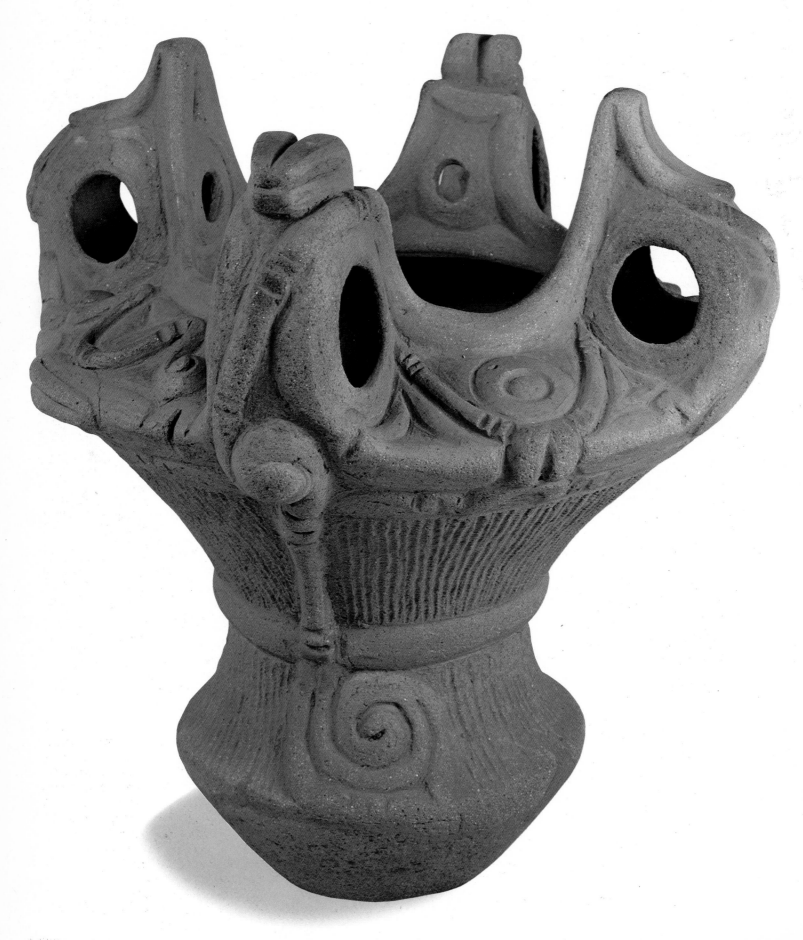

Opposite: vessel with handles and extensive decoration. Jōmon period. Archaeological Museum, Tokyo.
Above: jug with handle. Jōmon period.

human than the animal faces of Middle Jōmon. Triangular heads may be masks; stump arms and legs, enlarged breasts and protruding abdomens are characteristic of the coastal examples. Heart-shaped, tilted faces and more three-dimensional, and sometimes narrow bodies are inland features.

Thin-walled pots, vases and bowls in brown colours, made of refined clay, assumed unpretentious forms. The decoration, called erased cord-

marking (*surikeshi-jōmon*), that is, the rubbing off of the spill-over after the cord-marking was done in marked off areas and the surface was smoothed for neatness, spread to all parts of the country, from Hokkaido to Kyushu, as the people looked for better places in which to settle.

Some of the mountain shapes were dropped and new ones were added. There are spouted vessels with loops for attaching a rope handle, prototypes of the modern

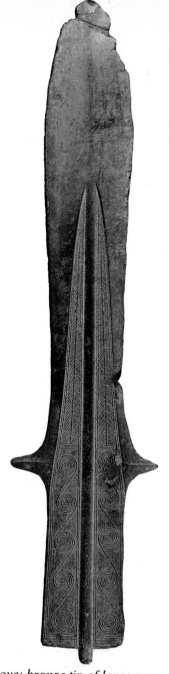

Above: bronze tip of lance or halberd with geometric decoration. Late Yayoi period. M. Oga Masaaki Collection, Okayama. Opposite: detail.

handled teapots, small cups and some strange and unique ritual shapes. Baskets may have replaced most of the large storage pots. Mat marks and leaf marks are sometimes seen on the bottom of these bases.

Vessels often have three or four peaks with which the areas of decoration are coordinated, for the first time making the patterns both recurrent and predictable. Shape was restored for its own effect, and the principle in Japanese ceramics of decorations enhancing shape was established as inviolable. Curiously enough, the poorest conditions produced Jōmon pottery's most characteristic theme, the refinement and taste of Late Jōmon zone cord-marking.

Lacquer, probably initially applied for waterproofing, appears first at the Early Jōmon site of Torihama shell mound in Fukui prefecture. Remains of baskets, combs and wooden bowls bearing red lacquer paint were found there. Lacquer soon became an art supplement. Latest Jōmon sites have yielded red lacquered combs, a basket and a wooden "sword."

The population was declining rapidly and Latest Jōmon in north Japan was the last spectacular flourish of a culture devoting more and more time to the ritual and social activities. All cultural and artistic vigour had disappeared in the south. The cemeteries were now much larger. Burials are grouped together and most of the remains are flexed. The Yoshigo shell mound in Aichi prefecture had about 340 individual preadult and adult skeletons. Stone circles had been in use in north Japan since Late Jōmon as burial and gathering places. Community ceremonies which enhanced social cohesion were increasing, perhaps as an unconscious response to the threat of extinction. The reason for this rapid decline is not at all clear, but may have to do with environmental exhaustion after Middle Jōmon overpopulation, nutritional deficiences from too specialized a diet, disease and infanticidal practices.

A distinction between ritual and domestic pottery can sometimes be drawn in the north. The former consists of numerous small vessels, usually decorated in low relief in horizontal registers of intense surface coverage. Interlocked S motifs and similar patterns are methodically repeated and move at different rhythms on different registers. They are cut back at an angle with a sharp tool, the technique resembling wood carving. Polyps along the rim are a popular feature. Textile and metal influences are implied by the many examples of black burnishing and red painting. There are pouring pots of very small capacity easily held in one hand, incense burners with openwork, limitless supplies of cups and bowls, and cooking vessels. All are in personalized sizes. Many are technically superb, the culmination of a rich artistic tradition.

Northern sites have yielded numerous female figurines. Many are hollow. Like the vessels, they may be polished and painted. Raised patterns are frequently cordmarked. There is much variety, but

the best known are the "goggle-eye" types with bloated bodies, arms and legs, and low relief decoration. The walls of some are paper-thin, a technique requiring production in sections and fitting together. The motive behind making them hollow may have been to provide space for the "resident spirit," giving "soul" to the object. Interpretations of the imposing eyes range from snow goggles through the "window of the soul" to the evil eye or hex. Personally, the symbolic element is more attractive, the eyes the route whereby the "soul" communicates with the higher spirits.

These are the most grotesque and provocative figurines. Few discoveries in the field have furnished decisive clues regarding the use to which the figurines were put, but in consideration of the length of time they were produced, several possibilities should be considered. They may have facilitated childbirth or have been used in effigy magic for diseases and have been intentionally broken at the point of pain, or they may have been simulated burials. This would not exhaust the range of possibilities.

By the end of the Jōmon period about 30 per cent of the skeletons have ornamental objects with them. Body and costume accessories were carved out of small pieces of bone, horn and occasionally stone. No two are alike. Carved stones include the so-called swords and slender phalli with decorated ends.

The turmoil in China associated with the break up of the Chou dynasty, the ruthless rule of the Ch'in and the enveloping of coastal tribes by the expansion of central power set in motion many of these fringe peoples. The spill-over into Korea – which was occupied in the north by the Han in the second century B.C. – sent ripples beyond. Migrants brought rice and metals into Japan.

Now it is known that rice reached Japan in the first millennium B.C., as indicated by charred grains on Late Jōmon pottery in Kyushu. It may have come from the east coast of China, carried by drifting fishermen. There is little to indicate at present that it was then being cultivated in the south of the Korean peninsula and Japan had no wild rice from which it could have been domesticated. One must look to a similar ecological zone for its source.

Bronze and iron objects were first brought over in about the second

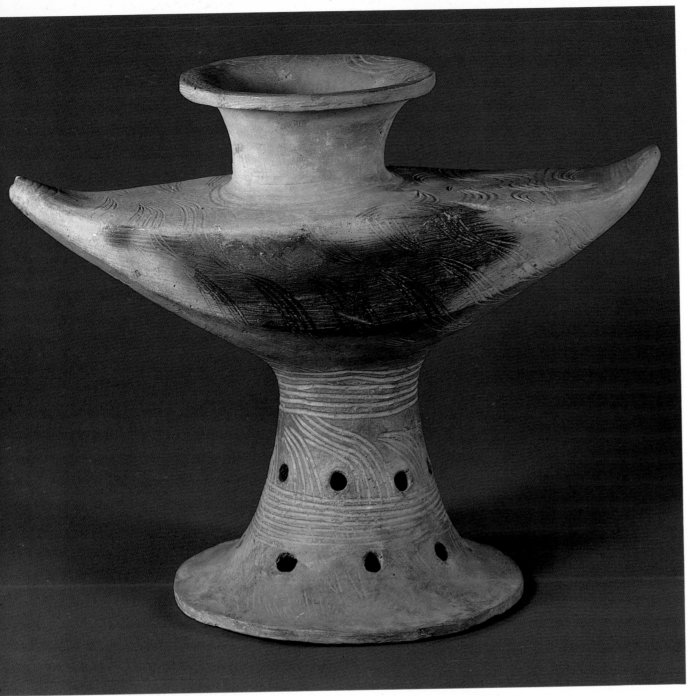

century B.C. and include bronze mirrors carried down by travellers from the Chinese colonies in north Korea. Bronze was used for ceremonial objects and iron for daily tools, the former being the mark of the aristocrat and the latter the sign of the labourer.

This stage of supplementing the regular acquisition of food with the cultivation of rice and the early use of metals is known as the Yayoi period. The name comes from Yayoi-chō, in the Hongō area of Tokyo, an area whose best known landmark is Tokyo University. A small shell mound had yielded non-Jōmon pottery from the time anthropologists of Tokyo University started to dig it in 1884. Yet it was decades before the material could be fitted into the evolving ideas of pre-historic chronology and it was not until after the Second World War that large Yayoi village sites were excavated and the real character of the culture was revealed.

North Kyushu had major markets for foreign goods, but rarely did these go further afield. Chinese objects were placed in or around jar burials in north Kyushu sites. The Japanese learned their bronze casting in the region of Fukuoka, at first producing Chinese and Korean-style weapons. But after copying foreign examples they turned to making ceremonial "weapons" of much greater size which they then proceeded to distribute eastward through the Inland Sea. The local metal trade moved rather briskly from north Kyushu toward the Kinki, while south Kyushu

Above: "boat-shaped" pot. Kofun period.
Opposite: cup with lid surmounted by a bird (or snake), discovered in the Sumiyoshi-Taira mound. Kofun period.

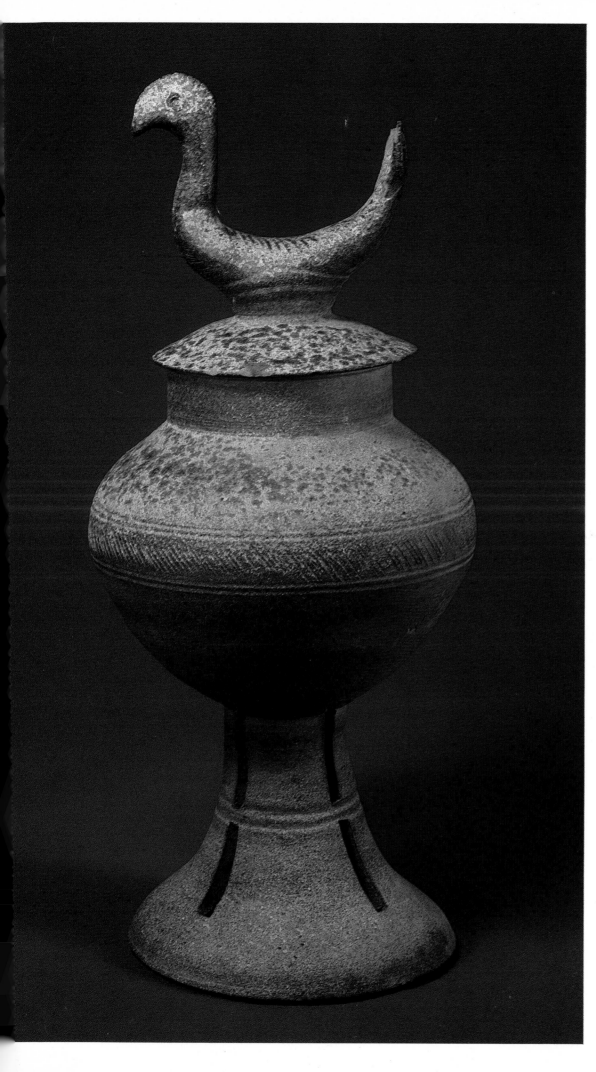

remained almost untouched by this stream.

Foreign bronze objects may have been melted down for local use, especially weapons and horse bells, or raw materials may have been acquired abroad. The relatively large production of bronze objects leads one to suppose that the supply problems were solved in favour of local materials as casting centers in the Kinki were established.

The first of the bronze bells were ineptly made and the decoration amateurishly handled. Within a century, however, they were cast in shops in the Kinki in a much improved technique and were widely circulated from there. Several hundred are known, and many that have been found in remote sites can be identified as having been produced in the same sandstone moulds. Their ultimate destination was burial in the ground, where they are sometimes found in groups, presumably to boost fertility and protect the crops. The distribution of the bells points to Yamato area controls on their production and benefactions granted in their distribution.

About ten per cent of the bells bear small "thread relief" figures, including some simple pictures of activities. These are valuable illustrations of hunting scenes, people pounding rice, storehouses and birds, animals and insects which had some meaning in the context of the earth's productivity. They also show the current concepts of artistic rendering. Other examples are scratched on pottery.

Such casting required only simple engraving on the mould. The bell with the largest number of figured panels is reportedly from northeastern Shikoku and was recovered early in the nineteenth century. The entire spectrum of early artistic principles appear on it. Two of 14 found in 1964 at Sakuragaoka in the hills above Kobe each have four panels on either side, all bearing figures. One has a curious scene of three figures. One man wields a sword and holds another person as though he is about to decapitate him. A third tries to intervene. A common Japanese interpretation calls it an effort to maintain peace, but it may be a sacrifice associated with the ceremonies, or is the dispatching of an enemy. The bell belongs to the time when the groups were forming larger alliances to control land and water sources and solidify their

gains. The "fortified" villages with high land surrounded by ditches are not a Kyushu phenomenon but are more frequently met much farther east, notably into the southern Kantō.

The bell from Shikoku is still the most ambitious. By considering the full scheme on both sides one notes that most creatures go in pairs: two salamanders, two dragonflies, two cranes with fish in their beaks, and two turtles. By inference of size and longer neck, one of the latter should be male, the other female. One hunting scene is of a deer, the hunter with a Japanese-style long bow, and another of a wild boar, the hunter aided by five trained dogs. Two people pound rice, a storehouse is planted firmly on the ground line, and a shamanistic figure is in the midst of an ecstatic leap, well up in the middle of the panel.

Graded from the top down as simple to complex scenes, the airborne, smaller creatures tend to be in upper panels, the bird and water creatures in the middle, and the terrestrial creatures in lower panels. The clarity of the pairing was sacrificed for this artistic scheme. Along with this are varied viewpoints. Small flying and crawling creatures appear in aerial view, larger ones and quadrupeds in side view, and humans in a kind of twisted form, the shoulders *en face*.

Once the animal world enters the art, scaling and proportioning come in for consideration. The solutions to these problems have no particular counterpart elsewhere in east Asia, giving the bell art a peculiarly Japanese character.

Interpretations of these subjects all lead to the theme of food: hunting, preparation, storage, ceremonial dances and auspicious fauna of the autumn season. It may be assumed that the burial of the bells was believed to ensure good harvests in succeeding years. The intensity of the ritual is underscored by the irretrievable nature of large quantities of the most valuable material of the time.

Turning to the pottery of the Yayoi period, it is distinct from Jōmon pottery in almost every respect. It was fired at a higher temperature, has a reddish colour, and was made in set shapes for cooking, storage and rituals. The first two are pots with appropriately wide or narrow mouths, and the third appeared by Middle Yayoi in the form of stands, supports and unutilitarian objects. Yayoi pottery has a practical, domestic, daily ware quality about it. Decoration is chiefly combing, some fine cord-marking north of Shizuoka, and sometimes red painting. The "flowing water" pattern is limited to the Kinki.

Pottery was used for burial jars, singly or doubly, but burials were carried out in other ways: wooden coffins, stone cists, mat burials, and trench burials on the four sides of a square, each side the length of a body or more.

In considering the production, transportation and some form of marketing of these and other goods, such as textiles, tools and farm products, it is apparent that a stratified society was developing. The Chinese description and the supporting archaeology indicate a flourishing trade or exchange business and some social ranking.

Among the other new arrivals which changed the complexion of the Japanese arts was a major one in architecture, the raised storehouse. It probably came from the east China coast. The Yayoi house was not a great departure from the Jōmon house in its oval plan, shallow depressed floor, rather consistent use of four supporting posts and a roof-top ventilator section.

On the other hand, the raised storehouses were constructed of sawed wall and floor boards and planks set at right angles, and therefore had the potential for regular inset doors and windows. Freestanding poles at either end of the granaries supported the ridge pole on top. Later clay models of storehouses dating from about the fifth century show them to be without windows. A single door on a short end was reached by a notched ladder. The floor was elevated well above the damp ground and away from most predatory creatures. The bases of the supporting posts were firmly set on wooden plates in the mushy soil, and rat guards at the top of the stilts fended off field mice. The sites of two storehouses found at Toro in Shizuoka suggest the use of one by the occupants of about five residences, and much emphasis on community ownership of tools and equipment.

Even before the end of the Yayoi period some prominent persons had elected to have residences in this style, apparently quite willing to forego a fireplace for a position of superiority over their neighbours. In any event, the history of this type of building is one of extraordinary importance in the evolution of Japanese architecture. It became an upper class dwelling, the home of the shaman or chief religious person, and the characteristic type of early Shinto shrine. The dual use of the Chinese written character *miya* or *gū* for Shinto shrine and prince (and by extension, palace) reflects one step in the direction of a "priest–king" system.

Tribes in western Japan may probably be identified with the early phase of the Yamato mythological cycle involving the conquest of the Eight Island Country by the grandson of the Sun Goddess. He and his entourage fought their way into the Kinki region, settling at Kashiwara, as ancient literature tells us. "Emperor" Jimmu is the personality around whom the stories revolve, and the cult symbol is a spear.

This story illustrates a cultural and economic shift of power from Kyushu to the Kinki. Chinese historians described – and geographically misplaced – the "country" of Yamatai, the chief kingdom of the land of Wa (Japan). Since medieval times this classic riddle has intrigued the Japanese, who write about one book a year on the subject: if the distance is right, the direction is wrong; if the direction is right, the distance is wrong. Yamatai was ruled by a female shaman known as Himiko who held her position from about A.D. 183 to 248. She was followed by an inept male ruler whose presence created nothing but chaos, so a young girl was installed to replace him. The Chinese historians say Wa was in a state of civil war. There are stone weapons and villages embanked for defense. The Jōmon people were entrenched and unfriendly to groups pushing east, which were sometimes very numerous. Those looking for better rice lands and raw ores were invading already occupied territory.

The myths took shape early and were either originated by the Yamato tribe or adopted by them. The people who settled in the Kinki used bronze bells as their cult symbol, but this fact failed to enter the literature in the same way as the spears did, suggesting that the mythology was based on their earlier, Kyushu experiences.

Opposite: bronze bell with figured panels, discovered at Sakuragaoka. Late Yayoi period. Hyogo Municipal Archaeological Museum, Kobe.

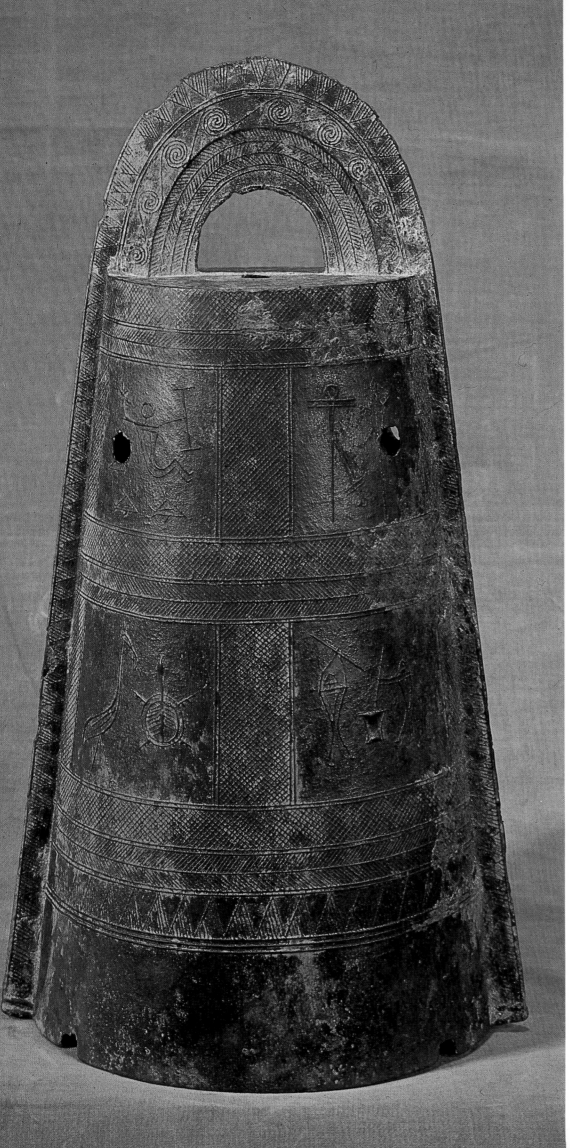

The foundations of Shinto ceremonial practices, the communities' celebrations of life and supplications for good harvests, offspring and improved conditions, were laid at this time. Yayoi has few personal relics. There are almost no body and costume ornaments. Most of the archaeology is witness to an overwhelming communal sense. The pervasive similarity in each kind of object is new to the arts and is the kind which arises when craftsmen and artisans are trained producers and they in turn train others.

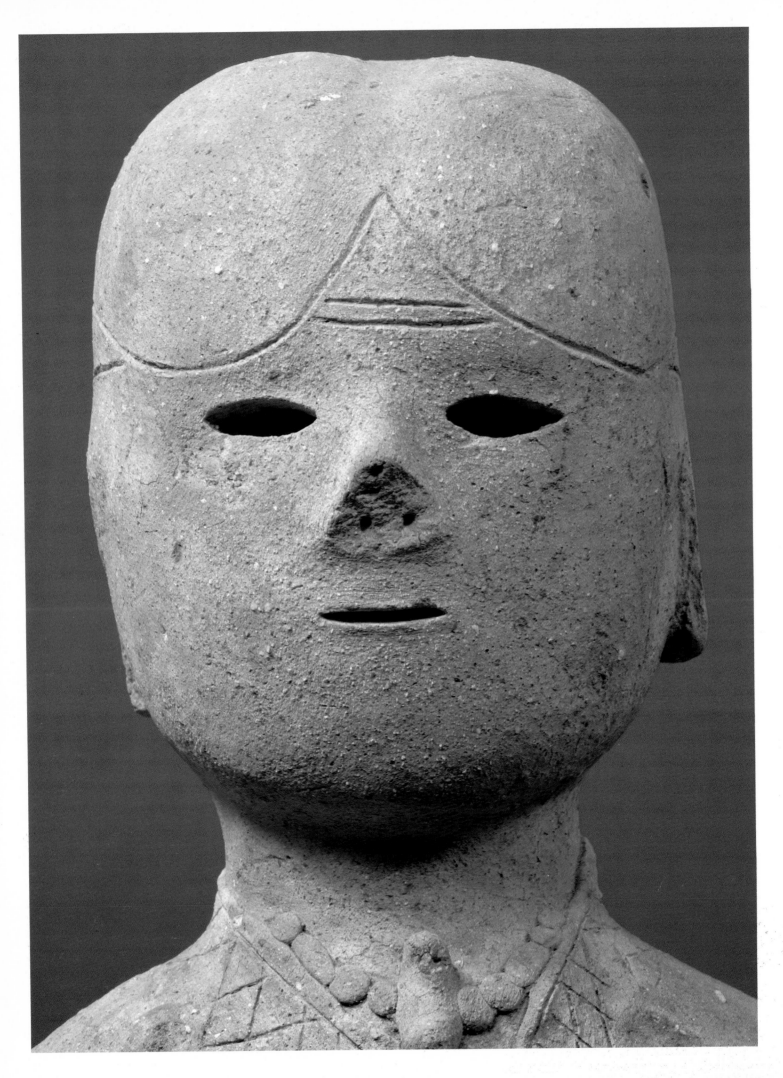

THE ART OF THE YAMATO ARISTOCRACY

FOURTH–SIXTH CENTURY

Archaeologists have designated the period known by the numerous tumuli scattered around the country as the Kofun period, the Old Mound or the Tomb period, and begin it near the end of the third or the beginning of the fourth century A.D. Historically, the Yamato state was formed at this time, as the imperial system and the noble families established their classical relationships.

Mound building had begun in a modest way in the Yayoi period, but the first monumental tumuli were constructed in the Kansai region, perhaps in the Nara basin, and spread from there to almost all parts of the country. The practice of burying the dead under earthen mounds had a long history in north Asia, China and Korea, but the Japanese seem to have added a rather particular feature to the tradition. Along with countless round mounds, one type is composed of a square in front and round knoll behind, *zempō-kōen* (square front, round back) popularly spoken of in English as keyhole-shaped.

It must be more than coincidental that the spread of keyhole tomb building seems to fit the extension of Yamato influence. They are like a Yamato trademark, and their construction in remote areas must have had a bearing on the expanding network of Yamato alliances. Perhaps their construction even signified a form of allegiance to the central authority.

In the earliest stage, the actual burial was done in a trench or consisted simply of stones piled up like a box at the top of the mound, but around the middle of the fifth century a new system of building a stone passageway and one or more stone chambers was begun in south Japan under Korean inspiration. As engineering techniques improved, this method moved into other parts of the country, stimulated in some areas by conducive geological conditions. A few tombs contain stone sarcophagi, and most were often profusely stocked with grave goods, in a lavish practice which invited much looting through the centuries.

Supplementing the archaeology of this period is the invaluable information from Japan's oldest texts, the official history books known as *Kojiki*, Records of Ancient Matters, submitted to the court in 712, and the *Nihongi* or *Nihon Shoki*, Chronicles of Japan, compiled in 720. Both books have much in common. Beginning with the so-called Age of the Gods, they carry the traditional mythology of the Yamato tribe into historical times, give detailed descriptions of the reigns of the "emperors" and describe the complexities of relations with Korea.

The *Kojiki* is concise and its last chapters are exclusively devoted to genealogy. The *Nihon Shoki* is far more complete, often offering several versions in the mythological sections, and carrying the narrative through the reign of Empress Jitō to 697. Writing the books was a process of rationalizing and validating, with court editors justifying the claims for authority through divine origins and great antiquity. Merging myth with history was inevitable, all purposefully done to serve the interests of the state. These books became at different times, and notably since the eighteenth century until 1945, the philosophical base for the divinity of the ruler and the superior state.

The earliest "emperors" can be dismissed as traditional types, but from the time of the official tenth ruler, Sujin, who by one account is called the "first ruler of the land," some degree of reliability seems to exist. He died about 258 or 318, in the 60-year cyclical dating system, and this makes a good starting point in considering the question of emergence of the Yamato state.

A theory first published in 1964 that horse-riding people from north Asia swept in from Korea – where they had settled long enough to learn the fine art of rice cultivation – and established the Yamato state gained a great deal of publicity and popular acceptance. The presence of horse riders in early Japan is an acknowledged fact, as 300 or more tombs have yielded horse trappings, but the theory did not match the archaeology and has been recognized as an oversimplification and a misdated concept.

A whole new set of grave goods began to appear in the new style of tombs after the middle of the fifth century. These include a variety of equipment used by horse riders, Sue pottery, costume and body ornaments, gold crowns, and wall and sarcophagus decorations in tombs. The economic system branched out rapidly under the *be*, well organized craft and other labour groups, whose occupational training was largely hereditary and Korean directed. With this economic base, the rulers were able to establish themselves more firmly, affiliate with and rank the tribes and test their loyalties.

Opposite: detail of a haniwa. *The* haniwa *were cylindrically-shaped funerary effigies of clay.*

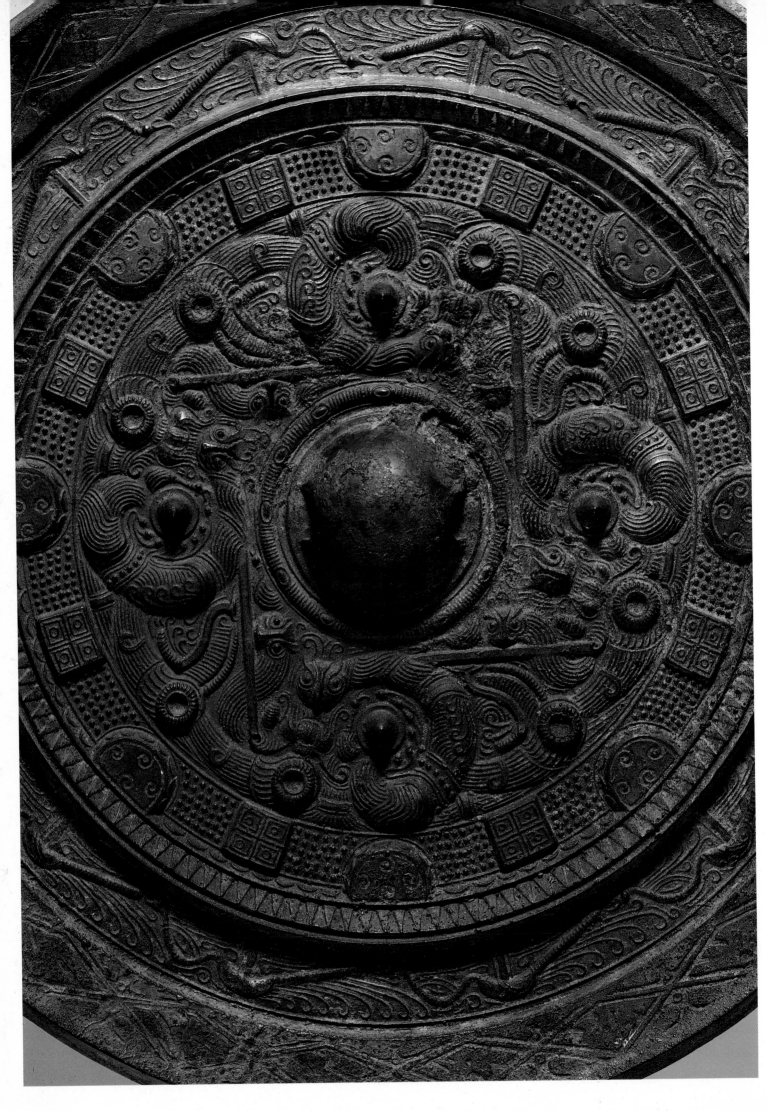

Throughout this critical phase Yamato writers made no secret of the presence of Korean instructors in almost every aspect of society and the arts. During the reign of Emperor Yūryaku, that is to say in the latter half of the fifth century, a plague was decimating the workmen, so the emperor ordered the Korean heads of the four *be* of potters, saddlers, painters and weavers, along with the interpreter, to be moved to a safe place. Men versed in the Chinese classics had arrived in the time of Emperor Ōjin.

One of the important crafts was the casting of mirrors. Bronze mirrors were adopted by the Sun Line as the major identifying symbol, a sign of the Sun Goddess, Amaterasu-ōmi-kami (literally, the Highest Heavenly Shining Deity). Mirrors signified her purity and protection of the spirit of the dead. Placed in the tombs, frequently in remarkable numbers, they often surround the corpse or lie alongside it, the reflecting sides turned up.

After the early flood of Chinese mirrors, local copies were made with variations. A few are uniquely Japanese. The local users were impressed by size. Coherent patterns of Chinese Taoist spirits were transformed into congested high relief fields of strange long-haired, wormy monsters characterized by flowing parallel lines. Outer circles are filled with sawteeth, lozenges and seal bands, the last a common Chinese vehicle for inscriptions, but in Japan the squares may be simply filled with lines. The output of mirrors tapered off rapidly after the fifth century.

The pottery used around the house was a low-fired reddish ceramic in the direct Yayoi tradition called *haji*. It was a particularly serviceable daily ware that had stood the test of time. A little of this *haji* found its way into tombs as grave goods in the earlier style of burials before the introduction of the sophisticated Sue pottery from Korea.

Opposite: back of a bronze mirror decorated with dragons. Kofun period. Imperial Household Agency, Tokyo.
Right: warrior haniwa. *Final phase of the Kofun period. Archaeological Museum, Aikawa, Gumma prefecture.*

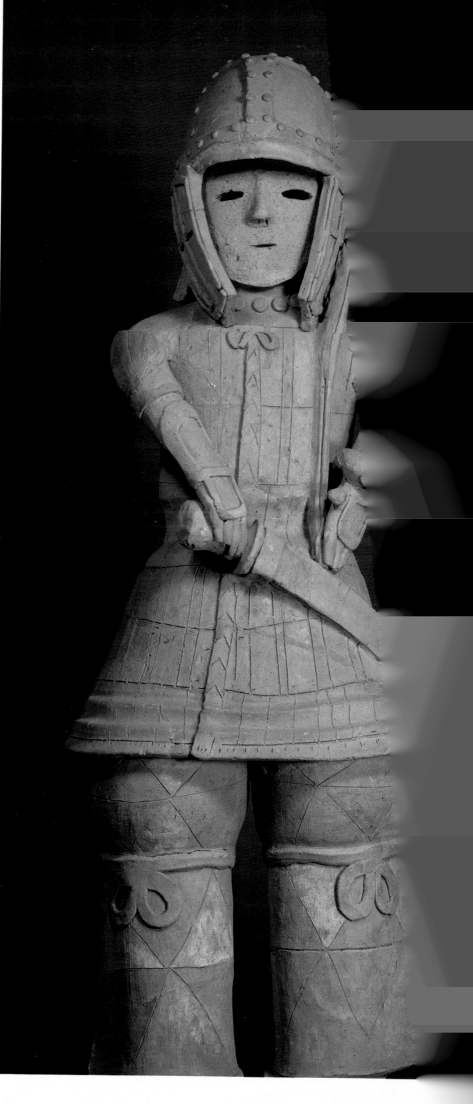

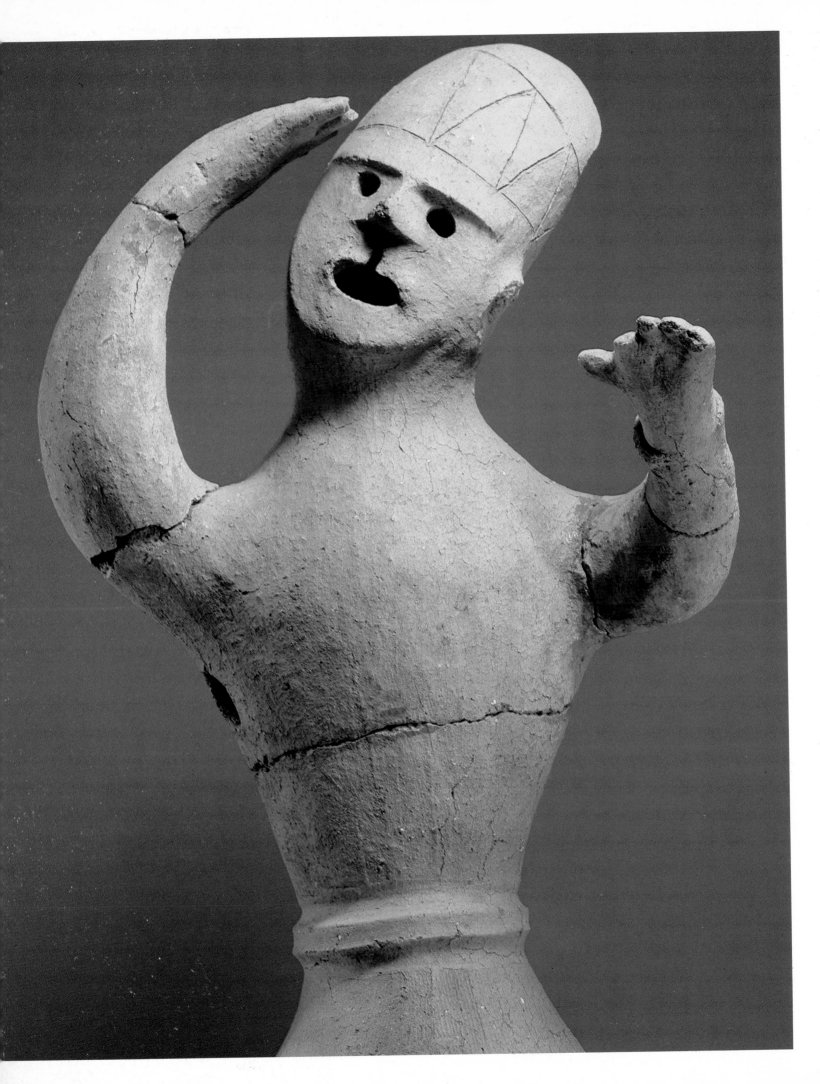

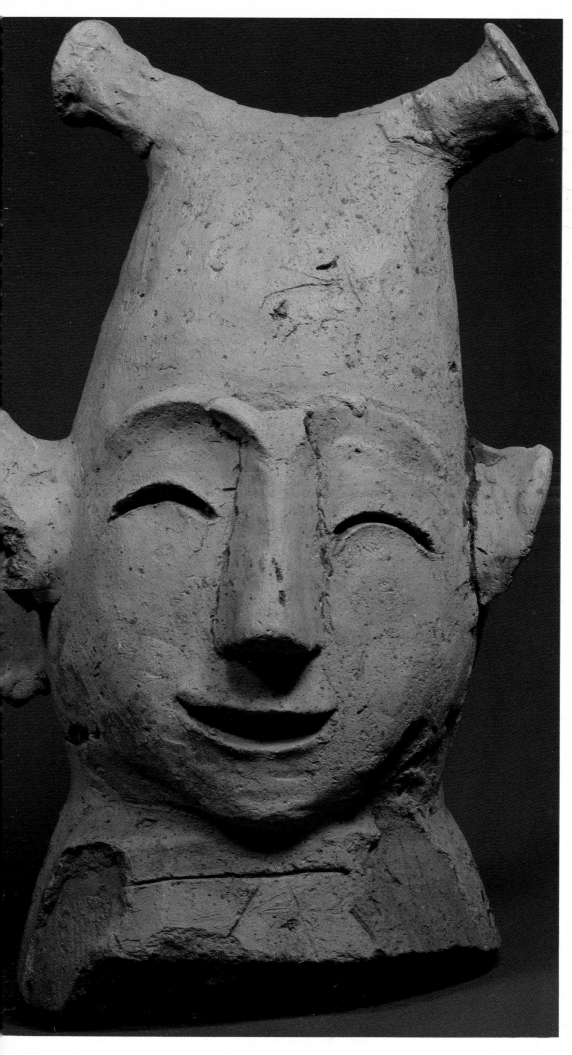

The *haji* and the clay sculptures for the tombs known as *haniwa* were made by the *haji-tsukuri-be* and baked in simple sloping hillside kilns. These kilns were large enough to fire many upright *haniwa* at one time, as quantity was always very important.

After the mounded tombs declined in fashion, the finer Sue pottery took over for everyday use and continued well into the Heian period. It was first made by Koreans from Silla in the Osaka area from about the middle of the fifth century and spread from there around 50 years later. By the seventh century it was being produced everywhere except north Honshu and areas of Kyushu. Archaeologists have identified more than 200 kiln sites, and many place names are phonetically related to Sue, although written with different characters.

The Sue is a high-fired, wheel-made, predominantly grey pottery produced by the *sue-tsukuri-be* for use in the tombs of the aristocrats. It is not unknown for a tomb to contain as many as 300 pieces.

The clay sculptures decorating the mounds of the tombs called *haniwa* are the most purely Japanese of this period. As a homegrown product they warranted an explanation in the *Nihon Shoki* as to why they were first made and how the practice became established. During the reign of Suinin, about the end of the third century, on the death of the emperor's uncle, the usual custom of burying his "personal attendants" up to their necks around the tomb was followed, but their slow deaths upset the neighbouring people and it was suggested that another way might be found. A celebrated wrestler, Nomi-no-Sukune, was invited to devise a plan and, on the occasion of the death of the empress, 100 clay workers of the *haji-be* were brought over from the Izumo region on the west side of Honshu to make images of "men, horses, and various objects." This was so well received that the emperor ordered the old system to be abandoned and clay figures to be used in its stead. The images were called *tatemono* (standing things) or *haniwa* (clay rings). Nomi-no-Sukune was given a

Opposite: haniwa *in the form of a dancing figure (Museum of Nagatoro) and, left, in the form of a smiling man (Institute of Anthropology, Tokyo University).*

working place, a title, Haji-no-ōmi, and the *haji-be* became the builders and custodians of the imperial tombs.

Only in one other instance is there mention of the *haniwa* in the old literature. In the reign of Emperor Yūryaku when a man was riding past the tomb of Emperor Ōjin at night and was overtaken by someone on a fleet charger, he was invited to exchange horses. The next morning he discovered a *haniwa* horse in his stable and, retracing his steps, found his own nag grazing on the tomb mound among the clay horses. One gathers from this story that once installed, the *haniwa* were seen as embodying certain magical properties.

Like many rationalizations, the explanation is vague with the facts and includes a reference to live burials the Japanese would like to ignore. The chief oversight can be forgiven as telescoping. The *haniwa* actually started as clay cylinders or pots on cylinders resembling morning glories, and these were followed by models of houses and then various ceremonial objects, animals and birds. Humans came last.

Cylinders were produced in quantity throughout the fifth century. For instance, while estimates vary widely, it has been suggested that at least 20,000 were aligned in as many as seven rows on the slopes of the tomb attributed to Emperor Nintoku south of Osaka. They were placed side by side on some tomb mounds and well apart on others. Such rows have been called magical enclosures, practical deterrents against erosion, or replacements for wooden fences. They may best be thought of as dividers, encircling the spirit of the dead and so protecting the living.

House models were made before the end of the fourth century in the Kinki and were soon accompanied by models of arms and armour. The houses were put directly above the spot where the corpse was laid to act as shelters for the soul.

The initial idea for human *haniwa* was conceived of in the Osaka area, but the number made there is very small. All the remaining examples appear to be women, so perhaps the idea was thought to be pertinent only for female shamans. The major development was in the north Kanto, in the prefectures of Gumma and Saitama and, to a lesser extent, Tochigi and Chiba. Gumma eventually became a major horse breed-ing center, furnishing the economic base for considerable independence and a strong artistic tradition.

Among these *haniwa* are heavily and lightly armed soldiers in full armour or corselets, shield bearers, civilian craftsmen and farmers, horse grooms and a few other identifiable types, such as a hawk trainer. Some are clearly participants in ceremonies and shown in dancing poses and worshipping gestures. High pointed caps with jingle bells or tassels are regarded as the marks of the shaman. Female figures are fewer in number, but some are very distinguished, with hair in a mortarboard-like shape. Legs are rarely shown. Usually the cylinder below just absorbs them. Women are most often carrying offerings or dancing and singing. One has a baby strapped to her back, another is nursing a baby.

In the most rudimentary style for human figures, the tubular body merges virtually neckless into the head and the top is merely a closed off cylinder. Eyes and mouth are elliptical or round holes, and the ears are rings of clay. The figures have a simple charm, heightened by the sharp contrasts of surface planes and strongly accented shadows. In the most calculated style, a warrior is dressed up with brimmed helmet, braided hair on either side of the head, circular earrings, body armour, arm and hand protectors, riding trousers, and sheathed sword, *tomo* (wrist protector), bow, quiver and pouch, probably for additional arrowheads. All the details are precisely documented, leaving a faithful record of a well attired nobleman.

The gold crowns or fragments of gold crowns from 30 or so Japanese tombs are no match in splendour for the shamanistic crowns of Korea. Not all are direct derivatives from Korea, especially the diadem rather than the vertical types. One unique example was recovered from the red-painted interior of a stone sarcophagus in the large Sammaizuka keyhole tomb in Ibaragi prefecture. It has a north Asian complexion, traceable to Scythian sources. There the top rim has a row of stags alternating with trees. Here, horses alternate with trees. The stylized cutouts are centered on a tree above a pair of bows, and the same stylized trees appear in the openwork, with wave patterns below. Gold discs hanging by wires from the rim silhouettes and the band are also a popular feature in north Asia and Korea.

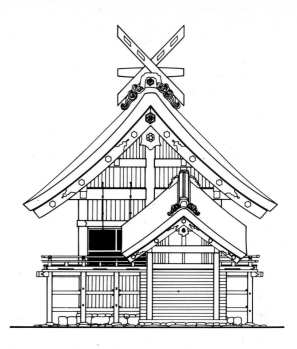

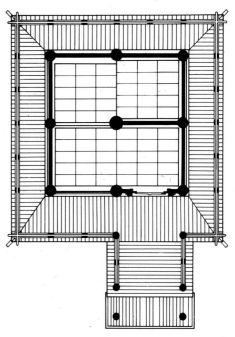

Above: elevation and ground plan of the Hondō *or main building of the Izumo Taisha in Shimane prefecture.*
Opposite: side elevation of the building.

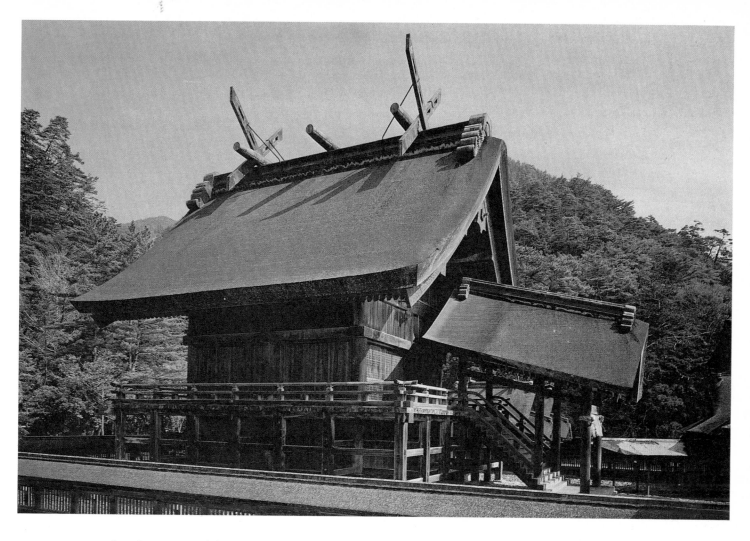

Immigrants arriving in north Kyushu brought with them generations of experience in decorated tombs, but they met an engineering vacuum in tomb construction, and a dearth of trained artists. Unplastered walls, for instance, would not have been tolerated by professional decorators.

The first of the decorated tombs fits roughly the time of Emperor Yūryaku when it is recorded that the heads of four *be* were being moved as protection against a rampant plague, but it is still a question as to what type of painting was being taught. The arrival of Buddhist art was 75 years off.

The earliest decorated tombs are chiefly in the Midori and Shira river basins in the prefecture of Kumamoto in central-western Kyushu. From there they spread to Fukuoka. A few are known in Saga and Ōita prefectures. Eventually some decoration was applied to some tombs in the middle Inland Sea, in the Osaka region and on the west side and an occasional one farther north, but by and large, outside the island of Kyushu they are widely scattered and isolated and seem to be stray elements from the Kyushu tradition.

At the time of arrival of the idea small corbel vaulted chambers were being constructed of rough stones, the smoothest surface turned inward. No effort was made to prepare the walls with plaster. A series of motifs – concentric circles to look like suns or mirrors, triangles, fern frond patterns, bows, swords, quivers, *tomo* and boats – were adapted to the size of the stones. One common solution to the problem of inadequate surfaces was to provide a well shaped long flat slab to run the length of the wall about waist high to carry the decoration. These wall screens must have been prepared in advance and were lined and carved in low relief, then painted.

As building techniques became more ambitious and large slabs of granite were used, the wall screens went out of style. More versatile space allowed a greater range and manipulation of subjects. They evolved to simple genre-level and shamanistic illustrations of human figures, birds, horses, boats, sun, moon, stars and, in most cases, coupled with some traditional geometric motifs.

Rarely were more than four col-

ours used in the paintings of any one tomb, although the palette contained six pigments: black, white, red, blue, yellow and green. All were mineral paints derived from clays and rocks, and were applied in pure form without mixing.

The most enigmatic pattern is one called *chokkomon*, meaning "straight-curved pattern," a geometric complex of straight and arc lines. This pattern starts very early with the decorated tombs and lasts in minor variations throughout the period. The pattern was used on several kinds of objects, particularly *haniwa*, mirrors, stone headrests and bracelets, most of which appear to have been destined as grave goods. Few can agree on its significance.

The most conceptually advanced of the painted tombs is one in Fukuoka known as Takehara, discovered in 1955. The chief painting on the granite block at the end is done exclusively in red and black. A large pair of standing fans frame a magical zone in which the universe is layered, sky activities at the top, earthly figures in the middle, wave patterns below. This follows the Chinese principle of rising through

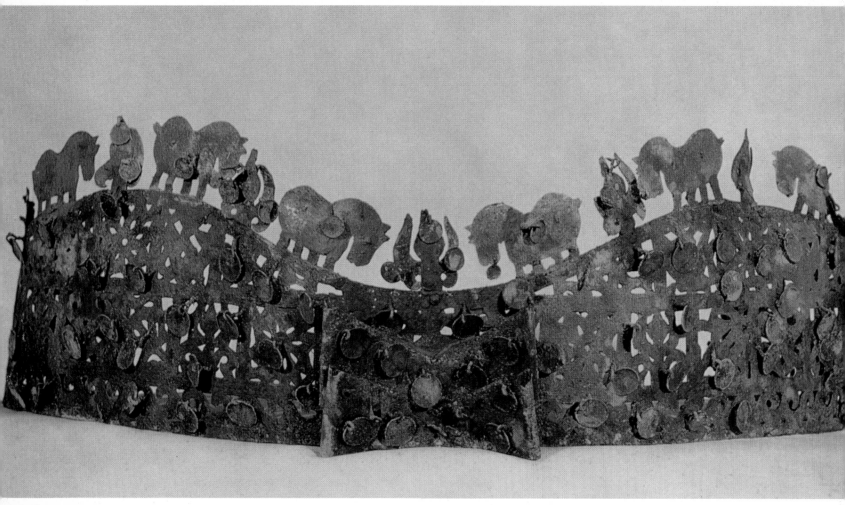

Gilt-bronze crown with frieze of horses and trees. Kofun period, sixth century. Museum of Art, Ibaragi.
Opposite: back of bronze mirror with geometrical decoration of chokkomon ("straight-curved pattern"). Kofun period. Imperial Household Agency, Tokyo.

the elements of water, earth and sky. At the top can be seen a small boat and "feathered" long-tailed horse; in the middle a groom in horse-riding costume, a long-tailed horse and a vertical row of triangles, and below a large boat over wave-like patterns.

The subject is shamanistic, the shaman's otherworldly vehicles of boat and fabulous quadruped at the top provided for him as a psychopompus to conduct the spirit of the deceased to the next world. The Chinese used "feathering" to indicate when their creatures were supernatural. The valuable material goods of this world are in the middle zone. The row of triangles may, in fact, be mountains.

By and large shamanistic themes dominate the tomb paintings. The shamans and their assistants took the responsibility for the wall deco-rations, not altogether willingly, but did their job as society expected, yet doing it as quickly and gingerly as possible in order to get out without leaving their traces through which they might be trapped by the spirit of the dead. Little time was spent on practice. The fern frond patterns of several tombs have to be seen in this context. They should be the north Asian shaman's horns, for which there is even textual evidence in Japan and, in effect, they should be the signature of the artists.

The initial step leading toward the earliest Shinto shrines was taken in Yayoi times when the raised store-house was adapted into an upper class dwelling. Appropriately, this became the shaman's house. As custodian of society's values, he was the medium with the invisible powers, the "abstainer" in the Chinese de-scriptions of the people of Wa, the diviner, and interpreter of omens. He received a house of special pro-portions which gave him status and superiority. As a shrine it is a hollow box, containing at most a single symbol like a mirror.

In the two contending major groups which get recognition in Yamato literature, Izumo and Yamato itself, each has preserved a distinctive type of shrine: the Izumo Taisha in Shimane prefecture, and the Ise Jingū in Mie prefecture. Ōkuninushi-no-mikoto (or Ōna-muji), the Master of the Great Land, is the deity at Izumo. He is identified with the brother of the Sun Goddess, Susano-o, patron de-ity of fishing, silk weaving and the medical arts. He was subordinated, yet related, to the Sun Goddess who stood on a higher philosophical plane than the everyday professions. The ultimate resolution of the con-flict between the two gave the Izumo people jurisdiction over religious affairs and the Yamato people charge of political affairs.

The Izumo Shrine is inordinately large, even today. Whether its size inspired the myth of a grand palace to which the *kami* retired or con-jured up the tradition that all eight million spirits meet there in the tenth month of each year, the shrine is known to have been the largest ancient building erected. The floor was reached by a long ramp. But ambition outstripped local architec-tural skills and ingenuity. It col-lapsed seven times within a 200-year span in the eleventh and twelfth centuries. The size was reduced in 1248, but a bigger shrine was tried

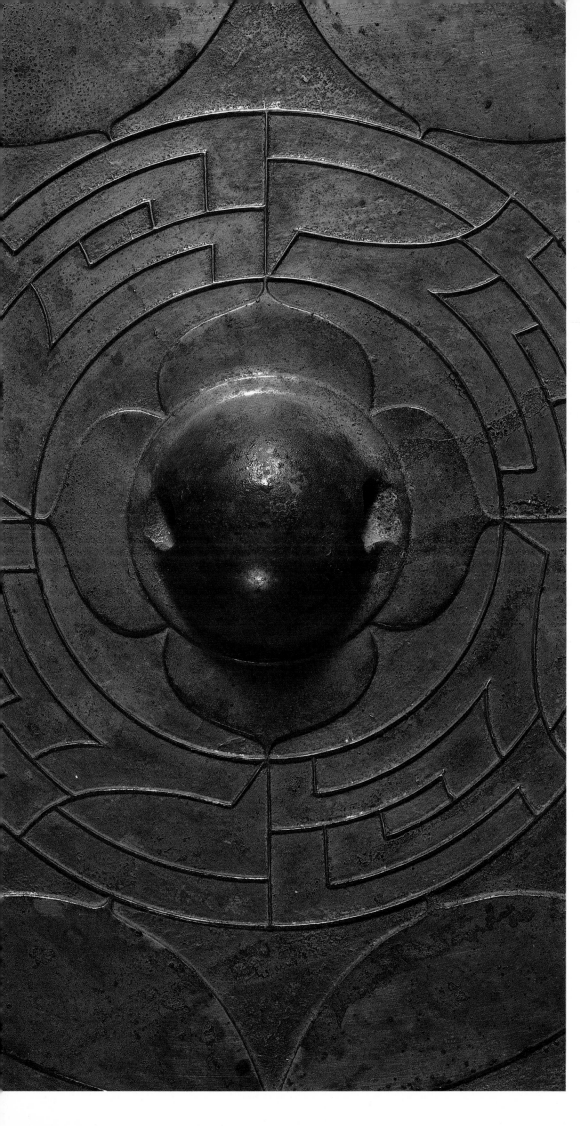

again in 1667, and the rebuilding of this structure in 1744 is essentially the one seen today. From the ground to the top of the gable extension (*chigi*) it is 80 *shaku* (or feet), and the floor is over 12 *shaku* above the ground. An upcurved thick bark roof towers over the simple wooden, unpainted plank walls. The plan is square with two bays to a side, a symbolically larger pillar in the middle. A screen from the east side to the center pillar cuts off the northeast quarter of the interior and creates an inner area of considerable privacy and comfort, as is thought to have existed in ancient houses. A door and a window fit the eastern and western bays of the south side. Liberties taken with the projections of the gables and ridge pole weights (*katsuogi*) – since early times the invariable symbols of Shinto architecture – have indented the former decoratively and reduced the latter numerically. Incongruous consoles have been tastelessly added to the ends of the ridge pole.

Such corrupting influences from Buddhist architecture are few at Ise, which remained a rare stronghold of resistance to tainting by later art styles. Indeed, in almost every respect it retains the most original and refined form of primitive architecture. Ise's anachronistic position, in view of the fact that few people in countries at the peak of modern development worship at shrines of a prehistoric type, is a succinct commentary on the history of Japan.

The two shrines at Ise, an Inner and Outer Shrine, are rebuilt every 20 years, conditions permitting, and all details are consciously and ritually preserved in every reconstruction. The Naikū and Gekū shrines each have adjoining lots for alternate rebuilding. The Inner Shrine houses the mirror of the Sun Goddess which was once kept in the palace of the ruler. The discomfort of Emperor Sujin was traced to the presence of the mirror, and a place was found for it near the present Nara. Then, in Suinin's reign, it was transferred to Ise. There are Moto-Ise shrines where the *kami* wandered and stayed before finally settling at Ise.

Both shrines are laid out in precisely rectangular lots in an area densely wooded with cryptomeria, separated by the Isuzu river. The

Overleaf: view of the Shinto shrines at Ise, Mie prefecture.

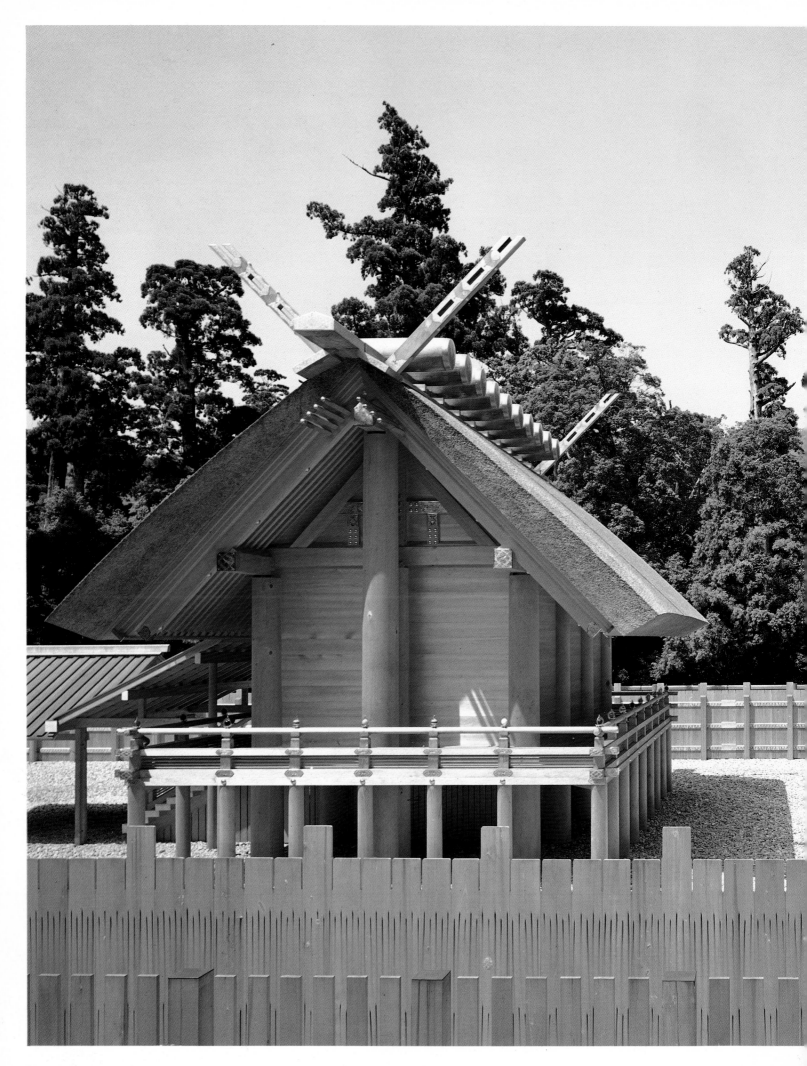

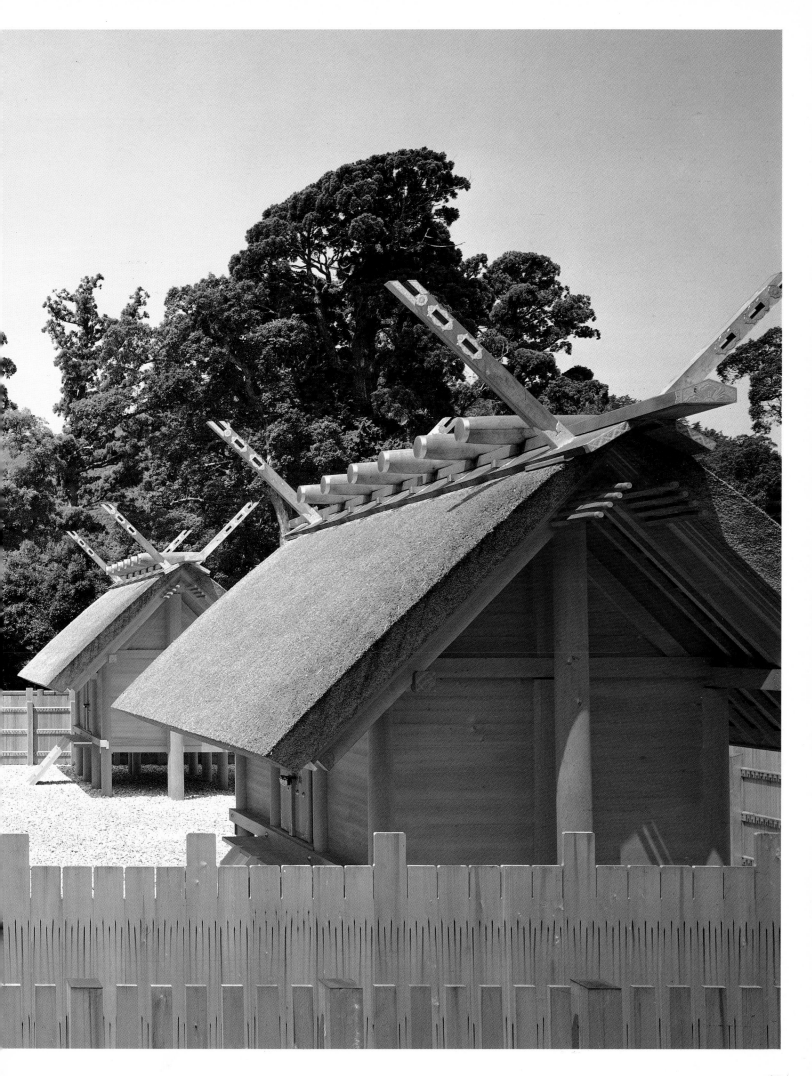

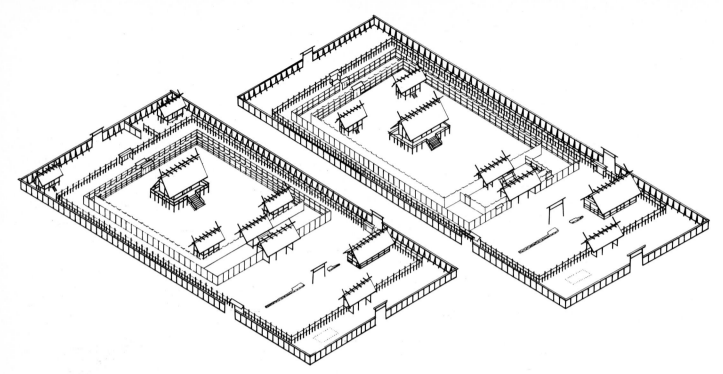

Above: plan of the Shinto complex at Ise.
Opposite: wall painting in red and black in the Takehara tomb, Fukuoka. Fifth–sixth century.

Inner Shrine lies on a slope, probably because it was started as a smaller edifice and then expanded toward the river. The front steps lead in at an angle. The buildings are situated on a rigid north-south axis except for the first gate. Four fences of different style are entered by a *torii* and succeeding gate houses. Within the rectangular precinct is only a main hall (*shōgū*) almost dead in the center of the innermost rectangle, and the east and west treasure houses on either side behind. The fences are close together at the back with a series of small gates.

A worshipper says prayers in front of the first gate of the second fence. The sanctity of the interior is fully respected, and the public seems to have no curiosity about its appearance. Priests display offerings in a small building on the left. The architecture has a total consistency in its monochromatic stripped wood and unadorned simplicity. Cypress (*hinoki*) is used throughout and miscanthus for the roof thatch.

The Outer Shrine is dedicated to the Grain Goddess and is rather similar to the Inner Shrine. It was probably modelled on it as, by tradition, it was erected in the reign of Emperor Yūryaku in the late fifth century. Its addition completed the natural cycle, the union of earth and sky deities.

The system of rebuilding every 20 years, climaxed by formally celebrating the rejuvenation of the Sun Goddess, is traced to the reign of Emperor Temmu. Though it was not always possible because of internal politics, 1973 witnessed the 60th reconstruction.

Each step is ceremonialized, as the selected workmen are purified and procedures commence for the total regeneration of the buildings and all of the articles they contain. This starts eight years ahead with the cutting of 13,200 trees in Nagano and Gifu prefectures. Afer five years of seasoning, each is shaped at Ise, wrapped in paper and stored under-cover.

The pillars went up in early 1972 in simple holes in the ground, ten for the main hall. A mortise and tenon system is used, and the wall boards are slipped into slots in the pillars. Raising the ridge pole, which rests largely on the two free-standing poles at either end, is a major ceremony that involves a huge number of priests. Five seasons are needed for cutting the 25,000 bundles of miscanthus which will cover the roofs. On the evening of October 2, 1973, in the Sengūshiki, the removal procession was led by an imperial messenger. The priests invited the Sun Goddess to ride by pulling a white hemp cloth to the new shrine. The ceremonial articles are carried in wooden boxes.

The Japanese may be partially right in denying any Buddhist influence at these shrines. The precision of the cloistered area of the early Buddhist temples would appear to have been imposed on the shrines here at an early date. Historically, Shinto shrines are hillside structures where such precision would be inapplicable and an injustice to the setting. The Ise shrines each have a Taoist "spirit screen" opposite the main sacred gate, a feature otherwise unknown in Japan but common in traditional China where it stood across from the entranceway as a barrier to foil evil spirits. This rigid geometry and the duality of the concepts are more likely to have been Taoist, which is best revealed in early Japan through the medium of Buddhist art.

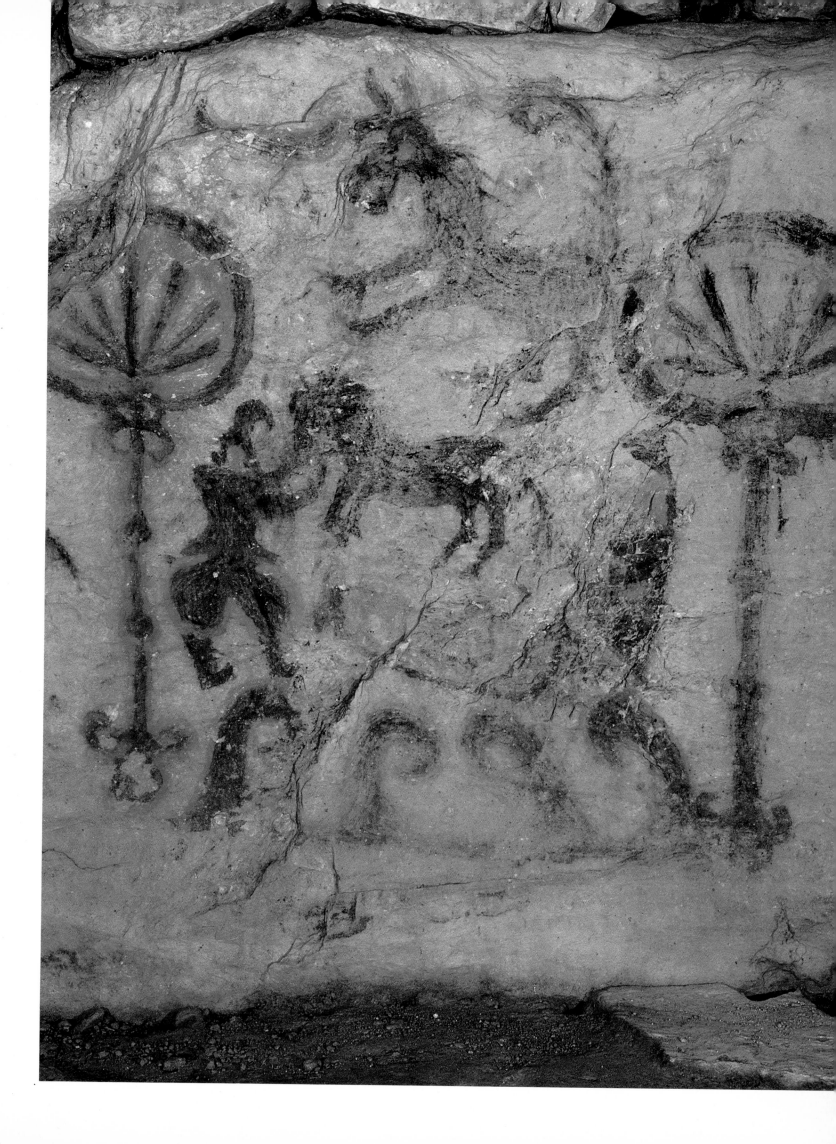

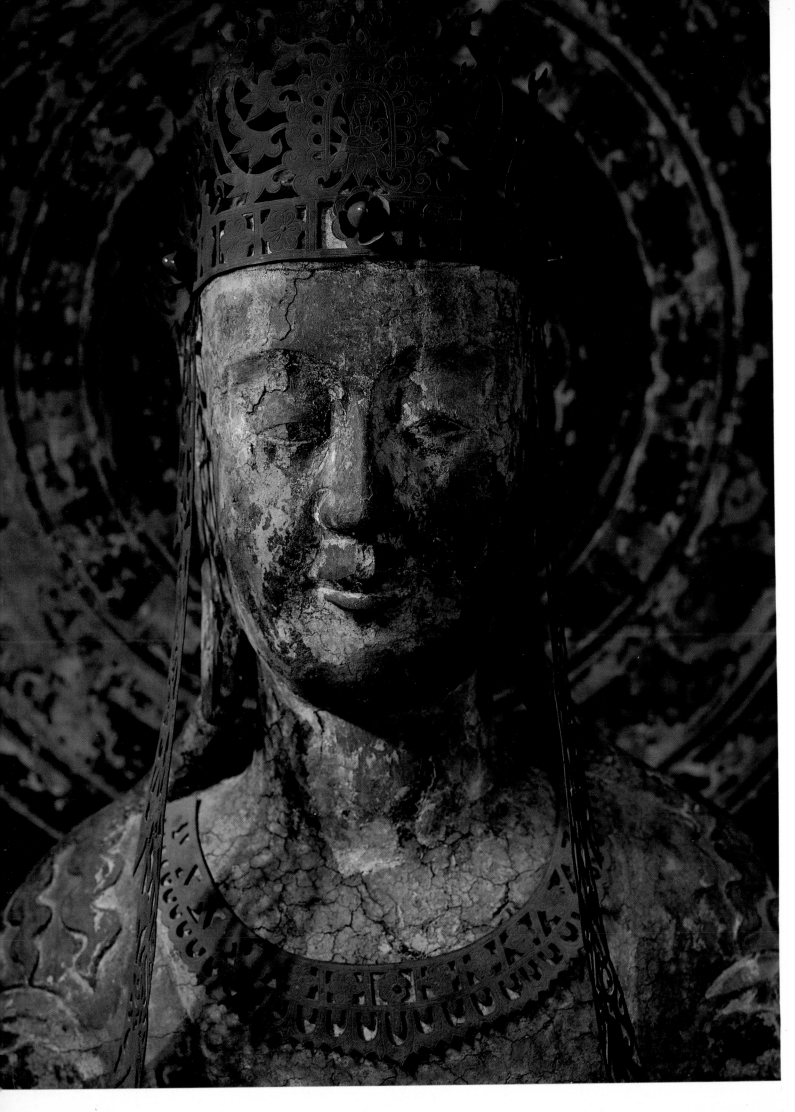

THE ASUKA PERIOD
552–645

Opposite: the Kudara Kannon, detail of the head. Hōryū-ji, Nara. For full illustration see page 51.

Buddhism reached the attention of the court and its potential patronage in one of the many overtures made by the king of Paikche to the Japanese ruler to request help against their common enemy, Silla. The king of Paikche gave it his highest recommendation. In the *Nihon Shoki* account for the year 552, first in the fifth month, emissaries requested troops from Japan to withstand the alliance of Koguryŏ and Silla, and again in the tenth month, a somewhat better prepared embassy brought gifts of a gilt bronze image of Shaka Buddha, several temple banners and umbrellas, and a number of volumes of scripture rolls. The note from the Korean king read: "This doctrine is amongst all doctrines the most excellent ... (it) can create religious merit and retribution without measure and without bounds, and so lead on to a full appreciation of the highest wisdom ... every prayer is fulfilled and naught is wanting..."

The emperor listened patiently then "leaped for joy." He asked the opinion of the Soga, Mononobe and Nakatomi ministers. Soga-no-Iname believed it was time for Japan to get in step with its continental neighbours. The others believed it would break the faith with the "one hundred and eighty *kami* of heaven and earth, land and grain."

The Soga then took the objects and placed them in a house, calling it a "temple." Within the year, a pestilence spread disease and death. The Mononobe and Nakatomi advised the emperor to have the Buddhist trappings disposed of to appease the local *kami*. The image was thrown into the Naniwa canal. The house Iname had used as a temple was burned. But no one could explain why some mysterious force caused a sudden burning of the great hall of the imperial palace in perfectly clear weather.

In the following year Emperor Kimmei promised troops, as he had been requested, and notified Paikche that it was rotation time for the resident Koreans in charge of medicine, divination and making the calendar. He asked for the latest books on drugs and on other subjects. But the Japanese never sent help. Their position in south Korea deteriorated progressively as internal struggles hampered the emperor's ability to honour his commitments.

Japan felt much menaced by the power of Silla, geographically the closest neighbour, and the Silla-Koguryŏ partnership against Paikche and Mimana or Imna (also sometimes referred to as Kaya), Japan's piece of land in the south of the peninsula, was a threat to the lifeline of Japanese culture. Mimana kept the door open for everything the court thought to be essential to national development. The records document almost daily events in Korea. For the scribes to have been so familiar with such activities can mean only two things: the Japanese saw their future as wholly dependent on maintaining their hold in south Korea, and the channels were so efficient Koreans must have been working at every level of the information service, including making the final notations.

From the records we learn that Senak was the first "emperor" to have lived in the Asuka area, a small place deep in the Nara Basin on the last level ground before the hills rise toward Yoshino. But not until Empress Suiko occupied her Toyura palace in 592 did the rulers make almost continuous use of the region.

Asuka was Soga territory, an established family with *omi* nobility rank which first emerged as ministers to the rulers at the time of Regent Jingu. Soga-no-Takeuchi was councillor to Emperor Ōjin who, if not actually Korean, certainly had a large contingent of Korean supporters, and the Soga went on to control the economy through the tax system, support the introduction of arts and crafts from Korea and, under Emperor Kimmei, to sponsor the adoption of Buddhism. Those opposing were the Mononobe and the Nakatomi, the former also a ranking noble family known as *muraji* with a background largely in professional soldiering, and the latter the official administrators of the country's Shinto rituals.

Only one generation elapsed from the time Kimmei received the gifts to the climax of the contention between the Soga and their opponents in the battle on Mt. Shigi when the Mononobe leaders were killed. Buddhism became fashionable at the court. Prince Tachibana-no-Tokoyo, later known as Yōmei (d. 587), when designated emperor "believed in the Law of the Buddha and reverenced the Way of the Gods." He was the prototype of the emperor who honoured his divine origins and subscribed to the humane way of Buddhist life and its budding promises for a future existence. All the rulers who came later

41

were at least nominally Buddhist.

Adding Buddhist ceremonies to the usual routine in no way meant discontinuing any of the others. Not supporting the country's existing traditions was unthinkable. Buddhism enriched the country in almost every way: philosophically, educationally, culturally and artistically. Spiritual meccas, literacy, welfare services and employment were among its benefits.

Asuka is the name by which the art period is known, but properly speaking it would be well to refer to the period as starting around 585 when full temples got under way and continuing until around 658 when Chinese influences began to appear. From then until the transfer of the capital to Fujiwara in 694 would be Late Asuka, and the 16 years the rulers lived at Fujiwara, perhaps Asuka-Fujiwara. Regional designations would then continue, using the name Nara (originally Heijō) after 710 and until 784, and Heian (Kyoto) after the Nagaoka interlude of 784 to 794.

Among the reasons Buddhism was accepted was its novel visual appeal. Shinto lacked the philosophy to formulate an anthropomorphic art. Even in later centuries, Shinto shrines lived in the shadow of Buddhist temples, retaining many early and simpler architectural characteristics, and Shinto arts were not within the current which could be periodically revitalized by foreign stimulation.

Once the direction of the court was set, the same energy that had gone into the building of tombs was directed toward the erection of temples. Construction accelerated at a staggering rate after the tutelage stage was over. Prince Shōtoku, regent under Empress Suiko, led the way in the late years of the sixth century. The *omi* and *muraji*, the ranking classes of nobles, "vied with each other in erecting temples," according to the *Nihon Shoki*. A training school for Buddhist painters was begun in 604.

In 623, a year after the death of the prince, a census records the existence of 46 temples maintained by 816 monks and 569 nuns. During

Interior of the Golden Hall of the Hōryū-ji, Nara. To the left is the Shaka triad, dated 623 and the work of Tori Busshi. In the foreground to the right is Jikoku-ten, one of the Four Heavenly Kings.

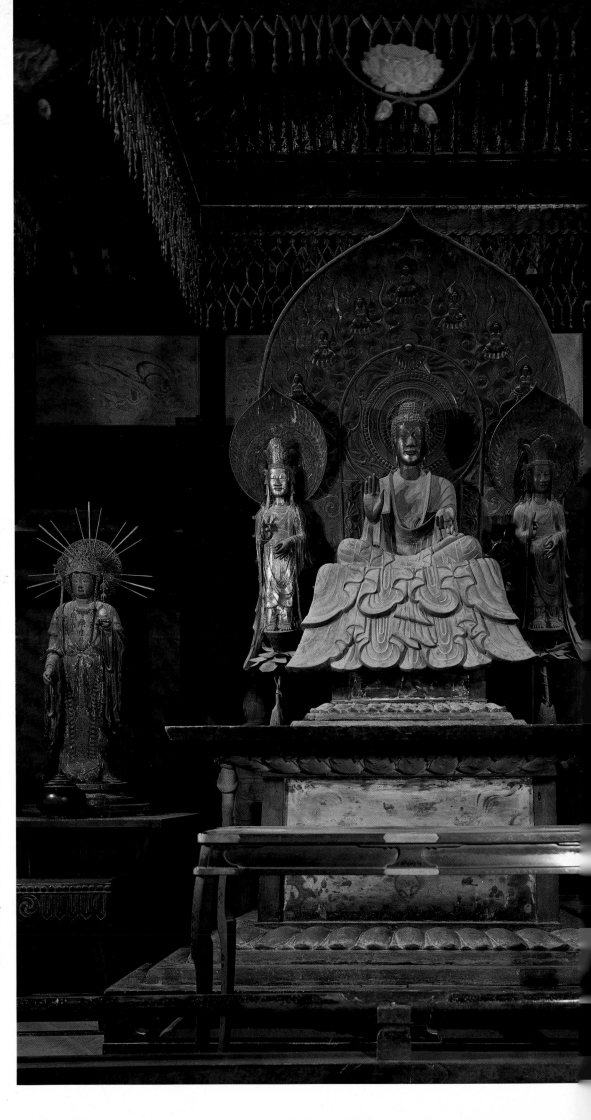

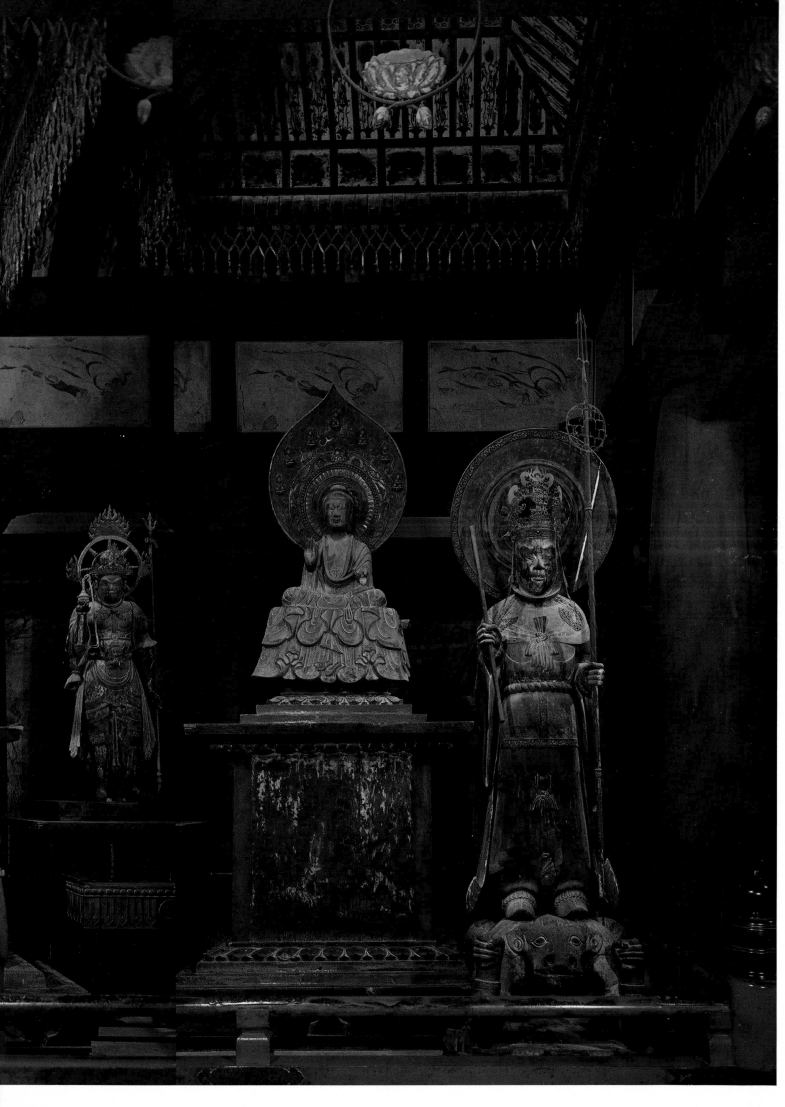

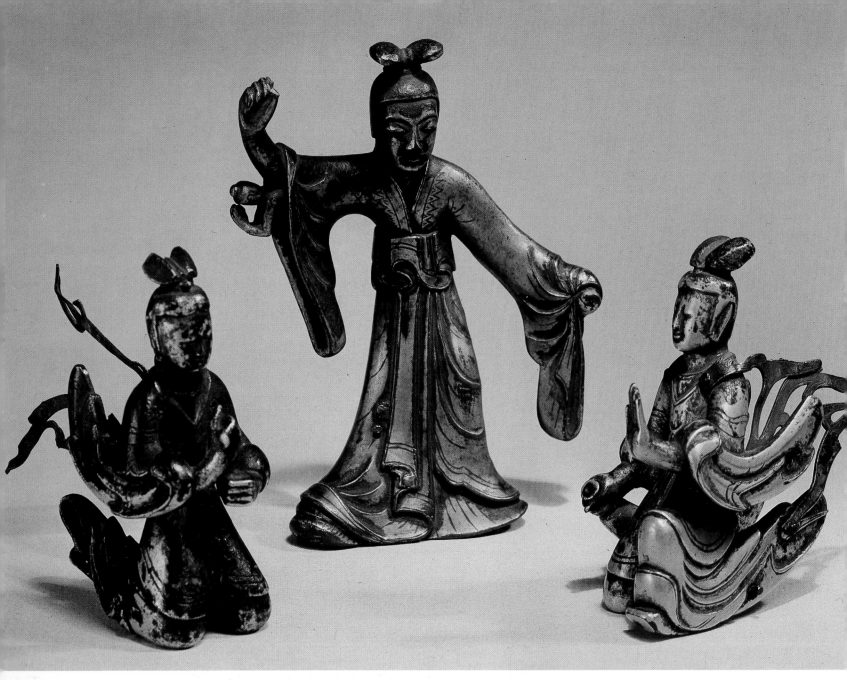

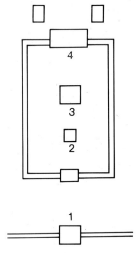

*Top: Maya with two maidservants.
National Museum, Tokyo. This
bronze sculpture portrays the birth
of Gautama Buddha, who,
according to legend, was born from
Maya's right side; he is here shown
emerging from her sleeve.
Above: plan of the Shitennō-ji;
1 Middle Gate, 2 Pagoda, 3 Golden
Hall, 4 Lecture Hall.*

the seventh century these temples multiplied many times over.

The teams of tutors and clergy sent over had unexpected proportions. Paikche sent some volumes of religious books in 577. The group bringing them consisted of a bronze caster, an architect, a nun, a monk, a reciter of magical spells and a shaman, and another group dispatched 11 years later to oversee the construction of the Asuka-dera included a bronze caster, two carpenters, four tile makers, one painter, one monk and four shamans. This remarkable ratio – one monk to a committee of shamans – says something about their number in Korea and their role in Buddhist activities. They served prior to and during the construction of the temples. The monks came into the picture after they were built. Shamans determined when and where the temples should be built and probably had much to communicate about each step along the way. When

Soga-no-Sukune became ill after setting up a "temple" in his house, it was a shaman who was consulted as to whether to continue. A shaman determined the future of Buddhism in Japan.

Buddhism had little sectarian focus during most of the seventh century, with only three deities singled out for any specific veneration: Shaka (Sākyamuni), the historic Buddha who was widely popular throughout most early centuries of Buddhism; Yakushi (Bhaisajya-guru-vaidūrya-prabhāsa), the Buddha of healing, using a borrowed Indian name (Yakshi), but with obscure Indian connections, a Buddha which was promoted through its magical-mystical elements; and Miroku (Maitreya), a bodhisattva type which completed the hierarchical scale below the Buddhas, symbolizing the life of Shaka as a prince before enlightenment and identified in Japan with Prince Shōtoku. This last deity was

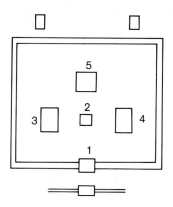

Plan of the Asuka-dera: 1 Middle Gate, 2 Pagoda, 3 West Golden Hall, 4 East Golden Hall, 5 Middle Golden Hall.

short-lived in Japan, perhaps because of its close association with the prince – who never became emperor. Otherwise, there were the bodhisattva attendants of Yakushi, Gakkō (Candra-prabha) and Nikkō (Sūrya-prabhāsana), sunlight and moonlight. Amida (Amitābhā), the Buddha of the Western Paradise, who became the counterpart of death to Yakushi of the east and life, appears toward the end of the century, along with his bodhisattva attendants, Kannon (Avalokitesvara) and Seishi (Mahāsthāma-prāpta).

The temples were the context for Asuka art and Japanese temples are the only remaining living context in east Asia. Though mostly rebuilt, but in ways faithful to their original appearance, they tell us much about the architecture of these early centuries that has been destroyed in Korea and China. The history books on architecture of these centuries are written in Japan.

After a short phase of private worship in a separate room of a house, followed by a phase where a whole house with perhaps an assigned monk was devoted to the purpose, full temples were built once the teams of instructors started to arrive from Paikche. The use and form of each temple building had been established long before the structure was adopted in Japan, as had the plans for all major complexes of buildings, the Chinese palace having been the model.

The compound had a surrounding wall and inner cloister. Within the cloister was a sequence of buildings oriented towards the south entered by a Middle Gate (*chūmon*). The first building a visitor encountered was the pagoda (*tō*) which marked

the location of the relics. Behind it was a Golden Hall (*kondō*), used to display the temple's images and, next, a Lecture Hall (*kōdō*), designed to serve as a common recitation room. This may sometimes have served also as a refectory.

Since the temple originated in the need to worship the remains of the Buddha, beginning with the stupa in India, the pagoda was its mystical center, the holiest spot and the first building in the line. A bell tower and a storehouse for the scripture scrolls, the sūtra repository, had to be conveniently located nearby. These were usually placed immediately behind the cloister.

The block of buildings composing the nucleus of these early temples is known as a *garan*, a word the Japanese adopted from the Sanskrit *samgharama*, made phonetically into *sōgarama* and abbreviated to *garan*.

These were the formal buildings of the temple, attracting the public. All the needs for daily but austere living had to be met for the monks or nuns and attached labourers. Accommodation had to be provided for visitors and pilgrims. The clerics themselves developed many skills and much of the early arts were either produced within the cloister or nearby. Carpentry shops, weaving rooms, writing and painting ateliers were located in the grounds. Metalworking sometimes was, but tiles were made rather close to the kilns, some of which have been found on hillsides not far from the temples they served, and pottery utensils were more likely to be acquired from professional production centers, such as from Sanage in the Aichi area.

Prince Shōtoku preferred a standard south Korean plan which he used without variation in the temples he constructed. Perhaps he built the Shitennō-ji in old Naniwa first, then the Tachibana-dera in Asuka, then the Hachioka-dera in Kyoto, then the Ikaruga-dera in Nara prefecture, but the plan can be seen today only at the Shitennō-ji, a temple that has been rebuilt since the Second World War in concrete to resemble wood. It is also a fact that today no buildings of the Asuka period actually exist if one goes by the strict definition of the dates of the period. It may, however, be assumed that changes were relatively slight and the buildings of the Hōryū-ji, the pagodas of the Hokki-ji and Hōrin-ji (the latter destroyed

by fire in 1944 and recently rebuilt), and the Shitennō-ji all represent the Asuka style as carried on into the next period.

The Chinese sense of relationships lent a striking system to the arrangement of buildings. The unit of measure that was used, *shaku*, had come from north Korea. In Japan it was known as the *koma-jaku*, after the northern kingdom. It was then equivalent to a length of about 35 cm (1 ft 2 in). The longitudinal axis of the typical temple built by Prince Shōtoku measured about 200 *shaku*, its shorter axis about 70 *shaku*. A *garan* of two *chō* (about 2.45 acres or 0.992 hectares) was the size for most "large" temples and about half that for the small temples.

Builders were slaves to these principles of positioning and layout, unless there were reasons for relationships beyond our ability to divine. In the Shitennō-ji plan, the distances are equal from the Middle Gate to the pagoda and the pagoda to the Golden Hall. It is half again as far to the Lecture Hall. The distance between the Golden Hall and the Lecture Hall is therefore about a quarter of the length of the courtyard. If there was any initial intention of putting the belfry and sūtra repository inside the cloister, this large, relatively useless space at the back might be better explained. Otherwise, it makes little sense to crowd the front buildings. The Golden Hall is more or less on the diagonals if one marks out a square for the north of the courtyard using a transverse line through the pagoda as its south side. Some proportions add to the harmony of the scheme: relative to the width of the courtyard, the south side of the Golden Hall is a quarter and the south side of the Lecture Hall is roughly one third.

Individual buildings were built on pounded earth platforms faced with well cut stone slabs. Regularly spaced wooden columns were erected above stone bases and capped with brackets, purlins, rafters, boards and a tile roof. The immense weight of the roof necessitated a sturdy system of rather evenly spaced columns supporting the roof at equidistant points. These points are vertical extensions above columns or placed evenly between them. Any variation on this calls for a complicated set of balancing levers. Major buildings have two roofs, the lower roof extending far enough over the platform to carry

away the water into a surrounding trough.

Internally, a space amply large for a Buddha platform (*butsudan*) was created by using long beams laterally, usually slightly arched, hence their name, "rainbow beam." The surrounding unit of space served as an ambulatory; it is bridged by rainbow tie beams, one end of each beam inserted into an ambulatory column. This walkway formed an ideal route for any large volume of human traffic paying respect to the images on the platform.

A main, centrally located hall was seen as needing more height and mass to suit its importance and position. The increase in size was carried out by adding the extra roof and raising the superstructure. A false ceiling hides a vast configuration of structural parts required to produce this effect. Everything is geared to appearance, and in this regard the major Japanese contribution to architectural modifications of earlier buildings was in the reconstruction of their roofs, referred to as hidden roofs (*noyane*).

The system of columns and horizontal beams produces a regular sequence of spaces and shapes. The standard unit is a bay (*ken*), usually close to six *shaku*, with minor variations. The two long north and south sides of a hall have an odd number of bays. Whether philosophically devised or otherwise, the doors and windows will be symmetrically placed. These simply fill a bay, the windows consisting of vertically aligned square rods over which shutters can be closed. Consequently, the internal space is composed of multiples of this fixed unit, creating effects of logical form, lateral balance and surface linearity. Expansion and contraction is in terms of adding and subtracting these units. The rigid scheme of these interiors is in keeping with the philosophical sense of law and order, but it is intractable and lacking in versatility. The interior rearrangement of furnishings rarely improves the situation, and constant repetition is wearing. The classical example at the very source of these principles would be the Imperial Palace in Peking. Size and distance from the point of entry may deepen the sense of mystery and heighten the aura of majesty, but the impact is reduced by lack of variety and the impersonality of it all.

The walls are simple enclosures of laths, plaster and white paint and

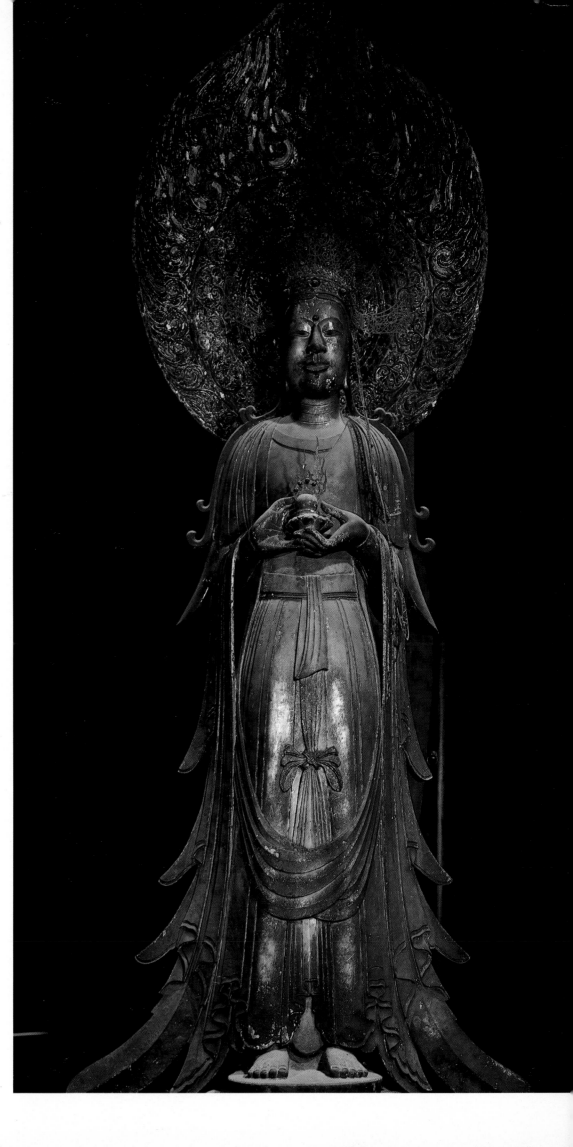

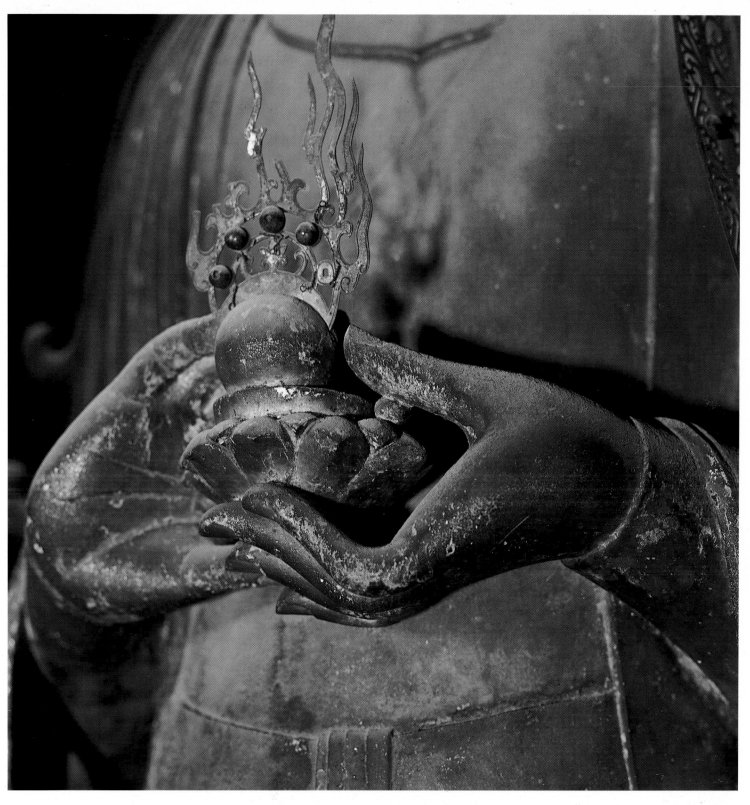

Opposite: the Yumedono Kannon, a wood sculpture in the Tori style preserved in the Yumedono of the Hōryū-ji, Nara. Known also as the Guze Kannon, saviour of the world, the figure wears an imposing and intricately worked gold crown. Above: detail of the hands, which are shown carrying the sacred jewel.

have no structural value. The structural elements themselves create their own decorative qualities in rhythm, proportions and transitions. Those visible in the wall plane lend a sense of exterior-interior organic unity to the building, projecting as they do from inside out without interruption by the solidity of walls. The large exterior area devoted to making the transition from the vertical to the horizontal supports gives the roof a wide overhang beyond the platform, raises the edges to allow a maximum of light to enter the building and adds elegance to the potential weightiness. When Japanese preferences prevail, the bracketing system stands alone without embellishment. The Japanese followed the Chinese lead in painting the woodwork red until sometimes Amidist and later Zen austerities – paradoxically – prompted plain, unpainted surfaces.

The Asuka-dera was to be a place to venerate the forefathers. For some reason other than the megalomania of its builder Soga-no-Umako, it was unaccountably large.

An ancestral house was destroyed and the temple built on the site. Relics had been brought from Paikche and a team of architects started planning it in 588. The wood was cut, seasoned and the main hall and cloister were erected in late 592. Coincidentally, this was just the time Umako was plotting to assassinate Emperor Sujun who was unwisely threatening to act independently of the Soga.

The pagoda of the temple received its relics and the center pole went up over them in the first month of 593. The construction was finished by 596. Umako's son was appointed manager and two Korean monks were assigned to the temple.

Not until 605 was it decided to rectify the omission of statues and hangings. Suiko asked Kuratsukuri-no-Tori to cast a *jōroku* image of Buddha, measuring 16 *shaku* – therefore a monumental one – and commissioned other craftsmen to weave a large tapestry. Japanese records tell us that the king of Koryo, hearing this, sent a gift of gold to use for gilding the statue.

By 606 both the Buddha and the tapestry were finished, but the unwieldy statue was too large for the door. The celebration was scheduled for the same day. Some wanted to tear down the door, but Tori apparently found a solution to the problem, thereby winning the eternal gratitude of the empress, who bestowed a title on him and gave him rice fields. Tori's cultural background can be seen in the light of his grandfather's emigration from Korea in 522, perhaps to head the saddlers' group, *kuratsukuri-be*. He had Chinese antecedents.

The Asuka-dera was formally the Hōkō-ji and as the court's chief temple received many distinguished visitors. It remained in operation until 1196 when a fire destroyed the pagoda and one other major building. However, it still boasts Japan's first Daibutsu, Great Buddha, rather misshapen by the blaze.

Archaeologists have revealed a layout of buildings quite unlike the standard plan sponsored by Prince Shōtoku in the Asuka period. The plan was taken from a large north Korean temple, known only through its foundations today, with three halls placed radially around a central building. This impressive complex stood within a latitudinally-oriented cloister. The Asuka-dera's Lecture Hall stood outside and behind, and the belfry and sūtra repository were probably on either side. The large buildings in the *garan* have been called the Middle, East and West Golden Halls, implying a similar use for all, but this is only conjecture. The plan was never repeated, presumably because such a layout was no longer needed, and styles changed.

Generally, the Korean sculptors of the time followed the style of the Wei dynasty of north China. The Wei were the foreign promoters of Buddhism and strong patrons of the arts. Numerous Central Asian monks occupied the mushrooming temples in the north. The stone carvings of the caves of Yun-kang in north Shansi are representative of their style, which was continued when they moved their capital in 494 to the Lo-yang area in Honan. Not far away are the carved stone grottoes of Lung-men. There were other sites of great importance, such as Tun-huang in the far west corner of the country from where the trails started through Central Asia. If Korean and Japanese travellers had not seen these, what they did become familiar with were statuettes which had been greatly influenced by the stone cave-sculpture style: blocky, visually effective from a frontal viewpoint, unfinished on the back, foreshortened with oversized heads as though to be seen from below, and the surface linearity of the stone carving technique.

Tori was able to cast the monumental image of Buddha for the Soga's Asuka-dera (Empress Suiko was a Soga) in the short span of a year. One cannot judge its style and quality today, but the importance of it now lies in the fact that work of that size could be done. Tori, whose early training in bronze casting techniques remains a mystery, emerges as the towering personality of the arts of the time.

At about the age of 30 Prince Shōtoku ordered work to begin on a palace in the Ikaruga area of Nara prefecture and moved there several years later. In 607 he built a temple nearby in the conventional plan he used, dedicating it to his father Emperor Yōmei, who had been the husband of Empress Suiko. Prince Shōtoku was Yōmei's second son and the grandson of Emperor Kimmei. His mother was Lady Kamusaki-no-Ōkisaki, the Empress Anahobe-no-Hashihito.

The Ikaruga-dera, later the Hōryū-ji, was the product of a vow made to gain the recovery of the emperor. Yōmei died in 587. An inscribed halo for a Yakushi Buddha gives the only information on the building of the first Hōryū-ji. The image is in the Tori style, although strangely enough, no monk or medieval historian tried to identify the work with him despite the immeasurable prestige value it would have had. These historians did attach Tori's name to other works, however, notably the wall paintings in the Shitennō-ji.

The gilt bronze Yakushi Buddha referred to is the one seated on the east side of the platform of the Golden Hall. One can compare the elements of the Tori style as evidenced in this and in the better known Shaka in the center of the platform: the large halo with the seven little Buddhas, flame patterns of fine parallel thread-relief lines; the physique, a large bun on the head, blocky face, almond-shaped eyes, the so-called "archaic" smile, strong jaw, tubular neck, and the left sole exposed; the costume, thick drapery and heavy ridged hems around the neck and hands, the inner and outer garment with fishtail sash ends at the waist and below, smooth canted arc edges of the drapery hanging well down in front, the overhang the same length as the body; and the mudrā, the right hand up with the palm exposed, the left hand down and forward, known as *semui* in Japan, essentially spoken of as fearlessness.

The temple's inventory of 747 lists the Yakushi Buddha first and the Shaka triad next, the present main images. The Shaka triad is recorded as occupying center stage in a document of 1078, but for long the temple had honoured its original dedicatory image.

Central to all of the arts of the period is this gilt bronze Shaka triad. In brief, the long inscription on the back of the halo says the prince was ill, and the statue was a supplication for his recovery. He died and the statue was completed to secure the repose of his soul in paradise. The maker was Shiba-no-Kuratsukuri-ibe-no-Obito Tori Busshi. It appears to have been ordered on the 22nd of the first month of 622 and was

Opposite: detail of the Komoku-ten, one of the Four Heavenly Kings. Golden Hall of the Hōryū-ji, Nara. The halo of one of the statues bears the inscription "Ōguchi Aya-no-Yamaguchi-no-Atai," which is believed to be the name of the sculptor.

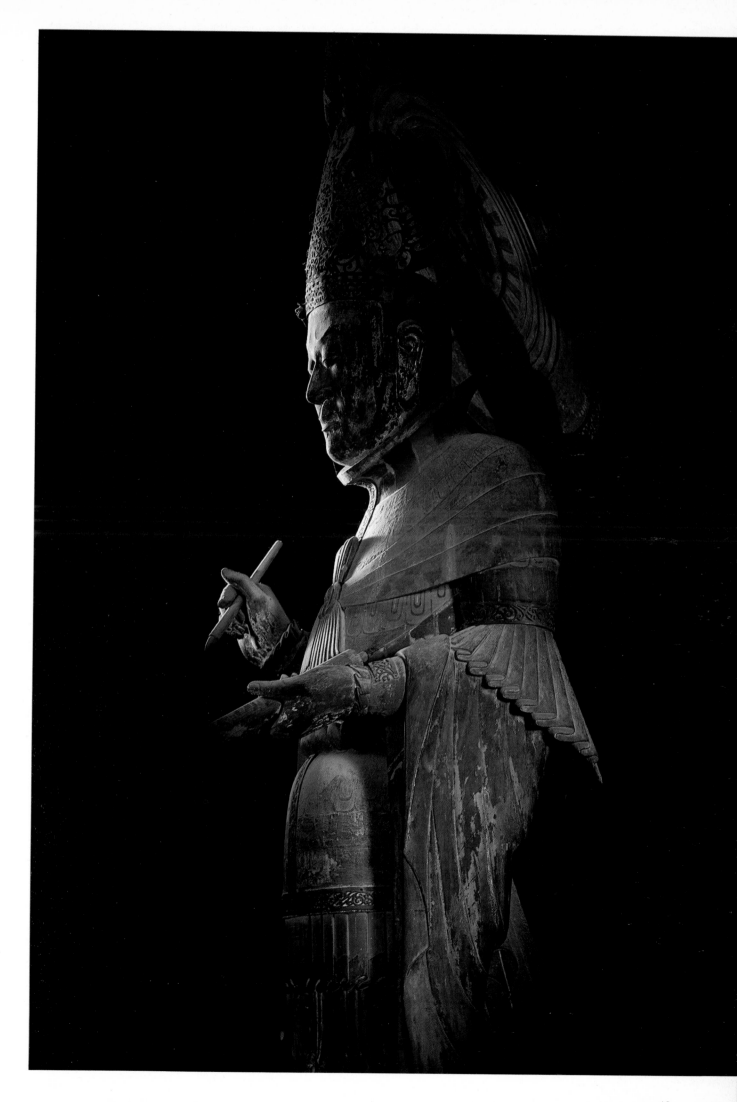

completed in the middle of the third month of 623. The prince died on the 22nd of the second month of 623 according to the *Nihon Shoki* account, leaving some discrepancy in the two sources of information. But in the most remarkable documentation for any early work of art in Japan the fundamental questions are answered: when it was made, why it was made and who made it. Despite this, occasional disbelievers contend its validity. Tori had come up the ladder. He was now a recognized master sculptor, a *busshi*.

The Tori style is mature enough to be highly personal. The Yakushi Buddha must have been the model, and its characteristics were applied here with only the modifications of time included. The "boat-shaped" mandorla embraces all three figures as was then the fashion, the face is long, the head, hands and legs enlarged, the ringlets of hair in high relief.

Patches of gold show through the surface accretions of the centuries and one of the bodhisattvas has been almost fully cleaned. The Shaka is made "in the image of the prince," in a reference to its size. Standing, this would be a man of about 1.77 m (5 ft 10 in).

The same kind of inference is made about the Yumedono Kannon, a wooden gilt figure of a very tall man for those days. Officially, this is the Guze Kannon of the Yumedono of the east subtemple of Hōryū-ji. It too is in the Tori style. Since it was kept wrapped until the late nineteenth century, its surface looks new, and infrequent exposure to the public continues to protect its appearance.

As with the other Tori sculptures this chief icon of the Dream Hall is stiffly erect. The body is manneristically elongated and flattened. Details look rather metallic. The shape of the face, wide nose, heavy jaw, fern frond hair and flared drapery scarves are Toriesque, but the body proportions are not, when judged against seated figures. The face was painted red. Quite unique for this time is the sacred jewel held in both hands, and few gold crowns compare with this one in quality of workmanship and intricacy of detail. The halo has strongly carved lively patterns. Curiously, it is unprofessionally nailed to the back of the head.

Tori's work dominates but does not blanket the period. The fruit of a very different tradition is the Kudara Kannon, a polychromed

wooden figure of long, slender proportions with Korean connotations in the title but without pedigree until reference in an Edo period document. Much paint has flaked off the sizing.

The source of the style would be central or south China. Those who say it was made in Japan point to the use of camphor wood (the base is Japanese cypress, *hinoki*) and the lack of similar examples in Korea and China.

Instead of exclusive concern with

a frontal view, the "fern frond" hair, which was used to give the Yumedono Kannon its interesting shoulder and arm silhouette, is here pressed down so as to be seen from the side, and the side-flaring drapery of the Wei style is here in the form of finely carved drapery scarves turned forward, encouraging angle views. The projected right arm also adds an extra dimension not normally known in the Asuka style.

Temple tradition names it Kokuzō, matrix of the sky, a rather

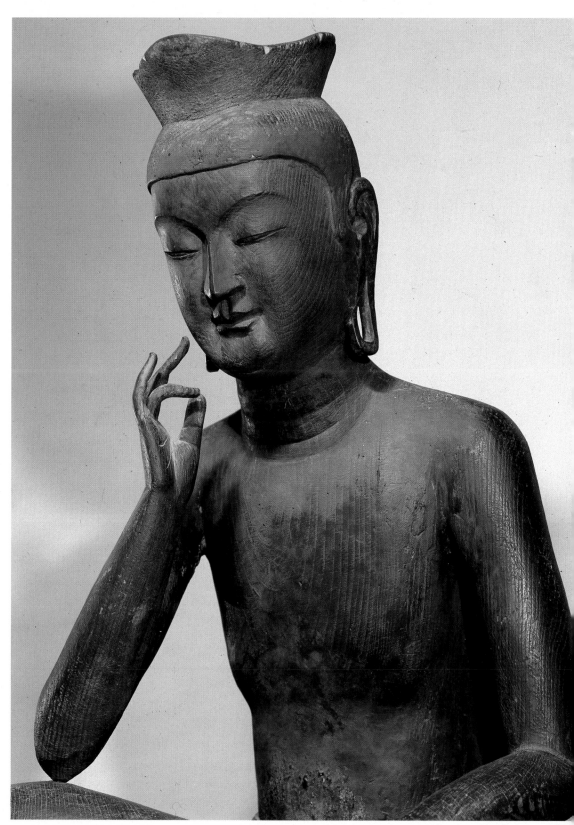

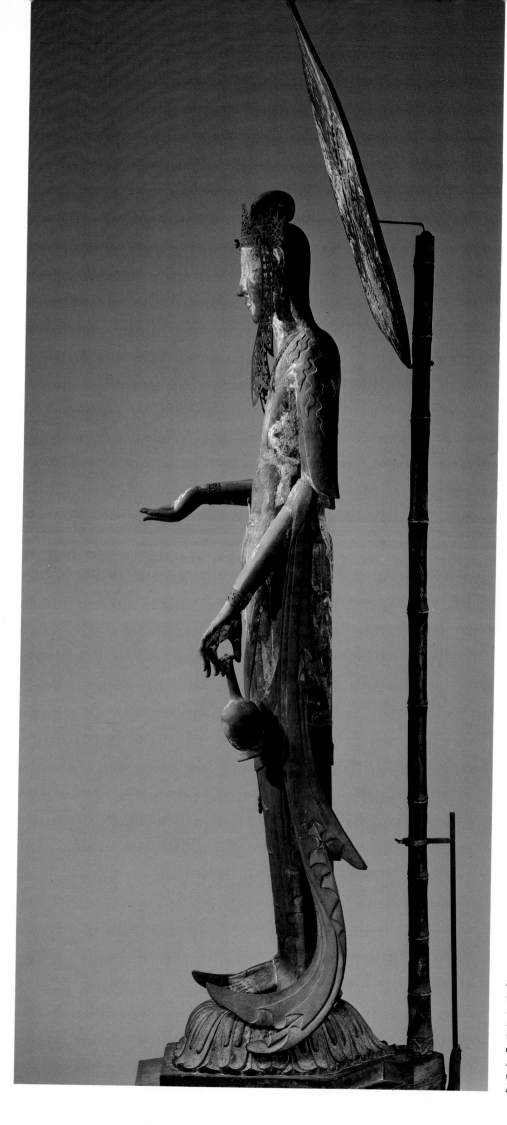

obscure bodhisattva of later times. The small Amida, barely visible above a jewel in the crown over the forehead, and the ambrosia vase in the left hand identify the image as a Kannon.

Attempts to place it later in time because of the technique, proportions, heightened side views and greater sense of spatial depth have been unsuccessful, as it still fails to fit with any later style. Tori measured the head to body ratio as around 1 to 6 or less. This is 1 to 7.

The Buddha platform is guarded by Japan's oldest Four Heavenly Kings (Shitennō), but ones not listed in the temple's inventory of 747. They can be dated to the middle of the seventh century by comparing an ink inscription on the back of the halo of one and a reference to a sculptor, Ōguchi Aya-no-Yamagu-chi-no-Atai, mentioned in the *Nihon Shoki*. The kings, demons below and the simulated rock bases were made in three separate pieces of camphor wood. Little restoration has been carried out on the polychromy.

Standing stiffly with feet slightly apart, the figures are blocky, almost cubic, and very stylized. The makers knew the Tori style. Arched eyebrows seeming slightly frivolous are intended to look unworldly. The Central Asian armour is almost hidden under the heavy and voluminous drapery. Narrow pleats hang smoothly, with frilly effects. The demons are a caricature on the theme of good over evil. Subhuman or bestial, they squat meekly. In a rare concession to the views a circumambulating worshipper would have of the platform and its images, the side scarves on the kings turn forward and up.

Among other bodhisattvas one type is identified philosophically with Prince Shōtoku and his time and appears only infrequently and

Opposite: Miroku (Sanskrit: "Maitreya") Bosatsu. Wood sculpture. Asuka period, seventh century. Koryu-ji, Kyoto.
Left: the Kudara Kannon. Nara, Hōryū-ji. For detail, see page 41.
Overleaf: fragments of a silk embroidery portraying part of the Mandala of Heavenly Longevity (Tenjukoku Mandara). Chūgū-ji, Nara.

rather archaistically later. This is the Miroku Bosatsu, the Maitreya type, usually known as the Buddha of the Future, but introduced as a bodhisattva connected with the contemplating Prince Siddhartha as seen in the Chinese Buddhist caves. Called "half-cross-legged in meditation" (*hanka-shi-i*), the large examples are roughly life-size and made of wood, and the small ones, such as the ten in the collection of the Forty-eight Buddhas from the Hōryū-ji now in the National Museum in Tokyo and others, are household size and made of gilt bronze. There are good Korean models from which the type was literally copied.

The camphor wood Miroku in the Chūgū-ji (the nunnery of the Hōryū-ji) is put together in several pieces: the head is two, the body another, and the drapery and legs one more. The gold crown and the torso ornaments are missing. Surface polishing now appears as a black, metallic sheen. Some writers see serenity and detachment in the introspective meditation of the downcast eyes, the light touch of the right fingers and the limp droop of the left hand. The halo and drapery folds are after the Tori manner, modified by the medium.

The art of embroidery is less known because the products have mostly disintegrated. The chief remaining pieces are small patched fragments of the Mandala of Heavenly Longevity (Tenjukoku Mandara) preserved in the Chūgū-ji. The tapestry, or in fact two tapestries, were made as a consequence of Empress Suiko acceding to a request from the wife of Prince Shōtoku to get a glimpse of the kind of paradise to which he had gone. They were therefore made as a memorial, probably very shortly after his death. They are said to have measured about 4.50 m by 4.50 m (15 ft × 15 ft).

A later writer indicates they were stored in the treasure house of the Hōryū-ji, then removed and copied in the thirteenth century before deterioration had become too bad. Some repairs must have been made at about that time, but the copy was destroyed by a fire in the fourteenth century and the original continued to disintegrate. An eighteenth-century Hōryū-ji monk mounted the salvageable fragments in the way they are seen today, with no regard for the original scene.

Differences in colours and the degree of fading are due to the materials which were used for threads and dyes. Those in the best condition are the oldest. Medieval writers could still read enough from the work to copy a long inscription of 400 characters woven into the backs of 100 tortoises. Hata and Aya names are included, some weavers coming from north Korea. No date is indicated, and the inscription does not really describe the subject.

The picture could hardly have resembled the conventional paradise scenes of the Hōryū-ji's wall paintings, for these grand schemes were only just entering the Chinese end of the pipeline leading to Japan. It probably resembled one of the large panels on the Tamamushi Shrine, that is, a landscape dominated by an exfoliated holy mountain. A sun and moon are at the top with parallel lines for clouds just below, the air and hillsides interspersed with spirits and new souls in paradise. Buddhist, Taoist or both, figures on lotuses, images in temples, tortoises for longevity, sun and moon – the present figures of the Mandala are no bigger than a finger, but others need not have been much larger as they also have these small dimensions on the panel of the Tamamushi Shrine. There may have been dozens if not hundreds of them in this tapestry.

People in court dress resemble women painted on the walls of the Takamatsuzuka tomb of the end of the seventh century. This paradise was a forerunner of *jōdo*, possibly with Maitreya connotations, in consideration of the close association the prince had enjoyed with the philosophy of Maitreya.

Opposite: apsara *(detail of the wooden canopy in the Golden Hall of the Hōryū-ji, Nara).*

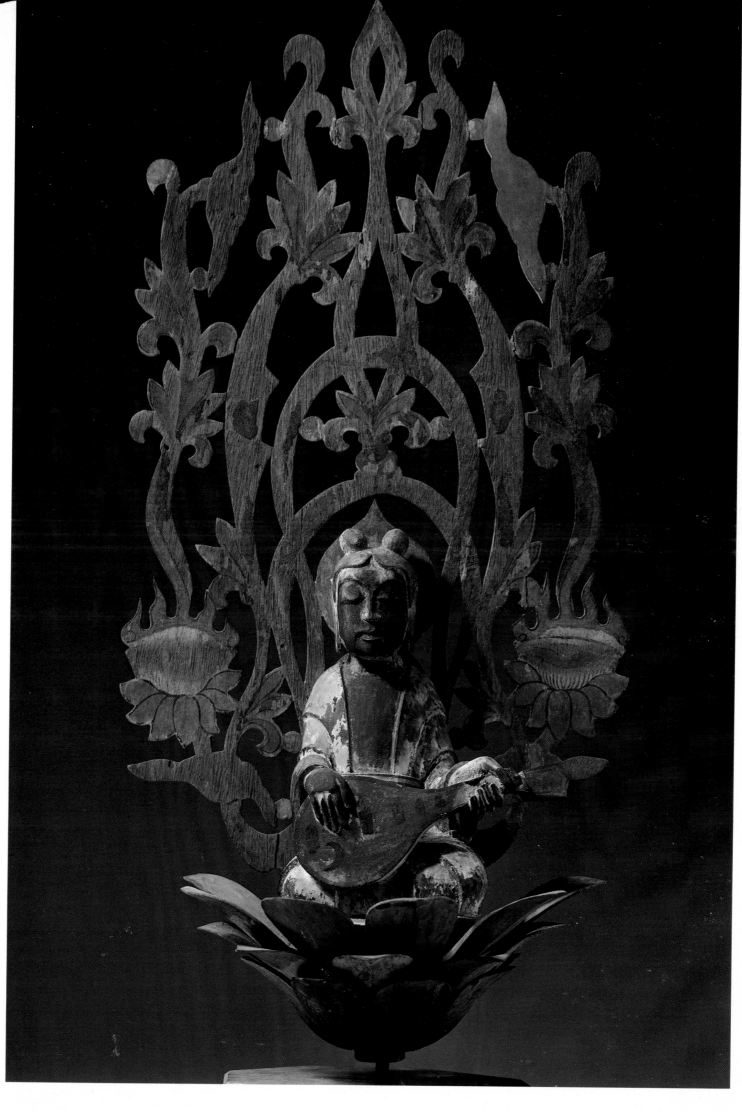

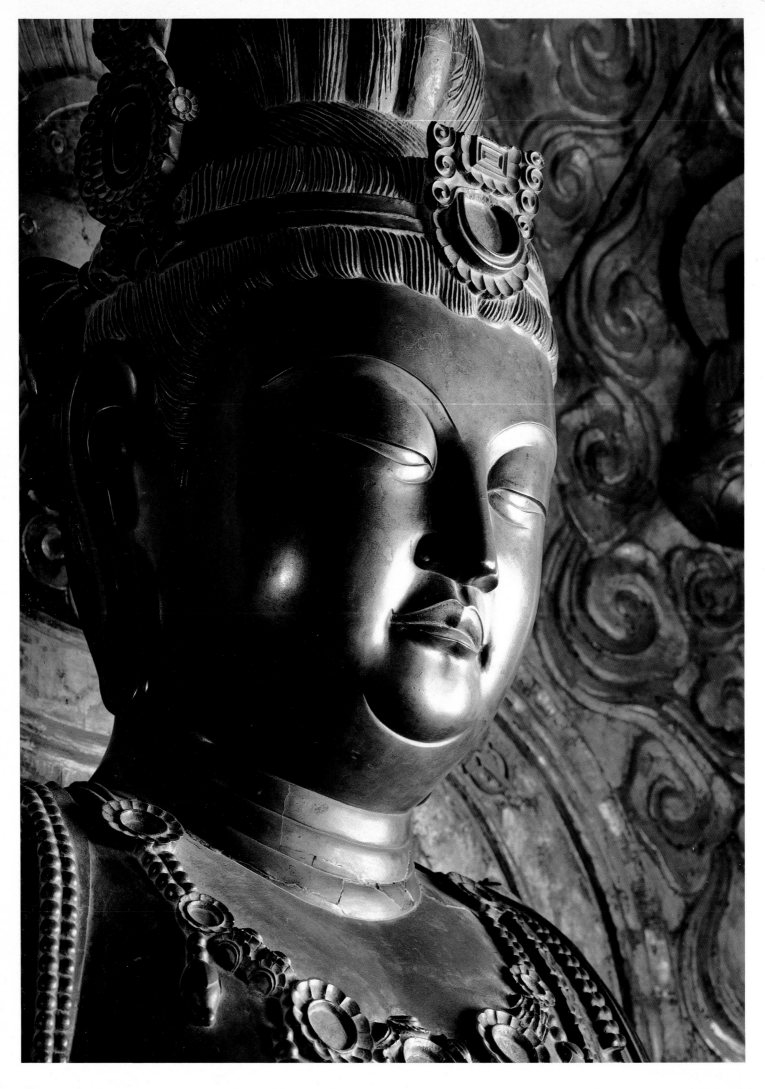

THE HAKUHŌ PERIOD
645–710

The name Hakuhō (650–54) is used today rather loosely to cover the period spanning the latter half of the seventh century, and now seems a strange and unwise choice. The very name is an enigma. It does not appear in the *Nihon Shoki*. Emperor Kōtoku changed the name of the era, Taika (Great Change) to Hakuji (White Pheasant) in the sixth year of his reign after one of his governors had caught a white pheasant. But at some point in time, perhaps in the eighth century, that name, which still appears in the history books, was changed to Hakuhō (White Phoenix). It does not even cover one tenth of this 65-year period.

Hakuhō marked the rise of the Fujiwara family from the old Nakatomi, following the elimination of the Soga clan in a palace coup. Kōtoku issued the Taika Reform edicts from Naniwa, not Asuka, and established a Chinese-style political structure embodying the power in the person of the emperor. Governing a still non existent city was a Minister of the Center, Nakatomi Kamatari, the prime engineer of the downfall of the Soga, later given the Fujiwara title on his deathbed; a Great Minister of the Left, Abe Kurahashimaro; and a Great Minister of the Right, Soga Kurayamada Ishikawamaro, the builder of the Yamada-dera in Asuka. The official advisers to these ministers were Buddhist priests recently returned from long and intense years of study in China.

The changes were drastic. Province officials were appointed, official roads and toll stations set up and land put under government control. New taxes were instituted. The traditional *omi* and *muraji* ranks were dissolved and the whole *uji* and related economic *be* system abolished. Private land belonging to former nobles was confiscated. Among the edicts was the Law of Hakusō, a regulation to reduce the construction of mounded tombs and prohibit the deposit of grave goods. This law was prompted by the inordinate expense of burials and the lavish ceremonies they entailed.

For years on end the old records go into exhaustive detail on increasingly unfavourable events in Korea and scarcely mention Japan, as though Japan was only of peripheral interest. Court officials were concerned at the prospect of losing their steady flow of trade, source of skilled craftsmen and, indeed, every elevating form of culture. Emperor Tenji suffered the indignity of losing the Japanese ships, sent to help Paikche, in a naval battle against the Chinese in 663. T'ang and Silla went on to destroy Koguryŏ in the north and Silla took over the entire peninsula. The exodus from Paikche added immeasurably to the reservoir of trained people in Japan.

As it turned out, the Chinese had other concerns and the Koreans had no grounds for invading. On realizing this, the Japanese turned their attention to developing their political system, looking forward to the next phase – the construction of a formal palace and adjunct capital city as the bureaucracy demanded, and which the tax system made possible. Within two years of the loss of Mimana, the Japanese had sent their first mission to T'ang China and in so doing had begun to tap the creative source directly and reduce the culture time-lag.

Tenji's successor, Temmu, survived a brief revolt and was formally crowned in 673. Jitō became his official consort. Temmu set himself up in a large, new style palace known as Kiyomigahara in Asuka and absorbed himself in Buddhist affairs. Jitō succeeded him after his death in 686.

From the time Temmu had dispatched diviners early in 684 to look for a site until Jitō moved in, ten years had elapsed. Fujiwara was laid out due north of Asuka in an open area defined by the Yamato Sanzan, three small cone-shaped hills, and crossed diagonally by the Asuka river.

Fujiwara, whose outlines appear today in the shape of the north–south and east–west roads, is believed to have measured about 3.1 km (2 miles) north to south and 2.1 km (1 mile) east to west. The area was not totally flat and it may not have been possible to lay out the entire grid system. The palace was situated in the middle of the north side in such a way that the Asuka river would pass but not cut its southwest corner. The Chinese capital cities were the model, with odd and even numbered streets to conform to the balances of nature. The main avenue led up through the center to a large red gate opening into the palace complex. The eight blocks across the south side, four on either side of this avenue, were each about 264 m (865 ft) long, less the width of the streets. It is unlikely that each block could have been an ideal square.

Opposite: detail of a bodhisattva Gakkō of the Yakushi triad. Golden Hall of the Yakushi-ji, Nara.

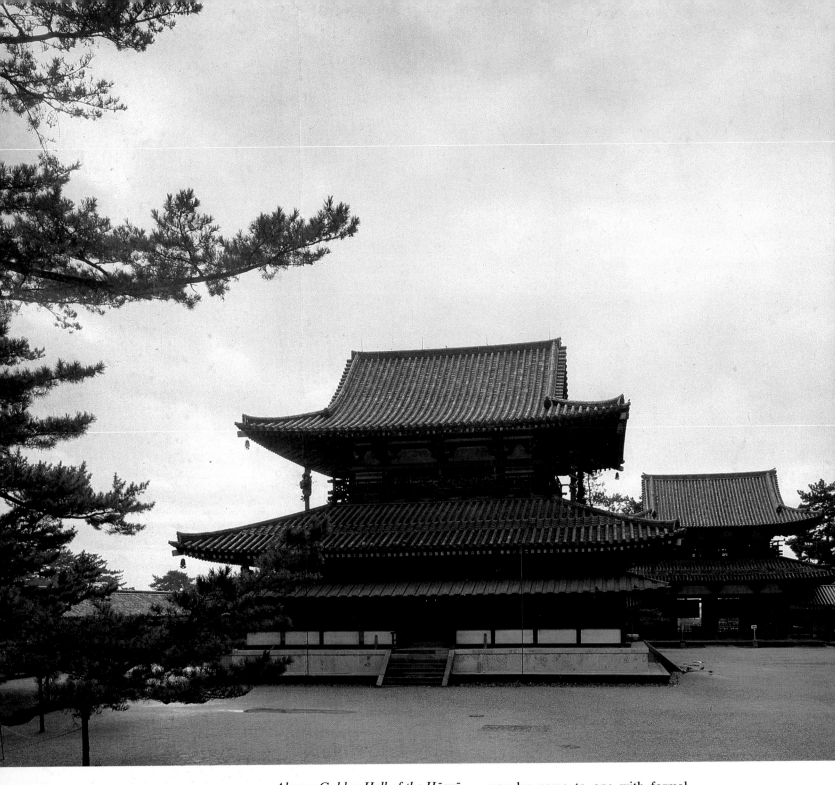

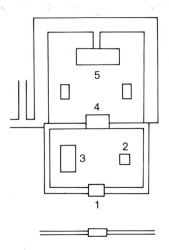

Above: Golden Hall of the Hōryū-ji, Nara.
Left: plan of the Kawara-dera;
1 Middle Gate, 2 Pagoda, 3 West Hall, 4 Middle Golden Hall, 5 Lecture Hall.

As the central political authority stimulated the economy and propelled the country forward dramatically, religious developments were in the forefront. One of the early sects, Hossō, was introduced by a Japanese priest named Dōshō, reportedly in 654. Its sūtras shaped the religious thought in many of the early temples.

In 679 all the temples were told to adopt a Chinese-style name, going from a geographical or sometimes popular name to one with formal implications. By way of an example, the Ikaruga-dera or Wakakusa-dera became Hōryū-ji. In fact, it was formally Hōryū Gakumon-ji (Prosperous Law Temple of Learning). In the following year the sustenance fiefs of the temples were cut to 30 years and the number of temple administrators reduced except in the case of those temples regarded as national. At the time of Empress Jitō, who moved into the Fujiwara palace in 694, there are said to have been 545 temples. The great expansion had taken place beyond the boundaries of the Home Provinces, for it seems that only two Asuka temples are known outside that region.

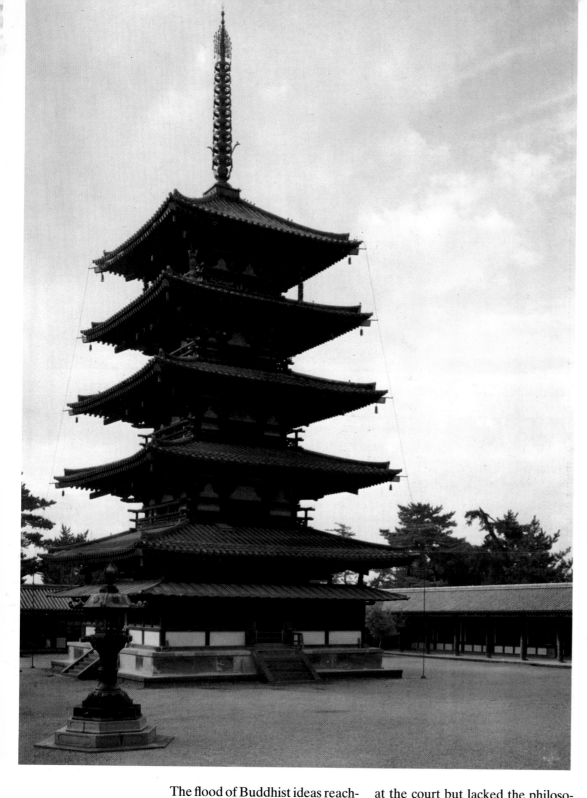

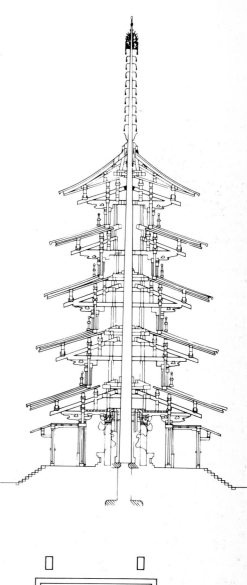

The flood of Buddhist ideas reaching Japan entered a melting pot of virtually indistinguishable shamanism, the Confucian social principles as espoused by Prince Shōtoku, Shinto and, already, some Taoism. Magical value was given to early Buddhist paraphernalia. A temporary role at least was found for almost every idea until each could be sorted out when the official stance of the government was established.

Taoism left its permanent mark on Japan in the term Shinto or, in colloquial Japanese, Kami-no-michi, the Way of the Gods. If the Paikche priest Kwal-leuk who came to Japan in 602 had been able to expound the laws of the universe he would have found a better audience

at the court but lacked the philosophy. Instead, he concentrated on a full range of practices, delving into black magic. The *Nihon Shoki* says he dealt with calendars, astrology, geomancy and the art of invisibility and magic. A few Japanese were assigned to study with him, but on the whole the court took a rather dim view of most of these practices, although they approved of the current calendar system, for which there was a practical need.

The Taoist elements which penetrated the arts did so through the medium of Buddhism. The earliest Buddhist works served a major social, commemorative and memorial function. They were often ordered by a wife, son or other kin

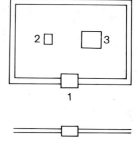

Above left: Pagoda of the Hōryū-ji.
Top: cross-section of the pagoda, showing the way in which the building is supported by a central beam made from a single tree trunk.
Above: plan of the Hōryū-ji;
1 Middle Gate, 2 Pagoda, 3 Golden Hall.

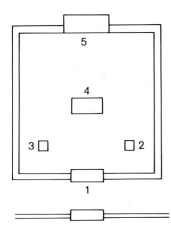

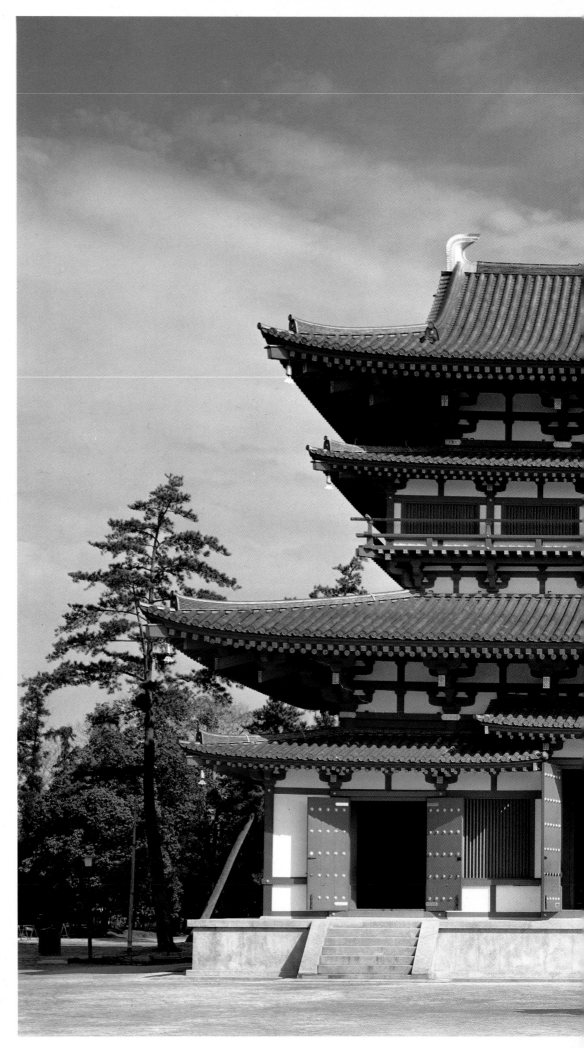

Right: the Kondō or Golden Hall of the Yakushi-ji, Nara. The temple is dedicated to the Buddha of healing. Above: plan of the Yakushi-ji; 1 Middle Gate, 2 East Pagoda, 3 West Pagoda, 4 Golden Hall, 5 Lecture Hall.

"to ensure repose for the soul in paradise." Temples built by Prince Shōtoku and icons later made for them were dedications. For instance, the original Hōryū-ji and the Tachibana-dera were dedicated to the prince's father Yōmei (whose name was Tachibana-no-Toyohi), and Chūgū-ji to his mother. The bronze Shaka triad and the tapestry Mandala of Heavenly Longevity of the Hōryū-ji were dedicated to the prince by his wife and relatives.

Long life was a pervasive theme, not only in the subject of the Mandala itself but in many of its individual motifs: tortoises, sun and moon symbols, the rabbit in the moon mixing the elixir of eternal life and probably, when it was complete, the Mountain of the Blessed as seen through the eyes of a Buddhist, a precipitous landscape like the one on the large back panel of the Tamamushi Shrine, where sun and moon symbols can also be seen.

The base of Buddhism was being broadened by these Taoist elements as Buddhists in Japan began to formulate the notion of an existence regarded as "rebirth" in a land of Eternal Bliss. They were trying to visualize Tokoyo-no-huni, lamely translated as External Land, an embryonic Jōdo, the later Amidist Pure Land. No longer were the spirits of the dead destined for Yomi-no-huni, the dark, indistinctly defined underground tunnel inhabited by horrible creatures in a state of limbo. It is no coincidence that the meaning of death and prospects

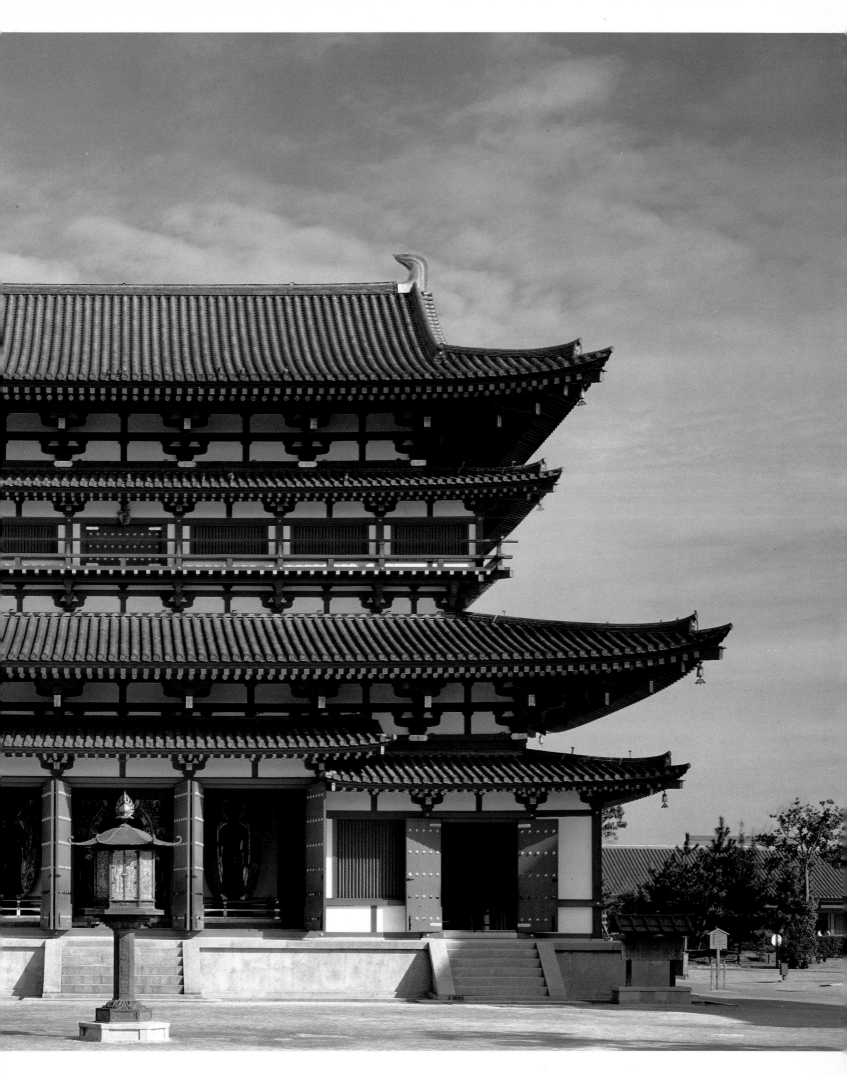

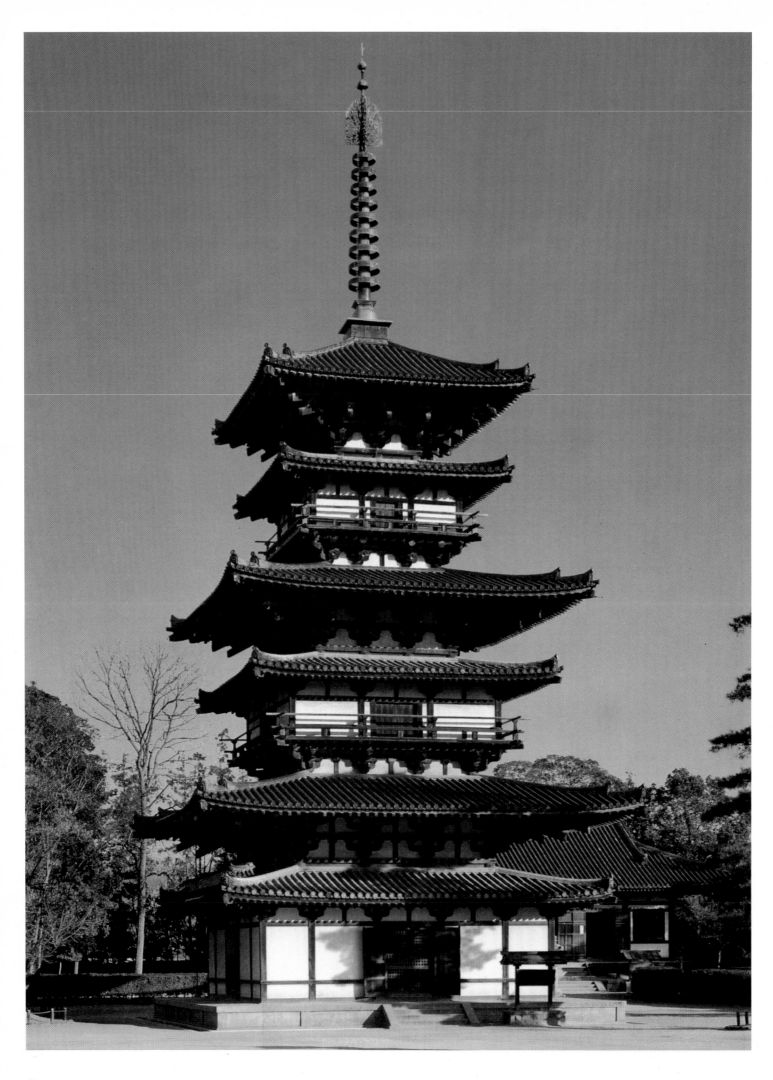

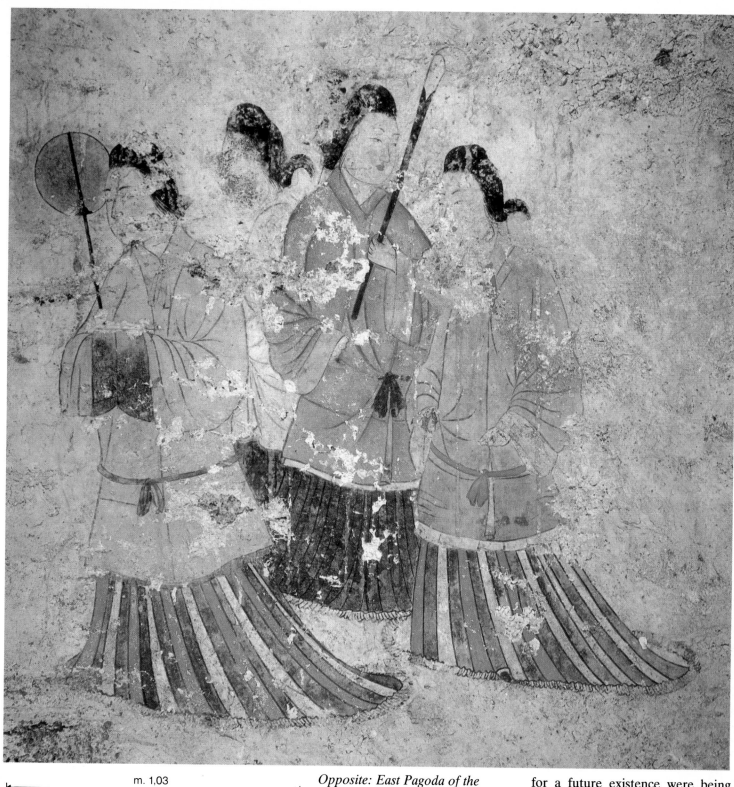

Opposite: East Pagoda of the Yakushi-ji, Nara.
Above: group of men, as depicted in the burial mound of Takamatsuzuka.
Left: layout of the tomb paintings; 1 Constellations, 2 Moon, 3 Group of men, 4 White Tiger, 5 Group of men, 6 Black Warrior, 7 Sun, 8 Group of women, 9 Azure Dragon, 10 Group of men.

for a future existence were being reevaluated during the regency of the prince. The effect on the arts was, of course, enormous.

Prince Shōtoku is said to have studied and annotated the Hokke-kyō, the Lotus Sūtra, the text expounding Pure Land. The Chinese founder of Pure Land Buddhism, Hui-yüan (333–418), emerged from a Taoist tradition and after his conversion is supposed to have used Taoist rhetoric to explain the Buddhist truths. Taoist ideas were firmly rooted when incipient Pure Land concepts were introduced to Japan. The Confucian element is more

pervasive, although the possibilities for assessing its influence directly are scant.

Showing that the prince could see value in everything but was intensely Buddhist, later proponents of Buddhism attributed to the prince the view that the religions of Japan took the form of a tree, in a succinct expression of the syncretistic nature of Japanese thought: Shinto, the roots, the most ancient of the traditions; Confucianism, the trunk and the limbs, the laws and moral values; and Buddhism, the essence which gives life to the blooms and fruit.

Asuka temples had all followed Korean plans faithfully. Once the Japanese started to tinker with the plan in the 660s, probably first with the Kawara-dera, the changes wrought moved rapidly into other areas. The ideal was reached at Ikaruga, a remarkable laboratory for invention where three temples were undergoing rebuilding work: Hōrin-ji, Hokki-ji and Hōryū-ji. All have conflicting traditions as to when their construction began, but all have a due north orientation and so belong at least to the latter half of the seventh century. The Hōryū-ji had been destroyed by fire in 669 or 670 and it was rebuilt a little to the northwest of the first temple in the last 15 years of the century.

Using the Asuka structural style which was already archaic elsewhere, perhaps out of respect for the memory of the prince, monks rebuilt the Hōryū-ji on a set of extraordinarily sensitive aesthetic principles. It was not the invention of these principles but their application which is the genius of the work.

The new temple's *garan* had a long east-west axis with a simple rectangular shape quite different in the north from what it is today. It was opened up for more spaciousness after a tenth-century fire with the inclusion of the Great Lecture Hall into the complex. At first the cloister contained only the Golden Hall and pagoda, both of which could be seen panoramically on entering by one or other of the two open bays of the Middle Gate. Each building came into a framed view as the gate acted as the entrée for a whole series of spatial relationships.

The cloister served as cover in inclement weather, offered privacy to people within, organized the architectural space and enhanced views of the buildings through framed areas of light and shade. Entasis is modest and, in some cases, the columns are weatherworn on exposed sides to sheer vertical lines.

The cloister extends eastward by one more bay to accommodate the ground area of the Golden Hall. The units were still the *komajaku*, although other temples were turning to the *tōjaku* (T'ang *shaku*) or *narajaku* as it later came to be known in Japan, a slightly shorter unit. The Middle Gate is three times the height of the cloister (14.1 m to 4.7 m, 46 ft to 15 ft) and the pagoda to the top of the spire is close to twice the height of the Golden Hall (31.65 m to 16.08 m, 103 ft to 52 ft). The lateral ratio shows the Golden Hall occupying three times the cubic space of the pagoda. These were meticulously weighed volumes in asymmetrical balance. The Golden Hall is 1.74 times the volume of the Middle Gate, which in turn is 1.74 times the volume of the pagoda.

The Middle or Inner Gate is virtually unique in plan, with a pair of wider inner bays and narrower outer bays. It is three rather than two bays deep. The architectural style of staggering the columns on the upper level, which is an exact but smaller version of the lower level, leaves only the line of the central pillars in perpendicular. In this way the gate makes its own contribution to the fundamental horizontality of the architectural lines throughout. The entasis and cloud-brackets are strongly shaped. The rafters supporting the roof boards and tiles are now consistently square, changed from the round ones common in most earlier temples. Immense rough stones which had been used in the first temple for column bases were moved over to this one. Some black and red surfaces from the fire are still visible.

The five by four bay Golden Hall is almost square, in the Chinese centerpiece tradition. The upper level is again a smaller form of the lower one. The cloud-brackets are more conventionally grooved than those of the Middle Gate. The "frog's-leg" bracket, the intervening support where less weight is involved, can be seen in Chinese-carved stone Buddhist caves in low relief façades of buildings, such as at Yun-kang (sixth century), but entasis and cloud-brackets are virtually impossible to recognize there. The inordinately wide eave spread is shared by both the Golden Hall and pagoda. It may be elegant, but it leaves one apprehensive. At some point the upper roofs received vertical supports, perhaps even in the initial construction, but the present ones with entwined dragons belong to the Edo period and were not put there with any thought for stylistic compatibility.

A visitor inside will feel the power of the entasis, the dark and crowded conditions caused by the false ceiling, three heavy canopies and enclosed porch. The porch is now the ambulatory. The functional space is approximately half of the total internal space, the other half consisting of the upper level combined with the space under the roof. This other half is designed strictly for external appearances, and gives the building the height and scale it needs for its place in the *garan*.

The pagoda is the masterpiece of the complex. A major interest in it grew out of an unpublicized investigation of the relics in 1927 after which a rumour circulated that the foot of the pole had rotted out. The pole was dangling in place. The details were revealed many years later and architecture historians were obliged to reassess the role of the center pole. It is only loosely attached to the structural members of the building to allow flexibility in the event of earthquakes. If anything, the pagoda supports the pole, not the pole the pagoda.

The relics were removed in 1944 from the hole in the stone beneath when the building was dismantled, and were copied and replaced. They include a T'ang dynasty Lion and Grape mirror, whose presence is assurance that these were not relics used for the first Hōryū-ji.

Since the pagoda was conceived of in mathematical terms, a look at it from that viewpoint should start with its proportions. It is 105 *shaku* high, although the Inventory of 747 missed the mark widely by saying its height is 160 *shaku*. From the first to the fifth storey, the wall face was reduced in regular progression by 50 per cent, that is, from 18 to 9 *shaku*, or 25 per cent each time. The height of each storey, however, is reduced in an irregular progression. The wall of the top storey is 40 per cent shorter than that of the first storey. The width of the roofs works on a third principle. From the bottom to the top, the width of the roof is reduced by 40 per cent. Reductions between give the inward and upward curve. This is coupled with a progressively flatter slope to each roof except for the fifth which has lines

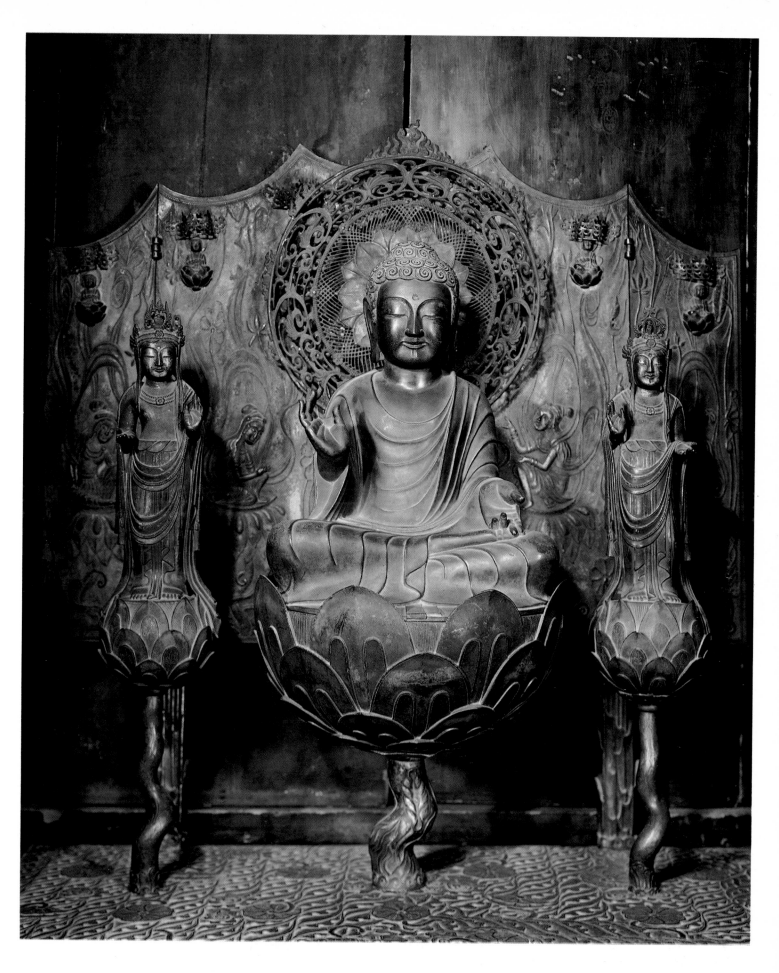

*Amida triad in the new treasure
house of the Hōryū-ji, Nara. The
Amida at the center is flanked by
Seishi (left) and Kannon (right). In
the background are* apsara, *seated,
like the triad, on lotus flowers.*

drawn down rather sharply, in effect anchoring the potentially soaring building and giving it both buoyancy and stability.

When his wife was suffering from an eye disease in 680, Emperor Temmu ordered the erection of a temple to Yakushi, the Buddha of healing. The construction failed to meet the projected schedule, for in the later years of Temmu's life, when worship was conducted in main temples to invoke aid in restoring his health, the Yakushi-ji was not available for use. But a large assembly was held there in 688 and the statues were dedicated in 697.

This leaves open the question of whether Temmu was responsible for the introduction of the two-pagoda system. He is, however, probably to be credited with stimulating the use of T'ang style monumental bronze, dry lacquer and unbaked clay images. In any event, his wife Jitō saw to the completion of the Yakushi-ji. She put a trusted nephew on the throne, abdicated in 702 and died the same year. She was cremated, thus giving respectability to a practice indulged in by priests in China, and started within the Hossō sect in Japan. Her ashes were buried at Asuka in the tumulus of her husband.

After the capital was transferred to Heijō (Nara) in 710, the temples slowly followed suit. The Yakushi-ji was assigned to a rather similar location in the new city. It was rebuilt in exactly the same way it had stood in Fujiwara. The pair of pagodas exhibit a rediscovered symmetry reflecting new connections with China. The west pagoda was destroyed by fire once, reconstructed, only to burn down again in 1716. It has just recently been rebuilt and was dedicated in 1981. The Golden Hall has also been reconstructed in recent years. The earlier one was a building of about 1600 of no special distinction. The original base stones were used for the new hall.

The guide for reconstruction of the modern Golden Hall came from notes in the diary of an extraordinary twelfth-century pilgrim, Ōe-no-Chikamichi, who followed the customary pilgrimage route leading

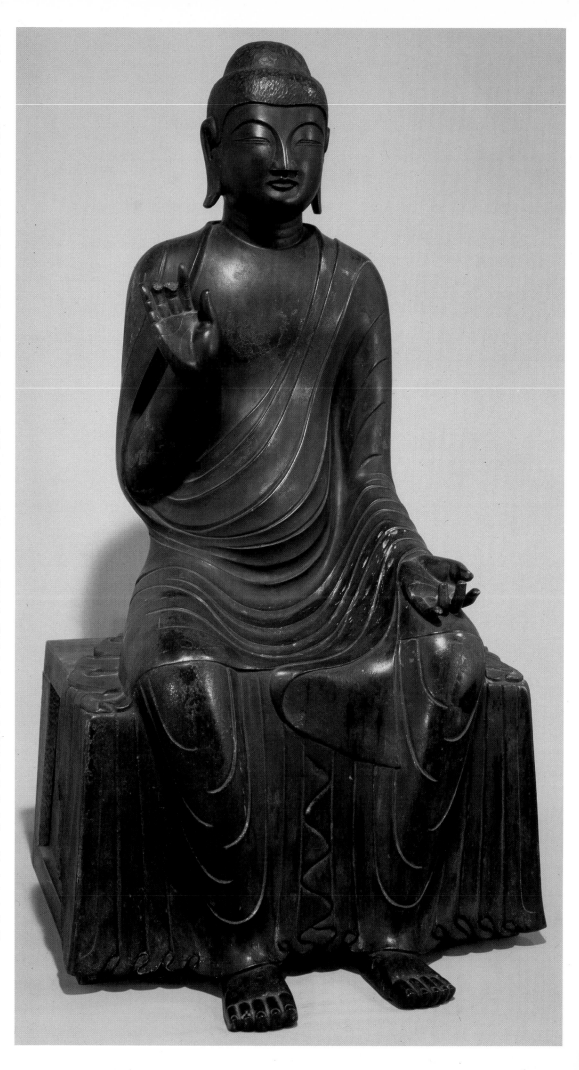

The Shaka Nyorai in the Jindai-ji, Tokyo. Seated in a European-style pose rarely found in the East, the figure is of bronze and dates from around 670.

66

through the temples of the "southern capital." He wrote of seeing "porches" on both levels of the large halls. He also mentioned the presence of an octagonal hall to the east, in the compound where the rectangular Tōin-dō now stands. These porches were included in the initial design of the buildings, whereas at the Hōryū-ji they were additions.

One pagoda is strictly ornamental and merely a concession to the continental preoccupation with symmetry. In diagrams of the temple the Golden Hall was laid out on the crossing of the diagonals of the cloister. The two pagodas were pulled far forward in a cloistered area roughly twice the size of the Hōryū-ji *garan*, perhaps already reflecting some effort to protect the main hall from fire. Lightning striking the mast of a pagoda frequently ignited fires which quickly spread to other buildings. The Yakushi-ji has a record of five fires, leaving only the east pagoda the lone survivor to modern times.

The structural system may have been started with the Kawara-dera (Kawahara-dera) in Asuka. The relative width of the bays is similar. The intercolumniation on the north and south sides of the five-bay Golden Hall of the Kawara-dera were 10:12:12:12:10 in *shaku* units. At the seven-bay Yakushi-ji they follow the same principle: 10:10:12.5:12.5:12.5:10:10. The structure was new, and not a modification of the Asuka system. The entasis, cloud-brackets and ponderous character of that style had given way to a bracketing system supporting three consoles and projected forward to hold the laterally extending levers. The roof rafters are doubled, the upper layer in square section, the lower in round section. Roughly twice the number of parts each do about half the work they did in the Asuka style.

The magnificent Yakushi triad should have been in place by the end of the century, if the *Nihon Shoki* note is accepted. However, the date has been much disputed by those who think the statues were made for their present location after the temple was moved. On stylistic, textual and technical grounds one might select the earlier date, for the Fujiwara temple, but two particular texts referring to this differ greatly in implication. An eleventh-century text says the statues were moved by cart from the old Yakushi-ji in a journey which required seven days.

A late seventeenth-century text says the statues were cast by Priest Gyōgi at Kanaoki-yama in the Yōrō era (717–24). Gyōgi's legendary feats as engineer and jack-of-all-trades may well have included this work, but the whereabouts of Kanaoki-yama are uncertain.

The Yoshino earthquake of 1952 did some damage to the image, and dismantling, investigation and minor strengthening had to be carried out. Within were the usual sand ballast along with two coins dating from the Wadō era (708–14), part of a small gilt bronze Yakushi Buddha, some seventeenth- and eighteenth-century coins and gilt bronze ornaments. The "nails" left from the casting moulds seemed indicative of a slightly more advanced technique than those inside the large Buddha head from the Yamada-dera, now in the Kōfuku-ji, known to date from 685.

Placed on a north Chinese white marble platform, the triad is for the first time of such a large size that the images all have their own mandorlas. These are replacements, as they are not the ones described by Ōe-no-Chikamichi. The images are in scale with the building and in harmony with the symmetry of the twin pagoda scheme. The body stances are mirror-images as each bodhisattva holds up the inside hand. Deeper three-dimensionality existed in scarves hanging down from the wrist where holes are now seen.

The Yakushi Buddha was cast almost entirely in one piece, except for the head, right arm and the falling drapery in front. These were brazed to the body. The bodhisattvas have only separate heads and pedestals.

A wide and deep table-like bronze socle supports the Yakushi Buddha. It is stepped at the bottom and reverse stepped at the top. Inside the surrounding lotus petals at the foot, the edge of three steps and the vertical corners of the box have rows of small rectangles bearing oval, rectangular or lozenge-shaped lotus patterns. The top edge is decorated with alternating grape and vine patterns.

At the middle of the top step on each side are the four tutelary deities: the Red Bird of the south, the Azure Dragon of the east, the White Tiger of the west, and the "Black Warrior," snake and tortoise, of the north. They fit spaces of two or four rectangles. The Red Bird is elegant

and pigeon-like. The elongated quadrupeds are winged, stealthy and, in the case of the dragon, fiery. Their fluidity is in contrast with the tortoise and snake, which are stilted and static. The dragon's neck is marked with a cross, a curious ornamental motif found on dragons of the Korean tombs along the Yalu River and on the dragon of the Takamatsuzuka painted tomb in Asuka.

The Animals of the Four Quarters of Taoist origin, no longer fashionable in their homeland, must be Hossō-related here. Six pairs of devilish, dwarf-like creatures sit and peer from the arched openings of caves, scowling and grimacing. The hair is kinky, the faces flat and their only covering is a loincloth. All are merely variations on two sets of poses and hand positions, and are not all that different from the subhuman dwarfs which are being overcome by the Four Heavenly Kings of the Tōdai-ji. Here they perform quite a different chore. They may not be literally prototypes for the Twelve Divine Generals which came to be associated with Yakushi by the late Nara period, but they are the first effort to personify the abstract ideas identified with him: Twelve Vows to save the world, 12 hours of the day, and 12 signs of the zodiac. These attributes may have evolved in Japan.

The center stage on the north and south sides is occupied by a kneeling "Atlas" figure supporting a column resembling a stack of jewelled cushions. Indian art represented the "world axis," identified with Ashoka's pillars (which gave authority to divine pronouncements) and included Atlas figures ever since the decoration on the stupa gates at Sanchi was carried out. Later, lotus bud stone columns took on an elaboration that sometimes looked like piled pillows.

The Shō Kannon of the Tōin-dō is a standing bronze image only a few years earlier than the Yakushi triad and probably from the same workshop. It has been the chief image of this hall in recent centuries. The very high ornamented bun, like the bodhisattvas of the triad, appears here for the first time, in its most exaggerated form. The upper torso is softly articulated, the light drapery scarves making a series of arcs that contribute to the form of the body. Side "wings" owe something to the Asuka tradition in Japan and much to the Gupta Indian way of

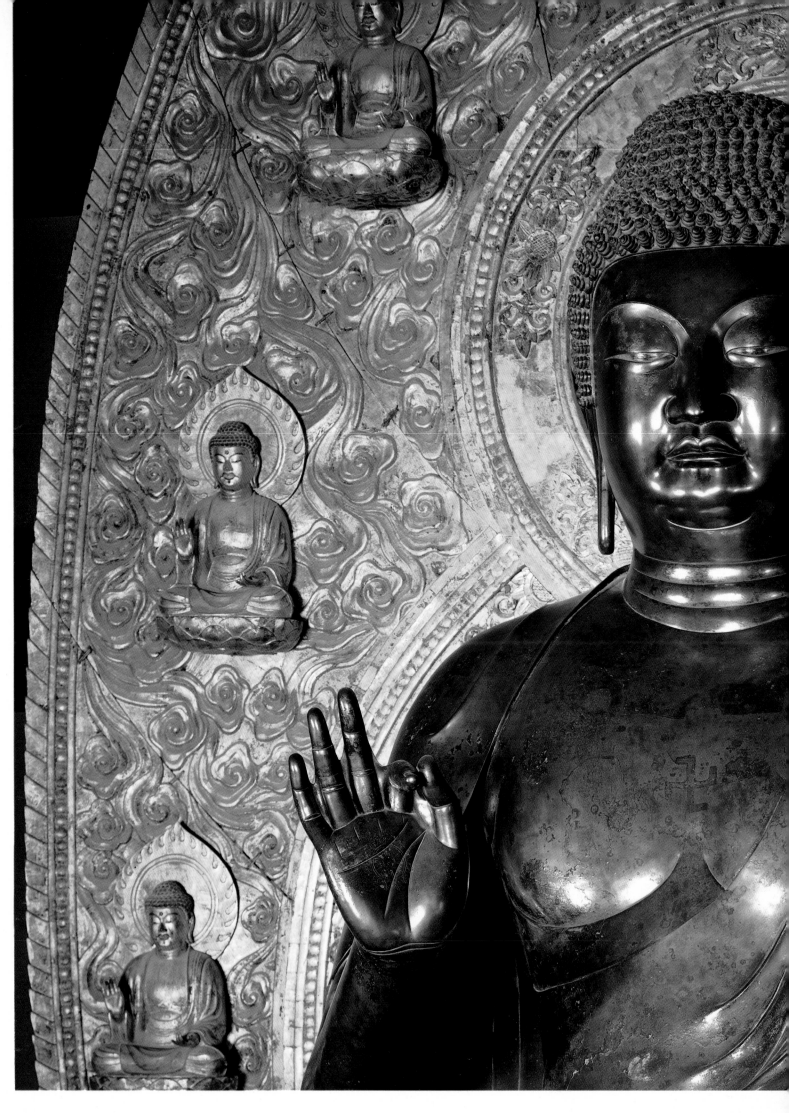

Detail of the seated, gilt-bronze figure of the Yakushi Nyorai, the Buddha of healing. Second half of the seventh century. Yakushi-ji, Nara. The statue forms part of a group known as the Yakushi triad, in which the Buddha is flanked by separate figures of the bodhisattvas Gakkō and Nikkō (illustrated on pages 72 and 73).

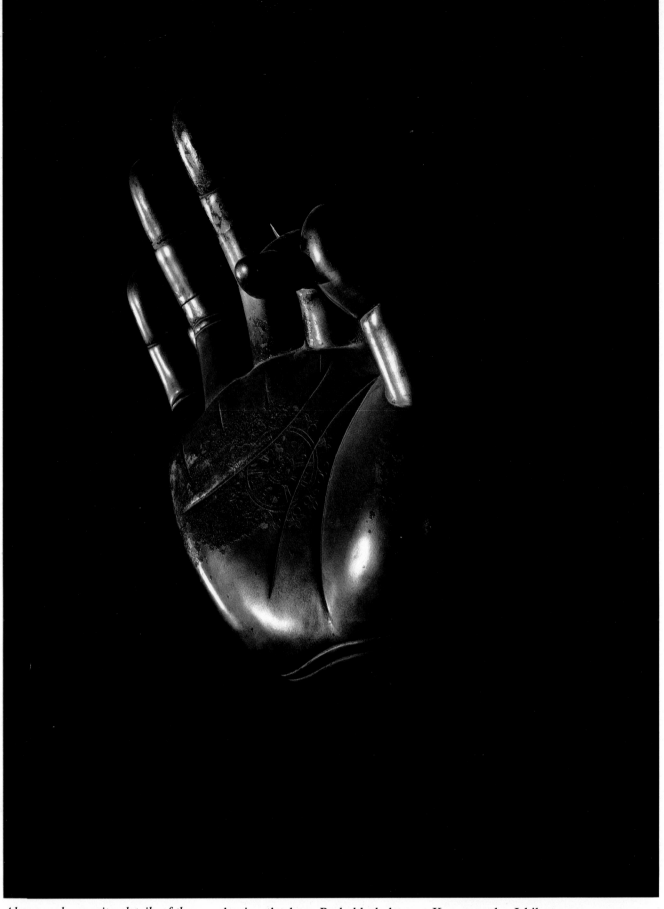

Above and opposite: details of the hand and foot of the Buddha of the Yakushi triad. Golden Hall of the Yakushi-ji, Nara.

shaping the legs. Probably belonging to the 670s, this Kannon is an inaugural example of the Indianization of the early T'ang style.

A large damaged head in the Kōfuku-ji is all that remains of an impressive bronze Buddhist triad, once the pride of the Yamada-dera in Asuka. The temple had a modest *garan* shaped like all those built by Prince Shōtoku. The founder, Soga Kurayamada Ishikawa-maro, was falsely accused of treason and committed suicide. Doubtless driven to placate his fretting spirit, his family and supporters rallied to complete the temple after his exoneration, investing most liberally.

The casting of the large sculptures was begun in 678 and their installation in the Lecture Hall was celebrated in 685, the 37th anniversary

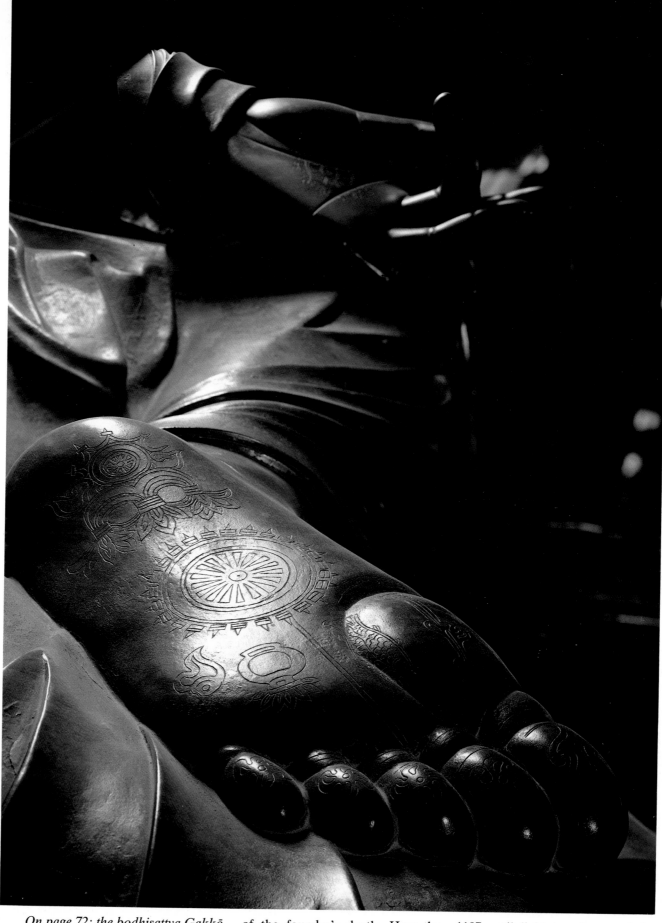

On page 72: the bodhisattva Gakkō and on page 73: the bodhisattva Nikkō, both of the Yakushi triad. Golden Hall of the Yakushi-ji, Nara.

of the founder's death. How the head of the Buddha became the property of the Kōfuku-ji in Nara is a story of medieval militancy, one of many told about monks of the Kōfuku-ji. They gave vent to their impatience over not getting replacements for statues lost in a fire around 1180 by commandeering the triad of the Yamada-dera. It served as the icon for the East Golden Hall from

1187 until lightning destroyed the building and its contents in 1411. In recent centuries it had been assumed that nothing had been salvaged, but quite by accident in 1937 the head was discovered under the Buddha platform during the course of repairs to the hall, and has been displayed since.

This is the first of the Japanese sculptures with aristocratic bearing

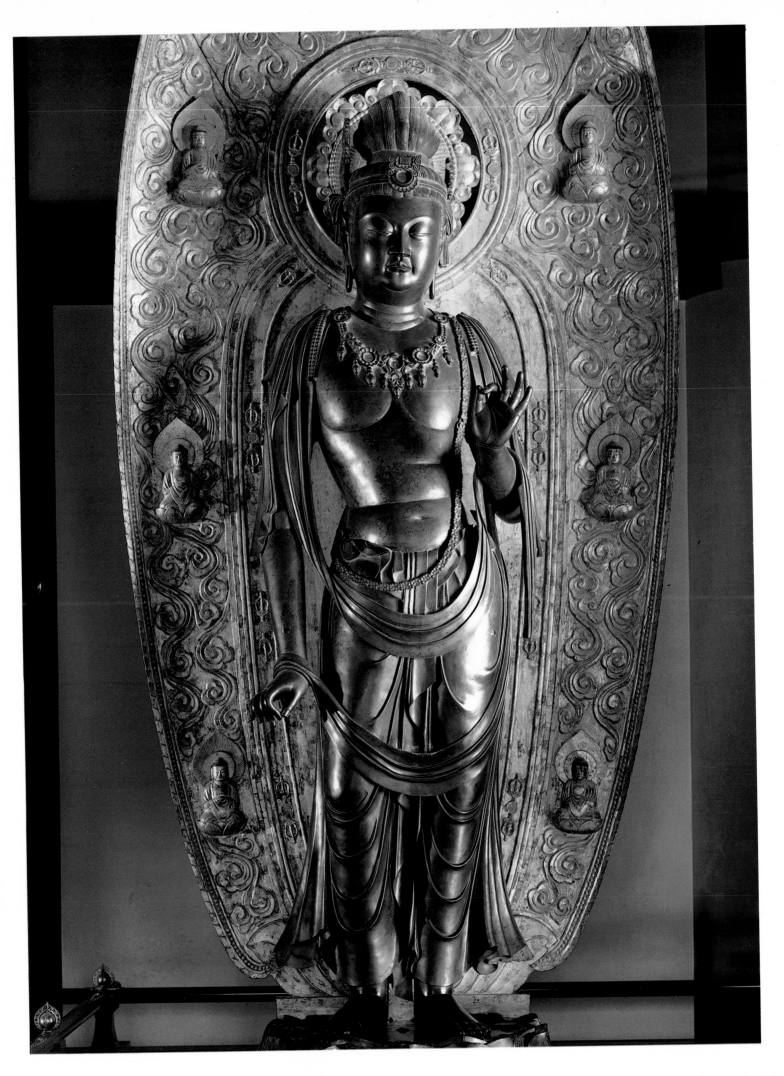

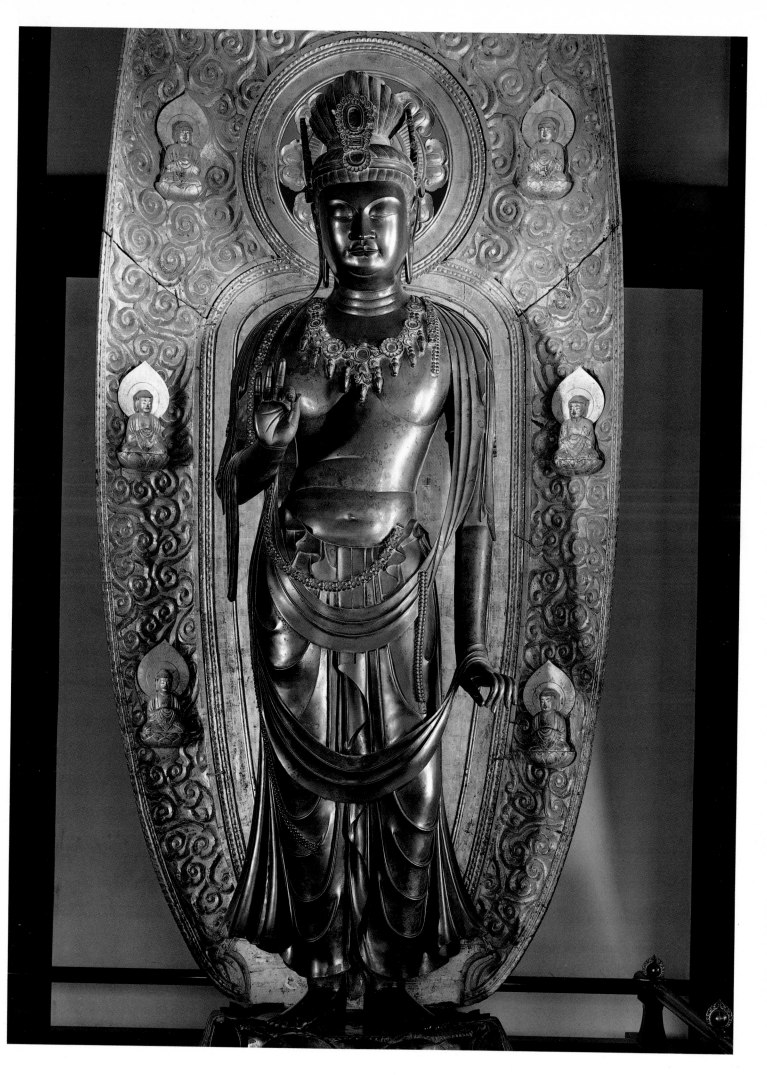

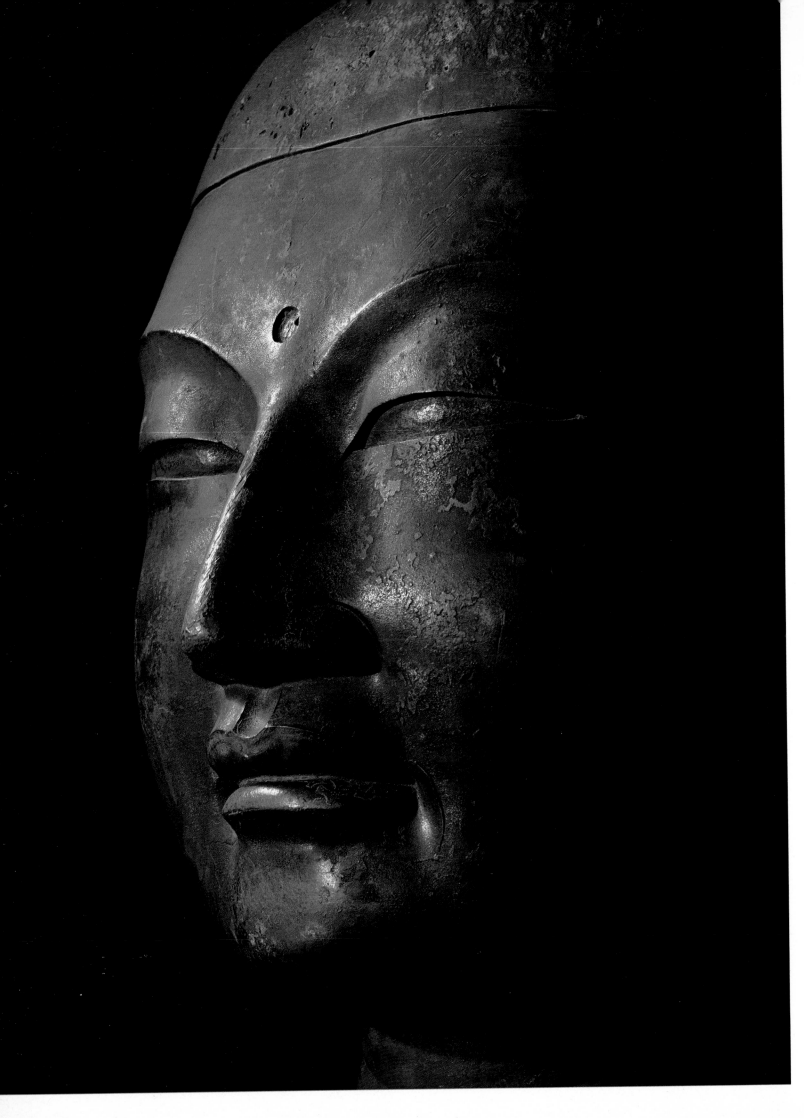

reflecting the gospel according to early T'ang. The surfaces of the head are crisp, clean and taut, with a kind of fresh adolescence typical of the Hakuhō period. All traces of gilding are gone. Marks may be seen on the forehead where a "third eye" had been, probably of crystal.

Sculptures of such monumental proportions would be expected to grace the interior of a Golden Hall. Recent excavations have revealed wooden remains of the southeast cloister of the Yamada-dera which had been destroyed by a landslide. The stone bases for the columns are elegantly shaped. The Golden Hall was a peculiarly small building, built when small ones were in style. Some kind of image was there, but when the grandiose plans for finishing the temple were put into effect, it proved to be too small for the current ambitions. Lecture Halls usually offered more floor space.

Temmu ordered all households to venerate little Buddhist images, and many families had these made as long as the materials were available. Once the government started to garner all the materials for the Great Buddha of the Tōdai-ji, however, the situation changed drastically, and little household images faded in style. The large number once kept by the Tachibana-dera in Asuka and later by the Hōryū-ji seem to have had almost no additions made to them after the Nara period.

The household shrine known by the name of its reputed owner, Lady Tachibana, has probably been in the Hōryū-ji since about the time of her death in 733. She was Tachibana-no-Michiyo, the mother-in-law of Emperor Shōmu and the mother of Empress Kōmyō. Painters decorated the awkwardly shaped, top-heavy box by drawing worshipping and adoring figures on the four sides of the base, and figures on the outside and inside of the doors. These are scarcely recognizable today. The box has lost its front doors and the side doors are replacements.

The ungainly box was to accommodate an Amida triad. These little gilt bronze images are supported above the Western Lake by compact globular lotuses, their stems curving up from the lotus pond. Seishi is on Amida's right and Kannon on his left. The latter may be identified by the miniature Buddha in his crown. Each bodhisattva holds up the inside hand. The Amida has clinging drapery over a substantial body, fin-ished only on the front and sides, still just short of the full three-dimensional style. The hair is matted, the eyes are so downcast as to be virtually closed, and the mouths are sickle-shaped.

The low relief patterns of floating scarves and undulating lotus stems of the adoring figures on the hinged screen create one of the finest lyrical rhythms in early Buddhist art. The projected heads, however, produce a discordant note for, with disjointed necks, all face the same angle regardless of the slant of the body as the figures crane their necks to gaze at the Buddha. Noses fail to follow the rest of the face. The seven little Buddhas (kebutsu) above sit under unusual openwork canopies. The large halo of intricate openwork is set against the broad planes and simple surfaces of the screen and triad in a perplexing lack of coordination. The lotus pond below, from which the stems rise, is one flat plaque of water ripples, primly patterned with slightly canted surfaces learned from Asuka casting. The neat rhythm is broken in the right corner where the stencil pattern was turned 90 degrees, redirecting the water flow.

The oldest dry-lacquer images are probably those at the Taima-dera in Nara perfecture. Dry lacquer (kanshitsu) was an expensive technique, perhaps made more so by the desire for imported raw lacquer. A simple frame which could later be discarded was constructed, over which layers of hemp cloth were shaped and worked with liquid lacquer, the rosin of the rhus vernicifera tree. The surface finishing was prepared with a mixture of flour and sawdust, pigments and sometimes gold. This surface had the malleability of clay but could be more sensitively worked, and the finished product was portable, a considerable advantage in fire-prone temple buildings.

The earliest Buddhist painting is a remarkably preserved, fully developed entity known as the Tamamushi Shrine. It consists of a model of a temple intended to house small images, a box-shaped pedestal, and a flared base with four legs. The cloud-brackets are arranged in a radial manner. The Shaka triad for which it was built has been missing since the thirteenth century. The inner walls are lined with thin bronze plaques bearing rows of little repoussé Buddhas, the so-called Thousand Buddhas.

The popular name of the shrine,

Left: head of Buddha. Kōfuku-ji, Nara. This is all that remains of a bronze Buddha triad, cast in 678 and destroyed in a fire.
Overleaf: two details of the drapery and of the bust of the bronze statue of Shō Kannon, which dates from around 670. Yakushi-ji, Nara.

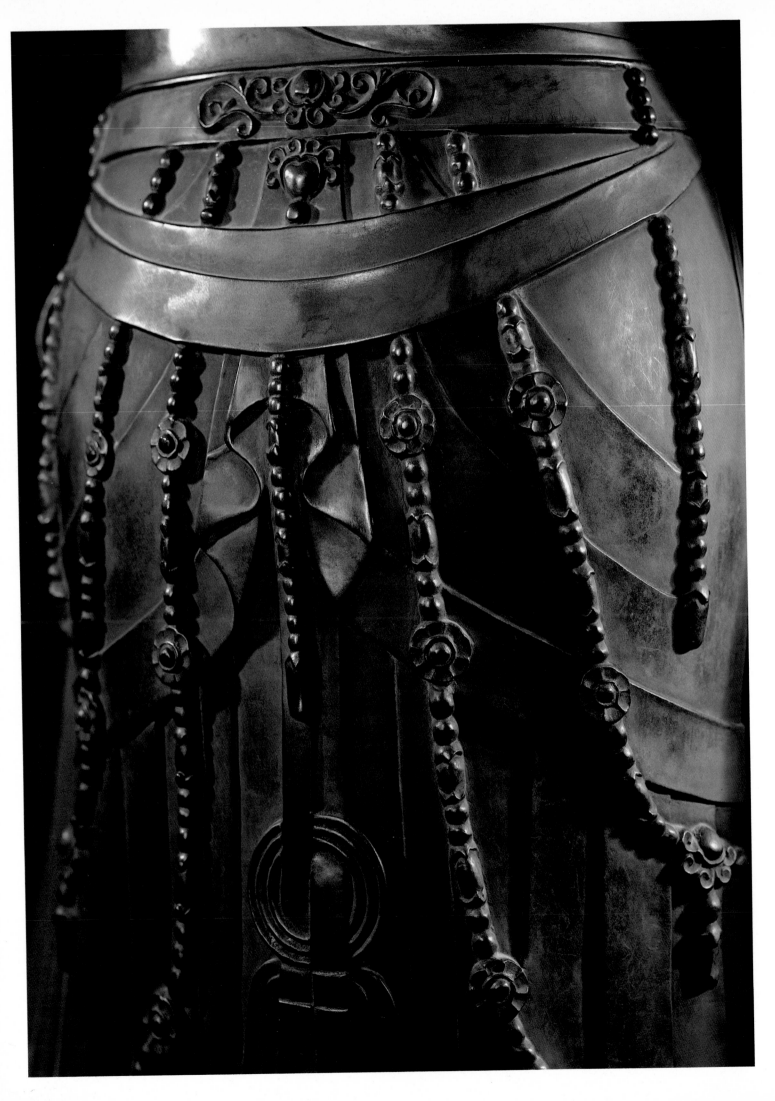

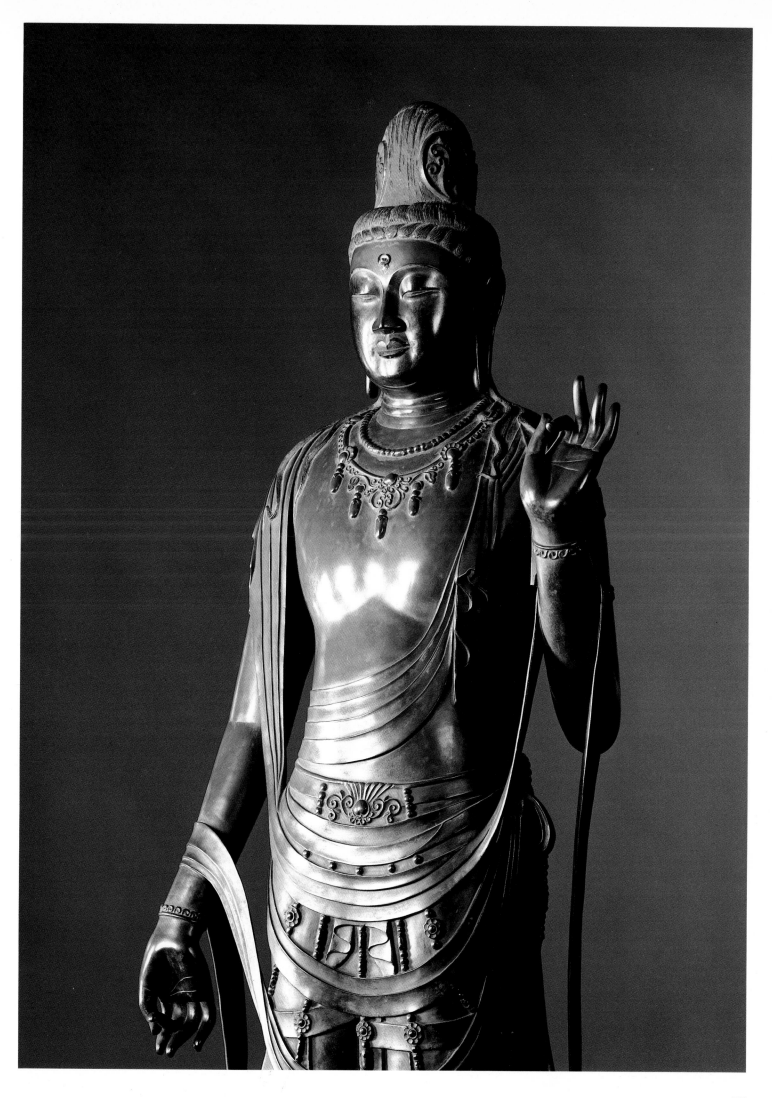

"jade-beetle," was already in use in medieval times. The sheaths of beetles' (*Chrysochroa elegans* Thunberg) wings were applied decoratively, perhaps in conjuction with the fine gold strips of floral openwork at all the edges and corners. This common beetle, the Yamato-mushi, is widely collected in the months of July and August for its attractive iridescent green and red stripes which run the length of the sheaths.

Recent research has revealed evidence of the use of both oil and lacquer paints. Beefsteak plant (*shiso*) seed oil was mixed with lead oxide (*mitsuda*), yellows were applied for skin colours and bluegreens for vegetation. Lacquer was mixed with red pigments for clothes and tigers, and black for physical body details. The *mitsuda* technique is known on at least one eighth-century Shoso-in object, but this is indication of its introduction 100 years earlier than conventional belief places it.

The gaudy lotus petals at the top and foot of the pedestal are crude additions, out of scale and damaging to the appearance of each panel of painting. The front doors bear paintings of a pair of deva kings on dwarf demons. Each side door has two bodhisattvas on twin lotuses. The larger back panel has three spired stupa-shaped structures with statues visible in their arched niches, ascetics in rocky caves, fabulous birds, flowers, heavenly "angels" and a sun and moon.

The scene on the front of the pedestal may be a memorial service. Two monks flank a relic container and two incense burners in vertical alignment. *Apsaras* descend from above. The back illustrates Mt. Sumeru, the Buddhist holy mountain rising from the ocean, protected by a dragon, buildings at its foot and summit, birds in the lower corners, and a moon-toad and three-legged sun-crow in the upper right and left corners. Small figures occupy appropriate places around the panel. The large temple building at the bottom has a seated image in the central bay and an adoring bodhisattva in each side bay.

In a rare use of *jataka* stories in Japan in the Theravada (Hinayana) tradition, two are included on the sides of the pedestal. From the large number of so-called birth stories of the Buddha or earlier existences, the two chosen are of the preexisting Buddha sacrificing himself to save the starving tigers, and sacrificing

himself to hear the second stanza of a poem.

These are narratives in a landscape setting, as though reproduced from hanging scrolls. Looping arcs of strange, otherworldly geological strata form overhanging cliffs on the left sides. The viewer faces the evolving story, following the key figure from the lower left in a large arc to the top and across and down to the lower right. The momentum is carefully controlled. In the first story, the prince hangs his jacket on the flowering tree – his body and the tree in parallel curves – and the story increases in pace, reaching an abrupt climax as the prince throws himself off the cliff on to the bamboo grove below. Slender stalks of bamboo appear to grow into the panel and break the otherwise exclusively single-plane rendering. Bamboo sprouts from the thin layers of the rocky ledges, wisteria hangs across the mouth of a cave and small lotuses and wispy clouds add a cheerful touch.

The other story is more difficult to tell coherently. It is not a straightforward narrative but a psychological test. As a Brahman ascetic, Buddha encountered Indra in the guise of a demon who quoted half a stanza of a poem but volunteered the second half only if his appetite for human flesh could be satisfied. Making an agreement with Indra, Buddha carved the full stanza on the rock and offered himself. Indra relented, however, and spared him. The demon is seen at the foot of the panel as a black, spotted ferocious creature clad in a loincloth.

The Taoist motifs in the Buddhist theme lead one to suggest that the Tamamushi shrine was a memorial. These motifs are chiefly in the works which were memorials or dedications, as they stress long and eternal life and natural relationships designed to put the spirit of the dead in harmony with the universe. One large panel shows what may be a memorial service for the deceased, possibly, if one had to choose, for some member of the royal family who had a special respect for Prince Shōtoku about the time of the Taika Reform.

Japan was not thought to have shared with China and Korea the practice of painting tomb walls once Buddhist arts were introduced until the sensational discovery of the Takamatsuzuka tomb in Asuka in 1972. Overnight the gap was filled and national pride rejuvenated.

Takamatsuzuka is a typical seventh-century small hilltop tomb. It had been plundered in early times and had apparently been left open, causing considerable damage to the paintings at the south end. Not all the grave goods had been looted, however, and a Chinese Lion and Grape mirror was recovered. A virtually identical mirror dating from 698 has been found in a tomb near Sian in China and the two may well have been cast in the same mould. This tomb was once listed in Tokugawa records as the tomb of Emperor Mommu. By the Meiji period, however, Mommu had been assigned a much more pretentious mound a little to the south and the Takamatsuzuka tomb was removed from the imperial list, making it eligible for excavation. Among three prominent candidates for occupancy are Takechi (Takaichi), Kusakabe and Osakabe, all royal princes. Takechi is the most likely. He was the son of Emperor Temmu and a secondary wife and had become the prime minister and the wealthiest man in the land. However, he was apparently on bad terms with Empress Jitō after Temmu's death. She took the throne, probably to keep him from it, and abdicated only after his death in 696. Her one and only son, Kusakabe, had died in 689 at the age of 28.

Despite damage at the south end caused by exposure, the paintings are rather well preserved elsewhere in the tomb. The theme is developed around four groups of men and women attendants, four to a group, the men at the south end and the women at the north. Between them are placed the Azure Dragon and the White Tiger, a sun and moon above each respectively. The ceiling had 72 small gold circles, marks of constellations, some connected by parallel lines. Most have only the red undercoating today. Here and elsewhere, the gold and silver was often scraped off. The north wall shows a small Black Warrior. The painter was a miniaturist at heart, each painting perhaps precisely

Opposite: the Tamamushi shrine in the Hōryū-ji, Nara. It takes the form of a model temple used to house small images. The edges are decorated with the wing-sheaths of the Yamato-mushi beetle inserted into metal openwork, and it is these iridescent wings which give the shrine its name.

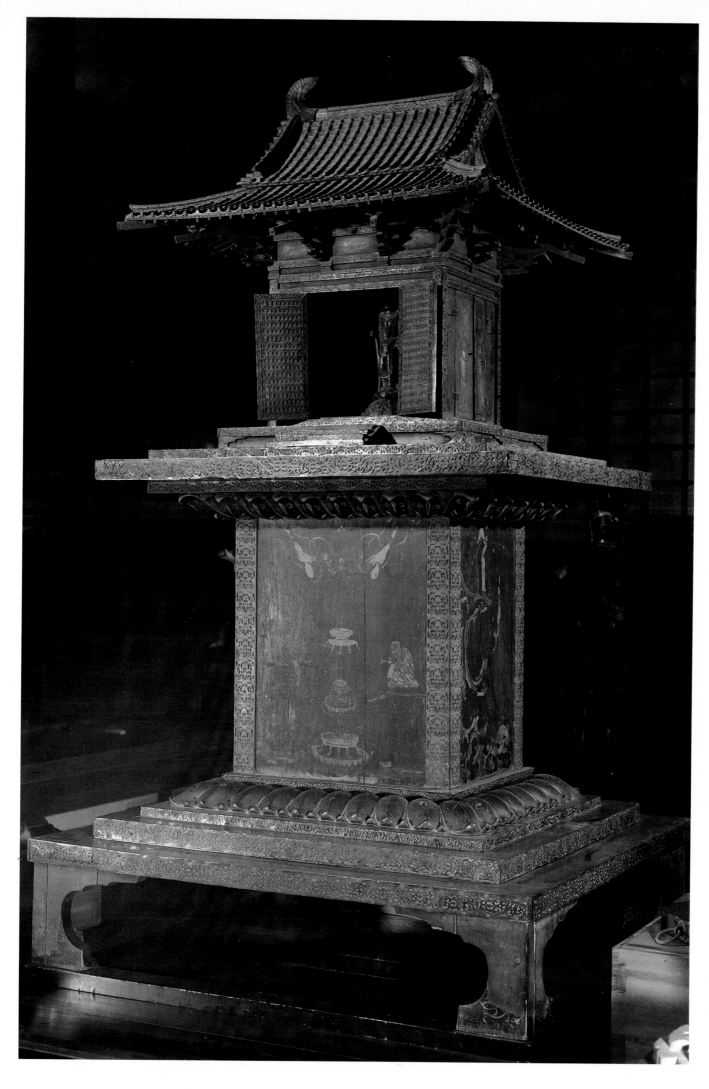

Above and opposite: detail of the painted pedestal of the Tamamushi shrine in the Hōryū-ji, Nara. The illustration above shows part of a jataka *story, one of the so-called "birth stories" of the Buddha or of his earlier existences. The illustration opposite shows two monks flanking a reliquary and two incense burners, with* apsara *descending from above.*

double the size of a copybook sketch. He had to work while sitting, squatting or kneeling, assuming that the engineering was finished before the walls were plastered and the painting got underway.

All the men depicted wear long robes. The deceased leads the procession on the east side, moving toward the southern entrance. He is followed by a ceremonial canopy

bearer. Behind him is a man carrying a satchel and, after him, one with a "wrapped spear." The man with the satchel bears a close resemblance to Prince Shōtoku. On the opposite wall from the south, the four men carry a folding stool, a "wrapped spear," a satchel and a curved stick called a priest's staff (*nyoi*) in Japan.

The painting of the women on the east side is especially well preserved. Their gorgeously coloured pleated skirts immediately conjure up Korean connections. Somewhat more gracefully overlapped than the men, two in each group of women are conversationally related. Defacement limits identification, but on the east side one female attendant carries a round fan, another a fan or whisk, and a third some other attribute. On the west side one carries a round fan, another a priest's staff, and another an object which is badly effaced. In other words, it appears that on either side one woman carries nothing, but all the men do except, perhaps, for the deceased.

All of the attributes have a long history in China as traditional marks of status except for the folding stool. They rarely appear in Korean tomb paintings. In the Chinese context, such as on Buddhist stelae of a century earlier, the deceased is recognizably of a higher social rank than the other figures because he is portrayed as taller. However, this convention was missed by the local artist who executed the Takamatsuzuka tomb paintings, as close inspection shows the heads to be parallel. The Chinese played polo and both men and women carried the mallets, but no one thinks polo was successfully introduced to Japan. In Japan the curved stick was a glorified back scratcher.

A systematic arrangement was the ultimate formula for a good Taoist burial. It is all here: a southern orientation, the Animals of the Four Quarters, the sun, moon, dome of heaven, and attendants with attributes to lend prestige to the aristocrat, who was successfully consigned to his cosmic cell. The four groups of figures were linked with the four directions, and the Yang and Yin principles can be seen in the men on the south, light, warm and good side,the women on the north, dark, cool and bad side. No occupant would have had all this done without knowing its full significance.

The "Korean" pleated dresses divert attention from the Chinese grace of stance and relationship. They were probably a common upper class costume at the Japanese court. The small tutelary deities are almost the same size as those on the socle of the Yakushi-ji and they may even be dateable to within a year or two of each other. The dragon also has the cross on its neck. A surmise is that the designs were developed in the same workshop, using old copybooks, but executed by painters knowledgeable in the current Chinese style.

A painting on paper of Prince Shōtoku and two young men was included in the gift to the Imperial Household in 1876 from the Hōryū-ji, in a desperate attempt to curry favour in the early Meiji doldrums.

The prince and presumably two of his sons (at least seven are known) are painted in light pastel colours at the foot of the sheet of paper, set in the fashionable three-fourths viewpoint and in the social scale for aristocrat and attendants. But the central figure is overbearing in size, an exaggeration of the Chinese formula. The costumes are broadly shaded in strong folds, and flared at the ankle to reveal undertrousers. The toes of the shoes are finely pointed. All the hands are covered.

It is best to date the painting to shortly after 684 following an edict on clothing requirements which specified, among other things, that trousers were to be tied at the bottom. These resemble cuffs. Prince Shōtoku wears a long robe and has looped his hair according to the required style, but his trousers hang loose. The oversize symbol is carried on its edge, not flat as protocol would dictate. The figure on the right has only a cover, as there is no sword handle, and the figure on the left has an odd tassel, its end resembling a sword sheath.

The final outlining deviates from the sketch, as is often the case in paintings in T'ang tombs. Some raising of the left shoulder of the prince produces a kind of *en face* view of the upper torso. In fact, the lower body is turned more and the feet still more, in a way common to Hakuhō rendering. The head and feet then become aligned with each other. All of this speaks for composite copybook sources, making anachronisms the order of the day.

Opposite: portrait of Prince Shōtoku and two young boys, probably his sons. Imperial Household Agency, Tokyo. The painting dates from shortly after 684.

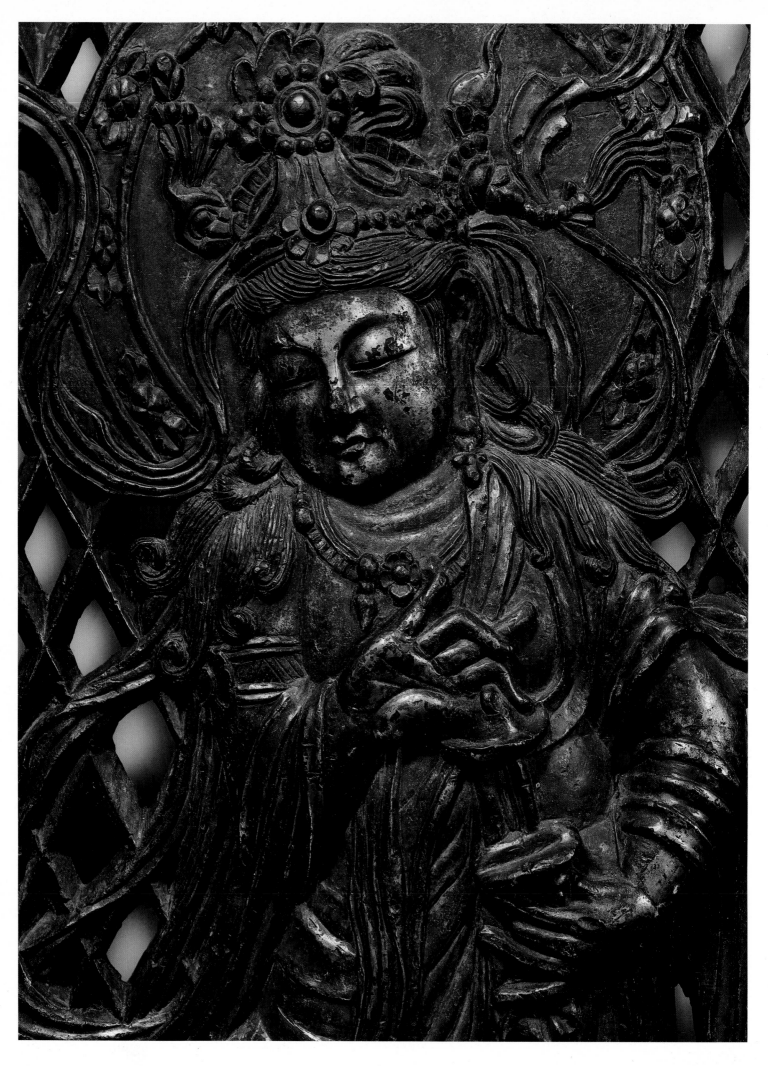

THE NARA PERIOD
710–794

The legalization of the government's authority and the adoption of penalty measures, laid down first in the Ōmi code and subsequently revised by Temmu, were shortly followed by the construction of the Fujiwara palace and city. A similar reinforcement of the imperial position in the Taihō Code of 701 also legitimized the search for a new and more commanding location where the codes could be practiced. These civil and penal codes remained in effect until around the middle of the eighth century, despite the writing of the Yōrō Code a few years after the new capital was occupied in 710.

The new capital, known as Heijō, was the dream of Emperor Mommu and the realization of Empress Gemmei (Gemmyō). She ruled in Heijō for five years and was followed by seven other emperors who alternately occupied parallel palaces in the northern part of the city until 784. Heijō gave the impression of stability, but this was far from the case, although the situation improved after the restless Emperor Shōmu left the throne (r. 724–749). Shōmu wanted to move anywhere, as long as it was farther north. He tried Naniwa (old Osaka) in 726, Kuni in 740, Shigaraki in 742 and Naniwa again in 744, but when he finally received word that the devastating earthquakes in the sixth month of 745 were warnings from the *kami* against moving, as reported by the committee of priests from the Shidaiji, the Four Great Temples, he realized that any further attempt to move would be political and economic folly and he settled down to have his great temple built. The economy was directly related to government spending, expansion of an unproductive city, ecclesiastical tax exemptions, ability to collect taxes and peasant resistance.

Heijō is the first capital about which very much is known. The experience with Fujiwara had been valuable, and the Chinese model was retained even in the title: Heijō, the Capital of Peace. The Chinese had used Ch'ang-an and later, Sian, Long Peace and West Peace. The era was Tempyō, Heavenly Peace, (722–748) and it was followed by three successive eras with Tempyō in their names (749–766).

Most of the old city is now under rice fields and the eastern part is a jumble of historic periods and modern buildings. A visitor who comes in today on the private train line from Kyoto arrives at what is exactly the eastern edge of the old city, and proceeds with it behind him in the direction of Nara Park and the familiar temple and shrine landmarks. The old roads still suggest the precision of the original grid pattern, and the ancient monuments are intact or have become spectacular archaeological sites. One can follow the tracks of the medieval pilgrim, as some do today, and feel some of the excitement of visiting the Seven Great Temples of the Southern Capital: Tōdai-ji, Daian-ji, Gankō-ji, Saidai-ji, Kōfuku-ji, Yakushi-ji and Hōryū-ji. The Tō-shōdai-ji will have to suffice for the Daian-ji, Gankō-ji or Saidai-ji, which have lost their character through fires and are without much of their land, but other sites can compensate: Shin-yakushi-ji, Aki-shino-dera, Kairyūō-ji, Futai-ji and Hokke-ji.

The entire area is an archaeologist's paradise and a developer's nightmare. Every square inch yields relics of history, and the laying of a pipeline has to wait until the ancient threads of the city's fabric can be recovered. The city site was selected for its flat ground and pair of rivers, Akishino and Sahō, and their tributaries. It ran nine blocks (*jō*) north and south and eight blocks (*bō*) east and west, with the main street, Sujaku-ōji, leading up the middle to the gate of the four blocks occupied by the palaces. The size of the city was determined by the decision to make the small block subdivisions each 400 *shaku* square, of which there were 16 to a *chō*, a main block. So at 36 by 32 *chō*, or 14,400 by 12,800 *shaku*, to which would be added the width of the streets for the total dimensions, the city covered an area of about 4 × 4.5 km ($2\frac{1}{2}$ × $2\frac{3}{4}$ miles).

The chief political officers of the country were the administrators, the Prime Minister (Dajōdaijin), in effect the mayor, the next in order, the Great Minister of the Left (Sadaijin) governing the east half, and then, the Great Minister of the Right (Udaijin) governing the west half.

The palaces were modelled on the Chinese principles of symmetry, and were used in a functionally symmetrical way. The emperor occupied one and the crown prince the other, one palace being vacant long enough to be refurbished for future use. In the palace plan, a forecourt led into the main court (*chōdō-in*) where there were initially eight buildings

Opposite: a bosatsu, as portrayed in a detail from a lantern in the Tōdai-ji, Nara. This bosatsu, the Japanese equivalent of the Sanskrit "bodhisattva," here shown playing a musical instrument, appears in one of the pierced bronze panels of an octagonal lantern that stands in front of the Daibutsuden or Hall of the Great Buddha.

for the Eight Ministries, four in line facing each other from opposite sides. As pressure grew for more space, four additional halls were placed in pairs on the south side, aligned east and west. The major ceremonies were conducted in this large courtyard. The emperor held court in a smaller block to the north (*daigoku-den*), usually a terraced area where he ruled above the people, and resided in private quarters (*dairi*) to the northeast, these quarters making the only break in the longitudinal axial system. All later palaces, in fact, were only variations of the type begun at Fujiwara, the spacing in the courtyards reflecting the needs of the swelling bureaucracy and the size of the hall of state the increased imperial prestige.

At about the time when the city came into use, 12 contiguous blocks were added in the northeast (*Gekyō*). The Kōfuku-ji got one large block, the Gankō-ji almost a full block, and three private temples each got small blocks. When Emperor Shōmu finally resigned himself to building his huge temple at Heijō, no space could be commandeered within the city. The eastern mountain had to be terraced to accommodate it.

Small additional blocks were added in the northwest, apparently after the Saidai-ji was built. Open spaces were retained for the two markets in the south, the eastern one favouring the terrain by being one block east of balance with the western one. Water conditions and topography were all better on the east and, after the city was abandoned as the capital and natural attrition began to take its course, the population drifted toward the eastern mountain, leaving only small hamlets around the pilgrimage temples.

The first decade was one of great vigour and activity. The first temple may have been the Hokke-ji, a convent due east of the palace. The Fujiwara were ready as the city was being planned and the new Kōfuku-ji, moved in from elsewhere, was underway in 710 in a good location beneath Kasuga hill. It had one pagoda on the east side. The political dimensions of the Kōfuku-ji expanded greatly with time, tied as it was to Fujiwara fortunes. But its later history is one of trying to retain its power through military means after its normal patronage had vanished.

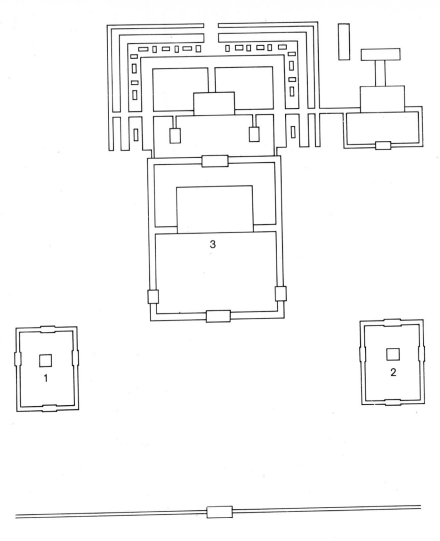

The Daikandai-ji was moved up from the former Fujiwara capital in 716, given a similarly prominent position on the east side and built into an immense twin pagoda temple, called the Daian-ji. Two years later the Asuka-dera or Hōkō-ji was transferred along with Yakushi-ji, the former becoming the Gankō-ji, with one pagoda, the latter rebuilt with its two pagodas exactly as it had stood in the old capital. It was granted a comparably good location on the west side and the two together, roughly positioned as they had been at Fujiwara near the middle of the city, cast their shadow of protection over each half of the city.

The earlier imperially-sponsored temples were therefore in their new places by 718. Other private temples followed shortly. The Tōdai-ji's location is partly Shōmu's fault for not having settled earlier in Heijō. He had ordered the casting of the Great Buddha to be begun at the Kōgai-ji at Shigaraki in Shiga prefecture, the old province of Ōmi, in 743. The technique, logistics or both failed, however, and as Shōmu came to realize that another move in so short

Above: plan of the Tōdai-ji, Nara. 1 West Pagoda, 2 East Pagoda, 3 Hall of the Great Buddha. Opposite: aerial view of the Tōdai-ji. The building at the center is the Daibutsuden or Hall of the Great Buddha, which dates from the mid eighth century. Overleaf: the Nehan (Parinirvana) or "death of Buddha" in the pagoda of the Hōryū-ji, Nara. The pagoda contains some 90 clay statuettes telling stories from the life of Buddha. The oldest date from 711, whilst others are later replacements.

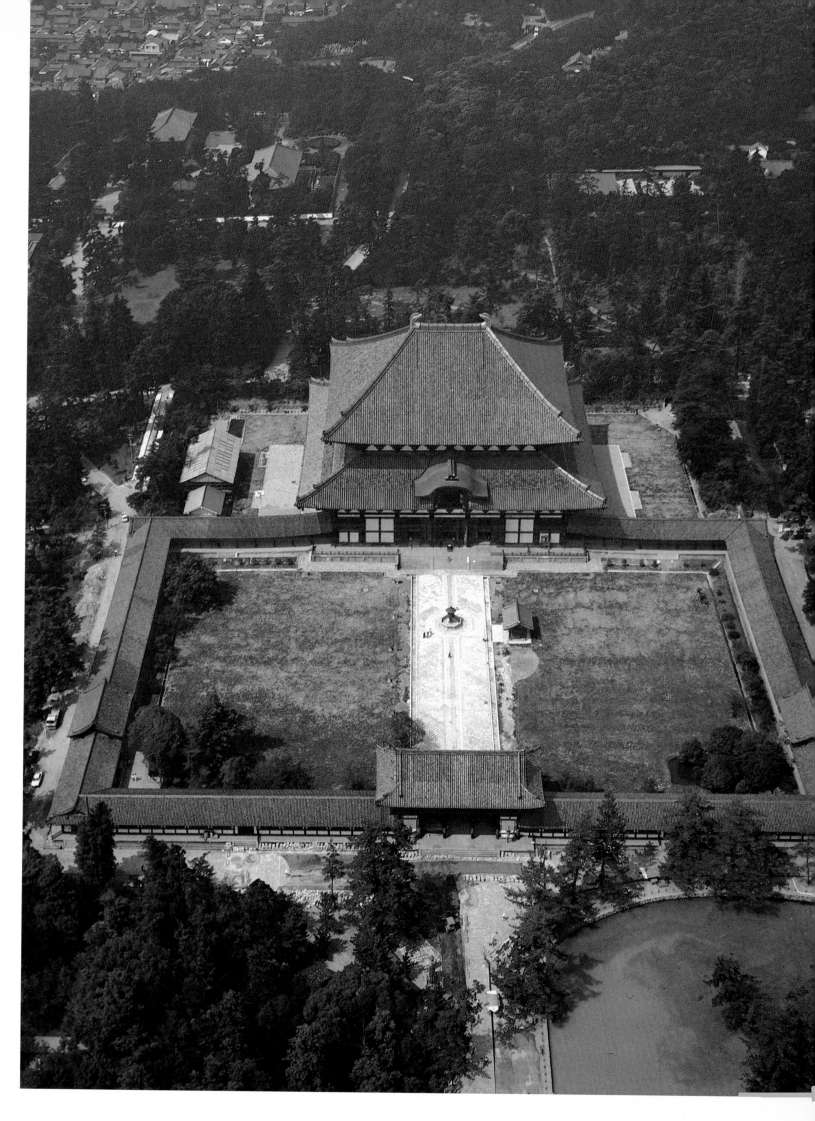

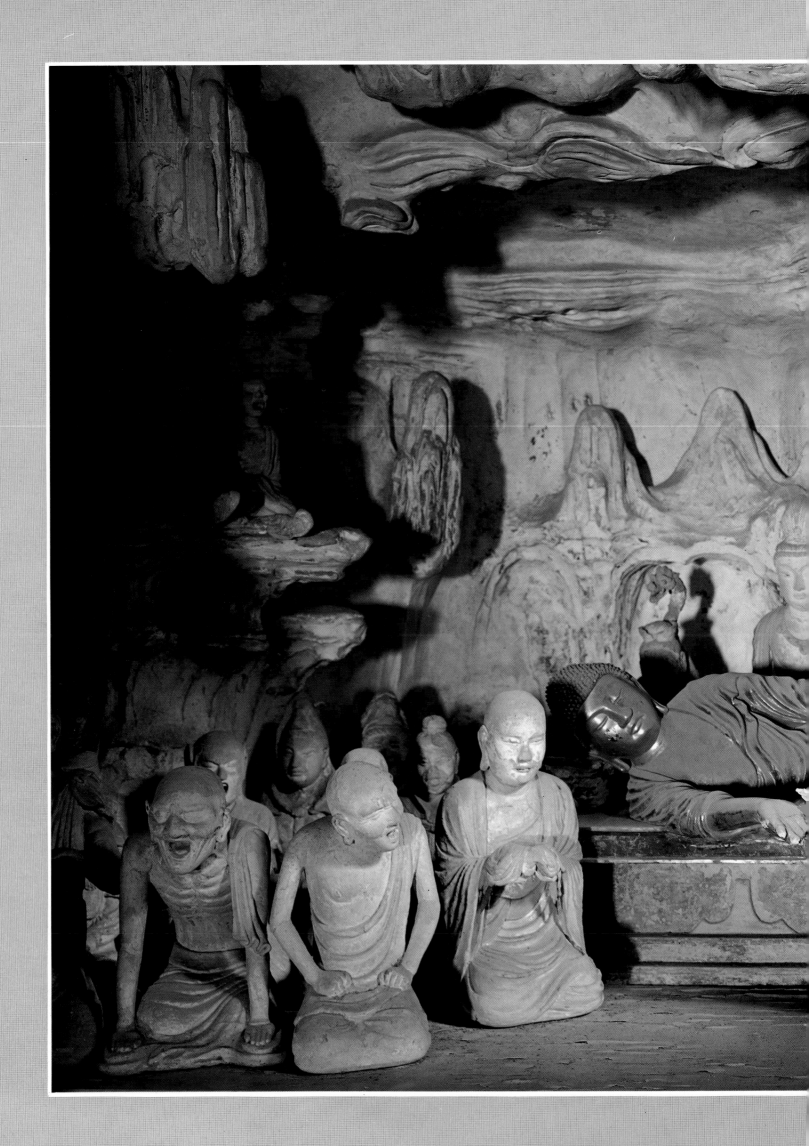

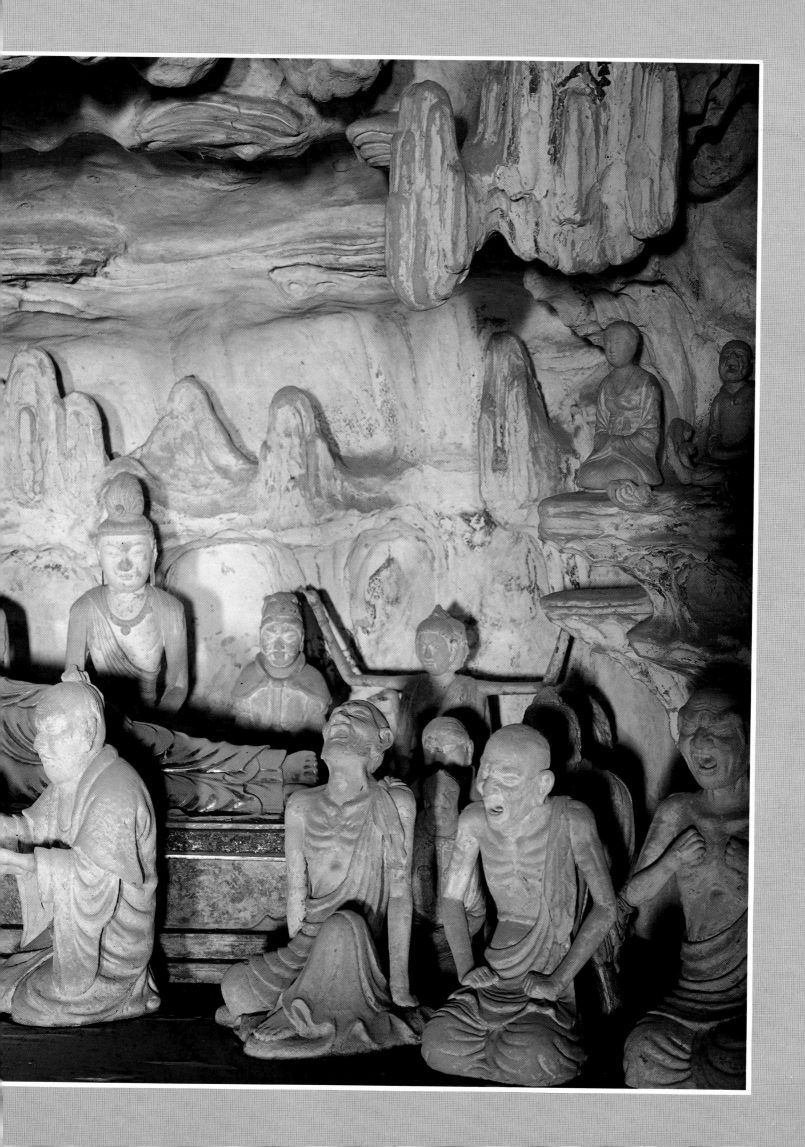

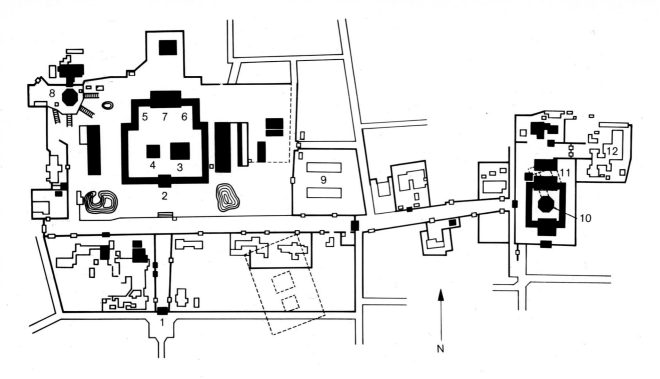

a time would be economically disastrous, the collapse of his enterprise there became immaterial. Under new directorship and with a new crew, a ranked south Korean technician named Kuninaka-no-muraji-Kimimaro headed the team at Heijō in 745 and the Great Buddha was cast in three years, the successful completion celebrated at the "eye-opening" ceremony in 752. Shōmu was among the 10,000 present, but had abdicated by this time and put his daughter on the throne.

The image of Vairocana Buddha consumed "all the copper resources of the land," a temple document says, amounting to about 440 tons of bronze including what had been salvaged from the Shigaraki fiasco. Bronze was, as a result, effectively eliminated from the available materials for centuries of later sculpture work.

The decline of the Fujiwara involved the old capital needlessly, and troops of Taira Shigemori burned the Tōdai-ji in 1180. The huge seven-storey pagodas had already gone the way of most. Modest rebuilding was carried out in Kamakura times to restore the temple, and the Daibutsu-den housing the badly mutilated Great Buddha was shortened from 11 bays to seven on the front and back, using a new structural style just learned from China.

The Great Buddha had survived a ninth-century earthquake with only the loss of the head, and was intact and close to its original condition at

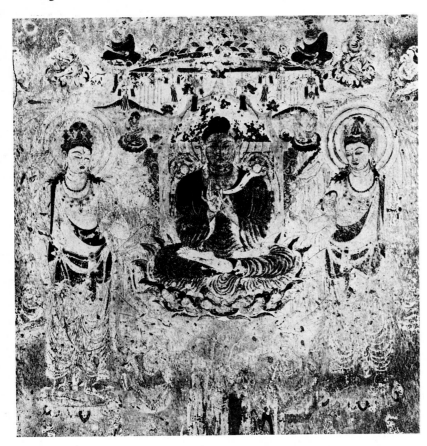

Above: plan of the Hōryū-ji complex at Nara. Western area: 1 Main South Gate, 2 Middle Gate, 3 Golden Hall, 4 Five-storey Pagoda, 5 Hall of the Sūtra, 6 Bell Hall, 7 Lecture Hall, 8 West Octagonal Hall, 9 Treasury. Eastern area: 10 Octagonal Hall, 11 Site of the Ikaruga-dera, 12 Chūgū-ji.
Left: Paradise fresco in the Golden Hall of the Hōryū-ji, showing Amida accompanied by two bodhisattvas and various dematerialized souls.
Opposite: detail of the head of Amida from the fresco.

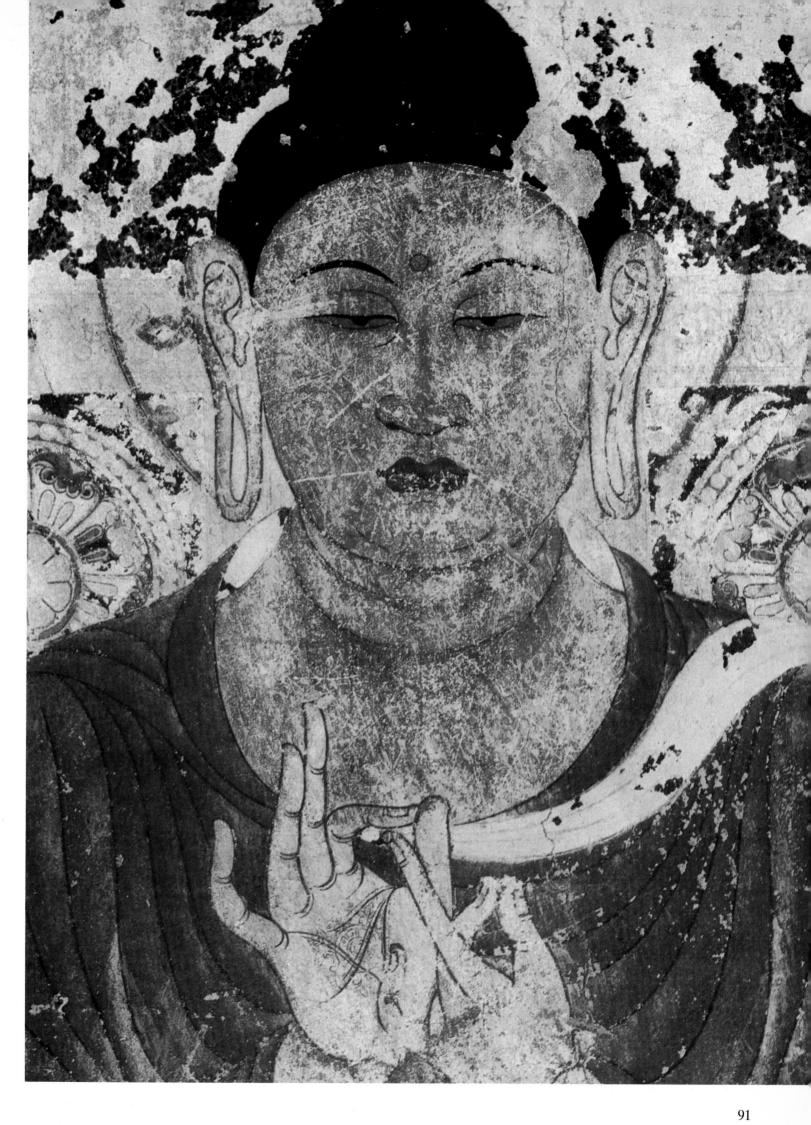

the end of the Late Heian period when the artist of one of the Shigi-san Engi scrolls portrayed the sister of the ascetic Myōren sitting in front of the image all night in prayer in an effort to learn her brother's whereabouts. This is the only existing illustration of the Buddha prior to the late twelfth-century fire, and the figure seems rather slim for the typical mid eighth-century corpulent style – or even a twelfth-century Buddha – which must be artistic licence combined with vague recall on the part of the monk-illustrator.

The engravings on the underside of the eight lotus petals that are regarded as the only original parts picture scenes from Kegon scripture of the Preaching Buddha. Shown is Shumisen, the holy mountain, the related Four Great Rivers, and the Twenty-five Heavens, graded in parallel lines resembling a vast musical score. One document suggests that the lotus base was not yet ready when the Buddha was dedicated, but the difference could not be great and the style would be similar. The Great Buddha undoubtedly resem-

The construction of the Tōdai-ji gave Heijō all but one of the Shichi-daiji. The last was the Saidai-ji, a lavish project of Empress Shōtoku after 765, and built by the same court construction office responsible for the other twin pagoda temples. This body had earlier built the Shin-yakushi-ji, and about 15 years later erected the Akishino-dera to the northwest of the city. The fact that the office did not build in tandem but only in sequence is indication of the immensity of the projects and the problems of scheduling employ-

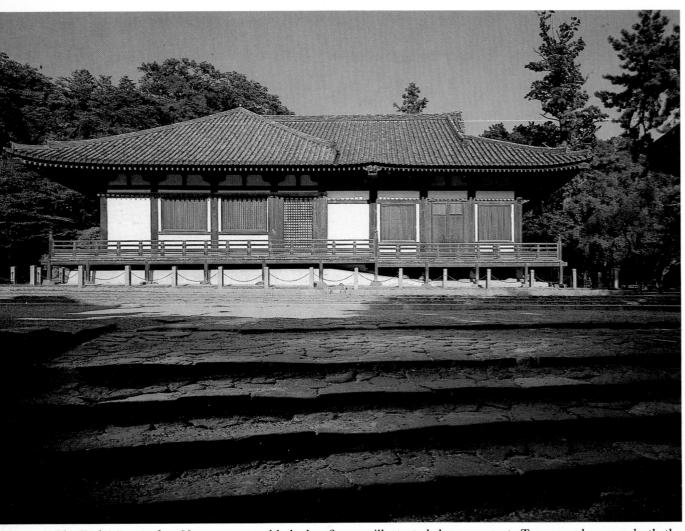

The Tōdai-ji complex, Nara.
Above: the Sangatsudō, the Hall of the Third Month, so called because it was used for scripture readings in the third month.
Opposite: the Daibutsuden or Hall of the Great Buddha. In the foreground is the eight-sided bronze lantern, a detail of whose decoration is shown on page 84.

bled the figures illustrated here. Each petal shows Shaka and his 22 bodhisattvas in roughly the same scene. The faces have reached the peak of roundness, without loose lines. The broad-shouldered Shaka bares the right shoulder and is voluminously draped in florid folds, as are his attendants. The linear effects still retain much of the sprightliness of high T'ang, not yet affected by the ponderous and blocky style of later T'ang. The latter can be identified with the arrival of the Chinese priest Ganjin and the establishment of the Tōshōdai-ji after his services were performed in 755.

ment. Two pagodas were both the imperial and construction office trademark, but the only Nara period temple today with two original pagodas is the rather small Taima-dera down on the west side of Nara prefecture, possibly built by Tai-mashi, a descendant of a son of Emperor Yōmei. His connections – even the founder of this temple is in question – were distant at best, but an aristocratic family with some connections could manage a small "imperial-style" temple at the time.

In most cases, where space would permit and as a fire precaution, the two pagodas were built well forward

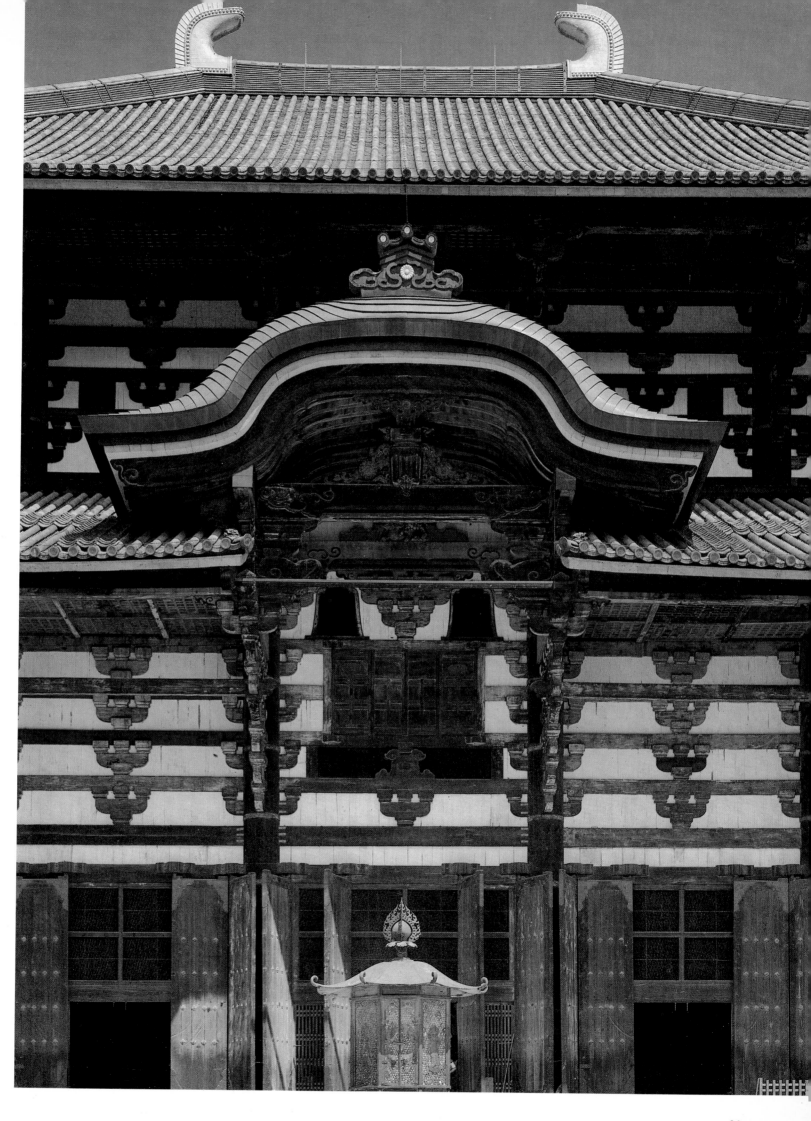

of the *garan*, and sometimes given their own cloisters. The simpler family style of one pagoda was shared by the Gankō-ji and Tōshō-dai-ji and smaller temples. One writer says he could see 50 pagodas while gazing out across the city. They were an impressive sight.

The early decades profited immeasurably from a resumption of the missions to China which had been discontinued since 667. Internally, local power struggles at the beginning of Temmu's reign, social restructuring and Empress Jitō's concern with the new palace and her successor were all factors which had contributed to the interruption of the missions. Over and above this, the staggering load of Hakuhō innovations was simply taking a great

and models, copy or barter for documents and sūtras and be prepared to make the information usable on their return. The Japanese set up offices for the arts to which the envoys could report directly. Imperial workshops therefore had a head start and directed their energies toward personal projects currently under promotion by the court. Some of the developments in the arts in Japan can be directly linked to the return of these missions.

Records tell of the Zō-Tōdaiji-shi, the Ministry for the Construction of the Tōdai Temple, doubtless the largest and best appointed, in which Buddhist images were made, having clerks (*shōryō*), skilled craftsmen (*zakkō*), drafted handymen

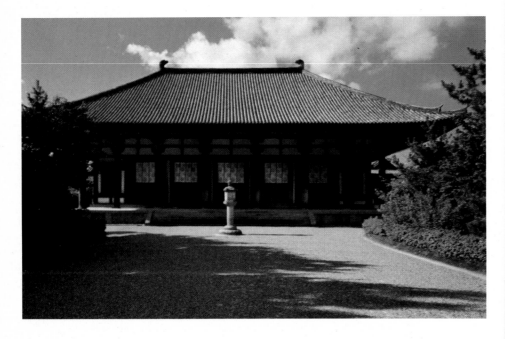

deal of time to absorb. The new burst of missions started in 702 and continued at average intervals of 15 years. Highly placed politicians and prominent personalities made the journey, the Japanese increasing the size and ranking in 717 to include hundreds of people and four boats at a time. Bad luck, inept seamanship and poor scheduling often resulted in devastating losses, but the effort was considered to be worthwhile.

The purposes of these missions had been sharpened with the arts, sciences and religion receiving the most attention. Trained specialists in architecture, sculpture, painting, metal and ceramic crafts, medicine, astronomy, scholars and priests were dispatched with clear assignments to refine their arts and were essential to the success of these missions. They were to make sketches and notes, collect examples

Above and right: views of the Golden Hall of the Tōshōdai-ji, Nara. Built around 760, this is an example of a Chinese "palace" of the T'ang dynasty (618–907). The illustration on the right shows the stone lantern in the foreground and, in the background, the statues contained within the Hall.

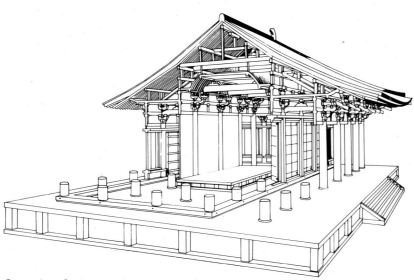

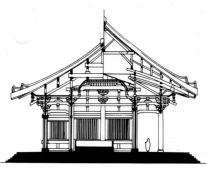

Above: cross-section of the Golden Hall; to the left, the roof as it is today, and to the right, the roof as it was originally.

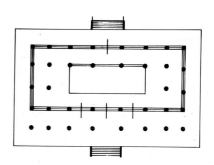

Opposite: the impressive interior of the Golden Hall of the Tōshōdai-ji, Nara. Note the ceiling and its complicated system of beams and brackets. The drawing above shows a cross-section of the building, while the diagram to the right provides a schematic ground plan showing the porch-like area at the front.

(*shicho*), daily hired labourers (*kofu*) and volunteers (*jishin*). The latter received gifts of cloth for their work. In 762 this workshop is listed as employing 1,616 people, among which were 1,292 skilled craftsmen. There were no volunteers at the time of writing. The large number of skilled craftsmen in contrast to the workshops producing bronze mirrors, lacquerware, paintings, roof tiles and other crafts is quite remarkable. Works that could be exhibited to the public, that is, the formal symbols of the spiritual side of the church to which the public responded, were then considered the highest art, and were much in demand.

The making of Buddhist images, in particular the unbaked clay figures but also the dry-lacquer ones, involved tedious and notoriously slow techniques. One record says the images were still not finished when the roofs needed retiling. Sculptors topped the list of craftsmen in terms of pay, coming above the mirror makers, the other metal workers, and, lower down the scale, the painters. Sculptors could turn out daily utensils and a variety of objects for secular needs and presumably therefore enjoy steadier work. The hierarchy may seem surprising. Painters are always thought to head such a list, but this was certainly not the case then. Painting

was unrelated to demand; the art had no room for personality at the time and painters in particular were seen as copyists, a process requiring more training than skill. The two sculpture techniques had more foreign exoticism about them and an accompanying mystique.

There was an Office of Painting (E-dokoro) which, under its director and assistant director, who were both political appointees, had an organization consisting of clerks, four department heads, and 60 diplomaed painters, 16 handymen and a security guard. This office and the Office for Copying Sūtras probably shared some common training ground, as the techniques were largely similar and the results served for decorating imperially-favoured temples and supplying them with works of art and documents. Painters may have been on loan from one or other of the offices where they were trained, as it was often necessary to call on their skills to finish the images.

Channelling the Chinese information through the imperial workshops fostered a centrally-controlled style scarcely affected by differences in technique. Yet a greater variety of techniques was available in the Nara period than at any other time in Japanese history. The media ranged from bronze, wood, dry lacquer and unbaked clay to stone. Unbaked

clay and dry lacquer were exorbitantly expensive and within the reach of only a few temples. With unbaked clay there was the problem of acquiring the right paints, and dry lacquer may have been costly because much of the raw material was imported. The cost of gilded surfaces for all sculptures was equally high.

Later writers referred to the Six Sects of the Nara Capital, implying more substance and structure than actually existed. These "sects" were more like groups reading selected sūtras. Three have survived, Kegon, Hossō and Ritsu, and have only nominal influence today. Shōmu favoured Kegon and his Tōdai-ji was built around the grand Chinese style of honouring Vairocana or Roshana Buddha. This style is echoed in the Tōshōdai-ji, the temple of Ganjin and his Chinese colleagues, which was Ritsu, (the Rules sect). The Gankō-ji, Kōfuku-ji and Hōryū-ji were Hossō; they had collections of Shaka-related statues and venerated

Overleaf: details of the heads of Zocho-ten and Jikoku-ten from the Four Heavenly Kings group in the Kaidan-in of the Tōdai-ji, Nara. The Four Heavenly Kings, their feet resting on demons, are guardians of Buddhist law; they wear armour and control the four points of the compass.

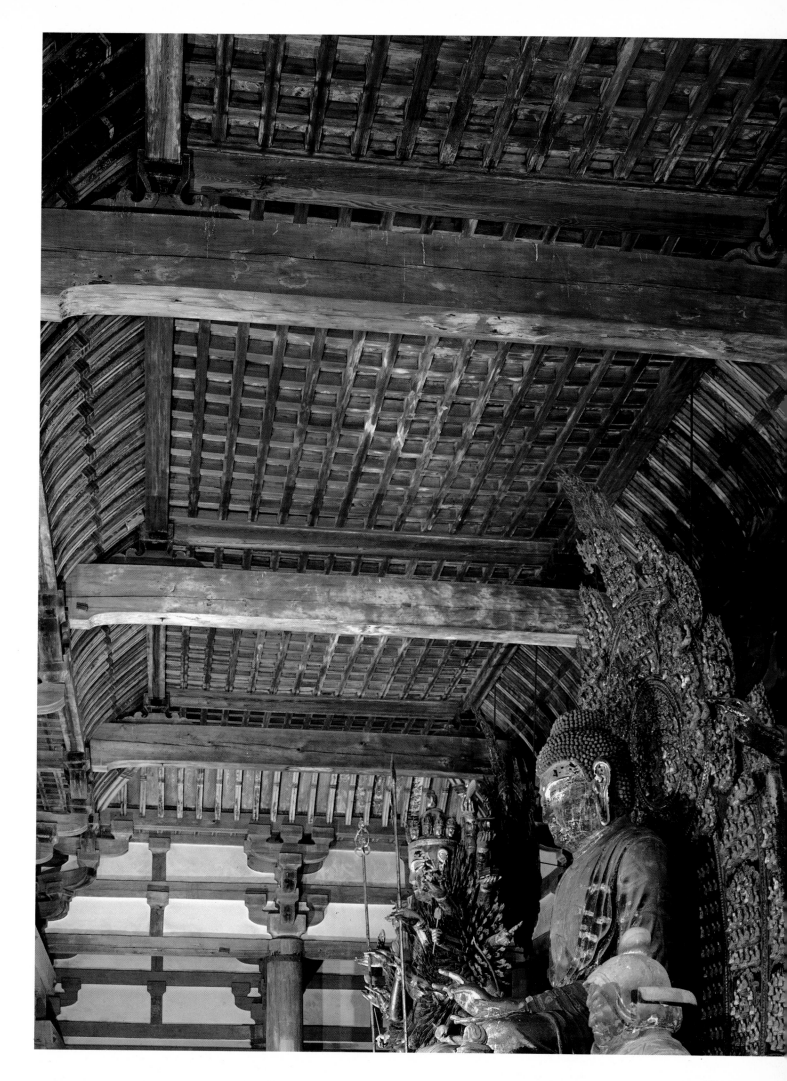

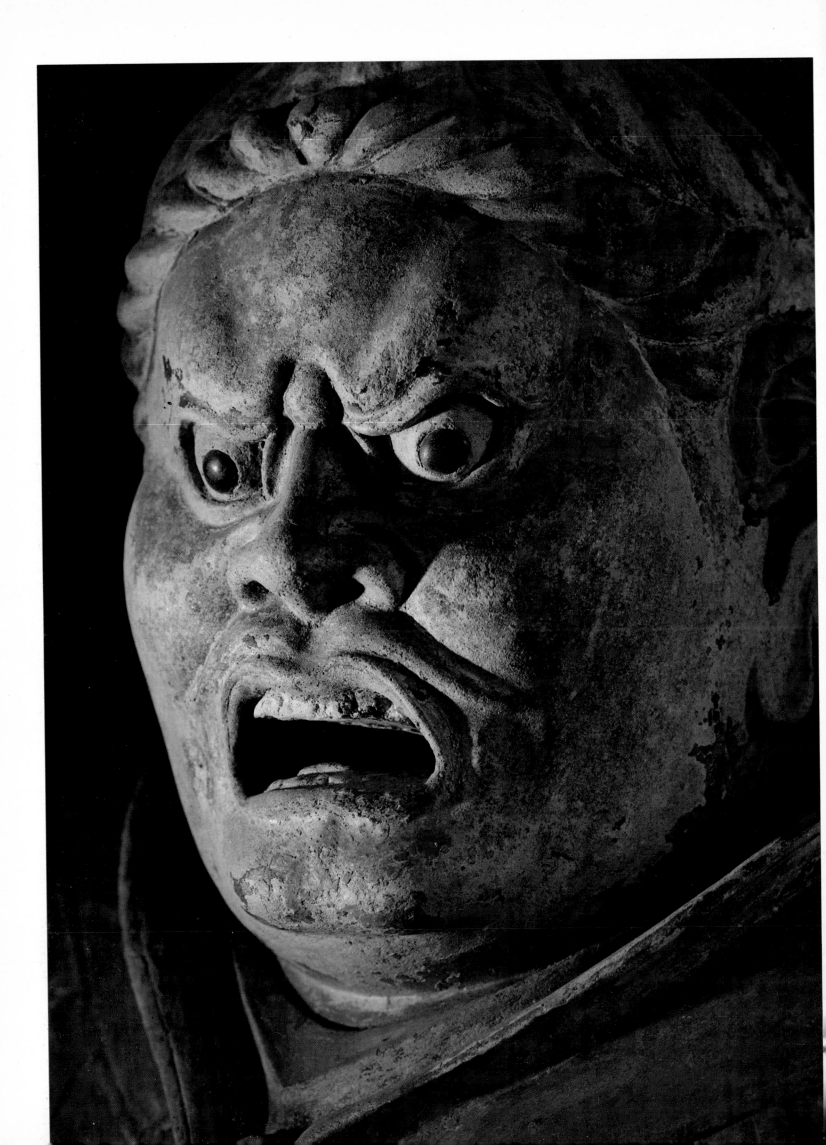

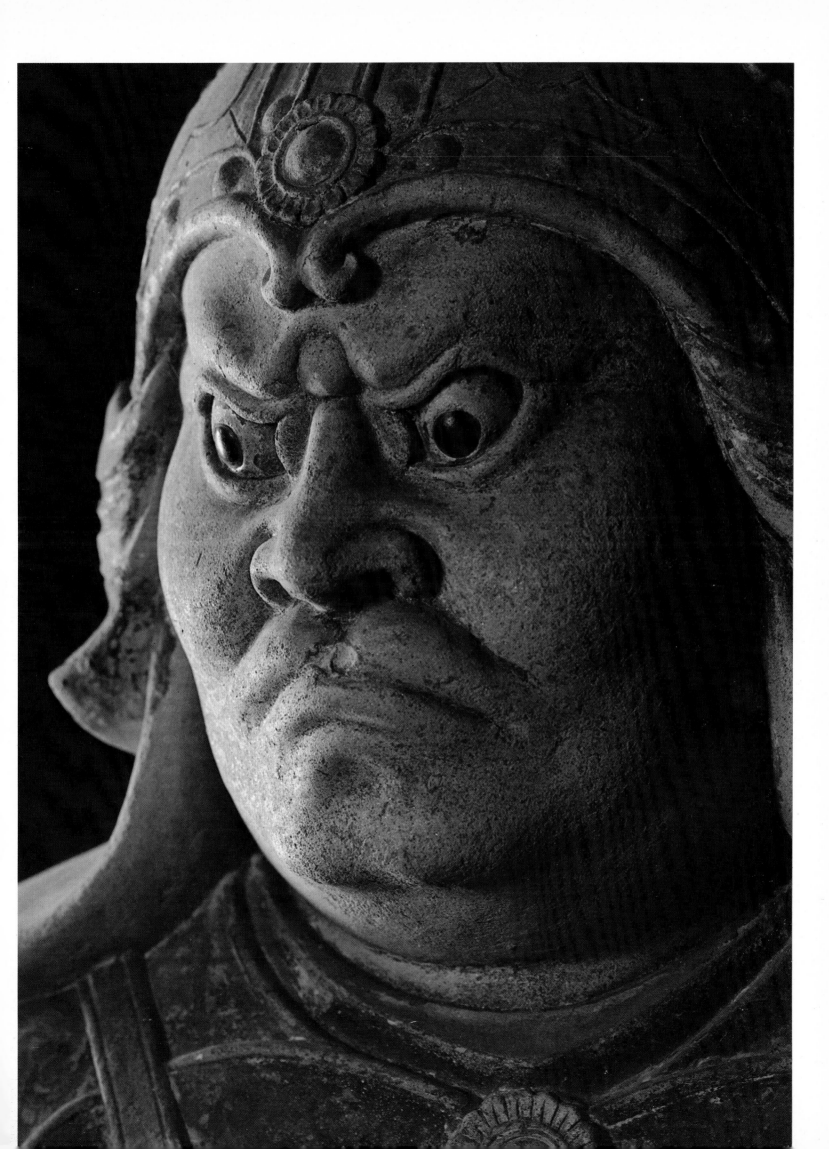

four Buddhas, distributing the interest fairly evenly between Shaka, Yakushi, Amida and Miroku. This gave certain Taoist harmonies which were buried in Hossō thought. Miroku received little promotion from other sects, remaining largely somnolent until the Kamakura period when revival of almost everything was in style, and then again in the Momoyama and earlier half of the Edo periods.

Amida did not gain in popularity in the Nara period, as might be expected, but did so after the introduction of esoteric practices and the Tendai worship of Yakushi, when Tendai priests found Amida to be the best route to the people. Once the Pure Land concepts were more clearly formulated, Amida started the longest run in Japanese iconographical history, and remains as popular today as ever. Only just behind in duration of popularity is the esoteric Fudō, with Jizō running a close third.

All of the others, especially Yakushi, Dainichi and Miroku, were ephemeral, Shaka alone among the early Buddhas maintaining a modest but steady degree of popularity. The temple guardians, Shitennō, increased in number after wood became the normal sculptural medium in the Early Heian period and tapered off only as the Edo period got underway. Quite important was the addition of esoteric types of images to the repertory, such as the multiarmed and multiheaded figures. These came in the wake of Shaka through the medium of Chinese art from India and appeared before the boat carrying the philosophy books arrived. If the "sects" leave some question as to what their impact was, there is no doubt that iconography had achieved a new hierarchical depth in this period, as rich as the many media in which the icons were being produced.

There were essentially two groups: one was made up of the workshops which were eventually organized under the Tōdai-ji working in the two decades before the middle of the century and responsible for the images of the Kōfuku-ji and Shin-yakushi-ji, and the other was a group active at the Tōshōdai-ji in the decades shortly after the middle of the century which was responsible for producing the remaining images of the Daian-ji.

The Hokke-dō or Sangatsu-dō, the site of scripture readings in the third month, has a display of 14 images of the Nara period in mixed techniques. They stand in the south end of the building, a strangely unsuited part added much later to what was probably Priest Rōben's original temple hall. These images are of dry lacquer and unbaked clay and are in incompatible sizes too disparate to have been anything but icons from several halls, gathered and installed in this manner during or after the Kamakura period. It is likely that the tall Fukūkenjaku Kannon of dry lacquer, the two clay figures which are called bodhisattvas, Nikkō and Gakkō, but actually Bon-ten and Taishaku-ten, and perhaps the Four Heavenly Kings of clay in the Kaidan-in were the original occupants of this building. From Asuka times, the use of consistent materials for images on one Buddha platform was never the case.

The eight-armed Fukūkenjaku Kannon fishes for souls. His three eyes – a pearl in the forehead – dusky complexion and complicated details are strikingly Indian. The elaborate crown contains a small silver Amida image and is studded with thousands of jewels and pearls. Now propped up on a high base, the image is above its aureole and halo, the later only partially visible behind the shoulders.

The records of the Tōdai-ji speak of Four Heavenly Kings of bronze, but no such images exist. The present ones, of clay, whose original sphere of protection is uncertain, though perhaps the Sangatsu-dō, have been housed in a small building, the Kaidan-in, since 1732. Such figures were built around a simple wooden frame wound with rice straw and covered with layers of clay. The outer surface consists of plaster. Some original gold leaf and polychromy are still to be seen under careful examination. All the figures have undergone minor repairs but no significant alterations, presumably in the Kamakura period when they were given obsidian eyes and, either then or later, new attributes for the hands.

As tertiary figures in the pantheon scale, they reflect more rapidly the stylistic changes and the subtleties of the three-dimensional art, characteristics not applicable to the bodhisattvas and even less so to the Buddhas. The bodies are turned to maintain a high level of interest from all angles, the surfaces are tight, seeming to control the implications of anger and physical power. The faces are expressive, though not much beyond warning and disapproving. The power is compact and contained, with even a slight touch of whimsy. They are not mechanically on duty as the sober Asuka ones are, nor posturing threateningly with a touch of the comic as the melodramatic Kamakura ones do.

Similar principles were followed for the Twelve Divine Generals (*Juni-shinshō*) of the Shin-yakushi-ji, that is, human size, realistic features and shifting body weight, but taken one step further. They were invigorated and dramatized. Their existence added substantially to Buddhism's growing array of symbols of magical protection, elevating the competition with Shinto which had for long had its own fetishes and festivals for that purpose. More personal and national security was being made available.

The Twelve Divine Generals symbolize the 12 vows of Yakushi which in sum were different ways to save mankind, and had a relationship with the signs of the zodiac, 12 divisions of the day and months of the year. By sign of birth and month, one identifies with a specific protector. The 12 images are in the only important secondary building surviving from the eighth century, now the Hondō (Main hall) of this temple, but these and the large wooden Yakushi Buddha of the Early Heian period were all grouped in some other way in another building or buildings.

Fujiwara patronage and imperial benefactions gave the Kōfuku-ji nothing but the best. The temple could once claim a full set of the "family of Shaka," dry-lacquer images housed in the West Golden Hall. These consisted of the customary platform sculptures of the Buddha, bodhisattvas, Four Heavenly Kings and probably a pair of monk-like intercessors, but these have all disappeared. Around them were Ten Great Disciples (*Jūdai-deshi*) and Eight Guardians (*Hachi-busshū*), and a probable total of 27 statues. The hall was erected in 734 and one assumes that the figures were made at the same time and that the platform images were in the same technique, for an old record complains that the cost of the statues surpassed that of the building, a comparison which would be difficult to make if the material and time did not correspond.

The chequered history of the Kōfuku-ji – the fifteenth-century five-storey pagoda, now Japan's second

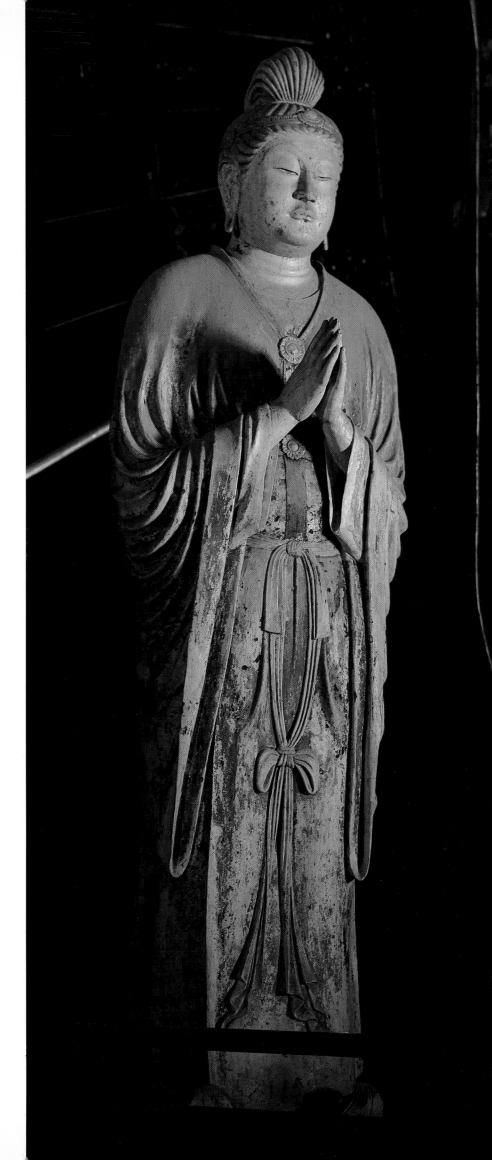

largest, is the fifth on the spot – included the thoughtless disposal of four of the Great Disciples to private collectors and all were tragically destroyed in the Great Kantō Earthquake of 1923. Damage to the entire group from the arson of 1180 and other fires had been mended by the thirteenth century, the multi-armed Ashura, for instance, getting a wooden lower right arm replacement. Some repainting was also done at the time.

Shaka's family comes in slightly smaller than human proportions. The Great Disciples stand motionless, elongated, the younger ones like Sharihotsu and Subodai, disciples identified with wisdom and the ultimate void, with small heads and delicate, even cherubic, features. Brows protrude over deep-set eyes. The older ones like Ragora and Furuna, identified with understanding the esoteric and understanding the Law, are more intense, with worn faces and middle-aged wrinkles. All but Kasenen, known for his familiarity with underlying principles, wear the long robe over both shoulders, and all but Ragora and Sharihotsu have both hands exposed. Kasenen and Furuna gesture with theirs as they play their parts. Each is represented as a distinct personality in what can be seen as the trend toward portraiture.

The foreignisms in the Eight Guardians are especially conspicuous at this juncture: red or dark skins, Indian costumes, Central Asian armour, the animal skin of Gobujō, the bird head of Karura, and the three faces and six arms of Ashura. These demigods are a disparate collection of Indian spirits of water, music, earth serpents, birds and others which were pressed into the service of Buddhism and "personified" within the anthropomorphic tradition of Indian art. They are normally associated with esotericism but, as has been mentioned, here they are portrayed simply, with the expository trappings that gave them meaning yet to come. The human ones also have doll heads, delicate features and pleasant expressions. Several of the

Gakkō, the "bodhisattva of sunlight." Eighth century. Tōdai-ji, Nara. The statue, made of coloured clay, seems to have been created as an image of Brahma, at that time identified with Gakkō.

wooden bases imitating eroded rock, which were finished in lacquer, are replacements.

These can be seen as the oldest esoteric icons in Japan if the 734 date is accepted as a dedication by Empress Kōmyō for her late mother, Tachibana-no-Michiyo. Views differ about the statues being brought to the Kōfuku-ji from the Gakuan-ji in the Kamakura period, but they must have come out of the Tōdai-ji–Kōfuku-ji workshop bearing the imperial stamp of approval.

The history of the Tōshōdai-ji is a graphic case of the Japanese sense of need for China and the Chinese response to it. Regarding itself as without a qualified priest to ordain neophytes, the Japanese court sent an invitation to China, but when no volunteers stepped forward and word of this reached the head of the Lü sect (Japanese: Kairitsu or Ritsu), he saw the task as worthy of his own attention and set out for Japan. Together with his young associates, this man, called Ganjin by the Japanese, met with one calamity after another, and arrived in Japan some 14 years after leaving his home temple in the province of Kiangsu. By this time he was blind from exposure after shipwrecks, but lived to the age of 77, dying in Japan in 763.

Ganjin performed the ordination ceremony in the courtyard of the Tōdai-ji and was rewarded with a fine plot of land north of the Yakushi-ji. Here the Tōshōdai-ji was built, initiated with the receipt of one of the residential buildings from the palace, a symbol of imperial good will and support. With minor modifications this building became the Lecture Hall, following the tradition of interchangeability known at least from the time when the Hōryū-ji received a rather similar building in 739 for the start of the Tō-in, the East Subtemple, the building known today as the Dempo-dō. At this point, the "permanence" of temple architecture and the "impermanence" of palace architecture met on common ground.

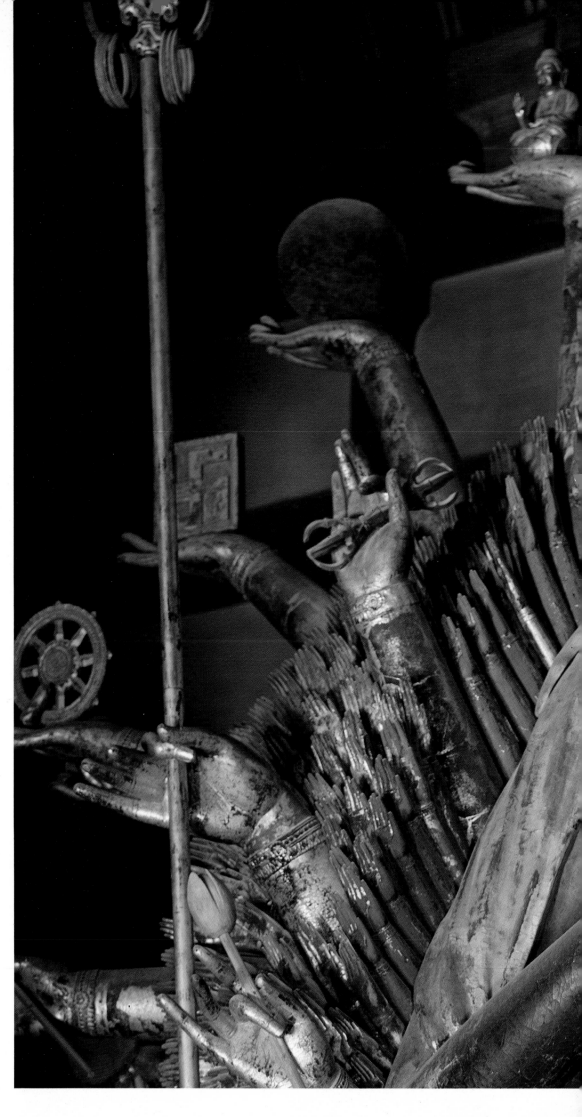

The Senju Kannon, the Thousand-armed Kannon. Dry lacquer. Tōshōdai-ji, Nara. The Kannon is here portrayed with innumerable arms and with 11 heads on his headdress to express his omnipotent and all-seeing nature.

102

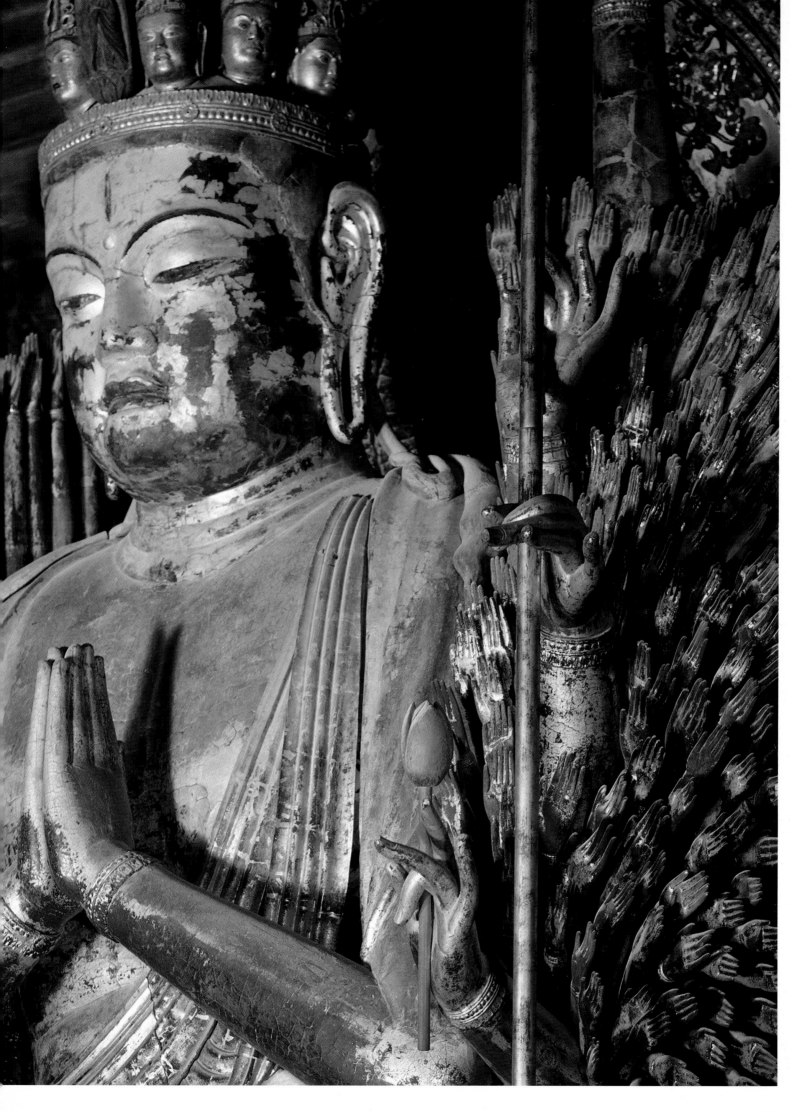

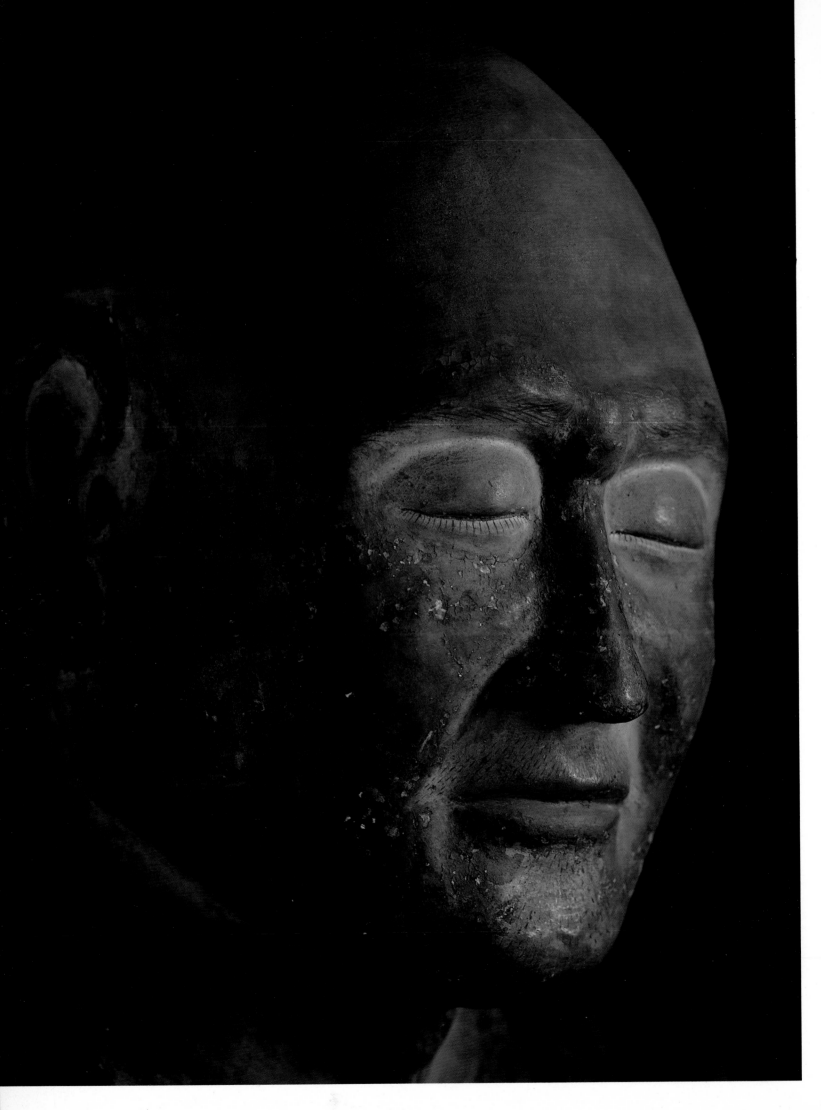

The use of such structures influenced the Japanese attitude toward major temple buildings, and they tended to make them longer and less deep than their Chinese models. The Lecture Hall of the Tōshōdai-ji, a 7 by 4 bay hall, is structurally simple and has an earth floor. The elegant low proportions are enhanced by the rhythmic repetition of the rectangular framing and strong linearity of the woodwork of each bay, the windows filling the spaces between the columns on either side of the central doors.

In contrast, the *kondō* is regarded as the classic example of the international structural style. The building is about twice as long as it is deep: 96 by 48 *narajaku*. Some modification of the Hakuhō style had shortened the corner levers and set up a pattern of graded bays, from the narrowest at the outside to the widest in the center. In the case of this Tōshōdai-ji building, the widths in *shaku* follow this scheme: 11:13:15:16:15:13:11. The huge Great Buddha Hall of the Tōdai-ji, three times as long, had this scheme: 23:23:26:29:29:30:29:29:26:23:23.

The concentration of focus on the monumental image of the Vairocana Buddha was further emphasized in the coordination of the scale of the statue with the size of the building. This much had been in the Hakuhō manner, but the degree to which the interest was centralized by manipulating the architecture was new. The south bay was left unwalled, like a porch, to allow an external framed view of the Buddha and bodhisattvas which, with wide open doors and well illuminated by candles at night, would have been especially effective for a worshipper standing outside. The candid approachability of the Universal Buddha was enhanced by the nuances of this architectural style.

A later reconstruction raised the roof, as was Japanese practice for almost all their temple buildings, in this case to a 1 to 1 ratio of wall to roof height, and set the *shibi*, the fish symbols of water and protection

Left: Bust of the blind monk Ganjin (688–763), created using the kanshitsu *or "dry-lacquer" technique (detail). It is preserved in the Tōshōdai-ji in Nara, the temple which Ganjin, a Chinese monk who settled in Japan, founded in 755.*

at the ridge ends, directly over the second column at either end. Later esoteric attitudes frowned on the light and airiness of such interiors, however, and the doors were narrowed by diaphragm walls. Only records remain to say that the walls were painted with 2,000 Buddhas.

Among the young Chinese priests who stayed with Ganjin were several accomplished sculptors. They made the largest seated image in dry lacquer to date. Perched on a high, alternately five-tiered lotus petal base, the heavy-set Buddha has all the force and power of the T'ang style at its peak, while the slackened flesh surface – to the point of squaring off the face and joining the head directly with the shoulders – are indicative of the T'ang power as it was receding. The worshipper's view stresses the upper torso and diminishes the effect of the lower body where the drapery accumulates in closer folds.

New to Japan, and in keeping with Kegon's concepts of the cosmic Buddha, is the aureole of One Thousand Buddhas in what is supposed to be 33 clusters. Sticky-fingered visitors and, one might guess, exchanges for contributions of a more substantial sort, have reduced them to 864.

The Chinese were also at work on other images in this group and may have been responsible for altering the dry-lacquer technique from the simple removable clay body to the so-called wood-core method. Whether this was due to problems of size, considering their very ambitious undertakings, or to the availability of adequate quality or quantites of lacquer, the change may have been devised at the Tōshōdai-ji. The Japanese would probably have been less likely to tamper with the technique, allowing it to run its natural course. The change signals its decline, making the technique impractical as it remained expensive and lost some of the malleability of the layers of hemp cloth and the portability of the hollow examples. The future lay with wood, and this was one step in that direction.

The Thousand-armed Kannon (Senjū Kannon) to the Vairocana Buddha's right is in this wood-core dry-lacquer medium. Over three times the height of a man, it is inevitably frontal because of the need to exhibit its three banks of arms: six of normal size, 34 of secondary size, and the remainder as small hands on copper wires. A further 47 have vanished.

The long arched eyebrow line emphasizes the width of the face, while the merging flesh of the jaws with the neck and crown line shape the squarish face that is the trademark of these images. The upper lip protrudes strongly. The junction of anatomy at the shoulders adds breadth to the torso, which is only lightly covered with drapery scarves. Regular folds accumulate past the sagging hips toward the feet, in an uncomfortably droopy way.

Rounding out the Buddha platform, to the Buddha's left is a standing Yakushi, also in wood-core dry lacquer and proportional in height, a pair of intercessors, Bon-ten and Taishaku-ten, the traditional Brahma and Indra types which had entered T'ang art, of wood and quite lilliputian in comparison, and the Four Heavenly Kings, also of wood, and even smaller. The concept of scale had gone awry whether through lack of will and understanding or sheer expense, and one must ask the question, did the Chinese lead the Japanese out of dry lacquer and into wood right here at the Tōshōdai-ji? The Early Heian images would indicate it.

The image of Ganjin as a life-size seated priest stimulated the practice of portraiture in Japan. It may have been the first such image. Priest Gyōshin, the builder of the eastern subtemple of the Hōryū-ji whose image sits in the octagonal Yumedono, executed the work at the request of the empress in 739, but a document speaks of his associated monks praying for him between 767 and 770, presumably when he was ill, and his sharply realistic statue may have been created then.

The surface of the statue of Ganjin is now rough and uneven as a result of early nineteenth-century repairs following a fire. Papier-mâché was applied over its three to six layers of lacquered hemp cloth, arms of wood were attached and the painting largely redone. At about that time the statue was affixed to a board.

Ganjin has a determined set, his face creased from the nose to the outer edges of the mouth, jowls heavy, eyes closed and literally unseeing, hunched shoulders belying his age more than his face, and the robe fully finished on the back. The sculpture was executed with profound feeling for the subject. It is the work of more than a good sculptor; the maker was an intimate associate.

As the new Hōryū-ji was celebrating its successful resurrection, the season reached its peak with the installation in 711 of the groups of miniature images on the first floor of the pagoda, backed by a clay model of the Buddhist holy mountain. This was a break with Hossō practice, in which a pagoda would have images of four Buddhas each facing a cardinal direction: Shaka on the south, Amida on the west, Miroku on the north and Yakushi on the east.

These little unbaked clay figures are set into configurations of caves and grottoes, lined up on terraces in formally balanced ways. The Hōryū-ji has the only set of these, but fragments have been excavated at the Yakushi-ji and Kawara-dera, which probably therefore had smaller versions and suggest that seventh-century Hossō philosophy was in an evolutionary stage. The Hōryū-ji frequently did things in the most traditional way.

The scene on the south is the prophecies of Miroku (Maitreya), the Buddha of the Future, an enthroned figure seated in Western fashion. On the west is the worship of the relics in which the figures are arrayed on either side of a coffin-shaped reliquary. On the north is the Nehan (Parinirvana), the death of Buddha, a scene rarely seen in sculpture in China and Japan. On the east is the visit to Yuima (Vimalakirti) by Monju (Manjuśri), the former a sick sage, the latter a Shaka attendant. The two are revised from the normal Chinese right-left hand relationship.

All are Shaka-connected subjects, even the future Buddha who eventually replaced the historic Shaka. The Hōryū-ji was conventionally a promoter of Shaka, perhaps because of identity with Prince Shōtoku, and still today claims the largest number of Shaka icons of any temple in Japan. Like T'ang tomb figurines, these little images play their roles silently and reverently, except for the foreground figures in the Nirvana scene which spring to life in a Chinese-style exhibition of public mourning. The emotional tension is dramatized by the front row's poses and expressions, more restrained in the back rows.

Karura, one of the Eight Guardians of Shaka. Painted dry lacquer. Slightly smaller than life-size. Kōfuku-ji, Nara.

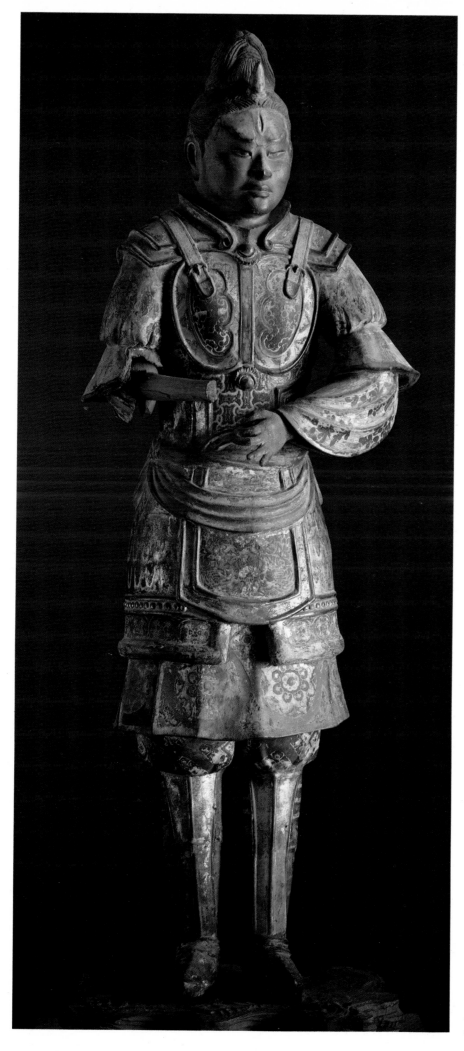

Before the tragic fire in 1949 of the Golden Hall of the Hōryū-ji, the temple claimed the finest cycle of early wall paintings in all of east Asia. Replacements are there today. Not many paintings exist from the Nara period, but textual references indicate the importance of the art and its wide use in supplementing the other icons of the temples.

Among those that do survive are the mechanically copied Inga-kyō, sūtras taken from earlier models illustrating stories of the life of Buddha, with the text running below the pictures. These, however, are of little value in understanding the current style. The Yakushi-ji has the small painting on hemp of Kichijo-ten (Mahāśri), a remarkable piece of art known for its classic *ungen* (rainbow shading) on the diaphanous drapery of the ethereal deity, a technique borrowed from textile decoration of graded colours also seen on about a dozen objects in the Shōsō-in. The wooden columns of the Eizan-ji in Gojō city, Nara prefecture, bear paintings dating from the years 763–4. The Hokke-dō Kompon Mandara in the Museum of Fine Arts, Boston, is known to have played an important part in services at the Todai-ji, and the Hōryū-ji had one or more similar paintings.

The subject is well known through the large tapestry once owned by the Kanshū-ji, now in the National Museum. The enthroned Shaka preaches at the Vulture Peak, with landscape features behind, a host of bodhisattvas around, heavenly figures above and monks and attendants below. Bilateral symmetry prevails throughout, and attention is drawn to the Buddha as the center of a strong vertical column of tree, canopy, throne, lotus, mat of flowers and what may be the donor at the foot. Concentration of opaque colour and scaled sizes of figures flatten the Buddha and elevate him magisterially.

These pictures on the theme of Shaka preaching were not much grander than the paradise panels of the Hōryū-ji, and both evolved from hierarchical compositions developed by the Chinese and best seen in the Buddhist caves at Tun-huang in northwest China. Taken as

Kinnara, one of the Eight Guardians of Shaka. Painted dry lacquer. Slightly smaller than life-size. Kōfuku-ji, Nara.

a whole, the Hōryū-ji cycle was an especially ambitious one and only possible in a temple with high-placed patronage. It has almost always been designated as early Nara, even late seventh-century, but the discovery of the Takamatsuzuka tomb, datable to around 695 or 700, with its unmistakable Hakuhō characteristics – costumes, shape of the heads, Taoist elements in the plan and symbols of the Four Quarters, and the connection with the Yakushi-ji – makes such an early date for the Hōryū-ji paintings no longer tenable. High Nara would be more suitable, probably after the Inventory of 747 was compiled for the court's ecclesiastical office since the paintings are not mentioned in that property list. In 749 the temple received special gifts of silk, cloth and cotton, along with rice and some land. This would be ample support for such a project.

The paintings were a highlight of the pilgrimage circuit, but medieval monks usually identified the paradises with esoteric Buddhas rather than with the Hossō philosophy which gave rise to them. The plan of such 5 by 4 bay halls leaves 12 wall panels for use, four large and eight small. A single door on the east, west and north sides and three on the south prevent a symmetrical scheme which was preferred in Hossō iconography by this time. Nevertheless, the familiar four Buddhas were used and logic dictated that the currently popular paradises of Buddha should appear on the large panels and single bodhisattvas on the small ones. The net had to be spread rather widely to find eight different bodhisattvas before the esoteric deluge, but a rhythmical pattern was developed using opposite walls: Nikkō and Gakkō for Yakushi, Seishi and Kannon for Amida, Monju and Fugen for Shaka, and one more Kannon and an Eleven-headed Kannon for Miroku, if this identification can be accepted.

Shaka was encountered first by the pilgrim who should have

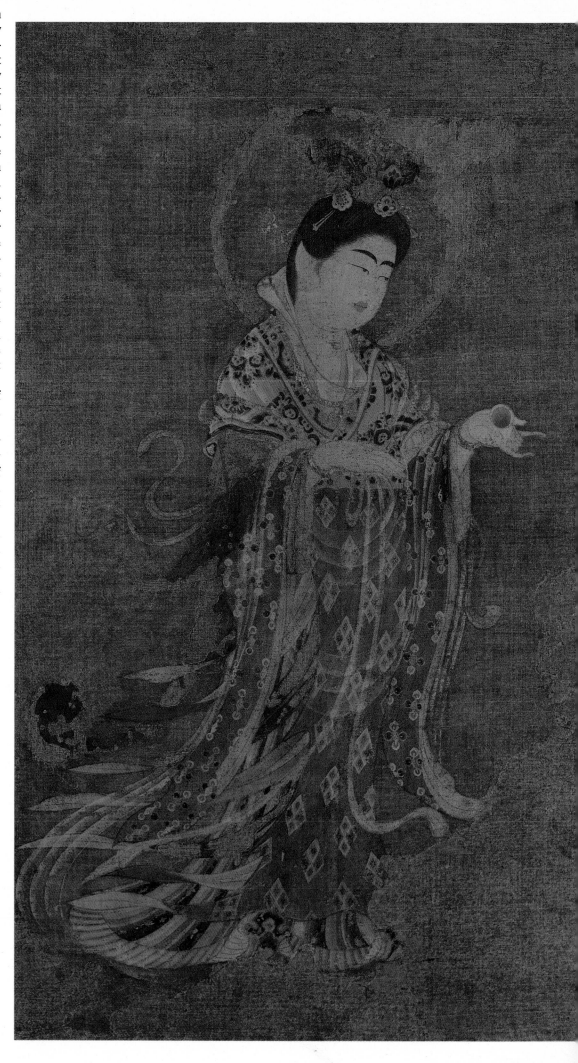

Right: the goddess Kichijo-ten. Yakushi-ji, Nara. Painting on hemp. This work appears in inventories in the temple archives from 773.
Opposite: The Journey to the East, detail from the stories of the Buddha's life. Scroll painting on parchment dating from around 750. Tōshōdai-ji, Nara.

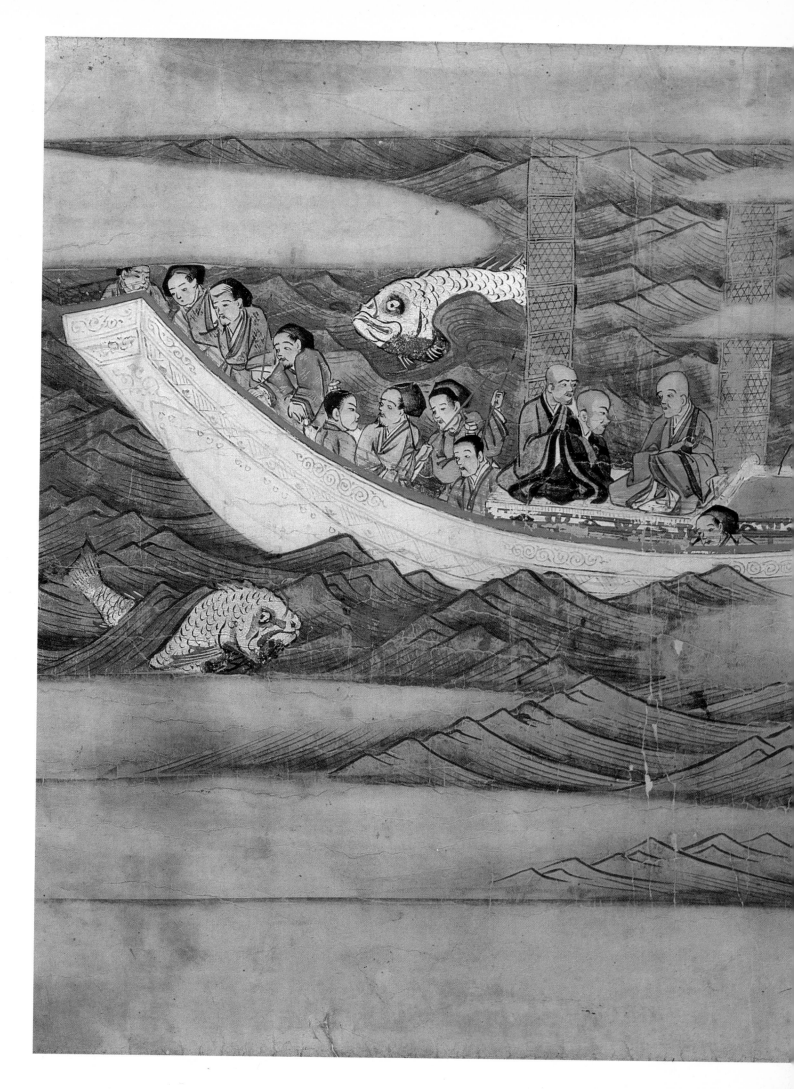

circumambulated through the east door, along the south side, west, north and back out the east door. Shaka is seated yoga style on a backless seat, a pair of bodhisattvas and his Ten Great Disciples flanking him. Amida is seated in the same way on the west wall on a spiky-petalled lotus with the back of a throne behind. He is a little higher in the frame and should be over a pond. Accompanying him are his two bodhisattvas and many dematerialized souls on lotuses in paradise. On the northwest wall, a panel usually identified as Miroku is probably Yakushi. He is seated Western style between a pair of bodhisattvas and a number of deva kings. Four little pygmy-like creatures, barely visible under the throne, may possibly be all the artist could include of the symbols of the 12 vows. On the northeast wall, the panel usually identified as Yakushi is probably Miroku. Four bohisattvas make a rare appearance, in all likelihood to emphasize the bodhisattvahood of Miroku. Here he is shown on the Jewel Throne in China.

What could not be done with the cardinal directions in terms of a major coordination is compensated for in many subtle balances and rhythms: roughly the same number of figures in the large panels on the north side; seated bodhisattvas with canopies overhead, standing ones without; bodhisattvas looking toward doors in systematic angle views, and colour correspondence echoing across the room.

The fine, firm line work can be traced to Central Asia along with the shading system, and the hierarchical formal regularity to China. The iconographical confusion might be local – seating positions mixed with thrones and some less important points. Faces are round, eyebrows composed of long crescents, bodies fleshy, and outlines of supernatural persons painted in red.

Contrary to the view held by many scholars, these wall paintings did not break new ground, nor did they set a precedent; nevertheless, few Golden Halls had been tried before, perhaps because the iconographic scheme could never be fully realized in such a setting, or interests were diverted as new philosophies reached Japan.

Emperor Shōmu's special aesthetic interests are evident in his spectacular collection of arts and crafts in the Shōsō-in, the wooden storehouse in the north of the Tōdai-ji compound in Nara. The foreign mission – imperial workshop pipeline enabled Shōmu to acquire fine pieces ranging from Iranian or Syrian glass to Indo-Chinese rhinoceros horn back-scratchers. Countless numbers of foreign objects had their origins at points in between. Replicas of the originals were made in court workshops.

Shōmu sent out the 733 mission and probably reaped the few fruits of the 752 mission, a large group which lost two of its four ships and saw its members return separately in 753 and 754 shortly before he died. Visiting dignitaries must have known that they would receive red-carpet treatment if they had frequented the dealers and workshops in Sian where everything known in the Eastern world was then circulating.

His wife dedicated Shōmu's possessions to the Buddha, "donated as an act of piety to contribute to his peaceful rest," the signed and witnessed document says, and other objects found their way into the storehouse: articles used in the dedication ceremony of the Great Buddha, in memorial services, and from other Tōdai-ji sources. There are costumes, games, furniture, screens, medicines, writing equipment, utensils and archive records of donations and conservation, including notes on losses by theft and occasional recoveries. Considerable care was taken of the Shōsō-in's contents until the Meiji era, then again in the twentieth century, and they are now preserved in a concrete building in the same yard.

The range is so vast and varied – 240 musical instruments, 164 gigaku masks, 57 pieces of the family of three-colour pottery, 3,763 arrows, over 60,000 gems, tens of thousands of textiles – to mention but a few items and techniques.

The three-colour ware (san-sai) was copied from the Chinese T'ang style, the Japanese brushing the colours on in chequerboard fashion, often in alternating colours, in a conventional effect the Chinese examples lack. Green and yellow were used, and white was considered to be the third colour. Most examples are green and white. Only five are actually three-coloured; the remainder are consistently green. The technique has close imperial associations in Japan. Fragments have been found in the palace and in the sites of temples and shrines that had been favoured by the court. The production of three-colour was phased out toward the end of the century.

Interestingly enough, the history of glass is quite similar in this century, which is more than coincidental. Like other exotic media, glass was linked to imperial power and the economy, and could not survive the recession. The Japanese imported blown glass from China and Korea which in turn had received it from farther west. Some cups are obviously Persian in provenance. The Japanese invented a unique technique of casting glass. The government's glass factory, Tenchūshi, must have been operated by converted metalworkers. Local use of moulds for making beads and amulets had its start in the Yayoi period, after the Japanese had seen Chinese glass and jade pieces.

Over 60 bronze mirrors are kept in the Shōsō-in, some unquestionably of Chinese manufacture. The exotically inlaid ones, on the other hand, using mother-of-pearl and semiprecious stones, came out of a court workshop familiar with this technique in China. They added elaboration and colour. Among numerous documents extant is one with instructions for the casting of bronze mirrors. Temples prided themselves on their mirror collections. A Daian-ji property list mentions 1,275. An imperial order in 762–3 for four mirrors occupied ten people for 124 days.

All of the T'ang dynasty mirror shapes appear: round, square and lobed. They bear landscapes, birds singly or in pairs, animals, "lion and grape" patterns, and floral motifs. Mirrors are often thought to have been wedding gifts, especially those with paired birds, the symbol of wedded bliss. By this time the intensity of the supernatural world as mirror decoration with all of its fearful spirits had been traded for the gaiety of the natural world and all of its elegant charms.

As China had welcomed troupes of foreign musicians and had sponsored tours to teach their techniques, the instruments themselves, or at least copies of them, reached Japan. There is a three-colour clay body of a drum similar in shape to one found in China not long ago. The sound boxes of the stringed instruments were either painted or inlaid with nacre and coloured stones. Decorating a five-stringed biwa is a musician riding on the back of a saddled Bactrian camel and

Above: Three-colour ware bowl of
Chinese inspiration. Below: dark
blue glass vase imported from Asia
or farther west. Both objects are
preserved in the Shōsō-in or
"treasury" of the Tōdai-ji, Nara.
The Shōsō-in contains items
collected by the Emperor Shomu
and then presented to the temple by
his widow in 756.

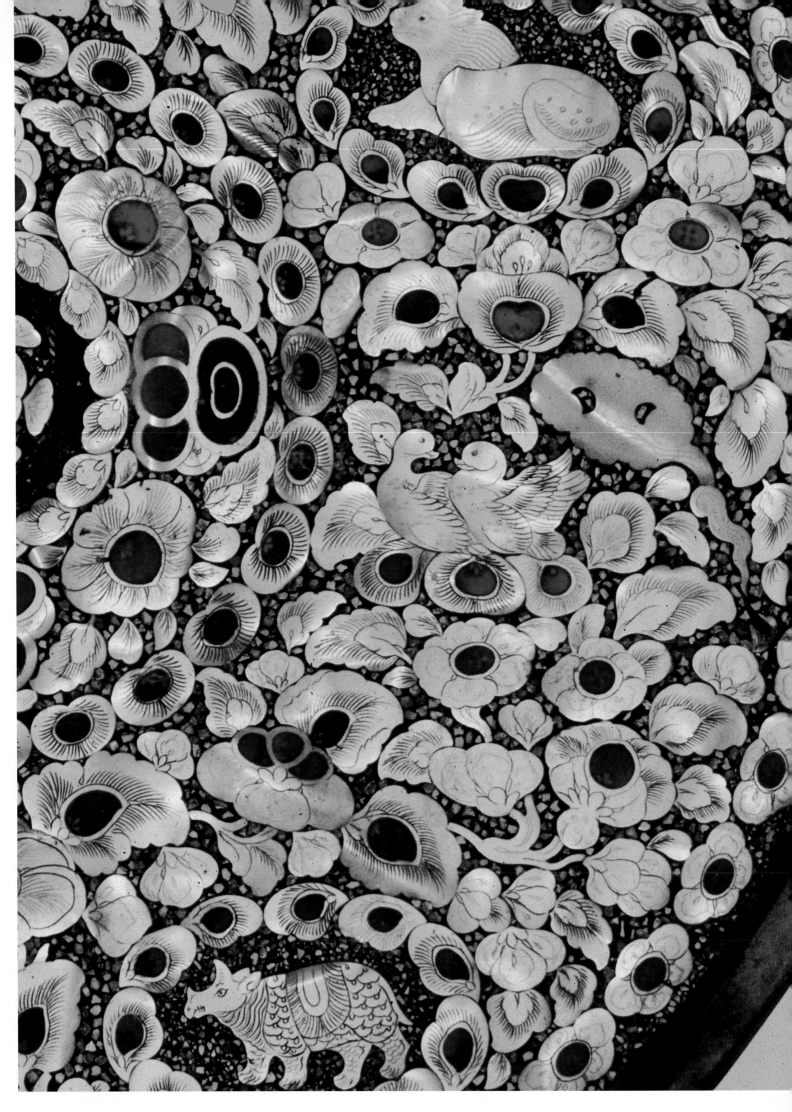

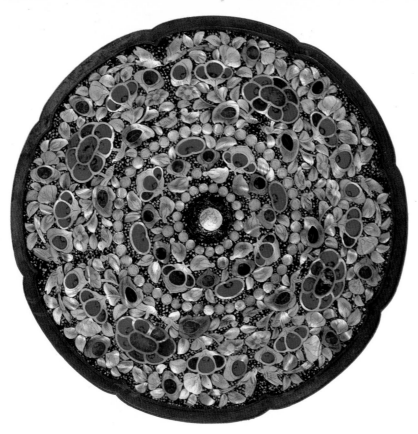

playing a four-stringed instrument with a plectrum. The camel turns his head back, eyeing his rider with a trace of dismay on his face.

The largest single category of articles retained in the Shōsō-in is the enormous store of fabrics. They represent all known techniques of brocades, twills, gauzes and silk tapestries. They were used for costumes, pillows, bags, covers and in many other ways. Thousands are only fragmentary, as would be expected from the perishable nature of the material.

Vegetable dyes were used in red, yellow, purple, blue, green and brown. Along with weaving, dye decorating was by wax resist, stencil and tie dyeing. The basic patterns of decoration for all of these works are not very many, but they occur in myriad variations. Most were taken from Chinese and Persian originals. Highly florid forms of the lotus in medallions are popular and, among others, are honeysuckle, grapes, paired animals, trees and animals, and random scattering of birds and flowers. The symmetrical Near Eastern "tree of life," together with animals and various exotic creatures are in keeping with the international flavour of these works yet at the same time seem quite foreign to the Japanese scene itself.

Above: eight-lobed bronze mirror with inlaid decoration of amber and mother-of-pearl. Opposite: detail of the mirror's decoration of flowers and animals. Below: board for the game of go. Inlaid and lacquered wood. Both these objects are preserved in the Shōsō-in of the Tōdai-ji, Nara.

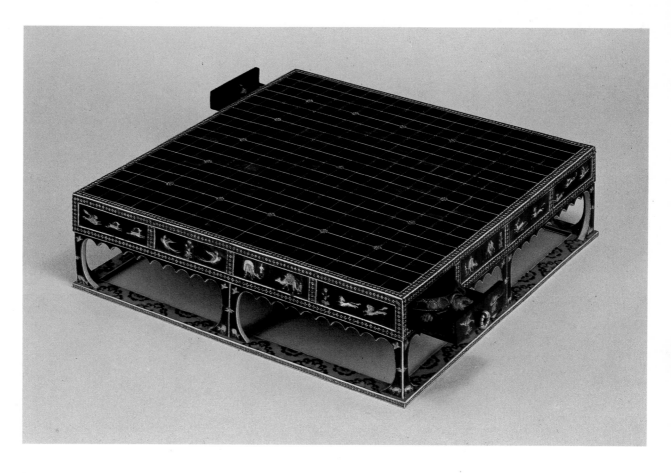

Below: musician riding a camel. This mother-of-pearl inlay in tortoise-shell occurs on a five-stringed musical instrument known as a biwa. Opposite: detail of an embroidery showing a peacock and flowering plants. Both works are preserved in the Shōsō-in of the Tōdai-ji, Nara.

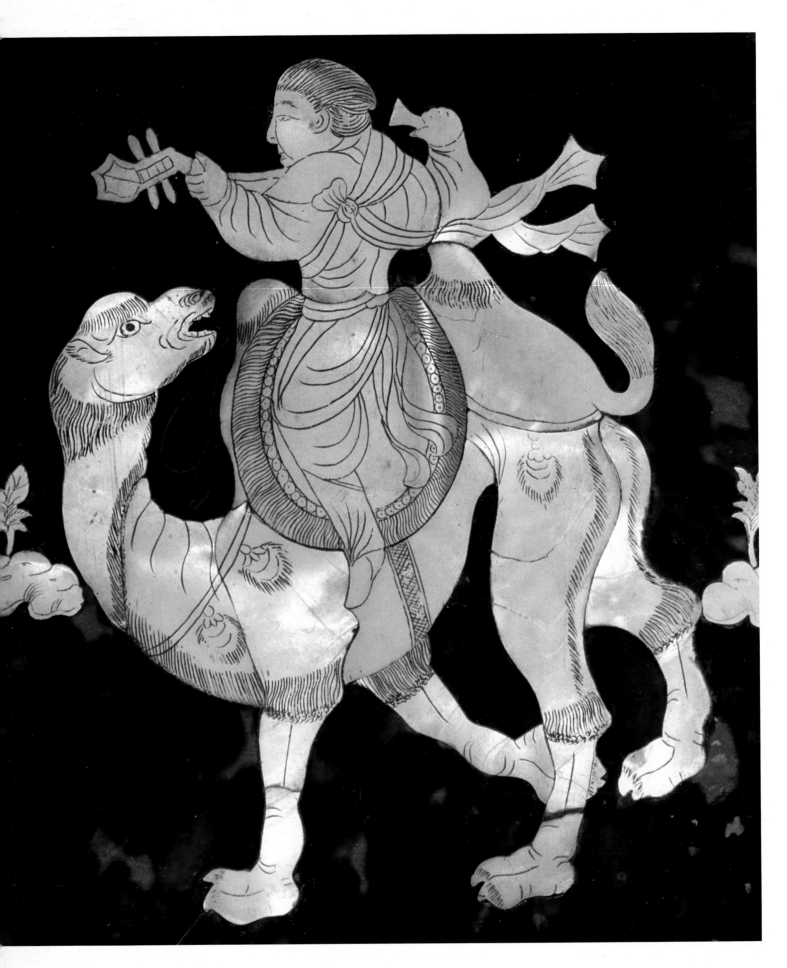

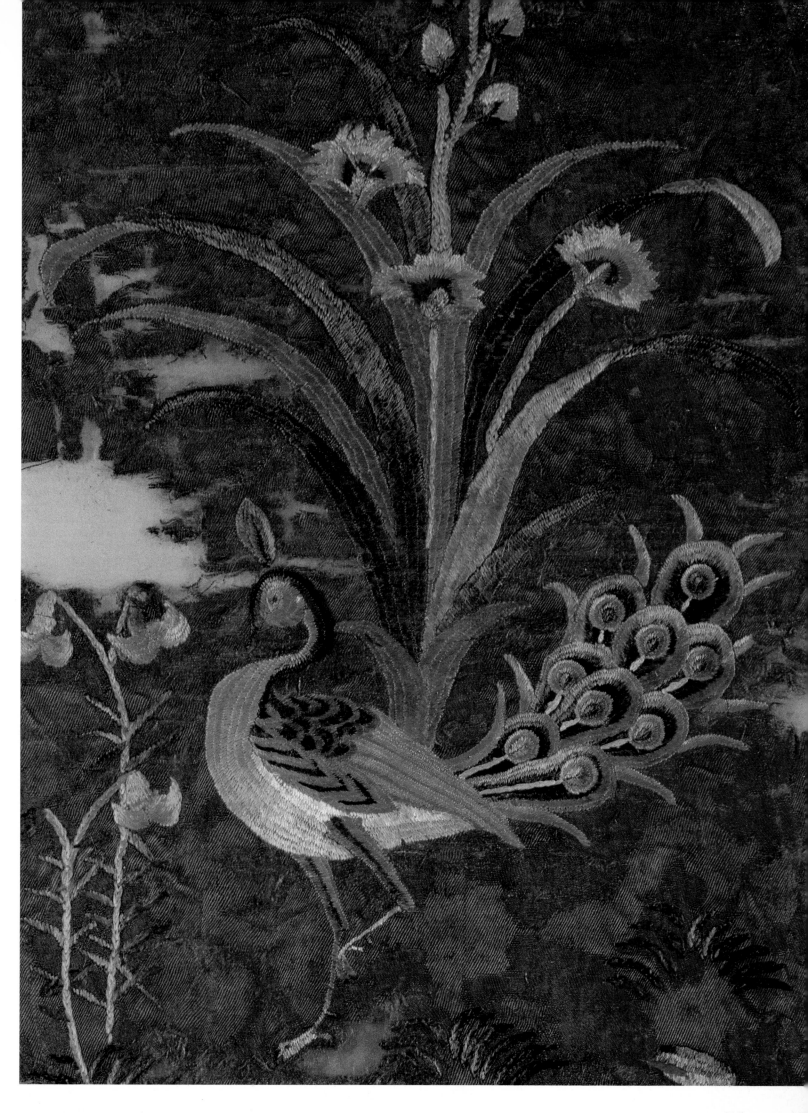

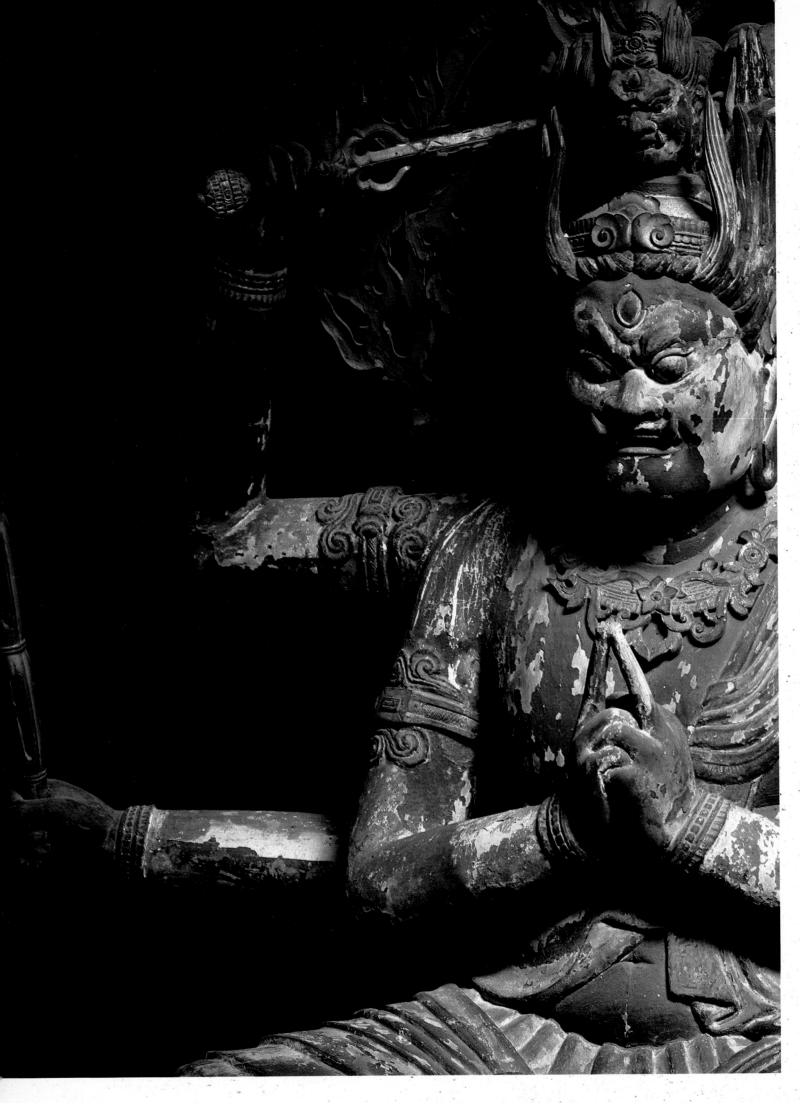

THE EARLY HEIAN PERIOD
794–893

The eighth century had witnessed the geographical spread of Buddhism when Emperor Shōmu ordered all the provinces to build seven-storey pagodas to house copies of the Konkōmyō-saishō-ō sūtra, the Realm Protecting Sūtra, and followed this later with an order to build full temples. Not long before, a disastrous epidemic of smallpox had numbered among its victims the heads of the four branches of the Fujiwara family. Since these *koku-bun-ji* were supervised by imperially appointed priests whose nearest neighbours were the governors of the provinces in their *kokufu*, the combination was seen as an undisguised attempt to extend government controls. As such and as financial burdens, the temples gained little favour with the local people. In fact, many were the object of arson during peasant revolts, and most are no more than preserved archaeological sites today. Their unpopularity elicited threats on the monks who, for their part, were confined to their monasteries with orders to avoid contact with the people. Shōmu had obviously been able to spread Buddhism by edict and institutionalize it as the state religion, but beyond its political impact it had no measurable philosophical significance.

The contention between the emperor and the clergy mounted after Emperor Shōmu's daughter ruled as empress. Her notorious liaison with Priest Dōkyō channelled unprecedented power to the clergy, who capitalized on their new privileges. But from the time Kammu ascended the throne in 781 until his death in 806 a continuous series of edicts cramped the activities of the Nara clergy. Not everything went according to Kammu's plan, however. The transfer of the capital to Nagaoka in 784 as engineered by the Fujiwara quickly proved to be a disaster. The assassination of the planner, Fujiwara Tanetsugu, decapitated the leadership and was seen as unmistakable evidence for rejection of the site. To move then became more important than reaping the fruits of the vast expense of pouring the taxes into Nagaoka directly in the mad scramble to have the palace and city built.

All early rulers coveted more efficient and practical water transportation systems. All the sites under consideration in the eighth century, such as Kuni, Hora and Shigaraki, were closer to Lake Biwa and along substantial rivers. They would have afforded reasonably good links with the north coast of Kyoto and Fukui and the eastern Inland Sea, but suggested moves to such distant points met with strong internal opposition. Heian (Kyoto) turned out to be the most ideal choice, as it was large enough for steady expansion in an area where valleys and plains brought these systems together.

This period is best designated as Early Heian, and can include the ten years of Nagaoka if desired. The decade was shadowed by the uncertain disposition of Prince Sawara, the supposed assassin who died on the way to exile, and serious losses against the Ezo on the northern front. Terms which keep recurring in Japanese books are period names but, like Hakuhō, they are not sufficiently inclusive, and are also not connected: Kōnin, 810–823/4, and Jōgan, 859–876/7. They may have been selected because they are the longest in the century.

The construction of Nagaoka and Heian carried the momentum forward in enlarging palace and city architecture, but embodied little new in plan. Socially, however, Heian involved Kammu's philosophy of power concentration. By allowing few temples to be built, the welfare services for the larger population, even if nominal, were reduced. These included medical, educational and hospitality services. In retrospect one wonders if Kyoto was able to afford these deficiencies. Even after the move Kammu cut the incomes of the Nara temples, barred farmers from giving or selling them land, ordered the indolent and non-celibate monks out of the cloisters and disciplined others. A large number of the estimated 200,000 residents of Heijō were in the employ or service of the temples.

This policy effectively delayed the emergence of Heian's own religious traditions, accounting for much nostalgia for the old city and the spiritual merit of making the pilgrimage to the Nantō Schichidai-ji, the Seven Great Temples of the Southern Capital. Periodic attempts to move back by early generations of Heian dwellers belie the official pronouncements from the court that all was harmony and contentment in the Capital of Peace and Tranquillity.

The new city was laid out much like Heijō, its two southern corners close to the Katsura and Kamo rivers which flowed toward lower land and met at a point south of the city. Additional rivers in the east,

Opposite: Daiitoku, the god of death. Detail of a sculpture in the Lecture Hall of the Tō-ji, Kyoto.

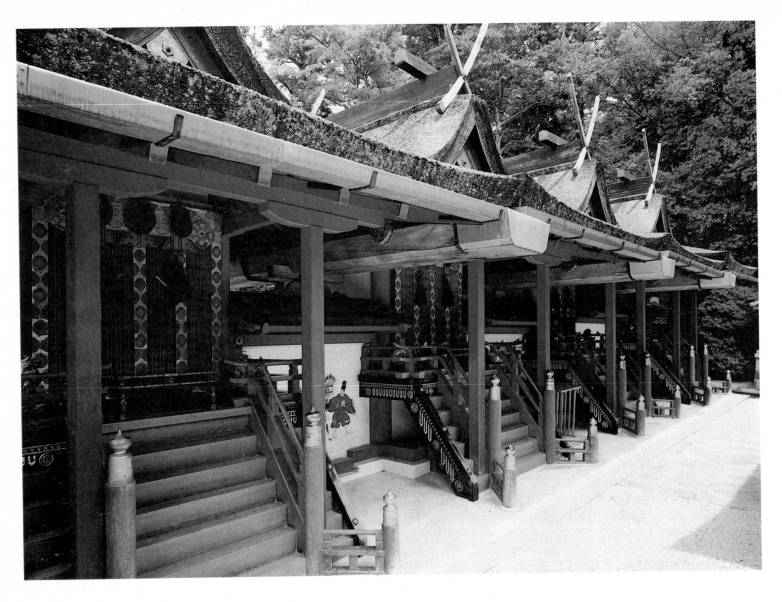

Above: the four buildings of the Kasuga Shrine, Nara, founded in 768.
Opposite: the five-storey pagoda of the Murō-ji, Nara, generally thought to date from the ninth century.

the Takano and Shira and their tributaries, were a major advantage. Heian had the usual rows of nine blocks on the north–south axis and eight on the east–west axis. The work was regarded as complete when the Office of Imperial Palace Construction was closed in 806, only three months before Kammu died.

Except for parts of Osaka, Kyoto is the only reminder in Japan of this history of city planning and is also evidence of changing moods and concessions to water needs. The city shifted toward the east, crossing the river and into the eastern range of hills where many temples were eventually built. It also expanded toward the hills in the northwest. As a consequence, in the last century it was felt necessary to move the palace to a new location further east to keep it properly in the center of the northern blocks of the city.

The area had been selected for its space and hospitable conditions, and the approval of the *kami* of Kamo, chief deities of the area, was solicited. Moreover, as the city rose

from the drawing boards it was essential to secure the right protection for it. Work was begun on a pair of temples at the south gate, the Tō-ji on the east and the Sai-ji on the west. The vulnerable northeast, from which the evil spirits were believed to attack, was to be guarded by a monastery on Mt. Hiei, appointed to Kammu's liking. An admired priest named Saichō was chosen. He had been sent by Kammu to China for further training. Later known as Enryaku-ji, an era name, the temple turned out to be a mixed blessing. It produced some of the country's greatest religious personalities, but it also spawned centuries of furious attacks on the city by its militant monks, the evil spirits incarnate.

Kammu was the last emperor to command such power. The vacuum left by the clergy remaining in Nara was quickly filled by the rapidly expanding nobility. Their support of the political system was rewarded with favours. The government was unable to assess taxes on newly

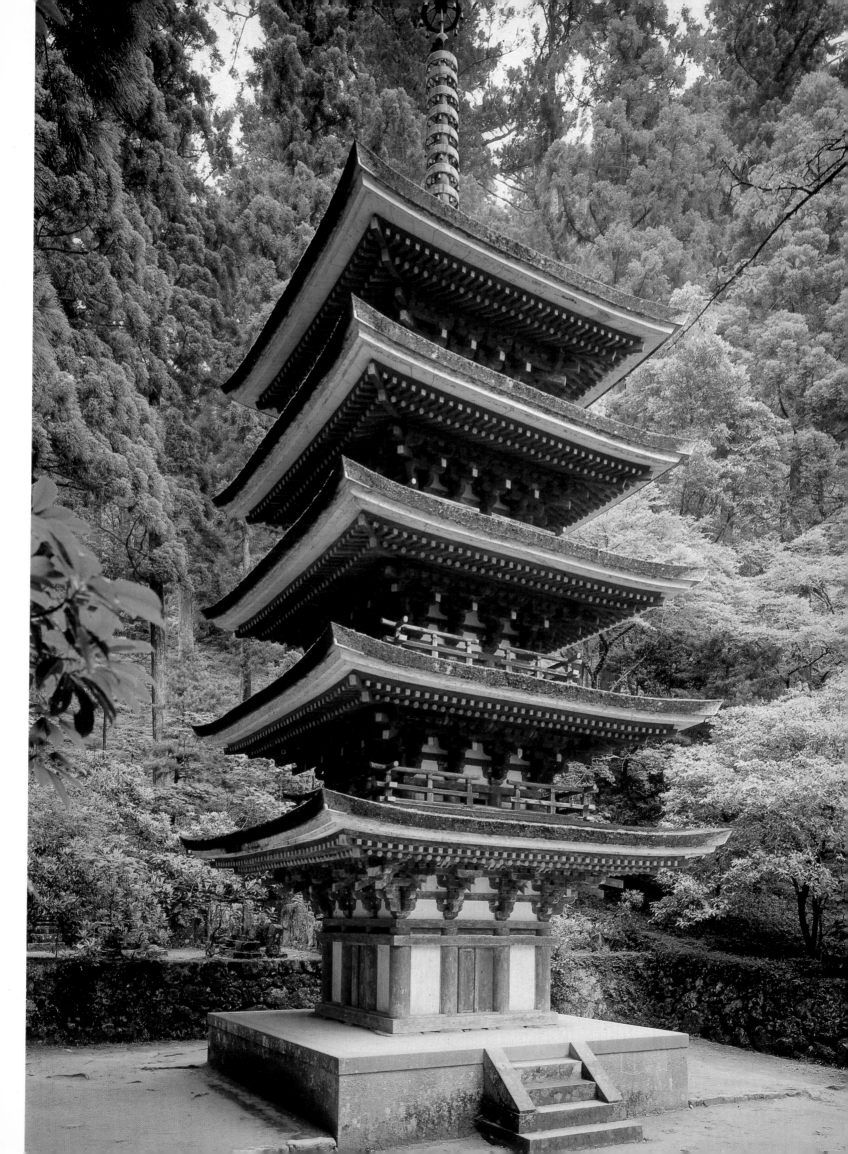

opened rice lands, and the conversion of older areas to private control in the form of manors or estates (shōen) from which they derived income involved subversion to its policies on all social levels. Kammu eventually picked a winning general, breaking the back of Ezo resistance in the north, but the victory freed numerous young men from military service who did not relish a return to peaceful farming. Management of the city and indeed the country-side became increasingly difficult. Among the evidence of economic instability are such edicts as the prohibition of interest rates over 50 per cent and the abandonment of the coinage system.

The power relationship among families was altered as capital locations were changed and land acquired. The Otomo and Saeki families, caught up in the Nagaoka fiasco, had virtually dropped out of sight. Among the contending branches of the Fujiwara, the so-called Northern Branch was victorious. Alongside them, though smaller and more of an elite, were the Sugawara.

Contacts with China were slowing down as the Japanese realistically assessed the conditions there during the declining T'ang decades. Japanese visitors were appalled by the Buddhist persecution in 845 which resulted in the destruction of 300 temples in Ch'ang-an alone. The period ended with the adoption of an official stance against the dispatch of more missions. In consequence, Japan found it necessary to concentrate on the most recent imports and explore in greater depth what had already been received. To some extent both were made possible by the fruits of the mission sent out during Kammu's time.

The changing character of religion in Japan had started in the eighth century and is attributed to the syncretic philosophy of Priest Gyōgi. Whether it evolved in any clarity at that time – the term Ryōbu-Shinto, Dual-Aspect Shinto, is probably a Heian period word – the Honchi-suijaku doctrine was expounded to rationalize the presence of Buddhist deities with the traditional Shinto kami. In a convoluted reasoning, mountain kami were said to be forms of Buddha in transit (from their original home in India). Shinto and Buddhist priests conducted each other's ceremonies. Jingū-ji were built, that is, temples designed to protect the kami of Shinto shrines.

As temples moved into mountain areas the approval of the local kami had to be sought and, in effect, they came to be worshipped as mountain spirits (gongen). In this way the foreign element was reconciled with the native, and the social base of Buddhism was substantially broadened.

The new developments in Buddhism had profound and lasting effects on the arts. Saichō and Kūkai went on the 804 mission to China, Saichō to Mt. T'ien-tai in Chekiang province and Kūkai to the capital at Ch'ang-an. Kukai was trained in the esoteric systems in China, known in Japan as mikkyō, the revealed or secret teachings of Dainichi, passed from master to pupil. He came back to teach Shingon, the True Word. Kūkai became associated with a temple in west Kyoto later known as Jingo-ji, where his reputation rose swiftly. In 819 he led some followers to Mt. Kōya in Wakayama prefecture and together they started a temple which blossomed into the Kongōbu-ji, a name applied to collective temples there. Today, well over 100 monasteries on Mt. Kōya have individual names and half accept overnight "guests," the mountain top being without commercial inns. The mountain was restricted to men until 1872.

Mt. Kōya became a mecca for pilgrims, especially after the death of Kūkai and the rise in popularity of several pilgrimage routes. Kūkai, better known as Kōbō Daishi posthumously, was a man of great energy and intelligence. He elicited boundless veneration and legends grew around him: a builder of hundreds of temples, calligrapher, sculptor, inventor of the kana phonetic written system, rainmaker and author. It is estimated that up to half a million dead are buried in the vast Oku-no-in, the cemetery near Kūkai's tomb where he is believed to be in endless meditation, teaching and saving. The pilgrimage most devotees pursue is one said to have been begun by him and involves the circuit of 88 temples on the island of Shikoku. Pilgrims seek cures and, through physical exertion, "commune with the Daishyi." Two things in particular had been learned in China: the power which can be transmitted by mountain spirits, and the effectiveness of ascetic practices.

Esotericism introduced a large hierarchy of deities and worshipped others already known in the Nara period. The Vairocana Buddha of

the eighth century was now seen as Dainichi (Mahāvairocana) Nyorai, the Great Illuminator Buddha, source of all existence, absolute and permanent. The mandala concept, in graphic terms essentially a magical diagram, was known to the Japanese through examples of paintings brought from China by Kūkai. It was a scheme applicable to the other arts and was used as an architectural plan when it could be employed from the blueprint stage. Kūkai used it for the Kongōbu-ji and in another medium for the sculptures in the Lecture Hall of the Tōji where he was obliged to accept the existing architectural form.

Mt. Kōya, where Kūkai preferred to reside and meditate, was a rather remote place from which to exert much political influence, but after Emperor Saga appointed him head of the Tō-ji in 824 the Tō-ji was the center for propagating esoteric beliefs and Kūkai became a major political force. Together with the Sai-ji, which was probably never finished and scarcely in operation as a temple, these temples were the meeting place of the elite and served as inns for visiting dignitaries making formal calls to the capital city. They wielded enormous influence.

Emperor Kammu supported Saichō and with his encouragement the Enryaku-ji was built on Mt. Hiei. Saichō petitioned for permission to institute ordinations which were at that time the exclusive prerogative of the Nara clergy, but he died before seeing his petition granted. Nevertheless, the temple later got the name he desired and, with imperial backing, he broke the monopoly of the Nara clergy and freed all later sects from Nara controls.

Tendai became progressively more esoteric under such later abbots as Ennin and Enchin. The underlying concept of compassion and salvation through knowledge of the "Buddha nature," often called the Middle Way, led to much emphasis on Amida worship. Tendai used the Lotus Sūtra (Saddharma-Pundarika) and derived its iconography and subject matter for the arts largely from this source, along with the beings which formed the ten levels of existence: Buddhas, bodhisattvas, Pratyekabuddhas, Arhats, gods, demons, humans, hungry ghosts, animals and beings in different hells. Since it was believed that all sūtras contained authoritative wisdom and were all taught by

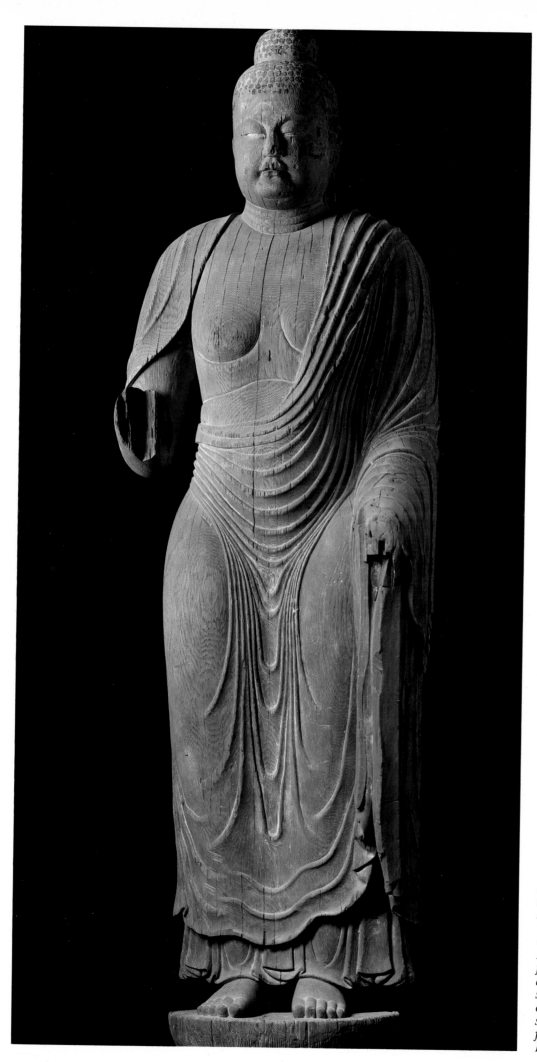

Wood sculpture, traditionally believed to be a representation of the Yakushi-nyorai, *the Buddha of healing. Lecture Hall of the Tōshōdai-ji, Nara.*
Overleaf: interior of the Lecture Hall of the Tō-ji or "Kyōōgokuku-ji" (the Realm-protecting Temple) at Kyoto, begun in 825. This spectacular row of statues is the oldest example of a mandala of sculptures. Out of a total of 21 figures, 15 belong to the Early Heian period.

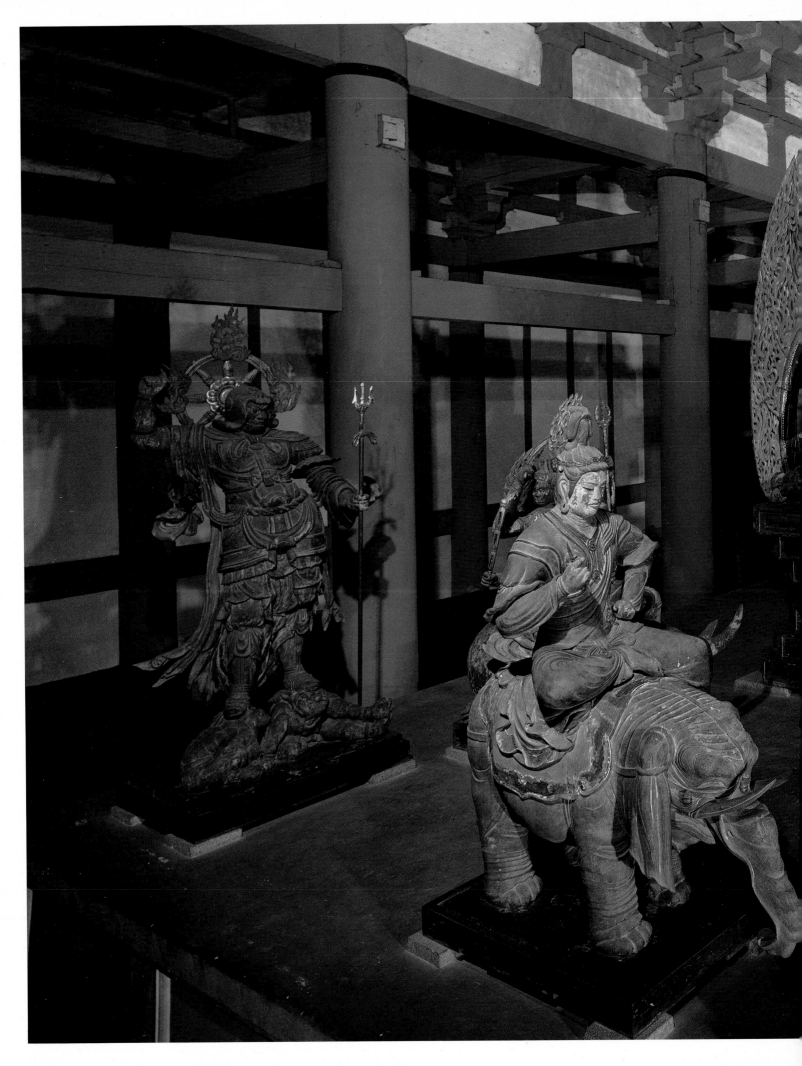

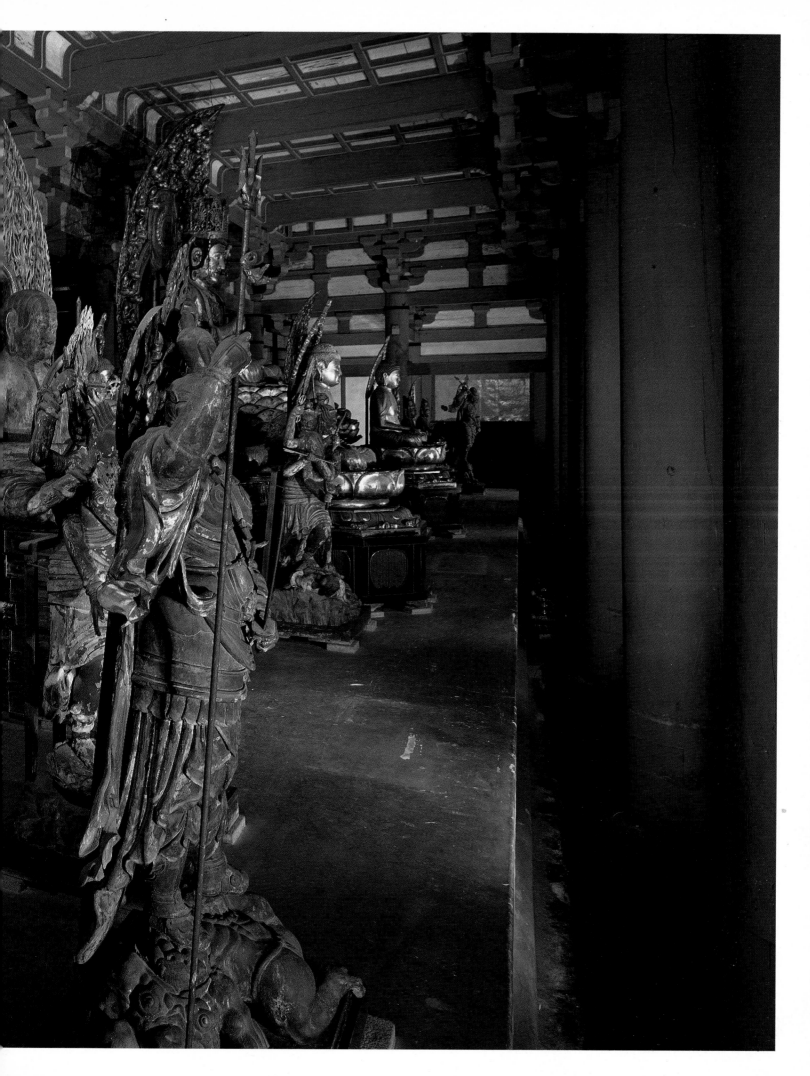

the Buddha at some stage to sentient beings of all levels, the net was widely cast and embraced all of the traditional arts. Tendai was dedicated to asserting the superiority of its own thought and practices, as was Shingon, but with far less certainty. Kūkai did not endear himself to sectarian Buddhists when he described the route to the highest understanding by grading ten stages in his treatise *Hizōbōyaku* (The Jewel Key to the Store of Mysteries). From subhuman desires one rose through moralism, mysticism, two levels of Theravada, Mahāyāna, Hossō, Tendai and Kegon to reach Shingon at the top.

Shingon's third center was Mt. Murō in Nara prefecture. It was never seen as a man's domain and has been referred to as the Women's Mt. Kōya. The supposed reconstruction of the temple by Kūkai sometime after 824 is little more than hazy legend. Since Murō-ji suffered a devastating fire in 1459, which the main hall and pagoda somehow managed to survive, its early records may have been lost before Edo times when so many old records were copied.

The old Dragon Hole shrine along the river at the foot of the mountain had attracted early cults, especially for rainmaking, and Nara priests were periodically dispatched to Mt. Murō to sit in extended prayer sessions. The area therefore had proven Shinto validity and enough magic to be shared.

Mountain temples defied the rigid *garan* system. The Chinese would have applied axial principles at least, but the Japanese were devoted to form and not philosophy and were free to decide the suitability of the form. They were comfortable with hillsides and irregular topography and appreciated the natural intimacy enjoyed by the traditional Shinto shrines. Because the number of followers was small, the craftsmen perhaps less experienced and the city workshops not close to hand, ambitions had to match the reality of the situation. The ninth century was the theater of a searching effort to formulate a Japanese conception of ecclesiastical architecture. Simpler materials were used, in more human sizes.

The few city temples which were built had all the established characteristics of regularity and structural sophistication. Nothing else would have been acceptable. In contrast, the Murō-ji buildings are fragile and

delicate looking. Two temple buildings, however, are rarely more different, especially if they both belong to the ninth century, as is generally supposed. The pagoda has all the rich depth of the history of structural systems, but the *kondō*, if anything, derives from the simple Lecture Hall style.

The pagoda is about half the height of the Hōryū-ji pagoda and is roofed with thatch. The walls of the *kondō* are built of boards and are (or were) painted white. Each roof of the pagoda is reduced only slightly from the one below, in a relationship which starts the Japanese trend. The bronze ornament above the nine ceremonial "umbrella" rings has no counterpart in other pagodas. The pagoda is dramatically poised at the top of a straight flight of stone steps. Other buildings are on terraces reached by zigzag paths.

The Golden Hall was an inordinately plain building when first erected. The south side was tampered with in early Edo times to increase its depth and make it more suitable for esoteric rituals, thus giving it the overhanging porch and south façade, including the break in the roof line where ornamental details under the eave reveal its date. Structurally it has no extant prototype. Hardly any two bays are of the same width. On the other hand, the pagoda's dominant features are its structural members, but they are there as a matter of form, as few of them are really necessary to support the negligible weight of the thatched roofs. The sharply clipped, almost horizontal roofs exhibit the bracketing as strictly ornamental.

The horizontal circumambulation ritual of the *garan* temples had now become a vertical ascent where, in some temples at least, a founder's hall was the goal. Respects could be paid to the sainted person who was assuming the status of deity to the faithful. The size, relationships and materials combined to produced a new psychology. A visitor can walk by the pagoda, turn and begin to look down on it before the curve of the path blocks the view. It resembles a toy in a glass case. For that purpose it need not have been any larger.

The social unity of the temple, once so interrelated with the established plans, was also breaking up, and larger temples were composed of subtemple units (*in*) even when built in city blocks. The system offered more personal intimacy and

Opposite: detail of a sculpture in the Lecture Hall of the Tō-ji, Kyoto. It represents Fudō, patron god of the samurai.

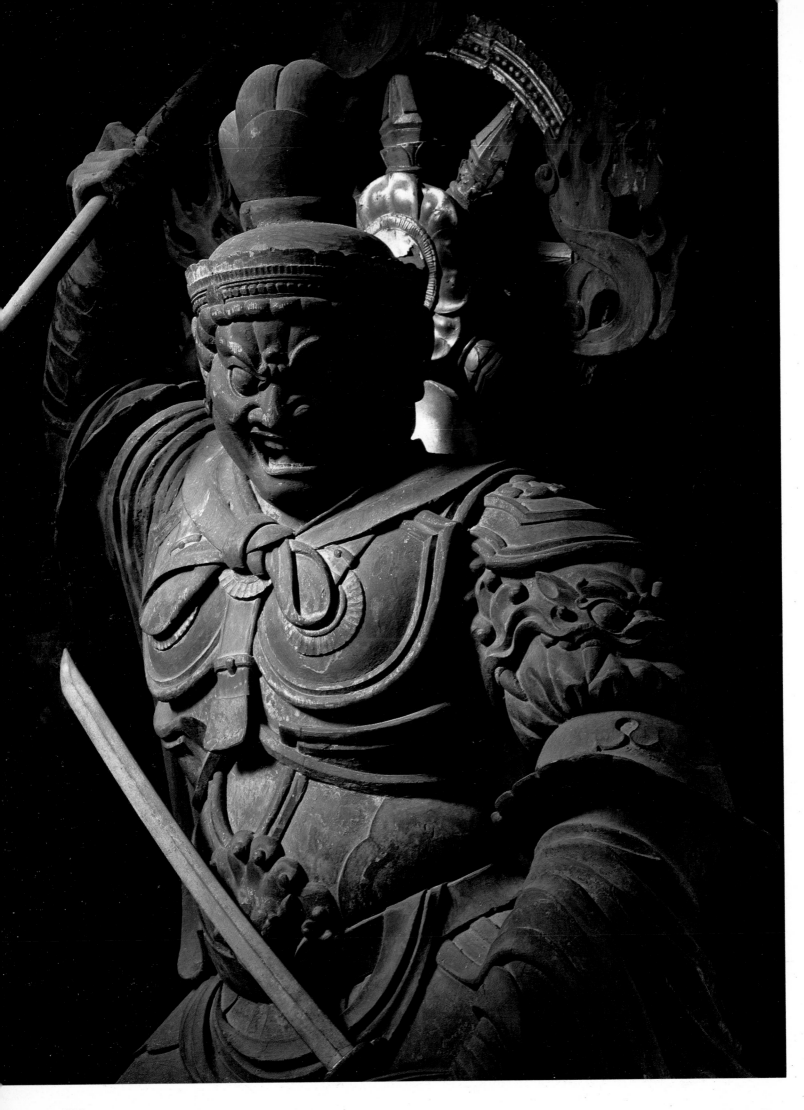

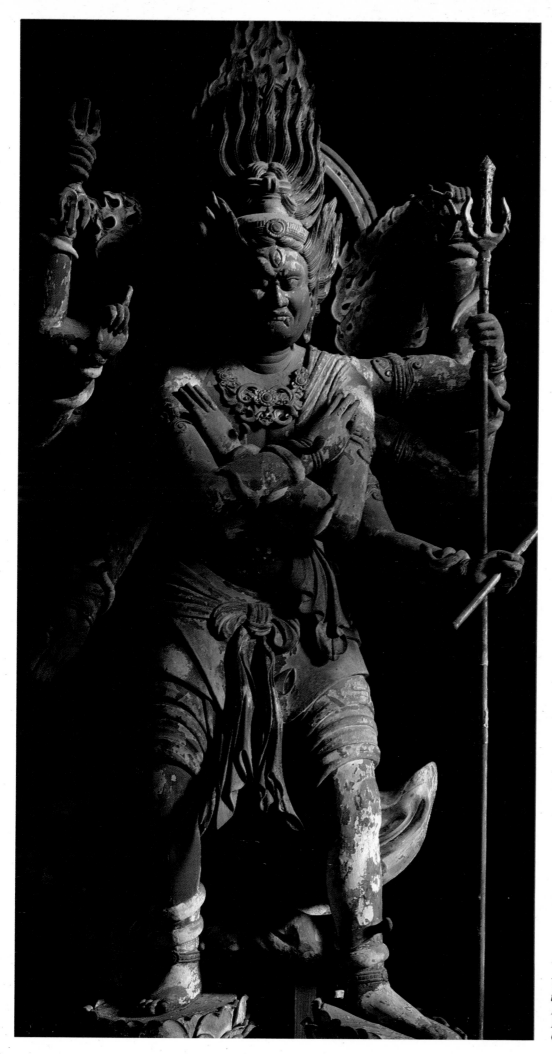

*View of the mandala of sculptures
in the Lecture Hall of the Tō-ji,
Kyoto.
Left: the figure of Gundari.
Opposite: detail of Zocho-ten.*

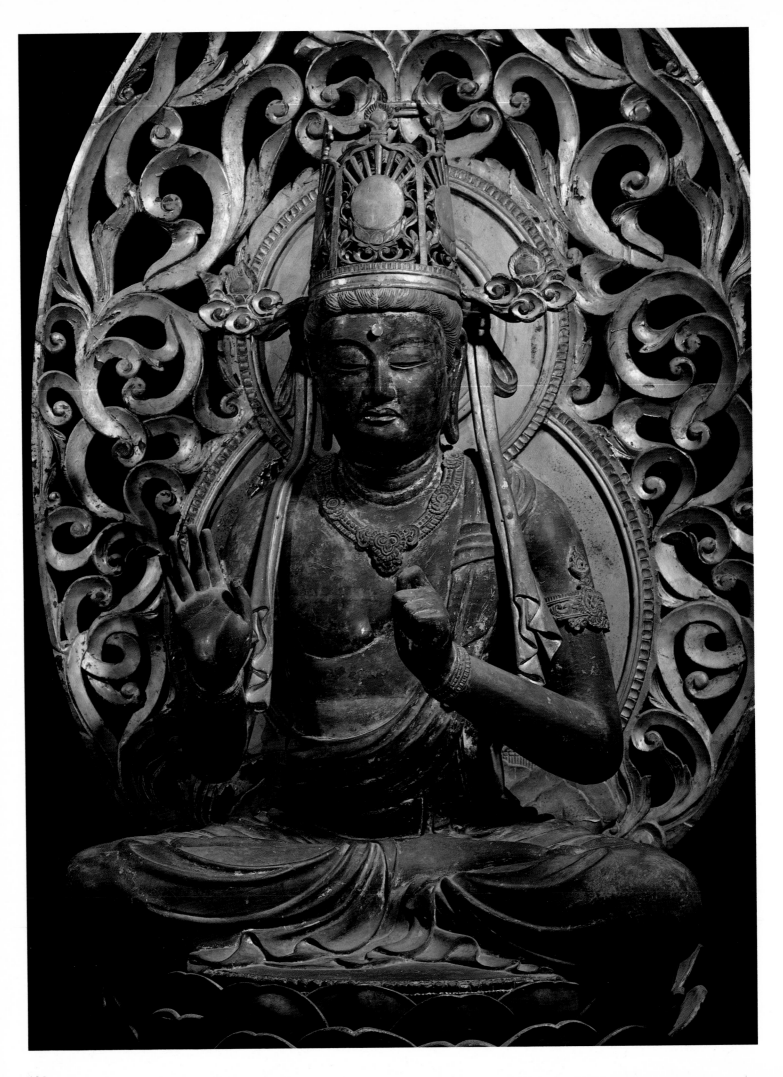

allowed the erection of smaller "temples" by aristocrats with limited resources.

A fourteenth-century document describes Mt. Murō as a huge mandala, with the cardinal directions marked by four temples, the area becoming a magical sphere in which a pilgrim shared the mysteries of Buddhahood. The mountain was dotted with 49 subtemples. Whether in the mind, on paper or actually existing – no one has ever found the four directional temples – this splendid mythical array was never rehabilitated after the fifteenth-century fire. Nevertheless, Murō-ji has had its own special attractions through the centuries and is no less popular today as one of the most enchanting mountains in Japan. No visitor leaves without experiencing its spell.

The sanctuaries of Shinto shrines underwent rather modest changes, remaining fairly simple and usually out of sight. But the Buddhist architectural borrowings give the impression of more substantial changes. The original structures of the Kasuga Shrine on the eastern hill overlooking Nara were erected in 768. The present ones date to a rather faithful rebuilding of early replacements in 1863.

Kasuga is the official shrine of the Fujiwara family. It was situated to protect the Tōdai-ji and was dedicated to two *kami* known for their physical prowess in early Yamato "history" and two other *kami* through whom the Fujiwara claimed ancestry. A row of four connected buildings at the north end of the compound offered visiting space for the *kami*. Two of the buildings on the west row of three, the Transfer Hall (*Utsushidono*), where the *kami* could rest while waiting for restoration work on the shrines, and the Entertainment Hall (*Naoraiden*) are close to the original Early Heian style.

The shrine exercised its right to rebuild every 20 years for many centuries. It was therefore in the elite class, one of the few which had received imperial permission to follow the Ise pattern. The 3,000 or more bronze and stone lanterns hanging from the eaves and lining the approaches to the shrine are lit on two annual occasions and have become the ornamental attraction for which the shrine is best known. They have, however, no particular antiquity. A section of the cloister is the work of the famous early Edo sculptor, Hidari-no-Jingoro.

Shinto architecture at this stage was embarking on a long process of unpretentious adjustment to changing requirements. The floors stay raised, the steps steep, the roofs thatched, generally using cypress, while the walls may be wooden boards or occasionally plastered. The shrines all learned to live with a small number of enhancing Buddhist features: upcurved roof lines, railings and lotus bud knobs, and sometimes red and white paint.

The few names used in identifying architectural types are mostly taken from actual shrines. The Kasuga type here has a roof like a peak of a cap over the porch and the short side is to the south. The Nagare type, which refers to the sweeping curve of the roof, has a wide continuous roof extension over the front porch and the long side faces the south, as at the Kamo-no-mioyano shrine (ancestral shrine of Kamo). The Hachiman type is named after Usa Hachiman in Ōita and was influenced by the paired buildings of esoteric Buddhism. It has individual but joined roofs, the front one continuous over the porch on the short side. The Hie type, named after the Hie shrine of Mt. Hiei, is a single block-like building subdivided inside, with a hip-gable roof style borrowed from Buddhist architecture. Variations and elaborations classified by roof shapes and internal arrangement are shrines like Yasaka and Kitano Tenmangū in Kyoto, Kibitsu in Okayama, Ōzaki Hachiman in Miyazaki, and the Tōshōgū at Nikko.

Sculptors turned almost exclusively to wood for Buddhist images. The expense and unavailability of other materials was an obvious factor. But the simple fact is that wood is easily worked by one person; in fact, it is almost the only sturdy material an individual can handle independently of material suppliers. The interior of one block was hollowed out to reduce splitting (*uchiguri*). Images were painted, rarely gilded, occasionally dry-lacquered, and left natural for exotic woods. Less and less surface application tended to transfer more interest to the wood finish.

The relative uniformity of the products from the Nara workshops had reflected a firm imperial grip on the arts. As a consequence of the relaxation of this control, however, some temples produced more on their own and local styles arose in the provinces.

Opposite: one of the Five Bodhisattvas in the Lecture Hall of the Tō-ji, Kyoto.

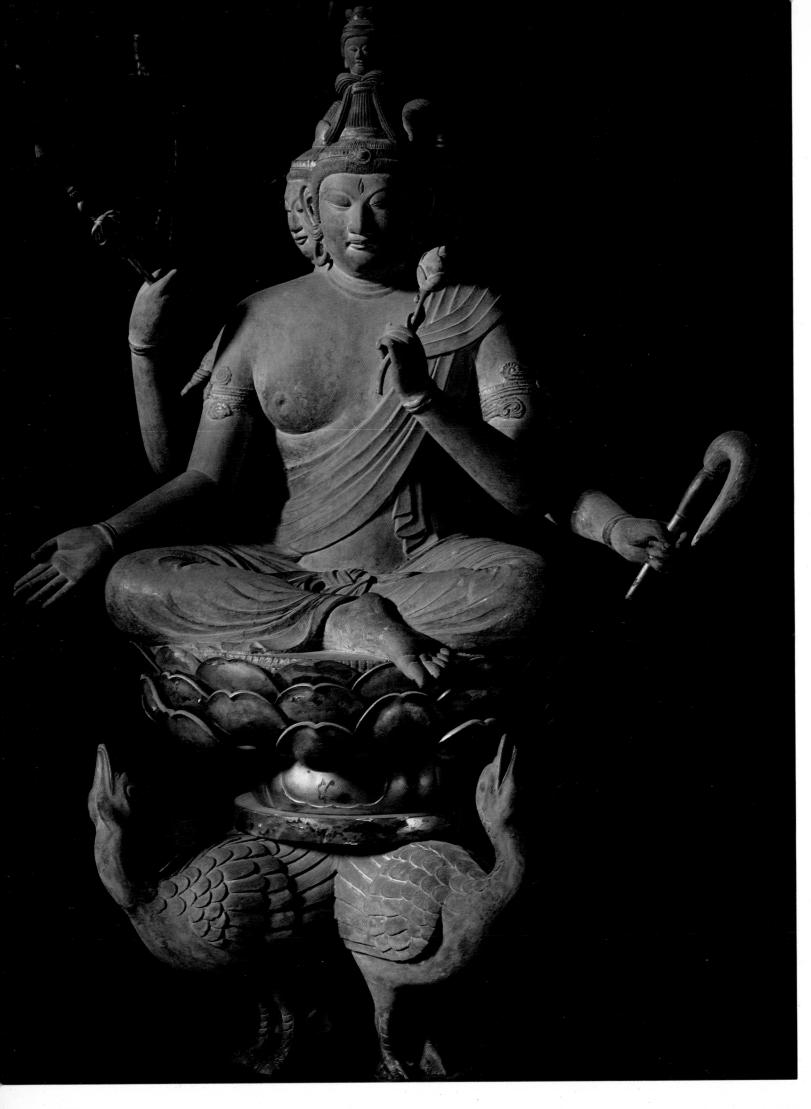

Opposite: Bon-ten (Sanskrit: "Brahma") is the Indian deity who was creator of all the worlds. Adopted by Buddhism, he is here represented with three heads and six arms, seated on a lotus flower that rests on four geese. Lecture Hall of the Tō-ji, Kyoto.

Below: sculpture of the Empress Jingu. Hachiman shrine in the Yakushi-ji, Nara. This is an imaginary portrait of the legendary "empress" who was deified by Shintoism.

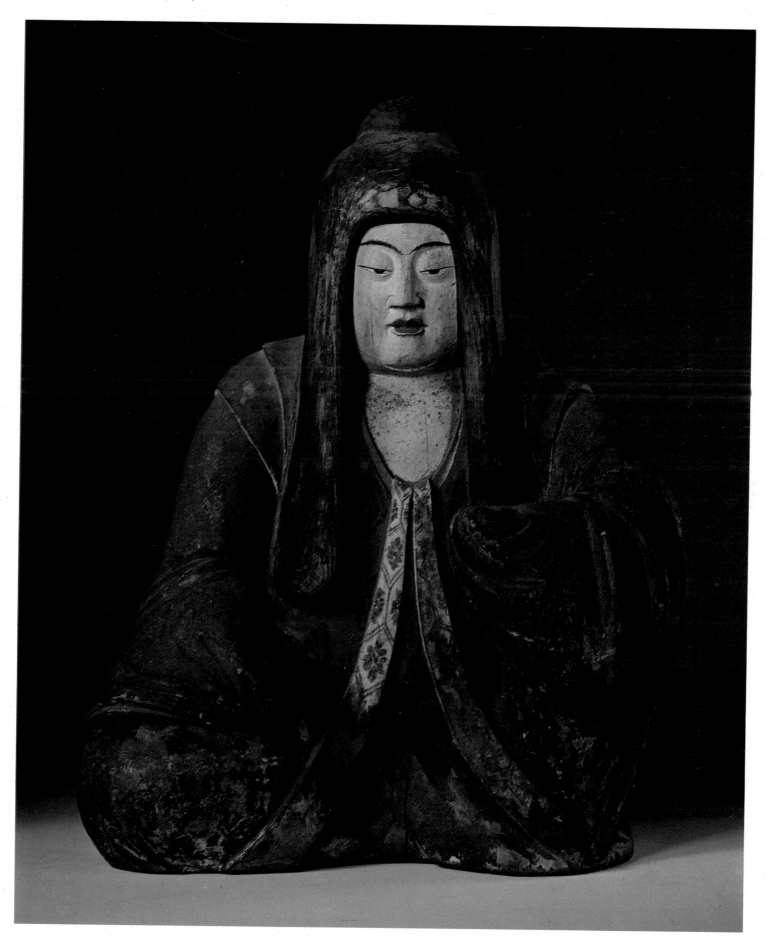

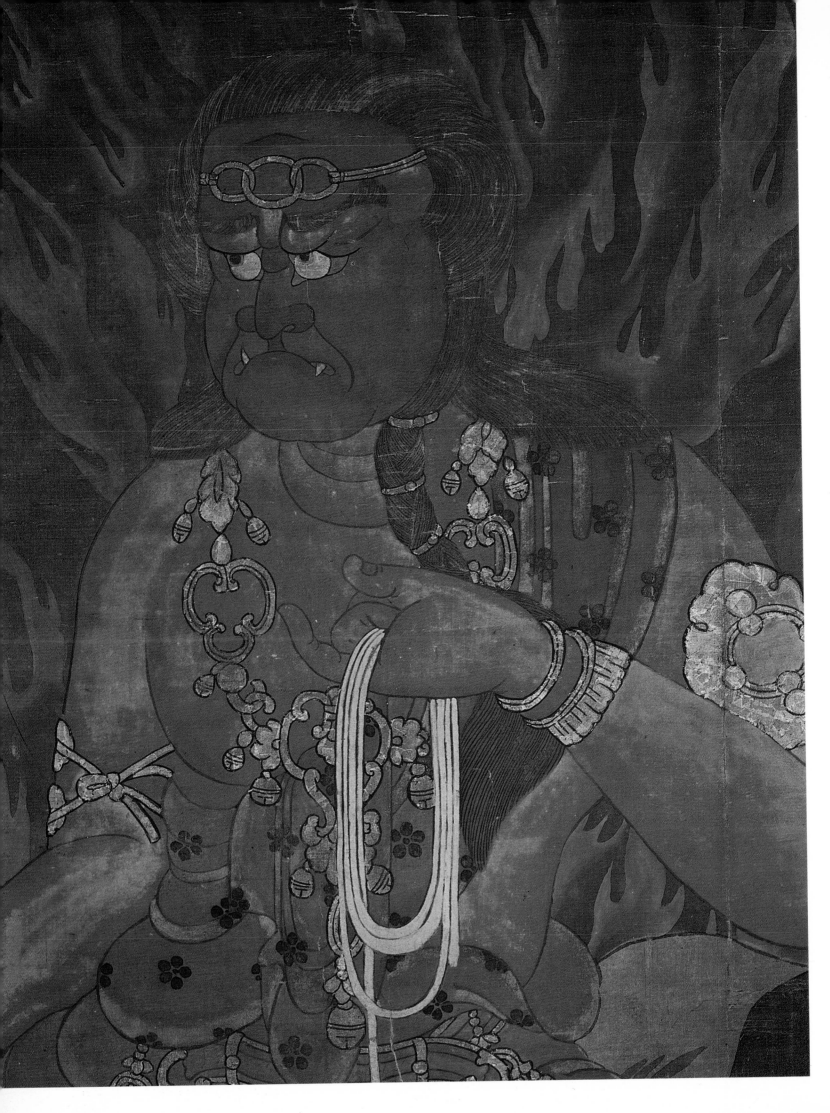

The Tōshōdai-ji kept its workshop active, from the late eighth century onwards, by turning out heavy-set standing and seated undifferentiated Buddhas and bodhisattvas. The massiveness and corpulence of late T'ang was the springboard for these frontal, columnar and sober figures. Following a strict formula of high relief regular folds called *hompa*, rolling waves, the drapery is pulled tight over the rounded bodies, emphasizing the torso and hips. Y-shaped folds spread out to shape ellipses on the upper legs.

This trademark of the Tōshōdai-ji crystallized into rather cold and mechanical repetition, in part the result of the standard width of the chisels then in use. Its regularity is dull and tiring, yet always distinctive enough to be an interesting measure of the diffusion of the Kinki style. In the Aizu region of Fukushima a northern Japanese elm (*harunire*) was used. In the Kanto yew (*kaya*) or Japanese Judas (redbud, *suō*) was preferred, and in Yamanashi it was cherry (*sakura*). The style reached the Inland Sea region and the island of Shikoku.

A good case of its late applications in Nara prefecture is the seated Shaka in Murō-ji. The image has lost its paint but retains the undercoating. As a "guest" statue, its provenance is unknown, but one assumes that it came from a workshop in the old city. The chiselling is sharp and angular, as though the sculptor was looking for more positive ways to enrich the visual effects.

Toward the end of the century the tree trunk was split, carved and hollowed out, then put together (*warihagi*), a technique that was satisfactory enough to remain in common use until the beginning of the eleventh century when the development of smaller pieces joined together had its start.

From the opening of the period one notes striking changes. The large Yakushi Buddha of the Shinyakushi-ji in Nara may have been carved around 793. Ponderousness

and exaggerations characterize this and much other Early Heian sculpture. The lowering expression results from a combination of swarthy, enlarged facial features, protruding eyes and drawn mouth. The flesh on the torso sags and hands are enormous. The left sole is exposed. Shades of *hompa* on the right leg show some stylistic mixing; otherwise, most of the drapery is cut at sharp angles.

Evidence of more pleasant exaggeration comes from the manneristic evolution of the Tōdai-ji style. The Eleven-headed Kannon of the Hokke-ji, a nunnery east of the old imperial palace in Nara, is a small image of white sandalwood. It is touched up in black and red colours on only the top of the head, face hair, eyes and lips. All is now quite darkened. The light rhythm of the S-shaped curves of the eighth century has taken on a heavy cast. The chest has almost evolved into a pair of breasts, the long arms reach the low-set knees, and the drooping drapery folds are close to the *hompa* style. The hard wood lends crispness to the carving and affords a fine surface finish. Only the head and left hand are separate pieces of wood. Several small sections are made of gilt bronze.

An unusual image called Tobatsu Bishamon-ten in the refectory of the Tō-ji defies explanation except through the medium of esotericism. The wood is Chinese, but the iconographic type has no known counterpart in China. Bishamon is the guardian of the north among the Four Heavenly Kings, but was often used alone. This figure was installed on the upper floor of Rashōmon (Rajōmon), the south gate of Kyoto, to keep the peace of the city, and was moved to the Tō-ji when the gate collapsed. Below him is Jiten, who holds him effortlessly in the palms of his hands, and two demons on either side, Ranba and Biranba, neither of whom seems to be suffering under his weight. There may be a phonetic allusion to T'o-pa, the Chinese Wei dynasty people, the foreign barbarians who entered from the north and ruled north China as strong patrons of Buddhism and the arts.

The Early Heian proportions are somewhat hidden by the cumbersome, heavily plaited costume and armour. From waist to feet the statue is inordinately long. The diabolical air is heightened by obsidian eyes, which are used elsewhere in the lions' faces.

As the period progressed, the conjunction of Buddhist and Shinto ideas elicited the making of a few Shinto images in wood. These were generally small and stylistically rather nondescript. The figures are seated, wear court or priestly robes, and are polychromed. Identification may be simply by sex, but certain selected ancient rulers took on the character of patron deities, in particular Emperor Ōjin, who much later came to be espoused by the Minamoto as Hachiman (then probably called Yahata), the "god of war," and his mother Regent Jingu, a female shaman who is credited in the ancient records with the conquest of Korea. Association of these Shinto images with such shadowy figures could have emerged only in times of considerable hostility when the aid of the highest powers was sought through identity with the supreme source of authority.

Each time the natural Japanese tendencies began to erode the Chinese-imposed earthly map of an orderly universe another version of it was on a boat coming over. The paired mandalas were a Chinese bilateral scheme of a single magical cosmic chart which owed its evolution to a combination of primitive, Tantric Buddhist and other mystical and magical traditions in India.

The mandala is said to have started as an array of ritual utensils on an altar floor of the *sumidan*, representing Mt. Sumeru. When used like a carpet it received too much wear, so the scheme was transcribed to painting on paper or silk and hung. Many types of mandalas emerged, but two are outstanding. These were suspended on either side of the altar in the hall where the ceremonies were conducted.

On the left, as one faced the altar, was the Kongō-kai mandala, the Diamond or permanent cycle (*Vajradhātu*) and on the right the Taizō-kai, the Womb or material cycle (*Garbhadhātu*). The former consists of circles and squares filled with deities in prescribed numbers, colours and relationships. The latter consists of a Dainichi in the center of an eight-petalled lotus, four petals each holding a seated Dhyani Buddha and four each holding a seated Dhyani bodhisattva, and other square-filling details. Dainichi, the "essence of the universe," is invariably recognized by the mudrā of gripping the first finger of the left hand in the closed right hand, the right hand thumb on top. Called the

Opposite: silk painting of Fudō, one of Japan's favourite deities. It is preserved in the Myō-ō-in on Mt. Kōya and dates from around the ninth century. Patron god of the samurai, Fudō is here represented holding a sword and a rope with which to kill and bind all evil spirits.

133

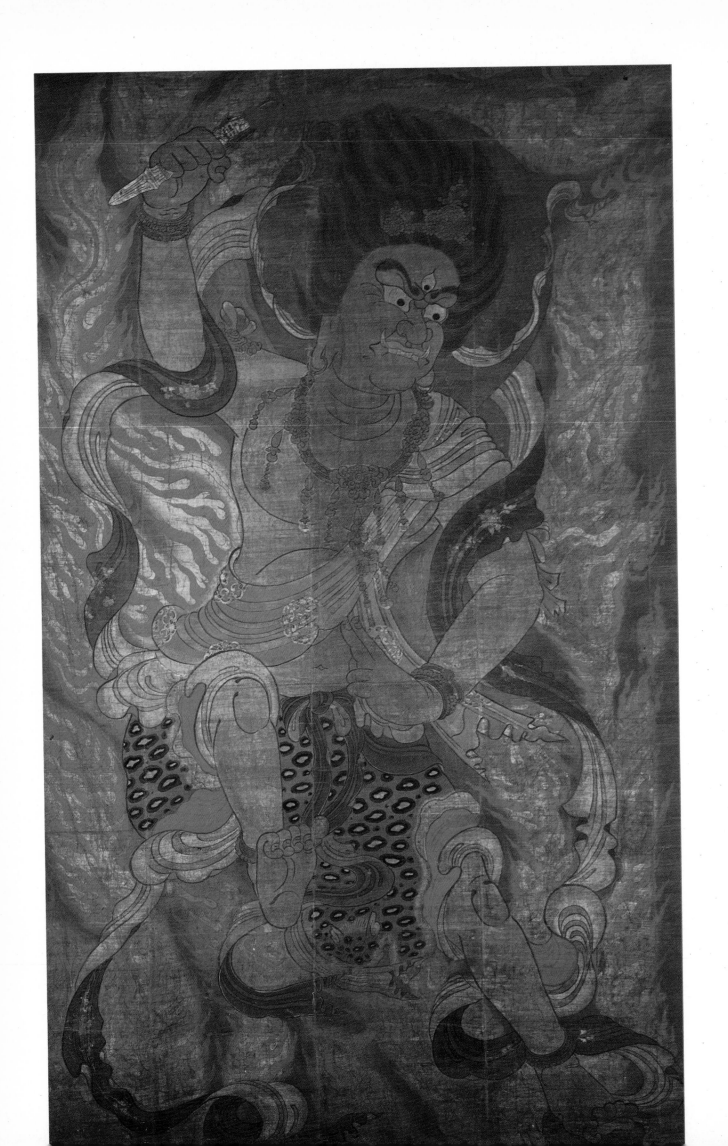

sign of the "knowledge fist," the mudrā is said to symbolize the sixth sense.

When Kūkai built the Kongōbu-ji on Mt. Kōya he conceived of the whole mountain in terms of the unity of the mandala. He saw eight petals of the lotus in the eight peaks surrounding the plateau, and by putting the Kongōbu-ji (Diamond Peak Temple) in the center, he joined the Womb World of the lotus flower with the Diamond World. The focus was the Kompon Daitō, the great sacred tower, a *tahōtō*, 160 *shaku* high, modelled after the reputed Iron Stupa of south India occupied by Nagarjuna, the transmitter of the esoteric concepts. Within it sat Vairocana, with the cosmic Buddhas on four sides. Other buildings were situated around as the rituals required quite a few and included the places for training, which took on more meaning. But in the looser Japanese interpretation the layout was freely adapted to the terrain, setting the pattern for arbitrary arrangements given validity by pronouncement. The buildings have been through several fires and none now antedates the twelfth century. The east pagoda is gone. The relatively recently built *tahōtō* seems awkwardly large in scale.

The *tahōtō* type evolved from the stupa by way of a different line from the pagoda. Japan's oldest extant *tahōtō* is at the Ishiyama-dera near Lake Biwa and belongs to the Kamakura period. By then a new architectural style from China made the complicated construction more facile, though not more rational. In a totally symbolic scheme, the building consists of the five elements of earth, water, fire, air and ether given the forms of a square (base), circle, triangle, semicircle and circle. The challenge was to convert them to buildable – not logical – wooden architectural forms. The *tahōtō* is a strangely narrow-necked structure, with a necklace of complicated woodwork making the transition from the circular section to the pyramidal roof. A firm base anchors it, aided by a "turtle belly" round dome.

The Tō-ji, properly speaking the Kyōōgokoku-ji, the Realm Protecting Temple, had several buildings in use when Kūkai assumed the abbotship. He petitioned to erect the Lecture Hall, which was approved and started in 825, and the pagoda in the following year. The latter was constructed in a fully traditional style befitting the size and purpose of the temple. The Lecture Hall displays on its Buddha platform the oldest example of a mandala of sculptures. Out of a total of 21, 15 belong to the Early Heian period and are attributed to the very hand of Kūkai by the Shingon faithful.

The scheme is said to be based on the Ninnyō-kyō, the Sūtra of Benevolent Kings, but there are discrepancies and problems of identification. The Kongōchō-kyō, the Diamond Crown Sūtra, was known to Kūkai as well. Three sets of images are arrayed on the long platform, the Five Buddhas of the Diamond World in the center, that is, Dainichi and the four cosmic Buddhas, the Five Bodhisattvas on the east, and the Five Great Kings of Light (Godai-myō-ō) on the west. Four Heavenly Kings mark the corners and the attendants Bon-ten and Taishaku-ten who represent one higher level of power, at the ends. All of the Dainichi-related figures in the middle and the central bodhisattva are replacements.

Among the original images, the Five Great Kings of Light make up a formidable group of intensely Indian deities surrounding a blue-painted Fudō (Acala). All should date from about 839, making this the oldest Fudō carved in Japan. One that has been in the Shinshō-ji at Narita since the twelfth century is often said to have been brought back by Kūkai from China.

Fudō is a form of Dainichi and one of the favourite deities in Japan. He is the patron god of the samurai, known for wisdom, invoked to bring rain, the destroyer of evil. As the Immovable One, he sits on a symbolic rock dramatically backed by flames, holding a sword and rope. Variations come only in the number of attendants, usually a pair of youths, but occasionally six or even eight. Red Fudō figures are the most common; a few are blue or yellow.

The large number of Indian, multiheaded, multiarmed and even multilegged figures is startling and must have seemed bizarre and inexplicable. They are so foreign, deriving as they do from an unassimilable philosophy, they are a rare sort of rigid form which cannot be Japanized. They look as foreign today as they must have looked then. All are haloed with clustered flames. Most are of one block of wood, with dry-lacquer clothing and hair, in the last surviving element of the Chinese technique. Only a spacious hall can

Opposite: silk painting from the early tenth century portraying Mujurikiku, one of the bodhisattvas of the Five Powers (faith, strength, memory, meditation, wisdom). Yushi-Hachimanko, Wakayama.

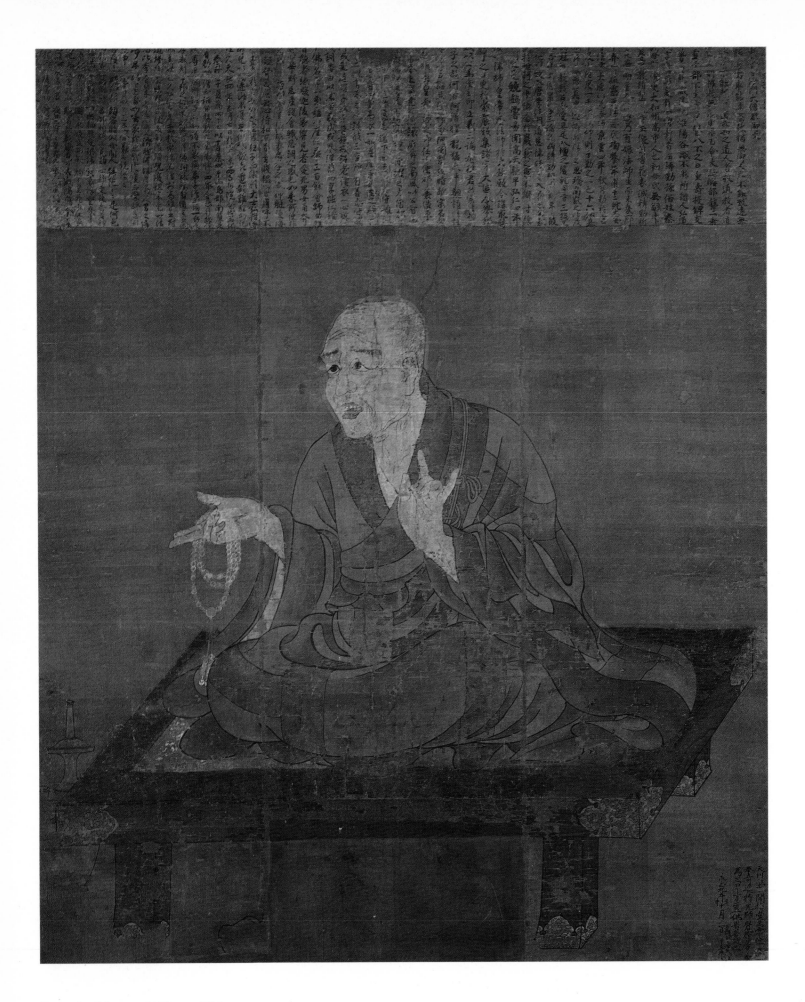

Portrait of the monk Gonso (754–827). Twelfth-century silk painting. Fumon-in, Wakayama. This portrait is one of the finest examples of painting from the Heian period.

accommodate the ferocious power and the sheer weight of the Indian iconography and its physical trappings, the unsoftened Indian faces and the heavy relief surfaces.

In the northeast is Kongōyashi (*Vajrayaksha*), with three heads and three arms, striding on two lotus pads. In the southeast is Gosanze (*Trailokyavijaya*) four-headed, eight-armed, each foot trampling a personified evil spirit who claimed to be the creator of the universe. On the southwest is Gundari (*Kundali*), single-headed, eight-armed, with high flaring hair, standing on two lotuses. And in the northwest is Daiitoku (*Mahātejas*), endowed with six heads (three on top), six arms and six legs, here riding a kneeling bull. He is particularly known in the Tibetan Tantric pantheon as Yamantaka, the god of the dead.

The Four Heavenly Kings are in a wide-bodied, bulky style, in exaggerated poses and florid drapery with upswept ends. Even iconographic types already known in Japan, the Bon-ten and Taishaku-ten at either end, the Indian Brahma and Indra, have been put through the intellectual gymnastics of esotericism and now have a fully exotic character. The multiheaded and stocky-torsoed Bon-ten sits on four geese, and the massive-shouldered Taishaku-ten rides the stocky elephant side-saddle, his head capped by a high coiffure and his frowning expression magnified by thick lips.

A fifteenth-century fire destroyed the hall, raising questions about Kūkai's original scheme. Drawings from the twelfth and fourteenth century exist, and a tenth-century chart which has the names of each deity in their mandala relationship. All are different, but the later ones have a good deal in common with the current arrangement. The manuscript of 922 should be the closest to the original. Nevertheless, even the precision of a mandala cannot survive the erosion of time.

In the role assigned to the arts in Shingon, their shock value was intended to induce meditation, and painting and sculpture were equal parts within a larger scheme. Fudō is the center of the dramatic stage, and his fellow actors are no less spectacular, their faces and bodies in unnatural, symbolic shades of red, blue or black. The hard black outline, the "steel wire" line, has much in common with the sharp edges of drapery in a wood carving. In the Fudō of the Myō-ō-in on Mt. Kōya, the figure is theatrically posed on a rock and pulled forward at a strong angle. Brilliant flames fill the background. Below right, two attendants form a striking asymmetry. Fudō, pictured in his effort to make his vow of destroying all evil come true, holds the dragon-entwined sword of wisdom in the right hand and the rope to coerce the wicked in the left. A kind of "reverse shading" appears on exposed flesh areas of the body. For all his frown, melodramatic expression and feigned ferocity, Fudō has the "bodhisattva heart." He originated from the Indian mix, an incarnation of Siva, the Immovable One.

The red is said to be the blood from the forehead of Chishō Daishi. The priest was meditating and saw a vision of Fudō. Wanting to preserve the image, he rubbed his head on the ground and with his blood sketched the appearance of the deity.

THE LATE HEIAN PERIOD
894–1186

The breakdown of the government-controlled land system opened up new areas to private ownership known as *shōen*. By the end of the Heian period about half of the arable land in the country was under *shōen* management. Labour had been attracted away from conscripted duties by better conditions on these estates and every social level below the emperor saw economic advantages in promoting private ownership. Members of the imperial family itself also became wealthy land owners.

The Fujiwara devised a power structure intended to ensure total control: *sesshō*, *kampaku* and *dajō-daijin*, or regent while the emperor was still too young to rule, administrator when the emperor matured and, finally, prime minister and head of the Supreme Council. Emperors usually had Fujiwara mothers and were therefore pawns, but most seem to have harboured thoughts of independence. Abdication on the part of the emperor came to be practiced as a move to escape the burdensome ceremonies of the court and gain free time for politics and personal interests. The emperor could also be involved in the choice of his successor.

By the tenth century Fujiwara Tadahira was able to claim control of the three great ministries, one under himself and two under his sons. The latter half of the century was dominated by three Fujiwara brothers who succeeded each other, culminating in Fujiwara Michinaga (966–1027) and his son Yorimichi (992–1074), the owner of an exceptionally fine villa in Uji. After Yorimichi, however, the decline was relatively swift.

Emperor Go-Sanjō was not of Fujiwara stock and broke the pattern which had prevailed for over a century. This gave rise to government by "cloistered" emperors which amounted to abdications and ruling in retirement (*insei*). Go-Sanjō had his own governmental structure, which was formally started by his son, Emperor Shirakawa, in 1086.

Literacy ran high in the Fujiwara family and many of the early writings of national history were their work. The cultured life of the court fostered new forms of literature. The best known single work is the court romance. *Genji Monogatari*, the Tale of Genji, said to have been written by Lady Murasaki and believed to date from the early years of the eleventh century. Its Japanese style marks the start of major changes in Japanese literature. Until this time writing was done in Chinese, a practice all learned men followed. Women were bound by no such restraints, however, and they produced a new genre of literature in the Japanese language with insights into court life quite outside the province of men. Such literature inspired painters to add elucidating pictures, along with temple legends, current popular stories and embellished historical accounts, thereby giving birth to the *yamato-e*, that is, Japanese-style painting of narrative scrolls.

Heian history ends with the warrior class (*buke*) wielding the political power. Their history is perhaps traceable to the late seventh century around the beginning of Emperor Temmu's reign. The endless training ground of the northern frontier war against the Ezo or Emishi produced a relatively large number of young men who could be hired for the protection of the ever-enlarging estates. From there the military class expanded with the changing times to become a major force in politics. The rise of provincial power had the further effect of regionalizing the arts.

Uprisings were focused on problems of succession or appointments, and family loyalties were frequently divided. The Taira, who had gained favour with Emperor Shirakawa through gifts of land and by suppressing the Inland Sea pirates, emerged with considerable power. Taira Kiyomori (1118–81) was allied with the Minamoto at this time and his appointment as prime minister in 1167 effectively signalled the end of Fujiwara control of the important bureaus. The Taira made their mark in the Hōgen Disturbance of 1150 and, after the Heiji Disturbance (Heike or Taira) in 1159, Kiyomori was the dominant figure in the country. Not only was it the first time a military man had been made prime minister, but it was also the first time the real power center was outside the old capital.

Kiyomori lived in great splendour near Kobe. The years between 1180 and 1185 were needlessly destructive, spurred on initially by Kiyomori's vindictiveness. After his death in 1181 Kiyomori's son Munemori found his position in the capital untenable and fled south. He tried several places in west Japan, but he and his followers were defeated in

Detail of the Genji Monogatari, *"The Tale of Genji," the magnificent prince, a masterpiece of classical Japanese literature from the eleventh century. This plate shows part of an illustrated scroll dating from the twelfth century. Tokugawa Reimeikai, Tokyo.*

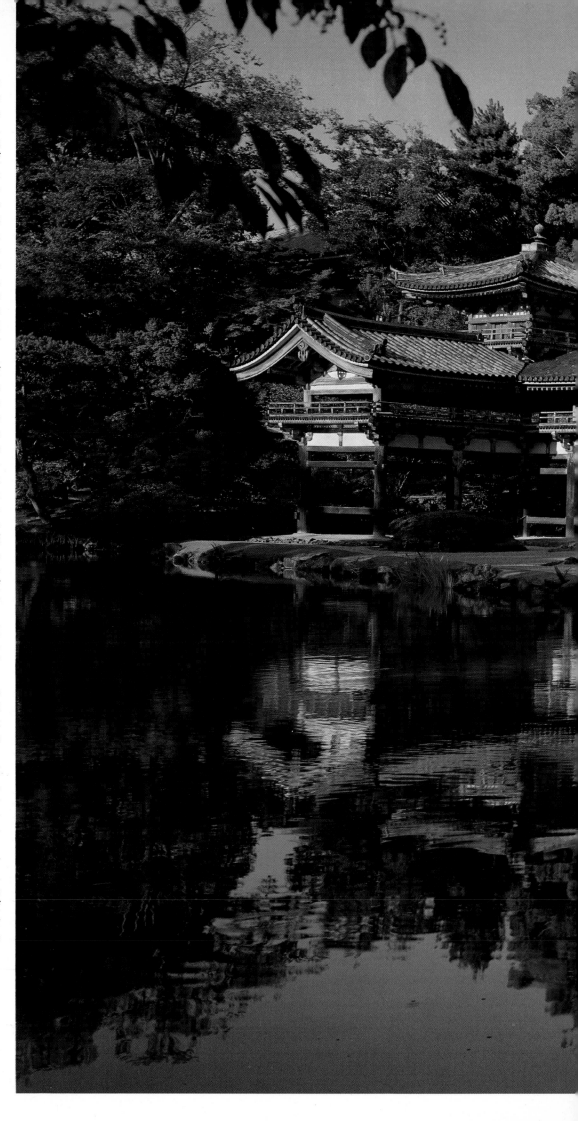

the naval battle called Dannoura. The victory was attributed largely to the bravery and daring of Minamoto Yoshitsune. His success aroused the jealousy of his brother Yoritomo, who then set out to kill him. This pursuit has made Yoshitsune one of the most celebrated tragic heroes in Japanese history, about whom endless stories have been written. He escaped toward the north and was presumably treacherously killed in the Hiraizumi area. By 1192 Yoritomo had settled in his home territory of Kamakura and the Heian era was over. This warrior class set the style for the culture and arts in the Kamakura period on a new social level and with a new intensity for Japan.

The spread of a popular form of Amida took a reinterpretation of the concept of Pure Land (Jōdo) as to how it should be achieved, but in the Heian period it still represented an upper class paradise. Its outlines were greatly sharpened in the descriptions given by Priest Genshin (or Eshin Sōzu, 942–1017) in *Ōjōyōshū*, written in 985 and variously titled in English as *The Essentials of Salvation* or *Birth in the Land of Purity*. The Pure Land was to be achieved by meditation and contemplation on the physical form of Buddha, with whom one eventually gained a total intellectual identity. An especially attractive sculptural and painting style in a well modulated Japanese idiom was the artists' response to this religious concept. Indeed, at no other time did the Buddhas match the charm they had in Late Heian when, for the first time, the images themselves were the subject of intense observation. They were no longer the medium; they were the deities. Meditation, however, was still rather intellectualized among the Fujiwara aristocracy and was in tune with the interests of the leisured classes.

Buddhism passed one of its major tests in the eleventh century. A mood of pessimism set in after the prediction that *Mappō*, the End of the Law, would arrive by the year 1052. *Mappō* is the last of three

Part of the Phoenix Hall of the Byōdō-in, Uji. This building owes its name to the pair of bronze phoenixes on the roof ridge ends. Originally a Fujiwara villa, it was converted into a monastery in 1053.

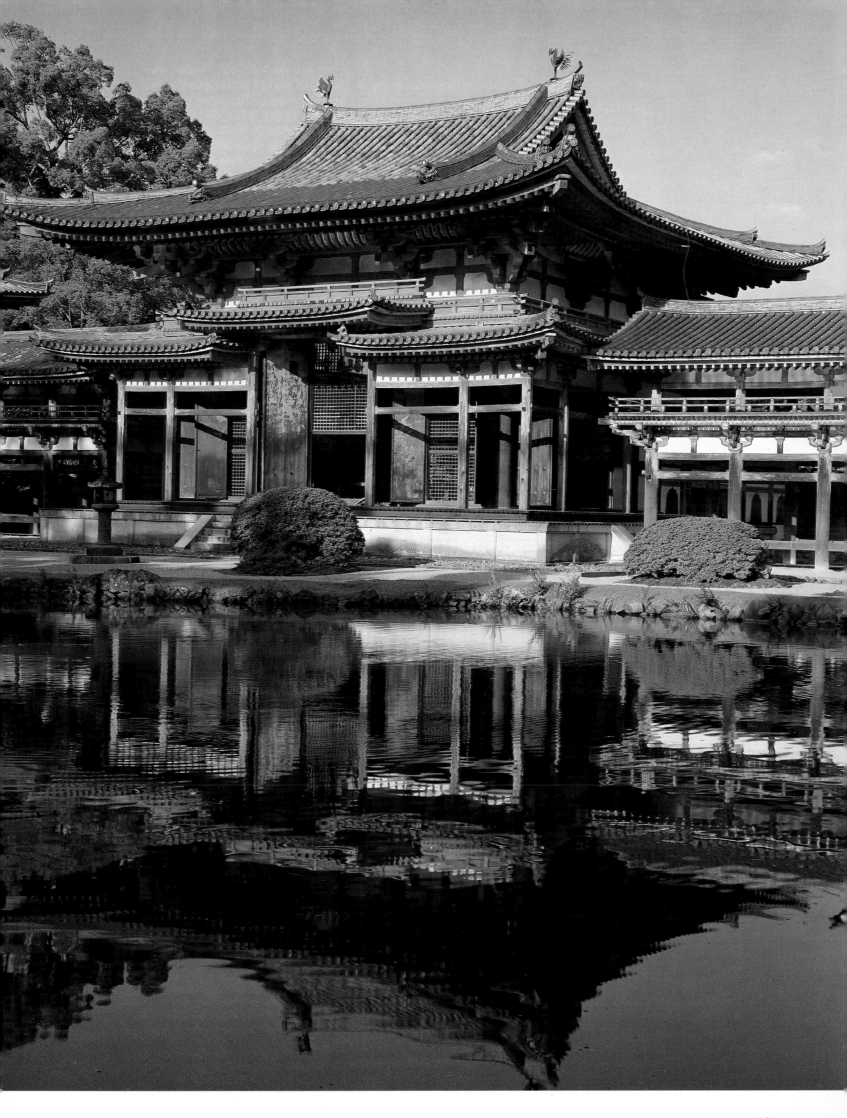

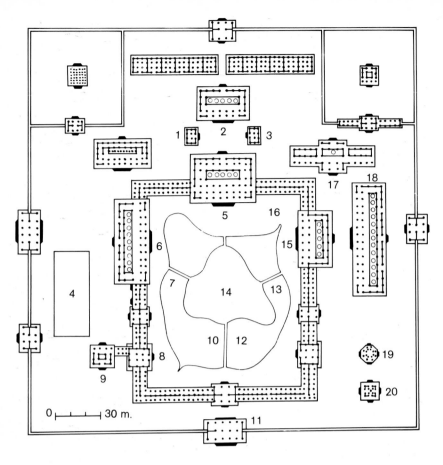

An example of Fujiwara
architecture is provided by the
Hōjō-ji in Kyoto, founded in 1019,
the layout of which is shown above.
1 Bell Hall, 2 Lecture Hall, 3 Sūtra
Hall, 4 Amida Hall after 1025,
5 Golden Hall, 6 Amida Hall,
7 West bridge, 8 Bell Hall,
9 Hokke-samaido, 10 South bridge,
11 Large South Gate, 12 Pond,
13 East bridge, 14 Island,
15 Godai-do, 16 Springs, 17 Shaka
Hall, 18 Yakushi-do, 19 Octagonal
Hall, 20 Pagoda.
Opposite: Amida. Gilt wood
sculpture by Jōchō (d. 1057) in the
Phoenix Hall, Uji.

stages of Buddhism when the power of Buddha was thought to decline and the situation might degenerate to the point where even the sūtras would disappear. In order to get through this critical period a practice of burying sūtras was started, introduced by a Tendai priest who returned from China in 847. The earliest dated sūtra mound (kyō-zuka) in Japan is 1007. The practice continued well into the Edo period, long after Mappō was past and forgotten.

Buddhism underwent a reinterpretation toward the end of the Late Heian, best known through the vigorous personalities of the Kamakura period. Hōnen, for instance, saw rebirth as possible only through recitation of the name of Amida Buddha. Popular participation thus became common. Open emotionalism was socially acceptable. A new concept in Late Heian Tendai known as Hongaku or Primordial Enlightenment had supplied the inflexible dogma for which

the new sect "reformers" were distinguished. Absoluteness was attributed to natural phenomena. The somewhat ephemeral nature of Amida was then viewed as eternal and absolute truth. Given the doctrinal validity for their beliefs, Kamakura proponents were convinced of the one and only way to salvation, and pursued their goals single-mindedly against all political and religious opposition.

The Fujiwara interest in Amida can be seen in the many Amida halls they built. Few, however, survive today. Such halls were square and often no larger than three by three bays, or about 5 by 5 meters (16 x 16 feet). Designed to facilitate rapid circumambulation around the Buddha platform, the interior was simple and uncluttered.

A larger than average one is the Amida Hall of the Hōkai-ji not far from Uji, southeast of Kyoto. As an elaboration of the basic type, a pyramidal roof of thatch is surrounded by roofs over extended porches

(hisashi), the building's "walls" consisting of hinged lattice panels. The gentle curves of the main roof and slightly flatter lines of the lower roofs enhance the deep and spacious porches and make the hall appear to be more complex than it actually is. The orderliness of a fully centralized architectural form is due to the coordination of the rows of columns throughout. This can be contrasted with the Hōō-dō, Phoenix Hall, at Uji, where the intention was different.

The Hōkai-ji has well preserved pillar paintings in roundels representing celestial beings and transom paintings, and a single somewhat conventionalized Amida Buddha seated in splendid isolation. Despite some rebuilding in the early Kamakura period, the fundamental form is Late Heian, as are the paintings and sculpture.

The Fujiwara erected over 30 halls to install images symbolizing the Nine States of Amida. These were long halls of 11 bays and usually four deep. The interest in these stemmed from the writings of a tenth-century Tendai monk, Ryōgen. *The Rebirth of the Nine Classes of Believers in Amida's Paradise* was the literary base for this development. Only one of these now remains, a temple known as Jōruri-ji in south Kyoto prefecture, which was started by an aristocrat from Kyoto. Amidist practices were introduced in the eleventh century and the present Amida Hall and its icons should belong to the early twelfth century. A fire gutted the temple in 1343, however, and successive patrons added only a replacement pagoda which had been dismantled from a city temple and rebuilt here in 1178. It fits a location across the pond from the Amida Hall. In this respect, the Jōruri-ji may also be the only temple to retain its original Amida Hall-Middle Island-pagoda relationship with regard to the pond. The idyllic setting is now uncluttered by buildings, remote from public transportation, and rather infrequently visited.

Overleaf: interior of the Phoenix Hall (Hōō-dō) in the Byōdō-in, Uji. The Hall contains a representation of Amida's descent from heaven (left), surrounded by the bodhisattvas and other spirit beings who were to accompany to the Western Paradise all those who had died in accordance with the doctrine of Pure Land.

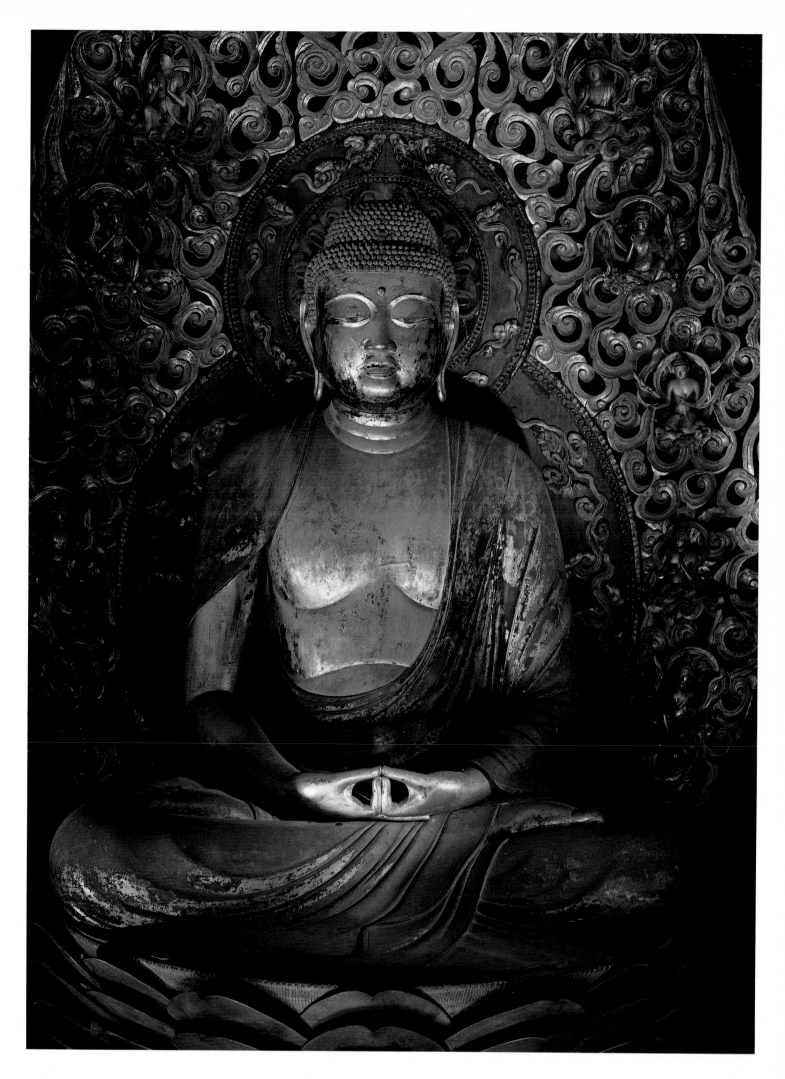

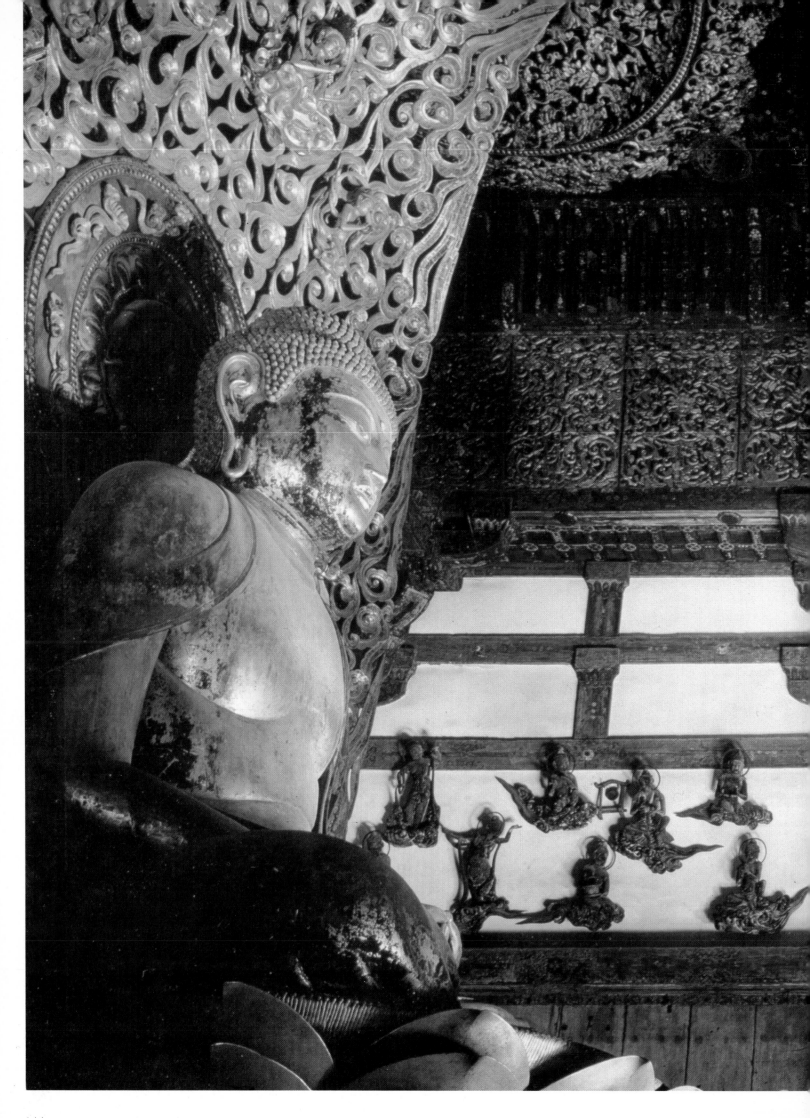

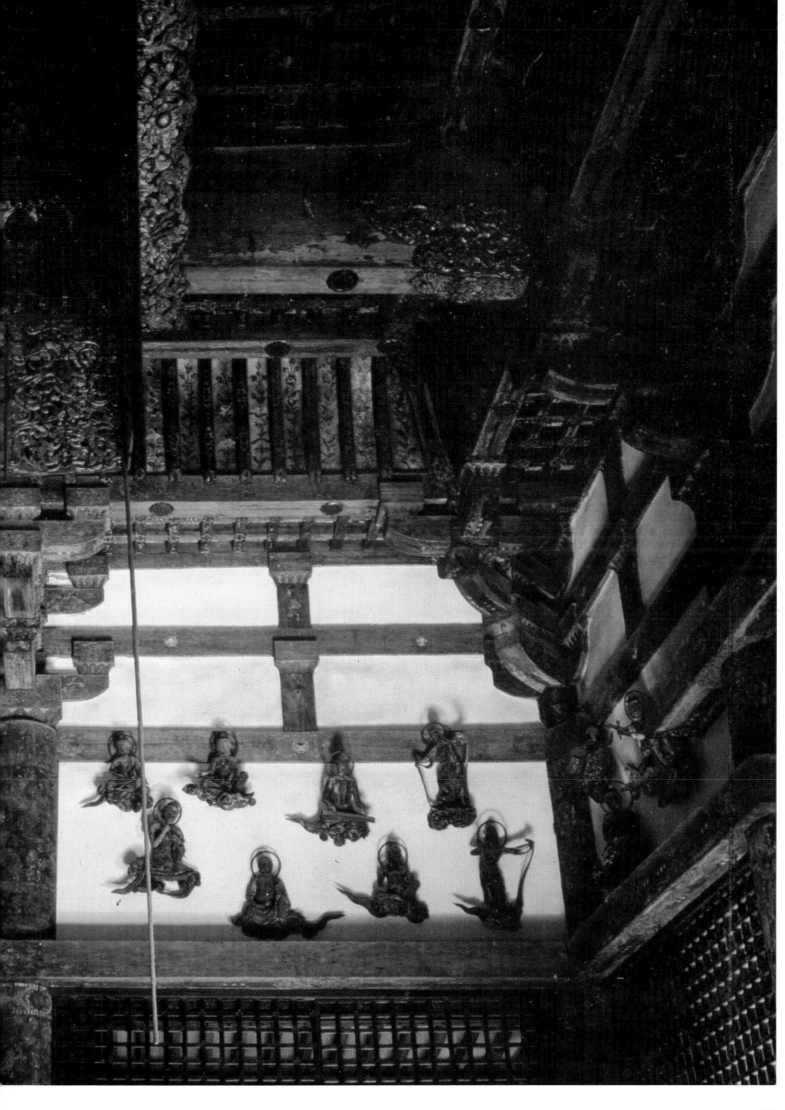

The nine Amida images are dominated by a large central Amida whose mudrā is at first glance the traditional one of appeasement rather than the meditation gesture shared by all of the others, but, in fact, in the way the fingers are touching the thumbs it means Lower Class Upper Life in the nine grades. The interior of the central bay is elevated but not widened to accommodate this central Amida, so that each bay space looks appropriately scaled for each image. This higher bay is absorbed within the "hidden roof" system which was devised at this time and was a way of adding a superstructure above the "ceiling" to support an adjustable roof height without regard for the lower structure of the building. In this manner, the Japanese felt free to impose their aesthetic on buildings over which they had rather little structural control. Many of the early buildings, if not all, were later reroofed in this fashion, so that even fundamentally Chinese buildings, like the *kondō* of the Tōshōdai-ji, were later given Japanese external proportions.

The number of Buddhas in these halls had several connotations: nine versions of the way Amida came down to welcome a pious soul, or three births of three degrees in paradise. The top degree was composed of saints, the second of virtuous men and the third of sinners, especially those who had caught fish, stolen canopies of temples and had been murderers.

Fujiwara Michinaga had a Nine States of Amida Hall for his Hōjō-ji in Kyoto. There he had a special prayer seat in front of the central Buddha with a cord coming from its hands, the same cord held by the other eight. He could grasp this daily while saying his *nembutsu*, reciting the name of Amida Buddha. The story, which is supposed to have ended with Michinaga entering his Gokuraku holding the ribbon, is not without umbilical overtones.

A brightly painted small wooden figure of the goddess Kichijō, the spirit of felicity and beauty, is kept in a black box in the Jōruri-ji Amida hall. The box is usually placed between the Buddhas and does nothing to improve the grand view of the interior and its icons. The image is structurally of small blocks of wood in the refined technique of the Kamakura period, but its ornateness and frilly effeminacy are close to the Late Heian style. It was delivered to the temple in 1212.

The great temples built in Heian at this time under imperial order for retiring sovereigns or by ranking Fujiwara have all been destroyed. This is unfortunate, as it was among these temples that genuine changes were taking place in plan and the organization of space. Essentially, each patron sought to produce a more ideal earthly paradise complete with garden, lotus pond, island and associated palatial buildings, where taking up residence would be merely another step forward toward the ultimate western paradise, the Land of Eternal Bliss.

The prescription was embodied in tradition, sūtras and Genshin's *Ōjōyōshū*. The Hōshō-ji, the Victorious Law Temple, built by Emperor Shirakawa in 1075 following his accession, was the earliest in a series of impressive temples used as retirement sites by former emperors and others. An area noted for its good water sources on the east side of the second block was selected. The southeast edge of the temple was just cut by the Shira river. The buildings were aligned toward a Middle Island in a pond and focused on a massive nine-storey pagoda. They consisted of the *kondō*, a Lecture Hall and a Yakushi Hall, the last one important for Tendai ceremonies. Extending laterally from the *kondō* and then toward the pond building with the garden. Some temples allowed access to the Middle Island only by boat. The Hōshō-ji were open galleries linking the had connecting bridges. The key to the whole scheme was an eastward-oriented Amida Hall in the southwest corner of the compound. Its position, which was a concession to the interests of the Shin sect so that a worshipper would be looking toward the west when facing the Buddha, could be made only to this degree in city temples. Bolder and more daring schemes were possible in the country. An Amida Hall could be a centrally-located main hall facing the east and, in effect, carry the rest of the temple plan with it. The best example is the Hōō-dō in Uji.

Such a radical change in a city may have bordered on heresy. Other retirement temples paid proper respect to tradition, but toyed with the idea of elevating the status of the Amida Hall. Among those added at Shirakawa was the Zenshō-ji. To its north was the Enshō-ji and north of it the Saishō-ji. The area came to be known as the Six Shō Temples.

Fortunately this one Fujiwara villa still stands, despite some losses to gallery sections, modifications to the pond and wanton neglect in the last century which left it at the mercy of curio collectors. The Hōō-dō, Phoenix Hall, of the Byōdō-in at Uji was inherited by Fujiwara Yorimichi. It was a comfortable 15 km (9 miles) from the location of the Heian palace at that time (the palace was moved to the east in the nineteenth century), and less from places where Yorimichi lived in Kyoto.

Villas were retreats from the pressures, noise and smells of the city and were to serve both as places of temporal enjoyment and of permanent interment, the latter following conversion to a temple in the old age of the owner or on his instructions after his death. In a series of parallels, the transition from the city to the country, from a villa to a temple, from a recreation spot to a grave, or from this world to the next, was seen as hardly a break in the pattern of human existence and only one more rite of passage. It may be significant that Yorimichi converted this villa into a monastery in 1053, the year after *Mappō* was to have begun. He retired from politics and settled here in 1068, and lived another six years, dying at the age of 82.

Representing the Shin sect, a branch of Jōdo, the Phoenix Hall faces the east and toward the Uji river. It was built a year after a *hondō* had been erected. When the river was banked up around the beginning of the seventeenth century, the view in that direction was obstructed, so that it could no longer be seen from the porch of the hall. About this same time the outlines of the pond were apparently changed. It now runs under the enclosed gallery behind the building.

Once the building became private property it was almost stripped of its ornaments. Reclaimed as a National Treasure by the government and protected, it was finally overhauled between 1950 and 1957 and many deteriorated sections of wood were replaced. Slight hollows and depressions indicate where bronze or gold decorations fitted on the woodwork, but the sculptures remained intact and some of the paintings on the wooden screen behind the Buddha and on the inside of the

Opposite: detail of the hands of Amida, a work by Jōchō in the Byōdō-in, Uji. The new cult of Amida was spread by followers of the Jōdo sect.

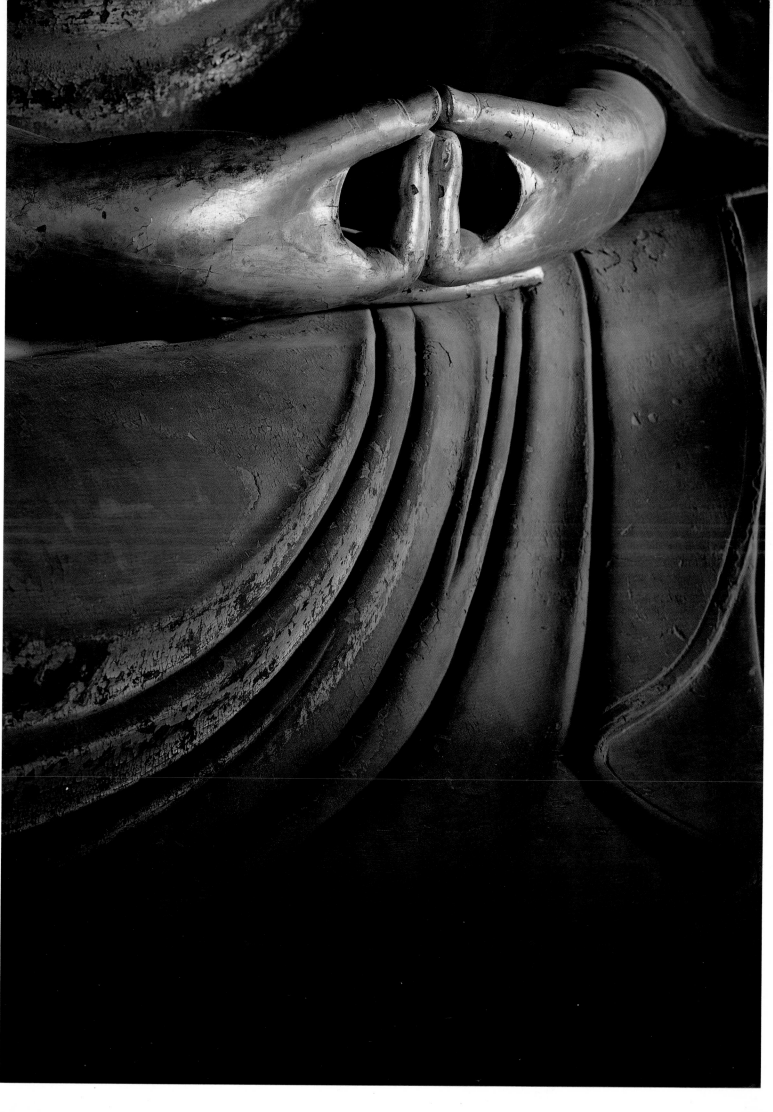

large doors survived adequately enough to be discernible.

Two bronze phoenixes at the roof ridge ends lend their name to the hall. Symbols of immortality that rejuvenate themselves from their own ashes every 500 years, the Chinese phoenixes travel alone. The building itself is often romantically described as a fabulous bird coming in for a landing, the wings still outspread.

The Phoenix Hall is actually a rather small three by two-bay Amida Hall faced with a porch supported by slender columns. Galleries project at either side and turn at right angles to continue forward toward the pond. The corners are marked by towers built above the roof. A fire in 1365 destroyed 20 or more eastern bays of the galleries. Since this style had about 15 bays running forward, as is known in the main temple of Mōtsu-ji in Hiraizumi, one can almost reconstruct the original plan. These open corridors are now cut off at the ends with boards placed across at knee height. Particularly attractive is the openness of the setting, the hall almost floating in the landscape, and the integration of the architecture with the landscape.

The structural system of the building is far more simple than it appears at first. The extra floor along the upper part of the galleries was included to increase the height, but in itself makes little sense. One wonders what was desired in the articulation, as the relationship between the parts is baffling. Horizontal lines do not run through. There is strong focus on the front door and its roof, but roofs cover only their particular unit regardless of the height. It should be remembered, however, that traditions call for each building to be an entity and galleries are "human" height, regardless of the size of the building.

Modern aerial views have come closest to revealing the real intentions of the designers, as do ground

The small Amida Hall, known as the Konjiki-dō or "Gold-coloured Hall," reconstructed in 1124 as part of the Chūson-ji at Hiraizumi, north Japan, and now exhibited in Tokyo.
Overleaf: details of sculptures in the Konjiki-dō; on page 150, Ten, one of the Four Heavenly Kings defending Buddhism; on page 151, one of the rows of figures of Jizō, a deity who protects children.

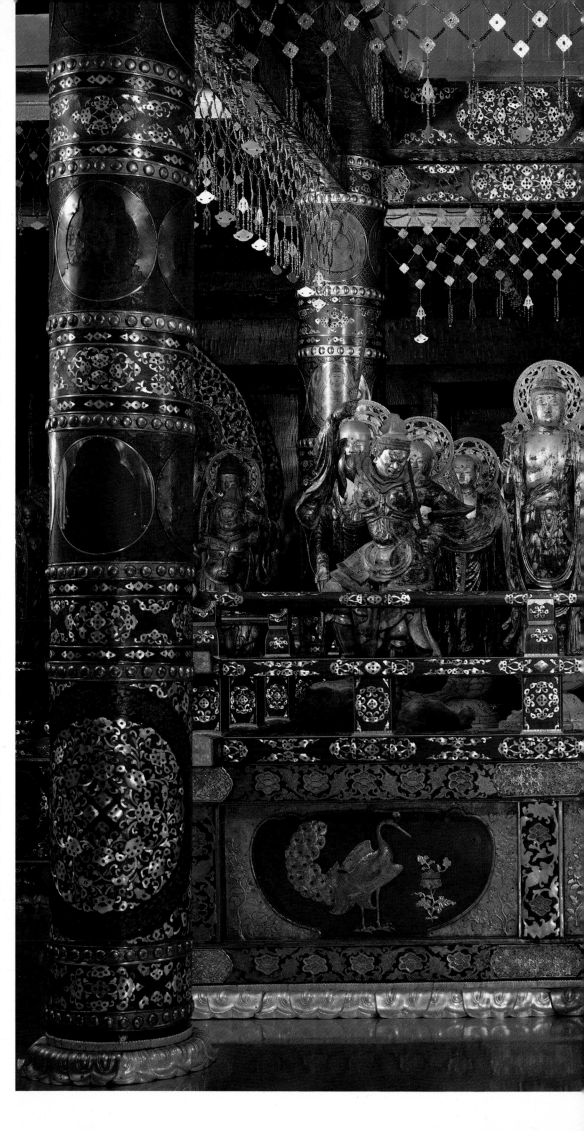

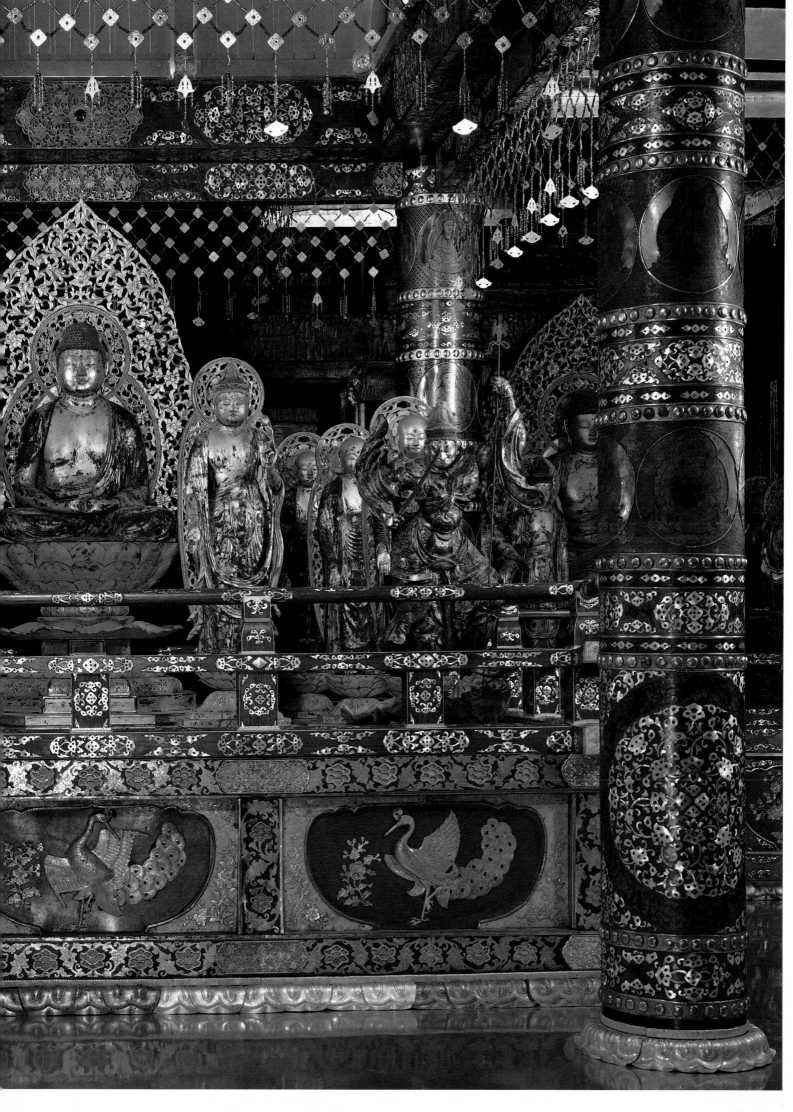

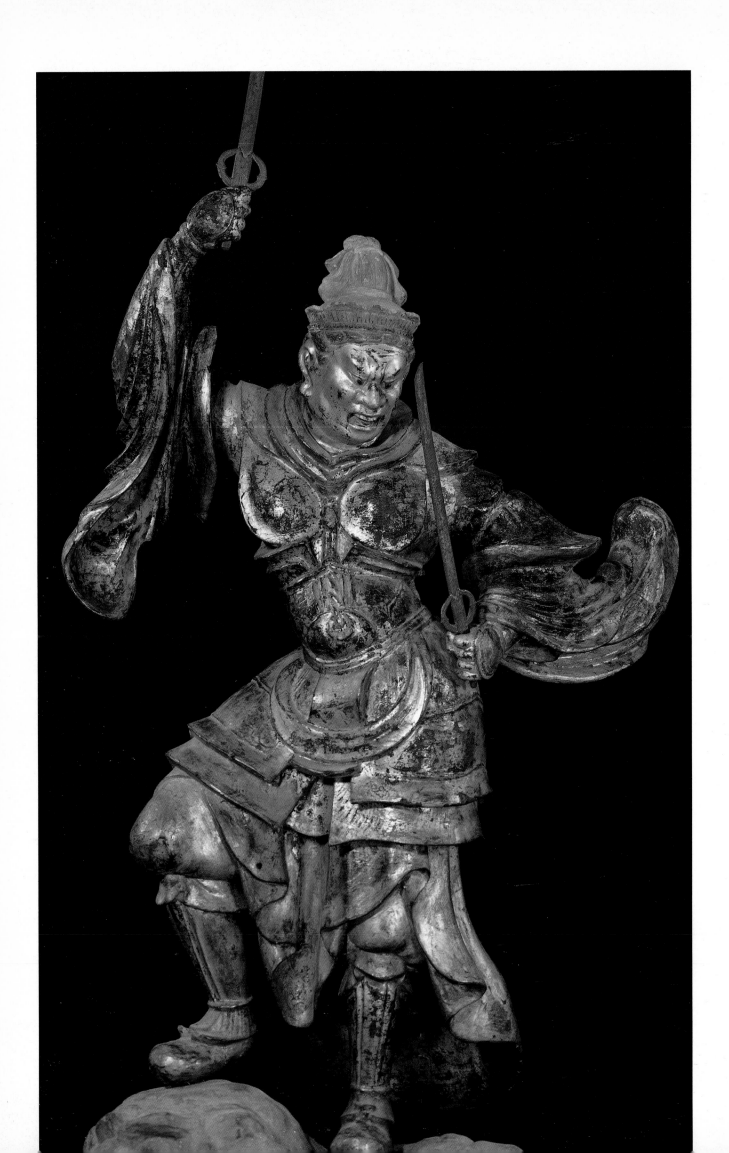

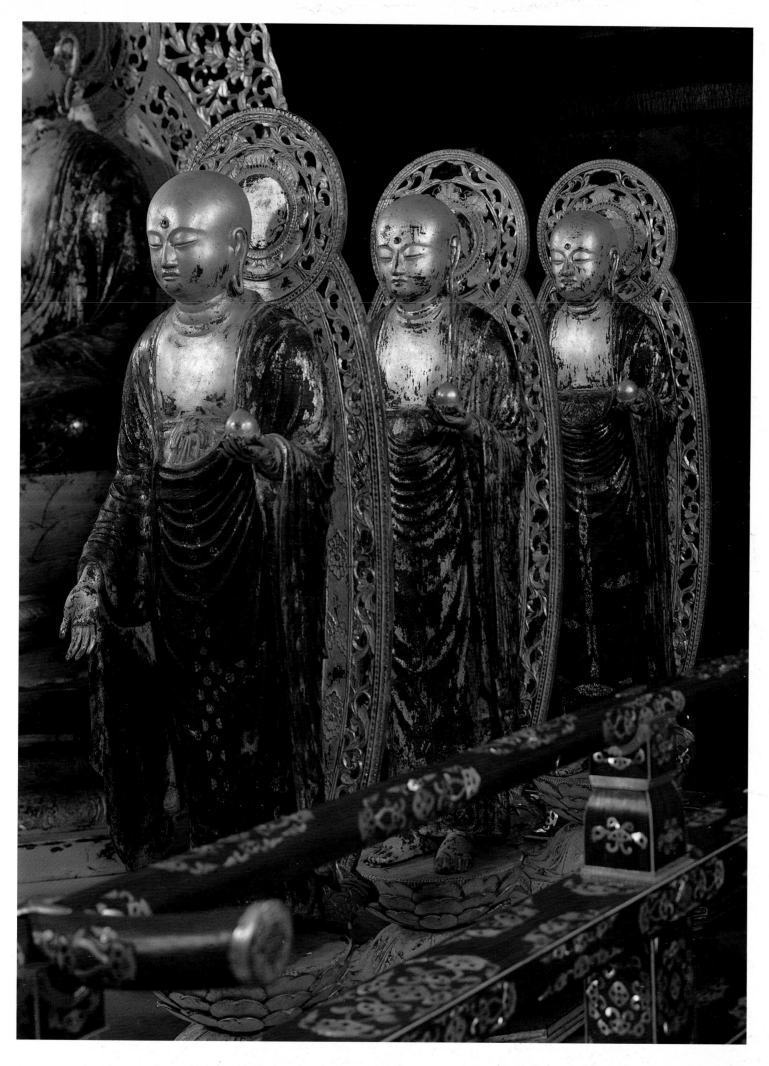

Above: detail of a column in the Konjiki-dō of the Chūson-ji. Opposite: detail of a painting on wood of the Scenes of Paradise by Takuma Tamenari on the back of the Amida in the Phoenix Hall of the Byōdō-in, Uji.

plans. The columns run in unbroken lines, making a unified horizontal scheme and the one which interrelated the architectural elements. The problem was as much iconographical as architectural. The very force of the idea is remarkable. The celestial bird, the soul, symbol in Japanese literature since Yamato times of the spirit of the dead and probably earlier in belief, was converted to functional architectural and landscape forms to represent both the descent of the Buddha to receive the deceased (*raigō*) in Amidist belief and the ascent of the soul in traditional lore. All of the arts – architecture, garden and landscape, sculpture, painting and crafts – were brought to bear on one theme. Never before in Japanese

history had such aesthetic coordination been tried, and rarely was such success achieved.

The noted sculptor Jōchō was employed by Yorimichi to make the Buddha. Work on the statue was carried out in the family workshop in Kyoto. Some 30 years of Jōchō's work are documented, but the only sculpture remaining today is the Amida in the Phoenix Hall. Jōchō died within four years of the completion of this work, but with commissions accepted by his workshop still to be executed.

Jōchō was greatly honoured by receiving the highest rank *hōgen*, normally bestowed only on members of the clergy. Other artists thus became qualified to receive the rank. Jōchō did, in fact, have a head

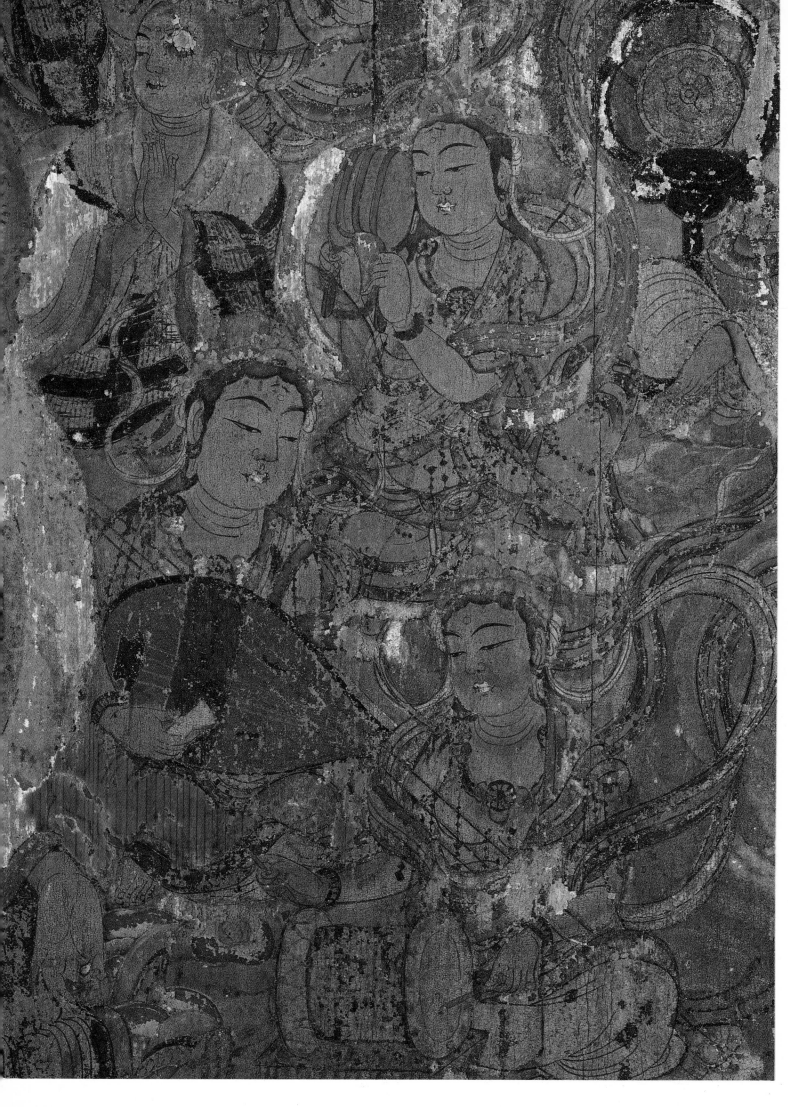

153

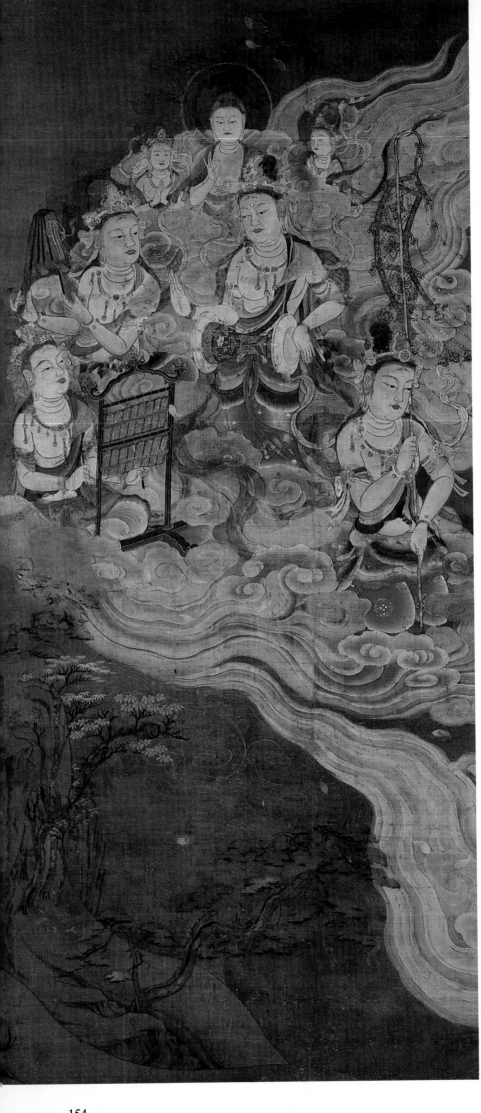

start since imperial blood had run in his family for five generations. His workshop in Kyoto had developed management methods that trained each apprentice in one stage of the production. The obvious problems of working in Kyoto and being installed in Uji were overcome by a system of joining small blocks of wood (*yosegi*) which could then be reassembled in Uji. This technique had evolved in an earlier generation, perhaps with Jōchō's father, and had the revolutionizing effect of making possible infinitely larger figures and ultimately more elaborate and dramatic sculptures. The technique proved to be a breakthrough for the burst of religious art in the Kamakura period.

Jōchō gave sculptures social respectability, organized the workshop for greater efficiency and was responsible for the application of the multiple-block technique. He created an image type which incorporated the best of the Japanese modifications of the earlier Chinese style and established a canon of proportions that stood as the model for several centuries. The heavy monumentality of the Chinese style was abandoned, the Japanese mannerisms which had crept in since the ninth century were eliminated and the Amida was shaped to give the body width but little thickness. The relatively thin legs make a firm base of a triangle with the shoulders and head. On closer inspection, the Buddha sits at a height of 2.95 m (9 feet). Jōchō was probably working with a 10-*shaku* measurement. The width across the knees is almost exactly the same. Lines drawn from the edge of the knees to the top of the head just touch the shoulders and complete an isosceles triangle.

This principle of proportions may have evolved in Jōchō's own work. Nevertheless, once established it became the norm and later seated Amida figures are recognized by it. It is little wonder that those that conform to it so closely are often thought to be the work of Jōchō's own workshop.

This Amida is not constituted of many blocks of wood. The front and back of the body each consist of two blocks on either side. The hands and knees are attached. In the hollow inside has been found a small polychromed lotus base holding a wooden disc marked with a prayer (*dhārani*) in black ink. The aureole and canopy are all of gilt wood and all contribute to the *raigō* concept.

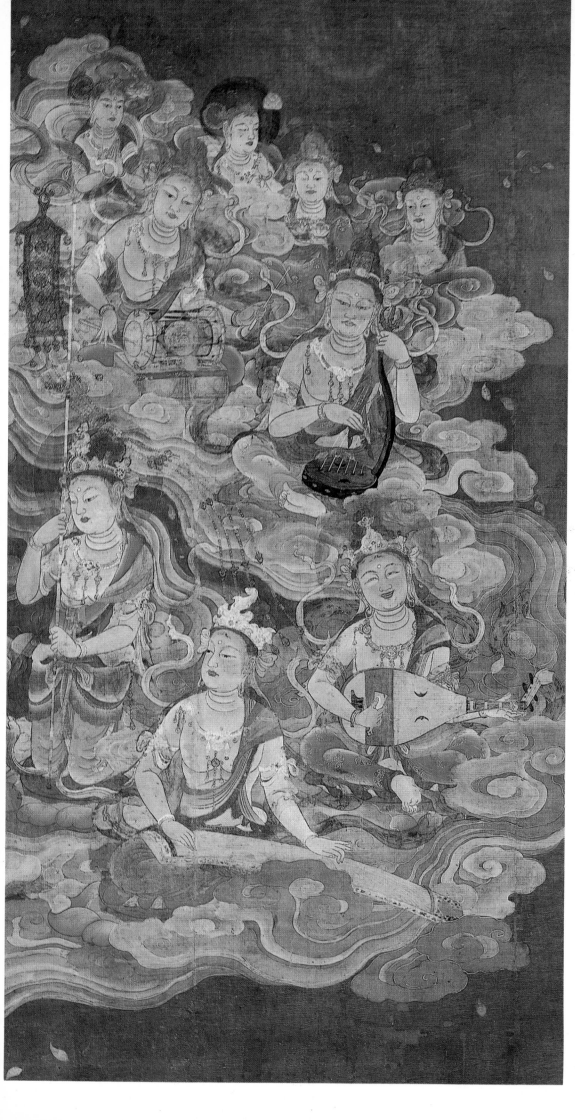

The celestial figures on clouds are in this new style, but may be a later modification.

The walls are decorated with 52 wooden figures floating on clouds, most of which are seated angelic bodhisattvas. Half are musicians, and a small number wear monks' robes. Some nine are of one piece of wood, others have several and usually different joined parts. They show remarkable imagination in their variety, but they are not the canonical 25 attendants according to the formal description of the event nor are they any proper multiple thereof.

The multiple-block technique reached the Kantō in the latter half of the twelfth century, about 50 years after Jōchō's style itself had arrived. The style also extended into the lower Tohoku by around the middle of the century. Some examples are in the older single-block method, but stylistically like Jōchō's work. A single-block Amida of 1098 in the Narushima Bishamon-dō in Iwate prefecture, which was originally an Eleven-headed Kannon but has had an Amida head put on it, has a somewhat distended abdomen, but the shallow carving of Jōchō's gentle drapery curves is present.

All of the interior surfaces of the Phoenix Hall were richly painted excluding the plastered areas. The upper part of the paintings are reasonably visible. Five large wooden doors and the four walls display the splendours of the Buddha's advent, with seasonal differences on the four sides as though emphasizing the year-round service. Groups of figures descend on clouds, buildings appear in paradise and idyllic landscapes form a background. Softly modulated blues and greens, gently undulating water outlines and hilltops are seen in the new Japanese rendition. A high or eye-level view of mountains creates a non Chinese two-dimensionality. By introducing landscape a locale is given to the occasion, bringing the subject closer to home and making it more intimately Japanese.

Left and opposite: details of the Descent of Amida, silk painting from the end of the eleventh century or the beginning of the twelfth. They portray two groups of musicians, a part of the entourage accompanying Amida to gather up the soul of the departed. Reiho-kan, Mt. Koya.

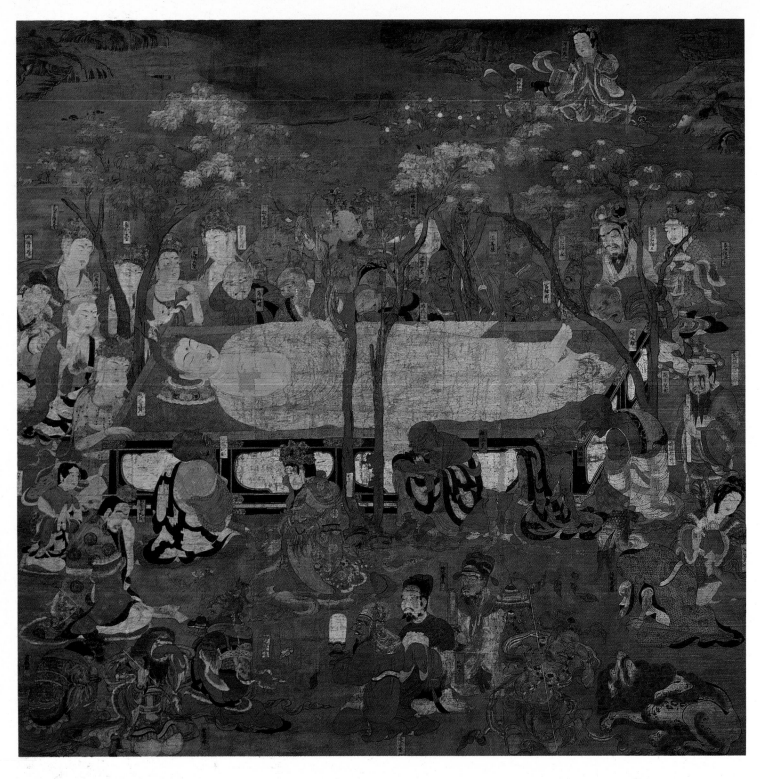

The Death of Buddha, as portrayed in a large silk painting from 1086. Kongōbu-ji, Wakayama. Buddha is shown entering Nirvana against the background of a delicately-drawn landscape, surrounded by his mother Maya (top) and figures of grieving mourners. The presence of the lion (below right) symbolizes the participation of the animal world.
Opposite: detail.

One of the paintings at the back on the right shows a building with projecting galleries placed with a pond and island in front. This is a picture of the type of hall which the Hōōdō represents, a type which had been known since the T'ang dynasty. It appears in T'ang tomb paintings. T'ang palaces followed this pattern, but in heavier materials. Aristocratic domestic architecture has a common derivation. It is kept alive in the nineteenth-century Heian Shrine in Kyoto. In the *Shinden-zukuri* (style) of the extended upper class dwelling, a complex of buildings included a main residence

and adjunct residences on either side connected by roofed walkways. More halls and corridors could be run toward the south where a stream and perhaps pond were part of a simple, open garden. Villas followed this form, which is why noblemen were so comfortable with the picture of paradise. In the Shinto atmosphere, the world of the *kami* – only a little better than this one – was not a distant exaggeration; it was well within reach.

The paintings have been attributed to an elusive figure known as Takuma Tamenari who lends his name to the Takuma School for

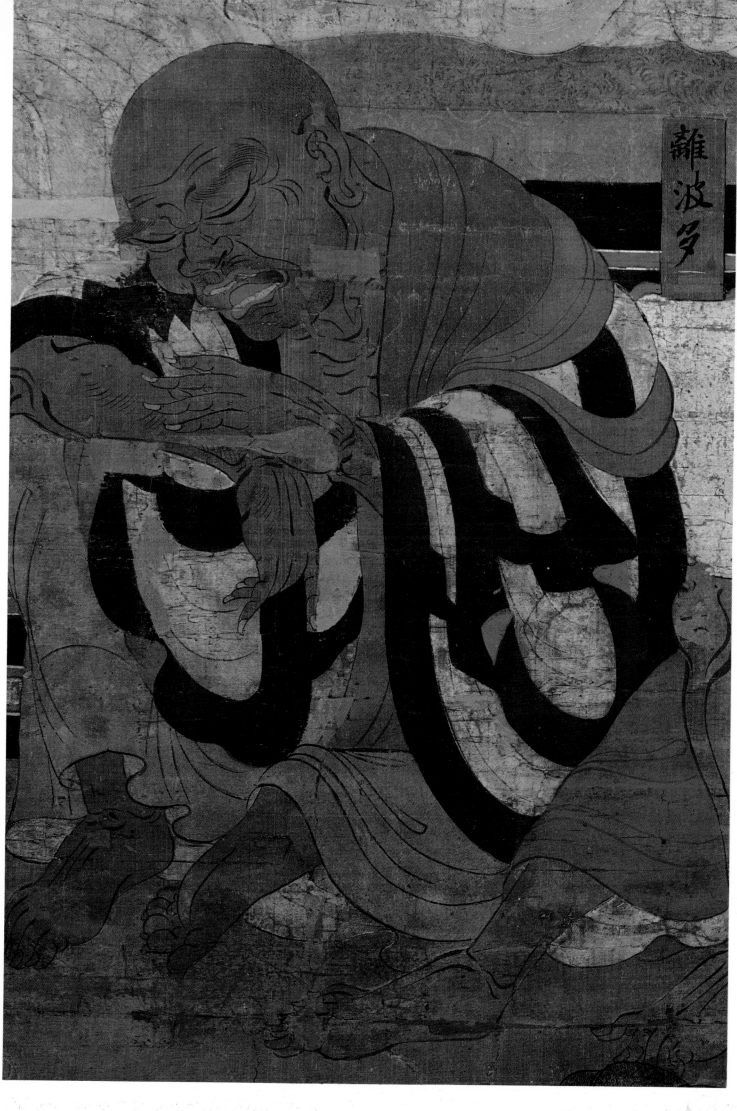

離波多

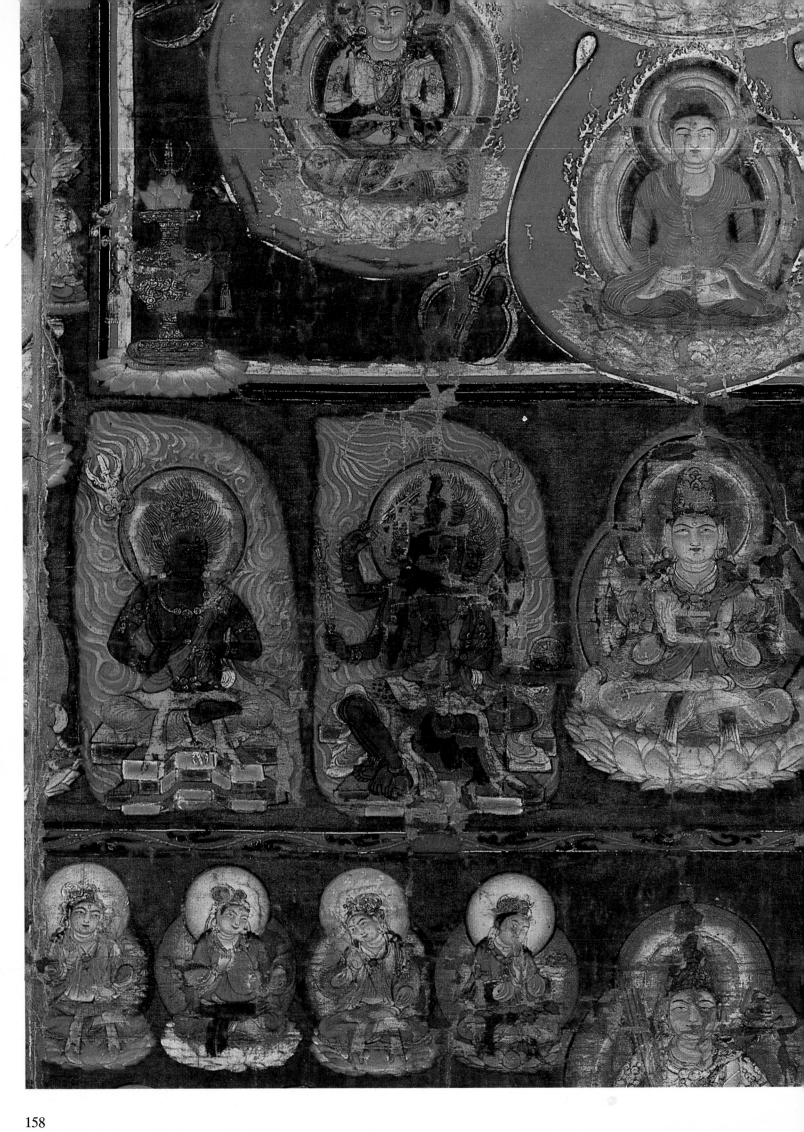

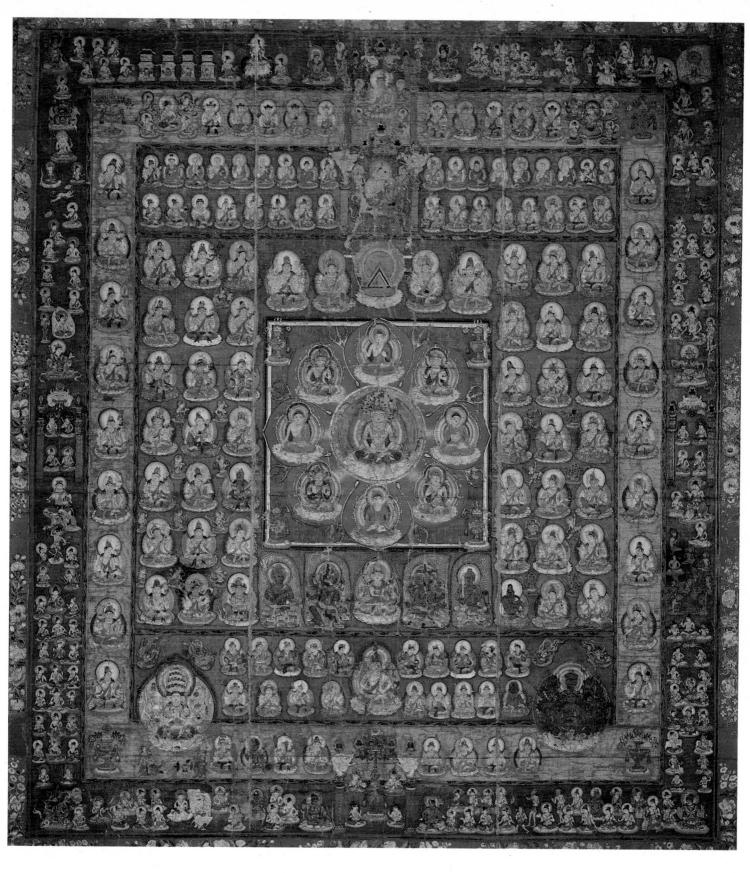

Above: tenth-century silk painting known as the mandala of Garbhadhātu and Vajradhātu. Tō-ji, Kyoto.
Opposite: detail.

religious paintings with landscape features. Another tradition speaks of Kose Hirotaka. The Takuma family was supposed to have been concerned chiefly with Chinese style landscape. This one is certainly not. The inclusion of landscape here in such a monumental form is a major step in the direction of a Japanese painting idiom.

Yamato-e is the term used to designate its inception and means simply Japanese-style painting. Like the use of the word Shinto, it could only have been used through an awareness that what was current was non Japanese. It is a reflection of a progressive realization of the great dependence on Chinese forms and principles. Hand in hand with the literature, the framework for the Chinese ideal was being dismantled

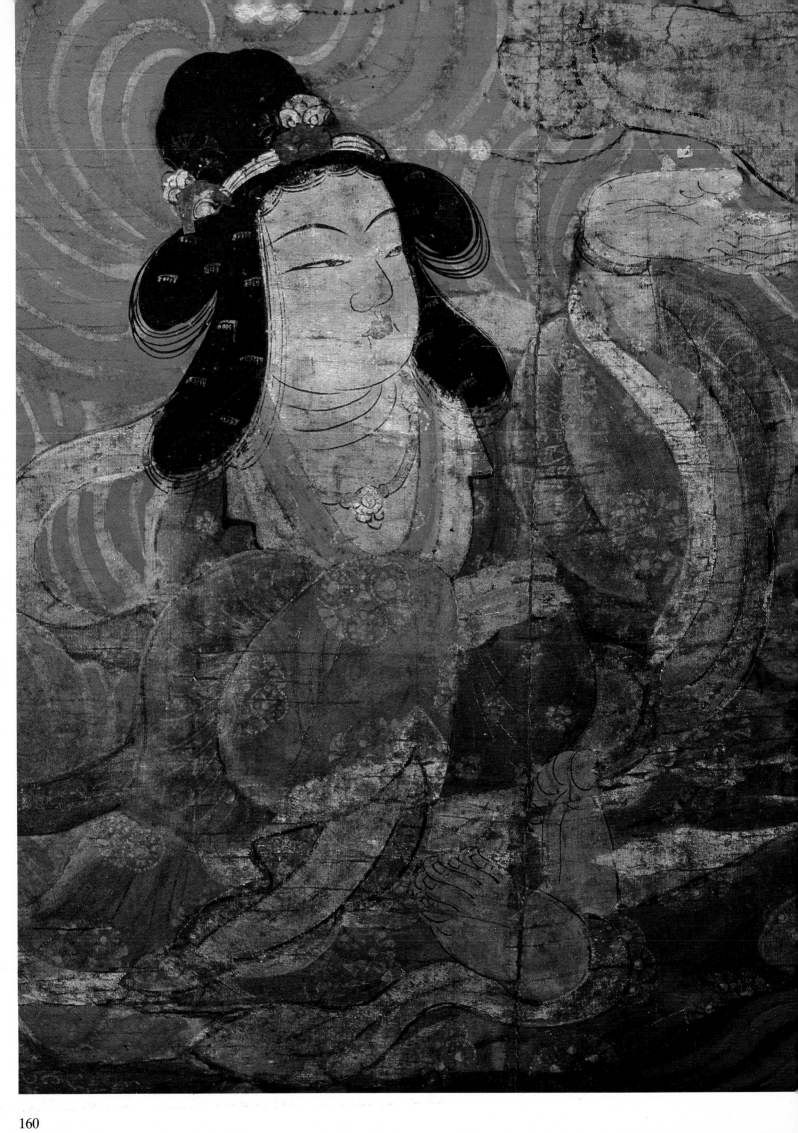

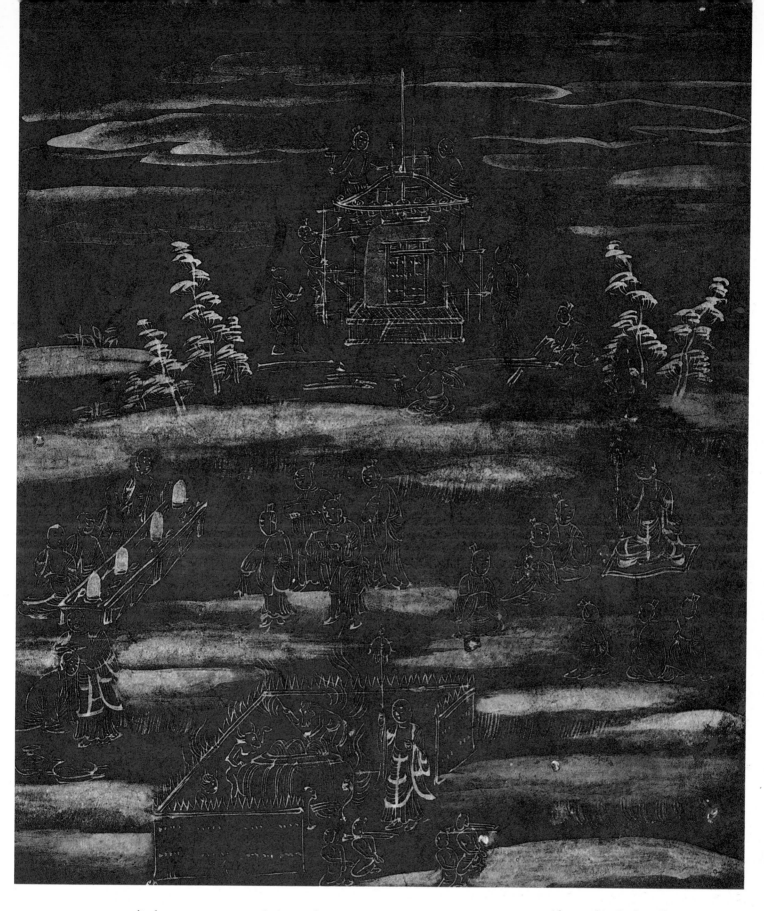

as it became more archaic and nothing new could be found to replace it. The term *yamato-e* first appeared in the diary of the poet Fujiwara Yukinari on the 30th day of the tenth month in the equivalent of the year 999. He says he drew a fan painting in *yamato-e* for a folding screen. The alternative, *kara-e*, was probably already by that time moving toward a black ink style of landscapes and adding more colour

was a natural Japanese reaction. Since the subject matter of *yamato-e* was drawn largely from Japanese literature at this stage, it was necessary to provide graphic contexts for stories in a uniquely Japanese manner.

References to the Phoenix Hall in Uji inevitably lead to comparison with the Chūson-ji in Hiraizumi, Iwate prefecture, in north Japan. There a local dynasty distantly

Above: detail of an illustration from a late twelfth-century sacred Buddhist text, finely drawn in gold on a blue ground. It is preserved in the Daichoju-in of the Chūson-ji. Opposite: detail of one of the silk paintings dedicated to the Godai-myō-ō (Five Great Kings of Light), the protectors of Buddhism. The painting, thought to date from 1127, is preserved in the Kyōōgokuku-ji, Kyoto.

related to the Fujiwara prospered for 100 years. It was always in touch with Kyoto, but in fact lagged about a generation behind in style. Called the Ōu Fujiwara from an old name for the northern region of the island, they were far enough from Kyoto to be untouchable and unaffected by the capital's politics and remote enough to be regarded as country cousins by the Kyoto rulers who treated them with disdain.

The founder of the dynasty, Fujiwara Kiyohira, died in 1126. His son and grandson, Motohira and Hidehira, kept the dynasty intact, the latter dying in 1187, but the fourth generation, Yasuhira, lost the territory to Minamoto Yoritomo who was out to clear the country of all hostile elements. Each ruled for about a generation. Their physical remains were stored in boxes under the three altars of the small mausoleum of the temple built by Kiyohira, Chūson-ji, and today all are preserved in mummy form elsewhere in the temple.

The Chūson-ji was a large hilltop temple in its heyday, lavishly furnished and known for its elaborate ceremonies and pageants. Local production of gold provided the dynasty with a firm economic base and made the area coveted from the Kansai. Other large temples were built below on the plain, notably the Mōtsu-ji. They were stocked with products by local craftsmen and sculptures and other arts ordered from Kyoto workshops and some from much more distant points. Occasionally orders were blocked when Kyoto rulers jealously eyed them materializing in their own shops.

The only important remaining building of the Chūson-ji is the mausoleum, a small Amida Hall known as the Konjiki-dō, Gold-coloured Hall. It was erected in 1124 and marked the completion of the building campaign for the temple. The hall is only about 17 by 17 *shaku* and was to serve as nothing more than the tomb for the male heads of the clan. The name comes from the richly gilded surfaces, which, along with various inlays, were all sealed with lacquer. This little building was enclosed within another full structure which was erected to envelop and protect it about 150 years later. During the twentieth century they were both dismantled, repaired in Tokyo and reassembled, but the covering barn-like structure was reerected several hundred yards

away and the Konjiki-dō put in a huge glass case where it may be viewed like a museum exhibit. It stands open, offering a good view of the interior. These two are within a concrete building vaguely resembling the original.

As a memorial chapel and grave, the main image is a seated Amida Buddha on the central altar. He is flanked by two bodhisattvas, Four Heavenly Kings on the corners and two rows of Jizō figures, the deity that favours children and enjoyed much popularity with the Fujiwara and Amida worshippers.

A little of the decoration is now missing, but most is intact and reveals the magnificence of the Heian craftsmanship. The pillars are a hard wood like teak, said to be from the south Pacific. The railings have thin decorative strips of sandalwood, also foreign. They carry gold medallions of the Twelve Light Buddhas, the Twelve Aspects of Amida, with floral patterns in shell inlay. The foot of each column bears plaques in gilt bronze. The platforms carry decorations of thin, gilt bronze sheets with engravings of flower patterns. Jewels were once embedded in key spots. The peacock was an appreciated subject, seen in bronze repoussé panels along the lower line of the platform. Also popular was the Karyōbinga (Kalavinka), a song bird of India with a bird body and human head, known in Japan since Shōsō-in times.

A painted wooden sculpture of Ichiji Kinrin, a form of Dainichi, the Buddha of Light, is kept in a special room in the treasure house. The new trend of realism emanating from Kyoto is seen to good advantage here: polychromed surfaces rather than gold, in natural flesh colours, life-size proportions, lifelike drapery and inset crystal eyes. No one doubts that the Ōu Fujiwara did their best to keep up with the Kyoto Fujiwara and did so rather successfully.

Buddha's descent to receive the soul of the deceased with the assurance of rebirth in the Land of Eternal Bliss was a strong appeal for which there was little resistance. It was warm, human and intellectually attractive. The large painting which inspired the later proliferation of copies was a product of one or more monks of Mt. Hiei. The *Painting of the Descent of the Twenty-five Bodhisattvas* (*Nijugō Bosatsu Raigō-zu*) is a triptych of substantial dimensions, now to be seen on Mt. Kōya.

It was removed by Oda Nobunaga's troops and later transferred to its present location. Edo traditions attribute it to Genshin himself, but it fails to follow adequately Genshin's own description of the event, and is likely to be at least a generation later.

Buddha's heavenly entourage numbers not 25 but 32, including a small triad in the distance which is very much like an afterthought. Genshin placed three monks significantly close to Amida. The attendants Seishi and Kannon are seated at different angles and somewhat lower and in front of Buddha on the right and left. Their position is sometimes useful in determining when a copy was made.

Among the attendants on clouds are singers and instrumentalists. All float effortlessly on the compact cluster of clouds above distant mountains, ponds and trees. At the foot is a person, probably the donor in his house, whose final wish is to share in this process of salvation. The Buddha is dark-skinned and only slightly lighter than in Chinese custom, seen against a darker aureole, fully frontal. He contrasts vividly with the sprightly celestial attendants whose joy and grace is expressed in red outlines, pleasant expressions, elegant ornaments, thin fluttering scarves and "reverse shading" in which the colours lose their body toward the edge. As happy participants they all contribute to the pleasure of the event. Their youthfulness evokes the continuity of existence.

A large painting of the Nirvana (*Nehan*) of Buddha was hung on the traditional anniversary of his death, now February 15th. It too served as a model for a popular type in painting, although it was never a popular subject for sculpture in either China or Japan. The painting bears a completion date of the seventh day of the fourth month in the equivalent of 1086. It was probably executed in a workshop on Mt. Kōya.

Buddha appears in gold and dies on a dado in complete peace and quiet in the presence both of his disciples and a number of other close

Opposite: detail of the decoration of the votive sūtra of the Taira family. This sūtra was dedicated in 1184 to the Itsukushima shrine in Hiroshima, where it is still preserved.

followers, whose identity is indicated through the old Chinese practice of including inscription cartouches. The sainted bodhisattva stands with a transparent halo at his head, and his mother Maya worships from the heavens.

The disciples are mostly Indian, as can be readily seen from the colour of their skin. Others look Chinese, with the flesh areas done in white pigments as was often the case at this time. While the dado is tilted up to improve the view, the Buddha himself is angled even more. But this is not reflected in the drapery which hangs as it would on a standing figure, following a model turned 90 degrees. Such a rendering was seen as dignified and meeting the principles of serenity.

Novel for Japan are the many landscape elements in such an intensely religious painting. The rising Japanese trend used landscape as background, but here it is intrusive to an almost claustrophobic degree. A stage hedged in by a jungle of vegetation closes out the world, drawing the onlooker into the inner circle. Flowering trees are behind; a pair of trees cuts boldly across the front, while other pairs are at the head and foot. There is more of an Indian than a Chinese flavour in this,

but the emotional control is Chinese and can only be appreciated if compared with the more dramatic expressions of feeling in some later examples. Animal life is symbolized by a single lion in the lower right hand corner, the totem of the clan from which the Buddha came.

Sūtra copying scored meritorious points and the interest of the sūtras was magnified with a frontispiece for which artists might be employed to add an illuminating touch. Through them one can see the evolving landscape style. Buddhas in mountains, heavenly beings making their offerings, wispy clouds, sprigs of trees and blades of grass were often drawn in sparing lines of gold paint. This followed established tradition, but with the proliferation of sūtras more colour and details were introduced and hierarchical compositions were in order. Jōdo sūtra frontispieces placed Buddhas and bodhisattvas on several levels, illustrating the grades of souls in paradise.

Mandala paintings reach their peak of use in Late Heian and Kamakura times. Large ones were hung over altars on the east and west sides of the Kanchō-dō. Such halls were divided for ceremonial purposes. The northern half of the building, the Seidō, was unap-

proachable except by the initiated. The west side (western paradise) held the indestructible cycle, the spiritual basis for the real world, while the east side did the same for the material and transient cycle. Though unalterably prescribed, variations were in fact constantly taking place.

The entire mandala concept was expanded through Tendai to embody hierarchical groups of images, in particular the Amida Jōdo mandalas, in much the same way the idea of the descent of Amida to receive the dying faithful came to encompass other Buddhas whose very existence as images could be interpreted as their being on earth to perform this service.

Ornamentalizing objects of daily use was a court pastime. The Shitennō-ji owns almost 100 sheets of exquisitely painted fan-shaped sūtras. Some are in other temples and collections. Apparently the basic line work was done with wood blocks, which was then followed by wash painting, details and calligraphy. Paper fans made for the aristocracy were used, with sets comprising a sūtra. Like leaves of a book, they were looked at and read in sequence. For instance, the set of 22 sheets in the Tokyo National

Two details of the Shigisan Engi *("Tales of Mt. Shigi") scrolls, a work of popular literature that illustrates stories of the power of Bishamon in the form of miracles worked through his medium, Myōren, an ascetic who lived on a mountain top. The scrolls date from the end of the twelfth century and are preserved in the Chōgosonshi-ji, Nara prefecture, which was built in the place where the events occurred.*

Museum are part of the Lotus Sūtra. All are readings from the last chapter.

The paintings of landscapes, buildings, courtiers and the rank and file have no recognizable connection with the religious texts, but they set a pleasant mood and liven up the otherwise abstruse subject matter. Wood-block printing was known to Japanese artists since at least the eighth century and at no time was it regarded as an apostasy of the art of painting. Just as reading the sūtras could be done by skimming and turning pages, a more mechanical way could be found to prepare the materials for sūtra copying. These are valuable for an understanding of the developing figure genre and the widening range of techniques being used.

The *yamato-e* developments were possible because of the Japanese freedom to select and chart new courses. They had no restricting philosophy of the arts, in particular the art of painting which was the art of statesmen and philosophers. The Chinese had endowed it with functions, such as enhancing the history of state, glorifying the imperial line, stressing proper social comportment, elevating individual status and harmonizing man's relationship with nature. Subject matter and art-

ists were not graded by critics as had been the case since the time of Hsieh Ho (sixth century). Classifiers inevitably emerged, and they had to make qualitative judgements. Fujiwara Kintō's listing of the Thirty-six Celebrated Poets, the Sanjūroku Kasen, around the beginning of the eleventh century, is a good example, but the rules were not hard and fast and room was always left for change. To sum up, there was no consensus as to what the arts should do and say.

Nevertheless, not only was the philosophy – or lack of it – in Japan favourable to the development of *yamato-e*, but natural Japanese predispositions were especially conducive to a successful prosecution of the art. The critical factor was the attitude toward line and space. The Chinese regard for space had expansive and Taoist cosmic overtones and has been thought to have reflected the vast areas and natural geography they knew and lived in. The Japanese attitude had a Shinto sense of intimacy to it and lacked the overawed reaction to nature. It grew out of the perspective of narrow valleys and spaces locked in by hills and mountains. Nature was never a threatening force to be reckoned with. Shinto *kami* kept it controll-

able and cooperative – albeit in one of the world's most disturbed areas volcanically and seismologically.

The style of the narrative scrolls was based on scenes which flowed easily from right to left parallel to the picture plane, the relatively shallow space keeping the stories moving steadily along. The landscape never dominates. It may lead the action, provide some understanding of the locale, set a seasonal or regional mood and indicate the scale, but it is always no more than complementary and often subordinate. The narrative could not stand any more. On the whole the boundaries of the landscape are soft and unobtrusive. Plants grow into the foot of the scenery, stylized clouds or mist often separate the scenes or make spatial transitions more rapid and help to reduce the quantity of irrelevant detail. If the story revolves around events which depend on the powers of nature, such as mountain spirits, enough landscape is present to evoke its magical character. Where subject matter portrays court activities the setting is of splendid interiors, and includes just enough of the exterior to show how that particular episode has unfolded.

The oldest preserved scrolls are already so mature no one doubts the existence of several generations of earlier history of the art. Reference to one of the Kose painters of the late ninth or early tenth century illustrating a story called *The Tale of the Bamboo Cutter* is informative, and it is known that both the *Ise Monogatari* and the *Utsubo Monogatari* were done in pictures in the tenth century. The antecedents were therefore popular stories and semi-historical accounts.

Sections of the *Genji Monogatari* painted scrolls may be the oldest now extant, but they probably date from a full century after the romance was written. Lady Murasaki is said

to have retired to the Ishiyama-dera near Lake Biwa to compose her intimate account of court life centered on Prince Genji. The four surviving scrolls, which consisted of alternating text and pictures and have been cut up and mounted, do not treat the story fully, so one assumes that more than twice as many would have been required in order to do so.

Popular opinion credits the paintings to Fujiwara Takayoshi who flourished around the middle of the twelfth century, but contemporary scholarship sees the work of several artists. A master designer marked the colours which were to be added along the assembly line, and the opaque overlays of pigments were often followed by terminal outlining. The calligraphy is likely to be the work of up to four persons.

The handling of several conventions is so consistent and competent it must have been begun earlier. These allow the views from exterior to interior to be unbroken by leaving off the roofs (*fukinuki-yatai*, blown away roofs); the movement from right to left enhanced by angled architecture (*shasen-byō*, oblique line rendering), and the room spaces tilted up to reveal more precisely the interior. The latter has the effect of sharply limiting the space and putting the people into close contact with each other. Costumes, curtains and screens give colour to each scene, but folding and sliding screens are decorated with monochromatic Chinese landscapes. Faces, hair and costumes are also drawn in highly conventionalized ways. The so-called drawn (line) eyes and hook-shaped nose (*hikime-kagihana*), used throughout, serves to depersonalize the figures and give them a common appearance. The ladies have a lock separated from the mass of their hair. Gorgeous patterning makes every scene a finished composition, as though each were a climax in the story. The slow tempo and leisured pace is an apt commentary on the artificial existence of court life.

Detail of the Shigisan Engi *("Tales of Mt. Shigi") scrolls. Of the three scrolls that make up the tales, two consist of text alone, but it is the third, illustrated one which has attracted the most interest.*

Detail of the painted scrolls of the Genji Monogatari (*"The Tale of Genji"*). *First half of the twelfth century. Tokugawa Reimeikai, Tokyo.*

Among other features is the apparent lack of privacy. Attendants or others wait behind screens, heads close together. Romantic encounters weave intricate webs. The 54 chapters are in uncertain order, and may have been circulated around the court as they were written. Personalities could be recognized. Genji was in the forefront until politically disgraced by his wife's adultery. Family and amorous relationships, family jealousies, scheming nobles and evasive or yearning ladies and handmaidens are the fabric of which it is made.

Diametrically opposed to the somber, unalleviated mood of court life is the *Shigisan Engi* (Tales of Mt. Shigi), a lively piece of popular literature. Three paper scrolls illustrate stories of the power of Bishamon, as miracles worked through his medium named Myōren, an ascetic residing on the mountain top. The Chōgosonshi-ji keeps the scrolls and marks the place where the events took place. The present temple buildings are mostly early seventeenth century.

In one scroll Myōren is able to restore the health of Emperor Daigo through prayers said on the mountain. In another his eldest sister, from whom he had been separated for 20 years and who set out to find him, sits in front of the Great Buddha in Nara overnight and in her dream is told to follow a purple cloud. She locates Myōren on the mountain top. Both scrolls have text at either end.

The scroll which attracts the most interest, however, has no text. Known as the Scroll of the Flying Storehouse, with scenes that run into each other and the repeated appearance of the key elements, it tells the story of the support of Myōren by a rich man living in the valley below. He fills a rice bowl from his storehouse daily which flies through the air to Myōren's side. But once, while taking stock of his supplies, the rich man fails to fill the bowl. Bursting with energy, the bowl takes the whole storehouse with it, guiding the building up the mountain. The man climbs the mountain to recover his rice, bales

Detail of the painted scrolls of the Genji Monogatari *("The Tale of Genji"). First half of the twelfth century. Tokugawa Reimeikai, Tokyo.*

169

of which are returned by Myōren together with the bowl, but he keeps the storehouse.

The daily flight of the rice bowl had been hardly worth noting, but when the entire storehouse sailed through the air, the populace ran out of their houses, waving and shouting wildly. Done in a rapid, sketchy fashion, the drama is caught from a sharp angle of vision, with the people perilously close to a sheer (and actually non-existent) cliff, postures and gestures violently exaggerated in the excitement of the moment. Bold lines and light washes of colour are loose and animated. There is an earthy, physical, spontaneous response that underscores a simple belief in the magical powers of the mountain deity.

Outwith these two narrative domains are the animal caricature scrolls kept in the Kozan-ji in the hills west of Kyoto, known as *Choju Giga*. There are four of these and they vary considerably in quality, inspiration and ingenuity. On paper, in black ink only, the most interesting and unique are the lightly painted frolicking rabbits, frogs and monkeys paying respects to a mimic Buddha. A landscape rendered with only a few strokes here and there of bushes, water, rocks and blades of grass is a spare but appropriate setting.

The scrolls are said to be the work of Kakuyu or Toba, titled Sojo, a priest who served in Kinki temples, particularly in the Mji-Dera near Lake Biwa, but few see any validity in the attribution. They were quite likely painted at the Kozan-ji and by several artists of different levels of competence and inspiration. A second scroll which mixes real with mythical creatures might belong to the same date, but a third and fourth scroll, which include monks and local people playing games, along with animals, are regarded as a little later in time.

Whatever the meaning of the caricaturistic attitude toward temple life – the frog as a seated Buddha fingering its navel, a monkey dressed as an abbot burning incense at its altar, a lotus leaf as a target in the shooting match, a fox with its tail on fire (not even Shinto is spared) – the charm and wit must have outshone the jaundiced satire, and the sheer virtuosity of the painting of the first scroll is enough to excuse any disrespectful intent.

Whether there is more here than meets the eye is a lingering question. When the entire first scroll can be

Detail of the painted scrolls of the Genji Monogatari ("The Tale of Genji"). Four scrolls have survived, which consist of alternating text and illustrations, but they do not treat the story fully. The paintings are traditionally ascribed to Fujiwara Takayoshi, who flourished around the middle of the twelfth century, but recent studies have attributed them to a number of different artists.

Below: wood mask of a smiling young woman. Kongo Collection, Kyoto.
Opposite: wood mask of a smiling man. Tamukeyama-jinja, Nara.

seen at one showing (or in the available photocopy miniatures of it) an interesting series of lesser countercurrents move from left to right. One wonders if it was even intended to be unrolled from right to left.

The production of ceramics suffered from a drying up of the sources of materials for green glaze, mounting expense for transportation of the goods, preference at the court for lacquer and finer things and the failure of the Japanese to raise the aesthetic level of their own products or to find a way to match the Sung celadons.

Many sūtra mounds yield small

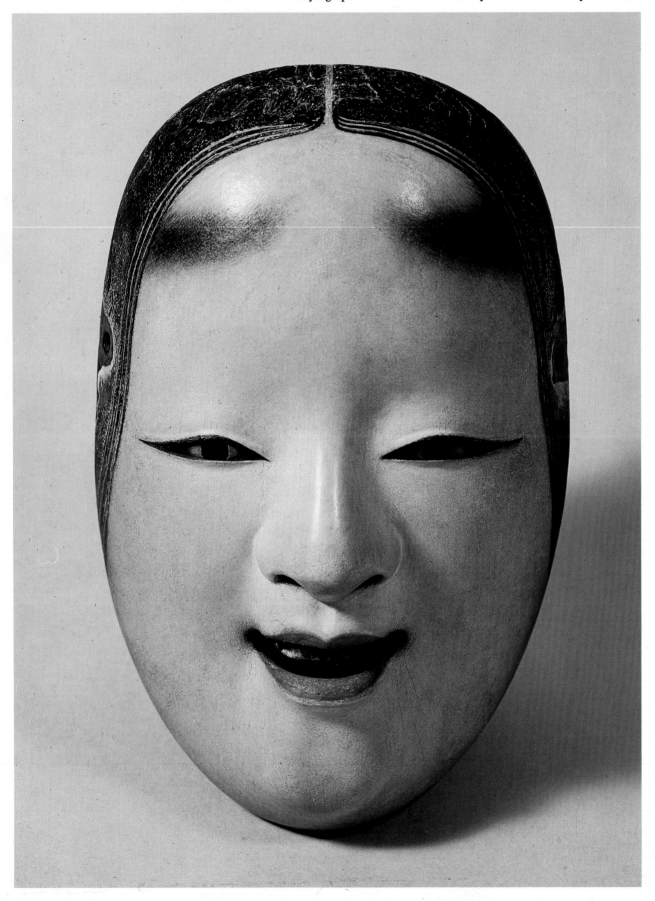

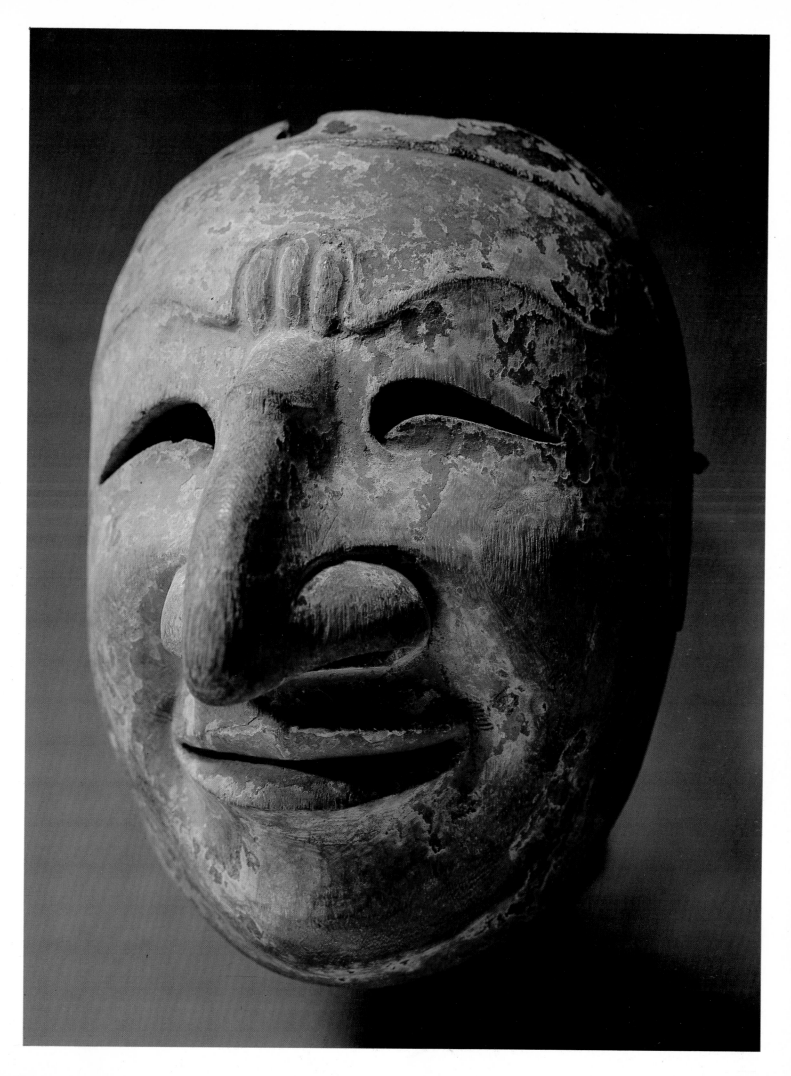

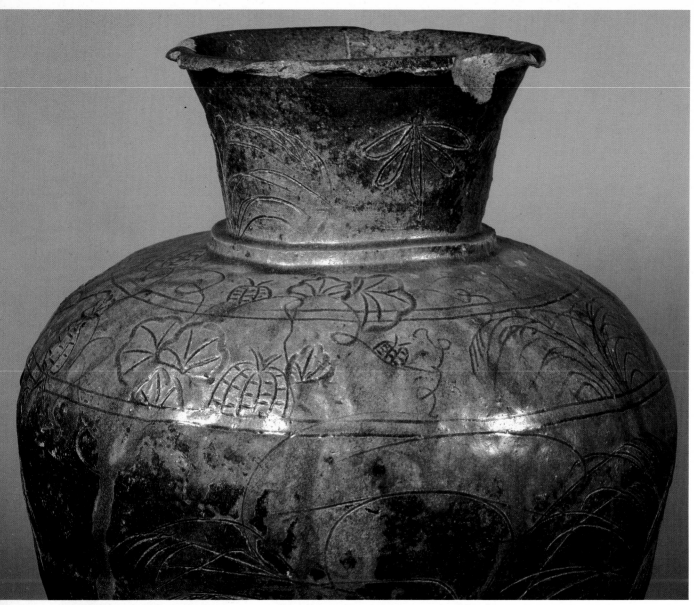

Above: detail of jar with decoration of autumnal plants. Twelfth–thirteenth century. Keio Gijuki University, Tokyo.
Opposite: jar with lotus petal design. Late Heian period (794–1185).

celadon containers. These may have been made in China just for this very Japanese *Mappō*-related market. Numerous other sites have been found to contain celadons, including Michinaga's Hōjō-ji. The large network established for the distribution of Sanage area ceramics in Aichi was still in operation for cheaper unglazed Sue wares used by home owners, traders and pilgrims.

The solid green glazes are rarely seen after the official cancellation in 894 of the missions to China. Local needs were met in the Bizen, Omi and Owari areas, but otherwise there seems to have been little demand. The first stirrings of something new came at Seto in the present prefecture of Aichi in an effort to

discover a glaze with a reasonable resemblance to celadon. The result was a far from successful murky yellowish-brown or green, but it was the first genuine stoneware and a return to glazing, which had been neglected for 200 or more years. Floral patterns were stamped or incised, taking their inspiration from Chinese wares.

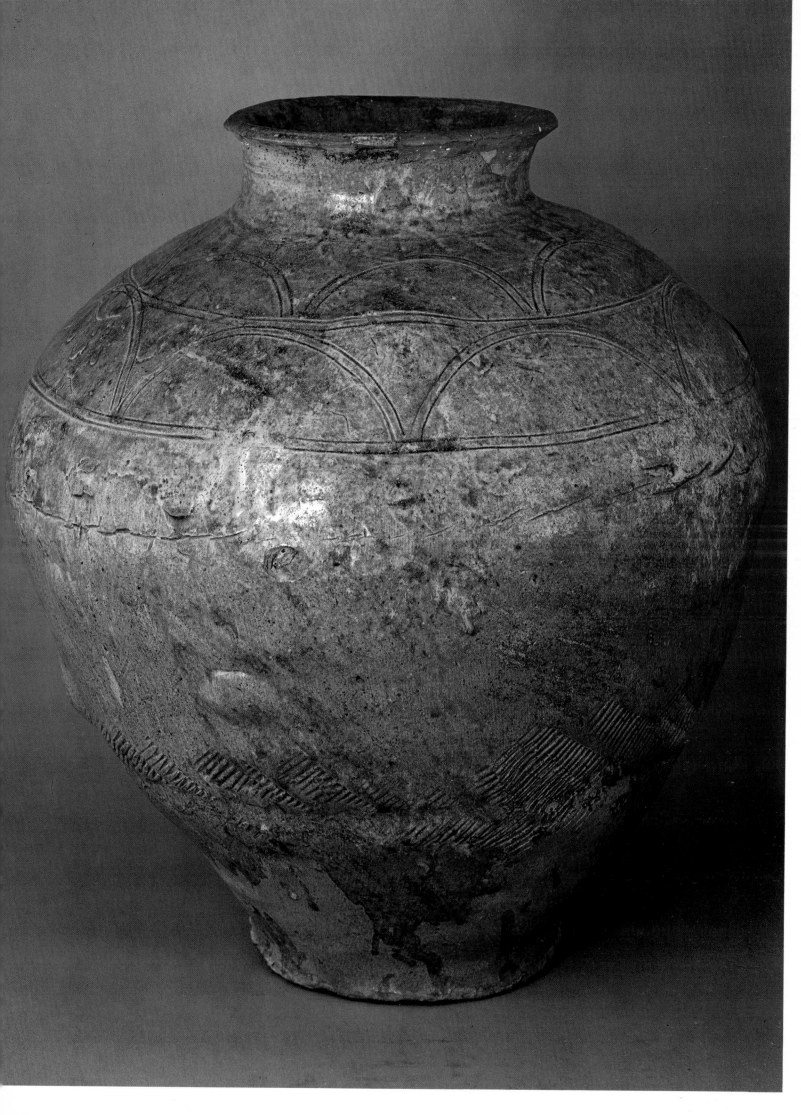

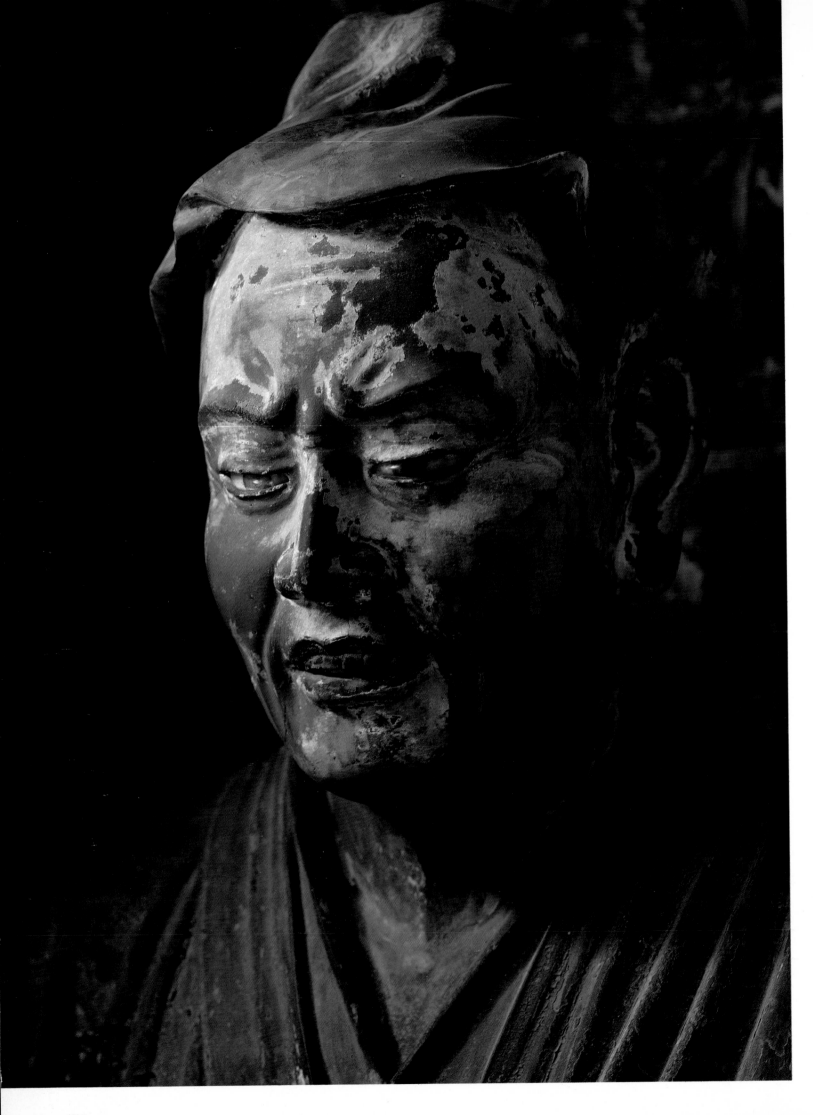

THE KAMAKURA PERIOD
1186–1333

Arguments over when the Kamakura period should be started are of minimal concern here. When Minamoto Yoritomo moved to Kamakura in 1180, he was given permission by the court to appoint the military governors in 1185, and received the title of *shōgun*, an abbreviation of a term meaning the equivalent of generalissimo, in 1192. Control by the *bakufu*, military government, opened a new era in Japanese history, radically altering the political structure, the social levels instrumental in cultural change and the patronage of the arts. Economic power was in the hands of a class which lacked the aristocratic touch so conspicuous in Late Heian arts. The placid arts of a languid court were mild, otherwordly, and needlessly extravagant. That would change. And contacts with China brought Japan's position back into perspective, as trade and ecclesiastical connections were maintained at a steady pace.

Yoritomo's mother was a Hōjō and this eastern Kanto area was familiar territory, but since he had ruthlessly wiped out most of his own family and the succession was young and weak, the line of authority fell naturally into the hands of the Hōjō. Some 16 Hōjō were regents for the shoguns from 1203 to 1333, and after 1226 they instituted a system of keeping imperial princes from Kyoto as nominal shoguns, all six of whom were chosen for their assured ineffectiveness. The Hōjō themselves became more and more inept and the dynasty finally decayed from within.

Hōjō sovereignty was primarily in the eastern region. The appointment of provincial officials, the granting of land rights, and the accompanying vassal relationship created a kind of feudal social structure, although in many respects unlike feudalism in Europe. The earlier expansion of the *shōen* system of private lands was reflected in increased rice production in the late thirteenth century, to some degree in excess of the population's needs. Since the flow of Chinese coins was being curbed on the Chinese side, the marketing network turned back more and more to exchange and barter.

The thirteenth century witnessed the warriors' greatest test. The Mongols had massed troops and built boats to attack Japan in anticipation of their final conquest in east Asia. A relatively small fleet of 150 ships approached southern Japan by way of the twin islands of Tsushima in 1274. Troops landed briefly on the coast of north Kyushu, but their commander was killed and a strong storm forced them to retire.

Emissarial contacts after this were met with beheadings, and an immense fleet of Mongols and Korean mercenaries arrived in the sixth month of 1281 from both China and Korea. The Japanese were well dug in and prepared with small fast boats and had built a long wall behind the landing beaches to prevent the attackers from deploying their cavalry. All of these obstacles slowed the invasion. But, after about a week of fighting, salvation came again in the form of a devastating storm. Over 100,000 invaders were killed or drowned, and the Japanese were able to say that two *kamikaze*, divine winds, were more than mere coincidence.

The temporary gains here were offset by the large number of trained soldiers with no spoils of war to distribute and with little interest in employment in peaceful pursuits. The Hōjō could not cope with the aftermath of demilitarization, and by the end of the first generation in the fourteenth century the situation had reached crisis proportions. In a series of unstable alliances, Ashikaga Takauji, who had a Hōjō mother, took Kyoto on the second try in 1336 and supported an emperor in residence when Go-Daigo fled after realizing he had been used as a pawn. Go-Daigo lived at Yoshino, and for 60 years the court was divided.

Amida worship turned to the popular form of *nembutsu* (invocations) and *daimoku* (chanting), generating wave after wave of pilgrimages while the roads were still relatively safe. Thousands sought solace and escaped the hardships of the city for spiritual enrichment, praying at the temples of the old Nara capital and walking south through the mountain passes to Nachi and its waterfalls and associated shrines. The pilgrims stayed in shrines and temples along the way.

The worship of Amida led inevitably to the formal founding of Jōdo as a sect, the followers of Priest Hōnen (or Genkū) dating this to 1175, a date perhaps not entirely coincidentally the climax of the intense family struggles. Like others who made a profound impact on the thought of the Kamakura period,

Opposite: detail of a statue of Yuima by the sculptor Kōkei. End of the twelfth century. Kōfuku-ji, Nara.

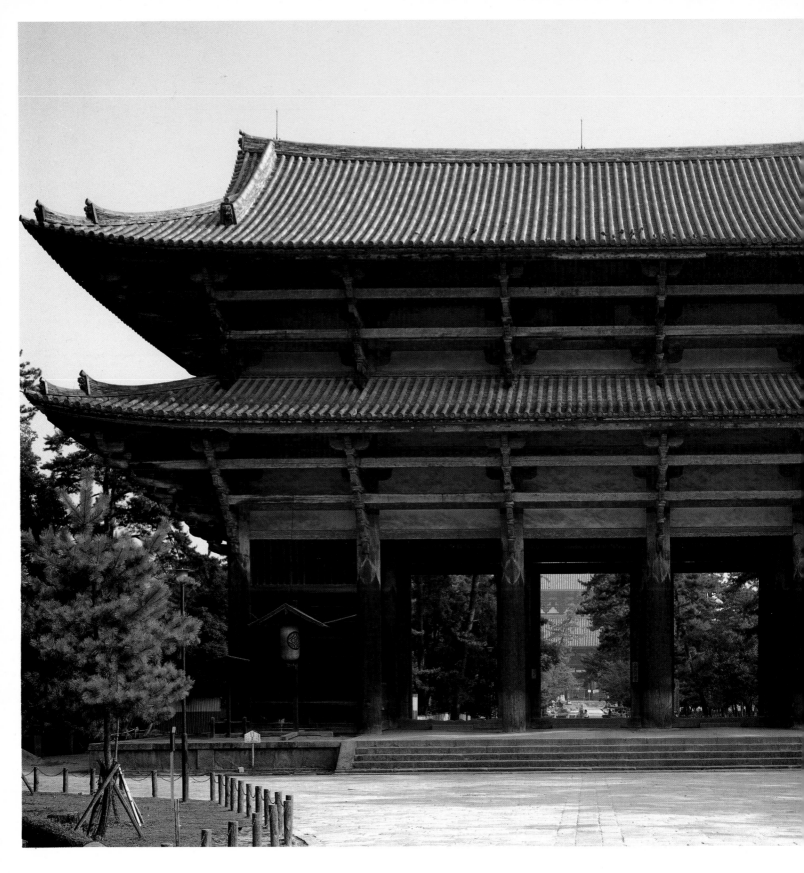

Hōnen had his training in Tendai on Mt. Hiei. And in the current militant spirit, a dogmatic pursuit of personal convictions characterized these religious movements. Hōnen's thesis, which dealt with the philosophical basis for *nembutsu*, the recitation of the name of Amida, earned his banishment in 1198 and, after his return, a second removal from the scene between 1206 and 1211. Later he built the Chion-in in Kyoto, a temple which grew into one of the city's largest institutions and headquarters of the sect.

Historically, however, a lesser known formalization of the *nembutsu* had taken place. The Yūzū-nembutsu was practiced by Ryōnin from 1124, the devotees say, and may be considered to be the first Amidist sect. Translated as "circulating" *nembutsu*, but uncertain as to the exact nature of the ritual, it was fully institutionalized by the eighteenth century. The headquarters is located in Osaka.

What appears to have been popular support for the reforms advocated by itinerant monks against official and established sect opposition is witness to the social tensions of the time. Shinran (d. 1262) dis-

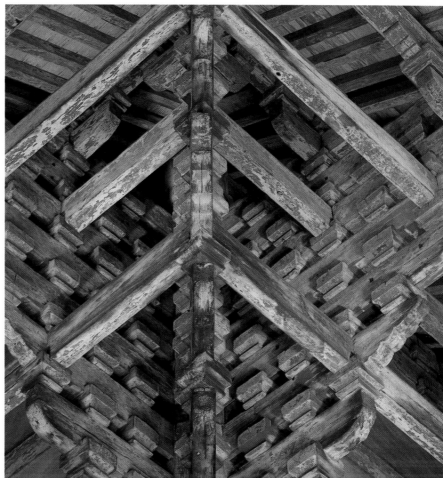

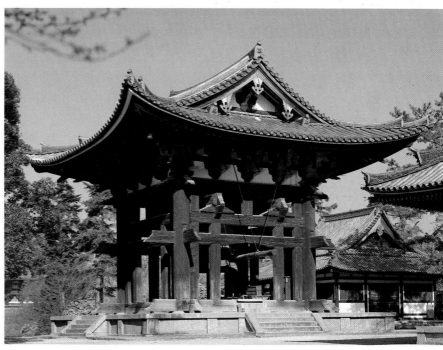

avowed celibacy for priests, directed his preaching to the rural population by stressing grace for the inevitable sinner, and set the scene for the formation of the Jōdo Shinshū, the True Pure Land sect, the one which has become the largest of all today, based in the Hongan-ji temples in Kyoto. Ippen (d. 1289) taught the *odori-nembutsu*, dancing *nembutsu*, and his followers took steps to for-

malize it as a fully-fledged sect.

Amida worship today is therefore no longer seen as emanating from Tendai but through the philosophical interpretations of Kamakura period monks and the organizations their adherents could construct. It has never lost its fundamental appeal and still thrives through the funeral business, as no other Buddhist philosophy has ever been able to

Buildings of the Tōdai-ji, Nara.
Opposite: the Nandai-mon (Great South Gate), the entrance pavilion to the shrine.
Top: detail of the interior structure of beams and brackets. Having collapsed during a storm in the tenth century, the Great South Gate was rebuilt in 1199.
Above: the Bell Hall.

179

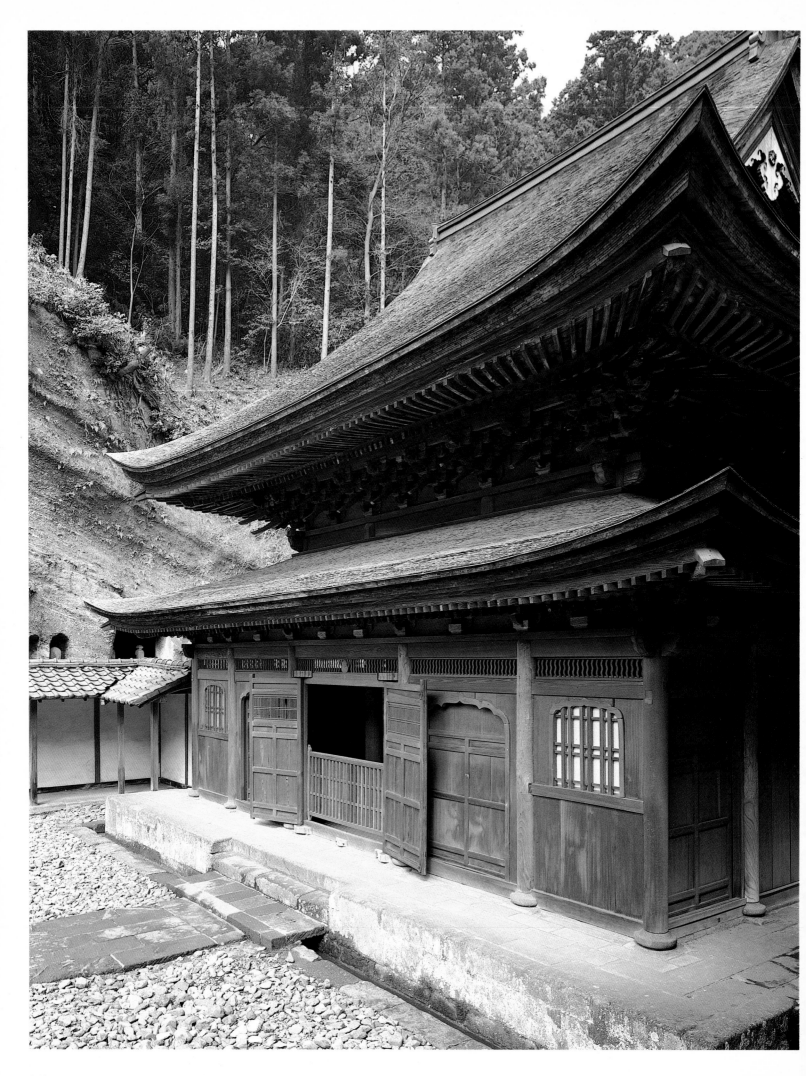

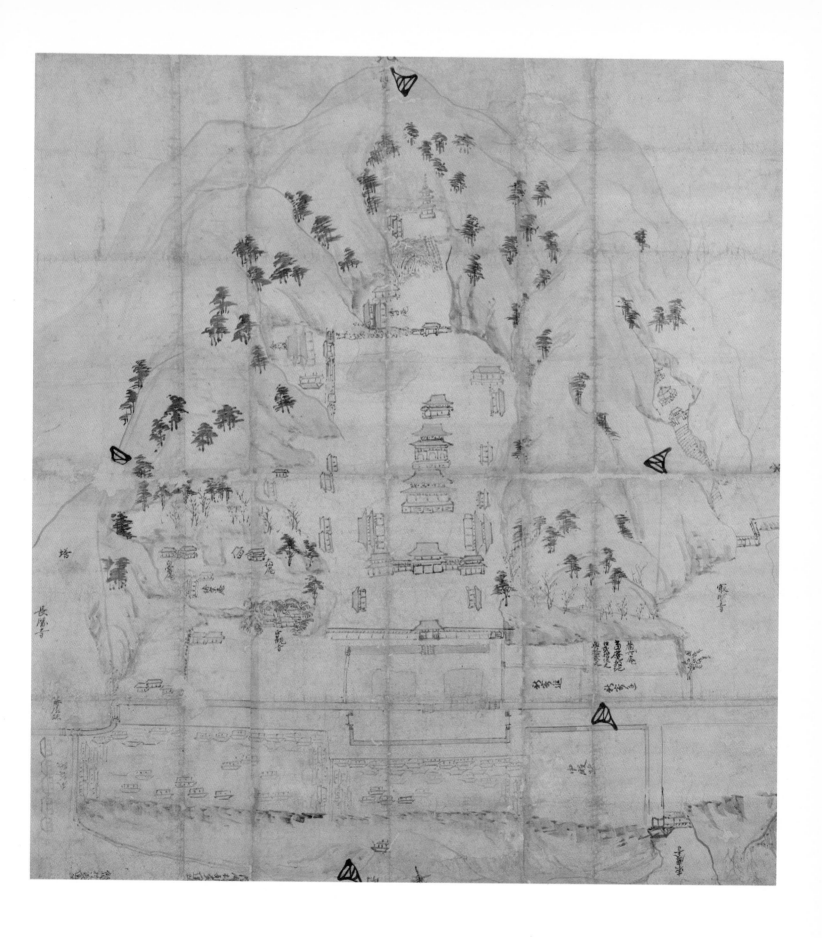

*Opposite: exterior of the Shariden
(Relic Hall) in the Engaku-ji,
Kamakura. The temple, built
between 1279 and 1282, is a typical
example of Chinese-style Zen
architecture.
Above: the temple complex, as
depicted in an old drawing.*

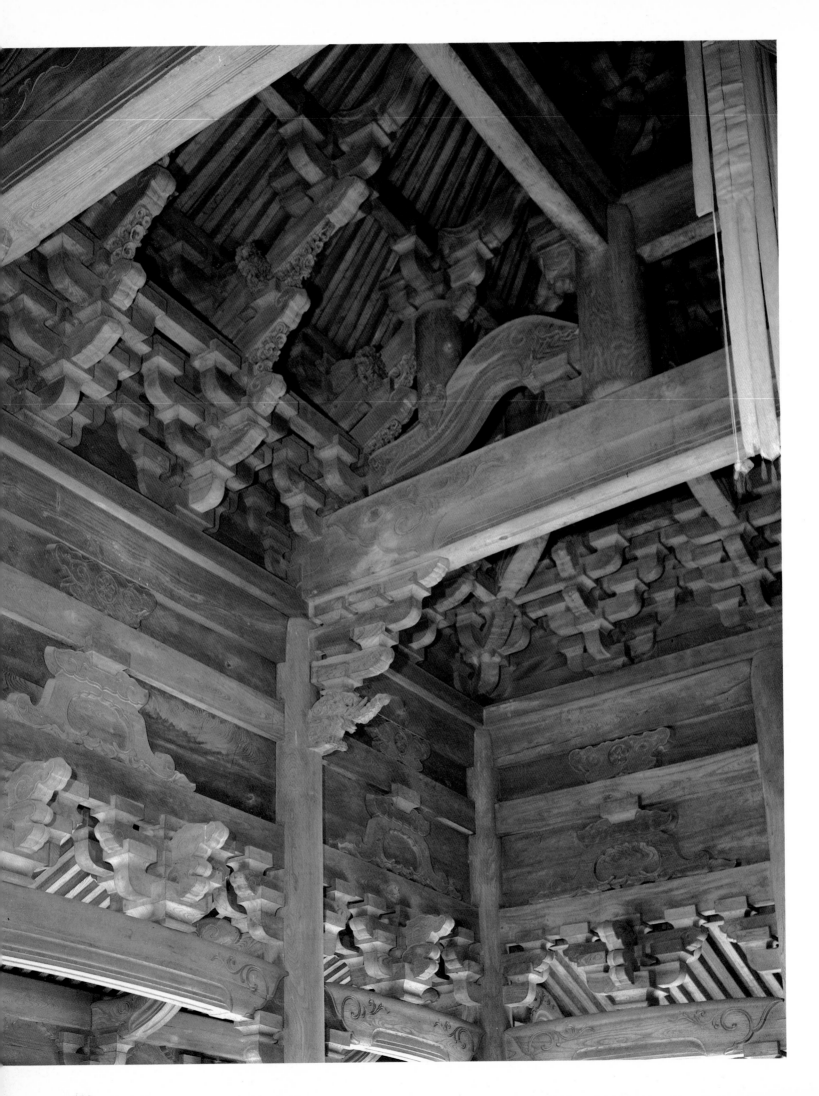

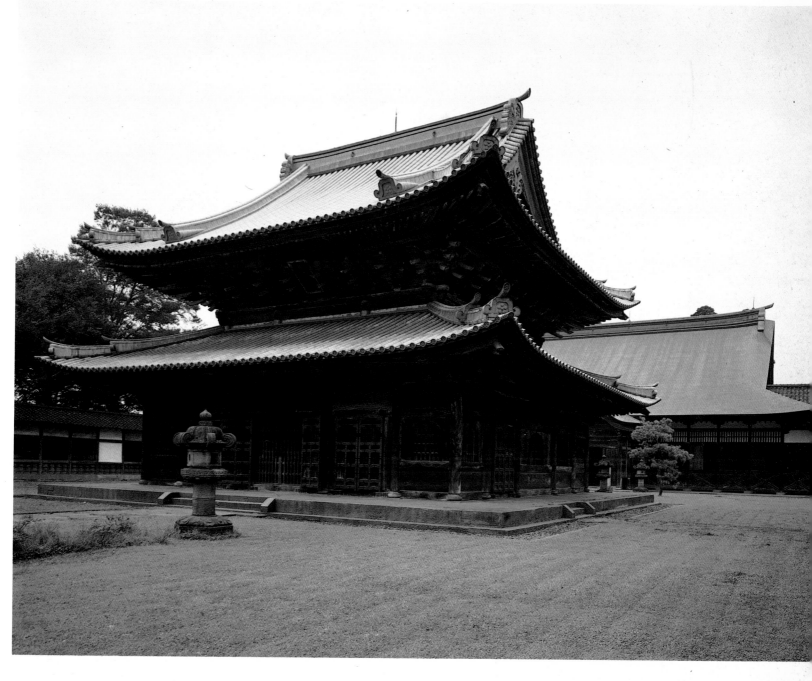

articulate the rewards so richly and assure for the soul such an ideal lasting peace.

Nichiren (d. 1282) also emerged from the Tendai school. He preached a return to Shaka worship, using the Lotus Sūtra as the basis for his writings and argumentation. Nichiren saw himself as a disciple of Shaka and was spoken of as a bodhisattva by his followers. They organized the Nichiren sect (or Hokkeshū, Lotus Sect) around his designation of the mantra *Namu-myōhō-rengekyō*, best translated as Homage to the Lotus of the Good Law, as the kernel of the Lotus Sūtra and a phrase aptly suited as an incantation. Known for his scathing attacks on everything he regarded as unjust, whether political or religious, he was exiled twice, the

second time to Sado Island, and was supposedly sentenced to death. But he survived to retire in Yamanashi prefecture. His followers in about 40 subsects still evangelize with considerable zeal and register an impatient concern for heresies. There followed from this a modest revival of Shaka and Shaka-related subjects in the arts, the historic Buddha which had been in limbo since the eighth century. Traditional-sect Nara temples gained a new lease of life and pilgrims found more incentive to make the trip.

While this popularizing process was underway in Amida and Shaka worship, another approach was attracting the attention of the military class. Zen already embodied some of the Chinese elements of Confucian loyalty when it was

Above: exterior of the Myōshin-ji, Kyoto, the mother house of the Rinzai order of Zen Buddhism. The temple's foundation dates back to 1337, but the present buildings are the result of later rebuilding. Opposite: the interior structure of beams and brackets in the building.

183

introduced, especially between teacher and disciple, and Zen thought dealt with ways for self-improvement, strengthening will power and frugality. The grace granted to the samurai from outside sources was less valuable than spiritual reinforcement from within and the discipline and reflection blended a sense of composure and of fatalism for the type of work the soldiers were trained.

Moreover, Zen appealed to the uneducated classes. No enlightenment could be gained through the written word; the sūtras were irrelevant. The saying of Bodhidarma (Japanese: Daruma), the first Zen patriarch, is paraphrased this way: Knowing the true mind is to achieve Buddhahood. It cannot be taught and it cannot be read.

Below: detail of the painted scroll depicting an imperial visit to the horse races. Thirteenth–fourteenth century. Sotaro Kubo Collection, Osaka.
Opposite: the Many-jewelled Pagoda in the Negoro-dera, Wakayama, founded in 1126 and rebuilt in 1515.

Masters passed teachings on to pupils and took on the aura of deities. Zen glorifies its patriarchs as no other sect does, in part because by banishing the icons it left little more than the founders in their place, given man's yearning for the direction and support from higher powers. Unquestionably far from the intention of the search for the Buddha nature within, the vacuum that was left in the desire for a personified celestial spirit was filled by portraits of Zen monks (*chinsō*), making a new genre of considerable artistic stature.

Zen (meditation or *dhyāna*, from the Chinese Ch'an) had once been brought over from China in the ninth century, but the social conditions were not then congenial, and it was not until Eisai (d. 1215) returned in 1191 from his second visit that it received serious attention. He gained the support of Hōjō Tokiyori and built the Kennin-ji in Kyoto in 1202. His form of Zen in Kyoto was a Tendai mix, however, based on Rinzai (Chinese: Lin-chi), reflecting concessions to the religious traditions of the capital and

the strength of the esoteric clergy. The stress was on paradoxical questions (*kōan*), tea drinking and sudden enlightenment. The aristocracy found it attractive, which was in contrast to Sōtō (Chinese: Ts'ao-tung) introduced by Priest Dōgen when he returned from China in 1227. His writings and teachings emphasized discipline, concerted effort, hard work and *zazen*, that is, using meditation as steps in the slow process of finding the Buddha nature through the "realization of self" in seated meditation. Sōtō borrowed much from local cult practices and espoused Amidist incantations. Altogether, Zen offered the philosophical principles for self-control and became the soldiers' religion.

After Tendai monks forced Dōgen to move, he settled in Fukui in 1244, founding a temple which later was called Eihei-ji, and became the headquarters of the largest Zen sect. Another and later addition to Zen was the seventeenth-century Ōbaku, located at the Chinese-style Mampuku-ji near Uji. Still heavily Chinese in ritual today, they adopted the *nembutsu* practice,

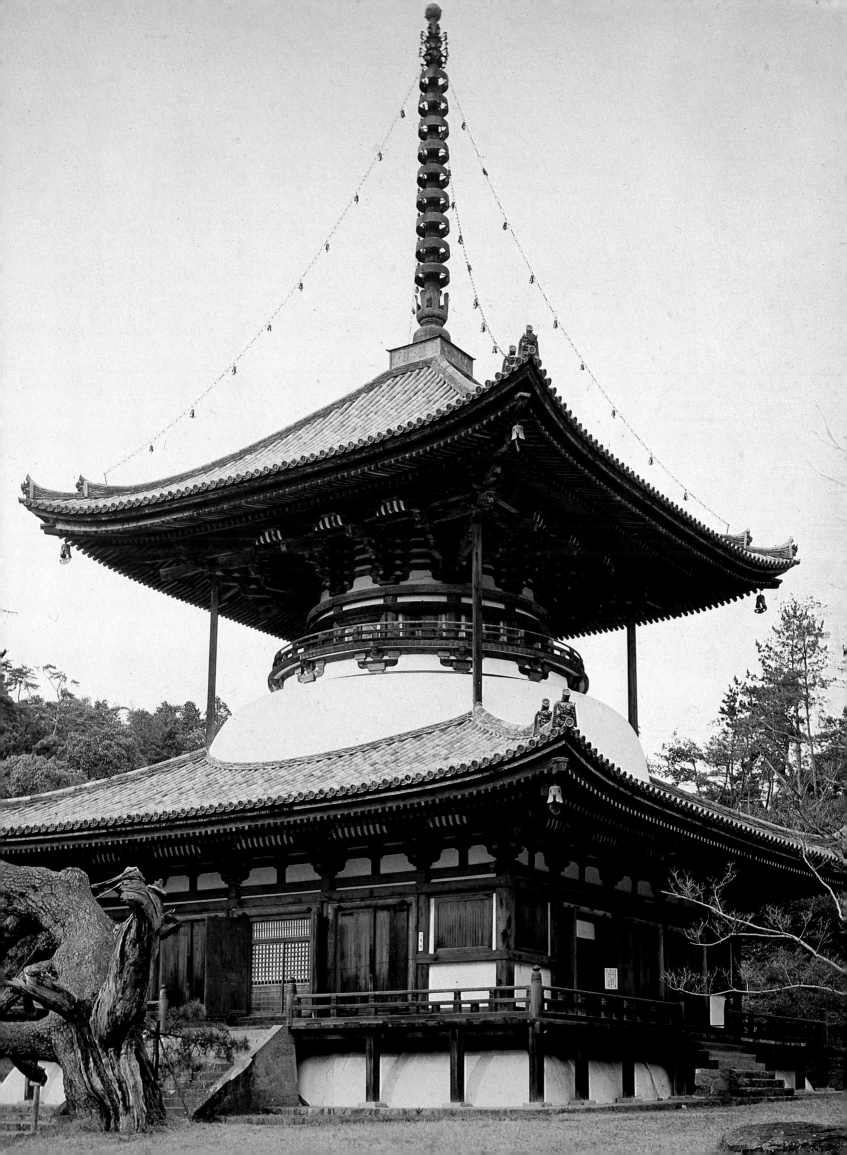

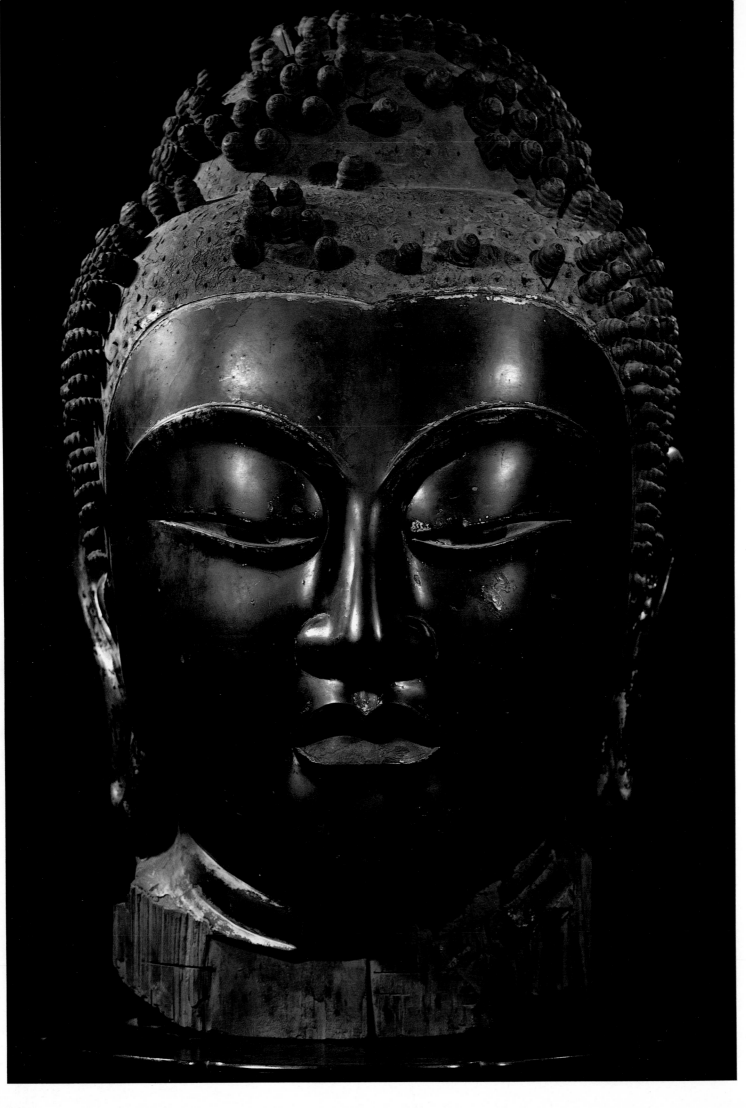

which is symptomatic of most of Zen as it broadened its appeal. After waging bitter war with established icon-using sects – most buildings in a Zen temple are intentionally bare – Zen monks reached back to invoke the name and claim the blessings of Prince Shōtoku and they sent the souls of their dead to the Pure Land of Amida.

Local interest set in motion a major rebuilding effort, especially for the old Nara temples, some of which were sadly neglected, and others, like the Tōdai-ji, almost reduced to ashes. Replacements, repairs and new statues were commissioned from workshops, which responded by expanding, sometimes subdividing, and becoming more efficient.

When the Japanese had decided that this should be done, they looked around for new ways of doing it. Individual monks travelling between Japan and China not only reported the latest in religious philosophy, which was not encouraging, but were examining every aspect of the Chinese arts as had once been the custom. All were affected by what the Japanese could find in China and not only did Japan now have its own rich traditions to draw on but found new types in almost all the arts to supplement them.

It should be kept in mind that two factors affected the arts, although in quite different ways. The power vacuum in Kyoto deprived the traditional arts of their sense of direction as set by imperial leadership since the time of Prince Shōtoku and, in an era which opened with violence and was dominated by a class trained in and maintaining its control through violence, the mood would be vigorous but unsettling – somewhat unpredictable, but rarely uninteresting.

Architecture in particular took a strikingly new turn with the introduction of whole new plans and structural systems brought by invited Chinese monks to erect Zen temples. How far Eisai could apply these principles to the Kennin-ji in Kyoto is unlikely to be known, but despite several fires its sequence of buildings is typical and represents the revival in Japan of the Chinese sense of formality and symmetry.

Yoritomo was probably already dead before any Zen temples were started in Kamakura, but Eisai's Jufuku-ji was begun shortly after his death at the instigation of his wife, Taira Masako, and may have been

the temple which launched the Zen style in that city. In any case, the style thrived and spread to other places where Zen monasteries went up.

Yoritomo did see about creating a capital atmosphere for Kamakura. The large hillside Tsurugaoka Hachiman Shrine, with its splendid avenue of approach, was placed here by Yoritomo in 1180. The spirit of the venerable shrine of Iwashimizu Hachiman-gū at Yawatachō on the Kyoto-Osaka border had been invited to Kamakura in the eleventh century and was now properly installed at Tsurugaoka to overlook the valley and provide protection. Emperor Ōjin and his mother, Regent Jingū, are the enshrined deities. But for all of the shoguns' efforts, they were not born to the purple like the Kyoto art patrons and laboured under a sense of cultural deficiency. Kamakura could in no way match the cultural depth of Kyoto – or even Nara for that matter – despite its special goal of setting the different styles.

Competitively, for symbolism, attraction and Buddhist benefactions, Yoritomo had work started on an image of a large Buddha. This came to be housed in the Kōtoku-in, in a building necessarily colossal to accommodate it. According to the temple's traditions, the present Amida was cast by Ōno Gorōemon in 1252. Sections were cast independently and brazed together in a technique which has left conspicuous joints. As experience with large bronze casting since the eighth century had been negligible, it may have been a production method learned from Chinese technicians. The Amida is just a few *shaku* shorter than the Vairocana Buddha in Nara, some 11.36 meters (37 feet) above its stone base.

One visitor to Kamakura described a large wooden image, called in one document a Shaka Buddha. Begun in 1238, some five years were required for its completion, and it stood for nine years before being replaced by the monumental bronze Amida statue.

The quality of the technique and merit of the work as art are both attested to by time and popular sentiment. The building suffered damage in both the fourteenth and fifteenth centuries, although how much the first time is not at all clear. In any event, a tidal wave destroyed the building in 1495 and no effort was made to replace it. Wooden

Opposite: head of Buddha from the Kamakura period (1189). Kōfuku-ji, Nara.

superstructure falling around the Buddha did not faze it and the Great Kantō Earthquake of 1923 which dispatched historic temple buildings like match sticks, only rocked the Buddha, though most violently. One must assume that the loops for guy wires were added in medieval times after one such frightening experience.

Artistically and technically, close daylight inspection was never the intention. The head is forward, the nose strong, the ringlets of hair heavily overhung, and the legs at first seem too narrow. But a remarkable foreshortening dominates the proportions and the bilaterally balanced drapery and *dyāna* mudrā of concentration, variations of which were used in the Late Heian period, combine to produce what is customarily spoken of as the "calm repose." As the survivor of natural disasters the image commands respect and, as it looks down benignly at the worshipper, it earns affection. Steps in the interior lead up into the body. The inside receives natural light through the wing flaps at the back.

It is safe to assume that the building constructed over the Great Buddha of Kamakura was a magnified Amida Hall, certainly large but perhaps not as sturdy as the eighth-century building which covered the Nara Buddha and less destructive when it collapsed. Since foreign styles of architecture were already on the drafting boards, the traditional style of temple architecture was referred to as *Wa-yō*, Japanese style, in what can be seen as history repeating itself when the need arose to distinguish the native from the foreign style.

Amidist temples went up in the familiar style, but two new styles were brought from China. They are strangely distinguished by knowing or naive misrepresentation as *Kara-yō*, Chinese style, and *Tenjiku-yō*, Indian style. The former was presumably the most sophisticated style then known at the Chinese cultural center, but the latter is apparently from southeast China and has no remote connection with India. Combinations of the two superimposed on the old Japanese style received the name of *Setchu-yō*, but the mix was not widely used; it is best known at some of the secondary buildings of the Tōdai-ji in Nara.

The field for cultivating the Zen style in Kamakura was rich and fertile. Major Zen monasteries were identified with five sacred mountains in China, a custom adopted for Kamakura and later for Kyoto and called Gozan. These were not necessarily named in the order in which they were built, but any temple in the list of five speaks well for its importance and political influence. An earlier temple founded by Ashikaga Yoshikane in 1188 and converted to Zen, the Jōmyō-ji in east Kamakura, and today of little significance, is the fifth, outranked by the Jōchi-ji, built by Hōjō Morotoki in 1283. Jufuku-ji, built by Yoritomo's wife around 1200 is the first Zen temple of Kamakura. The Kenchō-ji, the ranking temple of the city, and Engaku-ji, second in importance to it, were put up in 1250 and 1282 in the northern part and, together with the major shrine, formed the ecclesiastical center of the old regency. Both temples were razed by fire time after time, but unexpendable buildings were always re-erected in exactly the same original style. Whether *Kara-yō* was a generally current style in China or strictly Zen, it took on a peculiar identity with Zen in Japan and by doing so created one of the strangest quirks of fate in the history of Japanese art. The *Kara-yō* was the climax of centuries of refinement of a structural system in China of the most complicated kind. A pair of levers had been adjusted to support the superstructure below the roof instead of the simple equidistant blocks and a single lever or rafter, as had been the case since the eighth century. The lever system was necessary to use the brackets more aesthetically and increase their number. They rise in several steps, not only above the head of the columns but also between the columns, literally covering the wall face below the upper roof. Zen, with all of its professed simplicity, was saddled with the most intricate structural system ever conceived and, in its conservative nature, rebuilt it without variation.

Elements of the style beg to be recognized. Looking under the upper roof, as just mentioned, one sees long, extended beak-like projections known as tail rafters (*o-daruki*) densely packed. When a building is equipped with two roofs, rows of rafters on the upper level appear to come from a central point, the so-called fan rafters, rather than project at right angles to the wall face, and the slender columns are sharply tapered at the top and supported by finely shaped stone bases. Internally, false ceilings are less frequently used. The ends of the horizontal beams are shaped and bevelled, introducing again a sculptural treatment of architectural members not seen since the cloud bracket had disappeared from Asuka-Hakuhō temples. Window exteriors are bell-shaped and transoms have undulating slats. Thatch roofs may have been preferred in Kamakura, thus reducing expense, but they were doubly dangerous for fires and Kamakura temples rarely seemed to be elevated above a country rusticity, in contrast to the polish of the tiled city temples.

In order to realize his plan for a large and dominant Zen temple, Hōjō Tokiyori invited the Chinese priest Tao-lung, known in Japan as Dōryū, who had served at the Chinshan-ssu in Kiangsu. He arrived in 1247 and became the chief abbot of the Kenchō-ji a few years later. This gave him adequate time in Japan to give instructions on the plan and architectural details.

The Chinese axial system was imposed again, but in this terrain it followed the contours of the valley. The main buildings succeeded each other in sequence. They were preceded by the *Sōmon*, a small Messenger's Gate of a largely ceremonial nature, the Main Gate, and then the *San-mon*, written as Three or Mountain Gate. This last was an open structure in Kamakura temples on the lower level, but enclosed on the upper level. The two chief halls are the Buddha Hall (*Butsuden*), and Law Hall (*Hattō*), or the Daruma Hall. In the far north is the abbot's residence. Some buildings were joined by cloisters and secondary buildings stood along the sides, but cloisters were frequently not rebuilt after fires, and the small number of pagodas which accompanied the first Zen temples were regarded as the most expendable feature of all.

The Engaku-ji arose between the two Mongol invasions, in a period spanned by the tenure of Hōjō Tokimune. He invited Tsu-yüan (Japanese: Sogen) from the Ching-shanssu in Hangchou, who arrived in 1279 and built a temple to rival the Kenchō-ji, dedicated to the fallen heroes of the first attack and a prayer for any further aid the *kami* might be willing to bestow in the unsettling times when another invasion was expected. It is reported that architects were sent to China to

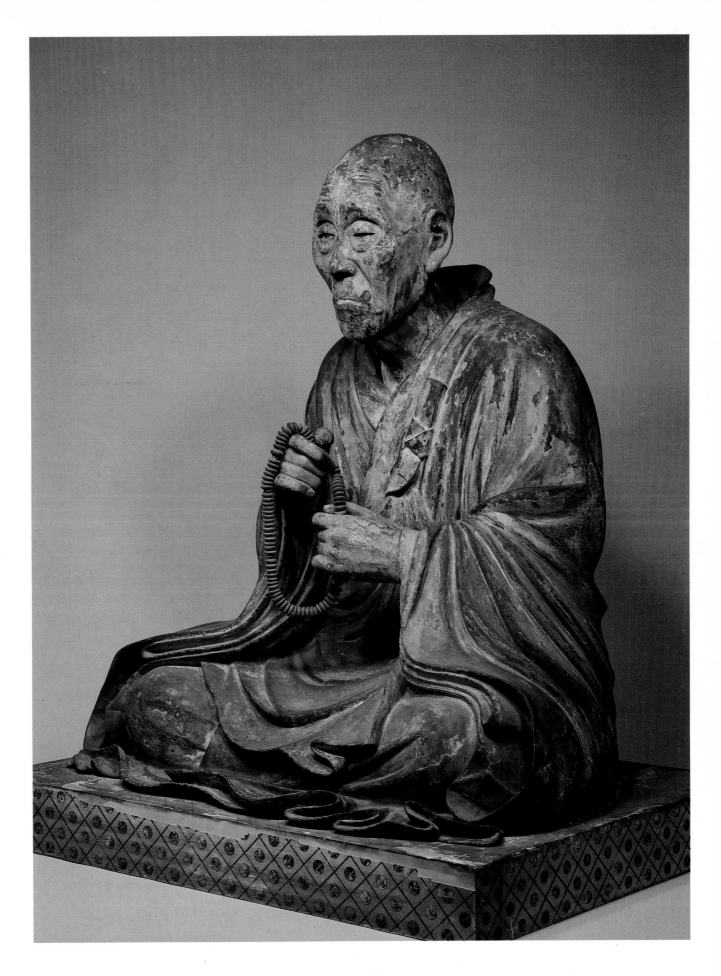

Portrait of the monk Chōgen (circa 1120–1206), wood sculpture. Late twelfth or early thirteenth century. Tōdai-ji, Nara, Hall of the Shunjodo. This Buddhist priest, here portrayed with extreme realism in accordance with the artistic canons of the time, is famous for having devoted the latter years of his life to the rebuilding of the Tōdai-ji after its destruction by fire.

study the latest construction systems, presumably on the advice of Sogen, and the Engaku-ji was dedicated in 1282. This has led to the suggestion that the Engaku-ji was the first real Zen temple, since it was constructed by trained Chinese builders, and the others were rebuilt in this style as replacements for halls were needed, which was all too frequently.

The Engaku-ji has one building which survived all the other ravages until the Great Kantō Earthquake by being well behind the main complex of halls. The *Shariden*, Relic Hall, was probably the oldest building in Kamakura until 1923, but it too went down at that time, though it has been rebuilt with most of its original materials.

The *Tenjiku-yō* was precisely the opposite of the labyrinthine exercise in mechanics of the *Kara-yō*. From its very inception it has been an enigma, particularly through its failure to make any real impact. The style is attributed to Priest Shun-jōbō-chōgen, who appears first in the records as a Shingon priest, then a leading pupil of Hōnen of Pure Land persuasion, and was selected by Emperor Go-Toba to supervise the restoration of the Tōdai-ji. According to the diary of an imperial advisor, Priest Chōgen made at least three trips to China, one of which was in the company of Priest Eisai on the latter's first trip in 1168. Chōgen devoted the last 25 years of his life to canvassing the country for funds and support. He was able to rebuild the Tōdai-ji, although on a somewhat modest scale, and died in 1206 at the age of 86.

In his perambulations raising public support for the Tōdai-ji he built three other temples. One is the Jōdo-ji in Hyōgo prefecture, another by the same name in Yamaguchi and a third, the Shin-daibutsu-ji in Mie. He also built in several other places, but only four buildings in this style remain: the Great South Gate (*Nandai-mon*), Great Buddha Hall (*Daibutsuden*), and Founder's Hall, all of the Tōdai-ji, and the *Jōdo-dō* of the Jōdo-ji in Hyōgo. It may be presumed that at least the later ones were constructed in the same style and therefore the style actually received rather wide exposure in Japan.

The Great South Gate had collapsed after a storm in the tenth century. The reconstruction was carried out in 1199 and the monumental Guardian Kings installed in 1203. The gate is of immense dimensions, overshadowed in size by few others, with the exception of the Chion-in gate in Kyoto. In this case the gate has long, narrow and high proportions and is capped with two roofs of equal projection. The features here are such a break from tradition and at this juncture in time such a contrast to the elaborate Zen style that it was not only its style but the timing of its use which determined the degree of its acceptance.

Instead of following the customary form of stepping the bracketing alternately up and out, arms are inserted into the pillars and projected forward in increased lengths, allowing for one additional block on each level. This makes a 1, 2, 3, 4, 5, 6, 6-step rise and one of 2 under the roof and, for the upper roof, a similar progression plus a 2 and 1 where the roof line makes the arm recede. In other words, the bracketing system projects from the face of the building only at right angles, leaving the wall surfaces otherwise uncomfortably bare. The same bareness can be seen in the interior. Instead of the natural flow of structural members through the "walls" and the rich play of shapes that makes up the logical transitions (or at least what everyone had become used to) the brackets stop on the outside and cease to exist except in miniscule single and paired blocks on the interior. One walks into an architectural blank and not into a constructed sense of space. The system, to put it simply, is bereft of the traditional exterior-interior organic unity.

A feature of this style that the others lacked is an economy in materials and labour which resulted from a mass assembly technique as yet undeveloped in other styles. Chōgen's personal style was frugal, and by building three other temples he made it go a long way in his lifetime. But since it was never again used in its pure form one must assume that its advantages did not outweigh its disadvantages. In a sense, with the none too popular imperial stamp on it, it was too imperial, and with the aesthetic insufficiency it was not imperial enough.

The Great Buddha Hall may have been reconstructed in its original size and perhaps even original style, but a disastrous fire in 1567 was enough cause to reduce it, when rebuilt, from 11 bays on the north and south to seven and to use the Kamakura structural system. The

Opposite: detail of a statue of the monk Mujaku by Unkei (1161–1223), now preserved in the Kōfuku-ji, Nara.

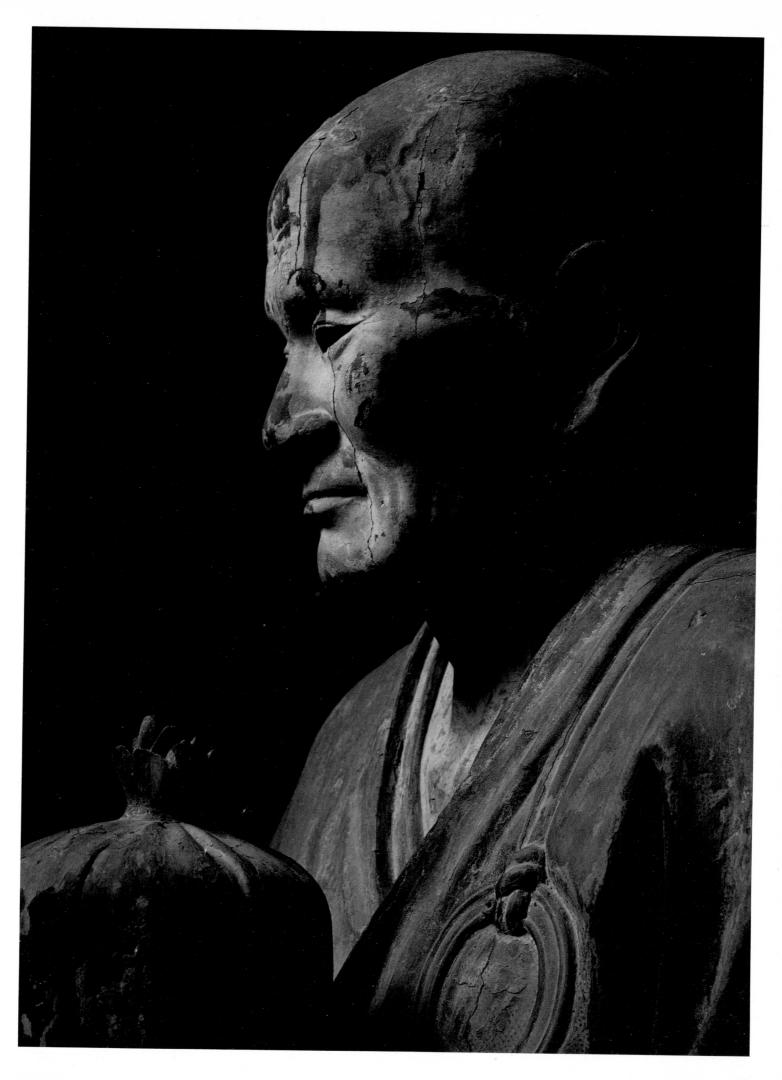

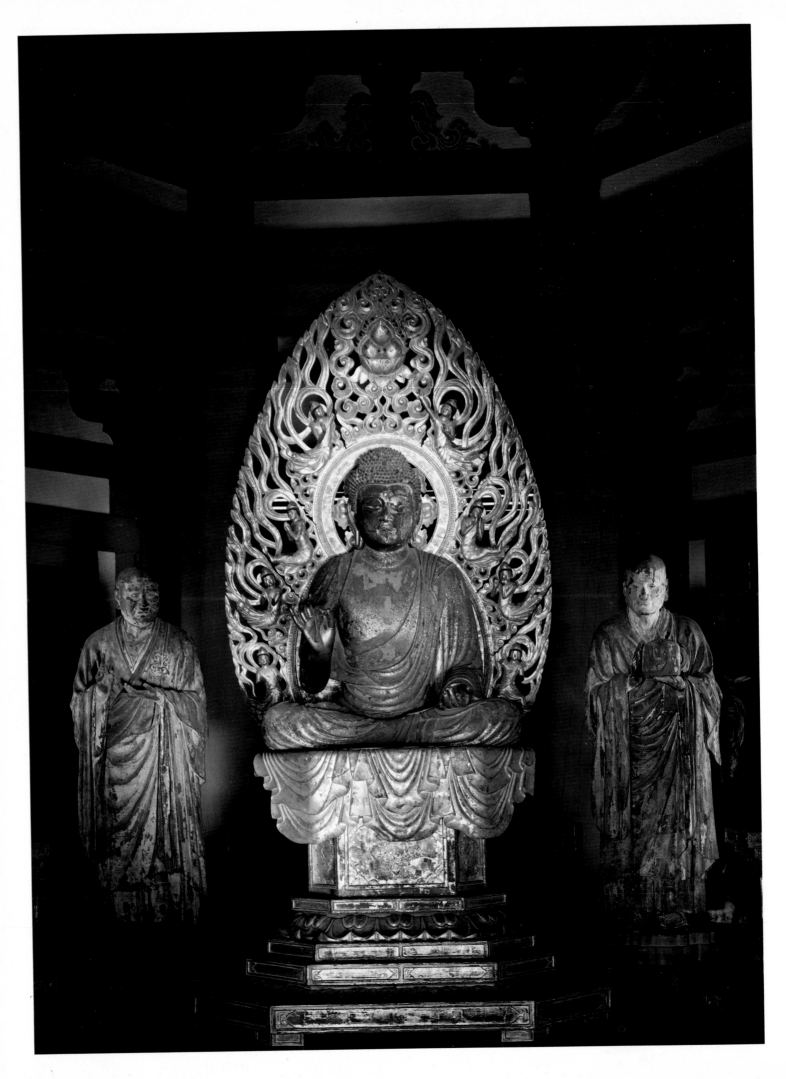

original dimensions of the height and depth were kept to suit the Great Buddha; center strengthening for greater protection of the statue was provided by the addition of four columns on either side.

The reconstruction of the Tōdai-ji was only part of a major revival of Nara temples and renewed interest in the surviving exoteric sects there. The Easy Path had been corrupting and degrading, and the recognition of the traditional values of literacy and a greater degree of philosophical intelligibility in Hossō, Ritsu and Kegon revealed a deep vein of sentiment in the capital in the public's response to the wanton destruction of the old monuments.

The narrative scrolls moved in the direction of what the critics had called *otoko-e*, masculine painting. With more intuition than rationality, the scroll subjects had been classified as *onna-e* and *otoko-e*, feminine and masculine, in effect, more passive and more active, using the Genji and the Shigi-san paintings as the standards. The classification's chief merit is its historical insight into the aesthete's response to the different styles.

When literary men in the Edo period surveyed the history of the scrolls they saw them in several groups: stories glorifying the warrior class and romanticizing revolts, spurred by the interests of the samurai (*monogatari*); stories of monks and the founding of sects and temples (*eden*) and of shrines, legends and miracles, derived from the concerns of the clergy (*engi*); diaries of individuals, usually of cultured persons at the court (*nikki*); stories that are essentially moralistic in nature, mostly the so-called *Rokudō-e*, Six Paths or Six Realms of Rebirth, from the cycle of which one is released only by achieving enlightenment (the term *soshi* or compound *-zoshi* came to be applied to these); and others, illustrating poets and their poetry (*kasen* and *uta-awase*).

Far more scrolls were painted than exist today, and a large number had military subjects, in particular stories drawn from the battles between the Taira (Heike) and Minamoto (Genji). They embodied excitement and created heroes for militant minds. As the art grew, monasteries used their skilled monks to record temple origins, sectarian personalities, saints and the supernatural. Their preoccupation with the Six Realms, in levels graded from celestial spirits down through human beings, angry demons, beasts, hungry ghosts and hell, was consonant with the pitch of the Buddhist reforms and the graphic realism that sprang from earthy, secular interests. The fertile imagination of facile painters portrayed diseases, grotesque personifications and the horrors of hell in appalling states, involved in the most disgusting acts of obscenity.

Many scrolls were copied and some are now known only through later copies. Conventionalizing processes were creeping in even during the fourteenth century and in later times stylization was habitual. Mist and cloud patterns took on hard outlines. Water, mountains and buildings were rendered in predictable shapes and decorative lines. Outside of this, the Tosa school kept the genre alive in a fresh way, partly by including more topical subjects.

Temples were natural repositories for scrolls, where they served as instruction for trainees and validation for practices. The largest number of preserved scrolls belongs to the group dealing with temple histories, founders of sects and miracles of associated spirits. These include such scrolls as *Kokawa-dera Engi*, one scroll illustrating a pair of miracles based on a Thousand-armed Kannon; *Kegon Engi*, six scrolls depicting in a semilegendary way a pair of Korean priests, the founders of the Kegon sect in Korea, making a trip to China and being protected by a woman who had fallen in love with one of them and who turned herself into a dragon to protect him on his return; *Taima Mandara Engi*, one scroll recording the magical weaving of the mandala by a princess with the advice of Amida and the aid of Kannon, and her reception in paradise after her death; *Kasuga Gongen Reigen Ki*, two scrolls portraying miracles performed by the guardian deity of the Fujiwara clan, painted in 1309; *Saigyō Monogatari Emaki*, two scrolls illustrating the wanderings of a warrior turned priest who found his inspiration in nature in the Yoshino and Kumano mountains; *Hasedera Engi Emaki*, three scrolls showing miracles connected with the making of the Kannon image of the temple and including a visit by Emperor Shōmu; *Hōnen Shōnin Eden*, 48 scrolls executed by several calligraphers and illustrators between 1307 and 1317, picturing the life of the founder of the Jōdo sect, a century

The Miroku Buddha (Miroku Nyorai) with the two monks Mujaku and Seshin, wood sculpture by Unkei dating from c. 1208. Kōfuku-ji, Nara, Mujaku and Seshin are the Japanese names for the two Indian monks, Asanga and Vasubandhu, who conceived the Hossō philosophy practiced in the Kōfuku-ji.
Overleaf: details of the polychrome wood sculptures of two Guardian Kings (Kongo Rikishi), Agyō and Ungyō. They are attributed to Jōkei and were executed between 1190 and 1198.

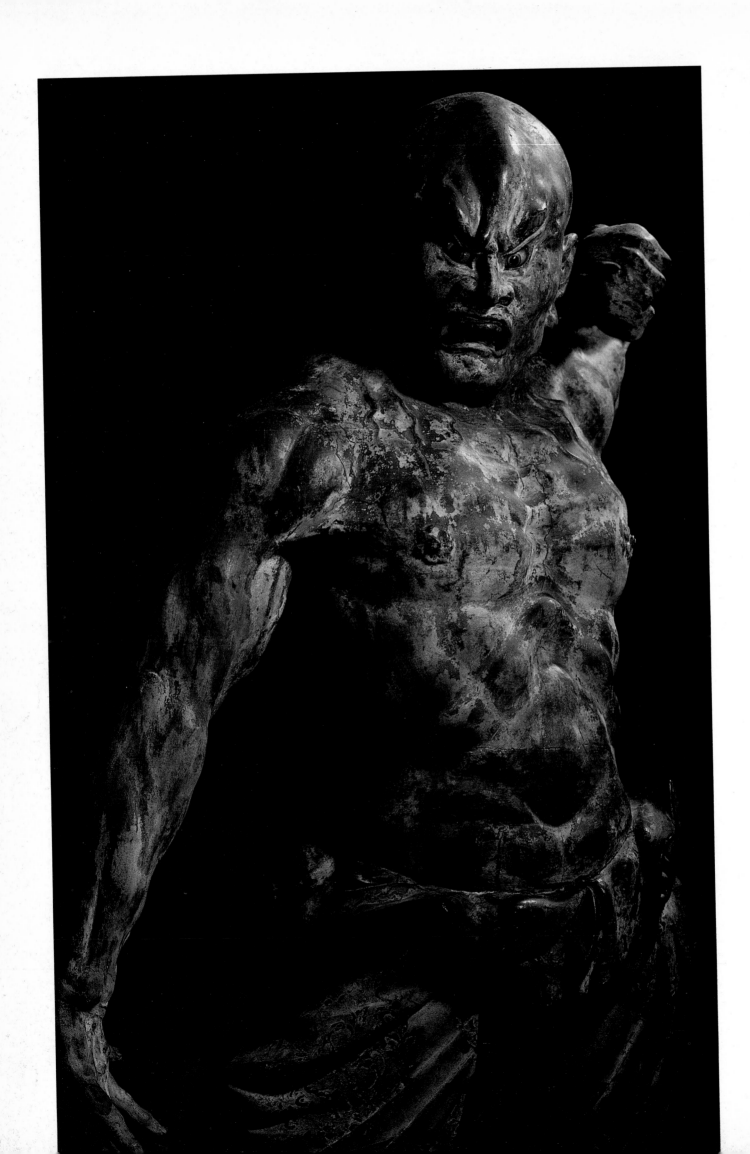

after his death, in an exceptionally comprehensive view of activities of the time, and a sample of what large temples and their affluence could do to give sectarian authority to their traditions.

A brief look at examples will put the narrative scrolls into perspective as one of the highest peaks in Japanese art. Behind the development are certain underlying assumptions. The stories cannot be told without action, human emotions and geographical settings. Action indicates an urgent sense of purpose in achieving a goal, maintains a high level of interest, entertains and marks the climaxes of a story. Human emotions were not to be publicly exposed by Heian aristocrats, especially by men, leading to the stereotypes of the Genji scrolls. Other social classes were without such inhibitions, and Chinese-style brushwork was used to render feelings and relationships in natural ways. Geographical settings were needed to show the choice of battle sites, trips abroad, mountain miracles, town streets or a particular shrine. The locale gave the story its immediacy, without which it would have little meaning.

Temple histories and legends go back to the seventh and eighth centuries. The *Tōsei Eden*, Eastern Journeys of Ganjin, portray the efforts of the Japanese monks Eiei and Fushō to conduct the Chinese priest safely to Japan. The story is a familiar one. With its message that all hardships can be overcome in the dedication to a cause, it was a source of endless inspiration, and the drama of the 14-year effort was fare on which the Kamakura spirit thrived.

Ganjin encountered seemingly innumerable disasters, being thwarted five or more times by storms, shipwrecks and pirates. The artist mentioned at the end of the five scrolls kept by the Tōshōdai-ji was a monk named Rokurōbei Rengyō and the scrolls were given to the

Detail of the figures of the Juni-ten (the Twelve Heavenly Deities). Right: Katen, the fire deity; opposite: Gatten, the moon deity. Silk paintings by Takuma Shoga, who is thought to have executed them for the Tō-ji, Kyoto, in 1191. The complete work is made up of two screens, with six figures on each.

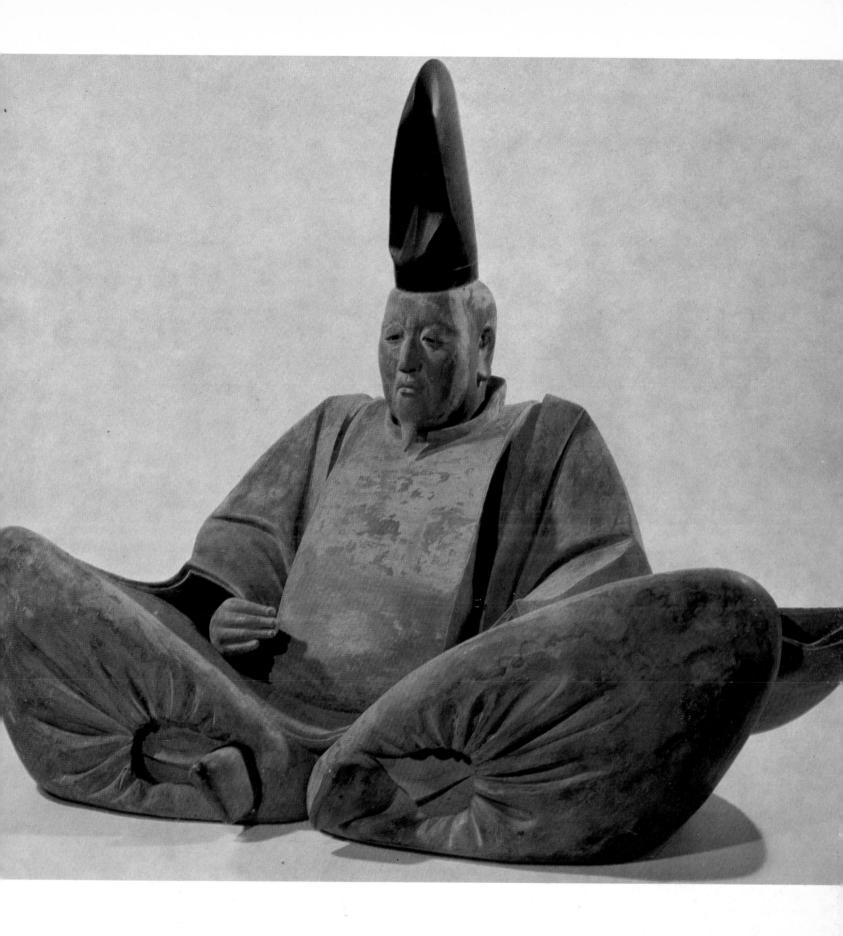

*Above: portrait of Uesugi
Shigefusa. Wood sculpture of the
thirteenth–fourteenth century.
Meigetsuin, Kanagawa.
Opposite: portrait of Minamoto
Yoritomo. Silk painting by
Fujiwara Takanobu, c. 1188.
Jingo-ji, Kyoto.*

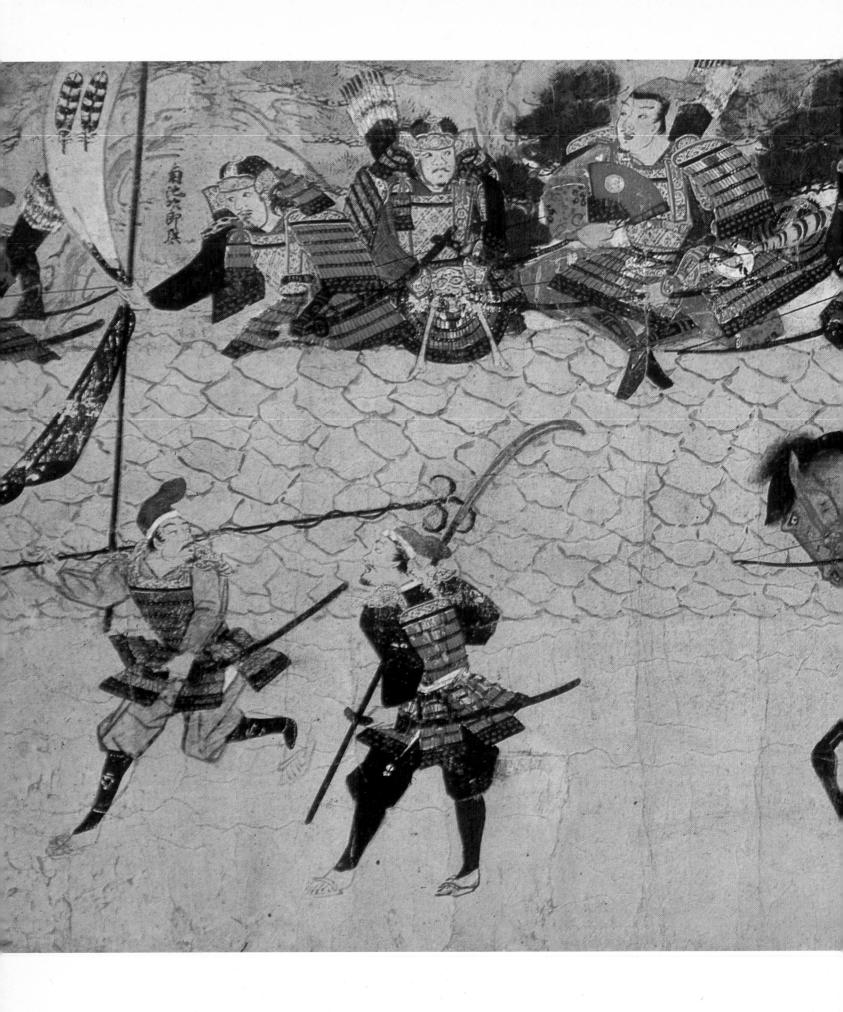

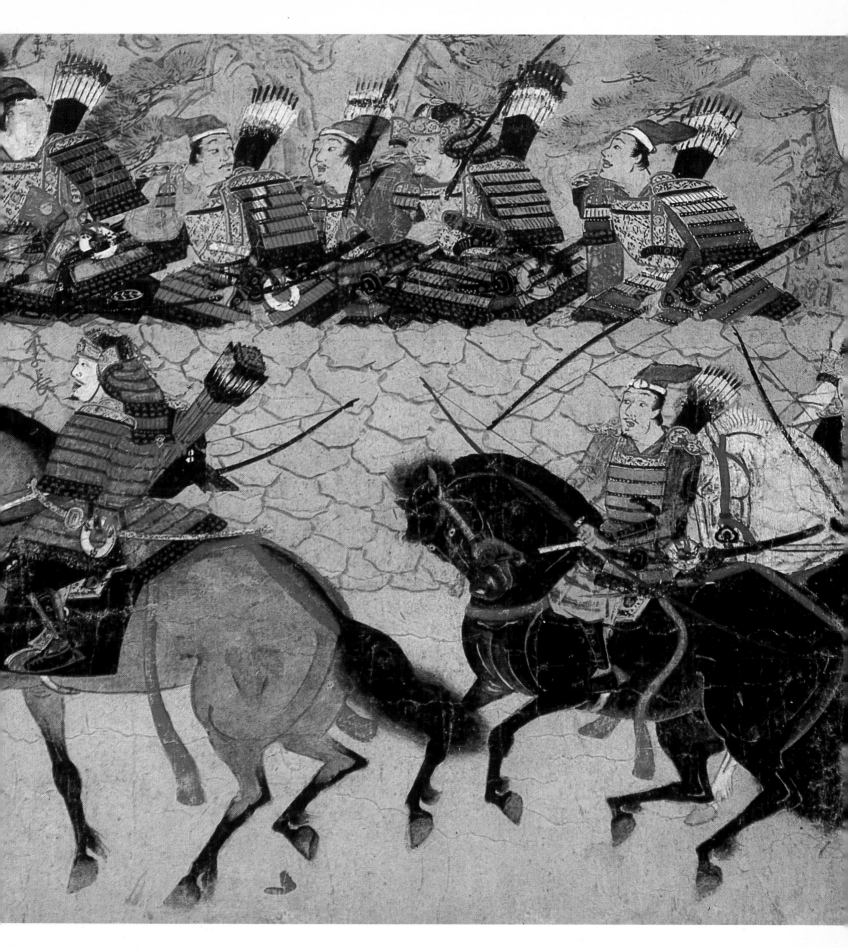

Detail of armed men from the painted scrolls known as Mōko Shūrai Ekotoba *("The Mongol Invasions"), which celebrate the victories won by Takezaki Suenaga over the invaders. The two surviving scrolls, which should date from shortly after 1281, provide comprehensive descriptions of the battles and lay great stress on the figure of the victorious general. Imperial Household Agency, Tokyo.*

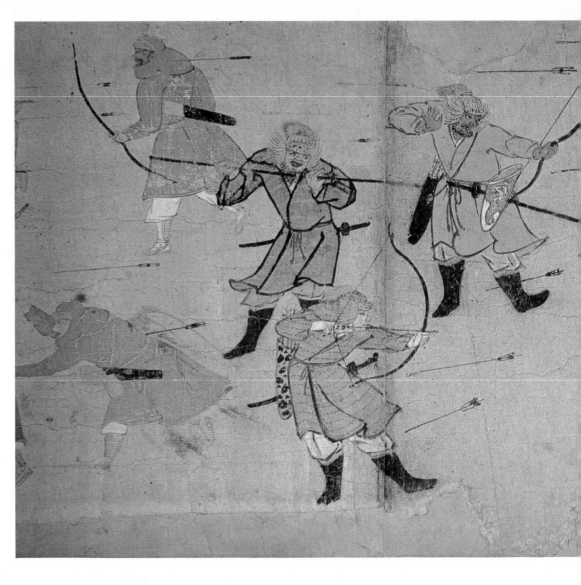

Another detail from the Mōko Shūrai Ekotoba *scrolls dealing with the victories won by the Japanese over the invading Mongols. Imperial Household Agency, Tokyo.*

temple in 1298 by Ninshō, chief priest of a Tōshōdai-ji-related temple in Kamakura. The artist may have at least seen the ocean from Kamakura and some useful Chinese paintings, but he was still forced to draw on his imagination and the results reveal this, though not with the degree of quaintness seen in the later Namban paintings, the Southern Barbarians, who, after all, were totally unfamiliar to the insular Japanese.

The entire country revelled in the victories won by Takezaki Suenaga against the Mongol invaders. The triumphant general commissioned scrolls to be painted, called *Mōko Shūrai Ekotoba*, The Mongol Invasions, two of which are preserved, probably dating from shortly after 1281. The purpose was transparently personal aggrandizement, and the larger, strategic view of the battles therefore does not emerge. Takezaki plays a consistently foreground role.

Essentially, the first part can be considered the successful skirmishes in the earlier assault, followed by the

intervening lull when Takezaki went up to Kamakura to notify the shogun of his victory, and concluding with the lively action of the second invasion attempt. The smaller Japanese boats make lightning thrusts at the lumbering foreign ships, and the one-sided slaughter of thousands of invaders needs no propaganda distortion to support it. The truth is wholly convincing.

The recent past was still fresh in the memory. Anti Taira feelings were strong at the end of the thirty years' war, especially in Nara where the Tōdai-ji and Kōfuku-ji lay in ruins, and the unexpected victory by the Minamoto was exhilarating in its limited way. In the hands of the artists this spirit comes through in the masterful handling of the animated battle scenes. Horses charge in fear and arrows fly furiously while soldiers fall and background buildings burn spectacularly. Not only did they catch the drama of the moment, the mêlée and confusion of the fight, but the painters could change the tempo abruptly to regroup the forces and survey the still and

mournful battlefield.

The *Heiji Monogatari Emaki* is known in only three scrolls today, but many more would be needed to recount and depict the entire sequence of events that began in 1159 (Heiji 1), precipitating the all out war between the Taira and Minamoto. The events that are shown all belong to the early stages of the war.

The most charming landscapes are the setting for the stories in the *Ippen Shōnin Eden*, in 12 scrolls illustrating the travels of the founder of the Ji sect who restlessly propogated the dancing *nembutsu*. The landscape is larger than usual and is seen from a very high viewpoint. Buildings are delicately painted and the figures are small. Ippen moves through open country, in temple or shrine grounds, or through streets lined with shops, stalls, vendors and craftsmen and he attracts the attention of the crowds when he and his followers dance to the beat of percussion instruments, as they do in Kyoto. The monk En'i finished the paintings in 1299, some ten years after the death of Ippen. En'i was

almost a miniaturist at heart, but with none of the static stylizations so often associated with miniaturistic work. Ippen's presence awakened the people, and real living begins to be portrayed. His face is often not seen, yet when it is he has a slightly pointed head, dark skin and intense eyes. He wears a dark robe and usually walks with hunched shoulders. A close look reveals vigorous brushwork to delineate a man of strong will and action.

Miracles are stressed to prove the validity of the *nembutsu*. One sees the Kumano *gongen*, the spirit of the mountain, accepting the absoluteness of the *nembutsu*, and in another vignette a dragon appears on a beach when the name of Amida is invoked, thus assuring salvation through the *nembutsu*.

Shingon painters continued to paint mandalas, but both Shingon and Tendai as such had a limited future. Their doctrines were beyond the reach of even the educated class and the scriptures so abstruse they could only be understood through art, as Kūkai himself had said:

through the aesthetic experience of just seeing a mandala one could attain Buddhahood. The esoteric line of reasoning had filtered through Amidist philosophy to assign esoteric identifications to earlier icons. The paradises of the wall paintings of the Hōryū-ji, for example, were identified with otherwise little known esoteric Buddhas, and some statues with lesser known bodhisattvas.

Painting portraits was part of the special ritual introduced with Zen doctrines from China. The earliest examples in Japan are Chinese, at least five of which are preserved in Zen temples in Kyoto. They are of course of Chinese monks and, in the Chinese fashion, are dated, all falling between the years of 1198 and 1265. During these decades Japanese "masters" taught their own pupils, and artists adapted the Sung dynasty technique of flexible brush strokes to produce a realistic portrayal of their models. In contrast to the Late Heian conventions, what was required was a lively line which could express features and the character of the individual. When it did come, the Japanese gave it strength and confidence, not only for the physiognomy but also for the costumes – which may have more character than the physical features.

Priest portraits were known since the eighth century, but few temples were fortunate enough to have painters with such gifts among their clergy and few professional artists were trained in portraiture. There was, in fact, some – and probably ancient – superstition against it. The demands were too limited for professional artists to do more than conventional face features. Predictably, *yamato-e* was not long in developing its own sets of conventions which could be taught and mastered easily.

Starting around 1260, Japanese painters assumed the task of making portraits, first using the revered Chinese monks residing in Japan as their models. Wu-an Pu-ning (Japanese, Gottan Funei) had been sponsored as head priest for the Kenchō-ji in Kamakura by Hōjō Tokiyori. Tokiyori died in 1263, however, and Funei decided to return to China two years later. His portrait was painted by two Japanese artists, one by Chōga, who must be Takuma Chōga, a man therefore trained in Buddhist subjects and in whose style the *yamato-e* element is revealed in the milder manner in which the portrait

is executed, and the other is by Seian, a man not otherwise known, but one who should not have come out of the same school. He adapted or developed his style for this genre by employing a much more energetic line.

Japan had not been without realistic portrait painters, but the fact that a very small number are singled out for mention is sufficient to indicate their rarity. Two of these were father and son, Fujiwara Takanobu (d. 1205) and Nobuzane (d. c. 1265), whose forte was *nise-e* or physical likeness painting. Among others, the famous portraits in the Jingo-ji are said in the *Takao-yama Jingo-ji Ryakki* of 1328 to be the work of Takanobu. It is reported that he was asked to add the faces on a set of sliding screens after other details and human features were done. Takanobu was a politician, *sakyō-daibu*, master of east Kyoto and once a provincial governor. His hobbies were painting and poetry. He was, in other words, not a professionally trained painter but a Renaissance man of considerable culture and talent.

Three of the four portraits owned by the Jingo-ji are obviously part of a set. The compatible ones represent Minamoto Yoritomo, Taira Shigemori and Fujiwara Mitsuyoshi. A fourth, of Priest Mongaku, might be a substitute for a former one of the group. The information in a diary of Kujō Kanesane speaks of an imperial pilgrimage by Emperor Go-Shirakawa accompanied by four men, that is to say, these three and Taira Kanefusa. The portraits may have been made to commemorate this visit to Mt. Kōya and were therefore composed of a set of five, an additional one of the emperor to be hung in the middle. If so, Yoritomo and Kanefusa looked at him on his right and Shigemori and Mitsuyoshi did the same on his left.

The portrait of Mongaku, friend of ex-Emperor Go-Toba and abbot of the temple, may then have been

Opposite: portrait of the Buddhist monk Gottan Osho dating from c. *1334. Although there are well known portraits of monks from as early as the eighth century, it was not until the mid thirteenth century that Japanese artists began to apply themselves seriously to portraiture. Amongst the earliest subjects were Chinese monks living in Japan.*

included later to pay him due honour as head of the temple. Even the others do not have the consistency of one artist's hand and raise the question of substitutes or copies.

Yoritomo, Shigemori and Mitsuyoshi have much in common, in particular the colours, pose and costumes. These are rather large paintings on silk, bordered with embroidered edges to suggest the subjects are seated on *tatami* mats. The portrait of Yoritomo is an eloquent and incisive work of art in its sense of compact and controlled power. Much is implied in sparing terms. The format is composed of plain black flat surfaces against a light background and minor undergarment breaks. Angles have knife-like edges. The details are precise, pale and grim; each hair is neatly in place. Symbols of position and authority, such as the sword handle and tablet, stand out sharply and give little relief from the heavy, humourless pall of disembodied surfaces. It is easier to project into this portrait what one knows of Yoritomo – a man of pitiless and remorseless personality.

Old materials were revived and new ones adopted in the art of sculpture, adding some variety and diversity. The Great Buddha of Kamakura was a return to bronze casting, although employing a new technique. Tomb stones were made with the image of Buddha in high relief. Stone roadside guardian figures appeared. A few iron figures were cast, including Fudō among other subjects, but limited to the Kantō region. Realism brought on a new type resembling a mannikin. Benzai-ten of Kamakura is an example, the water, music and, later, prosperity goddess. The image is a female body to be clothed, with arms in position to hold a stringed instrument.

Most of the sculpture was in wood. Cypress was preferred, but other woods were equally useful. The multiple-block technique was refined in smaller blocks, and the trend moved dramatically toward extreme forms of realism by carving life-size figures, using natural paint colours, and setting in eyes of crystal or obsidian. Some dismantled and repaired Nara period images were given a pair of such eyes – which makes the difference between somnolent detachment and intense immediacy.

A major task facing the sculptors was just this rehabilitation of the old

Nara temples. This task put them in direct contact with a style which had left off in Nara close to its peak and in its religious idealism was only a step to the secular realism employed by the Kamakura sculptors.

Fortunately for the current needs, sculptors working in wood had opened workshops in their own houses from about the first half of the eleventh century, adding substantially to the customary production issuing from the temple and government bureau workshops.

Kamakura Buddhist developments did not steer the arts along their customary course. Historically, once Buddhism had arrived, new introductions made or enlarged the pantheon and gave richness and depth to the iconography. This had the effect of creating work for the artists. Both the original exoteric sects and the later esoteric sects followed this pattern. But the practices of the Kamakura reformist monks tended to call for more of the same or revived dormant types, while Zen was actually inimical to the concept of images of abstract deities and its contribution to sculpture was itself a little like a revival of priest portraiture.

Several factors figured in the deterioration of the art following the thirteenth century: Zen's detraction from the medium, the impasse reached by a realistic style and the unmatchable quality of some of the personalities – which usually turned later Asian eyes backward and not forward – and Sung China was veering off into pictorial and less interesting directions. Together, Japan was left without a future in three-dimensional sculpture and many who would otherwise have continued to work in the art were slowly diverted to the field of architectural decoration, which became a major medium in the Kyoto area.

Kamakura sculpture therefore consists in large part of traditional, updated Late Heian-style work. There are some very striking archaisms. For example, the bronze Amida of the *kondō* of the Hōryū-ji was made to harmonize with the Shaka and Yakushi images of the Asuka period. It was installed on the Buddha platform in 1232. Statues of Prince Shōtoku and Kōbō Daishi at a young age were made for display on special occasions, and there are images of sect and temple founders, Shinto deities, many esoteric deities, in particular Fudō and Dainichi, and the consistently popular

Jizō. Shaka and Maitreya enjoyed a modest revival. Several groups, such as the Twelve Divine Generals of Yakushi and the Kings of Hell (*Emma-ō*) and Ten Judges of Hell (*Jū-ō*) in Chinese garb, the latter the arbiters of the soul's disposition who take their vacation in the summer thereby allowing the spirits of the dead to return temporarily to the land of the living (*o-bon*), were appreciated iconographic types.

The largest group of all is that of the 1,001 statues of Kannon in the Sanjūsangen-dō of the Myōhō-in in Kyoto, a hall 118 meters (387 feet) in length, rebuilt in 1266 after a fire destroyed its twelfth-century predecessor. The 33-bay hall, identified with the 33 manifestations of Kannon – but actually consisting of 35 bays – contains one of Kyoto's most spectacular sights, the work of one of the major workshops that is said to have required about 100 years to complete.

The two major workshops which flourished at this time were located some distance from each other in the city. The Shichijō Bussho was in the seventh block and traced its direct lineage to Kōshō, the father of Jōchō, who had opened the workshop shortly before the middle of the eleventh century. The other large workshop was a branch which had been begun only slightly later, Sanjō Bussho, in the third block. The latter attracted sculptors with a thoroughly competent training in traditional styles, but none became noted for his original contribution to the art.

Kyoto was essentially conservative, dominated as it was by patrons who wanted replacements for their art treasures in a familiar style, or new ones in much the same vein. This Third Block School came to be spoken of as En-pa that is, En School, as it numbered among its generations of sculptors such names as En-sei, Chō-en, Ken-en and Mei-en. A related workshop was operating at Shichijō Ōmiya on the west side of the city.

The original organization under Jōchō maintained some front distance as the style setter and, as time went on, it was the source for more branches. In contrasting terms, the Shichijō Bussho has often been spoken of as the Kei-ha, Kei School, it too having a succession of directors with a common character in their names. For example, Kōkei, Unkei and Tankei.

Demands became great enough for this shop to establish a branch in Nara where it dealt chiefly with commissions from the Tōdai-ji and Kōfuku-ji. In Kyoto it is best known for the almost endless undertaking of carving the wooden Kannon images for the Sanjūsangen-dō which according to the records were executed by 70 sculptors under Unkei and Tankei. A few Kannon figures had been saved from the fire, so these were used as models in an effort to retain a uniform Late Heian style. Tankei, although aged 82, had the prestigious assignment of the central 11-headed and 1,000-armed Kannon.

These terraces of images are impressive by their sheer quantity, but are also intriguing if one looks for the blocks of figures with slightly different costumes, hair styles and other details. Few sculptures, however, surpass the Twenty-eight Spirits under Kannon standing in the dim light of the extensive hall at the back. They should be looked at more closely than most observers do to understand the capabilities of the workshop. Such virtues of Kannon as compassion, beauty, wisdom, alms giving, devotion and exorcising evil are shown in personifications. Unkei's handiwork can be seen in their liveliness, variety of stances, slight imbalances and, sometimes, riveting realism. The Basu Sennin, the emaciated elderly mendicant who wears an animal skin and walks to save souls, had gained the respect and sympathy of all the sinners he met, having taken the burden from them. His undernourished physical condition heightens the piercing look of his crystal eyes.

Kōkei started the Nara workshop and it reached its peak under his son, Unkei. The familiarity and intimacy they gained while effecting repairs on Nara sculptures conditioned their directions, whereas the point of departure for the Kyoto sculptors was the Late Heian style. Sculptures supplied for various Kōfuku-ji buildings are now grouped in the Treasure Hall. Among the most distinguished are the figures of Mujaku and Seshin, Asanga and Vasubandhu, the Indian monks who conceived the Hossō philosophy. These are dated to 1208. In a sense universalized as types symbolizing intellectual, human and warm attributes, they are at the same time highly personalized portraits, an artistic version not unlike modern waxworks.

Two Guardian Kings (Kongō Rikishi), Agyō and Ungyō, are identi-

Opposite: equestrian portrait of Ashikaga Takauji. Moriya Collection, Kyoto.

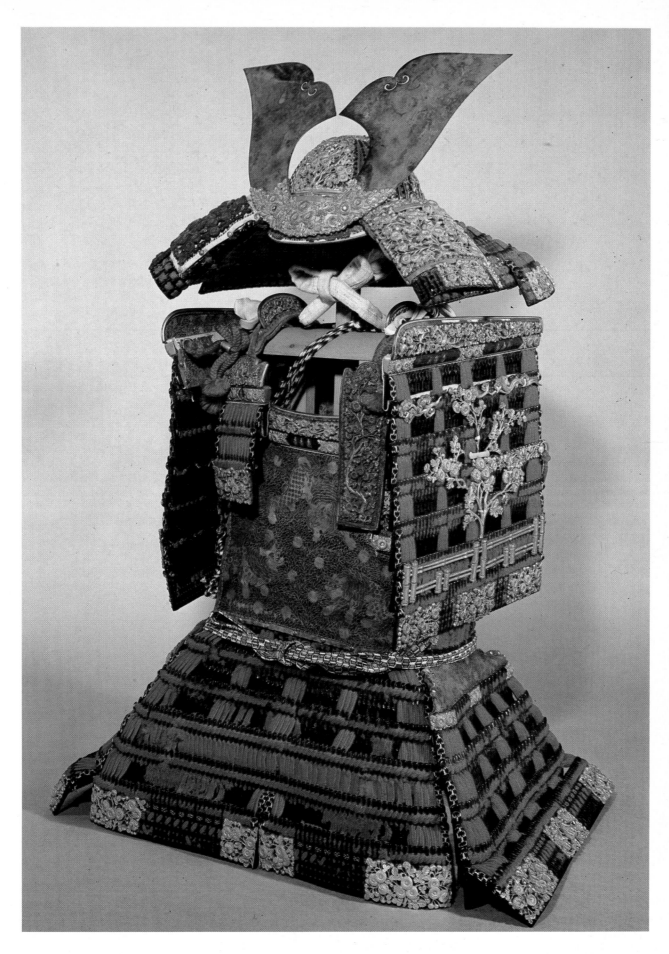

*Opposite: equestrian portrait of
Hosokawa Sumimoto. Eisei
Library, Tokyo.
Above: suit of armour laced
together with red cords. Late
fourteenth century. Kushibiki
Hachiman-gū, Aomori prefecture.*

fied with Jōkei by inscription and said to have been done in an era which falls between 1190 and 1198. As a pair, they balance each other. Together they personify the opposites that have guarded temple gates since Hōryū-ji times: the left hand up, mouth open; the right hand up, mouth closed. Muscles are flexed, surfaces ripple, veins crawl like snakes and skirts are pictorially windblown in a kind of convulsed sense of physical power.

Unkei's earliest dated work is the Dainichi Buddha of the Enjō-ji in Nara (1175). It has many traditional characteristics. Unkei worked for the Tō-ji in Kyoto, where he repaired some of the statues, and for the Jingo-ji in Kyoto, for temples in Kamakura and a temple in Shizuoka. In 1198 he was put in charge of the sculpture work of the Tō-ji, some of which had been ordered by members of the Minamoto family. The largest effort was the pair of Niō of the Great South Gate of the Tōdai-ji which stand about 8.3 meters (26 feet) high. Temple records say they were begun on the 24th day of the seventh month in Kennin 3 (1203) and installed on the third day of the tenth month in the same year, and the sculptors were Unkei, Kaikei, two other sculptors with master standing and 16 assistant sculptors. The remarkable feat of 72 days represents a staggering display of workshop efficiency. Unkei died 20 years later and never exceeded in quality the climax his style attained during these years.

Today the Guardian Kings are seen only after one enters the gate. They tower overhead, presiding over a grand entrée to the temple. It was probably a sixteenth-century restorer who decided to put thin walls across the two end bays to protect the images and then turned them inward. Such a large open gate provided little protection from rain and they were already rather damaged by that time. No touching up seems to have been done.

Another talented sculptor in the shop was Kōben, a son of Unkei who is known only through two remaining works. The Tentō-ki and Ryūtō-ki are short, squat and muscular lantern-bearing personified spirits, products of the deep reservoir of demons in the form of monstrous, subhuman creatures. Despite incompatible poses – which may mean there were actually more of them – they are probably both the work of Kōben. Only one, Ryūtō-ki, is inscribed. On the interior it says "(it/they was/were) made at the request of Priest Shōshō" and includes a date equivalent to 1215.

The remarkable wooden image of Priest Chōgen, rebuilder of the Tōdai-ji, where it is kept, is a lifelike statue of an old man, perhaps done in 1195 or about the year he died at 86 in 1206. The surface is completed with dry lacquer. The image lacks crystal eyes, the trademark of the Kei School, but it fits the style of the time as being so lifelike as to be unnerving. Portrait statues of Chōgen are also preserved in each of the three temples he founded in west Japan, but the one in the Jōdo-ji in Hyōgo is dated 1234 by inscription and is probably therefore based on either the Tōdai-ji or the Shin-daibutsu-ji image. The one in the temple in Yamaguchi is in a different format.

Another tack was followed for the small seated images of Uesugi Shigefusa, Minamoto Yoritomo and Hōjō Tokiyori. The size and style have some connection with the kneeling Izusan Gongen now in the Hannya-in in Shizuoka, a Shinto statue which was moved there when shrines had to be purified of all icons regarded as having a corrupting influence. As a personification of the mountain deity (*gongen*) of Izusan, it does not fit at all with the usual fierce *gongen* types. There is some other, mystifying connection. At any rate, it was worshipped along with Hakone *gongen* in the Kamakura period when it was known as Hashiriyu *gongen*.

These little figures are finely constructed and carved in flat planes with angular edges. Linear costume surfaces and a manifest symmetry give them a stiff formality quite becoming Kamakura aristocrats. A Kamakura trait is the double edge along the hems. The Uesugi family settled there in 1252 and rose to become important advisors to the shoguns. Portraits of secular temple patrons, in this case of the Zenkō-ji, were to show reverence to the ancestors, as a family member about 100 years after the death of Uesugi seems to have had this statue made and built a subtemple to house it in his honour.

Reflections on the development of the multiple-block technique and the realism of this style lead one to suggest that the technique's discovery was inevitable once other materials were abandoned as impractical, too extravagant or unavailable: unbaked clay, dry lacquer and bronze. With the best heads and hands turning their attention to wood, solutions to the problems were just a matter of course. Pressures to produce and the haste to rejuvenate the destroyed temples encouraged assembly line techniques. And the technique led to increases in size and reduced time on the production line. More detail, dramatic postures and sculptureesqueness were possible. There were also social and material gains. As the well-equipped workshops were enlarged and took more orders, the directors received further recognition and standing. Some were honoured with the prestigious titles traditionally bestowed on artists who had rendered exceptional service to the church.

Underlying these advantages were subtle dangers. Artistic quality was always threatened once the technique was perfected and in particular if a leader lost sight of the goals ahead. Tradition alone would not be enough. Creeping commercialization became insidious, as did the depersonalized technique. A strong leader with a flair for style could put his stamp on the products of a shop, but the realistic style of Unkei was too personalized for a worshop as a whole to maintain. Centuries of later sculptors looked back on the Kei-ha as the ideal, but the closest they could come was to mimic its late developments, which were melodramatic and theatrical, and their work bordered on the ludicrous.

Opposite: example of glazed ware from the Kamakura period. Vase with incised peony decoration of the Ko-seto ("old Seto") type. Kakuon-ji, Kanagawa.

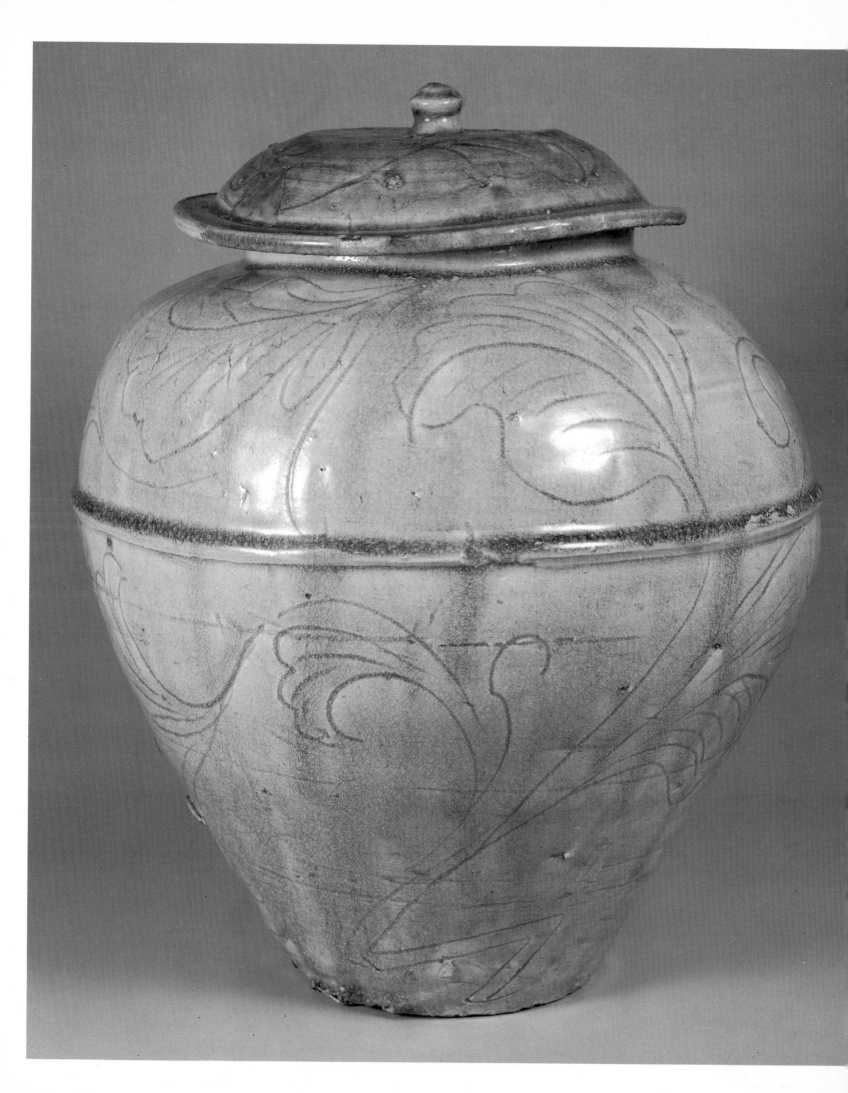

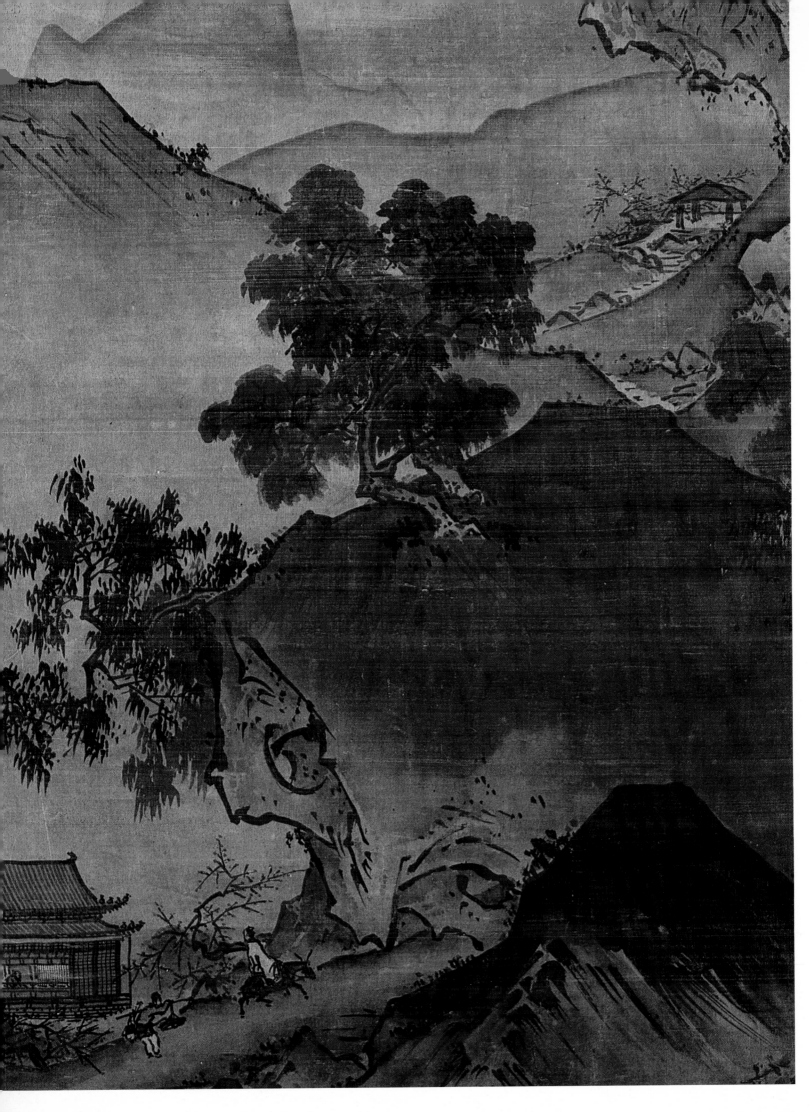

THE MUROMACHI PERIOD

1334–1573

The Ashikaga were of Minamoto stock and had acquired much land in the present Tochigi prefecture. Their connections were enhanced by intermarriage with the Hōjō, and their position improved as the Hōjō became weaker. They were called upon to suppress an effort in Kyoto to raise the position of the emperor, who had been confined to Oki island by the Hōjō. The removal of Go-Daigo from the scene did not alleviate the situation, and Ashikaga Takauji was selected to calm the capital. Takauji, however, had no sooner arrived than he switched his support to Go-Daigo to go with the winner. But when an erstwhile ally, Nitta Yoshisada, did the same thing, the two found themselves on a collision course for control of the capital. Takauji then saw fit to turn on Yoshisada and drove out Go-Daigo, who escaped to Yoshino. This set up the reign of two emperors in what has since been called the Nanboku-chō period, Northern and Southern Courts. Solution to this split came only in 1392 by an agreement between the parties to accept an arrangement whereby the two branches would take it in turn to provide the emperor.

Takauji's era was largely devoted to establishing the position of the Ashikaga, and he had little time and interest for the life style of the aesthete which characterized the dynasty. Kyoto was not alone in domestic troubles. The Ashikaga had particular difficulty in maintaining peace in their own home region. Selecting successors for the shogunate was rarely a simple decision, and the issue came to a head over who would follow Ashikaga Yoshimasa. The Ōnin War lasted the decade of 1467 to 1477, by the end of the which the Ashikaga were no longer an effective force. Historians have called the next century Sengoku Period, the Warring States Period, and closed it with Oda Nobunaga removing the last of the Ashikaga from office in 1573. By that time a new system of *daimyō*, local rulers, and new military alignments had emerged, and these local authorities, the builders of castles, were the ones the Tokugawa had to either ally with or keep under control.

Despite an almost continual state of siege in Kyoto, two of the shoguns set high standards for the arts and left major imprints on the history of culture. Ashikaga Yoshimitsu (1358–1408) became the third sho-gun in 1368. He used several different residences, but lived for some years in the Muromachi part of Kyoto where he built the Hana-no-Gosho, Flower Palace in 1379. This was between Muromachi and Kara-sumaru, just north of the present Imperial Palace, which was moved to this location in the late eighteenth century. He maintained a villa in the northwest of Kyoto, the Kitayama area, the remains of which came to be known under the temple name, Kinkaku-ji.

Yoshimitsu retired in 1395, entered the cloister and sent his army out to fight more effectively. He set the tone of a Zen-centered life (often referred to as the Kitayama Culture), engaged in trade with Ming dynasty China through the medium of Zen monks and renewed the flow of Chinese currency to Japan. His patronage of Zen monks encouraged major forms of ink painting and literature, the latter associated in particular with the Five Mountain Temples (the Gozan Literature). Nō drama was given its shape at this time by bringing in popular lore and great historical figures.

The Kitayama stage can be compared with that of Yoshimasa (1436–90) who succeeded his brother and assumed the mantle of the eighth shogun in 1443 at the young age of eight. Some ten years before his death he retired to the Higashiyama-dono, a villa on the east side, the remains of which are known through the temple which it became, Gin-kaku-ji. Yoshimasa built a smaller, less lavish establishment than the Kitayama-dono. But the Higashi-yama Culture was an island in a sea of destruction brought about by the confusion over the succession. Yoshimasa had promised to support his brother's son, but then had one of his own. Families took sides and the Ōnin War ensued. Kyoto was decimated while Yoshimasa drank tea and looked at Chinese paintings. Eventually his son, Yoshihisa, succeeded him as shogun, but Yoshihisa presided over further deterioration of the city and a century of chaos followed. The 15th shogun, Yoshiaki, fled the city in 1573, ending Ashikaga rule.

With the power again depending on control by Kyoto, the cultural baton was passed from the warrior class of the Kamakura era to the Muromachi Zen priesthood. Back in the Chinese-oriented and mild mannered Heian environment –

Opposite: detail from the Long Scroll painted by Sesshū (1420–1506), which illustrates Chinese scenes through the four seasons. National Museum, Tokyo.

in contrast to the street fighting – the direction and stimulus were laid down by the cloisters. The culture seemed to find natural roots and blossomed magnificently. Zen priests wielded political influence through the medium of trade and culture and were the arbiters of taste. More than ever, culture was religion and religion was culture.

Kyoto's crowded conditions were exacerbated by numerous natural disasters and the ravages of civil strife. This was hardly conducive to the preservation of the old monuments. The period had its share of plagues, earthquakes, typhoons, floods, fires, droughts and famines. Smallpox was rampant in 1366 and 1374. The Yodo River dropped so low in 1420 it could be crossed on foot. Corpses were piled high in the streets. A fire in 1434 destroyed more than 10,000 houses, while an epidemic in 1449 claimed 1,000 lives a day. Priests from the Enryaku-ji on Mt. Hiei preyed on the city and bands of brigands robbed the imperial palace on more than one occasion. A famine in the years around 1461 had brought people flocking into the capital.

The pilgrimage fervour, which had been fostered by popular enthusiasm in Kamakura times, ebbed for lack of physical safety, and disillusionment replaced the ardour. Civil groups advancing the cause of better government were often mercilessly wiped out and the leaders executed. By the end of the Ōnin War much of the capital had been evacuated and stood as open country. One estimate puts the population at around 40,000 by 1477. Temples were used as residences and headquarters by fighting groups and the mood was unsparing.

The Japanese had a history of continual use of armour from the time the horse riders had become plentiful in the second half of the fifth century. Iron cuirasses, the first armour to be introduced, tended to be replaced by lamellar armour, that is, iron or leather slats. These can be seen in actual excavated examples or as military wear on *haniwa* figures. Such armour provided full body coverage. The Shōsō-in had armour and at that time the Japanese tended to import what they needed from China. The earlier warrior class lost much importance as the city life of Nara and Kyoto developed, but official concern that there be properly trained cavalrymen can be seen in several orders requiring constant training in mounted fighting techniques. Not until the warrior class emerged politically toward the end of the Heian period did the Japanese find reason to develop their own armour. This is a unique Japanese type known as *yoroi*.

For various reasons, including identification in battle, prestige and preservation of iron in humid conditions, paint and lacquer were always used. Colour and ornament are, inevitably, important elements of Japanese armour. Most of the major parts of the body requiring protection were covered with rectangles of cow leather, wood or thin iron plates, painted in black and lacquered. Colourful cords were used to fasten them together. One kind was designed for the equestrian warriors (*ōyoroi*) who constituted the officer class, and another for the infantrymen (*haramaki*). Protection from flying arrows was the chief concern, as little fighting was hand to hand when the type was invented. Foot soldiers carried shields. The *yoroi* was then shielded with special large, loose shoulder guards which hung on either side to the waist. The slow reduction of these in size over a period of time was due to changing fighting styles. In the Kamakura period more close range fighting was developing.

Kamakura warriors, known for their *bushidō* spirit, devoted much personal attention to their equipment and its beauty, and elaboration brought on such things as the antlered ornaments of gilt copper (*kuwagata*) which rise over the front of the helmet. The oldest one of these is in the possession of the Seisui-ji in Nagano and may date from the eleventh century, but scroll paintings seem to indicate that it was not until around the fourteenth century that all full suits of *ōyoroi* included them. The term for these, hoe-shaped, must have come from early examples which had a slightly pointed hoe-shaped foot, but it was a shape long forgotten in later types. Breastplates often bore paintings of the Buddhist deities who protect warriors, and no one could be without crests and other signs.

Close range fighting, perhaps resulting from much experience in city fighting and the prohibitive expense of maintaining horses in any suburban area, especially under famine conditions when people could not be fed, had become more customary by the fourteenth century, so that armour was simplified for convenience and comfort and the *haramaki* proved to be more popular. Spears and shields were in common use. Guns were introduced by Portuguese traders into south Japan in 1543 and it did not take long for the Japanese to learn their use and to make similar ones. Part of the success of Oda Nobunaga is attributed to the training he gave his men in the use of firearms.

The Late Heian architectural style had the potential for monumentality and flexibility where the terrain was itself a significant factor. In most respects the choice of the setting and the plan of the buildings at the Itsukushima Shrine on Miyajima off Hiroshima in the Inland Sea is a masterpiece of topographical selection and genius in the application of current principles. Miyajima is popularly known as one of the three great sights of Japan.

Tradition takes the shrine back to the time of Empress Suiko, and it had grown to some importance by the ninth century when it is known to have been dedicated to three female *kami*, said to be daughters of Susano-o, brother of the Sun Goddess. Taira Kiyomori lavished considerable support on the shrine in 1167 and donated many sūtras, but much of that was lost by fire. Rebuilding was carried out in the following century, then a large fire occurred in 1548, for which reconstruction was carried out in 1556. The Late Heian style was retained and became a kind of Shinto and Buddhist architectural mix. Periodic later additions have given the shrine some of the structures for which it is well known: the large Senjōkaku, Hall of 1,000 Mats (1587), built by Toyotomi Hideyoshi, a somewhat awkwardly proportioned *kara-yō* pagoda, and the immense camphor wood *torii*, the ceremonial gate in the water, put there in 1875.

The buildings are erected on platforms over the water of a small natural, protected inlet, bulging on the east side. The buildings are oriented primarily in a northwest direction. The sequence of main

Opposite, above: aerial view of the Itsukushima shrine at Miyajima, near Hiroshima. This Shinto shrine had already achieved a certain importance by the ninth century, when it was dedicated to the three daughters of Susano-o, brother of the Sun Goddess. At high tide the entrance gate (torii) is partially submerged by the water. Opposite, below: view of the main buildings of the shrine.

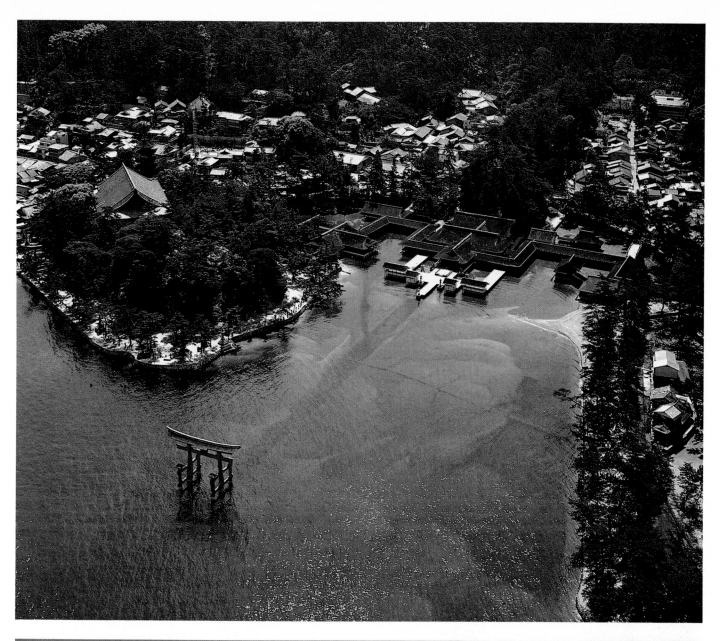

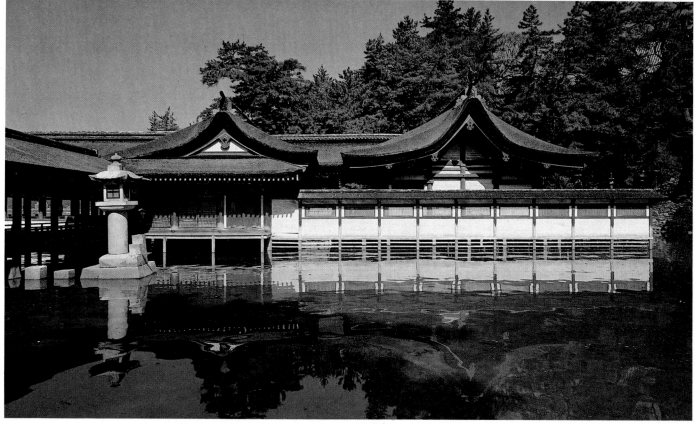

shrine halls and open stage is flanked by the two others, with no effort to form a balance. On the east is the Marōdo Shrine, which has its own series of buildings running toward the northeast, and on the west is the Nō stage and bridge. These clusters of buildings are joined laterally by bark-roofed galleries, and are made accessible by open walkways. The walkways connect directly with the shore at four points and a protected platform joins with the shore at one more point. All are what might be called unpredictable points and all are quite different distances apart. A worshipper incidentally, faces the mountain – the original *kami* – when looking toward the inner shrine building, as though he had come along an avenue from the *torii*. Water covers the sand at high tide and the buildings all appear to be floating.

A close look at the main set of shrine buildings shows they are not symmetrical, nor are they aligned with the *torii*. The galleries may at first appear to meet at right angles, yet there is, in fact, hardly a single 90 degree angle in the entire complex. From the initial selection of the site, with the knowledge of the tides, to the placement of the buildings, formal relationships were ignored for the benefit of dynamic and unexpected linear effects in what might be called a calculated asymmetry. A visitor walking along the corridors will sense this dynamic relationship by his inability to see aligned corridors and his appreciation of the many and diverse through-views.

Yoshimitsu liked the open Kitayama region of northwest Kyoto and acquired a villa which had formerly belonged to an aristocrat, enlarged it, and added an elaborate group of buildings, including a huge seven-storey pagoda, behind a big artificial pond. He constructed an especially fine pavilion over the pond, modelled after a Chinese park and lakeside kiosk. Yoshimitsu abdicated, became a monk and assumed residence there in 1399. Following the practice since Fujiwara times, the residence was converted to a temple after his death and known as the Rokuon-ji, after the name Rokuon which he had adopted when he was tonsured.

Yoshimitsu's wife tried to keep the villa intact, but buildings were lost or removed, as were stones from the garden and pond, leaving only the Kinkaku, Gold Pavilion, which too was burned down, by a mad

neophyte. It was soon rebuilt and in a more precise manner, closer to its Muromachi details, omitting minor interior modifications of the Edo period.

The pavilion is built on a rock and soil base projecting into the north side of the pond. Three floors are designed for different functions. The ground floor opens up across the five bays of the south side and two of the four bays on the east and west. The lower two floors are under one roof and both are surrounded by porches, but the second floor is enclosed with a recessed section on the south which makes that part of the porch deeper. The third floor is only three bays square. The interior is covered with gold. Doors are inserted in the middle bays and the other bays are filled with scalloped windows. Bark roofs and light construction give the building a fragile elegance and, not unlike the proportions of a few Amida halls, it has relaxed lines and a modest stance, despite the artificiality of the surfaces.

The top floor was intended to house bones and teeth of Buddha which Yoshimitsu had acquired from the Engaku-ji – the Shariden had been built about 1300 to receive bones – and the second floor to accommodate a statue of Kannon. The ground floor was for relaxation and contemplation. The building therefore had combined uses, employing gold because it was in the long run a *shariden*. Records indicate it was connected by a bridge from the second floor to another building, which is very difficult to imagine and, as now seen, at some point in time a boat slip was added for the pleasures of boating and fishing in the lake.

Less than a century later, Yoshimasa sought a place on the Higashiyama side of Kyoto for a retreat villa and finally settled on a shaded spot at the foot of Tsukimachiyama. He built a modest group of buildings in 1479. This Higashiyama-dono offered an escape from the politics of the state and was converted into a temple known as Jishō-ji. The popular name for the chief remaining building, Ginkaku, Silver Pavilion, was probably due to an Edo period misunderstanding that Yoshimasa had modelled it after the Kinkaku and intended to surface its upper interior floor with silver. But it is a smaller, two-storey structure planned as a Kannon-dō, and Yoshimasa's builders took as their inspi-

ration a somewhat similar, but now missing, building at the Saihō-ji, on the west side of the city.

Also preserved here is the Tōgudō, a *sukiya* or tea house built by Shukō, in the northeast corner of which is a small tea room of four and a half mats, the oldest known tea room and the prototype for many later ones. The room is simple, plain and fully Zen in concept. As flower arrangement schools also claim the start of their art here, one may assume that the entire philosophy of arrangement may have been shaped at that time.

Tea drinking was seen as having chiefly medicinal value, although Emperor Shōmu held tea drinking parties. Kōbō Daishi brought tea back with him from China, but it was not used extensively or regarded as particularly enjoyable until it was ritualized through the philosophies of Zen. The southern Chinese had made an art of tea drinking and, as an antidote to long hours of meditation after Eisai reintroduced it on one of his trips, tea drinking caught on as almost indispensable to the *zazen* practice. Once more bushes were grown on the south slopes of Kyoto hillsides, yielding tea for popular consumption. As the ceremony evolved, all the surrounding paraphernalia developed, from utensils to tea houses and gardens.

As if its own early man-made and natural disasters were not enough, the accidental fires of the eighteenth century and the arson of the nineteenth century did a staggering amount of damage to the city. The fire of 1705 is said to have destroyed 75 Buddhist temples and six Shinto shrines; the one of 1730, 39 temples and one shrine; and the one of 1788 over 200 temples and 37 shrines, including seven temple pagodas. Understandably, Kyoto has few old buildings and those that remain have survived miraculously.

Muromachi temple styles lived on tradition and added modest Japanese embellishments. Villa plans had changed from the Jōdo complex preferred by the Fujiwara when they idealized the Pure Land paradise on earth. The Ashikaga used a Chinese source, adapted it, personalized

Opposite: the octagonal pagoda of the Anraku-ji, Bessho Onsen, Nagaro prefecture.
Overleaf: the three-storey pagoda of the Kōshō-ji, Hiroshima (left) and the five-storey pagoda of the Rurikō-ji, Yamaguchi city (right).

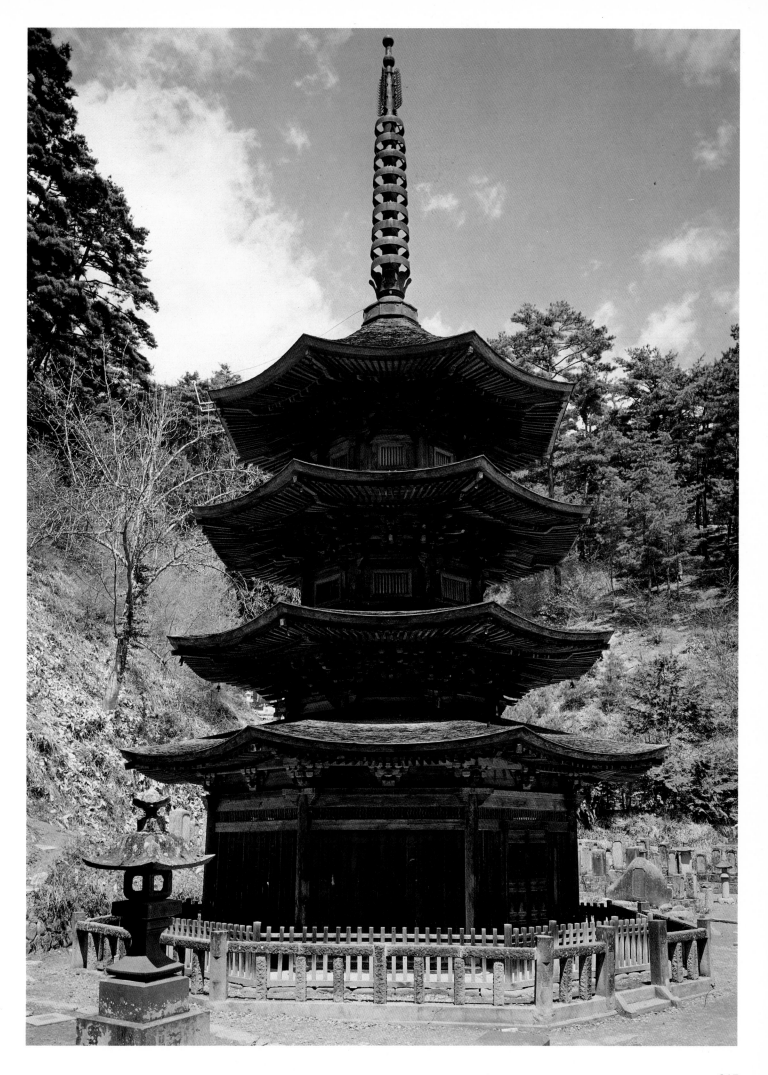

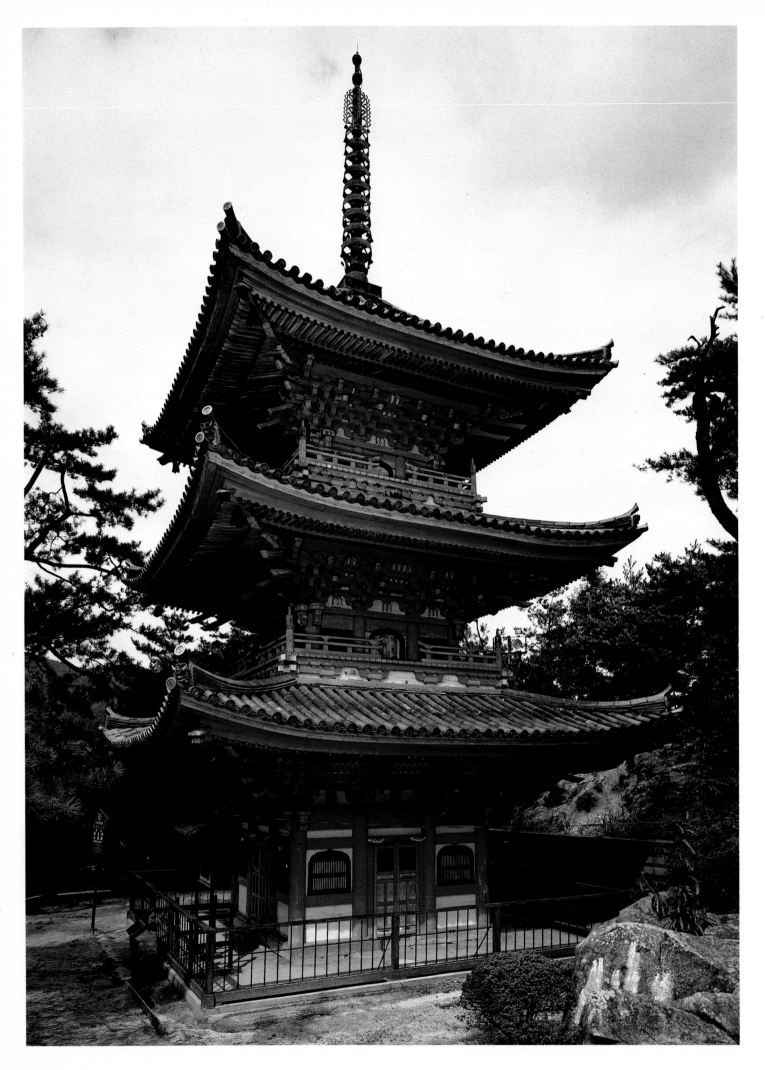

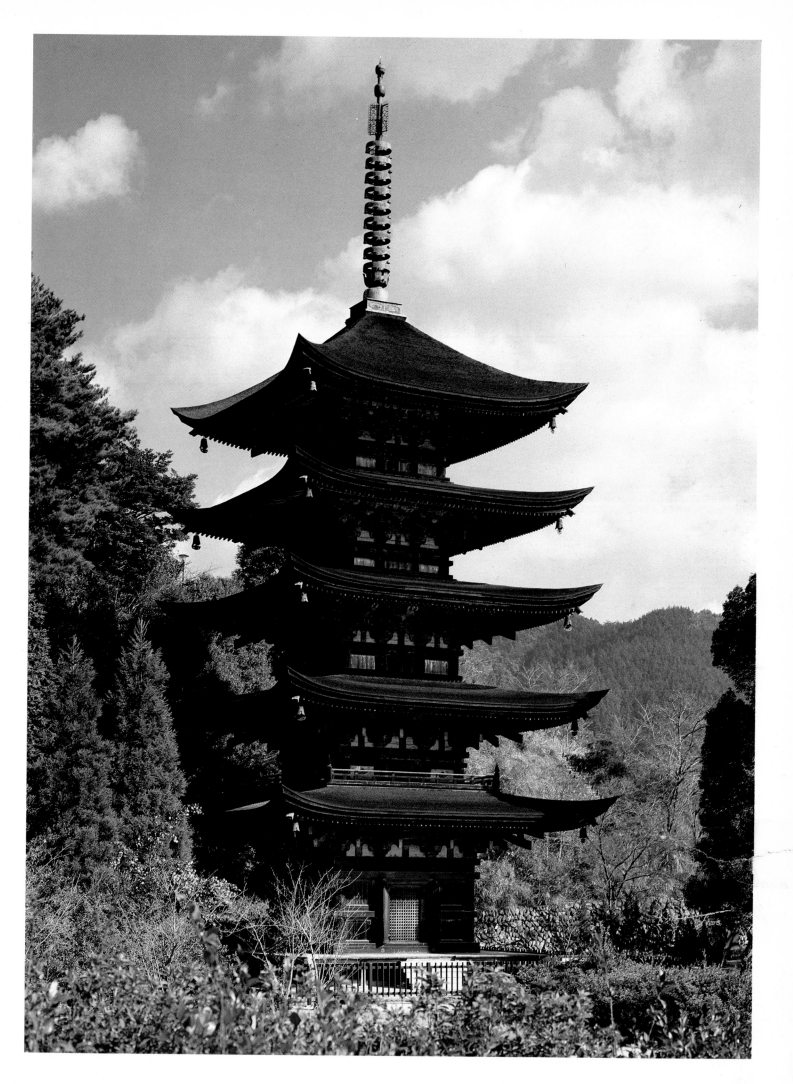

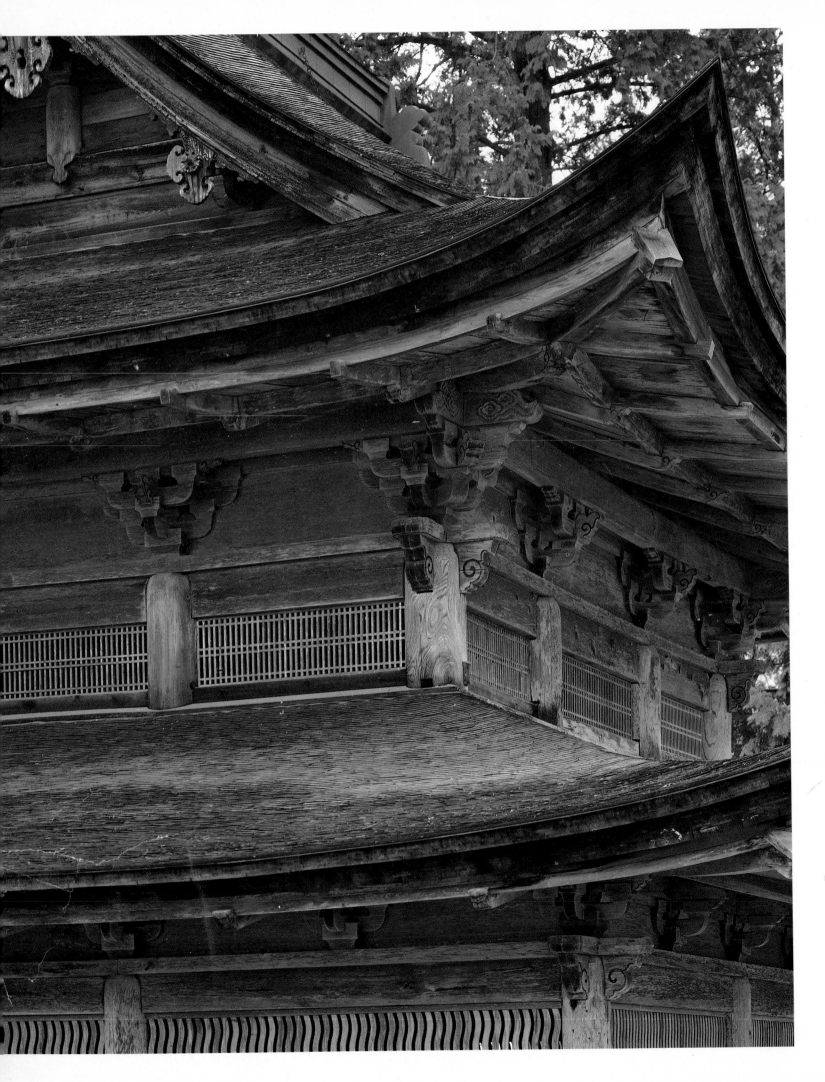

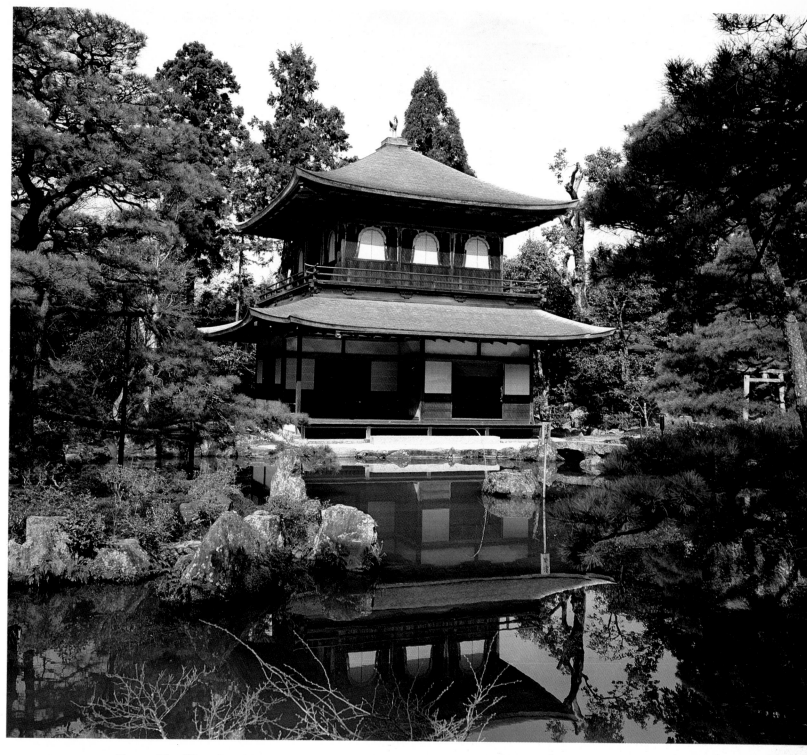

Above: The Silver Pavilion (Ginkaku), Kyoto. Built by Yoshima in 1479 as a country villa, it was later consecrated as a Buddhist temple. It is also known as the Jishō-ji.
Opposite: exterior of the Hall of the Sacred Buddhist Texts of the Ankoku-ji in Gifu prefecture.

it, and made it a more secure retreat – or at least Yoshimasa did when he buried himself in his Higashi-yama-dono and ignored the dis-integration of Kyoto around him.

Several fine buildings and pago-das in other parts of the country represent the Muromachi styles. The three-storey pagoda of the Kōshō-ji in Hiroshima prefecture, a Rinzai Zen temple lying along the southern length of the Onomichi for travellers going south, belongs to the early fifteenth century. The roofs are tiled and the windows flanking the central doors are scal-loped. A composite structural sys-tem has been used that involves long

slender tail rafters supported by highly florid ornamental blocks, and there are other, rather meaningless ornaments projecting from the cen-tral block of the bracket system.

The five-storey pagoda of the Rurikō-ji in Yamaguchi city, also a Zen temple, was erected on this spot in 1442. The Ōuchi family were the temple's patrons who, in the six-teenth century, extended their con-trols to north Kyushu, conducted a substantial foreign trade with Ming China and nurtured many refugees from the impoverished conditions of the capital. With many traditional elements, usually called *wa-yō*, the pagoda has bark roofs of thin flat

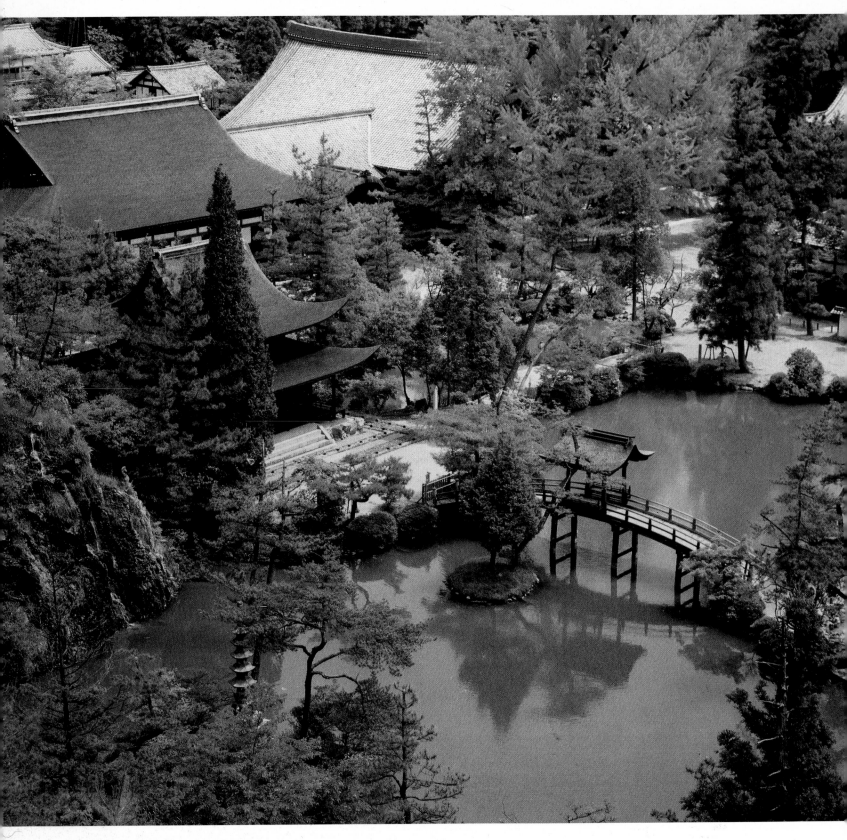

edges which curve up rather sharply at the corners. The third floor level has open surfaces, unlike the others, producing a strange break in the rhythm. Pagodas were built in rather standardized sizes. By modern measurements this one is 31 meters (101 feet) high. A rather similar but three-storeyed pagoda of the Shin-chōkoku-ji at Seki in Gifu prefecture, about 30 kilometers (18 miles) north as the crow flies, is 20 meters (65 feet) in height. Other examples

show that a common measurement for one storey ran about 30 *shaku*.

These buildings fit known categories and illustrate the major approaches of the Muromachi architects, but the octagonal pagoda of the Anraku-ji at Bessho Onsen in Nagano prefecture does not, despite the common disposition to classify it so. Not far away in Ueda, the site of the old Shinano provincial headquarters. The area had close connections with the Kantō going back

Temple gardens designed by the monk Musō Kokushi (1275–1351) Above: garden of the Eihō-ji at Tajimi in Gifu prefecture (c. 1314). Opposite, above: garden of the Tenryū-ji; below: garden of the Saihō-ji, popularly called "Moss Temple." Both are in Kyoto.

hundreds of years.

Octagonal pagodas are not known to have been built since the large nine-storey Hōshō-ji was erected in Kyoto by Emperor Shirakawa in 1077. Prior to that were the aborted Saidai-ji pagodas. They were started ambitiously as huge eight-sided structures, but abandoned in favour of a square plan. Though called *wayō*, here the shape, proportions and surrounding enclosed porch (*mokoshi*) are all features with inadequate recent prototypes, so one must conclude that a traveller in China had made notes on the details. The Chinese had a rather large selection of multi-sided pagodas to draw on. The Anraku-ji was closely connected with the Kenchō-ji in Kamakura, through which the Chinese connection could have been known.

The pagoda is the three-storey size (18.5 m or 59 ft) with narrowed walls on each level. The edge of each segment of roof is in the shape of a shallow arc, the progressive reduction of which on each level creates a pleasant rhythm. Proportionally ing. Along with the slender, almost needle-like end rafters seen outside, there are three decks of consoles and brackets visible inside until a false ceiling cuts off the view at the second storey level.

Large Zen temples in Kyoto had not only a main temple garden but always many smaller ones related to the subtemples. Each was personalized for the particular character of the setting and had a special intimacy with the buildings which the larger ones could not have. They were designed to stimulate and com-

Above: the "dry landscape" garden, composed of pebbles and vertical stones, attributed to Sōami (c. 1500). Ryōan-ji, Kyoto. Opposite: glimpse of the rock garden of the Daisen-in in the Daitoku-ji, Kyoto, also attributed to Sōami.

wide rings on the spire become ponderous (were they taken from a larger pagoda?), although its 25 per cent of the height of the pagoda is within the normal range at this time.

A very modest amount of shaping of the ends of the beams has some resemblance to Kamakura bevell-

plement contemplation by being in space small enough to be easily comprehended while sitting. They often had the proportions of a hanging scroll painting.

Garden design became a religious exercise quite the same way ink painting, the tea ceremony and

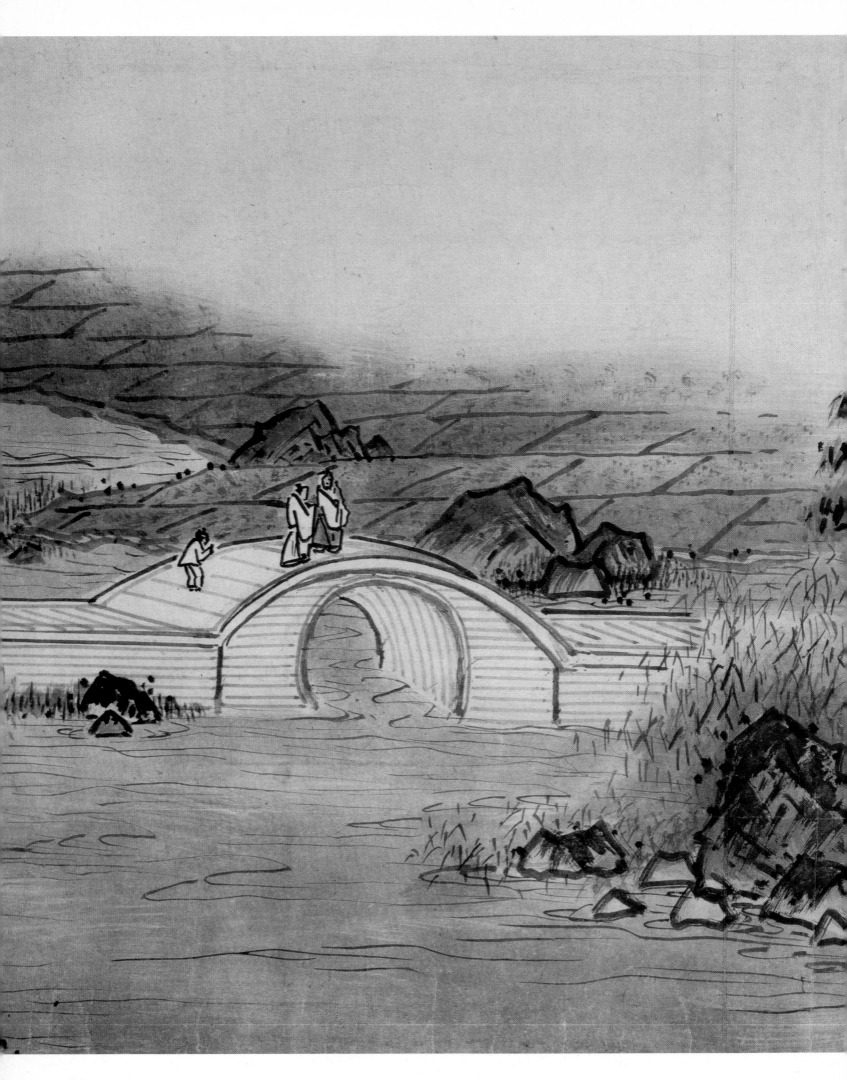

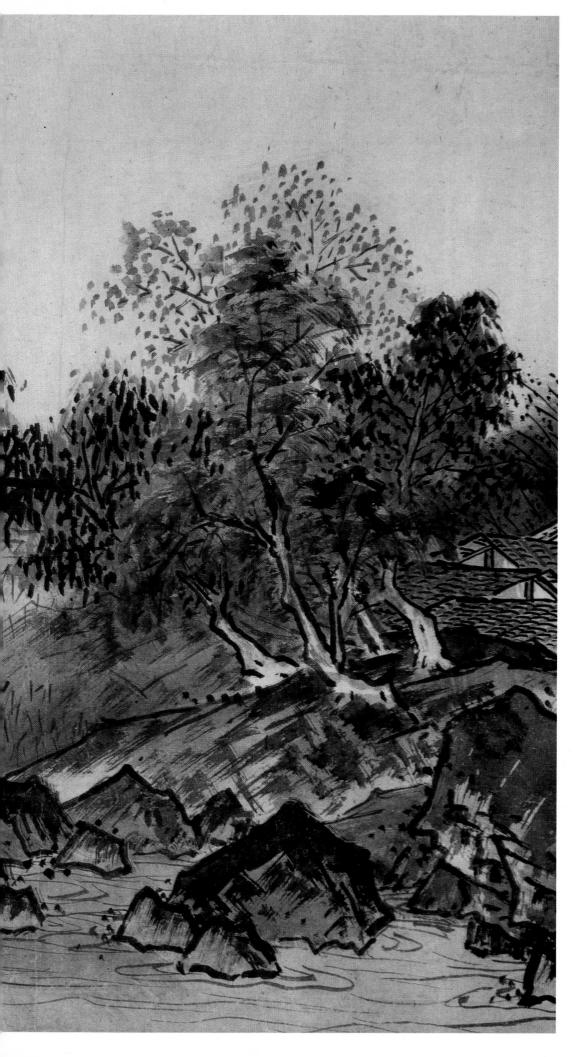

flower arrangement were now given philosophical bases. This put garden design in the category of magic, the unknown, and the application of geomancy principles. A book on garden design called *Sakuteiki*, Treatise on Garden Making, attributed to Fujiwara Nagatsune (eleventh century), gives rules for construction and errors to avoid. Any violation of the laws of aesthetics and nature provoke the spirits to retaliate. For instance, if a stone which is made to lie horizontally is stood upright, it will bring misfortune. Fear of running afoul of the spirits governs the selection of times, distances, directions and relationships throughout. In sum, the success of the garden is not understood in terms of reaching any positive aesthetic standards but the result of not doing anything wrong. In effect, if nothing is done wrong, everything is right.

The major achievement in garden design was the small, single viewpoint sand and rock garden with only incidental touches of vegetation, known as *kare-sansui*, dry landscapes. Few achieved the stark simplicity of the Ryōan-ji garden in Kyoto. Most, including the Ryōan-ji, it should be added, were manipulated and somewhat changed in the Edo period. Nevertheless, the initial garden, once attributed to Sōami, was laid out by around 1500. The present building, from which the long rectangular plane of coarse sand and rocks can be seen, is the abbot's residence which was moved to this spot following much destruction of the temple in the Ōnin War. The temple was, in fact, the temple of Hosokawa Katsumoto, the chief protagonist against Yamana Sōzen. Off home base, Hosokawa led his troops in east Kyoto; Sōzen kept his in west Kyoto, as he had come up from regions to the west.

A mottled brown wall confines the simple enclosure and sets the tone. Stones are in clusters of 5-2-3-2-3, the largest cluster near the entrance. This group of seven eastern stones is balanced by the spread of the more

Detail of the Long Scroll by Sesshū (1420–1506) depicting the four seasons. Yamaguchi City, Hofu Mori Hokokai Foundation. Overleaf: composition of flowers and birds, attributed to Sesshū. Detail of a painted screen. Kosaka Collection, Tokyo.

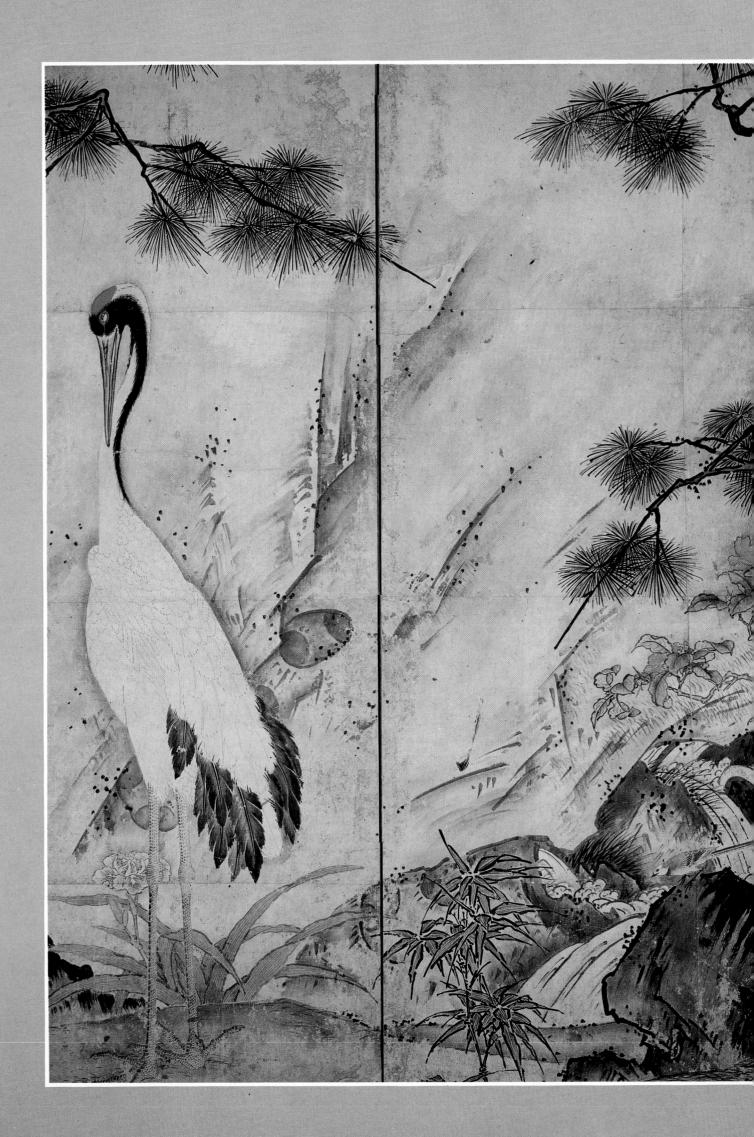

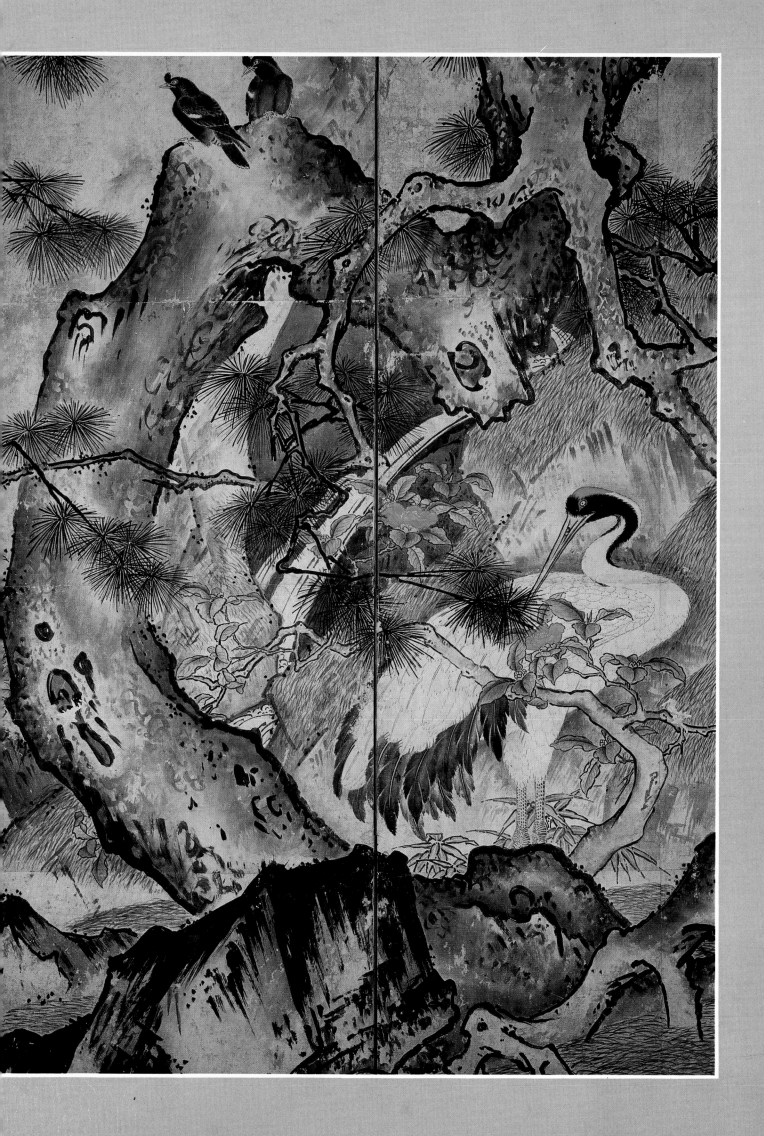

tightly composed groups of eight western, smaller stones. Writers have conjured up poetic images of islands, water and swimming felines as they see the stones emerging abruptly from the sand. Some perpetuate the charming myth that not all the stones can be seen from any one point along the veranda. I suggest trying a point opposite the second last group, two thirds of the way along the porch, where at least the edges of all the stones can be seen. But this does not make it any less Zen.

The Daitoku-ji in north Kyoto has several subtemples with splendid gardens. The Daisen-in garden has now been joined along three of its sides, north, east and south, to virtually surround the *hōjō*, priests' hall. The building is divided into six rooms by sliding screens, each designated for a specific use. If followed through methodically, the garden viewing room is in the northeast and, clockwise, rooms are for relaxation, sūtra chanting (the largest on the south), reception, Zen study, and lastly, on the north, paying respects to the founder of the temple.

The screen paintings in the rooms are by Kanō Motonobu, and were painted with thought toward the garden design. They add one more plane of depth in the illusion of nature created by the artists. Sōami still appears as a possible designer, as he had at Ryōan-ji. The building around which the garden is laid out is known to have been erected in 1509. The garden must also date from that time, and the paintings were executed within the following three or four years.

There is no attempt here to be as pristine as the Ryōan-ji garden. The L-shaped northeast corner is densely packed with vertical stones, to a degree that the wall is virtually unseen. Horizontal stones in front give a sense of flow against the rising simulated Chinese landscape. The background is named the Buddhist Treasure Mountain, Hōrai-san. The Chinese flavour is strong in the exceptional contrasts, even evoking the classic Chinese clichés: the high and the low, the near and the far, and the light and the dark. Temple literature speaks of images of the crane and the turtle. There are the distant stones and the stone treasure boat. The white sand contrasts with the deep shaded camellias. The literature also sees the stream of life flowing toward a sea of ultimate and lasting purity – the level sand of the south side.

In 1961 a windowed wall was put across a stone bridge after an old map was discovered with this feature sketched in. The garden has become two separate gardens as a result. Gardens are never static, however, and arguing their original appearance is fruitless. As with organic works of art, the wall is a part of the garden's progressive evolution.

The villa gardens are only far removed from the small temple gardens when the ambitions were very large. The Kinkaku-ji garden was for open-air strolling. Stones marked the irregular outlines of the pond, but the compositions are no longer intact as many were removed to be used elsewhere or on the other side of town. An especially good view of the garden must have been had from the second floor.

In contrast, the Ginkaku-ji garden has the more intimate properties of a temple walk-through garden. It is small, refined and heavily shaded. Much is made of the patterns of stones along the edges, where accents are given to the intricately shaped pond. Paths lead around and through, with points of immediate and direct interest. Most striking is the huge pile of sand, so overwhelming it seems quite un-Zen. But it too evoked picturesque imagery – Silver Sand Platform – and it and a smaller one, Mound Facing the Moon, are relics of excessive amounts of sand such gardens need without storage space to handle it. Like the rebuilding of Ise shrines every 20 years, the need was ritualized and was so absorbed that the original reason was lost. The sand piles are Edo period accumulations. They have tightened up the garden spatially and changed much of its character.

The classic garden of the Tenryū-ji on the west side of Kyoto was the design of Musō Kokushi (1275–1351) for Takauji. An earlier temple stood here and then an imperial mansion. It was constructed on a large scale and tampered with a number of times, yet the rocks and pond association with the abbot's residence is still superb. The temple was the center of a huge complex of related subtemples and chapels, totalling around 150, but most were destroyed during the civil wars and never rebuilt.

Especially noteworthy in this garden are seven rocks at a distant point which maintain a balanced relationship from all viewpoints. Reference is also made to the waterless waterfalls and the image of *shumisen*. As one of the first *shakkei* gardens, that is, "borrowed scenery," allusions are made in the design to the nearby hill, Arashiyama, and the famous bridge, Togetsu-kyō.

Musō Kokushi was also responsible for the magnificent Saihō-ji garden, popularly Moss Temple, not far away in 1399, or so tradition goes. It has an upper *kare-sansui* and a lower Western Paradise garden. Paths lead around a pond said to be shaped after the character *kokoro*, heart, meaning the Buddha nature, a theme also used at the Tenryū-ji. The low site, dense vegetation and monochromy have a somber cast. Because of its greenery, it is without parallel among Japanese gardens.

Among his other accomplishments the Rinzai priest founded the Eihō-ji at Tajimi in Gifu prefecture around 1314. He selected the site because of the magnificent verdant setting along a mountain stream. The plan of the temple garden places a pond directly in front of a two-roofed, plain Kannon-dō, and crossed by a half-moon bridge with a small open kiosk at its crest.

The founder's hall, dedicated to Musō Kokushi, was built in 1352 and consists of a complex relationship of three parts. First is a public worship building in the most complicated of the *kara-yō* style, then a connecting section, and behind a smaller and simpler building. Twin halls were used for esoteric rituals, one of which constituted the holy of holies. This was probably the influence here, which was also picked up by a few Shinto shrines.

The art of painting is most obviously indebted to China and is directly related to the special efforts the Japanese monks made to collect their materials when visiting Zen temples in China. Ink painting (*suiboku-ga* or *sumi-e*) based on Chinese models was nothing new, but the specific subject matter and goals were. Each painting was a Zen experience, each leading toward ultimate knowledge of one's Buddhahood and enlightenment. Ink painting is now, as then, thought of in terms of landscapes, and when traced back into T'ang dynasty work this is the line of pursuit. Landscapes

Opposite: ink painting of a landscape by Sesshū (1420–1506). National Museum, Tokyo.

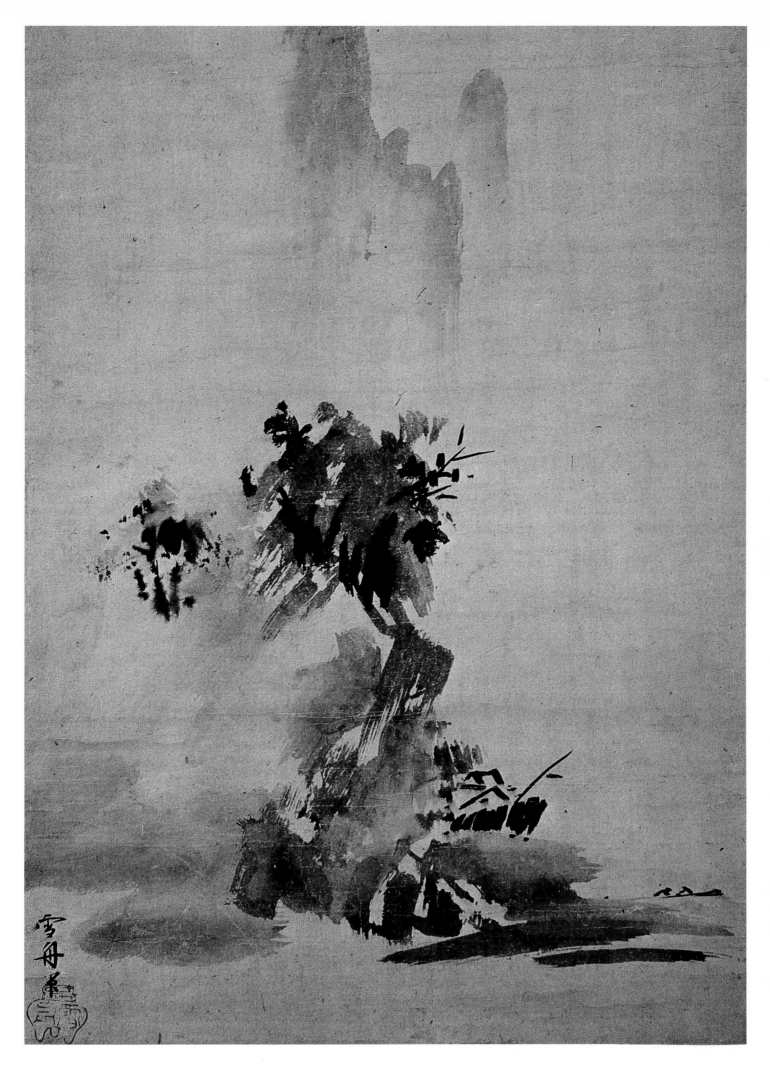

*The promontory of
Amanohashidate in a painting by
Sesshū (1420–1506). National
Museum, Tokyo.*

did become the most popular subject in Japan, perhaps because the bulk of the models were landscape paintings, but hermits, *rakan*, (*arhats* or *lohans*), holy men, portraits and other subjects likely to induce a religious (Zen) response all figured early in the development.

In much the same way one assumes the art had started in China on a personal plane and not among professional painters, it was an individual, cloistered art in Japan, used first for personal expression. It then became a subject for group stimulation as poems and colophons were added to paintings and only later did it pass into the hands of men trained in established workshops. At that point it was picked up by Kanō school painters, for example, and even others whose profession might be, for instance, soldiering. By the time it was socially indulged in, it had also been so dissected and formalized as to have lost most of its original meaning.

As Muromachi painters perused their large quantities of Chinese paintings they classified all the forms of brushwork of Sung and Yüan masters, called *hitsu-yō*, and had identified the brush types of Ma Yüan, Liang K'ai, Mu Ch'i and many others. They became adept at copying each one. These classifications themselves were narrowed to *shin*, *gyō* and *so*, formal, semi-formal and informal, or elaborate, intermediate and simple. The same classifications were used in other arts, and they were applied with the same imprecision to garden design.

It should not be forgotten that despite the professed emphasis on the spontaneous and the improvised, inspiration in Japan was not derived from nature as it was in China, and no treatises on man's subjective response to nature were written. Japanese ink painting was inspired exclusively by Chinese paintings – and later, by Japanese masters of the style. The art was therefore far removed from nature and was an intellectualization of the Chinese idealization of their natural world. This puts it into one of those occasional categories of art with foreordained aesthetic channels, which narrow into blind imitation or over-stylization.

Zen monks passed through several stages in life and religious development, assuming along the way several names, including a posthumous one. There is, however, normally one name by which they are best known. At a stage judged satisfactory by a mentor, a monk-painter would be allowed to sign his name to a painting. Poems, sometimes the circumstances of the painting, names and dates may appear in inscriptions. Signature changes are rarely as useful as one might hope in evaluating changing styles, and often have the effect of creating immense difficulties in matching names with one individual.

A little-known Zen monk named Kaō who died in 1345 may be credited as the first ink painter of birds and flowers following a prolonged stay in China. His primary connection in Kyoto was with the Nanzen-ji, where he is listed as the temple's 18th abbot.

In the first and second generations following the lead of such men, one knows of Mo-kuan (1318–73) from a Kamakura temple who spent much of his life in China and died there; Mutō Shūi (fl. 1346–69) at the Ten-ryū-ji; Josetsu (c. 1394–1428) at the Shōkoku-ji, and Minchō or Chō Densu (d. 1432) at the Tōfuku-ji. Shūi left a portrait of Musō Kokushi, his teacher. Josetsu is the author of the remarkable painting known as *Catching a Catfish with a Gourd*, a painting ordered by Ashikaga Yoshimochi and bearing above it 31 poems by as many contemporary monks. Like a *kōan* in black ink, a hermit alongside a river bank has the impossible charge of scooping up a large fish with too small a gourd. The pathos of this trenchant exposition of the stream of life is wrapped in an elegant package of S-curving river edge lines which are reflected in the shape of the fish and complemented by the lines of the bamboo.

Minchō is best known for his Five Hundred Rakan paintings and portraits, so surely he was a trained artist in the usual transmitted techniques. At one time he was associated with the Shōkoku-ji. His Daruma in strong colours was one of the first in Japan, and he himself did several others in monochrome as other artists did. Landscapes attributed to him are noted for their contrasting tonality and are regarded as being closer to Yüan than Sung China. Another characteristic is the attention to detail.

While all of the Gozan temples seem to have had skilled monk-painters, the most renowned came from the Shōkoku-ji in north Kyoto Sesshū (1420–1506) may have derived his most commonly used name from two teachers, Josetsu and Shū-bun according to one line of reasoning. He spent some early years in Kyoto, but in 1464 moved to Yamaguchi prefecture under the sponsorship of the Ōuchi domain, and lived in the family temple, Unkoku-an. Two years later he was sent on one of the missions to China, where he was treated with great honour and travelled to Peking. His discovery of the destruction of the Shōkoku-ji on his return persuaded him to settle elsewhere, and he spent most of his last 20 years in Ōita, though travelling frequently.

Sesshū was a recognized master by the age of 40 and entitled to sign his own paintings, but nothing remains of his work that can be identified with his Shōkoku-ji period. His best paintings come from his mature years following his return from China in 1469. There, his interest had been centered on the Sung and Yüan academy style, and he seems to have thoroughly enjoyed his reception and his experiences in the Chinese countryside. But his circumspect remarks on China have been taken to mean he was disappointed in the work of the contemporary painters.

Sesshū had an extraordinary command of the brush, often employing a variety of strokes in one painting and frequently using colour for accents. Seasonal paintings, such as hanging scrolls and screens, occupied some of his time after his return. It has been said that he could give a Japanese touch to the Chinese sense of space. He did bring the art form to its highest creative level, fully mature in its integration of the Chinese and Japanese qualities. In long scrolls with unfolding space he interpreted Hsia Kuei, and in his Long Scroll, which measures a full 18 meters (59 feet), which he executed in 1486 at the age of 67 according to his signature and note at the end, he developed a series of Chinese scenes through four seasons. The changes are imperceptible, yet one may see the fresh vegetation and more exposed rocks of spring, the richer growth, soft mist, water and greater horizontal distance and open windows of summer; the leisure hours after the harvest in the fall; and, alongside the

Opposite: horse racing at Kamo shrine. Detail of the Screen of Monkeys and Birds (Sarutori-byobu). Seventeenth century. Nishimura Collection, Shiga.

running theme of a Chinese city wall, the cool, treeless, snowy mountains, and finally the closed windows in the winter.

Small people stand and converse in pairs. There may be individual porters, toilers, fishermen, aristocrats and valets, but there are no farmers in the fields. In fact, there is rather little open farm land – not a theme of interest to experts in Chinese painting until the twentieth century – except in one autumn scene near a Chinese-style stone bridge. Sesshū included an occasional touch of colour for seasonal effects. Compositional organization is done through a mid-level viewpoint, placing most of the pairs of figures along eye-line, and the strong geometric shapes of the houses, pavilions, boats with masts, rock and walls give a kind of architectural strength to the panorama. The brushwork is chopped, brittle or slow and lazy for mood, and edge outlining was often done before the ink was dry to stress the shapes.

The "splashed ink" (haboku) landscape of full brush and rapid strokes is of peaked mountains in a hazy distance as seen from a low angle. A vegetated hilltop and a house at the foot and two men in a boat can be made out through the misty atmosphere. Sesshū was 76 when he did it, and he gave it to his pupil Sōen as recognition of the latter's enlightenment.

The pair of six-panelled folding screens of seasonal "flowers and birds," in this case pines and herons, bearing small patches of red, is only attributed to Sesshū. But as a brilliant and influential piece of work it is unlikely that anyone else could have done it. Here is the unveiling of compositional principles that later painters, such as master decorators like Kōrin, working with similar shapes, employed to create some of their masterpieces: a strong asymmetry built on clustered, larger elements on one side and balanced by fewer, smaller, exposed but more strongly accented elements on the other. Several are used, such as configurations of rocks, angles of tree branches, clumps of pine needles, bunches of reed leaves (which are all splayed out in exactly the same way) to produce a multiple rhythmical system in shapes, sizes and intensities. This is aided by the treatment of space which is done less through the diminution of objects as it is by reduced and vaguer details. At first the landscape feels pushed

forward, the rocks growing at one's feet, but then it appears to be moving away at a slight angle to the picture plane. The parthian shot is the deepest point at which precise details have been painted. The remainder is background.

The final achievement of Sesshū is something of an enigma. Amanohashidate, the famous scene on the Japan Sea coast of a long spit of land, is painted on more than 30 sheets of paper patched together. They measure 178.2 x 90 centimeters (69 x 35 inches). No other painting of an actual scene is known from Sesshū's hand, and it is full of uncharacteristic detail. The Chinese painted such scenes, and perhaps at the end of his long and rich life Sesshū wanted to find out what it felt like in Japan. He certainly sketched the countryside in China. Buildings such as temples are labelled and date the painting to after 1501 and therefore to within the very last years of his life. A distant, high viewpoint was chosen. For the natural world abstraction was not possible – which is why the Japanese artists stayed with Chinese landscapes – and so were in an art world, several steps away from reality.

One generation earlier than Sesshū was Sōtan (or Oguri Sukeshige) (1398–1464), a feudal lord who, when faced with defeat, escaped and entered the Shōkoku-ji. As evidence of how this ink painting style came to be regarded, he was appointed official painter for the military government around 1463. Jasoku (Dasoku) (d. 1483), thought by some to be one of the first professionals and by others to be a Zen priest, worked at the Shinju-an in the Daitoku-ji, painting landscapes and birds and flowers on sliding screens. It is both significant that the style which had been introduced as scroll paintings was now converted to large screens and that by middle Muromachi it may have passed into the hands of professionals. There is, however, some history of this, as it will be remembered that the screens appearing in the palace rooms of the Genji scrolls bear Chinese-style monochromatic landscapes.

Sesson (1504–89?) is the best known noncloistered painter, although he lived like a monk in his late years, practicing the inspiration of his art. He came from the Kantō and settled in the Aizu region of southern Tohoku. His work was based on his study of Sesshū and its

Chinese background, and he painted lyrical, highly polished landscapes of a totally imaginative kind, much as a city dweller would dream of an ideal countryside, using a meticulously controlled brush.

Three generations of Ami masters, known as San'ami, were of samurai stock and served as shogunate advisers (dōbōshū) in Kyoto. Nōami (1397–1471), Geiami (1431–85) and Sōami (?–1525) all made their mark as poets, garden designers, tea ceremony masters and ink painters. They were responsible for curatorial work in the art collection of Yoshimasa. Nōami is regarded as the founder of the Japanese system of art criticism. Sōami finished the editing of Yoshimasa's painting collection in 1511. Along with garden attributions, he is known especially in painting for soft, velvety and heavily misted landscapes, said to be in the Mu Ch'i tradition, but he was certainly most familiar with the work of Mi Fei and others who painted similar themes.

The Sanage region along the Owari-Mikawa province borders kept its business going as long as the demand existed for Sue type wares, including many with ash glazes. Kamakura period productions were chiefly the so-called yamachawan, tea bowls, at which time Sanage still had about 800 kilns in operation, or about two thirds of the total number known to have been in use in the region.

Other interests were rising, perhaps through exposure to Chinese ceramics, and a green glazed ware continued to be produced on a modest scale at various sites through at least middle Heian. Sanage was abandoned about Muromachi times when the potters started to move to Seto and Tokoname while in search of better clays to develop a stoneware after the Chinese porcelains or similar types.

Local lore says Kao Shirōzaemon (Toshiro) set up the first kiln at Seto at the beginning of the thirteenth century but, dissatisfied with his inability to make good quality ceramics, went to China to study for several years. Despite years of searching elsewhere after his return, he settled at Seto, convinced of the quality of the white clays and deter-

Opposite: festival at Hokoku shrine. Detail of seventeenth-century screen. Tokugawa Reimeikai, Tokyo.

Opposite: jar made at Tamba in Kyoto prefecture. Fourteenth century. Tamba Kotokan (Museum of Tamba Ceramics), Kyoto. Above: four-handled vase made at Bizen in Okayama, with inscription dating it to the second year of the Tenmon era (1533). National Museum, Tokyo.

Below: tea bowl with Chinese-inspired chrysanthemum design, best known by the Japanese name of temmoku. *Late Muromachi period, beginning of Momoyama. Fifteenth-sixteenth century. Fujita Museum, Osaka.*

mined to reproduce what he had seen on the mainland. Seto, at this stage, was the only major kiln area producing a glazed ware. It is a feeble straw brown imitation, that included incised floral patterns, now known as Old Seto (Ko-seto).

East Japan was still served from the Seto areas as it had been by Sanage, while west Japan received its ceramics through contacts with China. Chinese celadon was the model, production of which had begun in Kamakura times. Kyoto and Kanto aristocrats were supplied with a variety of jars and tea ceremony paraphernalia decorated in the closest thing to the Chinese monochromatic wares. This accommodated the home market, and Seto was able to add the reproduction of

the Chinese thickly glazed brown tea bowls, best known by the Japanese name of *temmoku*.

The other so-called Six Ancient Kilns, a term misleading enough to suggest little was being produced elsewhere, were in most cases areas turning from Sue to the medieval stoneware and all went through much the same stages, using clay with a high iron content for the production of unglazed water jars and other practical vessels: Echizen in Toyama prefecture, Tamba in Kyoto prefecture, Shigaraki in Shiga prefecture (often allied with Iga in Mie) and Bizen in Okayama.

The geographical proximity Seto enjoyed with the capital aided its production of tea ceremony wares, and the products of the other kilns

were not yet regarded as satisfactory for the aesthetic requirements of the ritual. Aristocrats preferred imported pieces, but the trade could not match the demands, and Seto potters were spurred on by the increasing need for flower vases, incense burners, cups, bowls, dishes, water containers and other utensils.

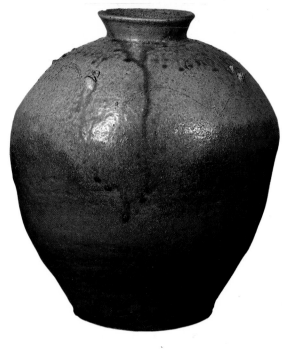

Left: Fourteenth-century stoneware vase from Tamba. Umezawa Kimenkan, Tokyo.
Above: detail.

THE MOMOYAMA PERIOD

1574–1614

Opposite: view of the garden of the Katsura Detached Palace (Imperial Villa) near Kyoto. Traditionally believed to have been laid out by Kobori Enshū, it was completed between 1620 and 1624.
Overleaf: façade of Himeji castle in Hyogo prefecture, known as White Heron castle because of the white plaster that covers the building. It belonged to Toyotomi Hideyoshi, the famous warlord, and was rebuilt by his son-in-law Ikeda Terumasa, who finished work on it in 1609.

Momoyama was a 50-year period of battles to decide who would control the country. Two warlords, Oda Nobunaga (1534–82) and Toyotomi Hideyoshi (1536–98) successfully prosecuted these wars and paved the way for centuries of Tokugawa rule. Nobunaga came from the Nagoya area and, after victories in which he established himself, set out to bring peace to Kyoto. He was assassinated by one of his generals. Hideyoshi fought his way up as one of Nobunaga's lieutenants. Both men regarded the arts as a means to enhance their position and bolster their power. Their ambitions drove them to see themselves as more than traditional regional warriors: they were embodiments of the state and the arts were state arts. The beginning of the period may be dated at either 1568, when Nobunaga invested the shogunate in Ashikaga Yoshiaki, or 1573, when the latter was driven from Kyoto and Nobunaga himself took over personal control of the capital.

Nobunaga had his headquarters at Azuchi not far from Lake Biwa in Shiga prefecture and, later, Hideyoshi had his at a place subsequently called Momoyama, southeast of Kyoto. The period has often received the designation of Azuchi-Momoyama. In each case sumptuous residential castles were built and decorated by Kanō painters. Direct artistic patronage gave the period a strong cultural flavour and produced brilliant and original art. Enough of this art survived the bitter wars to provide a good picture of the age.

After Nobunaga's death in 1582, Hideyoshi immediately set out to avenge his death and by so doing became the leading contender for power. A major opponent was Tokugawa Ieyasu from the present Aichi area. However, Hideyoshi masterminded an agreement with him while he fought on several fronts elsewhere. Shikoku and Kyushu were subdued, and the Kanto brought under control in the Odawara Campaign of 1590. Hōjō power was completely destroyed. Troops were sent north with orders to follow a scorched-earth policy and the Tohoku was secured in late 1591. Two Chūson-ji buildings escaped the fires.

Hideyoshi was still unsatisfied with the conquest of all Japan and he turned toward Korea. A huge army was organized, fleets assembled and an expedition dispatched in 1592. They overran Korea, but Chinese intervention forced them to withdraw and the Japanese demands were ignored. One more try in 1597 met with disaster and humiliation and Hideyoshi ordered the troops home. He died in the Fushimi castle in the following year. The single benefit the Japanese like to recall from the Korean campaigns is the contribution made by Korean potters who accompanied the returning troops, whether voluntarily or otherwise. They knew the technique of porcelain making and were instrumental in locating the kaolin clay essential for its production.

As a military strategist Nobunaga had been the first to train his soldiers in the use of firearms. He had gained support from the Kyoto populace by cutting the bureaucracy and eliminating the toll system which restricted free trade with the capital. He began a vast nationwide land survey which made taxes more equitable, but ultimately put more burden on the peasants. Uprisings of farmers instigated by the clergy were mercilessly stamped out.

Many devices often thought to have been of Tokugawa making were used to ensure total subservience, not the least of which were deprivations to the losers and rewards for the winners. Basic policies for controls were initiated that included a uniform currency system, confiscation of weapons, destruction of castles regarded as threatening, separation of warriors and farmers in castle towns, and hostaging family members. All of these ensured the later Tokugawa 250 years of peace and the flourishing of the *jōka machi*, castle towns.

Fortifications in Japan since the seventh century had been thought of as deterrents to foreign invasion, or for wars with non-assimilable people like the Emishi in the north. Other than earthworks and northern palisades these had been simple, but often long stone walls which were first built in fear of a Korean invasion in the late seventh century. The style was taught by Korean refugees themselves. After the first Mongol attack in the thirteenth century a long stone rampart was constructed to withstand the anticipated second assault.

When the country dissolved into *daimyō* domains stone-walled castles were constructed by every little local lord. Well over 1,000 of these were erected all over the country. In early stages they were built on high ground (*yamashiro*) and were not

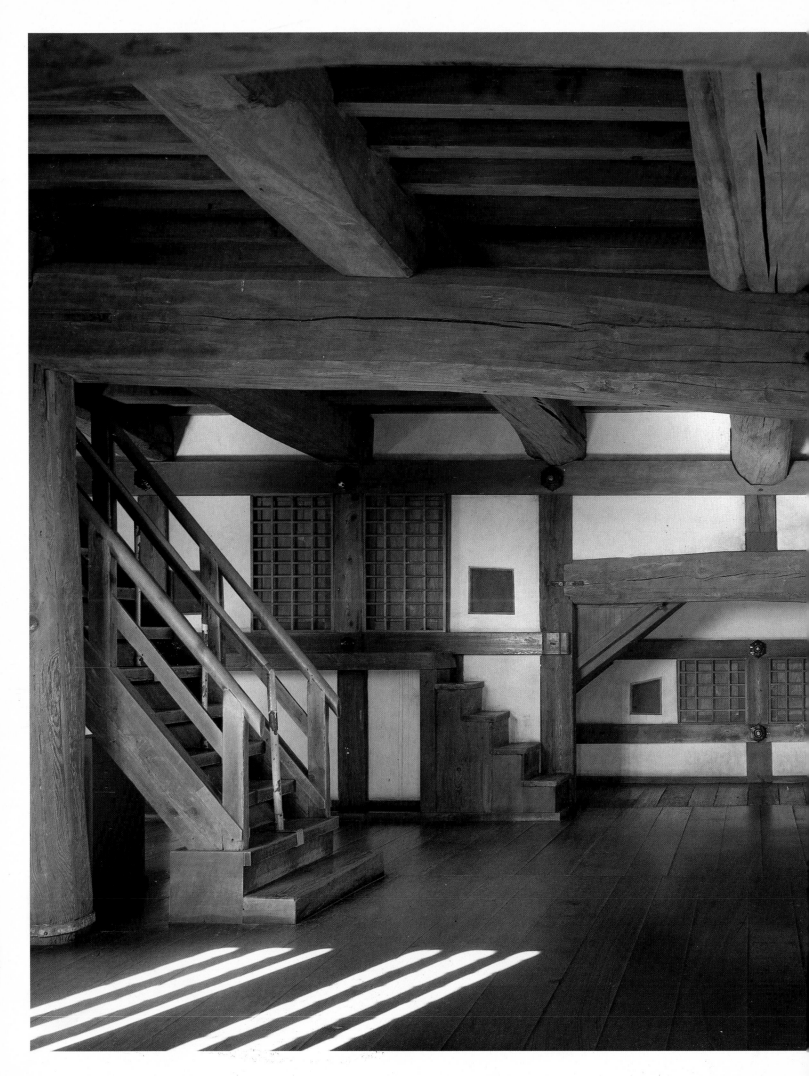

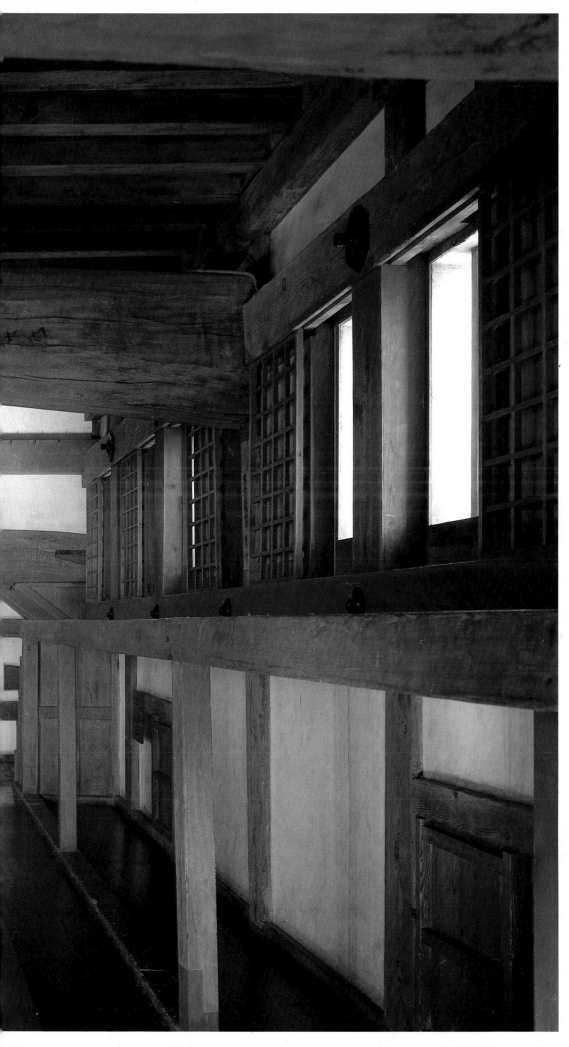

intended as primary residences, but when residences on the plains came under fire, safeguarding them involved the construction of surrounding walls, and the lowland castles (*hirajiro*) got their start. This was the origin of the 200 or more castle towns which expanded in widening circles around the walls. Most major cities except Edo owe their evolution to this process. Edo, however, was built as a central castle with outer walls over twice the circumference of Osaka – which had been the largest in the sixteenth century – running about 15 kilometers (9 miles), as space was needed for the *daimyō* from the provinces who had to spend half a year in Edo.

Rising above the stone walls is the most conspicuous feature of a castle, a multi-storeyed tower known as a *tenshukaku*, a donjon or keep. Donjons were built of wood, plastered and roofed with tiles. The use of firearms led to somewhat sturdier construction, but by no means to the obsolescence of castles. Flaming arrows did the most damage. The roof overhang is quite considerable, but apart from its simple function, the number of dormer or undulating gables and the combinations they take are governed by the discretion of the architect. Slatted windows and lattice add surface decoration. Windows are frequently paired. The top level is like a captain's walk and is a slightly taller storey to improve the visibility. It is sometimes balconied, but rarely seriously interrupted by dormer gables.

Stone walls were built to face natural slopes or tamped earth platforms and were laid at great cost to labour, time and often lives. Geological conditions were often not favourable and many stones had to be moved long distances. For instance, the southern Kantō has no such stone and the castle walls for Edo, which are mostly of andesite, were carried from the Izu peninsula, and for Osaka the walls, which are granite, were hauled from Shōdo island and the Inland Sea region. In both cases a good deal of transportation could be done by water.

The stones are large unshaped boulders with smaller stones fitted between, boulders chipped to size and shape, or so-called cut stones

Interior of the fourth floor of the main donjon of Himeji castle in Hyogo prefecture.

247

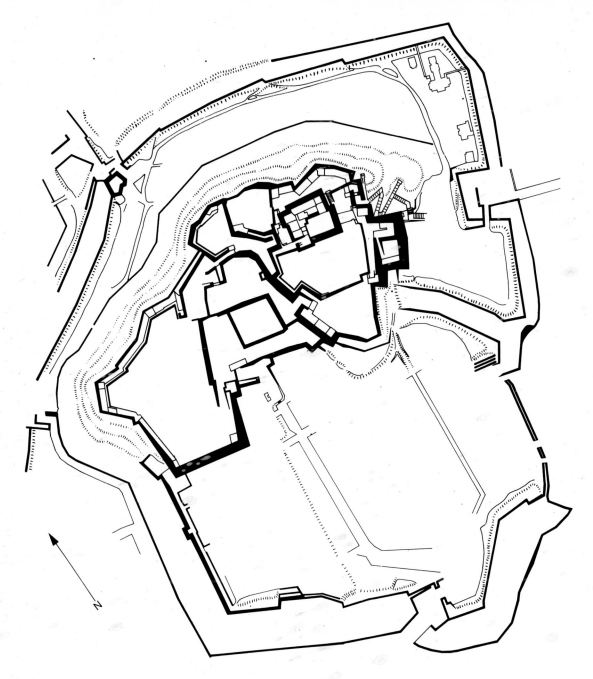

Above: plan of Himeji castle, showing the enclosing walls, the donjons and the outer moat. Opposite: view of a corner building of the castle.

(*kirikomi hagi*). The latter are rectangular ashlars which were laid in alternate lengths at the corners and shaped to make a convex but flattened curve toward the moat.

Castle plans are – intentionally – exceedingly complicated. Walls of unpredictable lengths cut odd angles at many corners. The donjon was placed at a deep point from the main entrance and was reached only by indirect routes that were designed to be treacherous and expose the attackers. Some castles have machicolations (*ishiotoshi*), that is, overhanging aprons through which defenders could pellet attackers trying to scale the walls. Such bulges on the first level of later castles just above the stone platform are merely decorative. All castles have some kind of escape steps at the back.

The old temple *shibi*, the fish-shaped symbols of water at the roof tips which had been out of style for centuries, were revived as *shachi*, a more sophisticated bronze or tile scaled sea monster. It has fins shaped like wings, spikes down the back and a spout hole behind the head. Unlike the *shibi*, these are complete creatures. They have their heads down and tails up, and come closest to resembling a dolphin. The origin is not clear, but there must be some connection with the gate and ridge terminals of south Asia called *makara*.

The Inuyama castle donjon in Aichi prefecture was for long regarded as the oldest, but it has been redated to near the end of the century. The Maruoka castle donjon in Fukui was probably built around 1576, and the Matsumoto castle in Nagano under the Ishikawa fief

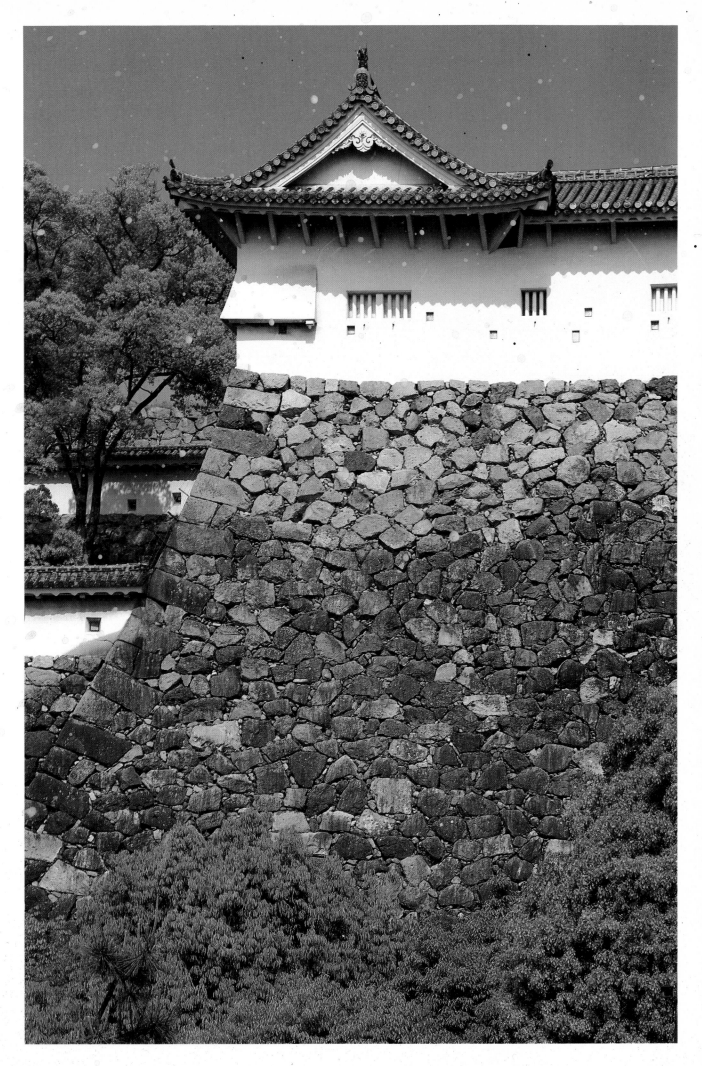

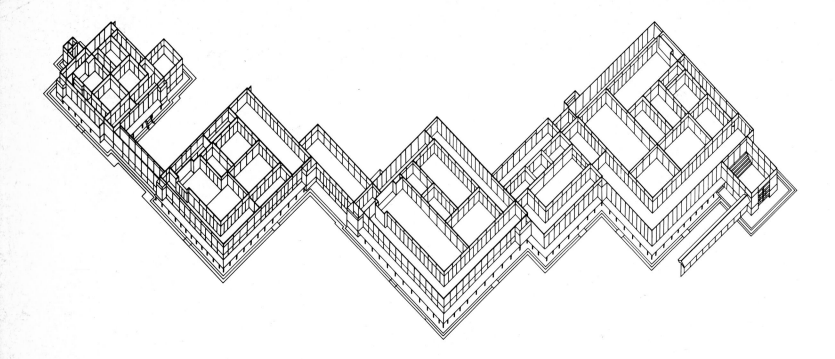

around 1594. Parts of the moat and walls of the earlier castle of 1504 are still visible in the early style of masonry construction. The donjon has five levels and six floors. The solid bands of black wooden panels are striking, especially in the way the roofs interleave to join the small donjon, but are ponderously somber. Matsumoto is "blind"; no windows pierce the usual white walls, but many look through the mysterious panelling.

Castle art was brought to its peak by Oda Nobunaga at Azuchi between 1576 and 1579. It was the first massive, sumptuous castle and was crowned by a donjon of seven stories rising 105 *shaku* from the floor, while the stone base itself was another 50 *shaku* above the ground. A Portuguese Jesuit wrote that the outer walls of the donjon were painted in different colours: red, blue and gold. By having the best painters decorate his residence and several floors of the donjon, he indulged in an exorbitant and what proved to be a highly expendable art which, thanks to the preservative power of temples, is at least partially known in other contexts.

Information on the Azuchi castle is found in several contemporary records. Only a handful of stones remain there today. Since it mixed religious and secular use by including a religious structure inside, a brief comment on how this had been evolving might be in order. This structure was either a reliquary or a cinerarium.

The separated *shariden*, a relic hall, had been a pagoda by tradition until the latter half of the eighth century. When over 60 pagodas were ordered to be built in the provinces, a practical difficulty arose in that there was an insufficient number of relics to go around, and a fair distribution of those that were available was impossible. The ingenious solution was to offer sūtras instead – ones to protect the country – which both hallowed the sūtra and changed the function of the pagoda. Kamakura Zen architects built pagodas, but all were as transient as the Shinto *kami*, and when the Engaku-ji received "genuine" relics, the temple built a regular *shariden*, not a pagoda, to preserve them. Even though Yoshimitsu erected a large pagoda in the Kitaya-madono complex in northwest Kyoto, when it came to housing relics he built a simple but magnificent edifice and put them in glittering surroundings on the top floor. The Kinkaku was a quasi-religious building for secular use. This process is not related to keeping a family altar, which was encouraged from the seventh century and has been widely practiced since. As one knows from European castles, having a chapel close by was a soldier's comfort. Nobunaga carried the relationship one step further at Azuchi, and perhaps as far as it could go.

Above: plan of the Ni-no-maru complex in the Nijō Detached Palace, Kyoto.
Opposite: detail of the wood and metal beams of one of the entrance gates.

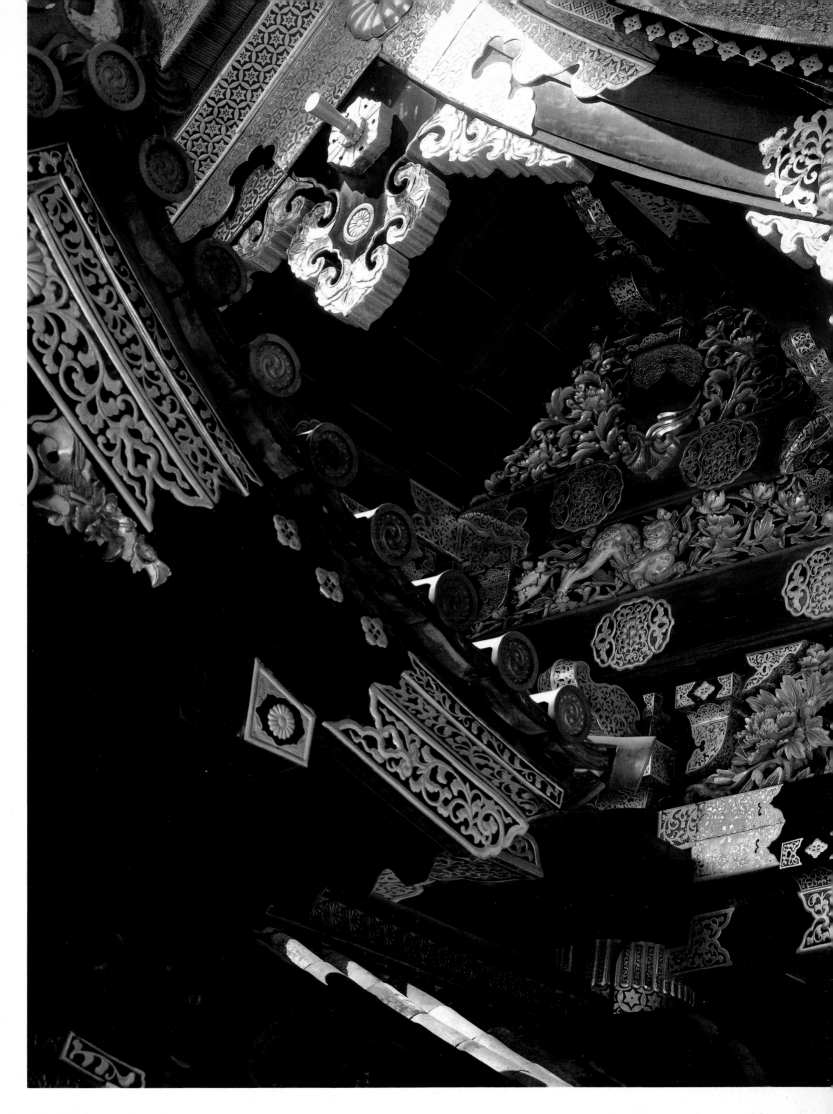

It is now believed that the donjon at Azuchi had an opening in the center for at least three floors through which rose a "tower," a stupa-like structure about 60 *shaku* (19 m or 62 feet) high. It is unlikely that it was a cinerarium, given known concerns about cremation at the time. It was probably a stepped structure with an inside cavity. Moreover, the donjon storeys themselves can be read as a mandala in plan. In ascending order, the room below the ground level was square. It was followed above ground by storeys of octagonal, rectangular, rectangular, octagonal and square shapes. Each was about 15 *shaku* high.

This effect constitutes the supreme effort to bring all the traditional magic of the mandala to bear on the idea of protection to which Nobunaga added the subjects of the paintings, as will be seen. Reconstruction of the Azuchi castle presents obvious problems which cannot be considered here. Nevertheless, as Himeji and other castles are now evidence, a view of the Azuchi exterior roof system, which rose in levels, did not indicate how many floors or storeys were inside. Azuchi had five levels on the exterior and seven floors on the interior. But one interior floor was below ground level, so that from ground level up, the inside and outside were only slightly staggered to arrive at the difference of one level/storey.

Customarily, the interior-exterior differences are said to be an early problem in architecture which can be explained by inexperience in enlarging earlier donjons, but the Kōchi castle as late as 1744 has six floors inside and three levels outside. This still occurred after a full century and a half of practice. It is also apparent that a castle did not reveal its secrets to the enemy. And in the all-important consideration of attack and defense it is said – for some castles at least – that no roofs were supposed to be too far apart to make a descending leap too dangerous. Those experienced in the art of invisibility (*ninjutsu*) may have had a say in their construction.

Aerial view of the Ni-no-maru complex in the Nijō Detached Palace, Kyoto. It was originally built by Tokugawa Ieyasu in 1603 for his sojourns in the imperial capital.

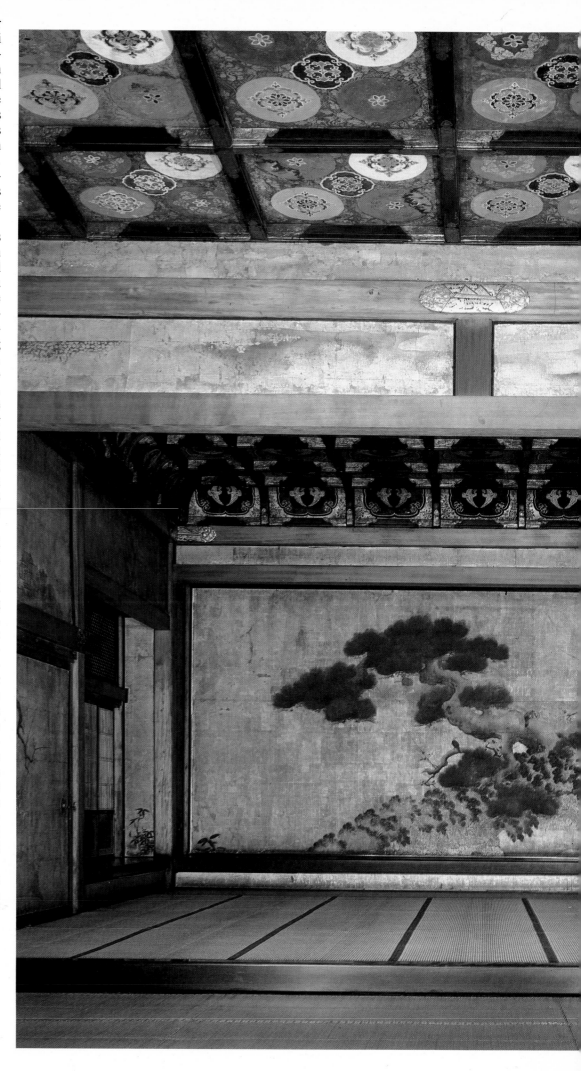

Azuchi was burned a year after Nobunaga died in 1582. Toyotomi Hideyoshi followed suit in the construction of the Osaka castle, which he occupied in 1584 and used until 1596. There is nothing to indicate that he had decorators paint screens or walls in the donjon. Retainers gave the immense granite stones in the walls as symbols of their loyalty. The large ones were "floated" behind rafts from Shōdo island. In its heyday Osaka castle is said to have had 48 large and 76 small towers.

Hideyoshi started other castles then concentrated his interest on Fushimi in 1596, where he lived until his death two years later. Tokugawa Ieyasu attacked Osaka castle where Hideyoshi's wife and son were living, forcing a negotiated arrangement to reduce its size by destroying its walls and filling its outer moats. Ieyasu was still dissatisfied, however, and attacked again in 1615. Hideyoshi's wife and son died in the conflagration. The Tokugawa later rebuilt the castle, but their own distant descendants burned it down in the struggle preceding the Meiji restoration in 1868. Today's donjon is a concrete structure of 1931 that is said to have been modelled after the earlier one.

Fushimi castle, where Hideyoshi had his best artists at work, suffered an even more ignominious demise. Hideyoshi had left a vassal to defend it, but the castle, built after a strong earthquake that occurred in 1596, was taken by Tokugawa forces, then burned down in the battles immediately before Sekigahara. The Tokugawa reconstructed Fushimi after their great victory in 1600 in order to checkmate Osaka, but once Osaka castle fell, Ieyasu decided to include it in his southern strategy and dismantle Fushimi. Osaka castle was rebuilt and the wooden buildings from Fushimi were given to temples in Kyoto. Most of the stones were transported to Osaka. The monumental structure crowning the hill today was put up after the Second World War.

Castle construction reached its peak at the height of the Momoyama era. The Tokugawa subsequently

Interior of the first room of the Kuro-shoin in the Nijō Detached Palace, Kyoto.
Overleaf: exterior of the Katsura Detached Palace (Imperial Villa) near Kyoto.

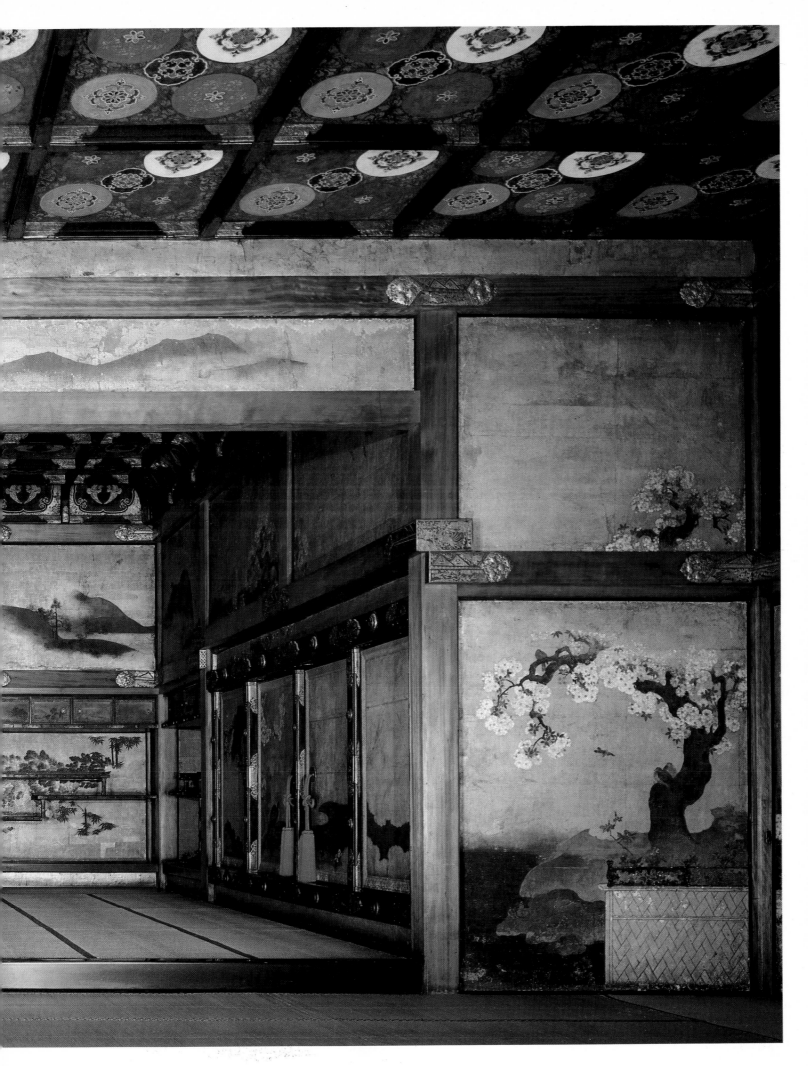

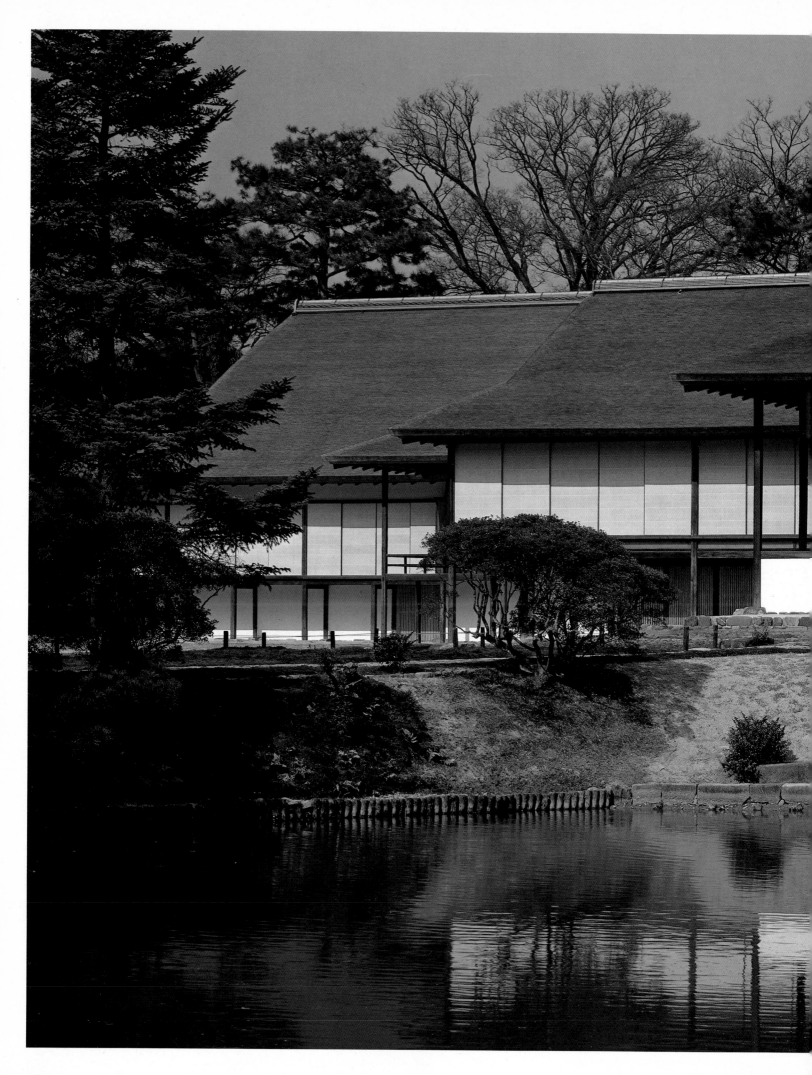

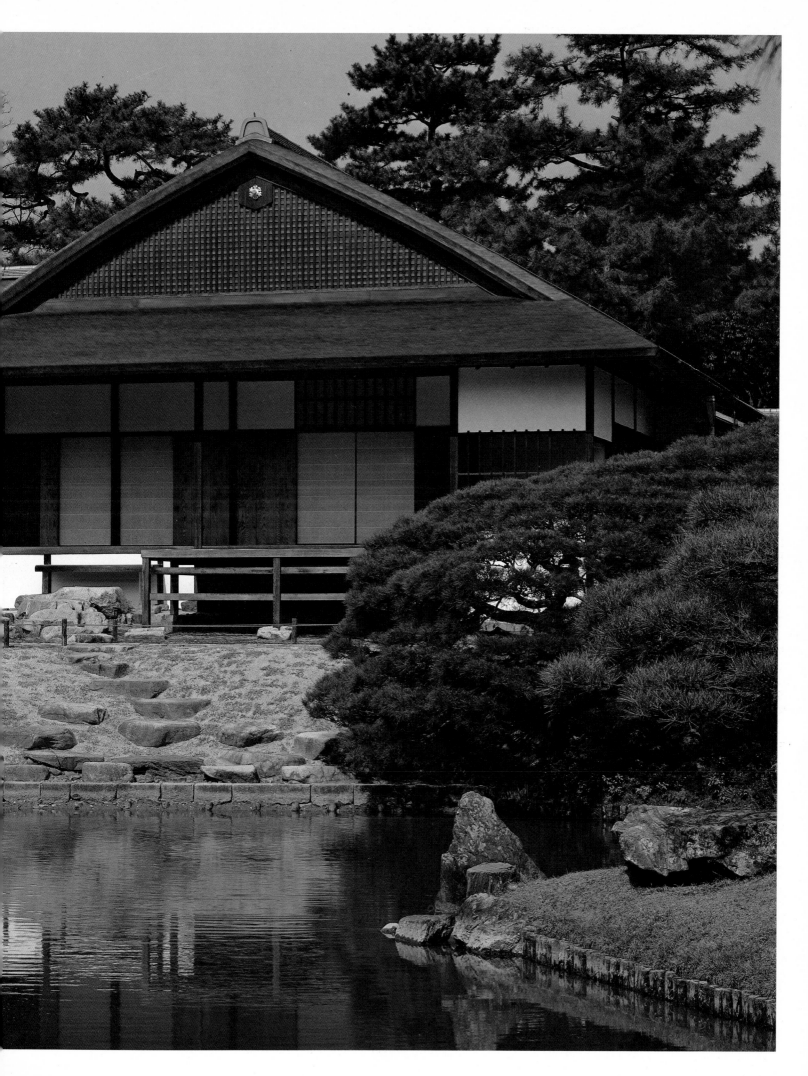

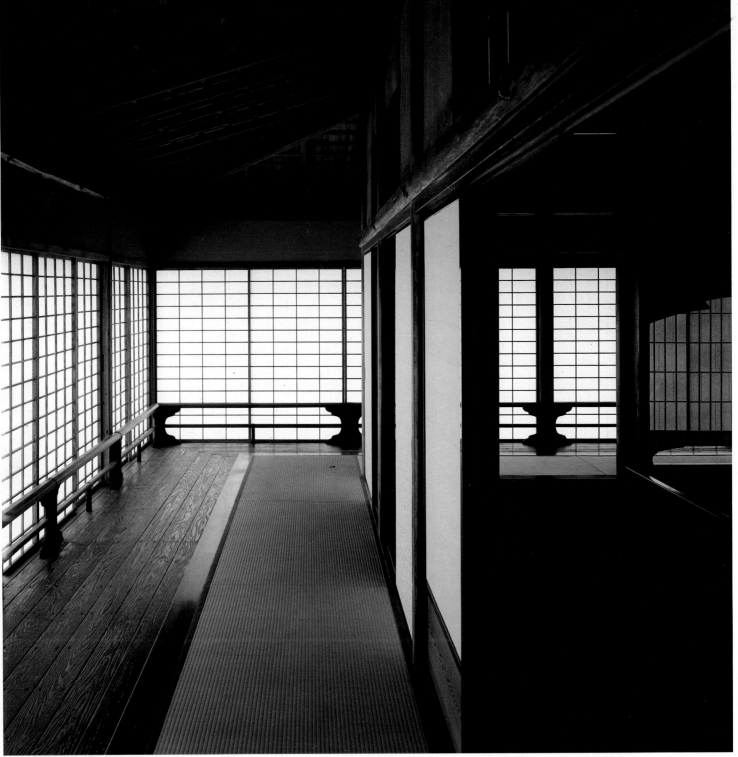

licensed their building or reconstruction, limiting each *daimyō* domain to one. Hundreds went under the axe, and stones were removed for use elsewhere. Castles served little purpose in the long era of peace in Tokugawa times, and when local *daimyō* finally had to face all the costs of upkeep even their grand symbols of rank were too much to maintain.

Nineteenth- and twentieth-century losses have been rather grave. The skirmishes of the Meiji Restoration accounted for the burning of Aizu-Wakamatsu in Fukushima and Kumamoto castles, and the Meiji government itself ordered the destruction of some in distrusted areas, such as Hagi in Yamaguchi and Kokura in Fukuoka. Bombing during the Second World War laid

waste Nagoya, Okayama and Hiroshima castles. Modern ones, that is to say, those built in recent decades, have ranged from tasteless imaginative structures to authentically reproduced originals and many serve their purpose rather well as local history museums.

Castle tower proportions were at their best in the early years of the seventeenth century. Later towers were often poorly proportioned and plagued by repetitive details. As has already been suggested, more room existed for controlling proportions than one realizes since the interior and exterior storeys/floors and levels/stages are frequently not coordinated. Himeji is the finest of the original castles and an important one in its own right, well beyond the luck of survival.

Hideyoshi had a fortress on the site, but it was given to the *daimyō* Ikeda Terumasa, who was married to Hideyoshi's daughter, and who rebuilt it as a key post in Ieyasu's southern strategy. Various stages in rebuilding account for the huge expansion of space from the orginal size. It was ready for full use by 1609. Along with the main donjon, which was one of the largest ever raised, is an unusual cluster of three smaller donjons, all of which are related by fortified two-storey passageways and aesthetically allied by articulated sets of roof lines. Each has a large triangular end gable running through one roof. Internally in donjons, massive wooden beams support a large open central room through which the steep steps ascend.

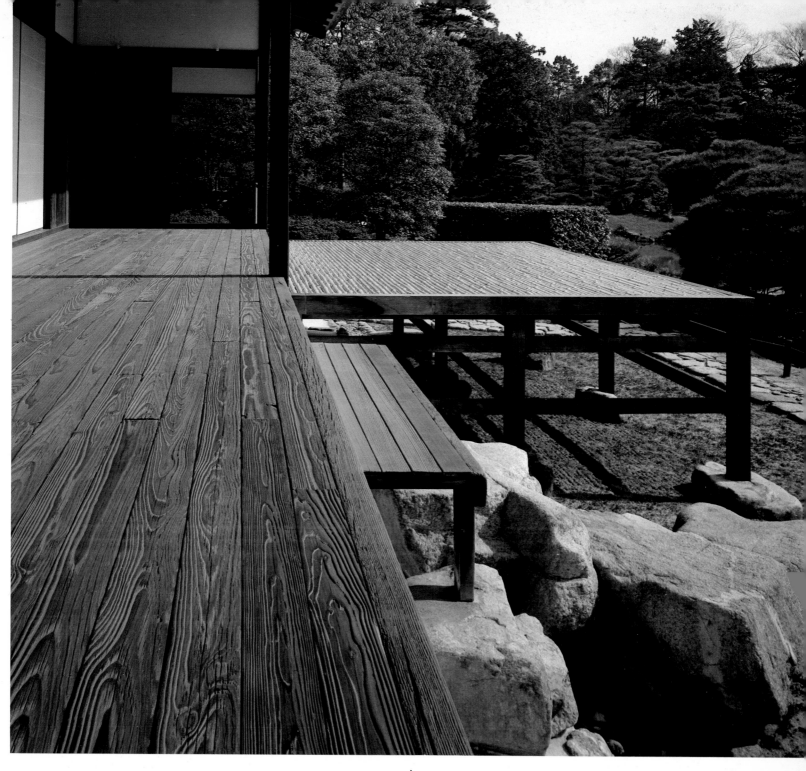

Views of the Imperial Villa.
Opposite: the veranda of the Shoin
Goten.
Above: detail of the open veranda
and garden.
Right: plan of the villa.

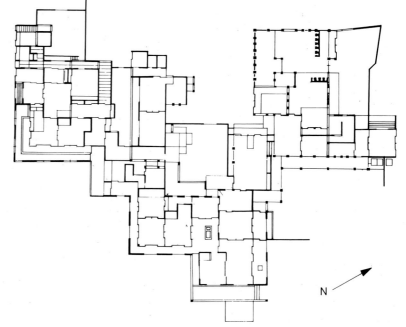

N

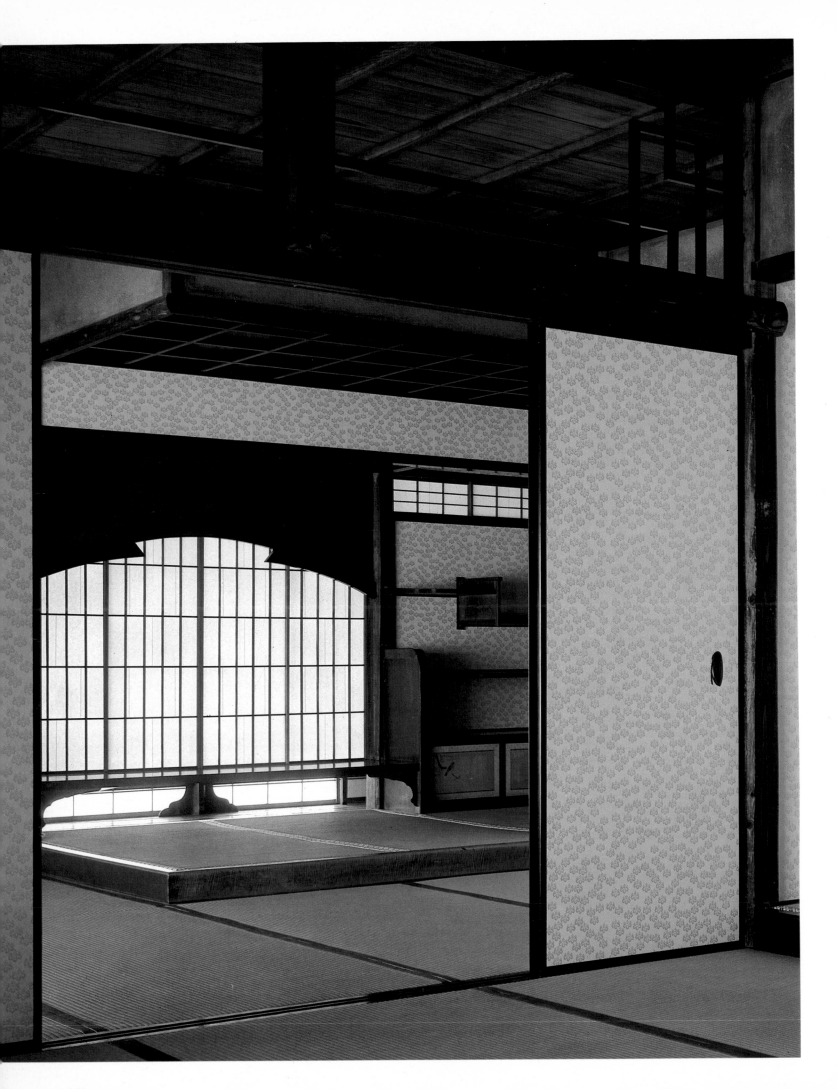

In the main donjon the floors are the same height but each level is a little higher than the one below. The former are actually seven in number, as the first one fits into the sloping terrain, while the latter are only five. Only between the second and third floor/level is there any real degree of coincidence. Real divergence starts at that point. The inside and outside, therefore, have neither a functional nor an aesthetic relationship. Architecturally, the inside is function, the outside is aesthetics. External evidence of the differences is imperceptible, but one should look at the set of the windows between roofs at Osaka castle, taking into account its twentieth-century rebuilding. The rhythm at Himeji is so complicated, the differences between storeys and levels is scarcely recognizable, but it is a charming, barely predictable work of Japanese art.

The upward progression of roof lines on the south side, the major face, varies from level to level as has been intimated. Other than the first unbroken line, the sequence is composed of a long undulating gable, a pair of dormer gables, a single dormer, and a short undulating gable. This compares with the east and west ends where, despite their own independent roof systems and a rather complicated interrelationship, one sees a small dormer gable, a large central gable running through two levels, a small undulating gable and a straight roof. Since each end terminates with a triangular gable, the rhythm of undulating gables on the south is simply repeated in triangular gables on the ends.

Among other points of interest are the different shapes of apertures for firing weapons, triangles for rifles, rectangular ones for archers and so on – a code easily read by the enemy. But here again, aesthetics played as important a role as function. An astute observer will notice ancient stone sarcophagi, their hollow interiors turned inward, used as corner stones in the wall.

The sixteenth century was not a happy one for temples and survival itself was no mean accomplishment. The Ise shrines were not rebuilt. The Tokugawa did much rebuilding, often with lavish displays of largesse, but few temples improved their lot. *Daimyō* supported the construction of family temples or sometimes adopted older ones in the area, and temples hired professional artists for quality and prestige if patronage met their ambitions.

Castle and residential styles of art were inseparable. The castle walls and donjon represent only the outwardly visible parts of a large complex of living and support buildings. Kanō artists painted decorations in these buildings at the Azuchi castle, and Nobunaga delighted in including them in the tours he conducted for visiting *daimyō* and retainers. The grand style of colourful screen painting which Kanō Eitoku developed as a castle art was then adapted in a modest way to palatial residences quite unrelated to castles and the business of warfare.

Important developments were also taking place in residential architecture. The one remaining example, but unquestionably one of the best ever built, if not the best, is the Katsura Detached Palace or Imperial Villa (Katsura Rikyū). It lies along the west bank of the Katsura, southwest of Kyoto, in an area which had been earlier favoured by Fujiwara aristocrats and others. Wood and stones were brought from distant points, the architects and garden designers were the best the capital could offer, and highest ranked Kanō painters were used to decorate the inner rooms.

Two imperial princes owned the villa successively: Toshihito, formally known as Hachijō-no-miya and later, Katsura-no-miya (1579–1629), and his son, Toshitada (1619–62). Toshihito, an accomplished literary statesman, was the younger brother of Emperor Go-yōzei and adviser to Emperor Go-mizuno-o; he had been adopted by Hideyoshi. On the arrival of Hideyoshi's own son, however, all earlier plans were altered and Toshihito began to build a residence in the imperial palace.

The Katsura plan was not a conceptually evolved one when Toshihito started in 1620, but it grew with time and ownership. The main section consists of three *shoin* style buildings attached to each other asymmetrically and stepped back progressively. *Shoin* gets a loose definition, but they were reading rooms, first used in temples that doubled as reception rooms. They had a mat floor, sliding room dividers (*fusuma*) and sliding wall panels (*shoji*). To be complete they had an alcove (*tokonoma*) and shelves (*chigaidana*). This became the formal nucleus of aristocratic Momoyama and Edo residences.

Opposite: detail of the first room of the Shoin Goten.

261

The three Katsura *shoin* are commonly spoken of as Old, Middle and New and are believed to have been erected in that order. The Old *shoin* may have been moved from the imperial palace where Toshihito had been living, and much of the garden was then laid out to relate to it. The nearby Geppa-rō teahouse and the Shōkin-tei teahouse on the island all fall into a rather uniform style.

The Middle *shoin* followed, probably put there by Toshihito a few years before his death, and the New *shoin* was added by Toshitada. This helps to explain why some floor levels do not match perfectly and some adjunct angles are not precisely 90 degrees. The garden was enlarged and elaborated so as to coordinate fully with each addition.

When Toshitada was expecting an imperial visit by ex-Emperor Go-mizuno-o in 1658, several changes were made, including the erection of an imperial gate and the laying of an entranceway stone pavement. An open veranda distinguishes the New *shoin* from the others. A raised dais (*jōdan*) was installed for the emperor's use and wall shelves and dressing, toilet and bath facilities built in. In fact, one notes the changes from the simpler more rudimentary character of the Old *shoin* to the stiffer, prim work of the Middle *shoin* and, finally, to the coldly perfect finish of every small detail in the New *shoin*. The first was a modest start with few pretensions; the last was befitting the imperial presence.

The integration of the garden with the buildings can be considered from several views: as framed from *shoin* rooms, as views of buildings when wandering around the garden, or as the garden seen from the teahouses. Even exclusive of its relationship to the buildings, which would be unjustified, the garden is a masterpiece of elegance and unpredictable low key beauty. The total space is not large. What is maintained measures about 130 meters (426 feet) in north to south dimensions and 150 meters (492 feet) east to west. An estimate is for perhaps one fifth of the total space to be occupied by the pond and other linked areas of water, and a water system actually cuts the entire lot into almost equal north-eastern and southwestern halves. Many narrow "streams" in marginal areas give water an unusual prominence.

The outlines of the pond are composed of intricate curves except where boats are tied up by the Shokin-tei teahouse. An encircling path of ingeniously laid stepping stones moves through widening and narrowing views, key points marked by lanterns. One large island and a pair of small islands, each joined to the mainland by bridges, occupy almost half of the central pond area. Involutions are particularly evident on the east side where river stones and a lantern simulating the promontory of Amanohashidate project into a bay shaped to receive it.

Tradition attributes the garden to Kobori Enshū (1579–1647) and, indeed, the architecture is often said to have been his work. But neither the buildings nor the garden are consistent designs, and the garden was modified in tandem with the erection of each new *shoin*. Changes in the garden, by the very nature of the materials, can be more easily obscured. The diaries of both Toshihito and Toshitada indicate that they themselves were knowledgeable in the principles of garden design and took a great interest in all of the work. Other names recently raised as being connected with both buildings and landscaping may have been minor personalities in the planning and execution of the scheme at different stages.

Strictly speaking, as Japanese classifications go, Katsura is *sukiya zukuri*, a teahouse style of residence which, in effect, is a residence built around and for the tea ceremony. It marks a new step in civilian life by introducing the tea ceremony as the major form of home entertainment. The New *shoin* has the imperial reading room, with shelves and lacquered surfaces. The Geppa-rō, from which the rising moon was to be viewed, was an early teahouse, as was the Shōkin-tei which, incidentally, affords the closest thing to a vista of the garden. It contains blue and white checked patterns in the alcove and on the *fusuma* of its first room. But in other respects, this teahouse is built in a rustic country house (*minka*) style, as is generally the case with buildings erected by Prince Toshihito. The Shoka-tei is a simple resting station, which, like many other features, is an allusion – here intended to suggest a teahouse in the open countryside. Other allusions are to mountains, valleys and rivers.

Katsura is said to be egalitarian – that is, among aristocrats. It does not have graded floor levels for ranked visitors. It does have the not uncommon aura of humility with

Opposite: view of the Shokin-tei teahouse in the Imperial Villa.

262

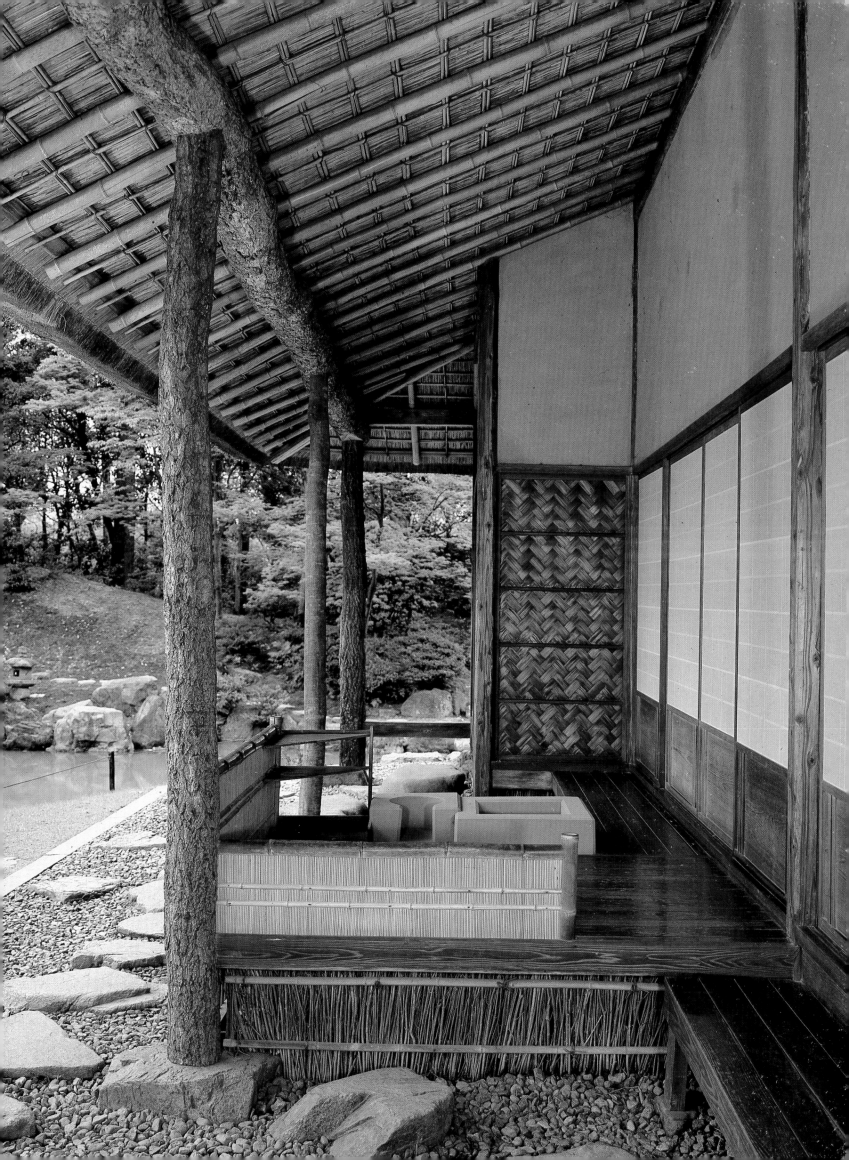

Two paintings by Kanō Eitoku (1543–90).
Above: detail of a painted sliding door in the Juko-in of the Daitoku-ji, Kyoto.
Opposite: view of Kyoto (detail of screen). Uesugi Collection, Yamagata.

which at least the trappings of the tea ceremony are endowed. The plan is studied asymmetry, allowing the maximum exposure to the south and to make the most of the garden views. Yet each *shoin* retreats from the garden as though to be a little more private from the prying eyes of circumambulators and as if to grade the perspectives of the garden. Overhanging porches and the veranda permit the greenery to subtend the buildings, and the first step from any one of the *shoin* is a step directly

into the garden.

The school of painting which had the family name of Kanō owed its independence from temple arts to the warrior origins of Kanō (born Fujiwara) Masanobu (1434–1530). At some stage, perhaps when in the employ of Yoshimasa in Kyoto, he took the name of the place in Shizuoka from which he had come. Yoshimasa appointed him to replace Sōtan as his official painter, which should be enough to measure his standing, but his extant work alone

is not sufficient to enable us to reach a judgement. Masanobu conformed to the ink-painting style still widely regarded as the highest achievement in the art at that time because of its origins in the font of all creation, and did paintings in the mode of Ma Yüan as interpreted by the brush of Shūbun.

The stamp of originality in this school belongs to his son Motonobu (1476–1559) whose marriage to the daughter of Tosa Mitsunobu (?–1522) and eventual assumption of the Tosa business was a fortuitous union of unusual significance for Japanese art – where unions were more consciously political than cultural. Motonobu, whose wife was a painter in her own right, succeeded Mitsunobu as head of the Office of Painting.

The history of introduced foreign lines and eventual convergences makes it possible to foresee the outcome. The Japanese elements of line and colour which had surfaced at the Late Heian court for linear patterns (i.e., *Genji Monogatari*), and the native ability in graphic raconteurship emanating from temples (i.e., *Shigisan Engi*) were dramatically interwoven in the Kamakura narratives. At this juncture it was just a question of time with the black ink style. The patrons, artists and conditions appeared on the same stage when Motonobu added colour to Chinese ink paintings on screens and walls in the subtemples of the Daitoku-ji, Myōshin-ji, Nanzen-ji, Seiryō-ji and perhaps others.

The time arrived when Oda Nobunaga built his luxurious castle at Azuchi. It was, unfortunately, to survive only long enough to set the new fashion. Kanō Eitoku (1543–90) was invited to decorate the residence and rooms of the donjon. No undertaking on this scale had been attempted before, and the subjects needed to be selected for their meaning to warriors. By putting all the resources of the state behind the project, Nobunaga gave the Kanō unprecedented recognition and the arts took on a personal character hitherto unknown.

Documentation now associates many artists with individual patrons in work done outside temples. And religious (i.e., Zen approved) arts were assuming more secular qualities

Maple trees. Detail of a screen painted by Hasegawa Tōhaku (1539–1610). Chishaku-in, a temple of the Shingon sect, Kyoto.

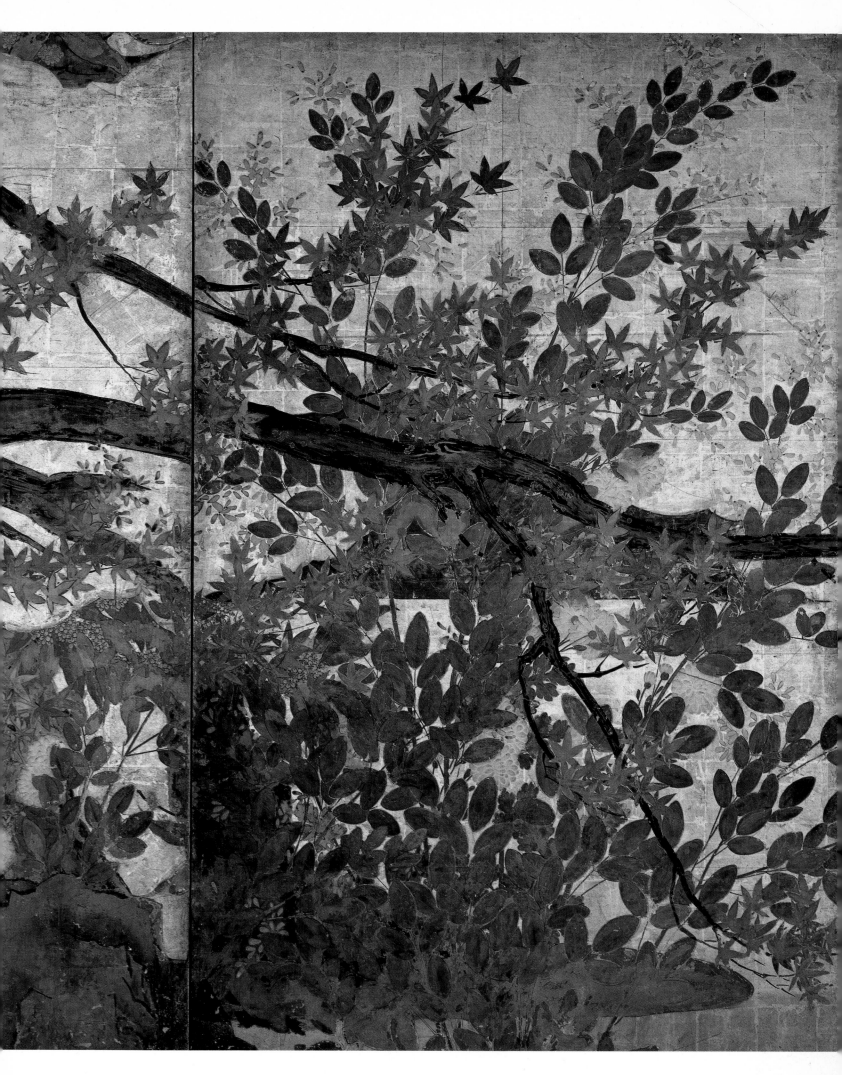

by virtue of the fact that temple arts had to be adapted to non religious circumstances. Zen, as is well known, had given religious meaning to subjects which would otherwise be regarded as secular – birds, animals, flowers, landscapes – and by so doing had made it likely that as the intensity slackened in succeeding generations, the slide into secularity was inevitable. But whether the arts are religious in a secular setting or secular in a religious setting is more

which this process has a chance of succeeding, the arts must be regarded as secular. One other factor enters in: commissioned art following the route of enlightenment will begin to suffer either as art or as religious expression. Later generations found the commissions more practical than the enlightenment.

Eitoku, with the help of his son Mitsunobu and some assistants, worked for about five years to complete the Azuchi project. The *Nobu-*

technique, in which gold leaf rectangles were used in the early stages and heavy painting of gold somewhat later. Gold had been used before, but never so lavishly or for landscape backgrounds. Landscapes were given a mystical artificiality, interiors were livened up, and literate people were inspired to record their observations.

Traditional birds and flowers adorned the second floor – the first had none – in this case chiefly plums,

like a *kōan* than a rational question, especially for Japan.

Zen arts skirted the grey line, relying on interpretation for their religious meaning. Zen is also a process, and without the instrument of the process whereby the painting is executed for personal enlightenment and the conditions under

naga-ko-ki (Records of Nobunaga) includes a description of the paintings on each floor of the donjon, although interpretations of this information vary. At least four interior floors were decorated, and paintings are said to have been coloured in gold. This is the first extensive application of the gold background

Detail of the painting "of the dragon and the tiger" by Hasegawa Tōhaku (1606). Museum of Fine Arts, Boston.

pigeons and pheasants, and some of these continued on the third floor. This third floor also had Taoist legendary figures, including the Queen Mother of the West. The reception rooms were on this floor, and ever since the time paintings were done on walls of Han dynasty tombs, the Queen Mother was fre-

quently shown presiding over the reception of the spirit of the dead in her Western Paradise. She is the symbol of immortality.

The fourth floor had dragons and tigers in competition, the most powerful of beasts, the symbolism of which would escape no one, and landscapes, including phoenixes

Landscape detail of a painted sliding door by Hasegawa Tōhaku (1599). Rinkain, Kyoto.

(immortality and rejuvenation) in bamboo groves and pine forests. The fifth floor was an open loft for supplies. The sixth floor had Buddhist and other subjects drawn from the old Chinese inventory.

The subjects were therefore largely Chinese, with strong Taoist overtones of longevity. Taking the arts all together, if one sees the landscapes, reliquary and Taoist subjects as life, death and immortality, the cycle is complete. Behind the exotic exterior is this sobering mood. On the other hand, no vertical progression of subjects emerges – Zen was a one-storey art – and one wonders if any Amida traditions might not have crept in, even in disguise. Amidist art had borrowed mandalas and the Western Paradise traces its origins in China to Taoism. In much the same way as the Fujiwara had combined their arts in the grand *raigō* theme, so had Nobunaga conceived of one for the warrior, though with a less coherent philosophy. The arts made this indirect contribution to the tragic hero theme.

Eitoku was the son of Shōei, grandson of Motonobu and great grandson of Masanobu. He first appears in 1566 as the painter of monochrome seasonal birds and flowers on sliding doors in one room in the Juko-in of the Daitoku-ji. This was followed by Nobunaga patronage for illustrations of activities in Kyoto (*rakuchū rakugai-zu*), which took the form of screens packed with scores of little people performing their daily chores. These were essentially the Tosa genre and were appreciated for their documentation of everyday life and sheer detail, but they often seem to be poor adaptations from scrolls, to which they were better suited in size for long hours of examination.

Eitokyu then came in the employ of Hideyoshi, executing the paintings for the Osaka castle in 1583, and four years later he was at work on the paintings in Hideyoshi's Juraku-dai residence in Kyoto. The latter must have been an exceptional piece of work, but neither of these survived the civil wars. Eitoku emerged from these projects as the towering figure of the *fin de siècle*.

Azuchi gave Eitoku a chance to perfect his style. He scaled his subjects to the large rooms, used gold as a natural reflector in the dim settings, and concentrated on single dominant birds, animals, and trees. Foreground features were

Above: detail of a screen painting "of the crow and the heron" by Hasegawa Tōhaku. Early seventeenth century. Japanese Ink Society, Tokyo.

Opposite: detail of a painting depicting a monkey swinging on a branch by Hasegawa Tōhaku. Myōshin-ji, Kyoto.

Two paintings by Hasegawa Nobuharu, who was active between the end of the sixteenth century and the beginning of the seventeenth.

Opposite: the deities of Fortune, Ebisu and Daikoku.
Below: landscape with horses (detail of a screen).
Both works are preserved in the National Museum, Tokyo.

magnified to close-ups, colours were strong and well orchestrated. Eitoku produced the grand style of the gold landscape screen with colours (*kimpeki* or *konpeki*). He has been credited with – or accused of – abbreviating the style when faced with short deadlines.

Nobunaga's personality comes through in the simplified, somewhat coarse and gaudy decorations. Temple landscapes with domestic creatures were transformed to wild and mythical birds and animals, and subjects intended to induce a mood of contemplation were transformed into subjects to inspire warriors in battle.

The paintings by which Eitoku is known today, such as screens of pine trees and lions, and their many later copies, are flashy and powerful. The lions are crass and caricaturish, neither real nor mythical. A reduced version of Sesshū's multiple rhythms characterizes the landscapes. The breadth and power are unusual in Japanese art, where detail and smallness are usually preferred, and show him to be an artist with a rare sense of imagination and technical skill.

Other Kanō painters worked in a finer, more intricate manner. Mitsunobu (*c.* 1561–1602), his son, and his adopted son Sanraku (1559–1635) were major figures in adapting the style to the less rowdy temple atmosphere. Sanraku is known through attractive screens at the Zen Daitoku-ji and Myōshin-ji, and at the Shingon Daigo-ji to the southeast of Kyoto. His birds and flowers are precisely composed in spaceless radiant backgrounds. The detail is more concentrated with flat overlaps of plant life. Each composition is carefully calculated, does not seem startling or intrusive in a room, and is well suited to harmonize the garden with the interior while softening the harshly geometric internal spaces.

By the end of the period when the shogunate was contemplating the move to Edo under the Tokugawa, Kanō masters could see a future in commissions there and set up a workshop headed by Kanō Tan'yū (1602–74). It flourished under Tan'yū, a remarkable child prodigy, who dominated the school in the seventeenth century as an artist in great demand. The Edo school subdivided, but no later Kanō painter added to its distinction and those still working in the nineteenth century bore a tattered standard.

Members trained in the school, however, had no patent on their creation and other artists shared their style. One of remarkable ability and phenomenal versatility was Hasegawa Tōhaku (1539–1610), a man who had had some training as a monk before coming to Kyoto. He studied with the Kanō, learned the Chinese style as all qualified painters did, and even planned to call himself Sesshū V. But the name was given to Tōgan (calld Sesshū III), for which Tōhaku was better off. Tōgan left almost no worthwhile legacy.

Sometimes alone, sometimes with his son and assistants, Tōhaku worked at the Daitoku-ji, Kennin-ji, Myōshin-ji, Nanzen-ji, Shōkoku-ji and Honpō-ji where he lived. Quite a large body of paintings is associated with him, but attributions present enormous problems and elicit wide differences of opinion. One painting done the year before his death is signed in four columns: Self Sesshū V; Hasegawa Hōgen; Tōhaku painted (it); 70 year. He held the *hōgen* rank, which he inserted between the names.

The Tōhaku style ranges from the purest Kanō *kinpeki* to simple monochromatic scenes in black ink. The subjects are Chinese landscapes with or without colour, numerous priest portraits, Daruma, sages in rocky settings, Buddhas, bodhisattvas, Sixteen Rakan, Thirty-six Poets, genre activities and legends, and various stories. One group of paintings believed to be by Tōhaku, his son Kyūzō and assistants is today to be seen in a special building at the Shingon sect temple Chishaku-in in Kyoto. Hideyoshi had ordered the screens for the residence of the Shōun-ji, a temple he had erected in memory of his infant son who died in 1591. Tokugawa Ieyasu subsequently gave the temple to the Chishaku-in after the eclipse of Hideyoshi's family. A fire in 1947 destroyed many of the paintings.

Paired flowering and non-flowering pine, maple, cherry and plum trees and hibiscus and chrysanthemums are combined on a screen. Against patternized patches of gold are pine needles in broad sweeping curves below and irregular, short scallops above; leaves as midground ornaments, some pointing toward the trees above; gracefully arched blades of grass; and rocks darkened to their upper, lower or outer edges. The compositional scheme consists of progressions of grass, stones, flowers and trees moving across the

surface, but usually with not more than a selection of three of these overlapping at any one time.

Tōhaku was at his best when he was most original, with a unique use of the Chinese ink-painting technique on lightly painted gold backgrounds. This was later tried by Maruyama Ōkyō (1733–95), but for a different reason and without the lyrical elegance. Six-panelled screens bear a softly painted bamboo grove, a bamboo grove with a crane, a pine grove, or monkeys on pine branches. The sumptuous format of gold (i.e., the unreal) was used to disclose the mysteries of nature (i.e., the real).

Strong clusters of the living forms mark the first or second panel as the natural scene fades back quickly to reappear vaguely in the distance on the fifth or sixth panel. The size is smaller, but the shapes are more heavily accented in a last, fleeting glimpse through the mist. One panel is almost untouched. It is as though a hazy shimmering background glow reveals just the right natural features in the indistinct light. His spatial sense would make the Chinese envious; the compositions are asymmetrically Japanese at their finest.

A school which carried the *yamato-e* traditions with little fanfare traces the origins of its art to Fujiwara Yukimitsu (fl. 1352–89), but his son, Tosa Yukihiro (fl. 1406–34), is the first to bear the Tosa name. Yukihiro was appointed governmor of Tosa province (Kōchi prefecture on Shikoku island), and some Tosa were priests or became priests, which was not unusual for cultured men. The school maintained a place of favour into the seventeenth century and achieved a modest revival toward the end of the century.

The Tosa place in history was established by Mitsunobu (?–1522) who had received the imperial appointment of Edokoro-azukari, the head of the Office of Painting, and at the same time was in the official employ of the *bakufu*. Tosa artists served their apprenticeship working on narrative scrolls and Mitsunobu gained considerable reputation for small handscrolls known as *ko-e*, which were in demand among the

Opposite: the God of Wind. Detail of a painted screen by Sōtatsu (died c. 1643) and assistants. Kennin-ji, Kyoto.

less affluent aristocracy of the capital and the *nouveaux riches* of the Kantō region. Fairy tales (*otogi-zōshi*), local lore, temple legends, old classics such as the Tale of Genji, and others were illustrated in an almost miniaturistic manner. Tosa art was a major channel for the transmission of subjects and styles in a conveniently portable form which, though it tended to be repetitive and banal, formed a significant link with the later popular arts.

When Tosa artists entered the field of the Kanō ink-painting technique and coloured landscape style and began playing the game according to Kanō rules, they were in a different league. Acting in a complementary relationship, Tosa had a recognized *raison d'être*, but it was no match for the flashiness and native linearity that marked Kanō painting. Temporary efforts to settle where business prospects appeared to be brighter led to the developing cities, and Mitsuyoshi (1539–1613), perhaps a younger brother of Mitsunobu, moved to Sakai south of Osaka, letting the Kyoto workshop languish. The merchants may have been promising patrons, but interest in historical subjects was minimal in the new cities, and sources for support for city temples, which offered some of the business, were derived more from the quantity rather than the quality of visitors. At best, the stage was unsettling, and ties with the past or promises for the future induced Mitsunori to return to Kyoto with his son Mitsuoki in 1634. The latter was appointed to the position of Edokoro-azukari in 1654 and ranked as *hōgen* in 1685. Within two generations a new branch was formed in Sumiyoshi north of Sakai, the *bakufu* appointed another Tosa as the official painter, and a branch was organized in Edo.

Above: two tea bowls, the first of Oribe *type, the second of* Raku *type. The latter is the work of Hon'ami Kōetsu (1558–1637). Right: lacquer box from the first half of the seventeenth century. MOA Museum, Shizuoka.*

276

*Veranda of the teahouse of the
Kōhō-an in the Daitoku-ji, Kyoto.
The gardens and the teahouse of the
Koho-an "hermitage" were planned
by Kobori Enshū (1579–1647).*

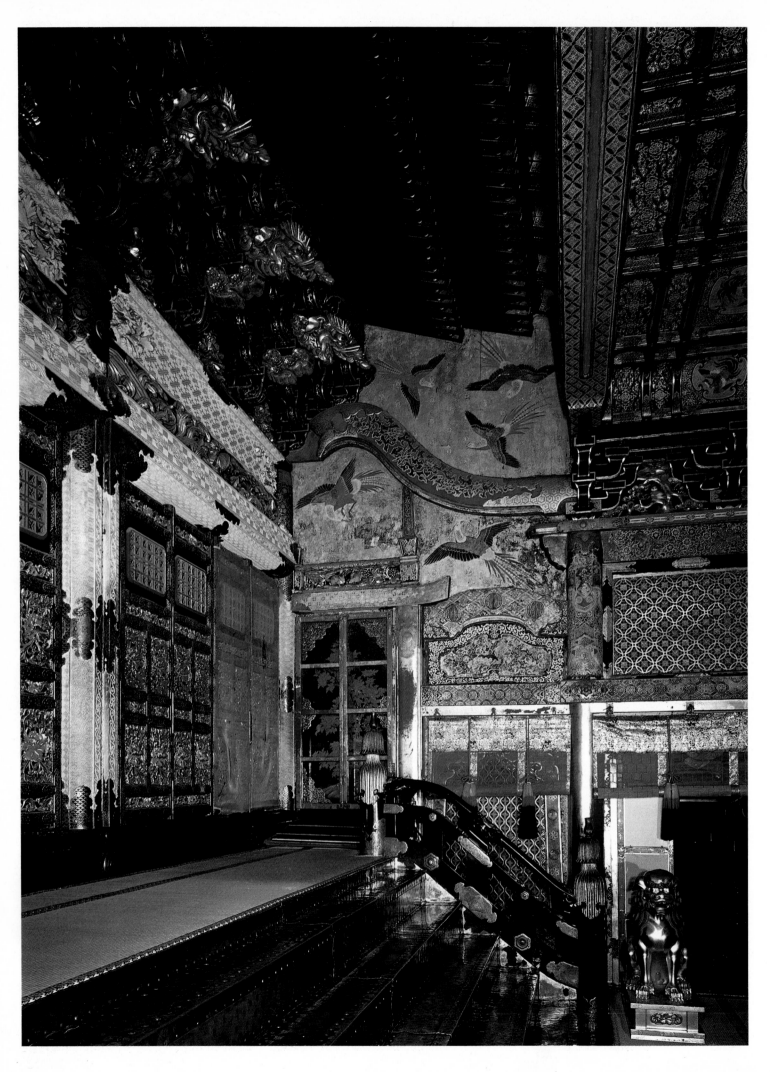

THE EDO PERIOD
1615–1868

Early Edo

Tokugawa Ieyasu was appointed *shōgun* in 1603, but he retired two years later in order to install his son Hidetada in office. This move did not deter his ambitions and he took up the wars even more vigorously and waged the Osaka campaigns. Regulations governing the social behaviour of the samurai and court nobles were issued after the final Osaka victory, and he was appointed prime minister (*dajō-dai-jin*) by the emperor.

The samurai had settled in the castle towns in large numbers and, as peace descended, they occupied the controlling political positions and formed the bureaucratic system. They were largely responsible for the development of the social grades and, because of their high position, were interested in maintaining the status quo. Additionally, they were a substantial consumer class. The merchants prospered and the cities were alive with small family enterprises, artisans, entertainers and service people.

About 270 *daimyō* administered the fiefs for which they were granted an annual pension of 10,000 bales of rice. All were vassals of the *shōgun*. The old court gentry (*kuge*) still held nominally superior positions, and the social strata made the townspeople (*chōnin*) subordinate to the samurai. The farmers were less clearly a part of the social grading.

Ieyasu designated as "outsider" *daimyō* (tozama) those *daimyō* who had not fought for him before Sekigahara but accepted vassalship later as the lesser of the evils, and by doing so created a group of implacably dissident feudal lords. They fretted century after century and were ultimately the ones who helped to overthrow the Tokugawa and set up the Meiji Restoration.

Abroad, Korea had withdrawn into itself and the Chinese were faced with the collapse of the Ming dynasty (1644). The Tokugawa were apprehensive of foreign threats, causing Ieyasu to issue a proscription on Christianity in 1613. He had initiated the process of closing the ports by the time he died in 1616.

The sixteenth century had seen a substantial increase in Western trading ships entering the ports of Asia. Portuguese and Spaniards arrived. St. Francis Xavier came in 1549 and stayed a little over two years. Sympathy for Christianity spread in some of the southern provinces and several *daimyō* sent representatives abroad. But Christianity seemed dangerously close to political sabotage to Hideyoshi, who initiated the first anti-Christian restrictions. He may well have wished to keep the traders. Dutch ships came and English ships slightly later, and they were given permission in 1609 and 1613 respectively to conduct their business out of Hirado island and Nagasaki.

The Japanese themselves kept up an active though licensed trade with China, the Philippines, Thailand and other areas of south Asia. Japanese goods began to be appreciated in foreign markets outside of Asia, Japanese ships even visiting Mexico.

Tokugawa Iemitsu decided to take stronger measures which he did by prohibiting both Japanese nationals from leaving Japan and those abroad from returning. Christian literature was banned. An uprising of Christians in the south was taken as proof of the insidious influence of Christianity and the country was closed to the Portuguese. The Dutch, Chinese and Koreans alone were given port rights, which were almost exclusively limited to Nagasaki. After 1641 the Dutch could use only the small island of Deshima. All this did not occur, however, before some western ideas and practices had begun to filter in, notably in scientific studies, literature and graphic arts.

The transmission of theoretical ideas in the Edo period was achieved through the medium of schools established by the feudal families for the education of their elite, while a very large number of Buddhist temples (*terakoya*) offered more down to earth elementary education for the merchant, crafts and farm people. Education for the upper classes was primarily in Confucian literature and was directed toward learning social principles and the art of statesmanship. Military and moral training were both strong in the schools.

The chief warp in the Confucian theory of order was the peculiar position of the emperors in Kyoto. They came to power early, abdicated early and spent the rest of their days as ex-emperors. The oldest to accede to the throne between 1612 and 1868 was an empress at the age of 23, and the youngest was five. The average age of accession was 13 and, if it can be averaged, the duration of any one reign was about 17 years before abdication. Four even lived

Opposite: interior of the Hall of Stone in the Tōshō-gū, Nikko, so called because of its stone pavement, here hidden from view by reed matting.

more than 40 years after abdication. This weird situation was maintained as an effective way of keeping the emperor stripped of any power, and it was not until outside pressure, starting at the end of the eighteenth century with the arrival of Russian and British ships demanding trade concessions, and further incidents that led to the appearance of Commodore Perry in 1853 with United States ships also demanding open ports, that the Tokugawa position was seriously undermined. In a relatively short time amity treaties were negotiated by the *bakufu* with the United States, England, Russia and Holland, and those led to trade treaties that included France.

Local anti-Tokugawa rebellions combined to return the power to the emperor. Meiji took the throne in 1867 at the age of 16 and remained there until his death in 1912. He symbolized the difficult process of modernizing all aspects of Japanese life, from the scientific through the technological to the educational and cultural. Japanese scholars were sent abroad and foreigners with specialities were welcomed in Japan. Japan established herself in Asia by winning two foreign wars in quick succession: the Sino-Japanese War of 1894–95 and the Russo-Japanese War of 1904–5. Another era had dawned. This time Japan was looking in the other direction and eagerly seeking ways of pulling abreast.

Ieyasu died in his Sumpu castle in Shizuoka in 1616. A temporary shrine – a magnificently florid set of buildings – was constructed at Kunō-zan to hold his body. His remains were moved in the following year to Nikko in Tochigi prefecture where he had requested to be buried. While they were placed there in a relatively lavish setting, the complex of buildings now composing the Tōshō-gū was constructed by order of Iemitsu, the third *shōgun* and grandson of Ieyasu, in an incredible burst of energy between 1634 and 1636. Iemitsu himself died in 1651 and was the only other shōgun to be buried at Nikko. Later ones, including the second shōgun, Hidetada, were buried more or less alternately

The Chinese Gate of the Tōshō-gū, Nikko, built in the first half of the seventeenth century in honour of Tokugawa Ieyasu, founder of the Tokugawa shogunate.

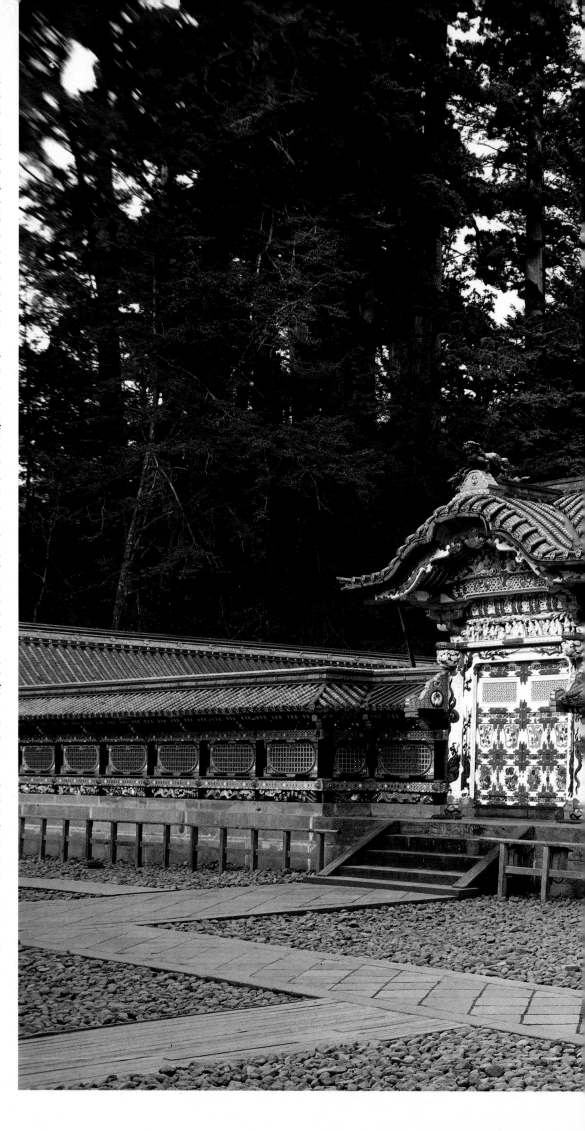

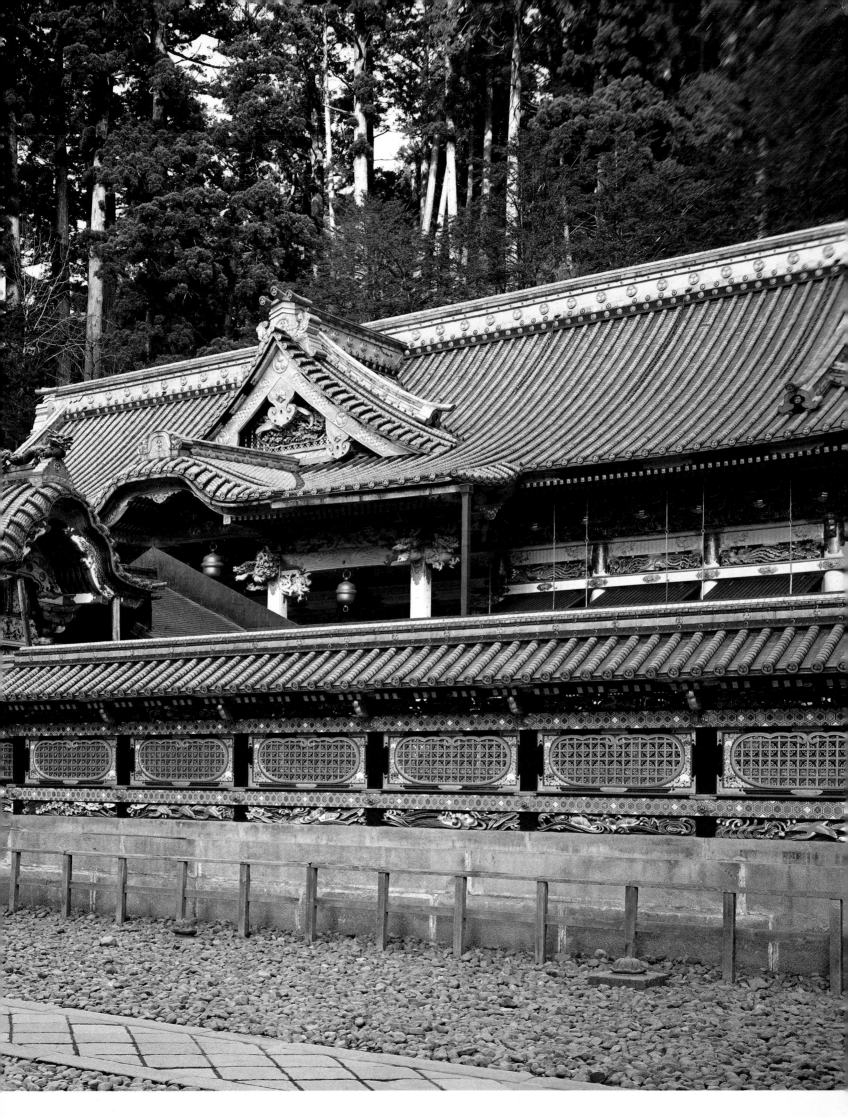

in Tokugawa temples in Tokyo, the Zōjō-ji in Shiba and the Kan'ei-ji in Ueno.

Further honours were awaiting Ieyasu. He expected deification and his mausoleum to become a national political shrine. He miscalculated historical reaction to sealing the country and controlling dissent. By now he should have discovered that the emperor who dethroned the Tokugawa is the one who is deified. But he had elevation of a sort. Ex-emperor Go-yōzei very quickly designated Ieyasu posthumously *Tōshō-dai-gongen*, a title which appears on a wooden plaque on the Yōmei-mon, the chief gate. It terms him the Buddha Incarnate, the Eastern Illuminator. *Gongen* were mountain *kami* and Ieyasu has the popular name of *Gongen-sama*, or honourable *gongen*, if it can be translated. The Tōshō-gū has not been overhauled and refurbished every 20 years in approved shrine fashion as he would have expected, but it has had several major repairs and is seen by more people today than, shall we say, the shrines of the war heroes who won the battles for Emperor Meiji.

There are four complexes of buildings in the shrine area at Nikko: Tōshō-gū, Taiyū-in, Futaarasan jinja and Rinnō-ji. The site was probably selected on proof of its favourability by the presence of a Shinto shrine and a Buddhist temple. Futaarasan, another pronunciation for Mt. Nantai, the volcanic mountain behind, has an old connection with the sacred mountain. It is dedicated to the ancient *kami* of the Izumo Shrine, Okuninushi-no-mikoto, and to his wife and child. Other small shrines in the area are associated with it. The Rinnō-ji is a Tendai temple with origins traced back to at least the ninth century when simple mountain temples were beginning to be established. The Sanbutsu-dō of this temple is an immense seventeenth-century hall accommodating three huge Buddhist images. The Taiyū-in is the tomb of Iemitsu and is more in the form of a Buddhist temple than a Shinto shrine.

The projects were now so vast and complex that a single family's expertise had to be complemented by several others. Like all the systems under the early Tokugawa, this was organized along bureaucratic lines in a new Office of Construction. It had full echelons of carpenters, builders, business managers and clerks. Heads of different families of craftsmen might have the same rank, such as Supervising Carpenter. Carpenters were becoming more important in the evolving style, as their work also included much wood sculpture and the painting finish. The sculpture was the real burden on time. It required the most training and now involved so many architectural parts.

Most of the families of carpenters had worked in the Kansai for generations. Some moved to Edo, as did others from the Tokai region, but when the Tōshō-gū was being planned, by far the largest number were brought up from the Kyoto area. They were divided up to work in competitive teams.

Systematization, which took other forms, had much to do with improving efficiency and meeting the impossibly short deadlines set by the *shōgun*. Several manuals were written, embodying information that had been transmitted for generations as secret skills. Ground and elevation plans were both drawn, and dimensions and proportions were standardized.

There was no precedent for a grand burial shrine since the introduction of cremation. It was luxurious arrogance, conceivable only under Confucian ancestor worship pretenses. At the time of Ieyasu's death, the Momoyama style in Kyoto was a relatively modest one and quite far from the completely overgrown character of the decoration at Nikko. Decoration at the Nijō Detached Palace accented door frames and transoms in brightly painted, high relief birds and flowers, but it was in predictable places and did not exceed any limits of taste.

By the 1630s the style had broken loose in the freedom permitted by the unlimited resources devoted to the project. Other factors played a part. The most skilled craftsmen were employed, including Kanō painters to do interiors, and Iemitsu intended to make it the most gorgeous sight in the country. Artisans were now free from other work – castles were even being dismantled except in Edo – military expenses had dropped dramatically, and I do not discount the feeling that Nikko seemed to be safely removed from the historical evanescence of the city and offered a genuine sense of building for the future. So, with unbridled enthusiasm, Iemitsu plunged into the task of raising the most exotic shrine for his dynasty that the national economy could afford.

The architect of the Tōshō-gū appeared in the employ of the Tokugawa at Fushimi in 1596, if one can go by his family records. Kōra Munehiro is supposed to have been in Edo in 1604 and worked in the imperial palace and at the Tokugawa's Zōjō-ji. He also built the five-storey pagoda of the Kan'ei-ji. Munehiro was a master builder from a family of carpenters, an able sculptor and an ingenious planner. The family hailed from Kōra, and is known to have had a good deal of experience in the construction and decoration of shrines.

Sloping paths and indirect, castle-like routes lead to the gates and buildings. Coupled with ascending levels of holiness in Shinto shrine style, one almost expects to find the remains of the shōgun in place of the *shintai*, "divine body." The effect is much the same. A poorly sited pagoda stands on the left, an early nineteenth-century replacement for an earlier structure, built by Ōkubo Kiheiji, and most notable for what one cannot see – the center pole suspended by sets of chains to keep it above the damp surface below. This is the ultimate effort in detaching the pole from the surface below and, one supposes, proof that the pole and structure have a minimum of organic relationship.

The storehouses or treasuries standing to the east on the next terrace are built in the traditional log construction. The middle one is deeply porched, leaving little façade for decoration, but, like the others, much red paint is used. The sacred stable is located to their south. The walls are plain, but the building is not devoid of decoration. The ceremonial horse is housed here in a stall on one side, while the room for the guards occupies the other side. The structure was modelled after stables for the horses of the *daimyō* in Kyoto, to judge by details in painted Momoyama period screens. The transom openwork consists chiefly of carvings of pines and monkeys among which in the second panel over the lattice doors are the famous three monkeys gesturing Hear no Evil, Speak no Evil and See no Evil. The washbasin is covered by a 12-legged structure no less ornate than other buildings, and beyond is a

Opposite: detail of the Chinese Gate of the Tōshō-gū, Nikko.

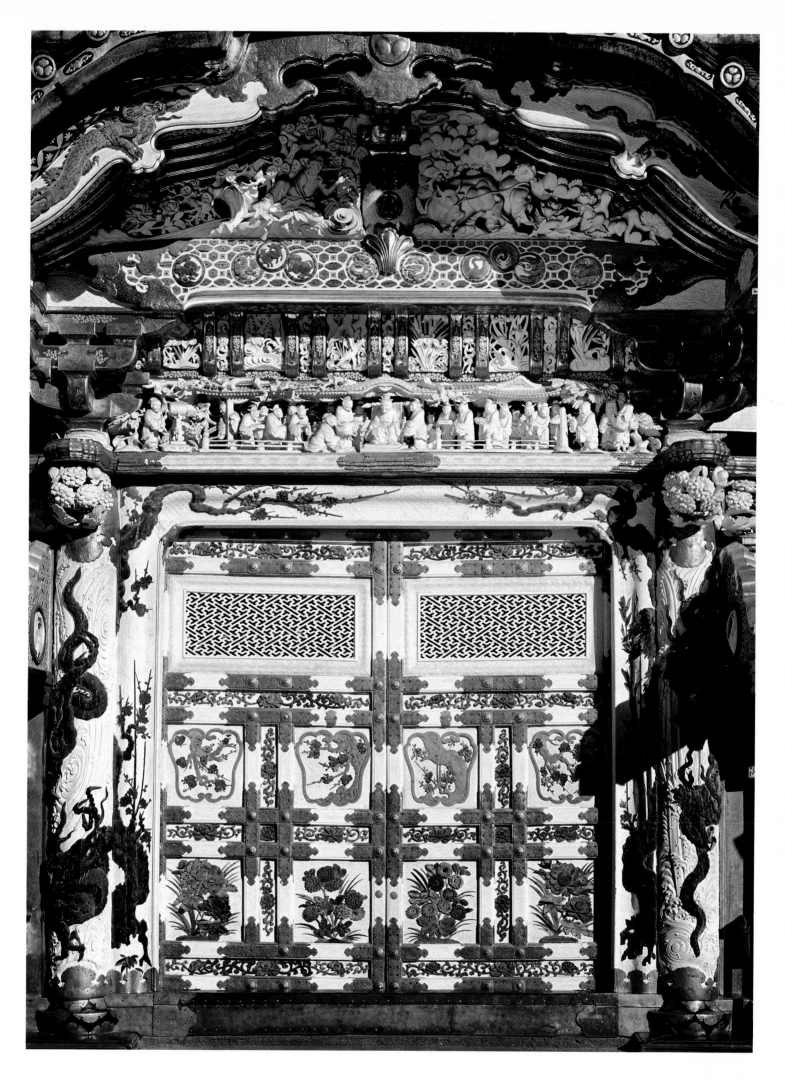

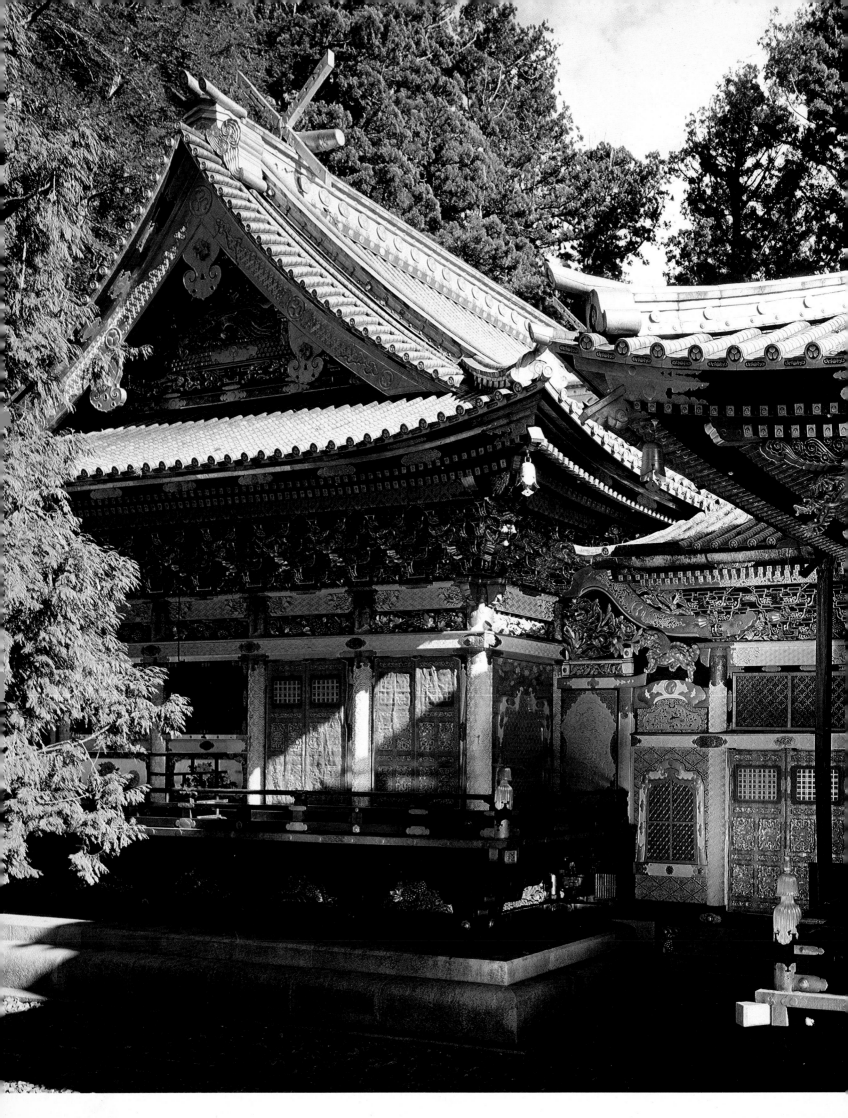

copper-roofed sūtra repository containing about 7,000 Buddhist scripture scrolls in a revolving bookcase of Chinese invention. To the left and right up a flight of steps are the drum tower and belfry, from which one sees the Yōmei-mon ahead. Panelled wooden screen walls on either side are carved with open-work medallions, those above of auspicious trees and birds and those below largely water birds in floral fields. Pure, brilliant colours abound.

The Yōmei-mon is not the end but only the beginning of more concentration on decoration-laden buildings. The Gate of Sunlight is often described by guide-books as "the most beautiful gate in Japan." It is certainly a gate, but it defies architectural analysis by being completely camouflaged by brightly painted, bold relief sculpture, and sculptural analysis because the details appear too trivial to be thematic. But its rich black lacquered surfaces with gold trim are striking, as are the black and white colour and texture contrasts. The dragons, clouds, peonies and lions on beam and bracket ends are an exhibition of a skill most suitable to a fantastic, irrational world of spirits, as the Tōshō-gū is. On the other hand, the Chinese children at play are misplaced toys, out of scale and irrelevant. That still leaves more to look for, however, including the conversation piece of inverted decoration on one of the pillars.

The emotional experience of entering this area increases gradually as long as the buildings are beyond arm's reach, but this is no longer true with the Yōmei-mon. The gate is so stunning it is impossible to avoid an aesthetic judgement. Yet it is also foolish and obtuse to dismiss it as "novel bric-a-brac" (as Bruno Taut said in 1933, when he compared it with the stately beauty of Katsura) and for public opinion to be so swayed by a Bauhaus attitude which reflected fears of being trapped in the recesses of European baroque palaces. If the early Tokugawa wished to live like Katsura and die like Tōshō-gū – to put it simply, the transient/replaceable against the eternal/restorable – that was their privilege, and the process by which Tōshō-gū was

Detail of the buildings of the Tōshō-gū, Nikko, showing the Hall of Worship or haiden *and the Hall of Stone or* ishi-no-ma.

reached and the purpose for which it was intended should always be kept in mind. Granted, there are some Ming influences from China, but Nikko is the culmination of the slow merging of all the Japanese artistic techniques since Kamakura times, and is not unlike the way other things were stirred in the melting pot, the most conspicuous of which were the merged religious philosophies.

The early Tokugawa did have too many resources at their command. Nikko is like a last battle the Tokugawa planned to fight, the arts against the elements. Every powerful visual weapon was mounted to counter the heavy forest, damp atmosphere and patchy light: dramatic surprise views; unexpected articulation of walls, gates and roof lines; gorgeous contrasting colours; high relief; sharp differences in lights and shadows. It is overwhelming, but it never fails to fascinate. One should note the copper roofs resembling tile.

Structures lying beyond the Yōmei-mon are the Chinese gate, recognized by its shape, plaster and decoration; the main building, a split hall, the south part of which is the worship unit, while the divided up north part contains a shrine for the spirits of Yoritomo, Hideyoshi and Ieyasu; connecting corridors; and on the right and left the stage for shrine *kagura* dances and the place to store the portable shrines. To the east is a flight of steps leading up to the Oku-no-in where an enclosure contains a worship building and the bronze stupa for the remains of Ieyasu. The original stone tomb was damaged by an earthquake in 1683 and replaced by this bronze one.

The Taiyū-in was built as the grave of Iemitsu and erected within two years after 1651. It is a somewhat reduced Tōshō-gū, adjusted to the terrain in much the same way and with the shōgun's burial stupa at the back and off to the right. The chief architect was Heinouchi Masanobu, a man who headed a well known family of carpenters and who may even have worked at the Tōshō-gū in his younger days. The buildings are also richly carved and painted, gilded and lacquered. The approach is a sequence of paths, approximate right angles and through gates. One of these is also Chinese. The main hall has the equivalent of a Buddhist altar in the form of a shrine containing a small wooden statue of Iemitsu. Why this complex was designed to appear

more like a Buddhist temple than a Shinto shrine and therefore contrasting with the Tōshō-gū, is largely a matter for conjecture. But Iemitsu, who ranked himself in history somewhat below Ieyasu, probably felt that the dynasty could tolerate only one of *kami* status. There he is identified with Ieyasu – which Hidetada wanted to avoid.

The traditional Tosa and Kanō schools met the conservative interests of the Edo and old Kyoto nobility, but had little new to offer. They were, in fact, the aristocrats of the art, and regarded those coming out of the craft schools, the town painters (*machi eshi*), and others working for middle class patrons as inferior and on the artisan level. Yet it was the new found wealth of the merchants which gave birth to the most original and fresh arts of early Edo, and which by the end of the seventeenth century had generated a magnificent stage of mutually stimulating arts.

The Genroku era (1688–1703), hence Genroku Culture, falls within the rule of Tsunayoshi, who was *shōgun* from 1680 to 1709. Tsunayoshi encouraged all of the arts, but drained the shogunate's resources in so doing. Scholarship achieved new levels through Confucian education and it was during his rule that Tokugawa Mitsukuni (1628–1700), called Mito Kōmon, governor of the Mito region, compiled the *Dai-Nihon-shi*, a massive historical study of Japan in over 240 volumes. The names in literature are the first that the modern age has learned to appreciate: Chikamatsu in drama, Saikaku in novels, and Bashō in poetry.

Tsunayoshi may be less remembered as the shogun of the Genroku era than as the protector of dogs, ordering capital punishment for anyone killing a living creature. Mitsukuni reflected the strong resurgence of Shinto thought, the swing away from Zen power and Buddhist thinking.

The first of the new schools of painting to flourish began so quietly next to nothing is known about its "founder." Sōtatsu was either born into or became associated with the Tawaraya, a wealthy merchant family-company of Kyoto, and was probably largely self-taught, though he had obvious familiarity with all the contemporary styles. He may have been associated with Hon'ami Kōetsu (1558–1637), but many discount the relationship as Kōetsu was

essentially a calligrapher and a potter, and a conoisseur with an expertise on swords much appreciated at the court.

Yet, despite Sōtatsu's unheralded entry to the art scene and the oversight of contemporary writers to include enough about him to know his dates, he rose rapidly, probably due to the paintings he did on sliding doors and cryptomeria wood screens at the Yōgen-in in Kyoto. As the first merchant-patronized artist to invade Kanō territory, and not one to be timid, he modelled his style after Eitoku. His images of lively lions, elephants and unicorns in pine tree settings, pressing the limits of the frames, had a dramatic impact. These paintings were executed after 1621 when the temple was rebuilt following a fire.

Sōtatsu began to sign his name after 1630, having the pride to do so as the recipient of the *hokkyō* rank. In the same year he received a commission from ex-Emperor Gomizuno-o for three pairs of screens to be painted with gold backgrounds. One pair carried willow and plum trees. He was still active in the early 1640s, but disappeared from references around 1643.

Sōtatsu's work evolved through three major stages, to judge by different sources and sometimes oblique information. One, as an artisan preparing gold and silver decorations on paper for calligraphy, especially for fan paintings to be mounted on screens; one of these bearing pines by the seashore and wisteria is dated to 1607. Others have elegant birds, flowers and animals. Two, the Yōgen-in Kanō style of great breadth and vigour, strong colour and linear designs, apparently done with the sense that the Kanō style was especially suited for the traditional context. And, three, interpretations in the new technique of classical themes, such as *Genji Monogatari* stories on screens, copies of scrolls of the travels of Priest Saigyō, and other subjects that fall into a middle ground somewhere betwen Kanō and Tosa. These were done on commission, so the subjects were in all likelihood specified.

The principles by which the Rimpa school of decorators is identified were set by Sōtatsu: fan, screen and album leaf paintings of traditional literary and natural subjects, done in strong colours with the Japanese feel for linear patterns and compositions. As these artists often had training in crafts and catholic

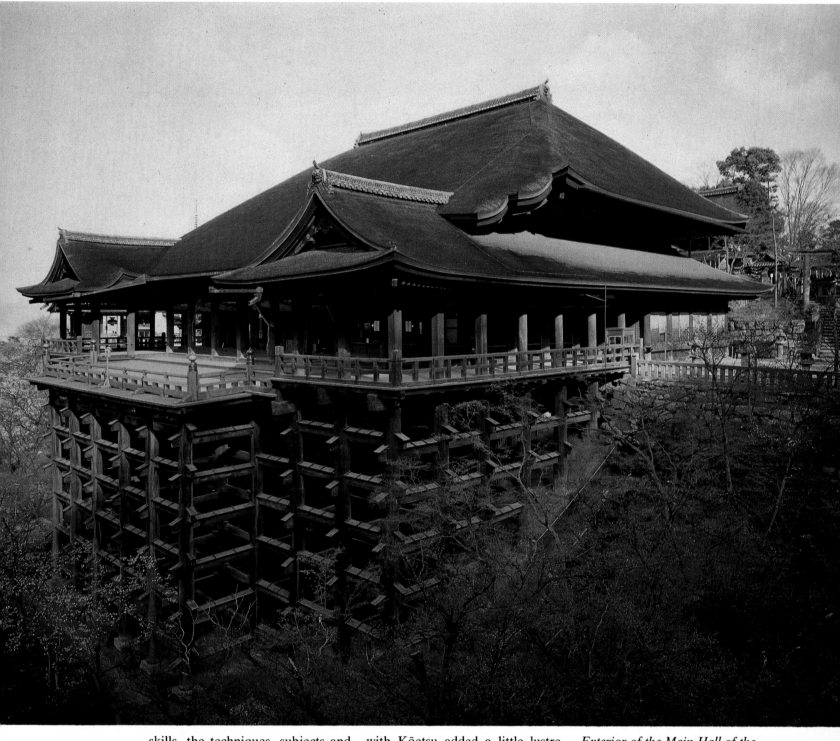

skills, the techniques, subjects and artistic styles of textiles, lacquer, ceramics and calligraphy were often worked in. Human figures appear as actors in familiar stories of earlier history. The ideal period was seen as the splendour of the peaceful Heian court, and stories of that time were romantically revived as reminiscent of the highest level of culture.

Various names were used for the school, but Rimpa was finally settled upon, using the last syllable of the name of Kōrin and the word for school. Kōrin (1658–1716) was a member of the Ogata merchant family whose standing had been gained through a profitable textile shop. Distant family connections

with Kōetsu added a little lustre. Kōrin was an exceptionally gifted artist with an engaging personality. This was fortunate for him, for when his life style in Kyoto led him into debt and he pawned some of the family heirlooms, he seems to have been isolated from the atelier and was forced to take up painting in earnest for his own personal support. Much of his later life was spent in Edo, where his contacts and skill aided him in building a substantial clientele. He was also greatly favoured by the Sakai family, which pensioned him in his later years. He had received the *hokkyō* title in 1701.

The early inspiration for Kōrin

Exterior of the Main Hall of the Kiyomizu-dera, Kyoto. The temple was originally founded in the eighth century, but the present layout dates from the seventeenth century, when it was rebuilt at the behest of Tokugawa Iemitsu.

came from Sōtatsu's art and he made some faithful copies of Sōtatsu's work. But Kōrin was responsible for the fundamental change in the aesthetic of Japanese painting, moving it away from the *kimpeki* screens of Chinese trees, rocks, animals, birds and flowers in angular shapes and staccato rhythms to Japanese flowering trees and plants, birds and animals in patterns of soft, smooth, sweeping and abstract curves. Nature was only to be interpreted in an artistic sense and was usually portrayed at its seasonal best. It was, in other words, romanticized for city patrons as charming, pleasant and promising. Residual Shinto, or the enjoyment of life, was always ready to surface if the heavy hand of Buddhist thought and its preoccupations with death or self did not stifle it.

This can, incidentally, be contrasted with a later but less encompassing development when a serious effort was made to do sketches of fauna and encyclopaedic illustrations by the "naturalists," in particular Maruyama Ōkyo (1733–95) and the so-called Shijō School. There was some western influence at

Hollyhocks (above) and peacock (opposite). Details of paintings by Ogata Kōrin (1658–1716) and Ogata Kenzan (1663–1743). Hinonara Collection, Tokyo.

work, and the use of line and implications of light to get form were an effort to produce something new.

Sōtatsu was closer to the Chinese-constructed compositions of Sesshū's time. Kōrin is more clearly Japanese in employing curvilinear rhythms. By way of examples, gold backgrounds on a pair of paper screens set off irises growing like bouquets as they gradually move back across the surface. *Matsushima*, also a six-panelled screen, is a glorified version of irregular cresting waves, bizarre rocks and gold finger-clouds. Distant details are as precisely painted as those in the foreground. Unevenly spaced, obliquely placed rocks, waves and whitecaps form the compositional elements, and these are rendered with tremendous and almost stormy animation. Grasses, morning glories, lilies, hollyhocks, Japanese lanterns, ferns, bamboo, plum, cherry and fir trees all grow gaily out of the foot of golden screens or sliding doors, leaving the upper third of the surface unbroken. There is often much detail and mixing of flowering plants. Spring flora are especially popular. But with Kōrin there were subjects for all men. To name a few, many are purely Chinese, some are Heian period personalities, and others are Zen sketches, sketches with poems, folk deities and Shinto subjects.

Lacquer was a vehicle for Kōrin's art. He was the elder brother of Kenzan (1663–1743), the noted potter who opened a kiln at Narutaki north of Kyoto in 1699 and worked there for about 13 years. Kōrin moved to Edo in 1704, probably because he had become *persona non grata* with both the authorities and his family. Kenzan made dishes in the early Narutaki period which Kōrin decorated. These were mostly square plates with a low rim. They bear quickly sketched Zen subjects with short poems and were done to add a personal touch to the tea ceremony. The charming imbalance of some of the sketches gives them the spontaneous Zen character.

Kenzan was a student of pottery familiar with Chinese and some Dutch work, and the Mino wares of Shino and Oribe. It is the latter which attracted him the most, and his style has some similarities with the Mino ceramics. He is sometimes also said to be the successor of Ninsei, the innovator of the Kyō-yaki of Kyoto, the type known for colourful, floral overglaze enamelling, but, while Kenzan did sometimes use the technique, he preferred to retain his own style.

The style of Kōrin was kept alive by Watanabe Shikō (1684–1755) and Sakai Hōitsu (1761–1828) in successive generations. Hōitsu's father was the daimyō of Himeji of the old Sakai family which had supported Kōrin for the last nine years of his life and had accumulated a large collection of his work. Hōitsu was widely trained, but he finally settled as a monk, studied Kōrin's paintings and popularized them through publishing his designs. He painted in a Kōrinesque style of considerable elegance and borrowed some of the naturalists' traits. He might be called a master of all the decorators' formulae.

Another form of painting, again with its roots in Chinese art, was the *bunjinga* or *nanga*, painting of the literati or southern painting. These are spoken of imprecisely in Japan as the work of scholar-painters, but as no intelligentsia existed independently of the military, the application of the Chinese term to a mythical class is not very close to the mark. Such painters were in various professions or lines of work and often sold their paintings if they needed income. This might put them in the category of professional painters.

The phenomenon was advanced in Japan by a revival of interest in Shinto, and Confucian training in the schools. It can be accounted for through the receipt of Chinese paintings in the early eighteenth century through the port of Nagasaki in the south. Ming dynasty landscapes were especially appreciated, and the early amateurs took these and tended to make direct copies. The painters appear to have been independently inspired and to have simply wanted to practice and develop their skill in Chinese brushwork. The second generation, however, diverged enough from this early approach and among them were artists who might properly be called professionals.

There had become available to the Japanese certain Chinese books on painting, one of the most notable of which was a manual called *Mustard Seed Garden*, written in 1679. It still remains a question as to exactly which Chinese materials were available to Japanese painters, but through the experience of the first generation and the accumulation of more information on techniques and form, the second generation found a way to convert the Chinese landscape into a Japanese scene and discover its meaning for Japan. Many proved themselves to be distinguished artists.

The most notable was Ikeno Taiga (1723–76), a Kyoto man of great imagination, energy, humour and output. Taiga, who went by scores of assumed names, worked through almost the whole gamut of styles then current for such artists: Tosa, Zen and Rimpa, and settled on *nanga* about mid century when he was studying in Edo. His influence came from early Ch'ing paintings. Taiga flaunted tradition by travelling extensively and painting Japanese country scenes. One particular love was the sacred mountains. Since the avowed purpose of their painting was to illustrate the rural beauties of the Chinese landscape by drawing inspiration from Chinese poetry, which often runs alongside the painting, this was contrary to accepted principles and shows a marvellous, fresh independence of convention. Taiga often painted large landscapes. The brushwork is lively, colours are warm and gentle, and many amusing pictorial anecdotes creep in.

A contemporary, who is perhaps less known today, was Yosa Buson (1716–83). After migrating restlessly, keeping Edo as his base, he spent his later life in Kyoto combining poetry and painting. Most of his paintings have inseparable inscriptions.

These painters were often acquainted with each other and sometimes collaborated, yet there was no formal agency for the transmission of the style. They had a commendable individuality. The cohesion was the fascination with Chinese painting, to which they applied the usual Japanese intellectual exercise, and validated it with a new ideology. There was little of the Zen search for mysterious meanings in nature and, as such, reflects more the pragmatic style of Ming and Ch'ing painting than the earlier subjective character of Sung.

The ink-painting – pastel-colour style, however, had taken on an archaic look by the time it was carried into the twentieth century. One of the last good exponents of

Opposite: portrait of Nakamura Kuranosuke by Kōrin and Kenzan. Yamato Bunka-kan Museum, Nara.

290

the style was Tomioka Tessai (1836–1924) who was popular with those who nurtured the old traditional values and were uncomfortable with weak imitations of European oil painting styles.

Late Edo

The history of wood block prints has been pushed back to A.D. 770 when the empress gave one million little lathe-made wooden pagodas to ten temples. The ones still preserved at the Hōryū-ji contain *dhārani* printed on paper, magical spells done in four different impressions. Examples of wood block printing on cloth of the eighth century are kept in the Shōsō-in.

In the eleventh century *imbutsu* were printed of Buddhist images and stuffed like entrails into the main wooden statue of Amida at the Jōruri-ji. These bear ten seated Buddhas in rows running vertically and horizontally, to total 100. Later copies of these are known, and fourteenth-century Buddhist evangelists who were doing missionary work in the country took with them printed illustrations which included stories of Buddha, the lives of the founders of sects, the life of Kōbō Daishi and other pictures. These were coloured by hand, if at all.

By the fifteenth century, secular and non Buddhist interests – these could be Shinto inspired or taken from popular legends of deities – saw value in the wood block print, and illustrations were made for books. These were books of fairy tales, the *otogi-zōshi*, which were widely sought after. Each book included several prints illustrating landscapes and human activities. A few were apparently coloured by hand. These are of genre subjects, so they are in fact the first of the type that constitutes the history of later Japanese prints. By the early seventeenth century, novels and romances might have a few prints per book.

The traditional father of the Japanese print, Hishikawa Moronobu (1618–94), owed a large debt to earlier practitioners of the art. He inaugurated the principles of the designer as an artist who was familiar with different historical styles and who collaborated with woodblock carvers and printers for the finished product. The technique and subjects came under the generic term of *ukiyo-e*, or pictures of the floating world, and eventually encompass a wide range of illustrations of daily activities, female figures, love scenes, historical events, entertainers and landscapes.

Moronobu had Tosa training, experience with textiles and business acumen. He produced a large number of illustrated books, some 59 of which bear his signature. The earliest one with a date is 1672. Finding that the interest in prints alone was enough to warrant producing single sheets, he was the first to print them individually and demonstrate their economic feasibility. He seems to have worked in monochrome only. Later owners may have added colours. It was earlier claimed that Moronobu followed Iwasa Matabei (1576–1650), and that he learned the print designing technique from him, but Matabei, a Tosa trained painter who once worked for Iemitsu in Edo, does not now appear to have had much influence on Moronobu. The latter specialized in female figures, but his subjects were by and large middle range genre.

A major influencing factor within this framework was the government's authorization around 1720 to permit the importation of European books on natural science. These books contained copper plate prints and just over a decade later a Japanese print artist, Okumura Masanobu (1686–1764), included a European style of realism with some attempts at western perspective in his prints.

Before polychromed prints were widely used, red was the customary colour. First applied with a brush, it was later mixed with a lacquer or glue to make it more opaque and lustrous. It was also the first colour to be applied with the use of a block. Yellow and green were added by around 1710, and in the early 1740s secondary blocks were employed. Shades of colour could be produced by thinning the pigment. Around 1765 the multiple-block colouring technique was perfected by the leading figure artist of the day, Suzuki Harunobu (1724–70), and since that time few changes have been made.

By way of definition, when a print is called an original, it was produced during the lifetime of the artist. Reprints were made from the original blocks, and since the blocks' reliefs were usually scraped or planed off after the artist's death, a reprint is normally a product of his lifetime and under his supervision. A reproduction is copied from the original print with newer blocks, but all made in the traditional process. Shops abound in reproductions.

Along with books on natural history, romances, novels, histories, advertising for entertainments such as plays and wrestling matches, the major focus of the eighteenth century was on beautiful women (*bijin*). Ladies, singly, in pairs, in small groups are at shrines, temples, festivals, viewing blossoms and in a host of other places. Love scenes are common. Courtesans are shown dallying and lounging, prettying themselves up, playing simple games and occasionally even reading. The market for these prints was boundless and embraced a substantial middle class of merchants, tradesmen, artisans and people in the entertainment world. Since much of the subject matter is low genre and the prints were used to illustrate erotic books and guides for brides – subjects which were also done in single prints – changing mores in the late nineteenth century discredited the prints with the upper classes and the normal collectors/preservers of Japanese art ignored or even shunned them completely. The best collections were formed outside of Japan. This was the art – if it could be called art – of the commoners, about entertainers for entertainers, largely erotica (*shunga*) whether explicit or not, and with no timeless, transcendental or ennobling features. This was the Meiji period retrospective view, but a younger generation can see them as an art of tremendous vitality, a genuine reflection of city life, down to earth and often exquisitely beautiful.

Harunobu perfected the use of many blocks of colour. His sweet, delicate female beauties, in three or four colours, were often occasionally even shaded. Harunobu's women are tender, gentle and naive, an effect achieved in colour, line and by a graceful elongation of the human form. Probably no other print maker reached the same high level of popularity, and he dominated the third quarter of the eighteenth century.

The man who replaced him in the next generation was Torii Kiyonaga (1752–1815). His beauties are more voluptuous, enveloped in long, flowing, stronger lines and in rich, yet soft colour tones. He often did more ambitious compositions of groups of women in more complicated landscape or architectural settings. His ladies can be distinguished

from the languid Harunobu dolls by their greater substance, more positive colours and expanding lines.

Sharaku (fl. 1794–95) is a strange aberration in the history of prints. He does not represent a main stream, he was not clearly influenced and influenced almost no one, and seems to have produced all of his work within the span of one year. At least, the scant information is simply that his prints were marketed by a dealer named Tsutaya Jūsaburō in a shop just outside the second of the licensed Yoshiwara areas. Parenthetically, the services offered by courtesans in Edo were widely available throughout much of the city, but in 1617 after a clean-up campaign to reduce the nuisance of soliciting, the ladies were confined to a quarter near Nihonbashi called Yoshiwara. As Nihonbashi grew to be the hub of commercial activities, the courtesans were moved in 1656 to an area north of Asakusa that came to be known as Shin-yoshiwara.

The conventional view is that Sharaku worked for ten months and produced 145 prints. Most of these are kabuki actors, strikingly caricatured, often in powerful close-ups, their contortions implying some degree of mental imbalance. It has been suggested that the enmity he must have created may have cost him his life, hence the abrupt termination of his work. But this does not explain his sudden appearance and overwhelming output in such a short span of time. A single print in those days required up to 40 days' work. A recent suggestion supposes that Sharaku was actually a minor kabuki actor from the Ōtani family, with the stage name of Nakamura Korezō. He had taken Tōshū as his surname and, on the basis of the small hands in the earliest prints and large hands in the later ones and several other stylistic discrepancies, some other artist was actually hired to finish the series after Tsutaya and Sharaku parted over a disagreement. While all of this may have a good deal of truth in it, there would still be the tremendous volume of prints to explain without discrediting the dates.

Sharaku's prints were too personal and incisive. A contemporary

Detail of kaki tree from a painting by Maruyama Ōkyō (1773). National University of Fine Arts and Music, Tokyo.

wrote that his exaggerations alienated the subjects and his popularity vanished. Mica printing had just been started and Sharaku employed it in many lavish actor portrait prints. He may have had few customers among kabuki actors, in other words, but a genteel class of buyers was waiting for his work.

The late eighteenth century and the early years of the nineteenth were a critical period in the history of print making. A major Edo artist, Kitagawa Utamaro (1753–1806), was in his 37th year in 1790 and had published some seven series of prints when the government, always suspicious of any possible devious methods of undermining it, clamped a censorship on the prints, requiring each one to receive a stamp of approval. Expensive materials were forbidden, and the silver mica backgrounds, which had done much to make portraits attractive, were outlawed in 1795. Some artists found that this so altered their style that their business declined sharply.

Among the factors which affected these changes were the shifting interests among the artists themselves, probably by no means separable from other events of the day. Kiyonaga, the great master of female figures, retired from print making. Lesser known, but certainly influential in his day, Kitao Masanobu (1761–1816) decided that writing was more to his liking, and he too abandoned print making. Katsukawa Shunshō died in 1792. Katsukawa Shunkō (1743–1812) suffered a stroke, donned the habit of the cleric and entered a monastery.

A major outcome of these revolutionary events was the emergence of Utamaro as the dominant figure and, in regard to the development of nineteenth-century prints, Utamaro's lesser known interest in landscapes. Utamaro's forte was female figures, hundreds of which are known, but his early work often dealt with landscape and natural history.

Utamaro had a Kanō school education in which landscape always played an important part, and a natural sense of the appropriateness of the landscape to the context, together with a feel for colour, form and the active forces of nature. His books on natural history include an early one on shells, another on insects, and others on crabs and fishes. It seems to have been around 1782 that he changed his name from Kitagawa Toyoaki to Utamaro. All of

these print artists used several names, some adopting others quite frequently.

When Utamaro reached the top by around 1800 he was already recognized as a past master in the illustration of feminine pulchritude. He moved from natural proportions to exaggeration and mannerism, providing glittering close-ups or full-length, elongated bodies. Women were all visualized as young, and came from all strata of society and occupations: working women, entertainers, wives, geisha and courtesans. Moreover, they were symbolic of all aspects of life and nature: the seasons and the elements; flowers and rivers; poems and dreams.

Before 1792 he had produced a series called *Ten Types of Women's Physiognomies*. Nothing about women was left unconsidered. After 1790, as he began to move into the sphere of exaggeration and abstraction, he was edging away from Kiyonaga influence and into his own characteristic and distinctive style. He created the female type which answered all the male dreams – an abstract ideal – almost beyond the reach of male attainment. The ladies

Above: woodcut from the series entitled The Twelve Hours in a House of Pleasure *by Kitagawa Utamaro (1753–1806). Opposite: detail.*

are lily-white, detached, superior, often untouchable. There is a pervading melancholy, perhaps due to toned down colours, and a fragility that arouses masculine feelings. In a characteristic Japanese combination, the figures may look both sensuous and spiritual at the same time.

Utamaro lived near the main gate of the Yoshiwara district. He documented the daily and nightly life there, illustrated festivals, New Year's activities, silk worm raising, wrestling scenes, and many more events. Whether he overstepped the bounds of allowable symbolism of the time or was quite innocent of whatever accusation was made by the shogunate, he was jailed for something that the officials disliked in a triptych print illustrating a nobleman accompanied by his five wives on a flower viewing excursion. Some regard it as including an offensive caricature. Utamaro died two years later, perhaps as a result of

poor treatment while in prison.

Utamaro may have seemed radical in his day, but after an observer in the late twentieth century has seen every conceivable form of treatment of the female body in the name of art from charming distortion to obscene mutilation, Utamaro has a pleasant temperance. The figures are stretched, drawn, turned, cramped, twisted, distorted, pulled and bent, but they are always elegant and graceful. The sheer virtuosity of the line work is one of the greatest achievements in the history of Japanese art.

It might come as a surprise to know that Utamaro, artist of the female form *par excellence*, and Hokusai, known to westerners primarily as a landscape artist, worked together on a book entitled *Dancing Songs for Men*. Hokusai was 46 when Utamaro died. Two great names loom above all others in the nineteenth century: Katsushika Hokusai (1760–1849) and Andō Hiroshige (1797–1858). Both have built their reputations outside of Japan through their treatment of the Japanese countryside. Happily, reports of their work or the notice westerners took of it more or less coincided with the outdoor movement in European art, and landscapes stimulated a broader interest in the prints than would have been the case had the art remained largely a figurative one. Hokusai himself studied European perspective with Shiba Kōkan (1747–1818), a man who was the first to try metal plate etchings and whose experiments in western perspective make his work distinctive. It was therefore already a two-way road before Perry opened up Japan and forced foreign commerce on the country.

One might well ask why landscapes seemed to flourish so suddenly. There is little question that Japanese art as a whole was wearing its subjects thin. The publishers sensed the need to meet a declining market and, with some official relaxation of the restrictions on individual travel, they entered the field with entrepreneurial enthusiasm. The consumers were obviously waiting. This was the first steady and

Opposite: Women cooking, a print by Kitagawa Utamaro.
Overleaf: Mt. Fuji across the water, from the series of prints Thirty-six Views of Mt. Fuji *by Katsushika Hokusai (1760–1849).*

protracted look the Japanese had taken of their natural scene in order to record it as art. It is one of the great revolutions in the history of Japanese art.

The most frequently represented scenes in the earlier nineteenth century were those of the most travelled road, the Tōkaidō, the eastern sea road linking Edo and Kyoto. It spanned a distance then of about 520 kilometers (about 320 miles) and was marked by 53 posting stations which acted as rest stops for the thousands of people who moved up and down it. The most noticeable among those journeying back and forth were troops of soldiers, and there are stories of loot being lifted from well-to-do travellers, and of scalpers and conniving waitresses luring or dragging weary travellers into their establishments. The arduousness of the trip was lessened by a hilarious series of comic episodes involving two men whose uncouth pranks and frequent stupidity were written about between 1802 and 1822 by someone calling himself Jippensha Ikku. The *Hiza-kurige*, usually known as Shank's Mare in English, is said to have popularized the road in literature in the same way the artists did so in prints.

Hokusai produced five sets of the stations around 1800 at about the age of 40. The best known is Hiroshige's *Fifty-three Posting Stations of the Tōkaidō* (1834) for which there are 55 prints, since Nihonbashi of Edo and Sanjō Bridge of Kyoto are the terminal points. Hiroshige himself tried other illustrations of the Tōkaidō, but none surpassed his first inspired effort, and he had really no need to do again what had already been done so well. On the other hand, the blocks had probably been disposed of or used over, and the first set having been so popular, the publisher needed a Tokaido II. It is said that 200 prints were made of each scene, and that these were sold before noon on the announced day of their publication.

Hiroshige was a born traveller. He sketched while walking between Edo and Kyoto, appreciating the subtleties of nature, the nuances of its moods and its quick and dramatic transformations. He let his imagination prevail when a station like Kambara was shown in deep snow.

Hokusai was such a student of the art that his humility is unnerving. He concedes that he was driven to draw as early as the age of six. He says that only when he was 63 years old did he

understand how to draw animals, birds, insects, fishes and plants well. At another point he says that until he was 70 he was not skilful. He was dissatisfied with everything he had done prior to his 70th year. He lived, incidentally, to be 89.

Between the ages of 29 and 49 he kept up a steady collaboration with the novelist Bakin (1767–1848), illustrating his books. He did various series called *One Hundred Views of Mt. Fuji*, *History of the Rōnin*, and others. Toward the end of this period Hokusai became interested in landscape and tackled the project of Mt. Fuji. There were points in his career when his popularity was threatened by the success of Hiroshige, and Hokusai's response was to take on more ambitious projects or change course temporarily.

In 1812 he started to publish the *Manga* (Sketches) in 15 volumes. This is a vast number of sketches of all aspects of life and the countryside. Nothing is untouched, from the birth of the child to the old man's death; daily activities include household chores, farming, specialized jobs, plays, festivities, entertainments, religious activities, and living creatures from insects up, natural features of trees, rivers, lakes, and temples, houses and castles. That involves the whole gamut of family life. One has to ask what was the purpose of it all. Surely Hokusai did not think of the fading scene of Japan and that it should all be documented before it disappeared. He was well before that era. But the work does have immense historical value today, and shows Hokusai to have been a powerful sketcher with the energy of a dozen men, committed to constant practice, perhaps marking time until he could find a way to focus his energy and skill.

Hokusai started his better landscape series when he was around 60. He entered on his third phase of work. There is the series of eight prints called *Views of the Ryūkyū Islands*, and the immortal *Thirty-six Views of Mt. Fuji*. At 65 he brought out a group of eight prints of famous waterfalls, and at 68 11 prints illustrating bridges of different provinces. At 70 he did two series, one of them being the *Imagery of the Poets* in 11 prints which is considered by many to be as great a set as the views of Mt. Fuji. At 74 he embarked on a series called *A Hundred Views of Mt. Fuji*, produced architectural drawings, and 10,000 drawings for industrial

workers, which sounds a little as though socialism had arrived.

In 1839 at the age of 79 a great calamity befell him. His house burnt down and all of his drawings in it were destroyed. It took him several years to recover from the shock, but with encouragement and advice, and pressure from his publisher, within some six years he was at work again as a book illustrator. At 88 he produced two volumes of a book which takes up the study of colour. When he died a year later, in 1849, he was given the finest burial in a temple any unranked citizen could receive.

The secret of Hokusai's ultimate success lay in his switch from seeing life around him as daily, incidental, even routine, genre to selecting those events which constituted the drama of life and those features of nature which ranked as great creations. He gave form, structure, balance, relationships and volumes to nature. He sought out the angle, arranged the features a little if need be, eliminated extraneous detail, used a limited palette and exaggerated the effect. He undertook series which he knew would last for years. His views of Mt. Fuji are sometimes rugged and bold or lofty and majestic. They vary by season, time of day, town or country, land or water foreground. Imagination was a useful tool. Geographical studies have shown that from several points they are said to have been done it is not possible to see Fuji. Mt. Fuji is simply a symbol. In a country so geologically unstable, there is a lot of consolation in a shape so permanent and unchanging.

Hokusai is reported to be the creator of 30,000 drawings and, along with other things, to have illustrated 500 books. His first inscribed name was Shunrō, but there are many others – about 20 in all – and he had a fairly large school, the Katsushika school, in which at least 20 of his students did well enough to be known by name.

Hokusai got a late start in the field which brought him international fame. Hiroshige was working on genre prints at a relatively young age. His travel interests showed early and his popularity grew on the strength of his landscapes. From his mid thirties he enjoyed wide public acclaim and a comfortable way of life. He is said to have been a fireman by profession, having been, like many others, trained in fire fighting techniques, and was called

upon in emergencies. In his own way he was the most professional of artists.

Hiroshige was born in Edo and studied under Utagawa Toyohiro around 1811, who named him Hiroshige in 1812. He therefore goes by the name of Utagawa Hiroshige or Andō Hiroshige, and he used the art names of Ichiryūsai and Rissai. He did his best work in the 1830s and followed this with 20 more years of production until his death during the cholera plague of 1858.

In the early stages of the nineteenth century Hiroshige was often close to Hokusai in style, but he constantly refined his work as he progressed and gradually moved in a different direction. The view that each had of nature was conditioned by their individual temperaments. Hokusai appreciated action and was able to record it; Hiroshige was more active in himself and less interested in documenting action. To Hokusai nature could be a blatant, violent and panoramic drama. To Hiroshige it could be subtle, poetic and idyllic. Hokusai was Japanese by being decorative and abstract, while Hiroshige was Japanese by being indirect and suggestive. Hiroshige did have a good sense of the spectacular, however, and could at times use more powerful colours than Hokusai. His sudden downpours, heavy snows, precipitous cliffs and deep blue oceans contain striking elements of surprise and may often imply turbulent movement. Hokusai could not match Hiroshige's atmospheric effects in which, with scarcely a specific line to state it, one can feel the damp cold, sense the sticky heat, fight the blustering wind, stand in awe at the beauty of the low-lying morning mist or appreciate the glossy surfaces on a moonlit night. The range of mood, suggestion and tonality find few comparisons within the work of one artist in Japan. At a time when it is generally conceded that all other aspects of the prints were on the decline, Hiroshige brought the art to a brilliant level.

Hokusai's *Views of the Ryūkyū Islands* came out in 1820 and his *Thirty-six Views of Mt. Fuji* between 1823 and 1829, whereas Hiroshige's *Fifty-three Posting Stations of the Tōkaidō* did not come out until around 1834. In other words, Hiroshige entered the field of landscape art after Hokusai did so seriously, despite his late start. There is his series of the *Kisokaidō*, the mountain road that comes down to the coast. A series called *Famous Views of Kyoto*, another, *Eight Views of Lake Biwa*, and another, *Eight Views of the Environs of Edo* were rolling off the presses. In 1856 he embarked on the *Hundred Views of Edo*, but only a few were completed when his death cut short the project.

Estimates range up to 5,500 different prints by Hiroshige, to which one may add examples of paintings, along with drawings and sketches. Within this large body of work it is hardly to be expected that top quality could be consistently maintained, as it is known that the publisher's pressures were at times almost unbearable. Nor is it a surprise that some prints look mislabelled, since it was not possible for Hiroshige to have seen everything he drew; there must have been some reliance on verbal descriptions, sketches by other artists and from memory. Again, the landscape is often symbolic of the forces of nature, the presence of the *kami*, the higher powers. It was a slightly awesome series of pictorial scenes, receding in zigzag spatial shapes. Hiroshige did not visualize scenes within scenes as Hokusai did. Each is an entity and the human figures are not dwarfed by their setting. They were a part of it and shared equally with the *kami* in its beauty.

Silk brocades (*nishiki*) had some place in temple decorations from the first appearance of Buddhism, and seventh- and eight-century rulers made special efforts to have weaving techniques taught in the provinces and more and better dyes discovered. Cloth was used for taxes and gifts, so the government had a vested interest in improved textiles.

Progress in the art during the Heian period was not as great as one might expect by looking at the magnificent "twelve-layer" dresses in the painted scrolls. One reason was the limiting clothing codes. Court dresses were truly colourful and court looms were far from idle, but with the demise of that way of court life, the samurai spirit and Zen frugality joined forces to produce a more unadorned style of monochromatic costumes during the Kamakura centuries. Not until merchants in the cities saw the market value of the industry did it really soar. Through Momoyama the textile art had been primarily directed at the upper class, but the conditions all fitted together to make a dramatic expansion in early Edo times. The popularity of Nō and kabuki was also a strong stimulus for the art.

The undergarment (*kosode*) emerged as the outer *kimono*, and noblewomen patronized their textile makers and tailors. Kimono designs were selected for appropriate times of the year as seasonal changes were in vogue. Designs were the work of *rimpa* and other artists. Kōrin made his contribution to a brilliant early climax of the art in the Genroku period. Wood block prints of ladies in glittering kimono are graphic evidence of the great pleasure the fairer sex had in dressing up, whether for intimate attraction in their sequestered quarters or for outings on festive occasion. Excitingly colourful costumes added immeasurably to the interest of city life.

Kimono were folded and stored in standard-size boxes and drawers in chests. These were often splendidly decorated and lacquered. Lacquer has an even older history than brocaded textiles. It maintained a considerable degree of popularity through the medieval centuries as both temples and the aristocracy of the Heian court appreciated it. Cosmetic and other boxes were greatly prized for their decoration, which was done in black with gold paint (*maki-e*) and sometimes mother-of-pearl, picturing chiefly flowers and fans.

The repertory of lacquered objects widened greatly in the Muromachi period and from Momoyama times the art, in conjunction with all of the other arts, found consumers throughout the social strata. The peak of luxury was reached in the Momoyama period when the art was an upper class product, but by middle to late Edo it was made in all grades of quality for all economic levels. For those who could afford them, numerous household items, including bowls, trays, racks, lamps, screen frames, chests, pillows, and a variety of boxes were enhanced with lacquer decoration. In some cases, a Chinese technique of deep carving of landscape and figurative scenes was followed.

As the tea ceremony (*cha-no-yu*, *sadō*) moved out of the temples and

Opposite: a portrait of the actor Ichikawa Ehizo in the role of a brigand, print by Hokusai (1791). Overleaf: further woodcuts by Hokusai. View of Ushigefuchi (page 302), and Hodogaya, from Thirty-six Views of Mt. Fuji (page 303).

Women on the jetty, silk painting by Hokusai dated 1820.
Overleaf: Downpour at Shono, woodcut from the series Fifty-three Posting Stations of the Tōkaidō *by Andō Hiroshige (1797–1858).*

into aristocratic homes as the formal way to entertain guests, it bred a new ceramic aesthetic philosophy, created a new social patron–potter relationship and opened a new market. This art involving the utensils of the tea ceremony was the work of amateurs and their unprofessionalism left its mark on the entire later history of the potter's art. Hon'ami Kōetsu and Kenzan made their own vessels. As potters they had bypassed the period of apprenticeship. The years of learning the skills as an apprentice were intended to deepen the reflex grooves and entrench the mental set of the one and only way to shape a pot. The

pottery amateurs were therefore not restricted by the results of rote practice and not inhibited by any established norms of the craft system. One might call them, in modern terms, free spirits.

Raku is a loose term for low-fired, soft tea ceremony pottery items from the Kyoto area, started by artists who fired them in a home kiln (*oniwa-yaki*, or small garden kiln). These are cups and bowls of heavy, rugged, uneven appearance in brown, black and deep red glaze colours. Sasaki Chōjirō is said to have been employed by the great tea master Sen no Rikyū (1521–91) and to have made the first *raku* utensils around the beginning of the last quarter of the sixteenth century. Sen no Rikyū was noted for his preference for somber and austere styles which took their form in the *shiki*, four basic rules for the ceremony: harmony, reverence, purity and tranquillity.

Pottery forms were established as

Above and opposite: two woodcuts by Andō Hiroshige from the series Four Seasons.

handmade, asymmetrical cups and bowls with thick dark glazes, and were irrevocably set. Irregularity, tactility, convenient size and somber tonality all took on cultic airs, inasmuch as they had received the blessing of artists, not artisans. This has been aptly put as the Zen "adoration of imperfection."

The ceramic art and the tea ceremony evolved in this intimate patron –potter relationship through the respect commanded by the tea ceremony masters. Their patronage of a potter conferred on him the blessings of sponsorship, and his social recognition contributed to his economic success. This special relationship elevated many potters to celebrity status, and the potter's art from a craft to a fine art. Because the medium was essential to the exercise of the ceremony, the potter was essential to the culture. A well known case of the benefits of the right patronage was that of the Kyoto tea master Kanamori Sōwa and Nonomura Ninsei. The Ninsei workshop began to prosper through this connection after the middle of the seventeenth century and Ninsei became a man of substantial means.

Kyoto itself had about a dozen operating kilns, and the geographical proximity to others deepened the relationship between the aristocrats of the tea ceremony art and the potters. This fortuitous geography was a prime factor in the potter–patron relationship and the high social position attained by the potters. In addition, one need not go far to find other flourishing kilns which were making articles for the tea ceremony: Shigaraki and Iga near Lake Biwa, the Mino kilns and Seto to the east, and even Tamba to the west. The Seto wares were the only intentionally glazed ceramics of the time and so were most suitable for tea cups and bowls. Larger water containers need not be glazed, and some came from other areas. These were unassuming pots of coarse clay in dark colours, quite in keeping with the mood of the ceremony.

There was no rush to produce porcelain while these standards prevailed. Heavy stoneware pots for a great many local uses were available from Echizen, Kutani, Tokoname, Bizen and other kilns. These met domestic and temple needs and could be put in the servants' quarters in the palace if they were to be used and not seen.

The court's access to porcelain was through the trade network with Korea and China, and a good deal came over to Japan this way. But the court also had the cultivated taste for unpretentious tea ceremony wares. The Chinese, for their part, had a history of far more stratified tastes in ceramics, enjoying the circulation at the court of white or monochromatic porcelains from the T'ang and Sung dynasties. These were distributed both at home and abroad. The preference of the Sung court for monochromatic feldspathic glazes and a minimum of adornment was quite acceptable to the Japanese. Even after Ming polychromed wares were in style at the Chinese court, the shogunate retained a large niche for monochromatic pottery because of its devotion to the tea ceremony.

Japanese travellers had seen *chien* wares in Chinese temples and brought pieces back as the ideal type for the tea ceremony. Eventually this type was reproduced as *temmoku* in Japan at Seto, first copied as deep-brown tea bowls. The Yellow Seto (*Ki-seto*) of Late Muromachi was Japan's answer to celadons, some of which the Japanese actually did use as tea ceremony utensils.

Shino wares were the first distinctive Japanese ceramics to be made for the tea ceremony, although one does not discount some Chinese influence. Shino pottery is attributed to a shadowy tea master, Shino by name, who is placed in the early sixteenth century. Thick

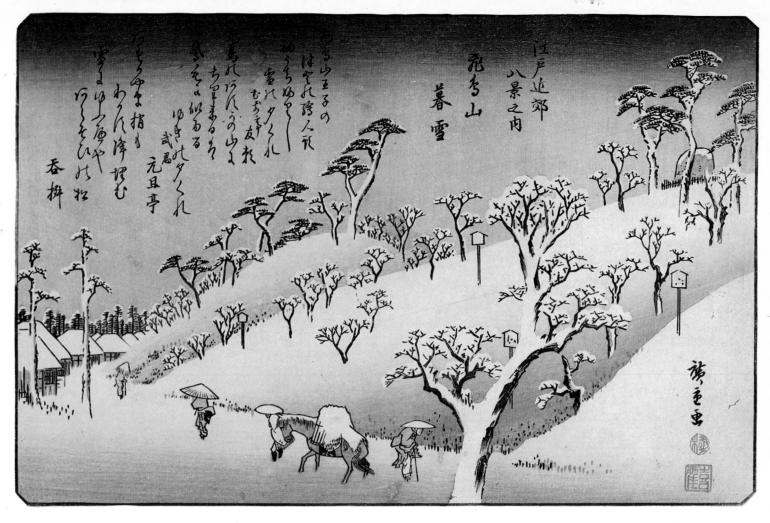

opaque feldspathic glazes of smooth but pitted surfaces cover simply painted iron coloured floral patterns on white clay. Cups, water jars and plates are in distinctive, uneven shapes. The Grey Shino, bearing lightly sketched floral patterns, has an especially mellow charm.

Resources in the same region led to other innovations, the next being the work of Furuta Oribe (1580–1615), a man of unusual imagination. His period of activity coincided with the flood of Korean potters into southwest Japan and the threshold of porcelain production. The entire country seemed to be poised for the impact of Hideyoshi's reverse invasion.

Since Japan's history of green glazing goes back to the eighth century, the copper-green glaze Oribe used may not have been his own invention but by applying it to square plates decorated with stripes and other original and angular patterns in iron oxide paint, the art reached an extraordinarily personal level.

Kyushu had been on the receiving end and locally it could afford to be somnolent through early centuries. But the craft exploded as the Koreans moved out with their families to look for the clays and build new kilns known as *ōgama*, large kilns, instead of the *anagama*, the open-ended

hillside kilns in use since Sue times. This was no small number of people. Documents record 23 Korean families going down to Satsuma alone to set up a factory.

The discovery of the kaolinite clays for porcelain is said to have been the work of Ri Sampei, as the Japanese call this Korean, and all the major kilns which got their start at this time were established by Koreans who fanned out from the Arita region. These Koreans are all known locally by name and revered as ancestors. Among others, these kilns include Karatsu in Saga, Takatori and Agano in Fukuoka, and Hagi in Yamaguchi. Old Karatsu employed modulated brown to grey glazes with exceedingly fine crackle over sketch-style plants growing from one point at the edge of plates and low bowls.

Local *daimyō* exploited the fortunate supply of quality clays in their domains and shared in the prosperity of their kilns. Kakiemon, Satsuma and Nabeshima got their start, the last as an exclusive family production in Saga prefecture. The production consisted of fine white porcelain in sets of up to 20 pieces. Nabeshima is a special case of non-commercial production, carried out under protected conditions, for family table use and gifts to the shogunate, court and congenial *dai-*

myō. The best work belongs to the early eighteenth century. Traditional designs were done by means of a tracing paper transfer technique using charcoal impressions for outlining, and consist of birds, flowers and nature patterns in a small number of bright, flat colours. They emulated the Chinese supervision and inspection system to ensure flawless products.

Kakiemon, like Nabeshima and later Satsuma of the Shimazu domain in south Kyushu, also reflected the aristocratic demand for technical perfection. Kakiemon Sakaida is supposed to have settled in Arita in Saga prefecture in the the early seventeenth century and to have learned the overglaze painting technique of Ming dynasty Chinese wares from a Chinese potter in Nagasaki by the middle of the century. Large plates bear bird and flower designs, dominated by a singularly attractive red colour. While Nabeshima had a special client, the others were on the competitive market, and the range of shapes, designs and colours were gauged to meet the demand.

The Arita kilns, and in particular Imari, are known for their rich polychromed wares with leading reds, followed by much blue and white (*sometsuke*) that took as its models Ming dynasty porcelains.

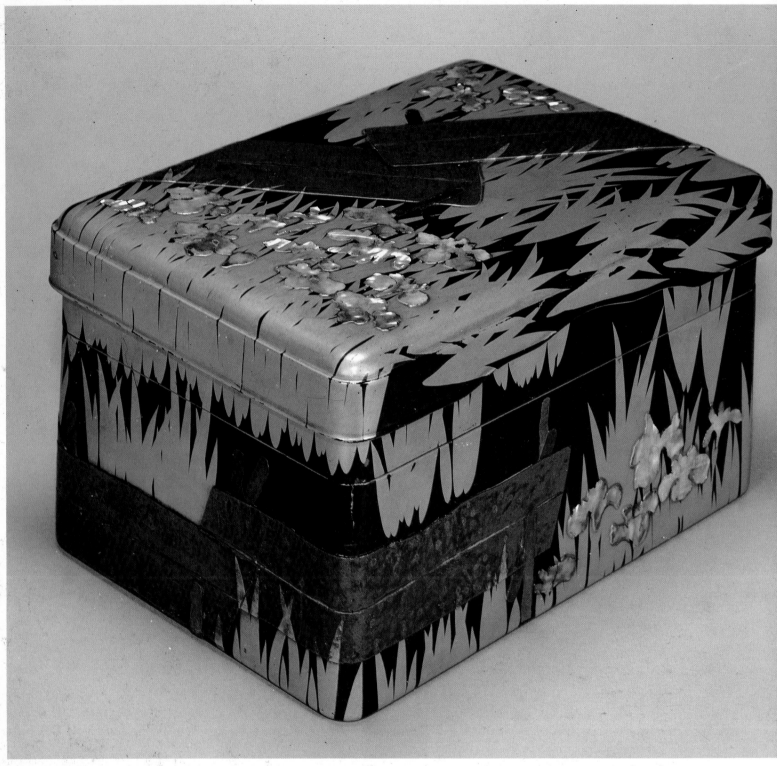

Above: writing box of wood decorated with gold lacquer on a black ground, with mother-of-pearl inlay and metal overlay, depicting irises. Ogata Kōrin (1658–1716). Opposite: short-sleeved silk undergarment (kosode) with a painted design of autumnal plants on a white ground.

The Japanese character in the blue and white was coming through more by the middle of the seventeenth century when the painters turned toward the use of more natural designs. Imari was the port through which the trade passed, and the name soon came to be used for the ceramics themselves. The widely exported blue and white wares are collectively known as Imari, although they came from several Arita kilns.

In retrospect, the good fortune Japan had of being close to Korea and China, but not so close as to be too seriously affected by the caprices of Korean and Chinese politics and having access to both their physical and cultural resources, allowed the Japanese to play their scenario in one of three ways: indiscriminate borrowing, discriminate borrowing, and ignoring the very existence of the continent. The danger of proximity was the danger of developing a complex of dependence and, when the source was dry, to be unable to uncover the cultural resources at home. Cultural flows from Korea and China need also to be looked at in terms of quality. For the arts, the Japanese could not always be too

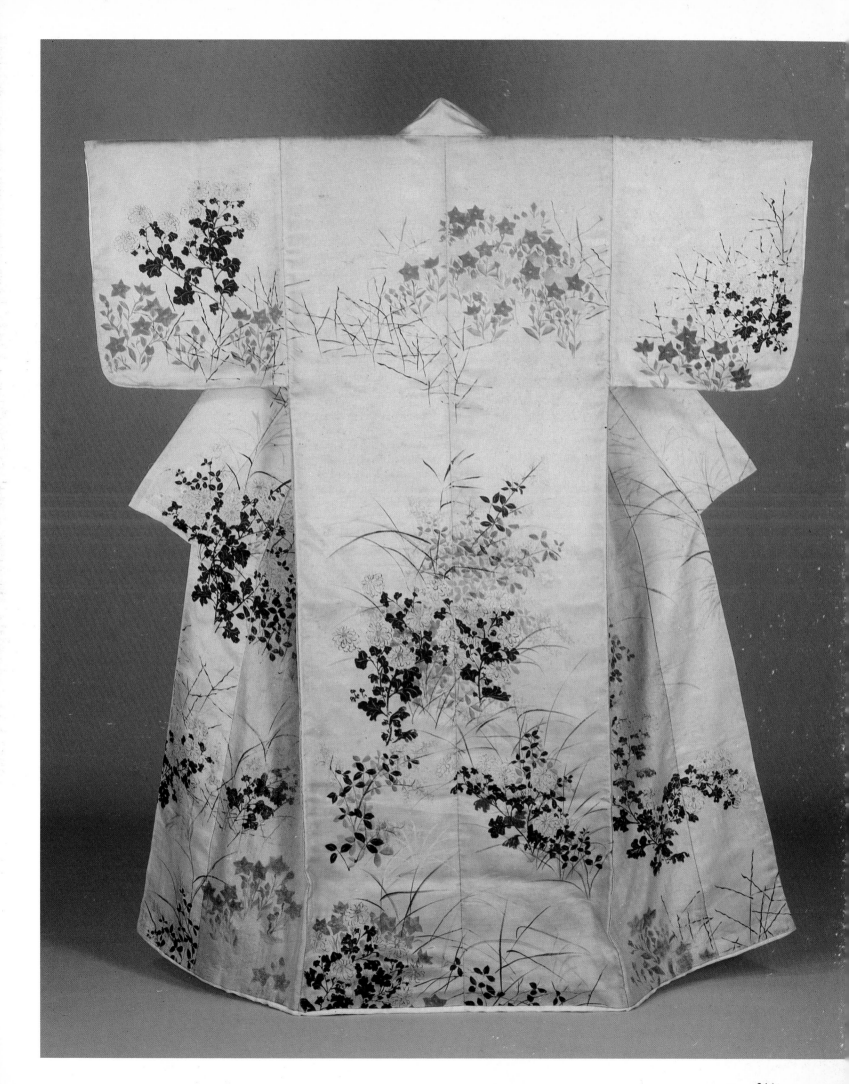

discriminating, yet they could and did discern whether the foreign art style was on the ascendancy, whether it was cresting or in a state of decline. A steady flow allowed the Japanese little reflective time, and this was needed for any assertion of the native arts. Such reflective periods tend to coincide not with the vigorous stages but with the depleted stages of Chinese culture.

A relatively routine process repeated itself in large historical cycles. To some degree its outcome in Japan was predictable. The routine was one of introduction, reproduction, adaptation and conventionalization. The last step was one taken toward formalizing the adaptation by setting up the means for transmitting it to succeeding generations. This was the most critical stage in Japanese art – a kind of cultural *Mappō* – which has built-in conventions of formalization and does not have far to go. The routine was fortunately saved at different times from the conventionalizing stage, despite the Japanese aptitude for regulating every aspect of life, including the forms and processes of the arts. It was usually saved by another foreign intervention.

The Japanese assumed too heavy a burden of debt to the Chinese because of their wholesale adoption of the Chinese writing system. This had advantages in the transmission of Buddhist and Confucian ideas, but great disadvantages in most other respects. The Japanese imposed restrictions on themselves, for example, that all proper writing should be done in Chinese – a hindrance until the women, who did not feel so culture-bound, decided to write. Shinto might have produced a philosophy if writing had become more facile.

The major borrowing from Korea started with the Yayoi period and ran through Kofun, Asuka and into Hakuhō. Korea was the closest neighbour, but once Buddhism began to enter, one step removed. Nevertheless, Korea was a good reflector of those elements in the Chinese culture which Japan seemed to want and, when Japan was obliged to transfer its cultural source in the 660s, the change was so imperceptible that only the finest

Opposite: detail of the decoration on a porcelain dish portraying a Chinese lady. Eighteenth century. Yoshida Collection.

eye would have noticed.

The community patronage in the Yayoi culture was later concentrated under the tribal system in the Yamato aristocracy and remained there in the early Buddhist periods as administered through the medium of the church. Once a consensus had been reached at the court to move in the direction of Buddhism, the entire culture became absorbed with the process. The clergy were pleased to become instruments of national policy, but could not see their power in perspective and abused it against the will of the emperor. Emperor Shōmu in the eighth century separated the court arts from the ecclesiastical arts and set a trend which the Fujiwara continued at the Heian court. The Heian court existed because the clergy had stretched their side of the tripartite emperor–nobility–clergy relationship.

The characteristically Japanese way of discovering compatibility between Shinto and Buddhism gave the culture a vertical depth without which the arts would have been less free to develop. This compatibility opened the way for the acceptance of the esoteric sects.

Contacts with China were terminated in a thoroughly calculated manner by the Japanese in the ninth century. The span of time following this until their renewal in the thirteenth century allowed a synthesis of the Chinese and Japanese elements in a brilliant era at the Fujiwara court. The arts were concentrated on certain themes, primarily Pure Land salvation. All the arts were elicited in intensifying the symbolism of salvation through the grace of Amida, and Late Heian was saved from decline by renewed contacts with China. Pictorial narration appeared spontaneously in the literate atmosphere of the court and the temples.

The collapse of the Fujiwara changed the course of Japanese history. Politics revolved around the family with the strongest military resources, and warrior politics established a social pattern that lasted into the nineteenth century. The Kamakura and Muromachi periods witnessed a series of imports under warrior-clergy patronage through the instrument of Zen: Chinese-style temple architecture, priest portraits, black ink painting, villa-style residential complexes and tea ceremony utensils. Various other allied arts could be mentioned.

The soldiers themselves produced the greatest social upheaval in the creation of the castle towns and in their successive growth. The social classes of the city diversified the patronage and, it might be said that the later arts reflect a more stratified society by being more stratified arts. The cities were secular, earthy, vigorous and responsive to a great variety of interests. Segments of society produced arts for other segments of society. If a new factor appeared of potential interest, such as the literati art, only one segment of the population went for it, not all.

The only group not exerting its customary influence was the clergy. The very nature of the city tended to diffuse the influence of the special interest groups and the clergy, no longer economically oriented, could not find a place of similar influence to that which they had traditionally enjoyed. Nobunaga had wiped out the conspicuous nonconformist clergy. Edo was not intentionally built away from the clergy's traditional centers of power, but the effect was much the same as Emperor Kammu's move to Nagaoka and Heian.

Patronage at Edo extended to all social levels. The *shōgun* appointed an *oku-eshi*, a painter for the "inner quarters" of the castle at Edo, Kanō Tan'yū, who was more than the official painter of the shogunate. The atelier was in the castle and the painter at the shōgun's beck and call. Extreme power bred extreme personal control of the arts. Otherwise, the social strata diffused other levels of patronage.

With a conscious policy of luring all art forms to Edo, where artisans and craftsmen thrived within the limits of the freedom imposed by the Tokugawa, the vitality was irrepressible, and the real and dream worlds found their full range of subjects in the various media. Stranded *daimyō*, bureaucratic samurai, competitive merchants and tradespeople, builders and craftsmen, shrine and temple priests, vendors and entertainers were producers or consumers, and frequently the subject of the arts. The rich depth of the Kanō, *Rimpa*, *ukiyo-e*, traditional Buddhist arts and independent work reflected the interests of all.

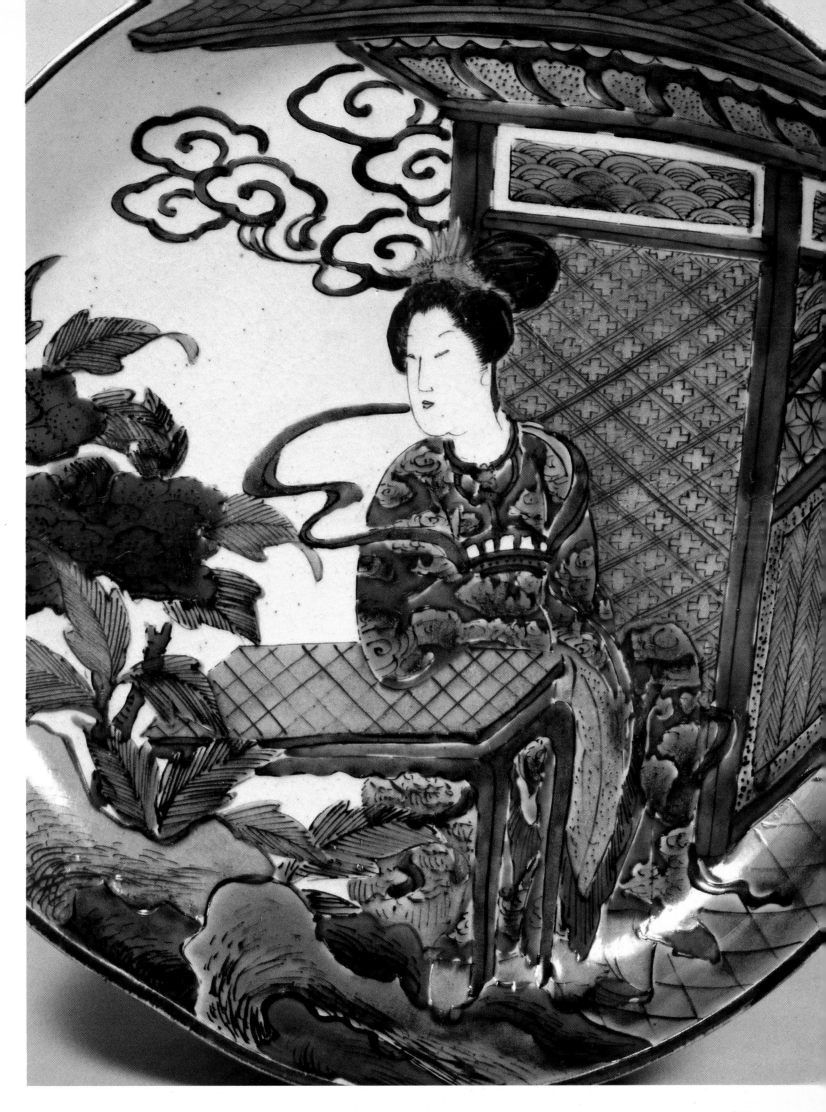

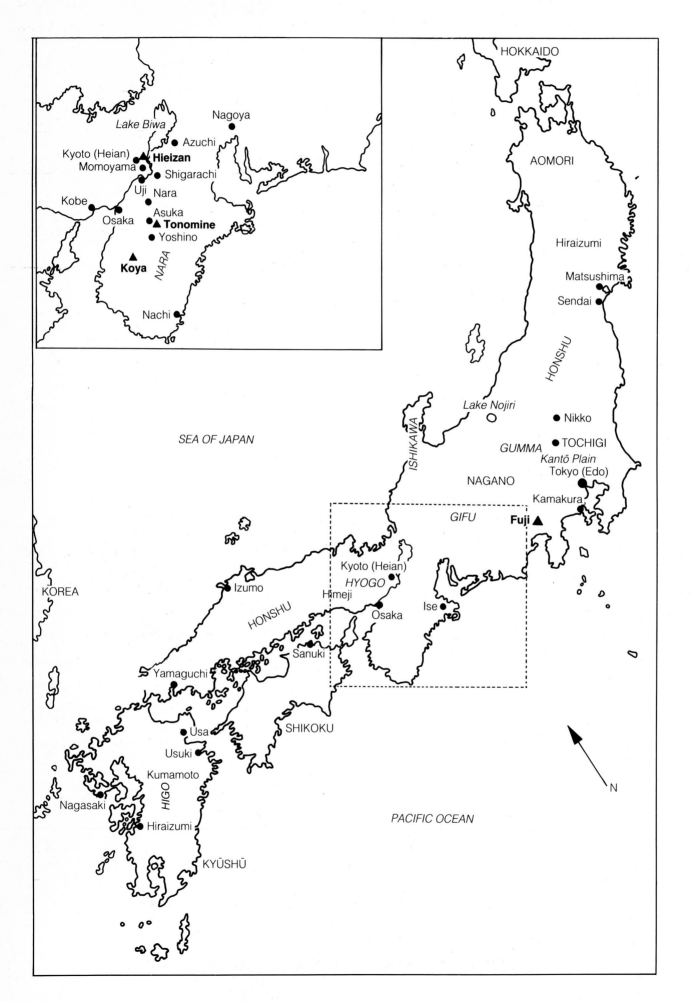

Lake Biwa
Nagoya
Azuchi
Kyoto (Heian)
Hieizan
Momoyama
Shigarachi
Uji
Nara
Kobe
Asuka
Osaka
Tonomine
Yoshino
Koya
NARA
Nachi

HOKKAIDO

AOMORI

Hiraizumi

Matsushima

Sendai

HONSHU

Lake Nojiri
Nikko
GUMMA
TOCHIGI
Kantō Plain
Tokyo (Edo)
NAGANO
Kamakura
GIFU
Fuji

SEA OF JAPAN

ISHIKAWA

Kyoto (Heian)
HYOGO
Himeji
Izumo
HONSHU
Osaka
Ise
KOREA

Sanuki

Yamaguchi
N
Usa
SHIKOKU
Usuki
Kumamoto
HIGO
Nagasaki
PACIFIC OCEAN
Hiraizumi
KYŪSHŪ

BIBLIOGRAPHY

General works on Japanese art

Akiyama, T. *Japanese Painting*, New York, 1961

Alex, W. *Japanese Architecture*, New York and London, 1963

Anderson, L.J. *Japanese Armour*, London, 1968

Blaser, W. *Japanese Temples and Tea Houses*, New York, 1956

Casal, U.A. *Japanese Art Lacquers*, Tokyo, 1961

Drexler, A. *The Architecture of Japan*, New York, 1955

Fontein, J. and Hickman, M. *Zen Painting and Calligraphy*, Boston, 1970

Fuller, R. *Japanese Art in the Seattle Art Museum*, Seattle, 1960

Hisamatsu, S. *Zen and the Fine Arts*, Tokyo, 1971

Jenyns, R.S. *Japanese Porcelain*, London, 1965

Japanese Pottery, London, 1971

Joly, H. *Legend in Japanese Art*, Rutland and Tokyo, 1967

Kageyama, H. and Kanda, C.G. *Shinto Arts, Nature, Gods, and Man in Japan*, New York, 1976

Kidder, J.E. *Masterpieces of Japanese Sculpture*, Rutland and Tokyo, 1961

Japanese Temples: Sculpture, Paintings, Gardens, and Architecture, Amsterdam, 1964, London, 1965

Kodansha Encyclopedia of Japan, Tokyo, 1983

Kuck, L.E. *The Art of Japanese Gardens*, New York, 1940

The World of the Japanese Garden, New York and Tokyo, 1968

Mainichi Newspapers, *Japan's Ancient Sculpture: 50 Selected National Treasures*, Tokyo, 1970

Munsterberg, H. *The Arts of Japan*, Rutland and Tokyo, 1957, London, 1958

The Ceramic Art of Japan: A Handbook for Collectors, Rutland, Tokyo and London, 1964

The Folk Arts of Japan, Rutland and Tokyo, 1958

Murase, M. *The Arts of Japan*, New York 1977, London 1978

Nishikawa, K. and Sano, E.J. *The Great Age of Japanese Buddhist Sculpture, AD 600–1300*, Seattle, 1983

Noma, S. *The Arts of Japan: Ancient and Medieval*, Tokyo and Palo Alto, 1966, London, 1976

The Arts of Japan: Late Medieval to Modern, Tokyo and Palo Alto, 1967, London, 1968

Paine, R.T. and Soper, A.C. *The Art and Architecture of Japan*, Baltimore and London, 1975

Ponsonby-Fane, R.A.B. *Studies in Shinto and Shrines*, Kyoto, 1953

Kyoto: The Old Capital of Japan, Kyoto, 1956

Rague, B. von *A History of Japanese Lacquerwork*, Toronto and Buffalo, 1976

Roberts, L.P. *A Dictionary of Japanese Artists*, Tokyo and New York, 1980

Robinson, H.R. *Japanese Arms and Armor*, New York and London, 1969

Rosenfield, J. and Shimada, S. *Traditions of Japanese Art: Selections from the Kimiko and John Powers Collection*, Cambridge, Mass., 1970

Sadler, A.L. *A Short History of Japanese Architecture*, Sydney and London, 1941

Salmon, P. *Japanese Antiques*, Tokyo, 1980

Schaarschmidt-Richter, I. and Mori, O. *Japanese Gardens*, New York, 1979

Saunders, E.D. *Mudra: A Study of Symbolic Gestures in Japanese Buddhist Sculpture*, New York, 1960, London, 1961

Saunders, N. *The World of Japanese Ceramics*, Tokyo, 1967

Society of Friends of Eastern Art, *Index of Japanese Painters*, Rutland and Tokyo, 1958

Soper, A.C. *The Evolution of Buddhist Architecture in Japan*, Princeton, 1942

Stanley-Baker, J. *Japanese Art*, London, 1984

Stern, H.P. and Lawton, T. *The Freer Gallery of Art II: Japan*, Tokyo, 1972

Swann, P. *Japan from the Jomon to the Tokugawa Period*, London, 1966

Taut, B. *Fundamentals of Japanese Architecture*, Tokyo, 1936

Houses and People of Japan, second edition, Tokyo, 1958

Tokyo National Museum Staff, *Pageant of Japanese Art*, 6 vols, Tokyo, 1952

Tokyo National Museum, *An Aid to the Understanding of Japanese Art*, Tokyo, 1964

Warner, L. *The Enduring Art of Japan*, Cambridge, Mass., 1952

Watson, W. *Sculpture of Japan from the Fifth to the Fifteenth Century*, London 1959

Yashiro, Y. *2000 Years of Japanese Art*, London 1958

Pre-Buddhist Art

Egami, *The Beginnings of Japanese Art*, New York and Tokyo, 1973

Kidder Jr., J.E. *Early Japanese Art: The Great Tombs and Treasures*, London 1964

The Birth of Japanese Art, New York and London, 1965

Prehistoric Japanese Arts: Jomon Pottery, Tokyo and Palo Alto, 1968

Miki, F. *Haniwa: The Clay Sculpture of Protohistoric Japan*, Rutland, Tokyo and London, 1960

Haniwa, New York and Tokyo, 1974

Watanabe, Y. *Shinto Art: Ise and Izumo Shrines*, New York and Tokyo, 1974

Ancient Buddhist Period

Hayashi, R. *The Silk Road and the Shoso-in*, New York and Tokyo, 1975

Imperial Treasury, *The Treasures of the Shoso-in*, Tokyo, 1965

Kurata, B. *Horyu-ji: Temple of the Exalted Law*, New York, 1981

Kobayashi, *Nara Buddhist Art: Todai-ji*, New York and Tokyo, 1975

Mizuno, *Asuka Buddhist Art: Horyu-ji*, New York and Tokyo, 1974

Naito, T. *The Wall-Paintings of Horyu-ji*, Baltimore, 1943

Ooka, M. *Temples of Nara and Their Art*, New York and Tokyo, 1973

Plutschow, *Historical Nara*, Tokyo, 1983

Suzuki, *Early Buddhist Architecture in Japan*, Tokyo, New York and San Francisco, 1980

Warner, L. *Japanese Sculpture of the Tempyo Period*, Cambridge, Mass., 1964

Medieval Period

Awakawa, Y. *Zen Painting*, Tokyo and Palo Alto, 1970

Barnet, S. and Burto, W. *Zen Ink Paintings*, Tokyo, New York and London, 1982

Covell, J.C. *Under the Seal of Sesshu*, New York, 1941

Fukuyama, T. *Heian Temples: Byodo-in and Chuson-ji*, New York and Tokyo, 1976

Ienaga, S. *Painting in the Yamato Style*, New York and Tokyo, 1973

Kanazawa, *Japanese Ink Painting: Early Zen Masterpieces*, Tokyo, New York and San Francisco, 1979

Kondo, I. *Japanese Genre Painting: The Lively Art of Renaissance Japan*, Rutland and Tokyo, 1961

Matsushita, *Ink Painting*, New York and Tokyo, 1974

Miller, R. *Muro-ji: An Eighth Century Japanese Temple, its Art and History*, Tokyo, n.d.

Mori, H. *Sculpture of the Kamakura Period*, New York and Tokyo, 1974

Murase, M. *Iconography of the Tale of Genji: Geni Monogatari Ekotoba*, Tokyo, 1983

Okawaki, *Pure Land Buddhist Painting*, Tokyo, 1977

Okudaira, H. *Emaki: Japanese Picture Scrolls*, Rutland and Tokyo, 1962

Narrative Picture Scrolls, New York and Tokyo, 1973

Rambach, P. *The Art of Japanese Tantrism*, London, 1979

Rosenfield, J.M. *Japanese Arts of the Heian Period*, New York, 1967

Sawa, T. *Art in Japanese Esoteric Buddhism*, New York and Tokyo, 1972

Seckel, D. *Emakimono*, New York and London, 1959

Shimizu, Y. and Wheelwright, C. *Japanese Ink Paintings*, Princeton, 1976

Tanaka, I. *Japanese Ink Painting: Shubun to Sesshu*, New York and Tokyo, 1972

Toda, K. *Japanese Scroll Painting*, Chicago, 1935

Momoyama and Edo Periods

Cahill, J. *Scholar Painters of Japan: The Nanga School*, New York, 1972

Cort, L. *Shigaraki, Potters' Valley*, Tokyo, 1979

Doi, T. *Momoyama Decorative Painting*, New York and Tokyo, 1977

Earle, J. *An Introduction to Japanese Prints*, London, 1980

Fujioka, R. *Tea Ceremony Utensils*, New York and Tokyo, 1973

Gray, B. *Japanese Screen Painting*, London, 1955

Grilli, E. *The Art of the Japanese Screen*, New York and Tokyo, 1970

Hayashiya, T., Nakamura, M. and Hayashiya, S. *Japanese Art and the Tea Ceremony*, New York and Tokyo, 1976

Hillier, J. *Japanese Colour Prints*, London 1966

Hiller, J. and Smith, L. *Japanese Prints: 300 Years of Albums and Books*, London, 1980

Hirai, K. *Feudal Architecture of Japan*, New York and Tokyo, 1973

Itoh, T. *The Elegant Japanese House: Traditional Sukiya Architecture*, New York and Tokyo, 1969

Itoh, T. and Futagawa, Y. *The Classic Tradition in Japanese Architecture*, Tokyo, 1972

Kirby, J.B. *From Castle to Teahouse: Japanese Architecture of the Momoyama Period*, Rutland and Tokyo, 1962

Lane, R. *Masters of the Japanese Print*, London 1962

Images from the Floating World, Oxford, 1978

Ledoux, L.V. *Japanese Prints of the Ledoux Collection*, 5 vols, New York and Princeton, 1942–51

Lee, S. *Tea Taste in Japanese Art*, New York, 1963

Michener, J.A. *The Floating World*, New York, 1954, London, 1955

Japanese Prints from the Early Masters to the Modern, Rutland and Tokyo, 1959, London, 1960

Mizuo, H. *Edo Painting: Sotatsu and Korin*, New York and Tokyo, 1972

Murase, M. *Byobu: Japanese Screens and from New York Collections*, New York 1971

Narazaki, M. *The Japanese Print: Its Evolution and Essence*, Tokyo and Palo Alto, 1966, London, 1967

Masterworks of Ukiyo-e: Early Paintings, Tokyo and Palo Alto, 1967

Naito, A. *Katsura*, Tokyo, 1977

Neuer, R. and Yoshida, S. *Ukiyo-e: 250 Years of Japanese Art*, New York and London, 1979

Noma, S. *Japanese Costume and Textile Arts*, New York and Tokyo, 1974

Okawa, N. *Edo Architecture: Katsura and Nikko*, New York and Tokyo, 1975

Rhodes, D. *Tamba Pottery*, Tokyo, 1972

Sato, M. *Kyoto Ceramics*, New York and Tokyo, 1973

Schmorleitz, M. *Castles in Japan*, Rutland and Tokyo, 1974

Stern, H.P. *Master Prints of Japan: Ukiyo-e Hanga*, New York, 1969

Rimpa: Masterworks of the Japanese Decorative School, New York, 1971

Takahashi, S. *Traditional Woodblock Prints of Japan*, New York and Tokyo, 1972

Takeda, T. *Kano Eitoku*, Tokyo, 1977

Tange, K. *Katsura: Tradition and Creation in Japanese Architecture*, New Haven 1960

Watson, W. (ed.), *The Great Japan Exhibition*, New York and London, 1981

Yamane, Y. *Sotatsu*, Tokyo, 1962

Yonezawa, Y. and Yoshizawa, C. *Japanese Painting in the Literati Style*, New York and Tokyo, 1974

Page numbers in italic refer to illustrations

Abe Kurahashimaro, 57
Agano kiln, 309
Aizu-Wakamatsu, 258
Akishino-dera, 85, 92
Amanohashidate, promontory of, *232–3*, 236, 262
Amida, cult of, 47, 100, 120, 142, 146, 152, 177, 178, 179, 183, 203, 312
Andō Hiroshige, 297, 301, *306–7*, *308*, *309*
Ankoku-ji, *220*
Anraku-ji, *217*, 222, 224
architecture *see under* individual names and types of buildings
Arita kilns, 309
armour, *209*, 214
arrowheads, *13*
Ashikaga family, 213, 216, 221
Ashikaga Takauji, 177, *207*, 213, 230
Ashikaga Yoshiaki, 213, 243
Ashikaga Yoshihisa, 213
Ashikaga Yoshikane, 188
Ashikaga Yoshimasa, 213, 216, 221, 236, 264
Ashikaga Yoshimitsu, 213, 216, 250
Ashikaga Yoshimochi, 234
Asuka, 41, 57, 66, 67, 75, 312
Asuka period, 41–54, 58, 64, 67, 75, 100, 205
Asuka-dera, 44, *45*, 47–8, 86
Azuchi castle, 243, 250, 252, 254, 261, 266, 268–70, 274

Bakin, 297
bakufu (military government), 177, 274, 276, 280
Bashō, 286
bells, bronze, 23–4, *25*
Bizen kiln, 240, 308
Bodhidarma *see* Daruma
brocades, 301
bronze, 90
Buddhism, 288, 301, 312
 adoption of, 41–2, 44
 and Chinese writing system, 312
 critical period, 140, 142
 earliest painting, 75, 78
 Middle Way, 120
 Pure Land, 60, 63–4, 100, 140, 179, 187, 216, 312
 reinterpretation, 142
 rhythm in, 75
 and Shinto, 100, 120, 133
 Tantric, 133
 see also Zen Buddhism
buke, 139, 140
bunjinga painting, 290

calligraphy, 164, 167
castles, 243, *244–5*, *246–7*, *248*, *249*
 art, 250, 261, 266
 donjons, 247, 248, 250, 252, 254, 258, 261, 266
 on high ground, 243, 247
 on low ground, 247
 peak of construction, 254
 plans, 248
celadon, 172, 174, 240, 308
ceramics *see* pottery
chien wares, 308
Chikamatsu, 286
Ch'in dynasty, 21
Ch'ing paintings, 290
Chion-in, 178, 190
Chisaku-in, 274
Chishō Daishi, 137
Chō Densu *see* Minchō
Chō-en, 206
Chōga *see* Takuma Chōga
Chōgen, Priest, *189*, 190, 210

Chōgosonshi-ji, 168
Choju Giga, 170, 172
Chou dynasty, 21
Christianity, 279
Chūgū-ji, 60
Chūson-ji, 161, 162, 243
clay, 236
 kaolinite, 243, 308
 and tea ceremony, 308
 unbaked, 96, 100, 106, 210
colour
 and armour, 214
 dyes, 113
 use of, 33
Confucianism, 59, 63–4, 183, 279, 286, 290, 312
costume, 301
crowns, 32, *34*

Dai-Nihon-Shi, 286
Daian-ji, 85, 86, 100, 110
Daigo, Emperor, 169
Daigo-ji, 274
Daikandai-ji, 86
Daitoku-ji, *225*, 230, 236, 266, 270, 274, *277*
Daruma, 184
Dasoku *see* Jasoku
decoration
 chokkomon, 33, *35*
 chrysanthemum design, *240*
 combing, 24
 cord-marking, 13, 16, 21
 erased cord-marking, 19
 of fabric, 113
 geometric, *20*, *21*, 33, *35*
 nail-marking, 13–14
 rouletting, 13
 shells, 13
 of sūtras, *163*
 zoomorphic motifs, 14, 16
Deshima Island, 279
Dōgen, Priest, 184
Dōkyo, Priest, 117
Dōryū, 188
Dōshō, 58
dyes, 113

Echizen kiln, 240, 308
Edo, 247, 274, 276, 282, 286, 287, 290, 292, 312
Edo period, 64, 100, 124, 142, 193, 216, 227, 230, 261, 274
 Early, 279–92
 Late, 292–312
Eiei (monk), 197
Eihei-ji, 184
Eihō-ji, *222*, 230
Eisai, Priest, 184, 187, 190, 216
Eitoku *see* Kanō Eitoku
Eizan-ji, 107
embroidery, *52–3*, 54, *115*
Emishi, 243; *see also* Ezo
En-pa (En School), 206
Enryaku-ji, 118, 120
En-sei, 206
Enchin, Abbot, 120
Engaku-ji, Kamakura, *180*, *181*, 190, 216, 250
En'i, 203
Enjō-ji, 210
Ennin, Abbot, 120
Enryaku-ji, 214
Eshin Sōzu *see* Genshin, Priest
Enshō-ji, 146
Esotericism, 120, 133
Ezo, 117, 120, 139

fabrics, 113
fertility objects, 9
flower arranging, 216
Fuji, Mt., 300
Fujiwara, 57
Fujiwara family, 57, 90, 100, 117, 120, 129, 139, 140, 142, 146, 162, 193, 216, 261, 270, 312

Fujiwara Hidehira, 162
Fujiwara Kintō, 165
Fujiwara Kiyohira, 162
Fujiwara Masanobu *see* Kanō Masanobu
Fujiwara Michinaga, 139, 146, 174
Fujiwara Mitsuyoshi, 205
Fujiwara Motohira, 162
Fujiwara Nagatsune, 227
Fujiwara Nobuzane, 205
Fujiwara palace, 58, 85, 86
Fujiwara Tadahira, 139
Fujiwara Takanobu, *198*, 205
Fujiwara Takayoshi, 167, 171
Fujiwara Tanetsugu, 117
Fujiwara Yasuhira, 162
Fujiwara Yorimichi, 139, 146, 152
Fujiwara Yukimitsu, 274
Fujiwara Yukinari, 161
Fukushina castle, 258
Furuta Oribe, 290, 308
Fushimi castle, 243, 254, 282
Fushō (monk), 197
Futaarasan jinja, 282
Futai-ji, 85

Gakuan-ji, 102
Ganjin, 92, 96, 102, *104*, 105, 197
Gankō-ji, 85, 86, 94, 96
gardens
 "borrowed scenery", 230
 design, 224, 227, 230
 "dry landscape", *224*, 227
 rock, *225*, 227
 temple, *222*, *223*, 227, 230
Geiami, 236
Gemmei (Gemmyō), Empress, 85
Genji, Prince, 167, 168
Genji Monogatari, *138*, 139, 165, 167, 168, *168*, 169, *170–71*, 193, 197, 236, 266, 286
Genroku Culture, 286
Genroku era, 286, 301
Genshin, Priest, 140, 146, 162
Gifu prefecture, 38
Ginkaku-ji, 213, 230
glass, 110
glazes, *211*, 309
 ash, 236
 green, 172, 174, 236, 309
 monochromatic feldspathic, 308
Go-Daigo, Emperor, 177, 213
Go-mizuno-o, Emperor, 261, 262
Go-Sanjō, Emperor, 139
Go-Shirakawa, Emperor, 205
Go-Toba, Emperor, 190, 205
Go-Yōzei, Emperor, 261, 282
Gonso, monk, *136*
Gottan Funei, 203
Gottan Osho, *204*
Great Kantō Earthquake, 101, 188, 190
Gumma prefecture, 32
Gyōgi, Priest, 67, 120
Gyōshin, Priest, 105

Hachinān-gū, 187
Hachioka-dera, 45
Hagi kiln, 309
Hagi castle, 258
haji, 29, 31
Hakuhō period, 57–82, 94, 105, 108, 117, 312
Hakusō, law of, 57
Han dynasty, 21, 269
Hana-no-Gosho, 213
haniwa, *26*, 29, *30*, 31, *31*, 32, 33, 214
Harunobu *see* Suzuki Harunobu
Hasedera Engi Emaki, 193
Hasegawa Kyūzō, 274
Hasegawa Nobuharu, *272*, *273*
Hasegawa Tōhaku, *266–7*, *268*, *269*, *270*, *271*, 274
Heian (Kyoto), 42, 117–18, 197, 312
Heian palace, 146
Heian period, 31, 287, 290, 301
 Early, 100, 105, 117–37

Middle, 236
 Late, 92, 139–74, 177, 188, 203, 206, 214, 266, 312
Heian Shrine, 156
Heiji Disturbance, 139
Heiji Monogatari Emaki, 203
Heijō (later Nara), 42, 66, 85, 90, 92, 117
Heinouchi Masanobu, 286
Hidari-no-Jingoro, 129
Hidehira *see* Fujiwara Hidehira
Hidetada *see* Tokugawa Hidetada
Hideyoshi *see* Toyotomi Hideyoshi
Hie Shrine, 129
Hiei, Mt., 118, 120, 162, 178, 214
Higashiyama Culture, 213
Higashiyama-dono, 213, 216, 221
Himeji Castle, *244–5*, *246–7*, *248*, *249*, 252, 258, 261, 290
Hiniko, 24
Hirado Island, 279
Hiroshige *see* Andō Hiroshige
Hiroshima Castle, 258
Hishikawa Moronobu, 292
hitsu-yō, 234
Hizōbōyaku, 124
Ho (sixth century), 165
hōgen (highest rank), 152
Hōjō area, 177
Hōjō family, 213, 243
Hōjō Morotoki, 188
Hōjō Tokimune, 188
Hōjō Tokiyori, 184, 188, 203, 210
Hōjō-ji, *142*, 146, 174
Hōkai-ji, 142
Hokke-dō Kompon Mandara, 107
Hokke-ji, 85, 86, 133
Hokke-shū, Lotus Sect *see* Nichiren Sect
Hokki-ji, 45, 64
Hōkō-ji *see* Asuka-dera
Hokuku Shrine, *237*
Hokusai *see* Katsushika Hokusai
honpa style, 133
Hon'ami Kōetsu, *276*, 286, 304
Honan, 48
Honchi-suijaku doctrine, 120
Hōnen, Priest (Genkū), 177–8, 190
Hōnen Shōnin Eden, 193, 197
Hongan-ji, 179
Honpō-ji, 274
Honshu, 31
Hora, 117
Hōrin-ji, 45, 64
Hōryū Gakumon-ji *see* Hōryū-ji
Hōryū-ji, Nara, *41*, *42–3*, 45, *49*, 50, 54, *55*, *58*, *59*, 60, 64, *65*, 67, 75, 78, *79*, *80*, *81*, 82, 85, *88–9*, 90, *91*, 96, 102, 105, 106–8, 203, 205, 292
Hōshō-ji, 146, 224
Hosokawa Katsumoto, 227
Hosokawa Sumimoto, *208*
Hossō sect, 58, 66, 96, 100, 106, 108, 124, 193, 206
Hsieh Poets, 165
Hui-yüan, 63

Ichikawa Ehizo, *300*
Iemitsu *see* Tokugawa Iemitsu
Ieyasu *see* Tokugawa Ieyasu
Iga kiln, 240, 308
Ikaruga, 64
Ikaruga-dera (later Hōryū-ji), 45, 48, 58
Ikeda Terumasa, 243, 258
Ikeno Taiga, 290
Imari ware, 310
imbutsu, 292
Imperial Palace, Kyoto, 213
Imperial Villa *see* Katsura Detached Palace
Indian influences, 67, 70, 101, 135, 137
ink painting, 213, 224, *231*, *232–3*, 234, 236, *264*, 266, *268–71*, 274, 290, 292, 312
Inuyama castle, 248

Ippen, 179, 203
Ippen Shonin Eden, 203
Ise shrines, 261
Ise Jingū shrine, 34, 35, *36–7*, 38, *38*
Ise Monogatari, 165
Ishikawa fief, 248
Ishikawa-maro *see* Soga Kurayamada Ishikawa-maro
Ishiyama-dera, 135, 167
Itsukushima shrine, *163*, 214, *215*, 216
Iwasa Matabei, 292
Iwashimizu Hachiman-gu *see* Hachiman-gū
Iwato, 9
Izu peninsula, 247
Izumo, 31, 34
Izumo Taisha shrine, *32*, *33*, 34–5, 282

Jasoku, 236
Ji Sect, 203
Jindai-ji, *66*
Jingo-ji, 120, 205, 210
Jingu, Regent, 41, *131*, 133, 187
jingu-ji, 120
Jisho-ji, 216, *221*
Jito, Empress, 27, 57, 58, 66, 78, 94
Jizō, *151*, 206
Jōchi-ji, 188
Jōchō, 142, *143*, *144–5*, *146*, 152, 154, 155, 206
Jōdo, 146, 164, 216
Jōdo Shinshū, 179, 193, 216
Jōdo-ji, Hyōgo, 190, 210
Jōdo-ji, Yamaguchi, 190
Jōgan, 117
Jōmon period, 9, 13–14, 16, 19, 21, 22, 24
Jōmyō-ji, 188
Jōruri-ji, 142, 146, 292
Jōkei, *194*, *195*, 210
Josetsu, 234
Jufuku-ji, 187, 188
Juraku-dai, 270

Kabuki, 293, 294, 301
Kaikei, 210
Kairyūō-ji, 85
Kakiemon family, 309
Kakiemon Sakaida, 309
Kakuyu, 170
Kamakura, 140, 187–8, 190, 202, 203, 210, 234
Kamakura period, 90, 100, 102, 135, 142, 146, 154, 164, 177–210, 213, 214, 236, 240, 250, 301, 312
Kammu, Emperor, 117, 118, 120, 312
Kamo-no-mioyano shrine, 129
Kanamori Sōwa, 308
Kanaoki-yama, 67
Kanefusa *see* Taira Kanefusa
Kan'ei-ji, 282
Kanō Eitoku, 261, *264*, *265*, 266, 268, 270, 274, 286
Kanō Masanobu, 264, 266, 270
Kanō Mitsunobu, 268, 274
Kanō Motonobu, 230, 266, 270
Kanō Sanraku, 274
Kanō School, 234, 243, 261, 264, 266, 274, 276, 282, 286, 295, 312
Kanō Shōei, 270
Kanō Tan'yū, 274, 312
Kansai region, 27, 162, 282
Kanshū-ji, 107
Kantō, 9, 13, 14, 24, 32, 133, 155, 177, 205, 222, 236, 240, 243, 247, 276
Kaō (monk), 234
Kao Shirōzaemon, 236, 240
Kara-e, 161
Kara-sumaru, 213
Karatsu kiln, 309
Kashiwari, 24
Kasuga Gongen Reigen Ki, 193
Kasuga Shrine, Nara, *118*, 129
Katsukawa Shunkō, 295
Katsukawa Shunshō, 295
Katsumoto *see* Hosokawa Katsumoto

Katsura Detached Palace, *242*, *256–7*, *258*, *259*, *260*, 261–2, *263*, 264, 285
Katsushika Hokusai, 297, *298–9*, 300, *300*, 301, *302*, *303*, *304–5*
Katsushika School, 300
Kawara-dera (Kawahara-dera), *58*, 64, 67, 106
Kegon Engi, 193
Kegon sect, 96, 105, 124, 193
Kei-ha (Kei School) *see* Shichijō Bussho
Ken-en, 206
Kenchō-ji, 188, 203, 224
Kennin-ji, 184, 187, 274
Kenzan *see* Ogata Kenzan
Ki-seto, 308
Kiangsu, 102, 188
Kibitsu Shrine, 129
Kimmei, Emperor, 41
Kinkaku-ji, 213, 230
Kinki, 22, 23, 24, 32, 133, 170
Kintō *see* Fujiwara Kintō
Kitagawa Toyoaki *see* Kitagawa Utamaro
Kitagawa Utamaro, *294*, 295, *296*, 297
Kitano Tenmangū Shrine, 129
Kitao Masanobu, 295
Kitaya-madono complex, 250
Kitayama area, 213, 216
Kitayama Culture, 213
Kiyohira *see* Fujiwara Kiyohira
Kiyomigahara, 57
Kiyomizu-dera, *287*
Kiyomori *see* Taira Kiyomeri
Kiyonaga *see* Torii Kiyonaga
Ko-e, 274, 276
Kobe, 139
Kōben, 210
Kōbō Daishi *see* Kūkai
Kobori Enshū, *242*, 262, *277*
Kōchi castle, 252
Kōetsu, 287
Kōfuku-ji (monk), 193
Kōfuku-ji, 67, 70, 71, *74*, 85, 86, 96, 100–101, 102, *106*, *107*, *176*, 193, 202, 206
Kofun period, 27, 312
Kōgai-ji, 86
Kōgei *see* Kitagawa
Kogai-ji, 86
Kōkei, *176*, 206
Koguryo, 41, 57
Kojiki, 27
Kokawa-dera Engi, 193
Kōkei, *176*, 206
Kokura castle, 258
Kōmyō, Empress, 75, 102
Kongōbu-ji, 120, 135, *156*, *157*
Kōnin, 117
Konkōmyō-saishō-ō, 117
Kōra, 282
Kōra Munehiro, 282
Kōrin *see* Ogata Kōrin
Koryo, 48
Kose Hirotaka, 159
Kose painters, 165
Kōshō, 206
Kōshō-ji, *218*, 221
Kosode, 201, *311*
Kōtoku, Emperor, 57
Kōtoku-in, 187
Kōya, Mt., 120, 135, 137, 162, 205
Kozan-ji, 170
Kujō Kanesane, 205
Kūkai, 120, 124, 135, 137, 203, 205, 216, 292
Kumamoto castle, 258
Kumamoto prefecture, 33
Kuni, 85, 117
Kuninaka-no-muraji-Kimimaro, 90
Kunō-Zan, 280
Kurahashimaro *see* Abe Kurahashimaro
Kusakabe, Prince, 78
Kutani kiln, 308
Kuwagata, 214
Kwal-leuk, 59
Kyō-yaki, 290
Kyō-zuka (sūtra mound), 142

Kyōōgokuku-ji, *161*
Kyoto (see also Heian), 45, 117, 118, 120, 133, 142, 146, 152, 154, 162, 177, 178, 179, 184, 187, 188, 190, 203, 205, 206, 213, 214, 216, 217, 224, 227, 234, 236, 240, 243, 254, 264, 270, 274, 276, 279, 282, 286, 287, 305, 308
Kyushu, island of, 13, 21, 22–3, 24, 31, 33, 177, 221, 243, 309
Kyūzō *see* Hasegawa Kyūzō

lacquer, 290
 and armour, 214
 dry (kanshitsu), 75, 96, 100, *104*, 105, 129, 210
 first used, 21
 on pottery, 13
 preference for, 172
 uses, 301
 wood-core dry, 105
landscape
 gold used in, 268, 270, 274
 ink painting, 230, *231*, *232–3*, 234
 Ming dynasty, 290
 Mu Chi tradition, 236
 in religious painting, 164
 "splashed ink", (*haboku*), 236
Literature, 159, 161, 268
 Confucian, 279
 Gozan, 213
 Women and Japanese language, 139
Long Scroll, *212*, *226–7*, 234, 236

Ma Yüan, 266
Mahāyāna, 124
Maitreya, 54, 206
Maki-e, 301
Mampuki-ji, 184
Mandala, 120, 133, 135, 164, 203
 and Amidist art, 270
 and castles, 252
 Kongō-Kai, 133
 Mt. Murō as, 129
 sculptures, *122–3*, *126*, *127*, 135
 Taizō-Kai, 133
Mandala of Garbhadhātu and Vajradhatu, *158*, *159*
Mandala of Heavenly Longevity *see* Tenjukoku Mandara
Mappō, 140, 142, 146
Marōdo Shrine, 216
Maruoka castle, 248
Maruyama Ōkyo, 274, 288, *292*
Masako *see* Taira Masako
masks
 terracotta, *12*
 wooden, *172*, *173*
Matsumoto castle, 248, 250
Mei-en, 206
Meiji, Emperor, 280, 282
Meiji period, 78, 82, 292
Meiji restoration, 254, 258, 279
Mi Fei, 236
Michinaga *see* Fujiwara Michinaga
Mie prefecture, 34, 190
Mij-Dera, 170
Mikkyō, 120
Mimana (Imna, Kaya), 41, 57
Minamoto family, 133, 139, 193, 202, 203, 210
Minamoto Yoritomo, 140, 162, 177, 187, 188, *198*, 205, 210, 286
Minamoto Yoshitsune, 140
Minchō, 234
Ming dynasty, 213, 221, 279, 286, 290, 308, 309
Mino, 290, 305
mirrors, *28*, *29*, 35, *35*, 64, 78, 110, *112*, *113*
Mito Kōmon *see* Tokugawa Mitsukuni
Mito region, 286
Mitsukuni *see* Tokugawa Mitsukuni
Mitsunori *see* Tosa Mitsunori
Mitsuoki *see* Tosa Mitsuoki
Mitsunobu *see* Tosa Mitsunobu

Mitsuyoshi *see* Fujiwara Mitsuyoshi
Mitsuyoshi (1539–1613) *see* Tosa Mitsuyoshi
Miyajima, 214
Mo-Kuan, 234
Mōko Shūrai Ekotoba, *200–201*, 202, *202–3*
Mommu, Emperor, 78, 85
Momoyama, 243
Momoyama period, 100, 243–76, 282, 301
Mongaku, Priest, 205
Mononobe, 41
Morotoki *see* Hōjō Morotoki
Morse, Prof. Edward S., 9
Motohira *see* Fujiwara Motohira
Mōtsu-ji, 148, 162
mound-building, 27, 57
Munemori *see* Taira Munemori
Murasaki, Lady, 139, 165, 167
Murō, Mt., 124, 129
Murō-ji, Nara, *119*, 124, 129, 133
Muromachi, 213
Muromachi period, 213–40, 308, 312
musical instruments, 110, 113, *114*
Musō Kokushi, *222*, *223*, 230, 234
Mustard Seed Garden, 290
Mutō Shūi, 234
Myō-ō-in, *132*, 137
Myōhō-in, 206
Myōren, 168, 169
Myōshin-ji, *182*, *183*, 266, 274

Nabeshima, 309
Nachi, 177
Nagano, prefecture of, 9, 38, 214
Nagatsune *see* Fujiwara Nagatsune
Nagaoka, 42, 117, 120, 312
Nagasaki, 9, 279, 309
Nagoya castle, 258
Nakamura Kuranosuke, *291*
Nakatomi family, 41, 57
Nakatomi Kamatari, 57
Namban paintings, 202
Nanbokucho period, 213
nanga painting *see* bunjinga painting
Naniwa (later Osaka), 45, 57, 85
Nantai, Mt., 282
Nantō Schichidai-ji, 117
Nanzen-ji, 234, 266, 274
Nara (monk), 193
Nara, 27, 35, 41, 42, 45, 48, 117, 118, 120, 129, 169, 177, 183, 187, 193, 202, 205, 206, 214
Nara period, 67, 75, 85–113, 205
Narita, 135
Narushima Bishamon-dō, 155
Narutaki, 290
Negoro-dera, *185*
Nichiren, 183
Nichiren sect, 183
Nihongi or *Nihon Shoki*, 27, 31, 41, 42, 50, 57, 59, 67
Nijō Detached Palace, 250, *251*, *252–3*, *254–5*, 282
Nikko, 280, 282, 286
Ninsei *see* Nonomura Ninsei
Nintoku, Emperor, 32
Ninsho Chief Priest, 202
nise-e, 205
nishiki, 301
Nitta Yoshisada, 213
Nō drama, 213, 216, 301
Nōami, 236
Nobuharu *see* Hasegawa Nobuharu
Nobunaga *see* Oda Nobunaga
Nobunaga-Ko-Ki, 268
Nobuzane *see* Fujiwara Nobuzane
Nomi-no-Sukune, 31–2
Nonomura Ninsei, 290, 308

Ōbaku, 184
Oda Nobunaga, 162, 213, 214, 243, 250, 252, 254, 261, 266, 270, 312
Odawara Campaign, 243
Ōe-no-Chikamichi, 66–7

Ogata family, 287
Ogata Kenzan, *289*, 290, *291*, 304
Ogata Kōrin, 236, 287–8, *288*, 290, *291*, 301, *310*
Ōguchi Aya-no-Yamaguchi-no-Atai, 48, 51
Oguri Sukeshige *see* Sōtan
Ōita prefecture, 9, 33, 129, 234
Ōjin, Emperor, 29, 32, 41, 133, 187
Ojoyoshu, 140, 146
Okayama castle, 258
Oki Island, 213
Ōkubo Kiheiji, 282
Okumura Masanobu, 292
Okuninushi-no-mikoto, 282
Ōmi code, 85
Ōmi province, 86, 174
Ōnin War, 213, 214, 227
onna-e, 193
Ōno Gorōemon, 187
Oribe *see* Furuta Oribe
ornaments
 kuwagata, 214
 prehistoric, *13*, *16*, 21, 25
Osaka (previously Naniwa), 31, 32, 33, 118, 178, 247
Osaka campaigns, 279
Osaka castle, 254, 270
Osakabe, Prince, 78
otogi-zōshi, 292
otoko-e, 193
Otomo family, 120
Ōu Fujiwara family, 162
Ouchi family, 221, 234
Owari area, 174
Ozaki Hachiman, 129

Paikche, 41, 44, 45, 48, 57
painting
 album leaf, 286
 change in aesthetic of, 288
 fan, 286
 feminine (*onna-e*), 193
 hitsu-yo, 234
 masculine (*otoko-e*), 193
 wash, 164
 see also ink painting; portrait painting; screen painting; silk painting
Perry, Commodore, 280, 297
Phoenix Hall of the Byodo-in, *140–41*, *144–5*, 146, 148, 152, *153*, 154, 155–6, 161
porcelain, 308, *313*
portrait painting, 203, 205, 312
pottery
 designs, 309
 Ko-seto type, *211*
 Korean contribution, 243
 problems in production, 172
 "Six Ancient Kilns", 240
 Sue, 29, 31, 174, 236
 and tea ceremony, 301, 304–8
 three-colour (*san-sai*), 110, *111*
 see also decoration; glazes
printing
 definition, 292
 mica, 295
 multiple-block colouring technique, 292
 subjects, 292
 Western influence, 292
 wood-block, 165, 292

raku, 301
Rashōmon (Rajōmon), 133
Ri Sampei, 308
Rimpa School, 286–7, 290, 312
Rinno-ji, 282
Rinzai, 184
Ritsu sect, 96, 102, 193
Rōben, Priest, 100
Rokuon-ji, 216
Rokurōbei Rengyō, 197, 202
Rurikō-ji, *219*, 221–2
Russo-Japanese War 1904–5, 280
Ryōan-ji, *224*, 227, 230

Ryōgen (monk), 142
Ryōnin, 178

Sado Island, 183
Saeki family, 120
Saga, Emperor, 120
Saga prefecture, 33, 309
Sai-ji, 118, 120
Saichō, Priest, 118, 120
Saidai-ji, 85, 86, 92, 224
Saigyō, Priest, 286
Saigyō Monogatari Emaki, 193
Saihō-ji, 216, *223*, 230
Saikaku, 286
Saishō-ji, 146
Saitama prefecture, 32
Sakai, 276
Sakai family, 287, 290
Sakai Hoitsu, 290
Sakuragaoka, 23
Sakuteiki, 227
Sammaizuka keyhole tomb, 32
Samurai, nature of, 279
Sanage area, 45, 174, 236, 240
San'ami, 236
Sanjō Bussho, 206
Sanjūroku Kasen *see* Hsieh Poets
Sanjūsangen-dō, 206
Sasaki Chōjirō, 305
Satsuma, 309
Sawara, Prince, 117
screen painting, *228–9*, 230, 234, 236, *237*, 261, *265*, *266–7*, 274, 286, 288, 290
scrolls
 earliest, 165, 167
 hand, 274, 276
 hanging, 234
 narrative, 165, 193, 197
 stylization, 193
 types of, 193; *see also* under individual names of scrolls; *yamato-e*
sculpture
 deterioration, 205, 210
 multiple-block technique, 154, 155, 205, 210
 principle of proportions, 154
 realism, 162, 205
 Tōshodai-ji style, 133
 uchiguri, 129
 use of wood for Buddhist images, 129
 warihagi, 133
Seian, 203, 205
Seiryō-ji, 266
Seisui-ji, 214
Sekigahara, 254
Sen no Rikyū, 305
Sengoku period, 213
Senka, 41
Sesshū, *212*, *226–7*, *228–9*, *231*, *232–3*, 234, 236, 274, 290
Sesshū III *see* Togan
Sesson, 236
Seto, 174, 236, 240, 308
Shaka triad, *42*, 48, 50, 60
Shamanism, 34, 44
Shansi, 48
Sharaku, 293, 295
Shiba Kōkan, 297
Shichijō Bussho, 206, 210
Shichijo Ōmiya, 206
Shidaiji, 85
Shiga prefecture, 86, 243
Shigaraki kiln, 85, 86, 90, 117, 240, 308
Shigemori *see* Taira Shigemori
Shigi-san Engi scrolls, 92, *164–5*, *166–7*, *168–70*, 193, 266
Shijō School, 288
Shikoku, Island of, 13, 23, 24, 120, 133, 243
Shimane prefecture, 34
Shin sect, 146
Shin-chōkoku-ji, 222
Shin-daibutsu-ji, 190, 210
Shin-yakushi-ji, 85, 92, 100, 133

Shinano, 222
Shingon, 120, 124, 135, 137, 203, 274
Shino, 290, 308–9
Shinran, 178–9
Shinshō-ji, 135
Shintoism, 25, 42, 59, 64, 100, 120, 131, 133, 156, 165, 170, 268, 288, 290, 312
Shirakawa, 146
Shirakawa, Emperor, 139, 146, 224
Shitenno-ji, *44*, 45, 48, 164
Shizuoka, 24, 210
Shōdo Island, 247, 254
Shōei *see* Kanō Shōei
Shoga *see* Takuma Shoga
Shoin, *258*, *260*, 261, *262*, 264
Shōkoku-ji, 234, 236, 274
Shōmu, Emperor, 75, 85, 86, 90, 96, 110, 111, 117, 193, 216, 312
Shōsō-in, 214, 292
Shōtoku, Empress, 92
Shōtoku, Prince, 42, 44, 45, 48, 50, 51, 54, 59, 60, 63, 64, 70, 78, 82, *83*, 106, 187, 205
shrine
 Hachiman type, 129
 Hie type, 129
 Kasuga type, 129
 Nagare type, 129; *see also* under names of individual shrines
Shūbun, 234, 266
Shukō, 216
Shunjōbō-chōgen, Priest *see* Chōgen, Priest
Shunkō *see* Katsukawa Shunkō
Shunshō *see* Katsukawa Shunshō
Sian, China, 78, 85, 110
silk painting, *132*, *134*, *136*, *154*, *155*, *156*, *157*, *158*, *159*, *161*, *196*, *197*, *198*, 205, *304–5*
Silla, 31, 41, 57
Sino-Japanese War 1894–5, 280
sliding doors, *264*, *269*, 270, 286
Sōami, *224*. *225*, 227, 230, 236
Soēn, 236
Soga family, 41, 57
Soga Kurayamada Ishikawa-maro, 57, 70
Soga-no-Iname, 41
Soga-no-Sukune, 44
Soga-no-Takeuchi, 41
Soga-no-Umako, 47, 48
Sogen, 188, 190
Sometsuke, 309
Sōtan, 236, 264
Sōtatsu, *275*, 286, 288, 290
Sōtō, 184
Sue pottery *see under* pottery
Sugawara, 120
suiboku-ga see ink painting
Suiko, Empress, 41, 42, 48, 54, 214
Suinin, Emperor, 31, 35
Sujin, Emperor, 27, 35
Sujun, Emperor, 48
sumi-e see ink painting
Sumimoto *see* Hosokawa Suminoto
Sumiyoshi, 276
Sumpu castle, 280
Sung dynasty, 172, 203, 205, 234, 290, 308
sūtra mounds, 172, 174
sūtras
 fan-shaped, 164–5
 illustration of, *163*, 164
 Kongocho-Kyo, 135
 Lotus (Hokke-Kyō), 63, 183
 Ninnyō-Kyō, 135
 and pagodas, 250
Suzuki Harunobu, 292, 293

Tachibana-dera, 60, 75
Tachibano-no-Michiyo, 75, 102
Tadahira *see* Fujiwara Tadahira
tahōtō, 135
Taihō Code, 85
Taika Reform, 57, 78

Taima Mandara Engi, 193
Taima-dera, 75, 92
Taimashi, 92
Taira family, 139, 193, 202, 203
Taira Kanefusa, 205
Taira Kiyomori, 139, 214
Taira Masako, 187
Taira Munemori, 139–40
Taira Shigemori, 90, 205
Taishaku-ten, 100, 105, 135, 137
Taiyu-in, 282, 286
Takamatsuzuka tomb, 54, *63*, 67, 78, 80, 82, 108
Takanobu *see* Fujiwara Takanobu
Takao-yama Jingo-ji Ryakki, 205
Takatori, 309
Takauji *see* Ashikaga Takauji
Takayoshi *see* Fujiwara Takayoshi
Takechi (Takaichi), Prince, 78
Takehara tomb, 33–4, *39*
Takezaki Suenaga, 201, 202
Takuma family, 159
Takuma Chōga, 203
Takuma Shoga, *196*, *197*
Takuma Tamenari, *153*, 156, 159
Tamamushi shrine, 54, 60, 75, 78, *79*, *80*, *81*
Tamba kiln, 240, 308
Tamenari *see* Takuma Tamenari
Tanetsuga *see* Fujiwara Tanetsuga
T'ang dynasty, 57, 64, 66, 70, 75, 82, 92, 105, 106, 110, 120, 133, 156, 230, 308
Tankei, 206
Tan'yū *see* Kanō Tan'yū
Tao-lung *see* Dōryū
Taoism, 59, 100, 108, 165, 270
 burial arrangements, 82
 influence on Buddhism, 60, 63
 motifs, 78
tatemono, 31
Taut, Bruno, 285
Tawaraya, 286
tea bowls, 236, 240, *240*, 308
 Oribe type, *276*
 Raku type, *276*
tea ceremony, 216, 224, 240, 301, 304, 305, 308, 312
tea houses, 216, 262, *263*, 277
temmoku see tea bowls
Temmu, Emperor, 38, 57, 66, 75, 78, 85, 94
temples
 jingū-ji, 120
 mountain, 124
 naming, 58
 retirement, 146
 size, 45, 64
 styles of, 188
Tempyō era, 85
Ten-chūshi, 110
Tendai, 100, 120, 124, 142, 146, 164, 178, 179, 183, 184, 203, 282
Tenji, Emperor, 57
Tenjukoku Mandara, *52–3*, 54, 60
Tenryu-ji, *223*, 230, 234
Theravada, 124
Tō-ji, *116*, 118, 120, *122–3*, *126*, *127*, *128*, *130*, 133, *158*, *159*, 210
T'o-pa, 133
Toba *see* Kakuyu
Tochigi prefecture, 32, 213
Tōdai-ji, 67, 75, *84*, 85, 86, *87*, 90, 92, *92*, *93*, 94, 96, *98*, 99, 100, *101*, 102, 105, 107, 110, *111*, *112*, *113*, 113, *114*, *115*, 129, 133, *178–9*, 187, 188, 190, 193, 202, 206, 210
Tōfuku-ji, 234
Tōgan (Sesshu III), 274
Tōhaku *see* Hasegawa Tōhaku
Tohoku, 155, 236, 243
Tokimune *see* Hōjō Tokimune
Tokiyori *see* Hōjō Tokiyori
Tokoname, 236, 308
Tokugawa, 78, 213, 243, 254, 258, 261, 274, 279, 282, 285, 286, 312

Tokugawa Hídetada, 279, 280, 286
Tokugawa Iemitsu, 279, 280, 282, 292
Tokugawa Ieyasu, 243, 252, 254, 258, 274, 279, 280, 282, 286, 287
Tokugawa Mitsukuni, 286
Tokyo, 9, 22, 162, 282
tombs
 decorated, 33
 keyhole, 27, 32
 see also under name of individual tomb
Tonioka Tessai, 292
Tori Busshi, *42*, 48, 50
Torihama shell mound, 21
Torii Kiyonaga, 292–3, 295
Toro, 24
Tosa Mitsunori, 276
Tosa Mitsuoki, 276
Tosa Mitsunobu, 266, 274, 276
Tosa Mitsuyoshi, 276
Tosa province, 274
Tosa school, 193, 270, 274, 286, 290, 292
Tosa Yukihoro, 274
Tōsei Eden, The, 197, 202
Toshihito (Hachijo-no-miya; Katsura-no-miya), 261, 262
Toshiro *see* Kao Shirōzaemon
Toshitada, 261, 262
Tōshōdai-ji, 92, 94, *94–5*, 96, *96*, *97*, 100, 102, *103*, *104*, 105, *109*, *121*, 133, 146, 197, 202
Tōshōgū shrine, 129, *278*, *280–81*, 282, *283*, *284–5*, 285–6
Toyotomi Hideyoshi, 214, 243, 254, 258, 261, 270, 274, 279, 286, 309
Toyura palace, 41
Tsu-Yüan *see* Sogen
Tsunayoshi, 286
Tsurogaoka Hachiman Shrine, 187
Tsushima, 177
Tsutaya Jūsaburō, 293
Tun-huang, China, 48, 107

uchiguri, 129
Ueda, 222
Uesugi family, 210
Uesugi Shigefusa, *199*, 210
Uji, 139, 142, 146, 154, 184
ukiyo-e, 292, 312
ungen, 107
Unkei, *191*, *192*, 206, 210
Unkoku-an, 234
Usa Hachiman, 129
Utagawa Hiroshige *see* Andō Hiroshige
Utagawa Toyohiro, 301
Utamaro *see* Kitagawa Utamaro
Utsubo Monogatari, 165

Wa, 24, 34
Wadō era, 67
Wakakusa-dera *see* Hōryū-ji
Wakayama prefecture, 120
wall paintings, 33–4, *39*, 54, *63*, 78, 80, 82, 107, 108
warihagi, 133
Watanabe Shikō, 290
weapons, *13*, *20*, *21*, 22, 23, 214
weaving, 113, 301
Wei dynasty, 48, 50, 133
writing system, 312
Wu-an Pu-ning *see* Gottan Funei

Xavier, St. Francis, 279

Yakushi-ji, *60–61*, *62*, 66–7, *68–9*, *70*, *71*, *73*, *76*, *77*, 82, 85, 86, 106, 107, *108*, *131*
yamachawan, 236, *240*
Yamada-dera, 57, 67, 70–71, 75
Yamaguchi prefecture, 190, 210, 234
Yamana Sōzen, 227
Yamanashi, 133, 183
Yamatai, 24
Yamato period, 23, 24, 27–38, 152, 312

Yamato-e, 139, 159, 161, 165, 203, 274
Yasaka shrine, 129
Yasuhira *see* Fujiwara Yasuhira
Yawatachō, 187
Yayoi period, 22–5, 27, 29, 110, 312
Yaoi-chō, 22
Yōgen-in, 286
Yokohama, 9
Yōmei, Emperor (Tachaibana-no-Tokoyo), 41, 48, 60, 92
Yorimichi *see* Fujiwara Yorimichi
Yoritomo *see* Minamoto Yoritomo
Yōrō Code, 85
Yōrō era, 67
yoroi, 214
Yosa Buson, 290
Yoshiaki *see* Ashikaga Yoshiaki
Yoshigo shell mound, 21
Yoshihisa *see* Ashikaga Yoshihisa
Yoshikane *see* Ashikaga Yoshikane
Yoshimasa *see* Ashikaga Yoshimasa
Yoshimitsu *see* Ashikaga Yoshimitsu
Yoshimochi *see* Ashikaga Yoshimochi
Yoshino, 41, 67, 177, 213
Yüan dynasty, 234
Yuima, *176*
Yukihiro *see* Tosa Yukihiro
Yukimitsu *see* Fujiwara Yukimitsu
Yukinari *see* Fujiwara Yukinari
Yun-Kang caves, 48
Yūryaku, Emperor, 29, 32, 33, 38
Yūzūnembutsu, 178

Zen Buddhism, 47, 183–4, 187, 203, 268, 290, 301
 and ink painting, 230, 234
 and sculpture, 205
 and secularism, 266, 268
 and tea drinking, 216
Zenkō-ji, 210
Zenshō-ji, 146
Zō-Tōdaiji-shi, 94, 96
Zōjō-ji, 282

13021
£40·00
12/3/86